JOHN F. PILE Interior Design FOURTH EDITION

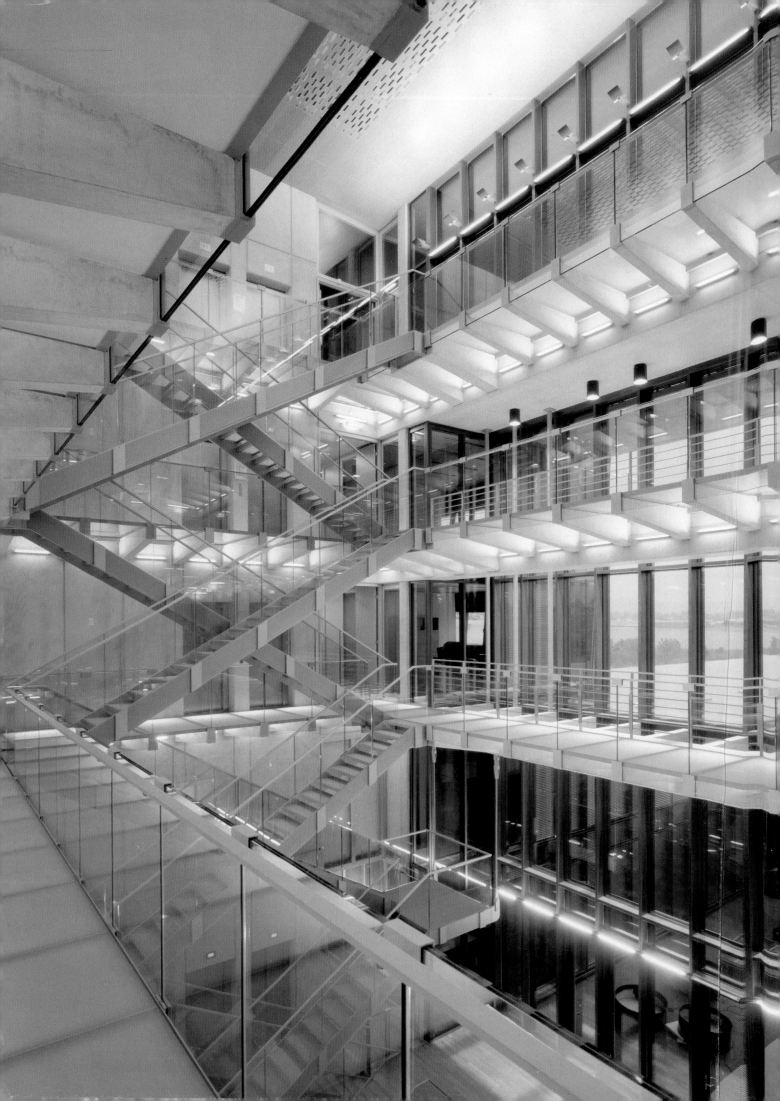

John F. Pile # Interior Design Fourth Edition

PEARSON
Prentice Hall

UPPER SADDLE RIVER, NJ 07458

Library of Congress Cataloging-in-Publication Data

Pile, John F.
 Interior design / John F. Pile—4th ed.
 p. cm.
 3rd ed. published as: Interior design: an introduction to architectural interiors. 1982.
 Includes bibliographical references and index.
 ISBN 0-13-232103-3 (case)—ISBN 0-13-240890-2 (pbk.)
 1. Interior decoration. 2. Interior architecture. I. Friedmann, Arnold. Interior design.
 II. Title.

NK2110.F678 2007
729—dc22 2006050317

Editor-in-Chief: Sarah Touborg
Editorial Assistant: Jacqueline Zea
Senior Managing Editor: Lisa Iarkowski
Manufacturing Buyer: Sherry Lewis
Director of Marketing: Brandy Dawson

Credits and acknowledgments of material borrowed from other sources and reproduced, with permission, in this textbook appear on page 595–6.

Pearson Education Ltd. Pearson Education, Canada, Ltd.
Pearson Education Australia PTY, Ltd. Pearson Educación de Mexico, S.A. de C.V
Pearson Education Singapore, Ptd. Ltd. Pearson Education–Japan
Pearson Education North Asia Ltd. Pearson Education Malaysia, Pte. Ltd.

 This book was designed and produced by
Laurence King Publishing Ltd, London
www.laurenceking.co.uk

Every effort has been made to contact the copyright holders, but should there be any errors or omissions, Laurence King Publishing Ltd would be pleased to insert the appropriate acknowledgment in any subsequent printing of this publication.

Editor: Richard Mason
Picture Researcher: Fredrika Lokholm
Designer: Mark Holt

Front cover: Olympic Tower Residence, New York, 2004, by Michael Gabellini. Picture credit: Copyright © Paul Warchol Photography, Inc.

10 9 8 7 6 5 4
ISBN 0–13–240890–2

Topical Outline

Contents

chapter one. Introduction

In our modern, technological world, most of us spend a major part of our lives indoors. In the nature of things, home means an indoor place—a room, an apartment, a house, a mobile home, even a trailer or a van. We study in schools and colleges, eat in restaurants, and work in shops, factories, or offices. We are born in hospitals and may die there, too. While most of us spend time out-of-doors, walking from one place to another, attending or participating in sports events, enjoying a garden, sailing, hiking, or even camping for a more extended period, these all tend to be brief interludes in lives spent largely inside human-created structures.

Some working careers still entail being outside—on a farm, on construction sites, or on a mail-delivery route. Statistical evidence, however, suggests that work of this kind is decreasing, while office work and indoor activities are on the rise. Even today's farmer may ride in the enclosed cab of a tractor, while the mail may be delivered from a car or truck. When we travel, we say that we are going "out," but cars, trains, buses, ships, and airplanes are almost as totally enclosed as buildings. Even wilderness camping is likely to involve a significant amount of time spent inside a comfortable and often beautiful tent.

If we estimate the portion of an average day spent inside some sort of enclosing space, we will probably find we typically spend about 90 percent of our time inside, with only 10 percent outside (except, perhaps, on vacation, when the balance may tip closer to 50-50). However much we may love nature, most of us must face the reality that modern life goes on, most of the time, inside. If we

are to be honest, we must also face the reality that many of the inside spaces where we spend our time are unsatisfactory. The rooms, corridors, and lobbies of typical schools, hospitals, offices, shops, and factories are often crowded, disorganized, unattractive, and depressing. We commute in trains or buses that are often agonizingly uncomfortable. At home, where interiors should be the way we want them, limitations often lead us to settle for compromises.

It can be an interesting exercise to make a rating chart evaluating the quality of the various indoor spaces in which we spend time, with, for example, a scale of 1 to 10 representing the range from worst experience to ideal. It is a fortunate person who reports an average much above 5. How does it come about that we subject ourselves to being shut up inside so many spaces that are so far from ideal—even downright unpleasant? We have, after all, constructed the enclosures that we live and work in and have done so, presumably, to make life better.

Obviously, any enclosure serves several basic purposes. It protects us against the weather; it provides privacy; it gives us places where we can keep the things we need in some more or less convenient relationship. While enclosure is basic to these needs, it is only a first necessity. Within enclosure we need equipment; places to sit and lie down; surfaces where food and drink can be prepared and served; places for work, reading, conversation, and entertainment. Increasingly, most of these activities demand special technology—for storage and communication; for cooking and refrigeration; for reproduction of sound and image.

1.1 The work that goes into creating a successful interior is masked by the simplicity of this living area in Riverbend House, Great Falls, Virginia. The Egyptian metal pots on the fireplace ledge and the Le Corbusier chaise covered with pony skin, also used as an area rug, soften the rectilinearity of the architectural elements. The designers were the sister team Hariri & Hariri–Architecture. (Photograph: © Jeff Goldberg/Esto)

The Development of Interior Design

Historically, most interiors were put together, and put together very successfully, as a natural part of the process of building structures. Ancient and still-surviving indigenous societies developed various forms of huts, tents, igloos, tepees, and yurts to solve the problems of shelter in a particular climate with particular available materials. They then simply took their few possessions inside, much as we might arrange ours in a tent while camping. The resulting interior was practical and often, in its own way, handsome.

Developing civilizations found appropriate ways of building more elaborate structures, which created their own kinds of interior space. One cannot think of a Gothic cathedral's interior apart from the structure of the building itself, and the glass, additions of carved wood, and other decorative elements create a consistent whole, inside and out. At least until modern times, cottages and farm buildings were always designed and built according to traditions that took into account the occupants' way of life. The furnishings evolved from similar traditions, creating interiors thoroughly compatible with both the enclosing structures and the inhabitants' needs and customs.

It is with the development of more elaborate buildings for aristocratic, often royal, owner-occupants that the idea of an interior as a designed unit, comparable to a fashionable costume as an expression of wealth and power as well as taste, emerged. The design professions began to take form in the Renaissance as strictly traditional practices yielded to a more personal way of thinking about design of every sort. Modern industrial society has added tremendous technical complications, both in the nature of buildings themselves and in the variety of specialized purposes that buildings are expected to serve.

Whatever the gains and losses of our modern civilization, we are clearly not likely to turn back to simpler ways of life; our modern habits of living indoors are destined to remain the norm. This gives us a powerful motive for attempting to make the indoor spaces we occupy as satisfactory, useful, pleasant, and generally supportive as possible. Since this seems overwhelmingly obvious, it takes some questioning to discover why we must so often settle for spaces that fall so far short of these goals.

Every situation will suggest its own list of reasons—historic, economic, social, technical, or various combinations of such realistic pressures—but many of these explanations will turn out to be, on close examination, excuses. As a society, we have overcome historical, economic, and technological hurdles to attain all sorts of astonishing achievements. We are able to travel in outer space, communicate instantly over vast distances, manipulate staggering masses of data automatically—in fact, we can, almost as a matter of course, do any number of things once considered miraculous.

We are also able to create spaces in which people can live comfortably, work well, and have pleasant experiences, as a large number of examples can demonstrate. These examples remain

extraordinary, however, in a world in which our artificial environments are all too often anything but comfortable and pleasant. We have lost connection with traditions that provide familiar, accessible answers to the problems of living space, and our industrialized civilization has done poorly at providing worthwhile alternatives.

We seem to suffer from some limitations in thinking, from a sort of block that makes us indifferent to our environment or, when we are not indifferent, that makes us inept to a degree that would never be tolerated in factory production, in financial management, or in scientific research. Towns, cities, and (often worst of all) suburbs are allowed to grow in chaos or to fall into decay. Buildings are erected with some care for their technical qualities (structural strength, mechanical systems) but with only the most minimal attention to design in any larger sense. In fact, the primary motivation for building is sometimes the quick profit rather than any concern for real use over a longer term. The spaces inside such buildings often limit the possibilities for making truly satisfactory settings for living or work.

Even when we build with good motives—schools, hospitals, other public buildings, or houses for our own occupancy—it often seems that the complicated tasks of putting together good interior spaces are botched in any number of ways. Because they are so familiar, the things that make up an interior space—an office, a living room, a bedroom, a kitchen—seem obvious and easy to arrange. All the evidence shows that this is not so. An interior turns out to be a very complex entity made up of many elements that, to be successful in terms of usefulness, comfort, and beauty, must somehow work together.

Probably the great majority of residential interiors are arranged by their occupants. Offices and other working spaces are also designed, at least to some degree, by the people who use them. While this is most likely among the self-employed or among people who work at home, even business offices are frequently designed, or at least modified, by their user-occupants. Quite standard offices often provide for some level of personalization, which allows the user to adjust the interior to his or her tastes.

It is a reality that a very large number of interiors can hardly be said to have been designed at all. Many people live in interiors composed of rooms left as they found them plus some paint from the painter's standard color card, rugs and curtains inherited, borrowed, or casually picked out at a local store, and furniture acquired in one way or another set about in any way it will fit in. With luck, the results may have some level of rough-and-ready comfort; more often the space is disorganized, inconvenient, and uncomfortable, if not depressing and unattractive.

If this is true of living spaces whose occupants are in full control, it is not surprising that public spaces fare even worse. Too many small shops and offices, restaurants and luncheonettes, school and college classrooms, hospitals, factories, airport terminals, and bus stations turn out to be chaotic jumbles of unrelated elements that seem to have no connection with the advanced civilization that has produced them.

Our modern world is also full of spaces that have been designed with some effort and concern, but with effort that has been misdi-

1.2 →

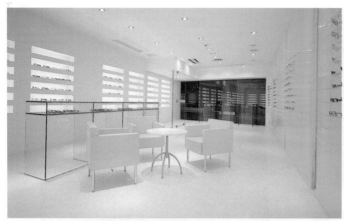

← 1.4

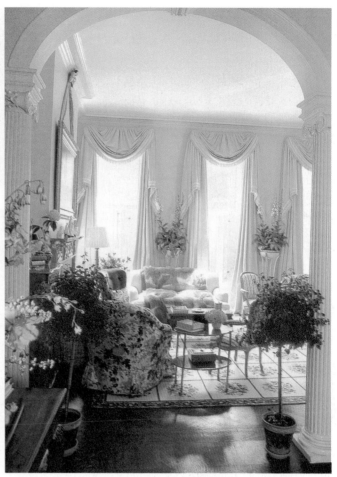

1.3 →

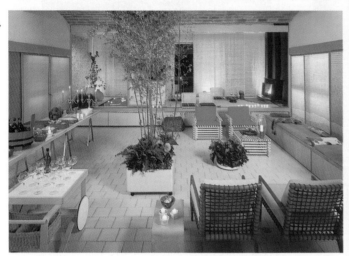

rected. Restaurants and shops, hotels and motels, offices and public buildings usually reflect some attempt at design, but it is often aimed at promoting some product or service and at pleasing what is thought of as "public taste"—defined as a lowest common denominator. Many motel interiors and fast-food outlets exemplify this kind of misguided design effort, which often relies on busy patterns, harsh color schemes, and fussy details. Exceptions to this rather gloomy evaluation of our current norms for interior design exist, but they are few. We have to seek out fine buildings and strain to remember offices, restaurants, and, particularly, homes that can truly be described as well designed.

When interiors are well designed, the success is rarely the result of chance. Most good interiors result from one of two approaches. The first approach is the use of skilled, talented, and well-trained professionals (figs. 1.2–1.4). We turn to experts for medical treatment, for financial guidance, even for automobile repair. We accept the idea that becoming a good cook, an able tennis player, or a passable musician will take study and practice. The same attitude should govern our approach to interior design, which must deal with furniture and lighting, color and layout, storage and art, among other elements.

The second approach, by untrained private individuals, is to learn something about what it takes to design an interior well and to give careful thought to the decision-making necessary (fig. 1.5). Becoming a qualified professional takes as much effort as becoming qualified in any other complex field, but learning to deal with the typical interior problems of home and office is within the reach of any interested person who wants to take the trouble.

The Practice of Interior Design

The term *interior design* has come to describe a group of related projects that are involved in making any interior space into an effective setting for whatever range of human activities are to take place there. It can be the name of the profession that concerns itself with these matters, but that profession is not as clearly defined as that of lawyer or doctor. Many people may contribute to the interior design of large and complex spaces.

1.2 Minimalism, glass, and limited but strong color create a striking interior at Poker Face, an optical shop in Tokyo, Japan. Design was by Studio 80/Shigeru Uchida, Tokyo. (Photograph: Tashi Asakawa) **1.3** The New York loft living space shown here set up as for a buffet supper was designed by textile designer Jack Lenor Larsen for his own use. The platform in the distance, ordinarily used for daybeds, has been cleared, the beds stored under the deck. Charles Forberg was the architect. (Photograph: Robert Grant, courtesy Larsen Design Studio)

1.4 The living room of a New York town house with such architectural details as classical moldings and mantel and Ionic columns supporting an archway has been treated in a timeless, traditional manner. The furniture, carpet, window treatment, and color scheme all suggest comfort and informality within a formal setting. Mario Buatta was the designer. (Photograph: Edgar de Evia)

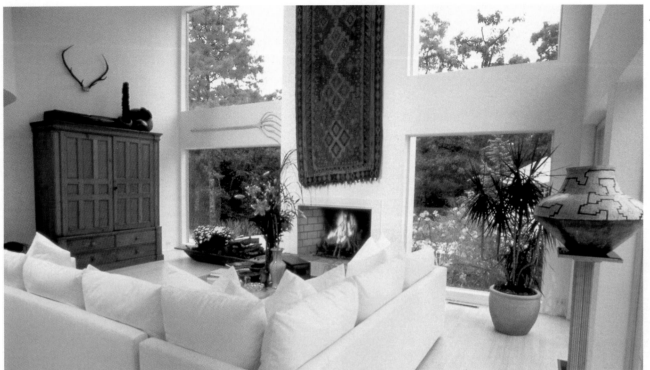

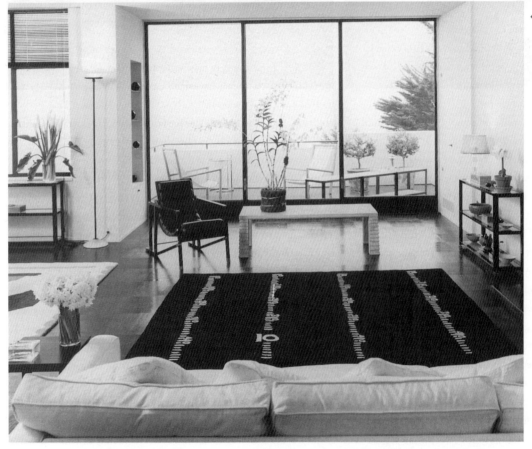

1.5 A living room in an austere modern house becomes a comfortable environment, rich with plants and a lively mix of attractive objects, including Native American pottery, a Turkish kilim rug (above the fireplace), an antique cabinet, and objects from a collection of old tools. Robert Luzzi, a graphic and package designer, acted as his own interior designer for this summer house in East Hampton, New York. (Photograph: Anthony Penninato, courtesy *Metropolitan Home*) **1.6** Elegance and reserve, hallmarks of the work of interior designer Andrée Putman are evident in this living area of a San Francisco apartment. The rug is a design of Eileen Gray. (Photograph: © Grant Mudford, courtesy *House & Garden*)

This book is concerned with exploring the issues that all interior designers, whether professional or amateur, must face. No book can pretend to offer a complete professional design education, but the basics are provided here in a way that can serve as a beginning for a professional design education, as a framework for dealing with one's own living and working situations, and as a background for selecting and working with design professionals if and when that turns out to be a wise course of action.

Making decisions about what interior design problems to deal with alone on a "do-it-yourself" basis, about when to call for professional help, and about when to consider turning professional oneself is not always as simple as it might seem. Many of the bad interiors we have referred to are the result of wrong decisions on these questions. The best way to begin looking at these issues is to consider the way in which the field is currently organized, into a maze of overlapping (and sometimes conflicting) specialized trades, professions, and practices.

Until recently, the practice of interior design had not been controlled by any legal restrictions. State laws establishing regulations similar to those in effect in many European countries that require the *professional* interior designer to meet some standards of competence are on the increase. (See discussion below and Appendix 7, "Professional Organizations.") Except where such new regulation has been adopted, anyone is free to design interiors and even to establish a professional business in the field without any qualifications beyond the necessary level of self-confidence. This situation contributes to the rather confusing nature of the field, in which many designers with varied backgrounds and with varied professional titles work on whatever projects they can sign up. The following listing sorts out and identifies the various professional titles in use in the interior field and defines what each title usually describes.

DECORATOR (OR INTERIOR DECORATOR)

The term *decorator* is the designation most widely used and understood by the general public today. The title, which gained currency in the late nineteenth and early twentieth centuries, applied to the large group of designers who were specialists in putting together interiors in the various traditional styles (Colonial; Louis XIV, XV, or XVI; Tudor; Georgian; or even "modernistic," for example) that it became popular to imitate. The term implies a focus on the decorative, ornamental, and movable aspects of interior design: color, furniture, rugs, drapery, and the fixed details of moldings, paneling, and similar small elements that can be introduced into an existing space with relative ease.

Many decorators were also dealers in the elements used in interiors, buying and reselling furniture and rugs and contracting for whatever on-site work needed to be done to pull together a finished project. This latter practice called into question the decorator's status as an independent professional, and with a decline in the emphasis on traditional stylistic work, the term has tended to take on some negative implications. At best, a decorator can produce work of top quality, but self-appointed decorators who may simply be painting contractors or salespeople in drapery outlets have discouraged others from using the term. Most decorators now prefer to call themselves interior designers, although it is more accurate to reserve that term for work approached in a somewhat different way, as described below.

INTERIOR DESIGNER

The term *interior designer* describes a professional approach to interiors that puts more emphasis on basic planning and functional design that *decoration* implies. In Europe, the term *interior architect* refers to designers who deal with the basic organization of spaces, lay out room arrangements, and manage technical issues (such as lighting and acoustics), much as architects design entire buildings. In the United States, where the term *architect* is legally limited (as described below), *interior designer* has become the accepted term for this kind of practice (fig. 1.6). Interior designers may work as individuals, in partnerships, or in firms that can grow quite large (with dozens of staff members). These last tend to work on larger projects in commercial, institutional, and office areas. The term *contract design* is also used for this type of practice. It refers to the fact that components and construction work are arranged for under contracts, not simply bought at retail.

Specialization is an increasing fact of life in interior design. Some modern design fields, such as healthcare facility design, have become so complex as to demand specialization. Other fields, such as office design, do not require specialization but have nevertheless attracted a specialized practice.

SPACE PLANNER AND OFFICE PLANNER

Firms providing space and office planning handle the development of large corporate and institutional offices that fill whole floors, many floors, or entire buildings with offices and their related services. Since office buildings are usually constructed as floors of open, undivided space, layout planning becomes an important first step in their design.

Many interior design firms, particularly those specializing in the office and healthcare fields, provide space planning as an integral part of their services. There are also specialized space planners who concentrate on this phase of project planning without moving on into interior design itself. Such planners are sometimes employed before interior design services have been contracted for. Their space planning work helps clients in selecting space to be occupied and becomes part of the information supplied to the interior designers as a basis for their ongoing work.

In addition to these professionals who specialize in interior design, several other design professions overlap the interior field, sometimes providing interior design. These include the following.

ARCHITECT

An architect must have formal training and experience and must pass an examination leading to *registration*, a type of license to

practice. Trained in basic building construction, architects are prepared to design buildings from the foundation up. In many cases, the architect's design includes many interior elements: room shapes, door and window locations, details and selection of materials, and such elements as lighting, heating, air-conditioning, plumbing, and related fixtures.

Traditionally, architects provided fairly complete interior design, sometimes stopping short of furniture and decorative elements and sometimes including these as well. In modern practice, architects design some buildings as shells (office buildings, for example), leaving the interior design to others. In other situations—a museum, church, school, house or apartment, for example—they provide complete interior design (see figs. 1.1, 1.7–1.9). Some large architectural offices (a few employ hundreds of designers and other specialists) include departments that are actually complete interior design firms within the larger organization.

INDUSTRIAL DESIGNER

Designers or design firms specializing in industrially manufactured objects typically work on *products*, such as appliances, furniture, machinery, and automobiles. Some products of industrial design, such as furniture, hardware, and light fixtures, become elements used in interior design. Since industrial designers also deal with the interiors of automobiles, trains (fig. 1.10), ships, and aircraft, many go one step further to design shops, restaurants, and similar projects. *Exhibition design*, although sometimes considered a specialized type of interior design, often comes within the province of industrial designers.

OTHER SPECIALISTS

In addition to the professional interior design fields described above, a number of specialists may make contributions to interior design projects in specific, limited ways. Although architects can and do undertake complete interior design assignments, they also often participate in the work of interior designers as consultants. This occurs when an interior project involves structural changes (moving a wall or adding a staircase, for example) or when the technical problems extend beyond the scope of the interior designer's training. Legal restrictions in many localities call for *filing plans* with a building department—plans that must be prepared by an architect or engineer to assure that a licensed professional is taking responsibility for the safety of the project and its compliance with all legal requirements. The interior designer may retain an architect to deal with these matters.

Both architects and interior designers turn to the still more specialized professional skills of engineers to manage complex and extensive technical issues. Among the many areas of specialization, *architectural engineers* are concerned with the structural and mechanical engineering of buildings. *Structural engineers* are required for larger buildings with a complex framing of steel or concrete. Designs for simpler structures are often checked by an engineer to assure sound construction. *Mechanical engineers* deal with the plumbing and electrical systems of buildings; heating, ventilating, and air-conditioning systems (known as HVAC); and such elements as elevators and escalators. Interior designers may turn to engineering consultation for help with such matters, or they may work through an architect to obtain engineering advice. Many larger architectural offices employ on-staff engineers. Engineers may file plans for legal approval and often design such buildings as factories and powerhouses.

Other consultants may contribute to interior projects. *Lighting consultants* plan good functional lighting for offices and schools or attractive lighting for stores and restaurants. They are often helpful in aspects of residential design work. *Acoustical consultants* deal with problems of noise (in a restaurant or cafeteria, for example), of obtaining good sound in a theater or concert hall, and of eliminating undesirable sound transmission through walls and floors. Some consultants are experts in specific types of spaces—hospitals, restaurants (and their kitchens), or theaters. Others deal with certain kinds of problems—furniture design, signs and graphic elements, or particularly when a major collection is being built up, the selection of works of art. Some large projects may involve almost every one of the specialists and consultants mentioned here, while many small projects may be the work of one designer throughout or may draw on one or two brief sessions with a consultant. Every designer needs to understand these various fields and to know when and where to seek specialized help.

RESIDENTIAL AND CONTRACT DESIGN

Interior projects can be divided into two broad classes, each with its own character. Some designers work in both areas, but most choose to concentrate in one field or the other. *Residential design* is concerned with projects that vary from small to medium in size. Even a large apartment or house is within the scope of an individual designer, possibly with an assistant or two. Residential design can be taken up by working on one's own room, apartment, or house, and then moving on to work for friends or relatives before becoming fully professional. Residential work tends to be particularly personal, with rapport between designer and client, a shared taste and point of view, being vital to success. It is work that calls for patience and a willingness to be involved in detail, often detail so small as to be troublesome. Many larger firms avoid residential work, finding the problems of client relationships and the level of detail too demanding in relation to the fees that can be charged. This remains an area in which, under favorable conditions, a designer can find opportunities for personal expression in varied and interesting projects (figs. 1.11–1.12).

Contract design, referring to more public spaces for commercial and institutional use, tends to generate larger projects (fig. 1.13), with clients ranging from individuals to large corporations or institutions. As mentioned above, contract design includes the selection and distribution of elements such as furniture, textiles,

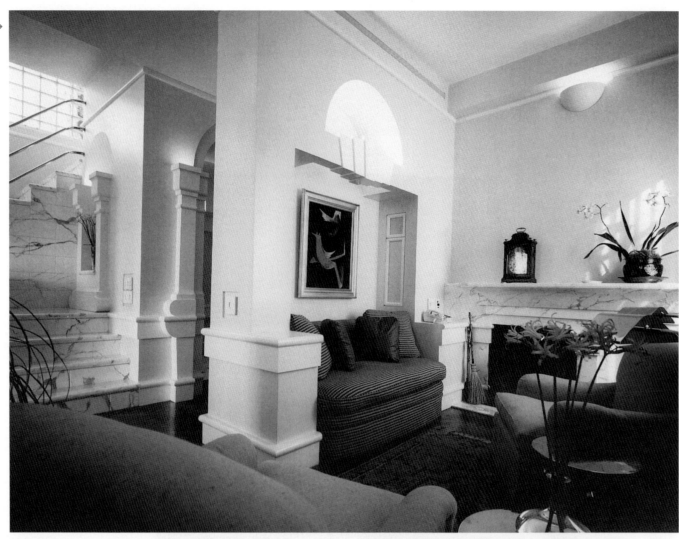

FLOOR PLAN

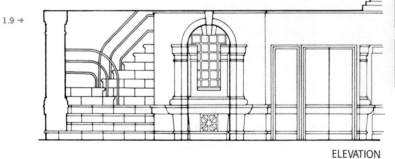

ELEVATION

1.7, 1.8, 1.9 Robert A. M. Stern Architects designed a large and elaborate duplex apartment in a 1920s New York landmark residential building. Figure 1.7 shows a small, parlorlike sitting room at the entrance to the apartment; a stairway across the hall leads to the upper floor.

The 1980–82 mix of modern architectural elements and more traditional details is in keeping with the building's eclectic style. In the plan of the apartment (fig. 1.8), the room illustrated is shaded. Fig. 1.9 depicts the hallway in elevation. (Photograph: Jaime Ardiles-Arce)

1.10 The inside of a vehicle for transportation—whether car, bus, train, or airplane—is as much a designed interior as any office, restaurant, or living room. In this passenger car of the Narita Express in Japan, the angled planes of the ceiling, the patterning of the seat upholstery, the

trim around the doorway at the end of the car, and the placement of lighting are effective design elements. Eastern Japan Railway Company was the designer. (Photograph courtesy Eastern Japan Railway Company)

← 1.11

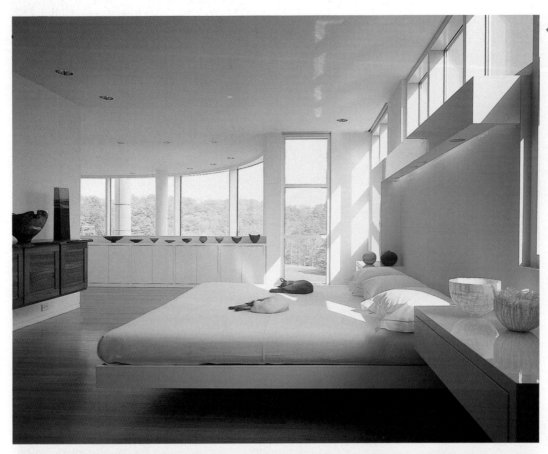

← 1.12

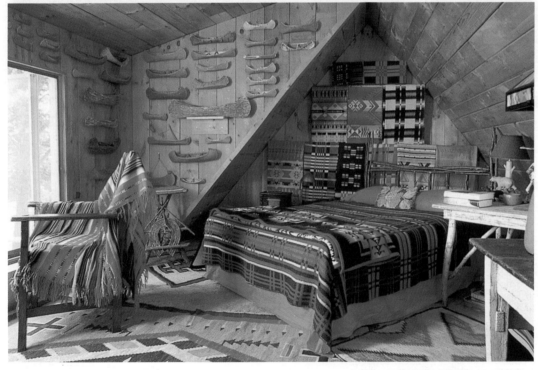

1.11, 1.12 Residential interiors can express any number of styles or attitudes, as demonstrated here by two bedrooms. The Minimalist austerity of a bedroom in the Grotta House in northern New Jersey (fig. 1.11), designed by architect Richard Meier, is softened by a collection of wood bowls by Bob Stocksdale, Del Stubbs, and Tapio Wirkkala. (Photograph: © Scott Frances/Esto, courtesy *House & Garden*) Collections of Navajo rugs and model birch-bark canoes in a Maine bedroom (fig. 1.12) add to the warm, rustic quality of the handmade timber house. The house is the work of builder John McLaughlin and owner-designer Carl Palazzolo. (Photograph: © Michael Mundy, courtesy *House & Garden*) **1.13** The MO Bar in the Landmark Mandarin Oriental hotel, Hong Kong, features a different setting from day to night. A stainless-steel lily pond hides a sunken liquor display during the day, making the bar area a breakfasting arena. At night the water is drained, the lily pond raised, and a lively bar becomes center stage. (Courtesy Tihany Design)

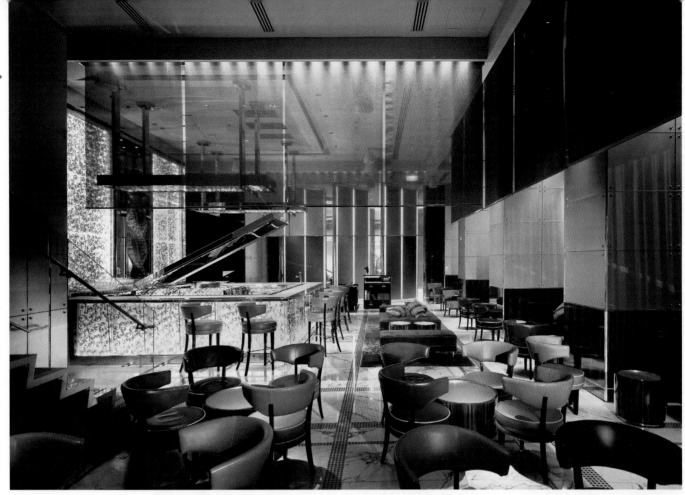

and light fixtures purchased under contracts rather than through retail channels. Because their needs and demands are less personal than those of residential clients, larger organizations are often represented by committees or by various individuals, possibly presenting communication problems to the designer. (The many types of contract design projects are reviewed in more detail in Chapter 17, "Public Interiors.") Specialization is most likely to develop in this kind of work, although larger design firms often manage involvement in a varied range of projects. The size of projects, their long duration, and the large fees involved make undertakings of this sort attractive to larger design firms.

For the interior design problems of public spaces, for hotels and motels, for restaurants and offices, schools and hospitals, people have come to realize that there is no alternative to the employment of top professionals from the appropriate design fields (fig. 1.14). The same attitude—that interior design is a complex endeavor requiring knowledge of its elements and how they fit together— would well serve residential interior design. While hiring the top professional talents is not always economically feasible, it is not necessary to settle for the lowest common denominator or make do with whatever is offered ready-made. Neither is it necessary to spend a great deal of money or follow the advice of the magazines on the newsstand. Putting together comfortable, even beautiful, interior spaces takes some effort and deserves some thought and study, but it is not a process out of the reach of anyone who will take the time to learn what is involved.

It is helpful to become aware of all the design around us in order to assess its quality and to reject bad design, even when it is com-

mercially successful and attractively packaged. A first step toward this goal is to turn away from the bulk of consumer-oriented material, both published and manufactured, in favor of publications and sources directed toward professional designers. Anyone can read professional books and magazines and visit contract showrooms, which present a world very different from the one displayed and promoted in furniture stores and consumer magazines. Becoming familiar with the books, exhibitions, and literature that interest professional designers and architects soon leads to a growing "feel" for quality in every aspect of design work. General knowledge can then be applied to the specifics of actual interior design work. In this way, those interested in the field may choose to step over the line from the role of consumer, user, and critic and to enter the world of working, creative design.

Professional Preparation

An interest in interior design usually begins with familiar problems in a home or office. Young people often design their own rooms at home or in a dormitory. Householders make choices of furniture, color, and materials for their own apartments or houses. Books such as this one can often provide the information needed to deal with home projects of modest extent. If the results of such efforts are admired and if the process has been interesting and enjoyable, thoughts of turning professional may come to mind. There are several routes into professionalism, and all involve training of one sort or another. Historically, the most

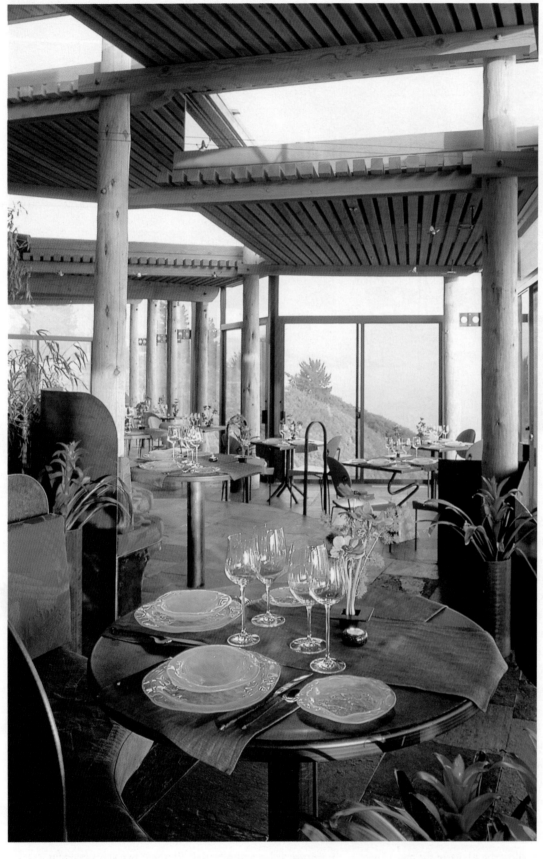

1.14 At the Sierra Mar Restaurant of the Post Ranch Inn, a resort in Big Sur, California, every table has a view of the ocean. Wood posts and clerestory windows in this cliffside space provide a strong sense of connection with the outdoors. The resort was designed to minimize violation to the site, and only one tree was cut down to make room for buildings. Mickey Muennig was the architect and Janet Gay Freed the interior designer for this project. (Photograph: © Larry Dale Gordon 1992)

common training involved working for a successful interior designer. Whether through a formal apprenticeship or simply by getting a job as an assistant to a designer, the real-life experience of working on projects can gradually build the skills that professional design work demands.

The path to professional practice more frequently begins with training at the college level in an art or design school, community college, or at a university. Although almost every college offers some courses in interior design, a few courses taken as electives or in an adult-education program can do no more than give a general overview of what full professional training involves. Institutions that grant a bachelor's degree in interior design usually require four years of regular college courses, including some liberal arts subjects and art history, in addition to a variety of courses in design itself. The content of such a program includes "design" studied through the use of a sequence of problems, as discussed in Chapter 6, "Planning," plus a number of courses in such specific subjects as color, materials, furniture, lighting, construction, and professional practice. A complete degree program of this kind is offered by many institutions with an art or architecture department and by some schools that teach design only but have an affiliation with a liberal arts college.

The quality of programs and their emphases vary considerably. Accreditation by the Foundation for Interior Design Education and Research (FIDER) indicates that a school program meets certain minimum standards of excellence. Correspondence courses and programs that do not meet FIDER standards are generally inadequate. Anyone who has received a bachelor's degree in some other field can consider graduate programs in interior design offered by some institutions. These programs usually require two or more years of work and stress design subjects presented at a level more advanced than in undergraduate courses. A master's degree in interior design offered in such programs can also be obtained by students whose undergraduate degree is in interior design.

Another road to professionalism involves study in an architecture school leading to either a bachelor's or master's degree in architecture. Architectural training emphasizes building construction and technology and concentrates on the design of complete buildings, which leads to limited treatment of the more specialized aspects of interior design. Many graduate architects become interested in interiors and make up for what their training omitted through their own study and experience. Although a number of architects feel fully qualified to design interiors, most focus on the total design of buildings and often refer the interior design aspects of projects to specialists, either designers employed by their offices or independent interior designers.

Successful completion of interior design training is normally followed by a period of employment in an interior design firm or in the interior design department of an architectural office. Working on real projects under supervision rounds out training and prepares a designer to take on professional assignments.

Licensing and Registration

The adoption, by a number of states, of licensing laws pertaining to the practice of interior design is one of several factors contributing to the increasing professionalism of the field. Doctors, lawyers, engineers, architects, and many other professionals must be licensed to practice their professions. The basis for such legal requirements is the realization that the health, safety, and welfare of their clients are influenced by the skill and responsibility of these professionals. Although in the past it was commonly thought that the work of designers, dealing solely with the aesthetics of color and ornament, had no impact on the health and safety of their clients, modern practice goes far beyond the aesthetics of decoration. Fire laws regulating exit routes and safety equipment, lighting requirements that influence ease of vision as well as energy consumption, and stair and railing design all involve safety issues. Air quality is affected both by materials in use and by systems of ventilation, with clear health implications. *Barrier-free access* for people with disabilities is an important "welfare" concern.

Licensing laws may be of two types: regulations concerning *title* merely restrict the use of the title or term *interior designer* to people who have passed the required test; those concerning *practice* define the kind of work that can be done only by licensed designers. Title laws are generally more liberal in their impact, leaving open the actual work of interior design to any practitioners as long as they do not publicly identify themselves by the restricted title. Practice laws control the profession more precisely, requiring the seal of a licensed designer on the plans and other drawings that will be used for a project. Over a period of time one usually sees a progression from the uncontrolled situation (in which anyone can announce a design practice and take on any project offered regardless of qualifications) to title control (which ensures that those who use the title meet some minimal requirements) to the adoption of practice laws (which establish a level of professionalism comparable to that of other licensed professions). As of 2006, twenty-four states, the District of Columbia, Puerto Rico, and eight Canadian provinces had registration or licensing laws. Only Connecticut, Florida, and the District of Columbia restrict practice in addition to the use of the interior design title. More states will no doubt soon pass licensing laws, and as time goes on, title acts will be upgraded to restrict practice. Requirements vary from state to state, with each state setting its own regulations. By meeting the requirements of the states setting the highest standards, a professional designer can feel free to work in any state, now or in the future.

The typical requirements of the strictest states are the following:

- Four to five years of formal design education after high school
- A total of six to eight years of combined design education and work experience
- Passage of the examination administered by the National Council for Interior Design Qualification (NCIDQ)

Compliance with these requirements not only satisfies the states with registration laws but also establishes the designer's level of competence in a way that offers reassurance to potential clients both in those states and in the states that as yet have no such requirements. Most of the professional organizations for interior designers have also made passage of the NCIDQ exam a requirement for membership.

Licensing laws, however, do not prevent anyone who feels qualified from working on his or her own living accommodations or on other projects as long as the licensed title (under title laws) is not used or aspects of interior work that have a clear impact on health, safety, and welfare (under practice laws) are not undertaken. Simple projects, such as furnishing a room or redecorating a house or apartment, are unlikely to involve work regulated by law. Moving a bearing wall, changing exit stairs, and other major efforts involving structure, wiring, and plumbing, however, *do* call for planning and supervision by a licensed professional.

NCIDQ Examination

Because the basis for licensing laws is the protection of the safety, health, and well-being of the public, the examination developed by the NCIDQ concentrates heavily on areas that most directly impinge on these matters. The training offered in design schools tends to focus on the aesthetic aspects of design and to deal with technical matters secondarily, leaving study of building codes and business matters to the students' postgraduation experience. It is often a surprise to examination candidates to find that aesthetic abilities are, for the examination, subordinate to these more mundane considerations. Even work experience is not necessarily an adequate preparation for the test. The NCIDQ provides a manual detailing the format and content of the exam, and various books have appeared that are useful study aids for those preparing to take the test. Cram courses are also offered by some schools to help candidates brush up on subjects in which they may need special preparation. (See "NCIDQ Examination: Format and Content" in box at right.)

Experienced professionals are increasingly inclined to take the exam, even in states where no licensing law has been passed, because the NCIDQ certificate attests to qualification in a way comparable to a license.

Setting higher professional standards not only raises the level of design training but also, in turn, the level of expectation on the part of prospective employers and clients. At the same time, clients such as major corporations and hotel and restaurant chains, having learned how much skilled interior designers can contribute, are employing them as *facilities planners*. As mentioned above, larger architectural offices now often include an interior design department staffed by designers whose professional status parallels that of the architects employed by the firm.

All of these patterns of professionalism are fairly recent, and they can be expected to grow and spread.

It is also possible to observe a trickle-down effect in which the increasing professionalism of the design fields improves the quality of the interior design services offered by some furniture and department stores and by individual designers who work in the traditions of interior decoration, usually specializing in residential work. This has been accompanied by the wider availability of well-designed products, furniture, textiles, carpets, accessories, and other major components of interior design. Not too long ago, such good design was available only through very limited channels, often accessible only to accredited professionals.

Professional Organizations

Many professional interior designers elect to join one or more of the professional organizations that have been created to represent the profession and provide various services to their members. These organizations can have a major impact on the direction of the industry. A listing of these organizations and a summary of their activities are presented in Appendix 7, "Professional Organizations." Membership usually entails meeting certain standards that give evidence of qualifications. In states where licensing is not yet required, membership in a major professional organization serves as an alternative means of establishing the professional standing of an interior designer. The American Society of Interior Designers (ASID) is the largest interior design organization representing the profession to the public, and to legislative bodies. Membership requires meeting specific requirements including passing the NCIDQ examination. ASID offers many services to members, organizes student chapters at many design schools, provides standard contracts and other business forms to members, and maintains communication with other interior design organizations.

The Foundation for Interior Design Education Research (FIDER) is an organization that accredits education programs at institutions with interior design programs. Teams of professional evaluators visit schools applying for accreditation and evaluate compliance with standards established by the organization. Accreditation by FIDER is required to meet the education requirements of ASID and those of most state registration laws.

The International Interior Design Association (IIDA) exists to represent interior design professionalism on an international basis. It maintains specialty forums in such areas as government, healthcare, hospitality, retail, and residential design. Events, meetings, and publications provide members with current information on developments affecting the profession.

A number of other professional organizations are concerned with specific aspects of design work such as lighting, healthcare, and other specialized fields of practice.

Current Issues, Future Directions

The future of interior design will be whatever its practitioners, their clients, and the public choose to make it. Each person involved in interior design or having any contact with the field can, by making decisions and choices, influence the direction that the field will take and so influence its future. Accepting or refusing a job or assignment, working in a particular way, selecting a certain material or product—all such steps make their own minute contribution to the aggregate of actions that becomes a trend, and thus a future direction.

PROFESSIONALISM

In recent years, the long-developing trend toward greater professionalism in interior design has become even clearer. This has made the field more serious and demanding, but it seems to be an inevitable drift in response to the complex demands of the modern world. The identification of the field with the amateurism of the eighteenth century and the craft traditions that stretch back into the distant past has largely broken down. Lord Burlington at Chiswick and Thomas Jefferson at Monticello were their own interior designers. Chippendale, Sheraton, and the Adam brothers were cabinetmakers, upholsterers, and, in the case of the last, what would now be called contractors as well as designers. In the late nineteenth and early twentieth centuries, many well-known interior designers were simply self-taught amateurs who decided to become professional or were fashion, display, or stage designers who drifted into the interior field. While this still happens occasionally, professional training is now the norm, and full four-year college courses are available.

SOCIAL AND ENVIRONMENTAL RESPONSIBILITY

The design professions are becoming increasingly concerned with social responsibility, the ways in which their work affects the public at large both in the short and long term. Every design project, no matter how small or large, personal or public, impacts society as a whole through its consumption of space, resources, and energy; its generation of waste; and its ability to affect mental and physical health. The word *green* has come to identify a particular group of concerns that have to do with the impact of human activities on the natural environment. Interior designers are involved in many decisions that can exhibit a surprising level of involvement in environmental and related issues (fig. 1.15). Choices of materials can be adjusted to minimize scarce and endangered species of plant and animal products. Maximal reliance on natural light and ventilation can reduce energy requirements that consume resources and are sources of air pollution. Avoidance of particular industrially produced materials and products can reduce or eliminate unsatisfactory indoor air quality. Preservation of existing structures and spaces (with conversion to new uses where appropriate) can reduce the burdens of waste disposal and the demands of new construction

NCIDQ Examination: Format and Content

EXAMINATION FORMAT

The National Council for Interior Design Qualification (NCIDQ) requires that applicants for the examination have a four- or five-year degree in interior design plus two years of work experience; a three-year certificate in interior design plus three years of experience; or a two-year certificate plus four years of experience. The examination is given twice a year at more than sixty locations in the United States and takes two full days. The three sections of the exam can be taken all at once or at different times. Although a failed section can be repeated until passed, all three sections must be passed within a five-year period. The three parts of the exam are as follows:

FIRST DAY

Section I: *Principles and Practices of Interior Design* (3½ hours)—125 multiple-choice questions plus 25 experimental questions

Section II: *Contract Development and Administration* (3½ hours)—100 multiple-choice questions plus 25 experimental questions

SECOND DAY

Section III: *Schematics and Design Development* (7 hours)— Practicum design

EXAMINATION CONTENT

The subject matter covered in the various sections of the NCIDQ exam are as follows:

Sections I and II Questions deal with theory, programming, contract documents, furniture, equipment, finishes, building and interior systems, sketching, drafting, perspective, business and professional practice, project coordination, and history. Other questions relate to contract documents, building and interior systems, safety, building and barrier-free codes, and testing standards.

Section III A design problem for this practicum is presented in written form. Two preprinted sheets are provided showing a plan of the space to be dealt with at a scale of ¼"= 1'0". The candidate must draw by hand a floor plan of the design solution complete with furniture on one sheet and a reflected ceiling plan on the other.

in terms of both materials and energy. Although the phrase "small is beautiful" may not be applicable to every situation, efforts to reduce rather than increase the size and cost of projects tend to have a "green" impact on design. Organizations have emerged that are concerned with green issues, among them the Greenguard Environmental Institute (GEI), concerned with testing products and materials in order to certify low-emission products having minimal adverse impact on air quality. The U.S. Green Building Council (USGBC) promotes environmentally responsible building design and development of related products through a rating system designated Leadership in Energy and Environmental Design, (LEED), which evaluates and certifies buildings and interiors that meet green environmental standards. Recycling of older buildings that lost their original functions, but that remain strong and valuable structures, converted to new uses, is a significant part of the drive toward sustainability. See Case study 4, an excellent example of such a reuse. The pressure on designers to integrate green concerns into their designs has been growing steadily and will likely continue to do so. This topic is discussed in more detail on pages 199–209, and throughout the book.

DIGITAL TECHNOLOGY

Computers for Design and Planning The use of computers has become routine for almost every design business (fig. 1.16). The most obvious evidence of the impact of new technology on design practice is the use of computers for design and visualization. A special value of the computer in a design office is in the preparation of drawings. Computer-aided design (CAD) is now taught in almost every design school and is a technique that can, with only moderate effort, be self-taught. Computer drawings take on a quality of mechanical precision, but this is a minor benefit compared with the ease with which a basic plan can be duplicated to generate "layers" that show various aspects of the designed space (a lighting plan, a furniture plan, a reflected ceiling plan based on a basic grid, for example). Design drawings, such as *elevations, sections*, and details can be generated in relation to a basic plan, and repeated elements can be inserted and moved about with ease. Revisions and alternative versions are simply and easily made with keyboard, mouse, and monitor; color can be added and changed as well (fig. 1.17).

Another use of the computer makes it particularly easy for the client to visualize and understand the designer's concept. Here, perspective drawings can be generated, modified, colored, and used as the basis for walk-through viewing or the production of what has come to be called *virtual reality*, simulation of motion-

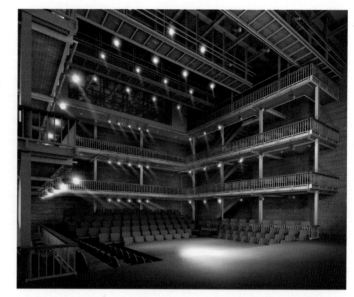

← 1.15

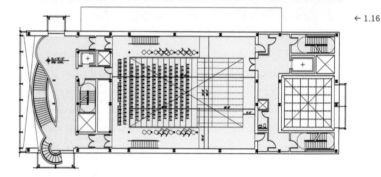

← 1.16

picture-like imagery of amazing realism (figs. 1.18, 1.19). Effects of daylight at any time of day at any latitude can also be created (figs. 1.20, 1.21), while effects of artificial lighting can be made to appear while the lighting equipment is being selected and located. In addition, computer-generated images can be combined with photographic views to illustrate new elements to be inserted into existing space. Some developing techniques make it possible to sketch directly on a digital drafting table with the drawing input entering directly into the computer. Rough sketch images can then be made to combine precisely with previously entered finished drawings.

Use of complex spatial forms has always been somewhat handicapped by the means available for drawing such forms on flat sheets of paper. Conventional drafting with T square, triangles, and compass deals best with straight lines and curves that are parts of circles. Forms using multiple curvatures in three dimensions and curvatures not based on circle radii are hard to describe in simple drawing terms, which has tended to discourage their use. Computer techniques (including those developed for use in

1.15, **1.16** Due for completion in 2008, the Theatre for a New Audience (TFANA) is part of a larger plan to redevelop the cultural district of the Academy of Music in Brooklyn, New York, along socially and environmentally responsible lines. The design explores the innovative use of windows and other materials. The building will be housed within shimmering shingles of stainless steel that catch and reflect light in dynamic patterns. Windows on both sides of the building will invite passers-by to see inside, and entrances on both sides of the lobby will allow visitors to pass through and enjoy the public space. The interior view is a computer-generated perspective, the plan is a computer drawing. (H3 Hardy Collaboration Architecture)

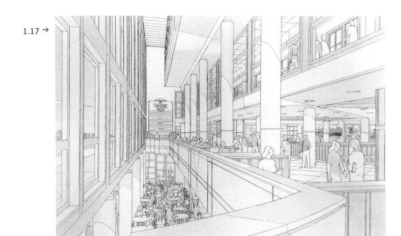

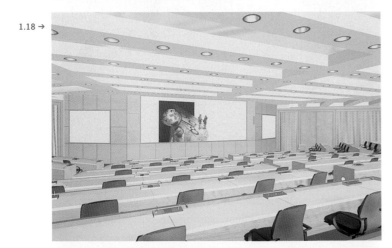

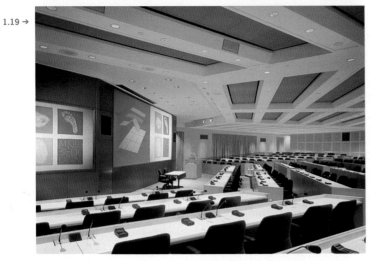

While sketching and drawing by hand remain in use as a basis for preliminary and conceptual design and survive for all design work in the practice of some individual designers or small firms, the increasing power and decreasing cost of computer equipment has made the acceptance of CAD widespread in design practice.

Aside from the making of drawings, there are computer programs available to aid in planning. When projects are complex, with many elements having intricate relationships (as in airport terminals, hospitals, and large office projects), the ordering of space relationships can reach a level that the human mind finds difficult to deal with. Programming the sizes of each functional unit and establishing a hierarchy of placement needs can generate a set of issues that can be dealt with through the use of the computer's vast capacity to manage large numbers of interrelationships. Proposed plans produced by computer programming can then form the basis for conventional planning, as discussed in more detail in Chapter 6, "Planning."

Computers for Communication Recent innovations in technology have enabled the design community to create more efficient and effective communication methods. E-mail and the Internet have made electronic communication the norm for designers in transmitting drawings and other documents and memoranda. Electronic communication greatly facilitates work on projects in locations remote from the design office by the ease with which drawings and other documents can be made available anywhere in the world instantaneously. Possibly most important is the ease of transmitting drawings to any destination—to client, to engineering or other consultants, and to contractors—without the trouble and delays of packing and mailing.

Research into technical information, code and other legal matters, and availability of materials and products is made quick and easy by these modern means of reaching information sources. In particular, websites can be accessed for specialized information and to simplify and make convenient the estimating and ordering of purchased components, such as furniture, lighting devices, plumbing fixtures, and appliances. Developing their own websites also offers designers a means to make their own work known to potential clients.

TYPES OF FUTURE PROJECTS

Currently, surveys indicate that in professional design about 9 percent of the work is residential, 33 percent commercial or industrial, 48 percent institutional, with the miscellaneous remainder of various projects amounting to about 10 percent. About 33 percent of

industrial design and aeronautical engineering) are available to deal with such complex forms. Many recently built projects would have been nearly impossible without computer development of forms, including the control of fabrication and production of construction materials and their assembly on-site.

1.17 The delicate line quality and pale coloring of this computer-generated perspective image of a lounge for the Frist Campus Center, Princeton University, Princeton, New Jersey, suggests a handdrawn rendering. Venturi, Scott Brown & Associates were the architects.

(Courtesy Venturi, Scott Brown & Associates) **1.18, 1.19** The highly realistic computer-generated image in figure 1.18 is of a lecture hall in a training facility designed by Skidmore, Owings & Merrill for a financial investment company in New York. (Courtesy Skidmore, Owings

& Merrill) A photograph of the built reality of the completed lecture hall (fig. 1.19) confirms the close relationship of the computer image to the finished interior. (Photograph: © Durston Saylor)

total professional design work involves renovations and additions to existing facilities. Among architectural firms, 60 percent indicate that they specialize in a single field, such as healthcare, hospitality, office, or residential design. The other 40 percent carry on a varied practice, dealing with whatever projects come to them. Among interior designers, the most common area of specialization will probably remain single-family residential projects.

A significant developing change in design practice is in some ways related to the increase in professionalism, mentioned earlier. This is the movement of interior design work toward two opposite poles that seem to grow further and further apart. These poles can be characterized, somewhat simplistically, as large and small projects.

The *large project* end of the scale is dominated by projects with corporate, institutional, commercial, and governmental sponsors. Such work is almost always placed in the hands of larger firms with a staff headed by trained professionals, possibly licensed or accredited in some formal way as architects, engineers, interior designers, or planners. The actual designing is assigned to staff members at various levels of experience and training, often working in areas of specialization such as space planning, design, drafting, materials and color, or specification and purchasing. Some projects may be designed by the interior design departments of large architectural firms, a growing trend as architects become increasingly active in design work. Office planning or space planning, as discussed above, encourages the development of comparably large and specialized design organizations.

In larger firms dealing with large projects, organization of staff into teams is almost inevitable. Large projects move beyond the ability of individual designers to be effective without team membership. A partner or senior designer may have responsibility for a large project, but the actual work of design production will usually be allocated among groups, each responsible for some part of the total project. Within these groups, structure may be somewhat authoritarian, with a project chief to whom other members of the team report, or it may be more open and democratic, with all team members having equal responsibility. This latter type of structure is on the increase with the discovery that it often leads to superior creativity and productivity.

Teamwork is also a factor in the collaborative patterns that emerge as various specialized consultants and experts are drawn into large design project development. This has long been necessary as engineers and lighting and acoustical consultants are called on to provide expertise in their varied areas. In current practice, however, many projects require consultation from such disciplines as sociology, psychology, and other fields that can offer designers aid in dealing with the complexities of modern projects. Successful collaboration and teamwork call for personal qualities that differ from the traditional image of the designer as a lone master, oblivious to all sources of information and aid outside his or her own thinking.

The *small project* end of the scale includes residential design and the design of other limited projects, such as smaller retail shops,

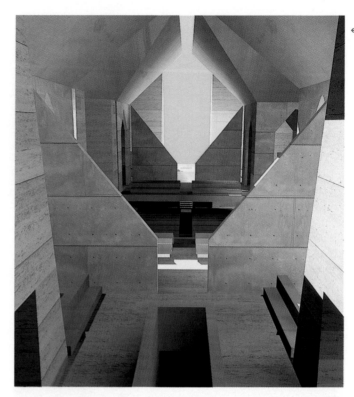

← 1.20

individual professional offices, and single spaces within larger buildings. Such design work rarely interests larger design organizations, which find dealing with a client, offering supervision, and all of the other complications that go with even the smallest projects too time-consuming in proportion to the fees. The individual private client usually expects a highly personal level of design service, which larger organizations are not equipped to offer even to their large clients.

This increases the opportunities for individual practitioners and very small firms, partnerships, or designers with one or two assistants. While this kind of design practice can also be highly professional, it is geared to a different scale and pace of work. Small firms can give individual clients the personal attention they demand, and can do so at fee levels in line with the scale of the work in question. All of this suggests a future in which the medium-sized, all-purpose design firm will become rare, while both large, highly organized firms and individual designers and small firms will flourish.

Design practice can be expected to follow the general trend toward a merging of workplace and home office. The individual practitioner has always had a choice between arranging a work area at home and finding a separate (possibly remote) office space, but there is now increased willingness on the part of larger firms to accept the idea of individual employees working at home most or all of the time. The computer, with its ease of instant communication, favors this possibility, not only for designers, but also for office workers of all sorts. The central office will change as this trend increases. It will be smaller and more a place for occasional meetings and personal encounters and less a scene of many identical workstations. The need for suitable equipment and layout for the home office (fig. 1.22) can be expected to increase (see also pages 510–511).

The expectation based on demographics that the average age of office workers will increase over the next decades suggests further

1.21 →

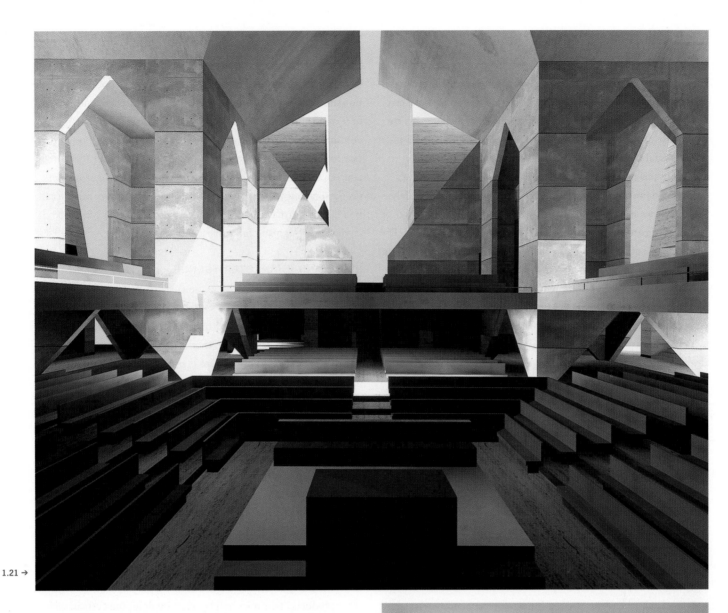

← 1.22

adjustments to the centralized office. Many older workers will choose to work at home, a possibility with special appeal to both older and disabled workers. The traditional office, insofar as it survives, will also need to change in ways that will make access easier, facilities more comfortable, and lighting better suited to the needs of older workers. Any improvements made to suit older workers will almost surely be advantageous to all workers, whatever their age. This trend is already noticeable in the introduction of improved task seating and adjustable furniture of all kinds. (See Chapter 13, "Furniture.")

USER PARTICIPATION IN DESIGN

In residential design, the user of the space, whether apartment, co-op, condominium, or house, tends not only to show more awareness of design excellence but also to claim a major role in the actual

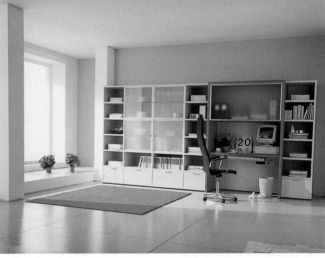

1.20, 1.21 Although never built, the Hurva Synagogue, designed by master architect Louis Kahn for a site in Jerusalem, has been brought to life through computer graphics. Starting with sketches and a model created by Kahn more than twenty-five years

ago, Kent Larson, a principal in the firm of Peter L. Gluck and Partners, used computer techniques to generate highly realistic images of the space as it would have been built. Photographs of actual materials—wood, travertine, concrete—were scanned to capture

colors and textures, while the effects of direct and reflected light were simulated through a software system called INTEGRA. (Courtesy Kent Larson)
1.22 A home office built up from standard components provided by Poliform Systems results in a setting

both practical and orderly. (Photograph courtesy Poliform Systems)

design process. Up to now, good interior design has generally been produced only by the professional decorator, designer, or architect, who could assert total control over a project. The costs of both professional design service and executing the professional's design are usually so high as to make this route available only to the well-to-do, the usual clients of architects and designers.

While this pattern still largely holds true, other forces are at work. Economic mobility in the general population, more widely available education, and an increasing recognition of the benefits of quality design are making design concerns more widely known. The phenomenon of design-oriented magazines, the continuing crowds attending design shows at museums, the sale of design books, and the success of retail shops devoted to home products of a high level of design excellence all point to a parallel trend toward the public's acceptance of a role in improving their home situations.

Self-help materials have been available in the field of interior design for many years, but most have consisted of watered-down versions of the more pretentious approaches of professional decoration. As their audience increasingly sees design as a tool for making life more comfortable and more attractive rather than as a way to display or attain status, authors of self-help books have responded. At the same time, design products have improved. Even well-informed householders are dependent on retail sources for well-designed products. Many of the unfortunate results of self-help owe as much to the badly designed merchandise in furniture and department stores as to any failure of public taste. As well-designed products become more widely available and respected, the quality of the undesigned residential interior is certain to rise.

Even real-estate developers planning apartments, condominiums, and suburban houses (long known for their indifference to design standards) seem to be showing an increasing interest in design quality. Public awareness of design standards leads to demand for excellence. Realization that improved design can be a marketing asset may motivate a rising quality standard in the living spaces available to average occupants.

CONSULTANT SERVICES

In a related trend, consultant design services are being offered to the general public as an aid in smaller, generally residential projects. A consultant of this kind does not attempt to prepare complete plans for a space but offers instead an advisory service on an hourly or per diem basis to deal with aspects of an interior problem that need expert attention. This may include a visit to the space, discussions of how particular problems might be solved, advice about color and materials, suggestions for furniture selection, and any other issues the householder may find problematic. The consultant may provide plans or sketches, access to catalogs and showrooms, and references to tradespeople and contractors known to have a good record for quality performance.

This kind of service can be very helpful when the full services of an interior design firm are unnecessary or beyond the individual's means. It can deal with simple questions (the choice of a color, rug, fabric, or single piece of furniture) or with special problems such as built-ins (shelves or cabinets) or bathroom or kitchen renovations, or it can simply offer advice about practical issues that may be difficult for laypeople to deal with. On another level, many people hesitate to turn over a project fully to professionals, not only because of concern over costs but also because they wish to retain control of decisions about their own homes. A limited consultant service can be a highly satisfactory middle ground between totally unaided do-it-yourself design and full professional service.

STYLE AND CHARACTER TRENDS

Aside from these issues of how interior design services are offered, provided, and executed, there is also the interesting issue of what future directions will bring to the actual character, style, and look of spaces (fig. 1.23). Increasing populations will give rise to a greater concentration of people in cities and urban regions, leading to crowding and a reduction in the per capita space available. As resources are consumed faster than they can be replaced, the cost of materials and products will increase. At the same time, computerization and automation promise to make production more efficient and less dependent on manual labor. Office work and work in service fields have already outpaced agricultural and factory production work in developed countries.

Extracting predictions about design from these general trends, it seems that spaces for living and working are likely to get smaller, focusing attention on ways of gaining reasonable comfort in smaller spaces (figs. 1.24, 1.25). The costs of materials will probably reverse the long-term trend toward lowered costs for furniture and other products. This may well be offset by dropping costs in technological products, the construction of which relies more on complex elements suitable to automated production than on materials. Such trends are already apparent in the manufacture of some automobiles that have grown smaller in size while increasing in price. At the same time, new versions of electronic goods, such as stereo equipment, television sets, and computers, that are both smaller and functionally improved are constantly being offered at lower prices. Taken together, these directions may help to reverse the long-standing trend toward rapid obsolescence and society's throwaway orientation and lead to an increased concern for high quality and long life in the selection of materials and products (fig. 1.26).

Many commentators have attempted to define recent changes in societal attitudes that seem to promise a fresh thematic character for the next few decades. Certainly, a new concern for values beyond the simple desire for luxury and display has emerged. Environmental issues relating to the consumption of energy and resources, the problems of waste disposal, and the protection of the environment are increasingly influencing how designs are realized. The special needs of the very young and the very old and the difficulties faced by people who have some sort of disability—temporary or permanent—have been recognized as critical.

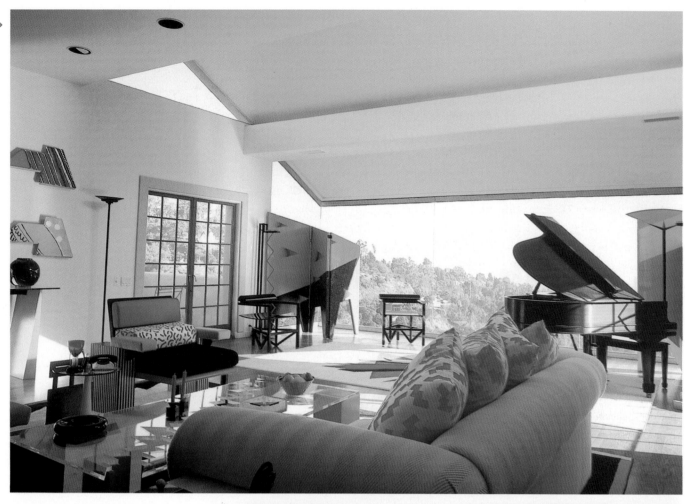

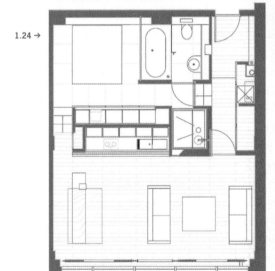

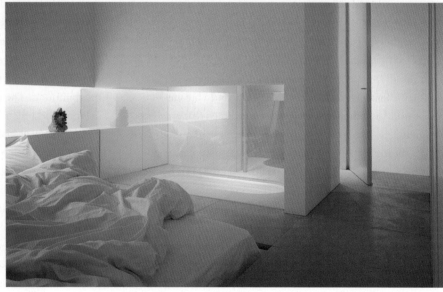

1.23 Anne D. McCulley was the set decorator for this set from *Ruthless People*, a film that popularized the then avant-garde imagery of Memphis furniture as only a mass medium can. (Photograph: © 1986 Touchstone Pictures) **1.24, 1.25** The plan (fig. 1.24) for a tiny loft apartment in a London Bankside building designed by Seth Stein Architects for Stein's own use carries spatial compression to an extreme yet preserves a sense of openness. A three-step level change sets the bedroom, bath-shower, and closets apart from the main living space and kitchen ribbon. Extensive use of glass generates spatial richness in spite of the tight dimensions. (Courtesy Seth Stein Architects) Figure 1.25 shows the bed in the left background with the glass wall of the bath to the right. The bathroom wall is of Privalite, a material that can be changed from transparent to translucent for privacy at the flick of a switch. (Photograph: © Arcaid/Richard Bryant)

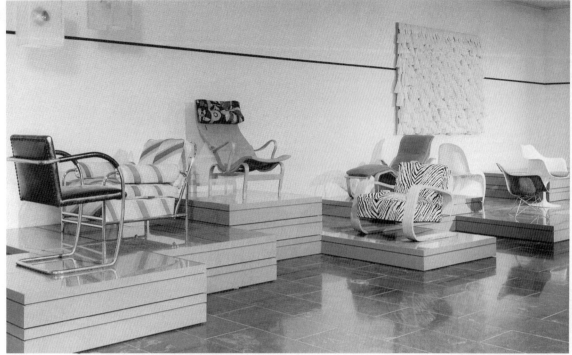

Although interior design is only one of many fields that must consider such issues, the profession can have a strong role—for better or for worse—in focusing attention on many basic human problems and in proposing solutions that are humane, reasonable, and practical. Numerous interior design projects of the 1990s seemed to glory in displays of affluence and power: private residences of staggering size and elaboration, corporate headquarters rivaling the royal palaces of the past, and malls and atriums that seemed to celebrate impulsive spending. A general repudiation of these materialistic patterns cannot be expected to bring about a total change of attitudes all at once. Nonetheless, it is clear that many designers and their clients have an interest in restraint and a broader sense of responsibility. Although it is sometimes assumed that excellence in design is dependent on the availability of unlimited funds, in reality the demands of economy and simplicity also have created design excellence. The palace of Versailles and the great houses of England unquestionably include elements of outstanding beauty and quality design, but the houses and churches of early American Colonial settlers, the communities of the American Shakers, and the quilts of the Pennsylvania Amish people represent a fully equal, albeit totally different, kind of excellence. If current predictions are valid, we can expect the twenty-first century to favor design values of an increasingly idealistic nature.

Futuristic thinking rooted in technology suggests that an escape from materialism might be explored through an expanded and more adventurous concept of computer-generated virtual reality than is currently being used to produce perspective views of design projects still in the planning stage. This version of virtual reality could replace actual reality in the same way that flight simulators replace the reality of flight maneuvers for pilots-in-training. An expanded and more varied concept of simulation suggests that reality could be replaced in a variety of ways. A number of popular computer games offer simplified versions of such possibilities.

By its very nature, built reality is costly. It takes up space and uses real materials. A virtual-reality environment would occupy no space, use no materials, and have no cost beyond that of its programming. The user would be provided with an illusion of being inside a room, a building, or any other environment, while being capable of looking and moving about and experiencing the visible, audible, and possibly even tactile and kinesthetic aspects of the simulated space (fig. 1.27).

Such an approach assumes that the physical conditions that real interiors provide—shelter, protection, and air quality, among others—are separable from the visual and other sensory stimuli that make up the total experience of a real space. If physical reality can be limited to the essential basics, the broader experiential realities could be supplied synthetically. One can imagine, for example, replacing a spacious executive office with a unit that amounted to no more than a seat in a simulator, which might be placed anywhere enclosure was available. The experience of the

1.26 More and more museums are recognizing well-designed furniture and other interior-related products as works of art, giving the museum-going public an opportunity to study objects to which they might otherwise not have access. This installation of twentieth-century furnishings was designed by R. Craig Miller. It is displayed in the design and architecture gallery in the Lila Acheson Wallace Wing of the Metropolitan Museum of Art, New York. (Photograph: © Peter Paige)

1.27 →

← 1.28

spacious and attractive room would be generated through virtual reality, disposing of the need to construct the real office. Costly and elaborate suites of offices, now such familiar settings for business and institutional life, could become no more than an empty loft space furnished with simulator units, each able to provide the illusion of a designed environment of whatever aesthetic qualities are desired.

Virtual-reality simulators might be installed in homes, where at will a user could seem to move into offices, conference rooms, or any other spaces (fig. 1.28). A virtual-reality setting out-of-doors, in the mountains or on the beach, could be available on demand. There are many obvious questions and objections, of course. How would people interact in such simulated settings? What would a virtual-reality store, restaurant, or classroom be like? Would a virtual-reality visit to a museum or gallery be an acceptable alternative to the experience of actuality? Before dismissing such possibilities as pure fantasy, however, we must remember that there is wide acceptance of music broadcast on radio or reproduced on tape or compact disk as an excellent alternative to the experience of the concert hall. Moving pictures and their equivalents on the television screen offer visual and auditory experience surprisingly close to reality as do a number of popular computer games. The comfort, safety, and convenience of watching a screen seems to many of us almost equal, perhaps in many ways even superior, to a comparable experience of reality.

If the end purpose of design is to deliver a sensory experience to the user or viewer, does it matter what techniques are used to deliver that experience? Would it be reasonable to select techniques that involve minimal cost and consumption of resources, as well as little or no environmental impact, if the resulting experiences are equal or superior to those encountered in real spaces? Is it necessary to build, furnish, equip, light, heat, air-condition, clean, service, and maintain a building if the same experiences it generates can be created synthetically? These are questions with no currently reliable answers, destined to be topics of concern in the design community within the immediate future.

1.27 The General Motors "Driversite," an automobile showroom in Houston, Texas, mingles computer-equipped kiosks with real-life cars in a setting planned to transform the viewer into a future-world buyer. This project was the work of Pavlik Design Team. (Courtesy Pavlik Design Team) **1.28** The proposed (unbuilt) Digital House was designed to demonstrate the potential impact of electronic technologies on interior design in the twenty-first century. The house is organized around a touch-activated digital spine of steel structure and glass enclosure made of liquid crystal display screens. The main habitable areas plug into the steel structure like industrial shelving units. In this computer-generated image of the kitchen, a wall screen shows a virtual image in which a professional chef demonstrates a cooking technique. Gesue and Mojgan Hariri were the designers. (Rendering: Hariri & Hariri–Architecture, courtesy *House Beautiful*)

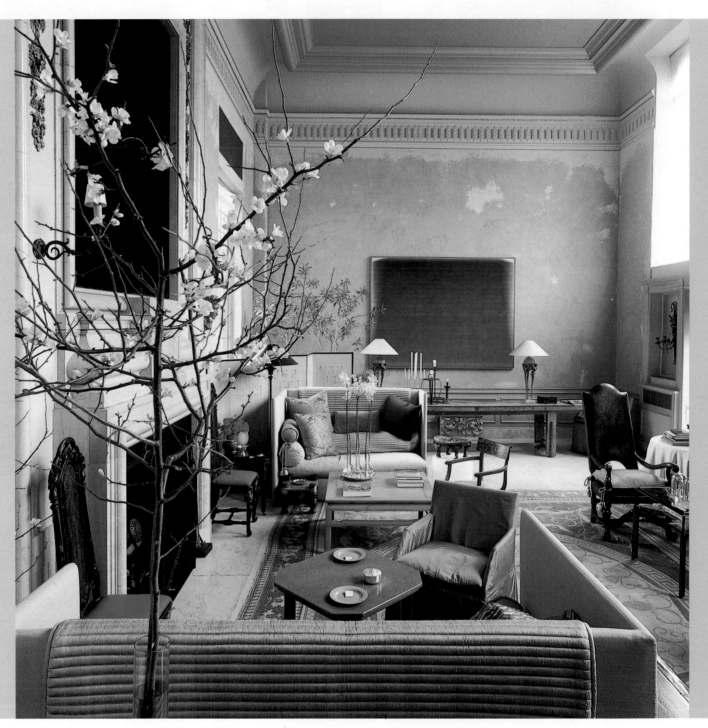

chapter two. Design Quality

All serious designers aim to achieve excellence in their work. While different designers may represent a variety of approaches and aesthetic attitudes, they share an understanding at some basic level of what quality is. An excellent design satisfies three essential criteria: it works well, serving the needs and requirements of its users; it is well made of good, appropriate materials; it is aesthetically successful.

Defining Design

Before looking more closely at these criteria, it is necessary, first of all, to define what we mean by *design*. This word has so many meanings and is used in so many contexts that it demands clarification. Many people think of it as meaning pattern or decoration, as, for example, a design for wallpaper or printed textiles. Other people associate it only with fashion design and stage design. In engineering, design may deal with sizing structural members, piping, or ducts, while in the fine arts it deals with the way an artist organizes the formal elements of line, shape, color, and texture in a space.

In interior design, industrial design, and architecture, the term describes all of the decisions that determine how a particular object, space, or building will *be*. It can also be described as *determination of form*, with *form* understood to mean every aspect of every quality, including size, shape, material, structure, texture, and color, that makes one particular physical reality different from any other. When we speak of a house, a living room, an office, an automobile, a chair, or a desk, we call to mind an item that contains certain general characteristics and that serves certain useful purposes, but the word tells us nothing of the specifics that make a particular house, living room, or office unique. It is design differences that distinguish one house from another, one room from another, and that also allow us to speak of one example as better or worse than another.

Evaluating Design

Evaluation of design can be very complex. The interior designer usually begins with spaces designed by someone else, often long ago, possibly for purposes quite different from those the designer must now satisfy. The client may be an owner, a developer, or a corporation creating space to sell to others or to serve users who have no direct relationship with the designer. The elements that make up the interior—its materials, furnishings, and details—are often designed by others, chosen from among the products available from manufacturers who have no awareness of the project in hand. The finished space, when put into use, may have to serve for years that stretch ahead into times when conditions will change and new generations of users will take over, bringing requirements that may well be different from anything that can be foreseen while design development is in process.

2.1 Designer John F. Saladino used a heterogeneous array of materials and textures in the living area of his own apartment in New York. The original architectural details—ceiling moldings and fireplace—were retained; textured painted wall surfaces, various textiles, rugs, mirror, and antique furniture relate well in color and scale. The result is a successful design. (Photograph: Lizzie Himmel)

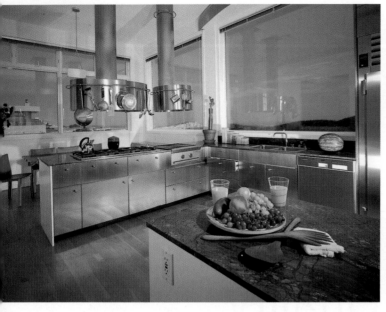

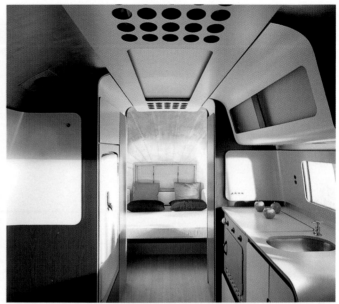

← 2.3

2.2 ↑

These realities make the interior designer's task more complex than might be suggested by the simple concept of a problem leading to a solution. Nevertheless, the design process can be analyzed in terms of a problem that can be defined and stated with as much clarity and precision as possible. Design proposals can then be viewed as proposed solutions to the stated problem that can be articulated (most often in drawings and models) and evaluated for their success in dealing with the problem.

In order to analyze and evaluate a proposed design, it can be viewed in terms of three closely related qualities: function, structure and materials, and aesthetics. This basic breakdown has a long history of acceptance going back at least to the ancient Roman architect Vitruvius (1st century b.c.e.), who used the Latin words *utilitas*, *firmitas*, and *venustas*, which translate into usefulness, firmness, and beauty, much the same as the modern concepts, a discussion of which follows.

FUNCTION

Function is the design world's favorite term to describe the practical purposes that any design is intended to serve. A chair serves as seating support; a living room as a gathering place for varied activities; a dining room as an eating space; an office as a work space; a shop as the arena for buying and selling; and so on. In order to be a success, any design must support its function. This goes beyond mere success or failure, becoming a matter of a scale of value in which the level of functional service can be related to the level of design quality.

Almost any chair can be sat in, and any room will serve for living or dining in some way. A truly well-designed chair will offer appropriate seating comfort for its intended use. A well-designed room will provide a superior setting for its intended function. Such a living room, for example, will provide comfortable settings for conversation, solitary reading, music listening, and TV watching, as well as a workable setting for entertaining. A dining room will offer space, seating, lighting, and atmosphere suitable to each meal to be taken there, for as few or as many people as may be expected at any one time. An office will provide suitable space for working, equipment, and storage, as well as space to receive visitors and hold small meetings if required. Superior functional performance is the first test of design quality (figs. 2.2, 2.3). Failure to function well reflects a larger design failure.

In addition to basic, or *primary*, function, designs must satisfy various secondary functions. Besides providing good seating, a chair should be practical to move, keep clean, repair, and maintain, and its production cost should be appropriate to its intended use. This last issue is so closely linked to the next group of design issues as to leave some uncertainty as to whether it is a functional issue at all. Certainly it ties together matters of function and construction.

STRUCTURE AND MATERIALS

In order to function, any design must be constructed of specific materials with available techniques of manufacture and technical mastery. While closely related to functional issues, quality of materials and construction techniques can be evaluated separately from functional performance. The choice of materials and methods of execution greatly influences an object's durability and its

2.2 Function is often the dominant consideration in the design of a kitchen, as in this example in Southampton, New York, designed by Wendy Evans Joseph Architecture. The gleaming stainless steel seems to symbolize the idea of functionalism. (Photograph: © Amiaga Photographers, Inc./www.amiaga.com)
2.3 The interior of this vintage Airstream travel trailer, designed by San Francisco-based architect and furniture designer Christopher Deam, is a triumph of design for comfortable living within a severely constricted environment. Intelligent use of space and color allow the gleaming functional forms of the space to speak for themselves. (Photograph: J. D. Merryweather)

initial and lifetime costs, values separate from function. A chair can be comfortable and serviceable (that is, serve its primary function)—at least for a time—even if poorly made of inappropriate materials.

An object's materials and construction techniques must be appropriate to its intended use. The longest-lasting and most expensive of materials do not best serve every situation. A temporary exhibit will be built very differently from a monumental space expected to endure for generations. A paper cup and a cup of solid gold can be equally well designed, as long as each suits an intended use and is well made.

In an interior, wood plank floors, plastered walls, and simple wood furniture may be appropriate to one set of requirements while marble, granite, leather, and stainless steel may suit another situation. In each case, excellence requires logical choices and quality skills and techniques suited to the materials selected.

AESTHETICS

In evaluating design, it is easy to focus on functional performance and quality of materials and technical mastery. While these are subject to debate—much as people argue over the best make of car—they offer generally understood criteria by which to judge. Aesthetic values, less easy to spell out, are all too often dismissed as "a matter of taste" that cannot be dealt with in any logical way. Teachers and students of design, as well as working designers, often slip into a belief that design can be evaluated only in terms of its practical aspects, since they cannot explain the aesthetic values at work.

Nonetheless, one can identify levels of aesthetic quality. In the evaluation of design, better is distinguishable from worse, and near-unanimity arises in selecting outstandingly good and bad designs.

Confusion stems from efforts to define aesthetic qualities in terms of *beauty*. The concept of beauty differs with time and place, with purpose and context. An ornate Victorian parlor, an austere modern living room, the interior of a factory or of a native hut will all be seen as beautiful or as unattractive by various viewers applying different standards. Our definitions of beauty and of unattractiveness may often be no more than our reactions to certain situations that we either like or dislike, attitudes that may arise from extraneous sources. We find it easy to like what is familiar, what is popular or fashionable, what one has learned to like from family, teachers, or friends, from books, magazines, and advertisements. Almost everyone can remember having had different tastes at some time in the past, tastes that have changed with growth, education, and experience.

The values that are usually called *aesthetic* can be better understood at another, more universally comprehensible level. Those aspects of a design that go beyond the functional and the constructional concern the specific way the design presents itself to the human senses. We use an object to serve some need or want, and we expect its physical structure to support that use. We know about an object through looking at it, handling it, and developing a sensory experience above and beyond its simple use. It is the task of the designer to shape an object so as to communicate to any viewer or user the ideas that define the reality of the object. When these ideas are appropriate and clear and when they are effectively expressed through the elements at the designer's disposal (form, shape, color, texture, and so on), we understand the design at a deep level and feel satisfaction in seeing, handling, and using it.

It is also true that objects can be made useful and sturdy without exhibiting any particular visual quality. It is the unique role of the designer to form designs in such a way that they come to have a meaning beyond their simple physical reality. Viewing them at second hand, in photographs of other illustrations, is one way to test their success. One can develop a certain rapport with a designed object that one has never actually seen if its visual quality is in itself strong enough to provide satisfaction.

Viewing the work of the interior designer in this way gives us a yardstick for measuring excellence. We expect a space to serve its practical purpose well, and we expect it to be well made of suitable materials. We also expect it to give us a sensory experience that will help us to understand its use and its structure, as well as offer a range of other ideas about its time, location, and the viewpoints of its designer and owner or client. This is the nature of experiencing a visit to a great cathedral, a fine château, or some other landmark building. In the same way, a visit to a more modest office, restaurant, or living room can offer pleasures that go beyond mere practical accommodation. In an ideal world, every space that we enter and use would be designed not only to serve its purpose well but also to offer a visual experience that would be appropriate, satisfying, and even memorable.

The emotional reaction of pleasure that we call *an aesthetic response* arises when we experience a highly successful visual expression of the realities that we are encountering. Knowing that a space can be used effectively, that it is well built and safe, gives us certain satisfactions that we tend to take for granted and only think about when there is some failure in these matters. We expect a room to be useful and adequately built, a chair to be comfortable and strong enough, but these basics do not generate the extra level of excellence that is generally called beauty. A beautiful room or a beautiful chair gains that designation because the viewer feels a special pleasure even without making use of the space or object—even when only seeing it in a photograph. As information about the thing in question is sent to the brain, this kind of reaction comes from the human senses. All five senses can contribute to the reaction, but it is the visual sense that dominates our experience of places and objects, and so we tend to call the qualities that bring forth our emotional reactions *visual expression*. A space or an object seems to speak to us visually, and if that speech is clear and meaningful we call it *expressive* and so aesthetically successful (fig. 2.4).

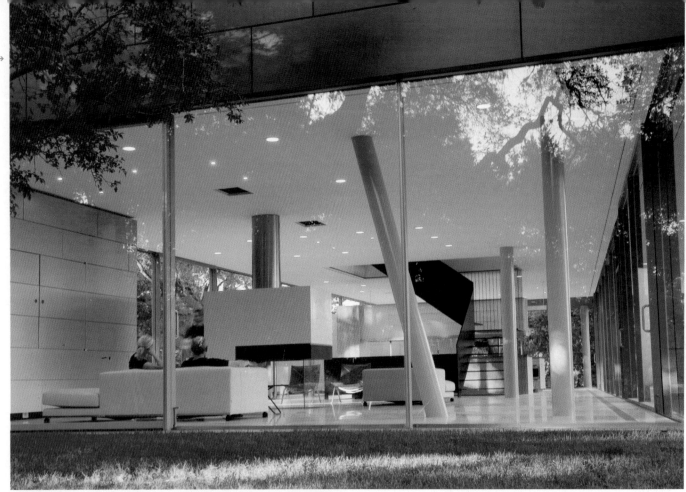

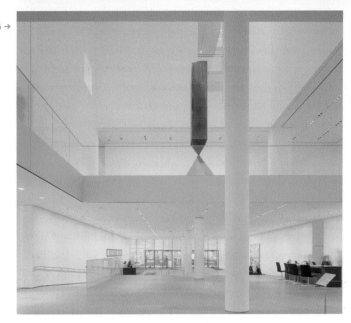

In reacting to design, the user or viewer may have reactions that are based on considerations unrelated to what is seen. Reactions formed by childhood experiences, influences through education, and preferences shaped by advertising and the preferences of one's friends and neighbors make up what is usually called *taste*. Taste is simply a particular set of preferences formed by such influences. There are no such things as "good taste" or "bad taste"—these terms merely identify a set of preferences held by a particular person or group. They have only limited bearing on the visual qualities that can be called *aesthetic standards* and that relate to the concepts of good or bad design.

Design in Other Contexts

Some confirmation of the validity of these basic design principles can be found by looking at situations outside the worlds of art and professional design. Examples of excellence in design are by no means confined to the works of designers. By examining such examples, we can analyze the qualities that generate satisfaction and try to define the ways in which we perceive excellence.

The Museum of Modern Art, New York (fig. 2.5), in its original form was one of the first modern buildings in that city. It has been redesigned several times. The most recent reinvention by Yoshio Taniguchi has received critical acclaim.

2.4 The Floating Box House in Austin, Texas, designed by Peter L. Gluck and Partners, seems to occupy a place between Austin's burgeoning city skyline and Texas's rural past. Large parts of the edifice are located below grade so as not to overwhelm the rural landscape. The floating box, the buried plinth, and the wholly transparent glassed enclosure all create a dual façade. The grassland and oak trees on one side and the Austin city skyline on the other side can therefore be seen quite clearly. (Courtesy Peter L. Gluck and Partners) **2.5** The main entrance lobby of the recently reconstructed MoMA, New York, as designed by Yoshio Taniguchi is an open and welcoming space in white and neutral tones. The grey form, top center of the image, is a sculpture by Barnet Newman on the upper level.

2.6 →

2.7 →

← 2.8

We can, in fact, begin with design that can develop without human contribution. It is almost a platitude to say that natural things are beautiful. Almost everyone considers trees, flowers, landscapes, birds, animals, even human beings beautiful. *Design in nature*, while a process that operates very differently from the human design process, only produces objects and settings that work well and satisfy us visually. A second area of design excellence not created by designers is *vernacular design*. This term refers to the products of people working in traditional and familiar ways. Their design arises in direct response to needs rather than from a conscious effort to create an individual object in a special way. A third area, one very much within human control, is *technological design*, most often the work of engineers. While engineers use the term *design*, they concentrate on function and structure, giving little or no thought to appearance in their work. Nevertheless, at least some technological design is of outstanding quality.

NATURE AND DESIGN

Nature normally produces its forms through processes independent of human control. Inanimate, or inorganic, nature can be described as the result of forces acting on materials in ways that follow natural laws that we have come to understand with increasing precision but whose origins remain unknown. A starry night sky, which, scientifically speaking, is simply a display of celestial bodies that rush through space and emit light, is universally viewed as beautiful. The Milky Way, the moon, a spiral

nebula (fig. 2.6)—all beautiful elements of the night sky—actually mean little to us beyond our recognition of them as visual traces of extremely remote realities. The earth gives us satisfying images closer to our direct experience—the sea, mountains, polar caps, the patterns of rocks, shells (fig. 2.7), pebbles, sand, cloud forms, and patterns of moving water—formations and conditions that can be identified and explained by the appropriate sciences.

The evolutionary processes that govern the biological world, or organic nature, have somewhat more kinship to the human design process. Among the great variety of living things, successful forms—in a functional, survival sense—prosper and develop, while less successful variants disappear. This process seems to explain why living things are invariably of excellent design. The growth patterns of plant forms, trees, and flowers can be analyzed in terms of geometric and mathematical principles that often parallel patterns in astronomical configurations. Both patterns, organic and inorganic, are responding to the same kinds of physical realities, although on a vastly different scale. They are also sources of visual satisfaction, true models for the human design effort (fig. 2.8).

Animal life, from the microscopic forms up to the largest of creatures, is comparably logical and beautiful in design terms. People who object that some living creatures, such as snakes and insects, look ugly are usually simply expressing their fear. Given reassurance against stings, bites, or other forms of attack, one can find design merit and inspiration in even the most threatening of life-forms (figs. 2.9, 2.10). Living species change over time as

2.6 Natural forms have an authority that has inspired design throughout human history. The spiral nebula in Virgo, a vast, unimaginably remote galaxy, is seen here through a powerful telescope. The spiral form is defined by the mathematics of the Fibonacci series. (Photograph: California Institute of Technology, Pasadena, courtesy American Museum of Natural History, New York) **2.7** The pattern of a snail shell's growth recalls, in miniature, the spiral of a remote nebula (fig. 2.6). This and other natural forms seem to have an almost universal attraction, suggesting that their mathematical basis generates an aesthetic that is intuitively understood. National Museum of Natural History, Washington, D.C. (Photograph: Chip Clark) **2.8** A staircase in the Midland Bank, Poultry, London (1924–37), designed by the English architect Sir Edwin Lutyens illustrates a spiral shape adapted to human use. The spiral is repeated in the decorative form of the stair rail. (Photograph: © James Mortimer—The Interior Archive)

conditions change. The great prehistoric reptiles, made obsolete by environmental change, can still be appreciated as superb designs for the conditions under which they prospered. It is interesting to note that some animals also produce objects: webs, nests, hives, dams, even lodges. These creations, the result of instinctive drives rather than of conscious planning, are as consistently excellent as the direct biological products of nature.

VERNACULAR DESIGN

Vernacular design, produced by human beings, has something in common with the processes of organic nature. The objects made by prehistoric and native populations, like the organic forms of evolution, emerged through trial and error, and then became *traditional* forms, repeated over generations with minimal change as long as they continued to serve the purposes for which they were developed. Simple tools and weapons, huts and tents, containers of pottery or basketry (fig. 2.11), and basic woven fabrics are not the design of a single creative person but rather *types* that show up in a particular society with only limited individual variation. These things draw our interest because of the excellence of design they often demonstrate, and because we also find

them beautiful in ways that more sophisticated design often has trouble equaling.

Vernacular design is by no means limited to the ancient and indigenous cultures. Modern examples surround us in such everyday objects as tools, kitchen implements, bottles, sporting gear, musical instruments, and the innumerable things for which the question, "Who designed this?" has no answer. The fisherman's dory, the lobster trap, the fireplug, and the telephone pole—all examples of generally excellent vernacular design—like the webs, nests, and hives of the animal world, evolved to fill a specific need without benefit of formal design efforts.

TECHNOLOGICAL DESIGN

Technology generates design that, while not at all simple or unselfconscious in a technical sense, in aesthetic terms is as *natural* as the products of nature or vernacular design. Indeed, the term *technological vernacular* is sometimes used to describe the design that has its origin in invention and engineering. The designs of ships, aircraft, bridges (fig. 2.12), and many kinds of machinery (figs. 2.13, 2.14), often deemed excellent, are carefully planned in terms of functional performance and structure but not in terms of aesthetics. In other

2.9 A display of beetles in the National Museum of Natural History, Washington, D.C., exhibits an astonishing variety of color and patterned markings. Their purposes—species recognition, camouflage, warning signals—often elude human inquiry, but their beauty is apparent. (Photograph: Chip Clark)

2.10 Shown here is a detail from a column capital, a feature of the Saddlery Building in Des Moines, Iowa, by Douglas A. Wells, architect. The forms and color are clearly inspired by natural patterns—of plants, animals, and insects. Compare this design, for example, with the beetles in figure 2.9. (Photograph: © 1986 Frederick Charles) **2.11** The traditional vernacular designs of native peoples have developed over millennia. These beaded baskets made by the Nevada Paiute people are strongly influenced by visual harmonies found in nature. The Denver Art Museum

words, aeronautical engineers, naval architects, designers of turbines, pumps, and printing presses design for performance and do not usually concern themselves with questions of beauty.

Nonetheless, their designs often look beautiful to us. In fact, gears, bearings, propellers, and similar technological objects have been gathered together and displayed in museums under the term *machine art*. We find it hard to believe that the designers of such objects do not take aesthetic considerations into account. We also find it surprising that efforts to improve technological design through the advice of design professionals often do more harm than good.

The design excellence of technological objects comes from the way in which their designs are developed—a way that closely parallels the designs of nature and the vernacular designers. Forms are suggested and guided by functional needs and the practical issues imposed by materials and manufacturing techniques. Each concept, each detail is tested by performance criteria—quite literally in a test laboratory, or in the long-term testing of use—so that better ideas survive while less successful ones fall away.

Designers of both buildings and interiors constantly turn to natural, vernacular, and technological design for inspiration and guidance. Their aim is not to imitate or borrow the forms of these designs, although this is not uncommon. Rather, it is to learn how the practical aspects of designing can lead to visual results that express the intentions behind the design process. We expect an interior space to serve its purposes well, that is, to offer comfort and convenience. We expect it to be well made from suitable materials put together with quality manufacturing techniques and expert skills. We also have a right to expect that the space will convey a sense of what it is and what it does and to convey this in a way that is clear and elegant.

A comparison with a written message may be helpful. A badly written paragraph, letter, or newspaper story, even if confusing and ungrammatical, can give accurate information, thus serving its basic purpose of conveying a message. The same content can be expressed in writing that communicates with clarity and ease, even writing that becomes a pleasure to read, or, at best, a form of art that goes far beyond the simple purpose of factual communication.

The old issues of *content* and *form* arise here. In design, purpose and structure make up the content of the visual product the designer creates. The *form* in which that content is expressed can be clumsy, confused, inappropriate, and sloppy. It can also be clear, organized, expressive of the design process and its methods, and expressive also of its time and place, its social context, and the ideas of the designer.

← 2.12

← 2.13

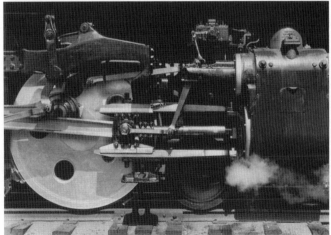
← 2.14

2.12 Technology can generate forms of great beauty, as in the Salginatobel Bridge of reinforced concrete, near Schiers, Switzerland, by the engineer Robert Maillart. (Photograph: John Pile) **2.13** Tanks and piping at an outdoor power plant in Sarasota, Florida. The forms of the strictly functional elements generate an aesthetic of their own. (Photograph: George Nelson) **2.14** The wheels of a steam locomotive of the 1930s were captured by artist Charles Sheeler in this 1930 photograph, *Wheels*. Later he transformed the subject into a painting called *Rolling Power*, which can be seen at Smith College Museum of Art. Northampton, Massachusetts. The J. Paul Getty Museum, Los Angeles

Table 1: Evaluating Spaces

FUNCTION: EXCELLENT EXAMPLE	FUNCTION: UNSATISFACTORY EXAMPLE
• Size and shape of space well suited to purpose • Placement and choice of furniture support use • Circulation well planned and convenient • Good lighting • Satisfactory acoustical environment	• Size and shape awkward and inconvenient • Placement and choice of furniture inappropriate • Awkward circulation patterns • Unsatisfactory lighting • Excessive noise and distraction
STRUCTURE AND MATERIALS: EXCELLENT EXAMPLE	STRUCTURE AND MATERIALS: UNSATISFACTORY EXAMPLE
• Choice of materials supports functional performance • Adequate durability and ease of maintenance • Construction of good quality • Cost of construction appropriate • Consideration of safety and environmental conditions	• Materials unsuitable to intended uses • Materials subject to rapid wear and hard to maintain • Construction obviously shoddy • Construction excessive in cost • Dangerous and hazardous conditions possible
AESTHETICS: EXCELLENT EXAMPLE	AESTHETICS: UNSATISFACTORY EXAMPLE
• Character and atmosphere appropriate to use • Time and place of design expressed • Character and quality of materials and construction honestly expressed • Design intentions clear and strongly developed	• Unsuitable atmosphere and visual character • False or obscure expression of time and place • Materials and structure falsified or obscured • Design intention vague or confused

Analyzing Existing Spaces

The generalizations offered here become more meaningful when they are applied to actual spaces that can be seen in drawings and photographs or, better still, visited and used. Direct comparison of good examples and bad examples can make theoretical points seem less abstract and more useful in real situations that call for evaluation. It is a helpful exercise to analyze some real interiors, choosing an outstandingly fine example and a distressingly unsatisfactory example in each of several functional categories. A possible list of candidates might include the following:

- A public space (lobby or concourse)
- A classroom
- An office
- A shop
- A restaurant
- A bathroom
- A living room
- A kitchen

Analysis can then proceed by developing evaluation under the familiar headings of function, structure and materials, and aesthetics, as suggested in Table 1, "Evaluating Spaces," above.

Many other observations will probably come to mind under each heading in the presence of an actual example. Similar tests can be applied to the various objects that make up a complete interior—the pieces of furniture, furniture systems, lamps and light fixtures, and small accessories that can each be viewed as a *design*.

Although the character of design may vary greatly from place to place and is subject to constant change over the passage of time, an analysis of the sort proposed will serve in every case, provided that time and place are taken into account. A castle, a palace, a cathedral, an igloo, or a yurt can be evaluated on this basis as logically and reasonably as can the most recent office, apartment, or loft. These standards apply equally to future directions destined to lead to design different from anything we now know. It is the obligation of every designer to work toward the highest levels of excellence that the realities of problems and the available solutions will permit.

case study 1. Residential Design Quality: House for Two Architect-Owners

STANLEY ABERCROMBIE AND PAUL VIEYRA,
ARCHITECTURE AND INTERIOR DESIGN

The house that architects Stanley Abercrombie and Paul Vieyra designed for their own use at Sonoma in the northern California wine country faces outward to a magnificent vista of surrounding country on one side while presenting a somewhat less open face to its opposite, entrance side. The long rectangle of the plan is divided internally into two bands that step downward to follow the slope of the hillside site (figs. 2.15–2.17). The narrow upper ribbon holds kitchen, dining space, and study, while four steps lower down the broader ribbon holds the large central living space plus, at each end, a bedroom and bath.

The two levels are divided by storage elements at each end, a fireplace wall at the center, and two broad stairs that connect the levels. Large glass areas open the lower level out to a broad terrace, pool, and the view beyond. The roof is flat across both levels except for a raised ribbon that permits clerestory windows to let light into the center of the house. Walls are of recycled polystyrene and cement in long blocks, their surfaces sprayed with a stuccolike mix of cement and earth, generating a soft tan color tone both inside and out.

The plan is strictly symmetrical, with divisions along its length in an A-b-AAA-b-a rhythm (see fig. 2.15). This virtually classical plan gives serene order and aesthetic power to the generally Modernist simplicity of the interiors. The main living space has end walls covered from floor to ceiling with bookshelves that provide color and variety through the spines of their contents.

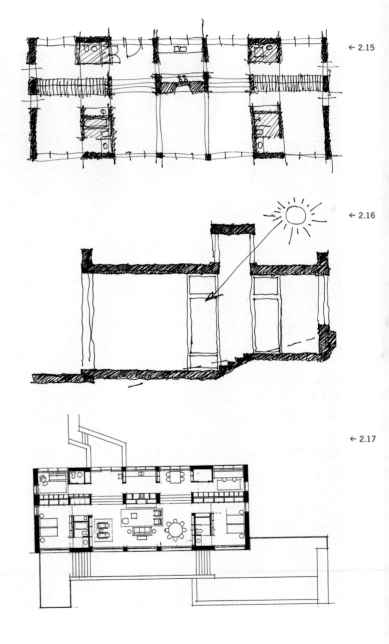

← 2.15

← 2.16

← 2.17

2.15 A sketch shows the developed plan of the Abercrombie-Vieyra House almost exactly as executed. A 15-inch module derived from the wall material elements controls the dimensions. Note the sequence of A (larger) and b (smaller) units of width in the A-b-AAA-b-A symmetrical pattern. (Courtesy Stanley Abercrombie and Paul Vieyra)

2.16 A cross-section sketch shows the floor levels following the slope of the hillside, while the flat roof is interrupted by the clerestory, which admits light into the center of the building. (Courtesy Stanley Abercrombie and Paul Vieyra)

2.17 Note the similarity of this finished floor plan to the initial sketch (fig. 2.15). (Courtesy Stanley Abercrombie Paul & Vieyra)

2.18 →

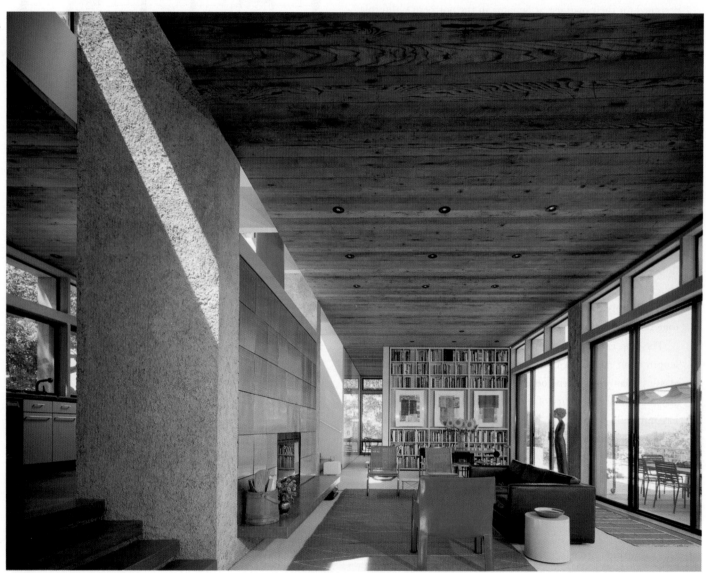

2.18 In the huge central living area, the floor is finished concrete, the rug Egyptian, and the ceiling reprocessed redwood planks recovered from a demolished warehouse. The fireplace elevation is faced in perforated aluminum tiles. (Photograph: Peter Paige)

2.19 The dining area on the upper level, with chairs by Finnish architect Alvar Aalto, is separated from the galley kitchen beyond by an open bookcase partition. The living room with its glass window-wall is on the left. The center clerestory illuminates spaces on both sides of the central axis. (Photograph: Peter Paige)

2.20 Touches of color enliven a monochromatic bedroom, supplied here by a yellow drum table and a sliding door painted orange. The chair is a Thonet classic, a favorite of Le Corbusier. (Photograph: Mark Darley/Esto)

2.19 →

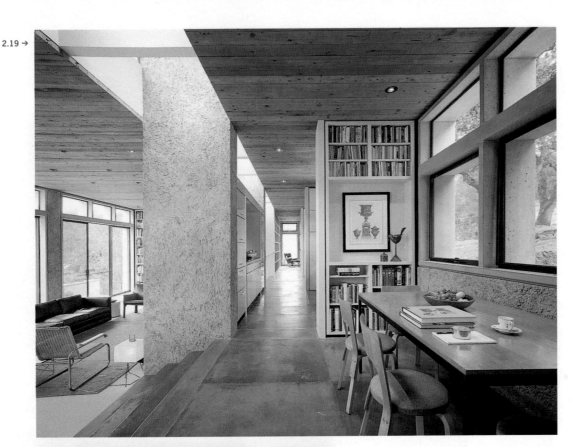

2.20 →

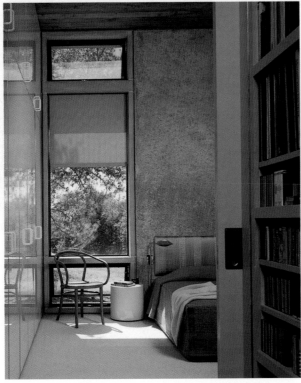

The glass outward-facing wall is its own decoration, while the fireplace wall, sheathed with perforated aluminum, introduces a metallic contrast to the tan structural walls (fig. 2.18). Classic modern furniture, carefully placed, and some artworks contribute to the sense of restrained beauty (figs. 2.19, 2.20). In its attention to matters of function, structure and materials, and aesthetics, the Abercrombie-Vieyra House is an excellent example of design quality.

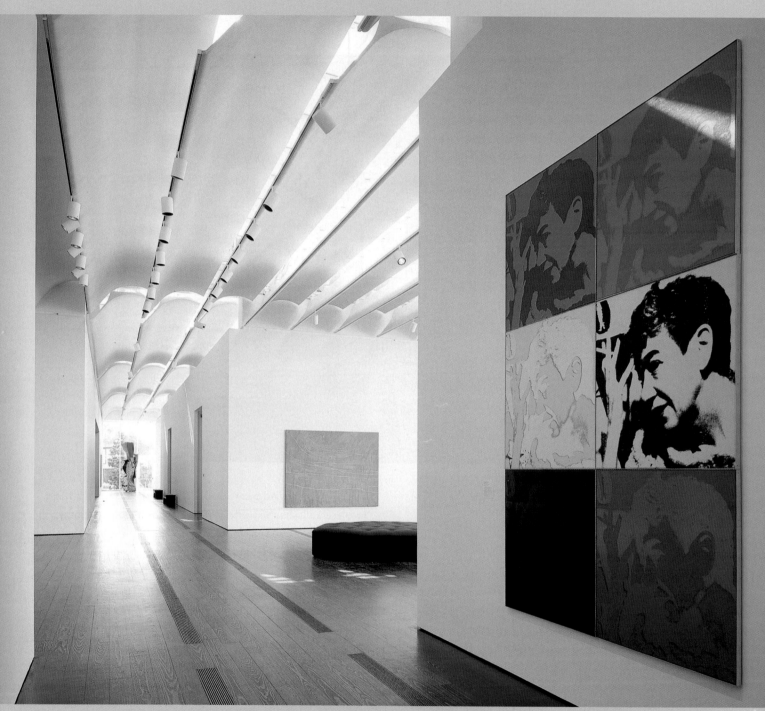

3.1 ↑

chapter three. Design Basics

Interior design is a complex subject involving many related considerations. These include building structure, functional planning, concern with spatial form in three dimensions, the relationship of one space to another, the placement of solid objects (furniture and accessories) within larger spaces, and effects of color, pattern, texture, and light. As a practical matter, these issues are usually thought about one by one, and they can be studied as separate, individual topics. In designing an interior, however, the aim is always to weave them together in order to create a whole that is more than the sum of its parts (fig. 3.1).

The term *basic design* indicates a body of ideas about design that is so general, so universal in application as to transcend the special and detailed concerns of design projects. Basic design deals with elements and principles that refer to all aspects of *all* design. Many design schools present basic design in introductory courses (sometimes called *foundation* courses) that explore these basic issues in an abstract way, apart from specific design applications.

An understanding of basic design elements and principles can evolve "from the bottom up," through the experience of working on design projects. However, an introductory study of basics viewed "from the top down"—that is, beginning with abstract and general concepts, including point and line; form and shape; texture, pattern, and ornament; value and color; size, scale, and proportion; unity and variety; balance; rhythm; and emphasis—can be useful in developing a framework of thought within which to relate the more everyday realities of design practice. Any hope for a set of rules that will guarantee design excellence must be put aside. Design, especially interior design, involves so many variables that these concepts can be used only to support the more intuitive ways of designing that have served for thousands of years. This chapter presents some of these basic issues as they might be presented in many design schools. (Since a full treatment of color theory is given in Chapter 10, "Color," it is dealt with only briefly here.)

Design and Human Perception

VISUAL PERCEPTION

The designer's aim is to make the realities of a designed space—its form, materials, furnishings, accessories, and so on—express in an appropriate way a set of ideas that the designer wishes to communicate. Since vision is the primary sense through which the design and the ideas behind it will reach an audience, basic design must be concerned with the field, both scientific and artistic, called *visual perception*. This study explores the ways in which the visual sense works to build a mental understanding of objects, spaces, and total environments through sight. No verbal description can ever equal the knowledge of reality that comes from actually seeing, although substitute visual images—that is, pictures—can to some extent approach the direct experience. While seeing is such a common experience as to seem to require no explanation, it actually involves many complex processes.

3.1 The ceiling treatment of the main corridor, with galleries opening on either side, permits controlled daylight illumination in the building housing the Menil Collection, Houston, Texas. The directness and simplicity of the design derives from a full understanding of the design elements and principles that bring about aesthetic success. Andy Warhol's *Portaits of Jermayne McAgy* is on the wall to the right. Renzo Piano was the architect. (Photograph: Hickey-Robertson, Houston, courtesy the Menil Collection)

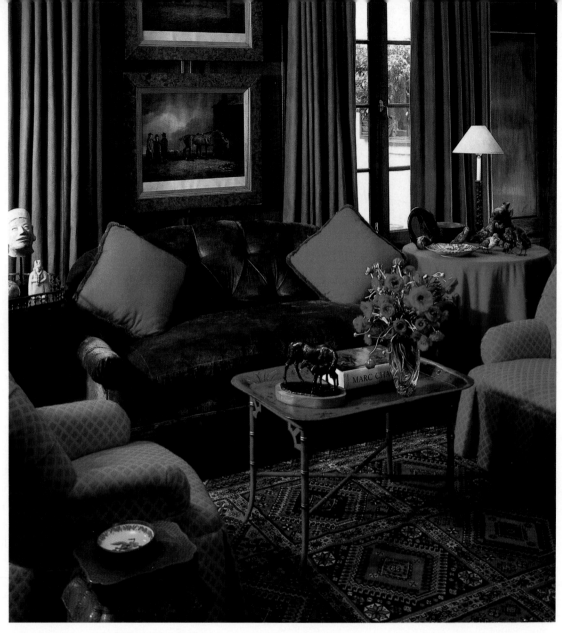

← 3.2

The mind pieces together its understanding of a three-dimensional object from information it receives from both eyes, each of which sends slightly different views. In addition, eye, head, and body movements supply a flow of changing images that, put together, create a mental *model* of the reality. This model can then be held in memory and viewed in the absence of the actual object.

This same process, combined with the physical action of walking, gives us an understanding of space. It is a special quality of space that its experience implies, even requires, movement. We must go *into* a space in order to see it, learn what it is like, and experience its unique qualities. Complex, multispace structures demand that we walk from one space to another, which involves not only motion but also time. Since motion cannot be thought

of apart from time, the modern physical concept of space-time becomes useful in designing interiors.

This concept is illustrated by a visit to a large building, a cathedral, a museum, or a concert hall, in which a full exploration of the interior space requires passing from room to room and from one level to another. We understand such a space not as a single entity fixed in time but as a sequence of experiences. As we add each new experience of the space in our progress through it, we substitute memories for the actual experience. The smallest of spatial sequences—a small house, a tiny apartment, even a single room—displays this quality to some degree. In order to truly know and understand any space, we must walk into it, look about in all directions—to all sides, up and down—sit down, move around, and spend some time

3.2 In this library of a renovated 1920s Texas home, interior designer Mark Hampton created an atmosphere of comfort and luxury by means of warm colors and rich textures. Objects on display range from pre-Columbian pieces to part of a collection of Austrian bird

bronzes. (Photograph: Feliciano, courtesy *House & Garden*) **3.3** Soft and curving shapes, pale colors, and transparent materials combine to suggest ease and relaxation in the living room of a vacation house near South Beach in Miami, Florida. The house was designed for designer

Glenn Pushelberg by the Toronto-based interior design firm Yabu Pushelberg. (Photograph: Quenton Bacon, as seen in *Metropolitan Home*, Jan./Feb. 2001)

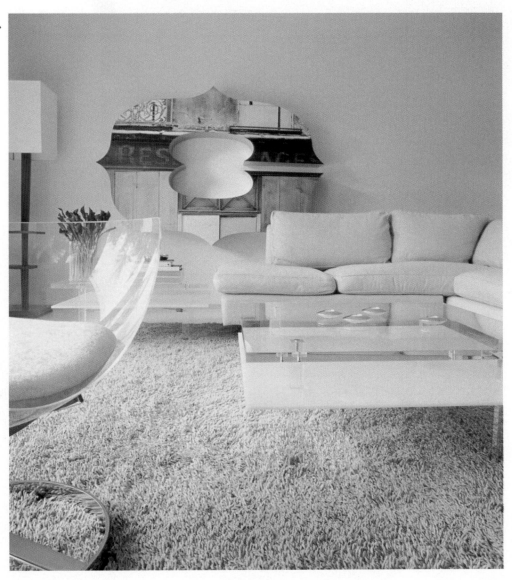

building up a series of impressions that combine into our final idea of the space.

VISUAL IMPRESSIONS

In addition to the understanding of reality that comes with vision and movement, a viewer receives impressions of a more abstract, even emotional, character. An object or a place may *look* quiet or lively, cheerful or depressing, solid or vaporous. We learn that a fire or bright sunlight is hot or warm, and so we associate the colors red and orange with heat (fig. 3.2). We see the sharp edges of tables and boxes and learn that they also feel hard and sharp, while the soft forms of cushions and draped fabric become associated with the sensation of softness (fig. 3.3). The horizontal surfaces of the sea, a lake, or a meadow connect repose with horizontality. The sturdy upright of a tree trunk relates naturally to a sense of solidity and stability, as do strong vertical elements (fig. 3.4). The bright colors of birds and flowers carry associations different from the browns and grays of earth and rocks.

All of these associations are reinforced by the kinetic impressions that we receive from our own bodily positions and move-ments. We learn that a horizontal position *is* restful, while standing upright promotes attention, formality, even resistance. When running, we lean forward in an aggressive diagonal. While we experience bodily *symmetry* as normal and stable, we can move body parts into *asymmetrical* positions, but we learn to do this in a way that maintains *balance*. A person tilted to one side will fall over unless the body is repositioned to maintain balance or support is found by leaning on or holding on to something.

Objects designed by humans also contribute to this buildup of interpretive reactions. We see an automobile or airplane that is capable of fast movement, and we come to say that the typical forms *look* fast, even when the object is at rest. When a room strikes us as cheerful, restful, dignified, or businesslike, we may be reacting to memory traces of experiences with rooms that looked a certain way and that turned out to *be* a certain way. It is difficult to say whether this is due to individual characteristics, such as form and shape, pattern, or color, or whether it comes from a total impression of the sort that the Gestalt school of psychology studies. Basic design begins with a study of the individual elements that go together to form the totality of an integrated structure, or *gestalt*.

Elements of Design

It is convenient to follow a progression in considering how visual impressions are developed.

POINT AND LINE

As conceived in geometry, a point is simply a location in space having neither dimensions nor substance—an abstract notion difficult to grasp. Two points, however, suggest a beginning and an end and lead to the idea of a connecting line (fig. 3.5). Points in a random scatter seem meaningless, but a cluster of points in a field of scatter suggests a focus or concentration of interest (fig. 3.6).

When a point moves through space or when two points are connected, *line* is generated. Line, which may be straight or curved, has length but not breadth. We seem to see lines where things have edges, where one plane meets another, or where there is a change of color or surface in a plane. Straight lines can be thought of as taking several typical positions: vertical, horizontal, diagonal, and curved (figs. 3.7, 3.8).

Vertical Lines Lines that are vertical suggest stability and immobility, and, by extension, dignity and permanence (see fig. 3.4). The significance of verticality comes, it seems, from the downward direction of the force of gravity. This force dictates verticals, always perpendicular to all horizontals, as the basic structural support. The vertical columns of a building suggest its solidity and permanence.

Horizontal Lines Lines that are horizontal suggest rest and repose. Gravity pulls materials down to a horizontal resting point parallel to the ground in a horizontal line, and earth and sky seem to

meet in a horizontal. Human experience of the horizontal reclining position in rest and sleep reinforces these perceptions. Floors and ceilings, normally horizontal, are the surfaces that give spaces their sense of reassuring normality.

Diagonal Lines Lines that slope suggest movement and activity (figs. 3.9, 3.10). These diagonal, or *oblique*, lines are always, in a sense, transitional between vertical and horizontal, the positions that gravity tolerates, and are held only through some special means of resistance to gravitational forces. A person leans for–ward to run, making us associate activity and movement with diagonal lines.

While there can be only one horizontal and one vertical direction, diagonal lines can take an infinite number of angular slopes. The combination of diagonal lines in alternate directions, called a *zigzag*, gives a sense of restless, rapid hyperactivity. It is used to symbolize lightning, electricity, and radio waves. A sloping ceiling or wall makes a space seem active, lively, even possibly disturbing through its implication of movement.

Curved Lines The path of a moving point that continually changes its direction produces a curved line. Curving forms occur more often in nature than right-angled forms, leading us to perceive curvatures as more natural, freer, and more "humane" than straight-lined forms. Circles and segments of circles, having a simple and clear geometric genesis, appear straightforward. More complex curvature, such as ellipses, parabolas, and hyperbolas, are more varied and subtle. *Free* curves that have no geometric controls and combinations of curvatures in S shapes or sinuous relationships suggest increasing levels of complexity, subtlety, and softness.

3.4 The entrance area and elevator lobby of the Swiss Re Building in London, designed by Foster and Partners. The dominant blue color gives the space a sense of openness, making a pleasant transition from outdoors to inside.
3.5 Any two points will generate a sense of relationship (A), which is mentally translated into a connecting line (B).
3.6 In a random scatter of points, any cluster becomes a focus of attention. The three clusters here bring to mind the form of a triangle.

VERTICAL LINES DIAGONAL LINES

3.7 →

← 3.8

A

B

C

HORIZONTAL LINES

FORM OR SHAPE

The terms *form* and *shape* are interchangeable. Form can have either two or three dimensions.

Two-Dimensional Forms A *plane* is a completely flat surface, created by intersecting lines. Planes are *two dimensional*, with length and width but no depth, as are *plane figures*—figures that lie completely in one plane—such as the triangle, square, circle, and so on. Planes also contain irregular or free shapes that conform to no particular geometric definition. The human mind seems to be drawn toward recognition of simple geometric shapes, perhaps because, being perfect forms, they can be held in memory and reproduced with ease. In a random scatter of points, the eye will seek out a triangle, square, or circle or find an image with a recognizable form (fig.

3.11). The constellations of the night sky are images suggested by the relationships of bright stars seen as points. The Big Dipper, for example, is simply an arrangement of bright points that suggest the form of a long-handled cup. Once that grouping is pointed out and named, it becomes easy to locate and recognize amid the vast number of other stars that surround it.

Design makes wide use of our attraction to perfect shapes, whose completeness and stability we find highly satisfying. Imperfect shapes, such as a square with a corner cut off or one irregular side, a circle with a dent, or a shape not fully closed, cause a sense of tension, which may be used to create a more dynamic, unusual design (fig. 3.12). However, if the "imperfection" is too strong, it leads to dissatisfaction and a sense of instability.

3.7 Dominant vertical lines contribute to a sense of dignity and solidity. Horizontality relates to feelings of tranquility, calm, and repose. Diagonal forms suggest movement and the dynamic relationship of forces; they promote feelings of activity and motion. In excess, they can be

disturbing. **3.8** Curving lines suggest softness and freedom. Segments of circles (A) carry some stability; segments of parabolas (B) and other more complex geometric forms are both freer and more subtle; free curves (C)—curves that are not parts of circles or any other geometric

figures—may be flowing, aggressive, or active. **3.9, 3.10** The diagonal lines and angular and broken shapes of this bedroom give rise to a sense of activity and motion. The plan (fig. 3.10) shows the apartment's unusual triangular layout, which inspired the room's design. The associations with a

ship are intentional; the space is treated as a lookout, with a telescope pointing toward the apex of the triangle. The chair, titled Hell's Angel, is by Patrick Naggar. Andrée Putman designed this showcase apartment in the Metropolitan Tower, New York. (Photograph: © Peter Paige)

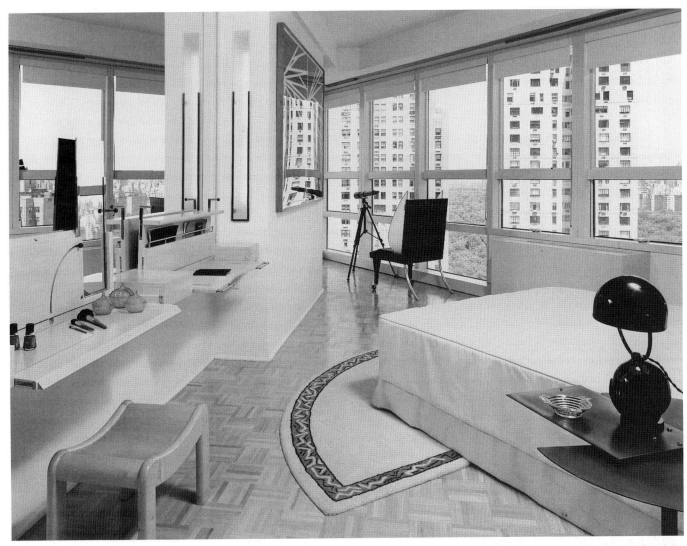

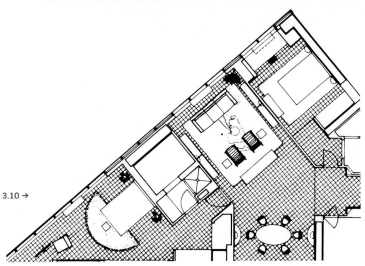

3.10 →

← 3.11

← 3.12

3.11 In a random scatter of points (A), the mind and eye search out relationships that can be seen as recognizable geometric figures (B). **3.12** Figures that would form a simple geometric shape but for some irregularity are perceived as being defective and cause the mind to struggle to supply a "correction." Figure A is clearly a square, slightly modified. B is seen as an imperfect circle. C appears as a truncated triangle rather than the irregular quadrangle that it actually is.

More complex forms, such as rectangles of various proportions, other quadrilaterals, polygons, and curved forms, regular and irregular, all have both practical uses and expressive visual qualities of varied sorts.

Three-Dimensional Forms Adding depth, or volume, to a two-dimensional form creates a *three-dimensional form*. Furniture, some architectural elements (such as columns or stairs), and buildings are three-dimensional solids. Interior design is particularly concerned with hollow three-dimensional form, or space: rooms or other spaces within buildings, which are the primary element of interior design. Hollow space is defined by planes of enclosure, that is, floors, walls, and ceilings, which separate space inside from space outside and determine the nature of the interior space.

In most interior spaces, the planes of floors, walls, and ceilings are organized in 90-degree, or right-angled, relationships, usually called *rectilinear*, which are considered the most stable of forms. In fact, such boxlike room forms are so common that they have come to be criticized for their monotony and lack of imagination. Small, boxlike enclosed spaces can suggest confinement and restriction or, on the other hand, privacy and intimacy.

Nonrectilinear three-dimensional room forms can be generated by using non-right-angled relationships for one or more of the enclosing planes, as, for example, a sloping ceiling or an angled wall, or by the use of curving planes of enclosure (fig. 3.13). Curved forms, because they are not so sharply defined by lines, suggest openness and free space. Round or elliptical rooms have a special character, while domes as a ceiling or roof inspire feelings of grandeur and awe by suggesting the infinite openness of the universe (fig. 3.14). *Domes* automatically make an internal space special, even monumental, as, for example, the *rotundas* of many famous buildings.

Complex hollow space can be developed by connecting several simpler forms (as in the design of Gothic and Renaissance churches, whose plans are usually based on connecting quadrilaterals and semicircles); by opening simple spaces into one another with large doorways, open wells, and similar devices; or by providing more than one level in a single space. Stairways, in addition to overing oblique planes, can be designed in complex three-dimensional terms, such as the helix of the popular spiral stair. These are all common ways to introduce movement, openness, and variety into a space. Complex spaces can also include areas of intimacy without losing their impression of openness, as, for example, when a lowered ceiling is used over a conversation area that looks out to an open space beyond it. (A more detailed discussion of the role of three-dimensional space as a key element in all interior design will be presented below [see pages 65–69], following the continued discussion of concepts regarded as fundamental to all design activities.)

TEXTURE, PATTERN, ORNAMENT

Three particularly useful elements of design are texture, pattern, and ornament.

Texture Texture is a characteristic of all materials. There is a wide range, from the smoothness of polished glass or metal to the roughness of coarse sandpaper. Many substances are made in a variety of textures; brick and tile can be smooth and glossy or rough in varied degrees. Paints are available in a range named *gloss* to flat, or *matte*. When paint is applied to a material, the resulting surface is created by a combination of the texture of the underlying material and the character of the paint. Such natural materials as wood and stone have qualities that permit their textures to be modified by various ways of working and finishing. Rough-hewn wood and stone have very different textures from the same materials smoothly cut and polished. Woven materials have textures generated by the fibers used and the nature of the weave. Silks can be smooth and shiny, while coarse woolen weaves are rough and nubbly. The term *hand* is used to describe the tactile qualities of textiles. Woven carpets and rugs exhibit textures that are produced by their fibers, the nature of the weave, and the various finishing processes and can vary from flat and somewhat smooth to the extremes of shag weaves.

Textures can readily be felt by touching, but observation of a texture's surface, even without touching, suggests a tactile sensation and thus communicates a sense of physical contact that has a strong ability to enrich visual perception. Experience has made it a familiar reality that smooth surfaces conduct heat away from the body and so are cool to the touch, while rough surfaces are less conductive and so feel warm. That experience is then transferred to visual impressions that create a sense of greater or lesser warmth even when the surfaces in question are not actually touched. The terms *hard* and *soft* actually describe physical properties of materials, but hardness or softness is also *implied* by textures.

Texture has a strong influence on the perception of color. Colors that can be recognized with certainty when seen in totally flat or matte form can appear much altered when given a glossy texture that reflects some light, much in the way that a mirror reflects an image. Texture is usually thought of as a characteristic of materials that develops at a small scale, but it is possible to think of textures at the larger scale of an entire wall or a large object or group of objects. A brick wall has a texture generated in part by the bricks but also influenced by the joints between bricks and the pattern in which they are laid. In working with materials and colors, it is easy to take textures for granted, but some focus on textural qualities is helpful in all interior design work.

Texture also has implications for acoustical considerations. Hard and smooth surfaces reflect sound while softer textures are absorptive. This means that a space with a preponderance of hard and smooth materials tends to be noisy, a familiar circumstance in cafeterias and fast-food restaurants. Softer textures tend to quiet sounds, leading to a hushed ambience. In auditoriums and concert halls, a balance of hard and soft surfaces is required to obtain acoustics that are neither too brilliant and harsh nor too muffled or dull.

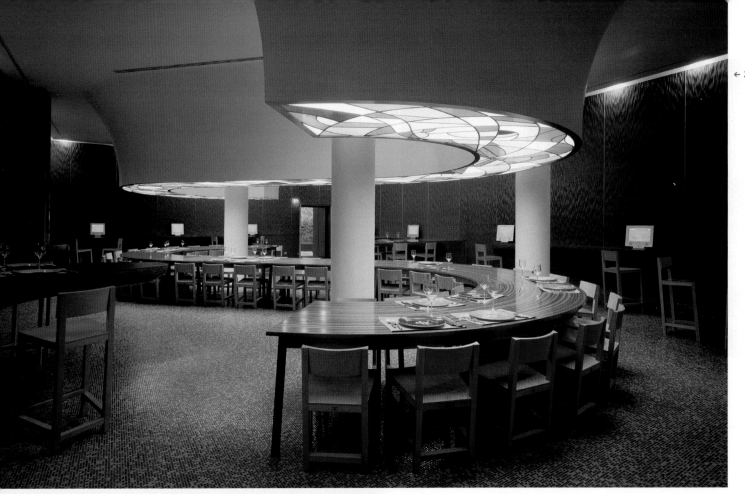

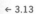

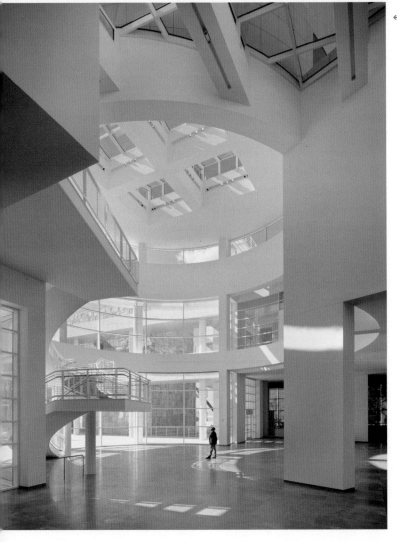

3.13 A dining area in the UNA Hotel in Florence, Italy, designed by Fabio Novembre. The sinuous curving forms of the table (designed by Joep van Lieshout), overhead lighting elements, and enclosing walls give the room a unique character. (Courtesy Fabio Novembre)

3.14 An entrance and stair lobby at the Getty Center in Los Angeles, California. Richard Meier & Partners were the architects. White is the color most often associated with this architect's work. The curving stair offers attractive access to the upper floor level.

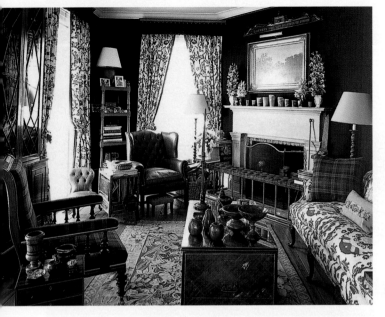

Pattern Unlike texture, which is usually small in scale and integral with a material, pattern is large in scale and is applied to a material or surface or is a result of the way in which material is assembled. A brick wall or a tiled surface has a pattern resulting from the joints of the materials in use. A tile pattern can be created by placing varied colored tiles in a planned arrangement. Patterns may be printed on wallpaper or fabric, woven into a textile, or created by some process, such as stenciled paint.

Smooth surfaces are defined only by their limits, edges, or corners. A patterned surface has visible presence in every part of its extent. The eye focuses on pattern and uses it to help measure size and shape, to gain information about material, and to interpret the mood of the design (fig. 3.15). The fact that pattern is usually repetitious gives it rhythmic qualities on a small scale. Like color—or used in combination with color—pattern can make a surface more or less important or a space seem larger or smaller than it actually is. For example, stripes running vertically make a surface seem narrower and higher, and running horizontally, wider and lower.

At the same time, the elements of a pattern can convey messages. Little flowers and regular stripes create very different moods. Geometric squares and naturalistic curves imply different attitudes. In addition to such expressive qualities, pattern has the ability to hide, or at least minimize, soiling and visible traces of damage. Plain surfaces expose every flaw, while pattern tends to camouflage imperfections.

Ornament The term *ornament* refers to visual extras unnecessary for practical reasons but added to show off expertise, introduce variety, and enrich a uniform surface. Ornament played a prominent role in most design of the historical periods. The wall and ceiling moldings, eggs and darts, Greek keys, and similar motifs of classical design, and the carved leaves and gargoyles of medieval design clearly express the thinking and the craft skills of their respective eras.

With modern mechanical reproduction, ornament became easier to produce but less meaningful, no longer made by a skilled craftsperson for a particular context. The modern movement often responded by omitting ornament entirely. (Adolf Loos went so far as to say, "Ornament is a crime.") Still, the gleaming edges of glass, chrome, and marble in the modern interior serve some of the same purposes as applied ornament. Recently, ornament has been rediscovered. It now appears in the re-creation of historic styles (fig. 3.16) and in much contemporary work, often quite brashly and aggressively as an expressive tool.

In historic interiors, ornament often played a major role. Moldings, carved woodwork, and molded plaster were generously used and were significant in giving to each period its particular character. In the restoration of historic interiors, it is important to preserve and restore ornament and to match any new work required to replace damaged or lost elements with existing older ornament.

In all ornamentation, the key to value is the issue of *meaning*. Why is the ornament there? Does it add something or does it merely cover over and confuse? Good ornament emphasizes what is important, draws attention to what is significant, and tells something about the materials and technical mastery involved. The molding around a door or window emphasizes that element's size, shape, and position. Moldings at a cornice or baseboard strengthen the line of intersection of walls, floor, and ceiling. A rosette where a light fixture hangs from a ceiling makes the place of hanging more important. The moldings around panels of furniture or room interiors make the size, shape, and pattern of the paneling stronger, clearer, and more decisive. Carved detail on a chair tells us the place and time of its origin, as well as something about the attitudes and crafts skill of its maker. An object that serves a useful function can at the same time become an expressive carrier of a message by the addition of meaningful painted surface designs. Ornament fails or clutters when it has no meaning, is introduced only for show, and has no real relationship with the object or space it adorns. However, when its purpose is genuine and useful, it can be a valuable communicative tool.

VALUE AND COLOR

The term *value* refers to the level of lightness or darkness of any material or object and ranges in tone in a scale from black to white

3.15 Pattern is an overwhelming theme in the study of an upstate New York home designed by Greg Jordan. Bold florals and tartans for window treatment, upholstery, pillows, rug, and trunk are unified by a consistent color scheme, successfully communicating warmth and comfort. (Photograph: Jan Baldwin, from David Linley's *Design and Detail in the Home*)

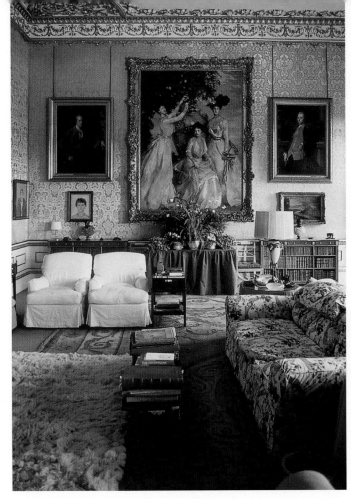

← 3.16

← 3.17

(see fig 10.9). It is part of the terminology of color systems, but it also can be used to describe elements of any interior. The words *high* and *low* relate to lightness (high) and darkness (low). A window wall with sheer drapery has, in daytime, a high value while a dark granite floor is of low value. *High key* is a term often used to describe the qualities of an interior that is dominated by elements of high lightness value (fig. 3.17). Value is an important aspect of the atmosphere that can be sensed in any interior. High and low value have no relationship to merit—low value may communicate a sense of dignity, calm, and coziness but can also be depressing. High value seems to relate to cheer and liveliness, but it can be disturbing in some contexts. Within a particular space, use of mostly high or mostly low value emphasizes the implications of the level selected. A mix of high and low in various uses generates contrasts that can have their own implications of activity and significance. Contrast of value can be used to emphasize some elements of an interior and subordinate others. The designer needs to face the value relationships that are being created as materials and colors are selected in order to ensure that a desired ambiance is being created.

Color is a major element in the design of any interior. Design work is often started with sketches and drawings in black and white, but the character of the space being developed only emerges when color choices bring the designed forms to life. Color is studied in terms of its three aspects: hue, value, and saturation, or *chroma*. The importance of color has justified an entire chapter of this book (Chapter 10, "Color") and is therefore only mentioned briefly here.

OPACITY, TRANSPARENCY, TRANSLUCENCY

The qualities of opacity, transparency, and translucency are characteristics of materials and the objects made from them and have a major bearing on interior design planning. *Opacity*, or imperviousness to light, is the most common quality of most materials and therefore of the surfaces and objects made from them. Brick and stone, wood and metal cannot transmit light and are therefore inevitably opaque.

Transparency, or the ability to transmit light in such a way that what is lying behind is clearly visible, is the most obvious quality of glass and of a number of glasslike plastics in the forms in which they are most often used. The transparency of the glass of windows permits light to enter interior spaces and permits outward or inward visibility. Not all glass is transparent, however;

3.16 Gilded and painted ceiling and chair-rail moldings in the English great house of Chatsworth, Derbyshire (William Talman, architect, 1687–96), provide architectural detail to set off the paintings and furnishings of the Blue Drawing Room. Carr of York decorated the room in the 1770s with brocade-covered walls. The large painting is Sargent's portrait of the Acheson Sisters. (Photograph: © James Pipkin)

3.17 White and pale colors produce an extremely high-key bathroom scheme at the Hudson Hotel, New York, designed by Philippe Starck. (Photograph: Nikolas Koenig, courtesy Full Picture)

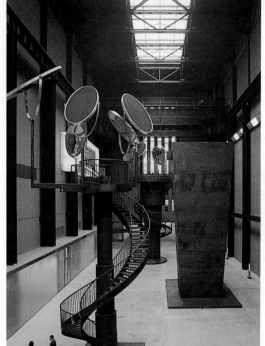

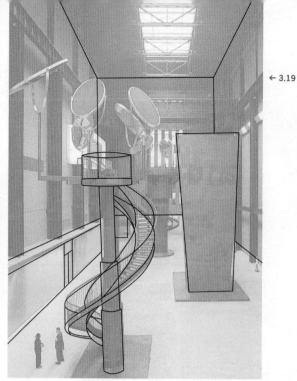

there is black glass and glass of such dense color as to be opaque. There are also the mixed qualities of glass and similar materials made with patterning that breaks up the visibility of objects. Such "obscure glass" and related materials such as glass block can thus transmit light but block visibility.

Translucency is the term often used for such characteristics but is more exactly descriptive of materials that transmit light but block vision as a result of their inherent qualities. Glass is made in translucent forms by mixing into the glass color pigments that block transparency. The term *opal glass* is used to describe glass with such integral coloring (usually white); there are a number of other translucent materials, including many plastics and even paper. Translucency is useful in interiors where passage of light is desired while blocking vision. Translucent materials have extensive use in lighting devices, including the familiar paper, fabric, or plastic lampshade and the sconce reflector.

Many objects combine materials having several of these qualities. In addition to lamps and light fixtures, furniture with an opaque base and a transparent top surface, such as in a table or desk, is a familiar example. Mirror may be mentioned here since, although it is glass, it is made opaque by a silver surface that makes it reflective. An interesting variant is the half-silvered mirror that may appear opaque or transparent according to the lighting level existing on each of its two sides. To the designer, degrees of opacity, transparency, and translucency offer another element to be manipulated in efforts to achieve desired optima in terms of function and visual qualities.

Principles of Design

SIZE, SCALE, PROPORTION

In organizing line, surface, and hollow space, a number of other basic concepts will enter into design decisions. Some of these concepts are size, scale, and proportion.

Size We think of things as large or small in relative terms, in relation to both the human body and other things. A large living room may be much smaller than a large church, but it appears large in relation to an adjacent small entrance hall. Absolute size is usually less important than relative size.

Scale The term *scale* is widely used in design and architecture to describe a rather subtle consideration related to size. It refers to the proportion of an object or space in relation to all other objects, to human beings, and to the space to which it belongs (figs. 3.18, 3.19). Designers achieve *good scale* by choosing elements that seem to be of an appropriate size for the space they will inhabit, that relate well to human dimensions, and, above all, that look their actual size. Small pieces of furniture often look lost in a large space, while large objects may seem overbearing when crammed into a small room. A large space that appears too small is out of scale. Good scale is indicated when things look so right that the issue does not even come to mind.

Proportion The concept of proportion addresses the size of parts of a design in relation to each other and to the whole. Good propor-

3.18, 3.19 A dramatic range of scale is apparent in the old Turbine Hall of the former power station that is now the Tate Gallery of Modern Art, London. The vastness of the space and the huge size of Louise Bourgeois's sculpture, specially commissioned for the space, are made comprehensible by the normal size of the winding staircases and the seemingly tiny size of the normal doors visible on the left. Figure 3.19 plots the relationship of the major forms. Herzog & de Meuron were the architects. (Photograph: © Arcaid/-Richard Bryant) **3.20** Geometric analysis can demonstrate the mathematical basis behind many classical and Renaissance designs. This plan of Andrea Palladio's Villa Foscari (La Malcontenta), Mira, Italy (A), is based on simple arithmetic proportions (B). If the smallest dimensional unit is given a value of 1, the width of the building can be seen to be divided into a rhythmic sequence of 2-1-2-1-2 (making a total of 8 units). The length turns out to total 5½ units, divided in the somewhat more complex relationship of 2-2-1½. (The relationships can also be expressed in whole numbers

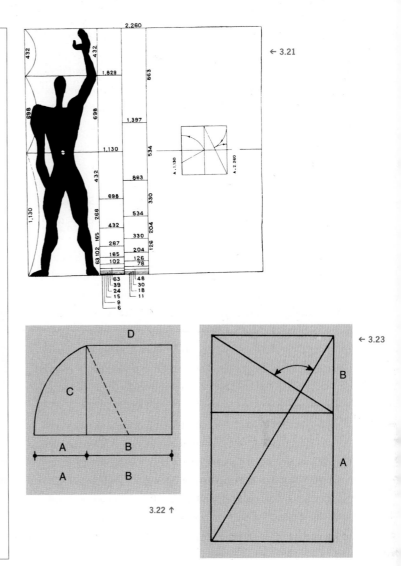

3.22 ↑

tion is a much-discussed concept in the arts and in design and is considered a key requirement in any aesthetic success. It is not hard to tell if an existing space is well or badly proportioned. In the former case, it looks visually "right"; in the latter case, a room may seem too long and narrow, or an element such as a door, window, or piece of furniture may appear awkwardly placed. Achieving good proportions is less easy than recognizing them, although many efforts have been made to develop systems for doing so.

One approach, using mathematical relationships analogous to the rules of harmony in music, suggests organizing proportions according to geometric ratios of simple whole numbers, such as 1:2, 2:3, 3:4, and 3:5. Many Renaissance architects, including Leon Battista Alberti (1404–1472) and Andrea Palladio (1508–1580), based their structures on such systems (fig. 3.20). Other approaches, such as the *Modulor* of Swiss architect Charles-Édouard Jeanneret, known as Le Corbusier (fig. 3.21), base dimen-

sional units on human body proportions, such as height and arm reach, and extend these through numerical multiplication into a system for controlling dimensions and their relationships.

The Modulor also makes use of one particular mathematical relationship, often referred to as the *golden ratio* or *golden section* and designated by the Greek letter phi (Φ). It has had so much influence on design throughout history as to deserve some special discussion. The terms *golden mean*, *golden ratio*, and *golden section* all refer to a proportional relationship that satisfies a certain requirement. If one divides a line into two unequal segments so that the ratio of the short segment to the long segment equals the ratio of the long segment to the total line length (the short segment plus the long segment), this requirement is satisfied. The resulting ratio

$$\frac{.618}{1} = \frac{1}{1.618}$$

is expressed in the irrational number .618...(figs. 3.22, 3.23).

by giving the smallest unit the value of 2. The width is expressed as 4-2-4-2-4; the length as 4-4-3. The totals are then W = 16, L = 11. Reducing these figures to a ratio gives a proportional relationship of 11:16 or .687.) **3.21** Le Corbusier's Modulor is a modern, complex system

that uses geometric ratios based on the proportions of the human body to determine the patterns of architectural design. **3.22** To divide a line into golden ratio proportions, a dotted line is drawn from the midpoint of side B of the square to the intersection of sides C

and D; then an arc is swung downward to the base line. A/B forms a golden ratio. **3.23** A golden rectangle with a square cut off (A) produces a smaller golden rectangle (B). The diagonals of the larger and smaller rectangles intersect at a right angle.

This proportion can be found in the designs of many famous structures and works of art (fig. 3.24). Various experiments and comparisons of measurements show a strong preference for the golden ratio among human beings and a high level of occurrence in nature.

UNITY AND VARIETY

The terms *unity* and *variety* describe concepts with clear bearing on design, although no precise way of defining an "ideal" measure for each can be defined.

Unity, or harmony, allows the viewer to experience a design as a whole rather than seeing it as a collection of elements. All the parts of the design will relate so well as to create a unit in which, ideally, nothing can be added, taken away, or altered without changing the totality (figs. 3.25, 3.26). Matching or coordinated patterns, closely related colors, and stylistic consistency all lead to unity, but they also carry the threat of monotony, as in the room in which everything matches everything else in an obsessive way.

Variety, or contrast, the countervailing quality of unity, can relieve monotony, giving the eye a number of different shapes, textures, colors, or details to look at (fig. 3.27). Variety heightens values through comparison. A light color will seem lighter if placed near a dark color, a large object larger in contrast with something small. In this context, variety may be viewed as a way to punctuate unity, heightening the space's overall impact.

BALANCE

The principle of balance concerns the achievement of a state of equilibrium between forces. We are familiar with balance through our direct experience with gravity, which exerts a force on us that we must counter by maintaining an upright position or by using a support that holds us up in a secure relationship. Visually, we find unbalanced relationships tenuous and disturbing, while balanced relationships look normal, at rest, and comfortable (fig. 3.28).

There are several ways to achieve balance. The most obvious balanced relationships are *symmetrical*, in which the arrangement of forms on one side of an imaginary central dividing line, axis, or plane is the mirror image of the other side. Such *bilateral symmetry* is characteristic of the human body and the forms of many living creatures. It is thus associated with the beauty of nature. In design, the identical visual weights and the importance of the center create an effect of repose and dignity. A high proportion of

← 3.24

EAST ELEVATION NORTH ELEVATION

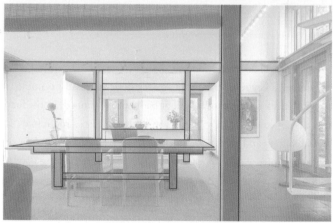

← 3.25

← 3.26

historic buildings, interiors, and objects exhibit the symmetrical balance of bilateral organization (fig. 3.29). Symmetrical balance can be achieved around a larger number of axes as well. *Radial symmetry* establishes balance around a central point, as, for example, the hub of a wheel, with the design elements radiating out like the wheel's spokes (fig. 3.30).

3.24 In his design for the Ozenfant House in Paris (1922), Le Corbusier used the golden ratio as the basis of his design geometry. This diagram is based on the illustration he used in *Towards a New Architecture* (1923). **3.25, 3.26** Unity of design is established by the consistent horizontals and verticals of the wood framing, the table, and the shelf in the distance in this view from the living room through the dining area and into the kitchen of the East Hampton, New York, house of the designer, Benjamin Baldwin (fig. 3.25). Figure 3.26 analyzes the basic structure of this view. (Photograph: Jaime Ardiles-Arce) **3.27** This bedroom in Milan, Italy, combines dramatically diverse styles—antique and modern furniture together with striking modern art within a space of markedly historic character—to achieve both contrast and variety without jarring conflicts. (Photograph: Jaime Ardiles-Arce) **3.28** Symmetrical balance demands exact equality between two sides of a composition. A centered doorway seems normal; the same door slightly off-center is disturbing (A). Identical elements on each side of a

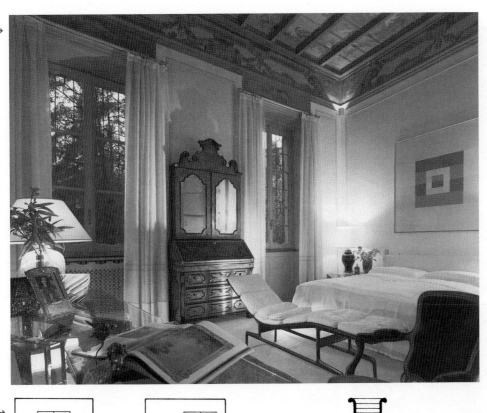

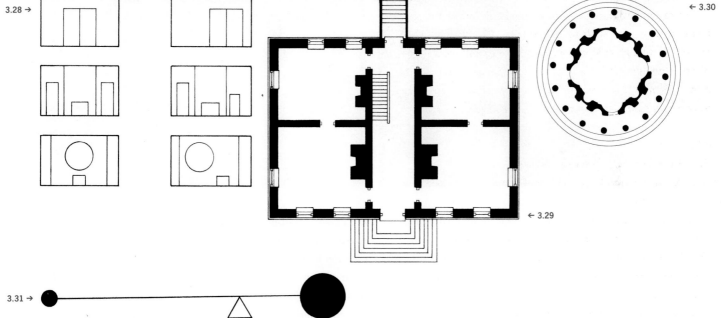

A more subtle concept, *asymmetrical* balance brings into equilibrium elements that are equivalent but not matching. The principle is demonstrated by a scale of the type in which an object is weighed by moving a weight closer to or farther away from a balance point. A small weight hanging from a long arm will balance a heavy weight placed close to the *fulcrum*, or balance point (fig. 3.31). This concept, in which different things of different size or weight seem to come into balance through placement, can also apply to shapes, colors, sizes, and other aspects of objects.

Symmetrical and asymmetrical design are often a product of the architectural structure of a space. For instance, a house with

fireplace are perfectly balanced; a smaller door on the right is perceived as an error (B). The displacement of the central element in C is similarly disturbing. **3.29** Bilateral (two-sided) symmetry is familiar as the basis for the planning of many buildings, with rooms, windows, and other elements carefully placed on each side of a central axis to create the kind of balanced pattern that occurs in many natural forms, including the human body. This plan of an American Colonial house is a typical example. **3.30** In radial symmetry, elements are arranged around one or more central points like the spokes radiating from a wheel. This plan of Bramante's Tempietto at San Pietro in Montorio, Rome, is radially symmetrical around four axes. Most radially symmetrical plans have two or possibly four axes of symmetry. Other numbers of axes, even odd numbers such as three or five, are possible, if unusual. **3.31** The concept of asymmetrical balance relates to the physical laws that make it possible for a light weight on a long lever arm (left) to balance a heavier weight on a short lever arm (right)

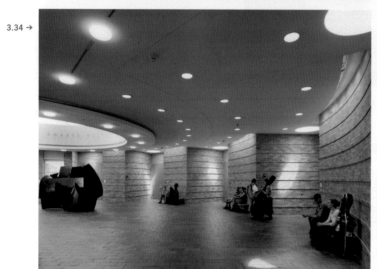

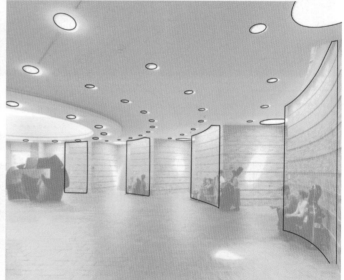

a center hall and rooms of similar size to right and left begins with a built-in symmetrical structure that leads naturally to visual symmetry in its design (see fig. 3.29). Other building plans and room layouts cannot offer symmetry. A room may have windows on one side only, or an entrance located to the left or right of center. In such situations, asymmetry is best accepted and the room brought into aesthetic balance by means other than strict symmetry. Some historic designs used false elements (a dummy door, for example) to force symmetry where it did not occur naturally. This kind of solution rarely works in modern practice. In addition, symmetry tends to express a sense of formality, dignity, stability, and conservatism. The more the central axis is emphasized, the more strongly these values will be felt—

as in many traditional designs for church and temple interiors, courtrooms, throne rooms, and similar ceremonial interiors. A centered fireplace and mantel or a large central window or door in an otherwise symmetrical room add to the feeling of formality (figs. 3.32, 3.33). Asymmetry, in contrast, suggests more openness to change, a more informal and active intention. Many modern buildings and interiors employ asymmetry to express these qualities.

RHYTHM

Another concept borrowed from music, *rhythm* relates visual elements together in a regular pattern. It can be achieved by *repetition*, whether simple, as in a rhythm such as I I I I, or more

3.32, 3.33 The library of the house of owners Candia Lutyens and Paul Peterson in London, designed by Candia's grandfather Sir Edwin Lutyens using a pair of his unique asymmetrical chairs, illustrates symmetrical balance in the way the left side of the view mirrors

the right side. The major relationships are diagrammed in figure 3.33. (Photograph: © James Mortimer–The Interior Archive) **3.34, 3.35** Repetition of forms along a circulation space in the Bucksbaum Center for the Arts, Grinnell College, Grinnell, Iowa, establishes a

pleasing rhythm. The irregular play of light on walls and floor relieves any tendency to monotony. Figure 3.35 diagrams the repeating elements on the ceiling and walls. (Also see figs. 3.13, 3.38.) Cesar Pelli & Associates were the architects. (Photograph: © Timothy

Hursley, courtesy Cesar Pelli & Associates Inc.)

complex, as in I III I III I III I. The number I might stand for a window opening, a column, or a subdivision in a paneled wall.

The mind enjoys rhythm, and it is an important element in both historic and modern design (figs. 3.34, 3.35). The classic architectural *orders* (Doric, Ionic, and Corinthian) are rhythmic systems (see figs. 4.6–4.8), while modern modular furniture and structural systems generate rhythmic patterns. The use of rhythm—the choice of small or large units, close together or widely spaced—should be appropriate to the situation. Since repetition can lead to monotony, it must also be balanced against the need for variety.

EMPHASIS

One of the ways to transmit meaning in design is through *emphasis*, which ensures that important elements *look* important while minor and trivial elements look subordinate. This is achieved through balancing size, placement, value, color, and selection of materials. A large door centrally placed becomes a point of focus. A brightly colored object in an otherwise quiet space calls attention to itself.

The designer must decide the levels of importance of all the elements that make up an interior and then find a visual expression for each of these levels, from the most important through the less important to the least important. A handsome fireplace mantel centered in one wall of a room is a natural focal point (figs. 3.36. 3.37) that is emphasized by placing a fine painting above the mantel. Placing the seating furniture—a sofa and chairs, perhaps—so that it relates to the fireplace while choosing a suitable cover fabric that does not compete with the painting will give the furniture grouping a secondary level of importance. Carpet, ceiling color, and lighting can be treated to appear neutral, almost unnoticeable. Alternatively, a colorful and strongly patterned rug, a strikingly designed seating group, or a spectacular light fixture could be an emphatic focus, in which case the other elements would be deliberately subordinated.

Design as an Expressive Medium

The fundamental concern of interior design is to resolve how space can be used as an expressive medium. As they create and modify spaces, both architects and interior designers communicate ideas, concepts, and feelings to all those who see, use, and occupy those spaces. Although we may not be conscious of such meanings in any overt way, we can all think of places that have been depressing or inspiring, dignified or cheerful, snug and cozy, or bleak and cold. Many spaces are designed with little or no thought of such matters; created predominantly to serve some functional purpose or to be practical and economical, they may have an impact on users that is inappropriate. Perhaps

this does not matter in a warehouse or an automated factory; in spaces intended for human use, however, it can be disastrous.

Spaces can all too easily be monotonous, confusing, or claustrophobic, even while serving their primary purpose reasonably well. A hospital may house patients and visitors and provide all the special services needed for medical treatment yet still be cold and depressing. An office can provide spaces for desks, chairs, and office equipment but appear confusing and become tiresome. The skilled designer not only plans for functional efficiency but also will evaluate the messages that various forms of designed space can convey and will plan accordingly.

To convey the appropriate messages through spatial elements, the designer must develop a vocabulary of spatial meanings. Although such meanings are grasped by everyone, they are rarely studied or understood with clarity; once pointed out, many may seem obvious. The following survey can help to provide a basis for both creative decisions and design-proposal evaluations.

THE BASIC ENCLOSURE

The concept of space, a specific space, implies enclosure. The most familiar spaces are those we call rooms. Most rooms are boxlike, a quality that can suggest security, define areas of movement, and focus purpose—all positive meanings that have unhappy opposites, such as confinement, isolation, and boredom. A very small room, when properly designed, can be comforting, personal, and private; when poorly designed, it may suggest the claustrophobia of a cell. A large room can be dignified, exciting, even awe-inspiring; it can also be monotonous, confusing, and intimidating. Although size is not in itself a determinant of meaning, *relative size* is. In general, bigger means more important, smaller means less significant. Familiar terms such as *great hall, master bedroom*, and *manager's office* make us think of larger spaces, while *vestibule, guest room*, and *workstation* suggest spaces at once smaller and less consequential.

The general rule that large equals important is not invariably trustworthy. It takes some special effort, however, to reverse it. A small space may be given added significance within a surround of larger elements, but it will require further treatment through shape, location, light, color, or some other means to give it real emphasis. A small chapel in a large cathedral, for example, might be given such value, as is the Oval Office in the White House, which gains impact from its unusual shape and central position.

Meanings associated with size can be emphasized by relationships between connecting spaces. A large space seems even bigger when entered from a smaller space because the contrast exaggerates its quality, as when stepping into a sizable concert hall or church after passing through a little lobby or vestibule. Height variations are particularly striking in this way. A very low ceiling in an access space makes the destination area seem dramatically higher than it may actually be.

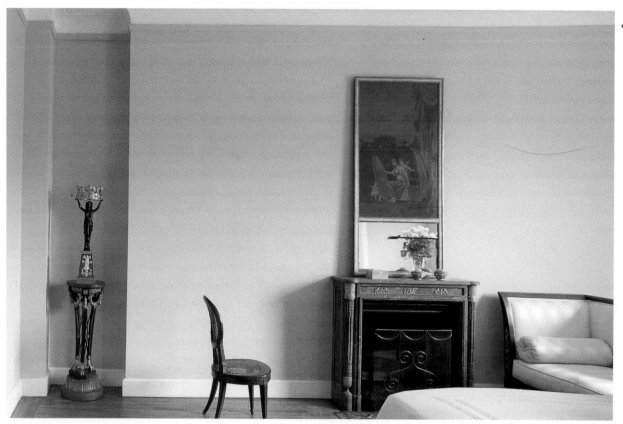

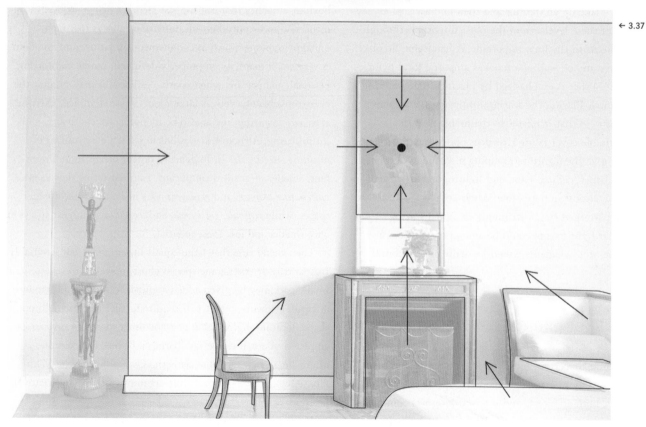

3.36, 3.37 In a New York apartment by designer Suzie Frankfurt, the fireplace, mantel, and picture form an emphatic axis, which is balanced by the niche at the left of the arrangement of furniture in an elegantly weighted, asymmetrical relationship. The directional lines in figure 3.37 show how the various elements contribute to the sense of emphasis. (Photograph: Lizzie Himmel)

Shape involves less obvious values. The familiar "box," or rectangular room, actually occurs in a variety of shapes. A square, the simplest of shapes, is easy to comprehend and so tends to imply stability and order through the identical dimension of each side. If the height matches the side dimension, forming a cube, that impression may be even stronger, suggesting monumentality through simplicity. Rectangles, the most common of shapes, have no particular meaning, although certain mathematical proportions (such as 3:5, or the *golden ratio* of 1:1.618, discussed above) seem to be more readily understandable and hence more aesthetic than random proportional relationships. The *double-cube room* of Wilton House, Wiltshire, England, is a well-known example of an impressive space whose elegance is augmented through its proportions of 1:2:1, literally double the shape of a cube. Box-form rooms that are longer than four times their width tend to become corridorlike, emphasizing lengthwise movement. A long, narrow living room, for example, seems to lack the central focus so crucial to a comfortable feeling of "together" containment. Such predominant length can be quite appropriate to spaces that are approaches to a destination or that serve as galleries through which people are expected to move. True corridors can become tedious and depressing if they appear to stretch into the remote distance.

Boxlike rooms sometimes seem both commonplace and stiff; curved forms, on the other hand, tend to communicate a sense of specialness, perhaps because they are in fact less common. Round rooms, often called *rotundas*, are favored by architects as monumental spaces; the rotunda of the U.S. Capitol in Washington, D.C., as well as those in numerous state capital buildings, is but one example. Many churches and chapels are also round; the Pantheon, Rome (see fig 4.11), was an especially valued Roman temple. A round room gives a powerful sense of enclosure and containment whether in a small African hut or in the large church of St.-Louis-des-Invalides, Paris. The dome, a popular roof for rotundas, adds to the sense of containment and also often provides acoustical effects of echoes or a *whispering gallery*, which further advance the feeling of specialness or even awe.

Rooms that are half round in plan are rare. The combination of a square or rectangular space with a half-round area generates a strong focus on the curved end. Used for a church or chapel, a courtroom, or an entrance hall, the form suggests concentration on a central point. More complex curved shapes, such as the oval and the ellipse, are less readily grasped at a glance and thus seem more subtle, possibly even mysterious. Irregularly curved spatial forms suggest freedom and flowing movement. When carried to extremes they become disturbing and confusing.

Every space, whatever its shape in plan, is strongly conditioned by its height and by the form of its roof or ceiling. Rooms that are low in relation to other dimensions can seem cozy and humane, as in many Frank Lloyd Wright houses, or oppressive, as in countless subway tunnels or in the dramatically claustrophobic interior of a submarine. Height is generally considered to add an airy sense of openness to a space; at times it may also lead to a loss of desired intimacy. The high ceiling of Victorian parlors may make them seem pretentious. Small but very high rooms are sometimes found to be unpleasant and become targets for a *dropped ceiling*, which is thought to improve proportions. Very tall spaces are impressive locations for stairs and emphasize transitions between floor levels. The *atrium* spaces popular in many modern hotels and shopping spaces attempt grandeur through height; although they sometimes achieve it, more often than not the result is oppressive and meaningless.

The various types of vaults (the tunnel-like *barrel vault*, the complexities of *groin vaults*) are important factors in the development of the special characteristics of many spaces in historic architecture. A curved ceiling, or a curved *cove* that softens the transition from wall to ceiling, can relieve the confining sense of boxiness in simple room shapes. Ceilings that stop at a distance away from walls to create a cove also add the impression of a *floating ceiling*, which deemphasizes the intersection of walls and ceilings. The reverse, a band of lower ceiling surrounding a higher middle area, can give a sense of differentiation between the central space and its edges, as is frequently seen in ballrooms, where the inner dance floor and the outer area of seating or tables are each related to their own height dimension. The triangular form generated by the common gable roof creates an internal space that repeats the associated external shape of the house, resulting in the familiar (although misnamed) *cathedral ceiling*. Sloping ceilings can also free spaces from boxiness, as occurs under a pent roof or an asymmetrical gable.

COMBINED SPATIAL FORMS

As spatial forms are combined, the emerging complex spaces may express ideas with clarity or they may generate confusion. A clear shape slightly modified tends to introduce uncertainty and stress. A classic example is a room with a corner cut off with rectangular or diagonal planes. Sometimes such a form explains itself—the diagonal may accommodate a fireplace. A rectangular closet built into a corner, however, may explain itself but also suggests a makeshift concept of planning. A room with an added-on subsidiary space, such as a living room with a dining alcove or sleeping area, is a familiar combination that appears generally ambiguous unless the alcove has defined limits at each side.

More complex spatial combinations can be studied in many well-known historic buildings, including churches with elements such as aisles, higher spaces with balconies or mezzanines, and round spaces with radiating or surrounding secondary spaces. The Gothic cathedral, with its high central spaces, lower aisles, extending transepts, and choir, often with chapels clustered about, is a superb example of spatial complexity. It cannot be comprehended from any one position but must be explored by

3.38 →

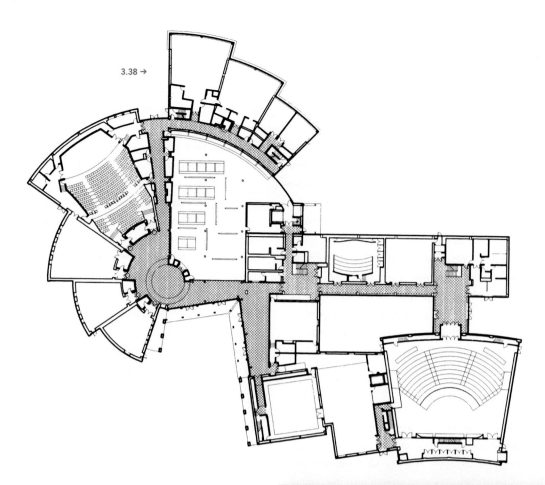

← 3.39

walking about, thus generating a kinesthetic or space-time experience.

As spaces are grouped, other meanings emerge. A row of identical spaces implies similarity of purpose (hotel rooms, offices, or hospital patient rooms) whether in a common straight line along a corridor or in staggered placement. Many small spaces combined with one or more larger areas imply a hierarchy of importance. Narrow and overly complex circulation paths generate confusion and annoyance. In space relationships, as in all design, symmetry suggests equality of function, while asymmetry suggests a relationship having a single orientation. Stairs at each side of an area or the frequently encountered balanced placement of men's and women's rest rooms typify the logic of symmetry. The relationship of a kitchen to a dining area is characteristic of an asymmetric relationship. Overlapping spaces occur in many modern plans where complexity and ambiguity are sought as goals. Unusual spaces imply unique or extraordinary intentions and can be quite successful in their very specialness. One thinks of I. M. Pei's triangular plan for the East Wing of the National Gallery of Art in Washington, D.C. (see fig. 4.80) and Frank Lloyd Wright's hexagon-based house plans or the helical interior space of his Solomon R. Guggenheim

3.38 This complex floor plan of the Bucksbaum Center for the Arts, Grinnell College, Grinnell, Iowa, has varied spaces for performance, practice, and teaching. The central lobby is shown in figure 3.14. Cesar Pelli & Associates were the architects. (Courtesy Cesar Pelli & Associates Inc.) **3.39** The main living space of the "Split House" at New Canaan, Connecticut, by Peter L. Gluck and Partners. architects. White and the natural colors of materials make no attempt to compete with the scene of nature outdoors. Only the red of the classic Saarinnen dining chairs provides a contrasting accent. (Courtesy Peter L. Cluck and Partners)

Museum, New York (see fig. 4.63). Cesar Pelli's design for the Bucksbaum Center for the Arts at Grinnell College, Iowa, is a more recent example (fig. 3.38).

OPENINGS IN THE ENCLOSURE

Spaces are rarely completely closed. Windows, doorways, and other openings not only relate spaces to one another but also communicate meanings about the nature of the relationship. A room with a door suggests potential isolation. A wide opening implies easy connection. Spaces such as balconies facilitate a relationship between two levels in which an observer on the upper level is both within and yet separated from the space below (Fig. 3.39). Stairways and ramps provide actual movement between levels, as well as a transitional relationship that the use of elevators denies. Large windows forge a strong link with the exterior environment, pushed in some modern examples to an extreme in which all-glass walls are used to escape from the enclosed quality of conventional spaces (fig. 3.40).

CONTENTS OF THE ENCLOSURE

Whatever their form, spaces are further modified by their contents and by the treatments of their surfaces. A room crowded with an excess of large furniture can seem small, and a low ceiling may seem even lower if painted a dark color. A glass wall can suggest expansiveness, openness, or, in a less positive context, a loss of privacy. A heavy door that closes with a firm sound suggests security and isolation. Massive, seemingly immovable furniture gives a feeling of permanence and stability but also communicates rigidity and even stodginess. Light, easily moved, portable, and demountable furniture, in contrast, communicates openness, flexibility, and activity but may also imply impermanence and instability.

THE ENCLOSURE-TO-OCCUPANT CONTEXT

The relationship of occupants to the spaces they use has become a stimulating field of study within environmental psychology. Issues of privacy and territoriality, the desire of individuals to modify or personalize a given space, and the ways in which space can influence behavior have all been the subjects of investigations by psychologists and anthropologists. Such much-discussed publications as E. T. Hall's *The Hidden Dimension*, Robert Sommer's *Personal Space*, and Corwin Bennett's *Spaces for People* have been influential in broadening designers' understanding of the interaction between people and the spaces they occupy.

3.40 An unobstructed view of distant mountains becomes the primary design feature of an otherwise simple bedroom in a Colorado house. The project is by designers Ettore Sottsass and Johanna Grawunder. (Photograph: Antoine Bootz, courtesy *Metropolitan Home*)

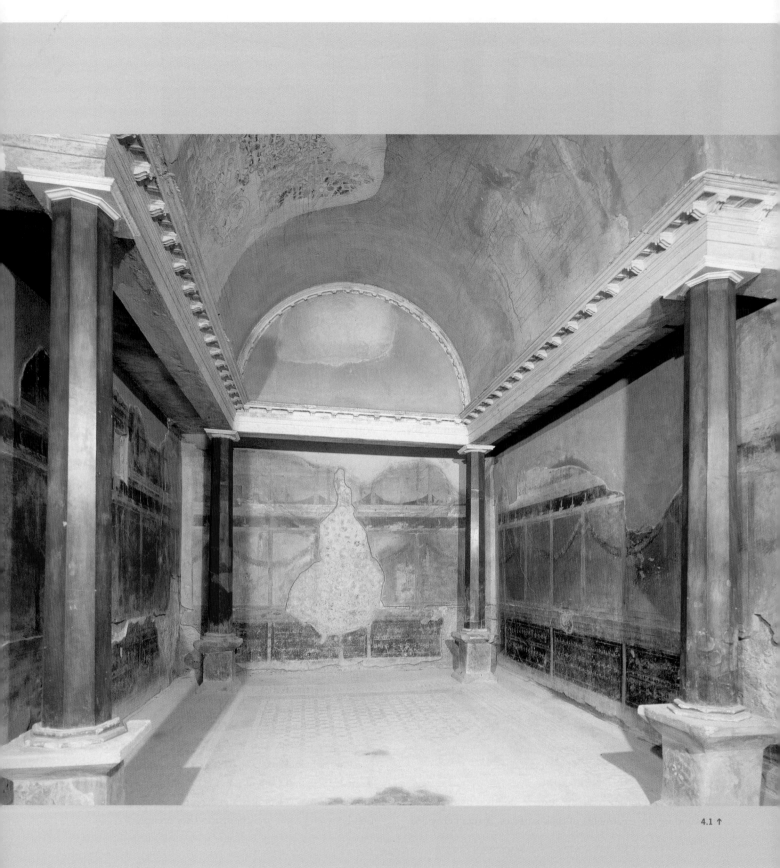

4.1 ↑

chapter four. Design History

The history of interior design draws upon several different fields of scholarly study. It is based in architectural history but incorporates elements of the decorative arts, including furniture, metalwork, glass, ceramics, and textiles, which are often collected and displayed separately. Many books deal with one or another of these subjects, often emphasizing the interests of antiquarians and collectors over those of the practicing designer. For the interior designer, such fragmentation hampers an understanding of the unified way in which all of these things developed together in a particular historic period. Current interest in interior design history emphasizes understanding design as an expression of its own time and as a resource for stimulating new ideas.

A different approach treats historic interior design as a basis for modern imitation. This view of history, which has an extensive literature, was dominant from the end of the nineteenth century until well into the twentieth century before fading out gradually. During that period, the study of interior design was largely a matter of learning the historic periods in order to adapt or imitate them in the interiors of the eclectic buildings of the time. While the leaders of Modernism rejected this approach, they were usually devoted students of historical design. However, overenthusiastic followers, in their rebellion against imitative design, often seemed to encourage an indifference to historical study. The many educators among these followers passed this attitude down to their students.

Recent years have witnessed a renewed interest in historic design, not as a basis for imitation but as the foundation for a broad understanding of the lines of development that have led to current ways of thinking about design. Designers now demonstrate a fresh willingness to make references to historic elements in a new, modern context. Even if references are sometimes picked up quite literally, the intention is never the direct imitation of whole rooms or even whole buildings of the past. At the same time, there is heightened interest in preserving and restoring historic buildings and interiors, work in which a detailed and precise knowledge of history is vital.

In the space available here, it is not possible to do more than give a general outline of the essential development of interior design in the Western tradition, with names and terms important in describing historic work and the significant people who have influenced its direction. Several traditions of non-European design are also represented because they have influenced European and American design and because many designers today have global businesses. Reading in the specialized literature of architectural and design history—increasingly available in scholarly and well-illustrated books—is an important part of every designer's education. Visiting actual historic interiors, in museums and, especially, in surviving buildings, is the best as well as the most enjoyable way to become fully aware of historical design development.

4.1 At Pompeii, a simple space in the so-called House of the Silver Wedding, 2nd century BC, used four octagonal columns of red marble to support the cornices that, in turn, support a barrel-vaulted ceiling. The ceiling vault and the wall surfaces are covered with mosaic images that are the room's only decoration.

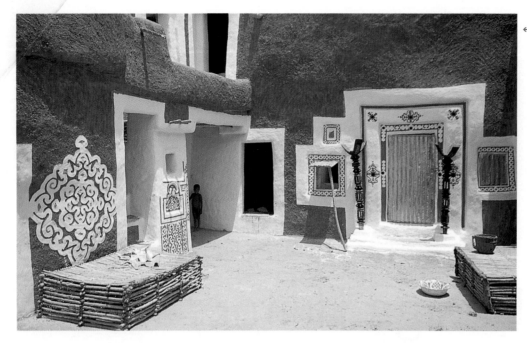

Prehistoric and Indigenous Design

Quite a few modern viewers find greater interest in prehistoric and indigenous design than in many of the period works of the more familiar cultures of the European, Euro-American, and Asian worlds. Modern art has been strongly influenced by native art. While modern design may not have undergone as deep an influence, there are often strong affinities between the directness of design produced by indigenous peoples and that found in the most respected of modern work. Weavings such as rugs and blankets, pottery and baskets, and small household utensils from Africa, Oceania, and the Arctic and Native American cultures are familiar examples of the kind of design that seems as vital and significant as the best contemporary equivalents. There is little access, directly or through photographs, to the total interior in which such objects belong, but a sense of their complete environment can be generated from looking at both the individual objects and any existing photographs or illustrations of the typical house structures (fig. 4.2).

Ancient World

EGYPT

The first major historic civilizations appeared in Egypt and in the Tigris-Euphrates valley of Mesopotamia. Knowledge of interiors from the latter region is fragmentary because the primary building material was unfired mud brick of poor lasting quality. Egypt, however, has left enduring visual evidence of its design because many temples and tombs were built of stone, some even cut into solid rock, and have survived well. The Great Pyramids at Giza (fig. 4.3) are remarkable not only for their great size but also for their purity of form and subtle geometry making use of the *golden section* proportion (see Chapter 3, "Design Basics"). The internal spaces of the pyramids, of minimal aesthetic significance, are ingeniously arranged passages and chambers, tiny in relation to the total mass of these structures. Egyptian temples are characterized by the vast *hypostyle hall*, a large space filled with rows of columns to support stone roofing, the forms of the stone columns based either on earlier columns of bundled reeds plastered with mud or on other plant forms. The Egyptian custom of carving and painting walls with written and illustrated inscriptions gives further information on the ancient Egyptian environment.

Egyptian tombs have yielded up a wide range of objects, including furniture in good states of preservation, placed inside to accompany the body into an afterlife. The interiors of more everyday structures, such as houses, do not survive, but miniature models found in some tombs give an idea of the setting of Egyptian daily life (fig. 4.4). They suggest spaces with only minimal furniture, lively color in wall decoration and woven materials, and, where they occur, the treatment of columns as strong decorative elements. Interiors were closely connected with the out-of-doors through open *loggias* and courtyards; even parts of

4.2 In this courtyard of an African house at Walata, Mauritania, the stone walls are plastered with a reddish clay while the openings are edged in white and ornamented. The doorway is the entrance to a woman's room. The white linear forms and dark bands closest to the openings are called "chains" and are thought to refer to women's jewelry. (Photograph: John Wright/Hutchison Library, London)

← 4.3

rooms were open to the sky with only cloth awning protection. The light and simple furniture, much of it folding and portable, could be extremely elegant, with finely observed proportions, restrained carved ornamentation, and, sometimes, extremely colorful painted details.

GREECE

Greek art and design is widely admired by Western cultures as a high point in aesthetic achievement. The Greeks built important buildings in stone but used wood for roofing, with the result that ancient Greek buildings survive only as ruins. Combined with such artifacts as pottery decorated with painted imagery, these ruins give a sense of early interiors. One of the most spectacular structures was built by members of the Minoan civilization, which flourished on the island of Crete in the Aegean Sea south of the Greek mainland. The restored portions of the palace at Knossos on Crete (C. 1700–1300 B.C.E., including the great staircase with its columns and the throne room with wall painting decoration, present a vivid picture of early design that influenced the later Greeks (fig. 4.5).

The historic, high civilization of Greece (C. 600–320 B.C.E) produced the famous temple architecture that has had such extensive influence in subsequent design history. The typical Greek temple is a simple, windowless, rectangular enclosure either surrounded by columns on all sides or with a front *portico* using columns designed according to a codified system called an *order*. The three major orders, Doric, Ionic, and Corinthian (each

← 4.4

named for the supposed place of origin), are characterized by a particular column design and a well-standardized system of detailing the *entablature* (the topmost band of which is the *cornice*) above, which ornaments the stone *lintels* spanning from column to column (figs. 4.6–4.8). The details seem to be based on a translation into stone of an earlier system of wood building.

4.3 The pyramids of Egypt are among the oldest surviving and most impressive of all stone constructions. About 2,300,000 stone blocks, weighing approximately two and a half tons each, make up the largest of the three Great Pyramids at Giza, Egypt. (Photograph: Hirmer Fotoarchiv) **4.4** Much of our knowledge of the typical Egyptian house is derived from beautifully detailed and painted models that were sometimes placed in tombs. This model of the house of Meket-Re, from circa 2000 B.C.E., shows a mud-brick house at the rear of a walled garden with a central pool. The columns, of bound papyrus reeds plastered over with mud, are painted in strong, bright colors. A hanging cloth and painted walls round out a characteristic color scheme. The Metropolitan Museum of Art, New York. Museum Excavations.

1919–1920: Rogers Fund, supplemented by a contribution of Edward S. Harkness.

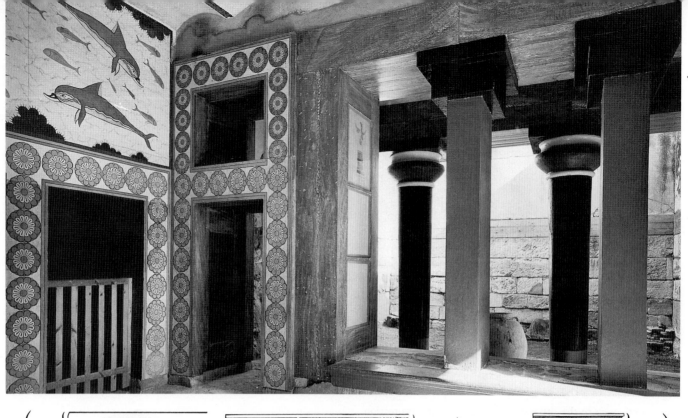

← 4.5

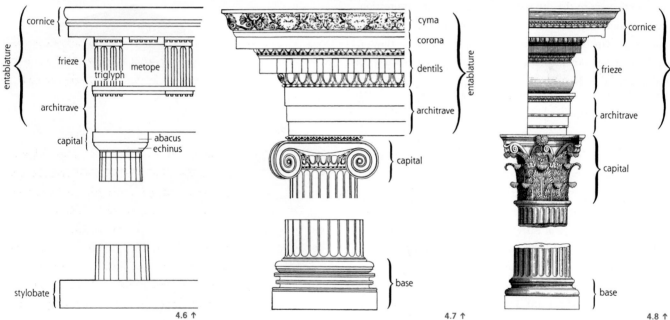

cornice
entablature
frieze
triglyph metope
architrave
capital
abacus
echinus
stylobate

4.6 ↑

cyma
corona
dentils
architrave
entablature
capital
base

4.7 ↑

cornice
frieze
architrave
capital
base

4.8 ↑

The simple Doric order has an austere column with no base and a plain block *capital*. It is usually considered strong, pure, dignified, perhaps the most beautiful of the orders (fig. 4.9). The Ionic order, with its spiral, voluted capital, is sometimes described as feminine, gracious, and charming as compared with the sturdy and restrained Doric. The Corinthian order displays a more elaborate capital with acanthus-leaf decoration. In comparison with the Doric and Ionic orders, it seems rich and elaborate.

Plans of ancient Greek houses can be reconstructed from excavated ruins, whereas knowledge of Greek interior design and furniture is surprisingly complete as a result of its frequent, precise representation in vase paintings. A typical Greek house had rooms arranged around a central courtyard, a plan that became the norm of residential design in Mediterranean regions until modern times. The generally simple rooms used restrained *moldings* and details borrowed from the architectural systems. Strong color appeared in textile elements such as hangings,

4.5 The Queen's Chamber in the Palace of Minos at Knossos, Crete, dating from circa 1500–1300 B.C.E., has been extensively restored. The columns, originally of wood (now replaced with stone), exhibit the downward tapering form typical of this time and place. They are painted black with red capitals. The Doric order, which emerged much later, may have evolved from this type. The restored wall paintings are based on traces of the original frescoes. (Photograph: Hirmer Fotoarchiv) **4.6** The three orders of architecture developed by the Greeks are systems of columns and related details. The Greek Doric order, the simplest of the three, is often regarded as the most beautiful. The column has no base and rests on the three-stepped platform *stylobate* (continuous base). The entablature, which spans from column to column, is made up of three sections called, from top to bottom, *cornice*, *frieze*, and *architrave*. (Drawing after Grinnell) The Greek Doric frieze alternates panels called *triglyphs* and *metopes*. The famous Elgin Marbles (British Museum, London) include the carved metopes from

4.9 →

4.10 →

that animal horns may have been a precedent, a form that is inappropriate structurally when translated into wood. Extended, the same basic design generated a couch or a bed. Tables and chests were of simple form, with unostentatious, often colored decoration.

ROME

Even before their military conquest of Greece in the second century B.C.E., the Romans began taking over Greek concepts of art and design. With their typical energy, practicality, and engineering skill, the Romans soon made these concepts their own. Roman architecture employed the Greek orders with certain changes, especially in the Doric order, modifying its proportions and adding a base. The Romans preferred the rich Corinthian order, and they adopted it as a favorite part of Roman design. Among their constructional innovations were the development and extensive use of *concrete*, the utilization of good-quality bricks, arch construction, vaulting, and domes, which, for the first time, permitted buildings roofed over in masonry. Many Roman temples survive in good condition; the domed interior of the Pantheon (c. 118–c.125 C.E.) remains a fine example of a Roman interior (fig. 4.11).

The catastrophic eruption of Mount Vesuvius in 79 C.E. buried entire neighborhoods in Pompeii and Herculaneum. Roman temples, baths, theaters, and private residences were preserved under volcanic ash and debris, thus providing

cushions, and coverings. Smaller utilitarian objects such as cups, dishes, and vases probably provided important decorative accents. The chair type called a *klismos* is characteristic of ancient Greece (fig. 4.10). Its outward-curving legs suggest

the Parthenon, Athens, the greatest of all ancient Greek buildings (see fig. 4.9). **4.7** The Ionic order is characterized by the spiral *volutes* of the column *capital.* Each column has a square base as well. In this example, from the Temple of Athena Polias at Priene, Turkey, begun circa 340

B.C.E., the entablature omits a frieze. The use of dentils and egg-and-dart moldings as decorative details is typical. The architect was Pythios. (From *Priene*, by T. Wiegand and H. Schrader, 1904) **4.8** The third Greek order, Corinthian, became a special favorite of Roman architects.

This example is a Roman version from the fourth-century C.E. basilica of San Giovanni Laterano in Rome, as illustrated in the Italian architect Andrea Palladio's *Four Books of Architecture* of 1570. **4.9** Perhaps the most admired building ever constructed is the Greek Doric temple on

the Acropolis in Athens known as the Parthenon, built circa 447–432 B.C.E. (Photograph: John Pile) **4.10** Knowledge of ancient Greek furniture design comes from images on painted vases and plates. The vase dates from circa 440 B.C.E. (Photograph: Alison Frantz)

4.11 The Pantheon in Rome of 118–25 c.e. is one of the earliest domed, all-masonry structures with a vast interior space. Beneath its *coffered* rotunda, the interior of the Pantheon. 142 feet high and 142 feet wide, is one of the most impressive of all domed masonry constructions, shown here in a painting by Giovanni Paolo Panini of circa 1750. The bright disc on the wall is sunlight shining down through the *oculus*. the unglazed opening at the top of the dome. National Gallery of Art, Washington, D.C. Samuel H. Kress Collection **4.12** The walls in the Ixion Room of the House of the Vettii, Pompeii (63–79 c.e.), are decorated with frescoes, including some highly realistic perspective effects of architectural subjects. The dominant colors are the typical Pompeian red and black. (Photograph: Ludovico Canali, Capriolo)

extensive information about Roman interiors. Houses were planned with rooms surrounding a central courtyard, or *atrium*, open to the sky (see fig. 4.1). Larger houses had more than one such court, which supplied all or most of the building's light, since rooms had few or no windows. The more luxurious villas of patrician families displayed elaborate wall decoration using both marble inlays and painting, typically in black, gilt, and the shade of red now often called *Pompeian* (fig. 4.12). Wall paintings were generally realistic, and their representation of everyday scenes is a valuable source of information about furniture and other decorative details. Some homes contain elaborate mosaics that provided decorative treatment of floors.

The books of the Roman architect and engineer Vitruvius—constituting the first systematic handbook of architectural practice, written in the late first century B.C.E.—were translated during the Renaissance and provided codified data about the orders of architecture. Roman architectural design, known from the surviving (and ruined) major buildings, from the excavation of lesser, domestic buildings of Pompeii and Herculaneum, and through Vitruvius's books, has had a recurring influence in the design work of Western societies, an influence that continues to be exerted, through both direct imitation (in buildings such as the former Pennsylvania Railroad Station in New York City; see fig. 4.57) and a more subtle and indirect incorporation of such concepts as symmetry and order into the basic approaches to architectural thinking.

Middle Ages

The Roman Empire split into Western and Eastern Empires in 395, and the Western Empire collapsed in 476. The decline and eventual breakup of the Roman Empire led to a comparable collapse in the Roman classical traditions of design. The lack of a strong central governmental force left Europe in a state of political anarchy and social misery. Christianity became the central focus in almost every aspect of life, and design was almost exclusively at its service.

Medieval developments can be considered under four stylistic designations, the first two relating to the remaining aspects of Roman traditions, the latter two representing the formation of a new tradition destined to lead gradually toward the modern world.

EARLY CHRISTIAN DESIGN

As Christianity gained official acceptance (Emperor Constantine issued the Edict of Milan in 313, granting religious toleration), churches began to appear as a significant building type. The Roman court *basilica*—a large rectangular building often used by the Romans as a court building—became the model for the Early Christian church. The basilica-plan church had an open interior space with flanking aisles permitting a *clerestory* (a high, windowed wall) to light the central space. Arches and columns based on Roman practice were used, but their detail is less classical (in the sense of academically accurate) and systematic, with fragments of Roman orders used in an improvisational way; some of the fragments were bits of carving simply taken from older Roman buildings. The art of mosaic became a major decorative device for geometric floors and walls and in pictorial representations of religious subjects. The best examples of Early Christian work are in Rome.

BYZANTINE DESIGN

Byzantine architecture developed from the Roman model after Constantinople became the capital of the Roman Empire in 330 C.E. It, too, is primarily a church-building development that employs Roman structural techniques and details along with an elaborate mosaic decorative art. Byzantine building includes major domed structures, such as the famous Church of Hagia Sophia (Holy Wisdom) in Constantinople (532–37), and reaches a level of elaboration and richness beyond the characteristic austerity of Early Christian work (fig. 4.13). The Byzantine style extended westward to Italy to produce such buildings as the churches and tombs at Ravenna (sixth century) and the Church (now Cathedral) of San Marco in Venice (1063–94).

ROMANESQUE DESIGN

In spite of its name, Romanesque design has less connection with Roman architecture than do the styles described above. It is the style of the Early Middle Ages, from about 900 to 1200 in Europe and, under the name *Norman*, in the British Isles. Surviving buildings, built in stone, are mostly churches, monasteries, and castles, the last the new building type so characteristic of the Middle Ages.

The typical feature of Romanesque stone structures is the semicircular arch and vault, a remnant of Roman structural technique (fig. 4.14). Monasticism produced a large number of building complexes, many surviving in reasonably good

4.13 The most spectacular of Byzantine interior spaces, the vast nave of Hagia Sophia in Istanbul, 532–37, is crowned by a 100-foot dome on pendentives. The pendentive is a curved, triangular element, introduced to fit a round dome over a square space beneath it. The original gilded and mosaic wall decoration, with its typical intricate and complex motifs, has been partially obliterated, but the overall richness and complexity remain impressive. (Photograph: Hirmer Fotoarchiv)

4.13 →

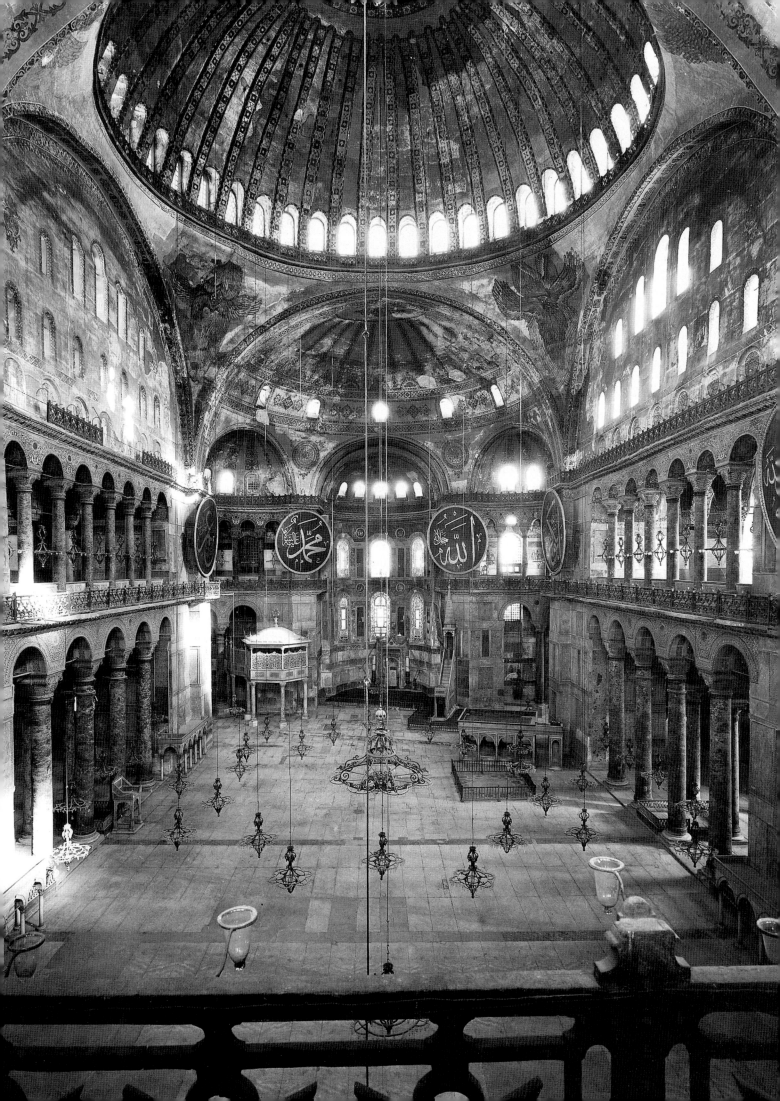

condition. In these, simplicity became a matter of religious conviction as well as a practical necessity, creating churches, chapter houses, cloisters, and dormitories with interiors of great beauty, emphasizing spatially impressive structure, minimally decorated.

Early medieval castles were often simple tower houses built in easily defended locations. Existing interiors with stone floors and roofs reveal such details as stone window seats at the small slit-like window openings, fireplaces for heat and cooking, and the generally unornamented functional character of Romanesque design (fig. 4.15). Furniture was minimal, partly because of undeveloped standards of comfort and partly because castle occupants moved from one location to another, maintaining their authority in the territory under their control through their presence. Thus, the typical inventory of household fittings included plank-on-trestle tables, benches and stools of simple design, demountable, portable beds, trunklike chests for storage, and tapestries as wall coverings. Average people, the peasantry, had much less in the way of possessions, and furniture of only the simplest sort.

Toward the end of the Romanesque era, larger churches began to show more elaborate decorative detail, and structural experiments in buttressed vaulting moved the style toward the development of Gothic architecture. Many buildings from the gradual transition period have earlier portions in the Romanesque style and later elements in the Gothic style.

GOTHIC DESIGN

Gothic building is widely regarded as one of the great achievements of the Middle Ages. The characteristic feature of Gothic architecture is the *pointed arch and vault*, a technical development that made it possible to raise the height of the building and fill the walls with large window areas. The multiple ribs used in the vaulting of some Gothic cathedrals, such as Exeter in England (fig. 4.16), created the rich visual patterning known as *fan vaulting*. At its peak, the Gothic cathedral became a skeletal stone cage with wall areas largely filled with stained-glass windows, which served as both decorative art and illustrations of religious narratives. Sculptural carved detail was often used in the same way.

Castles and town fortifications survive in many locations, and some houses and other buildings of wood-frame construction, often with the exposed framing called *half-timber* work and with interiors more or less as they were in the twelfth to fourteenth century, still stand. The Guildhall at Thaxted, England, used half-timber construction; its upper floors are cantilevered out beyond the floors below so that each floor is larger than the one underneath—one way of gaining interior space in a crowded medieval town (fig. 4.17). There is no typical medieval house plan. Layouts seem to have been improvised to suit site and function. Although complete rooms with furniture and lesser decorative details rarely survive intact, depictions of rooms in medieval art are frequently detailed and realistic in a way that makes it possible to visualize the Gothic interior quite accurately.

4.14 The stone barrel vaulting of the nave of the church of Saint-Sernin, Toulouse, France (1080–1120), demonstrates the most advanced structural techniques available to builders of the Romanesque era. (Photograph: Jean Roubier) **4.15** Although the original medieval manor house was rebuilt between 1490 and 1520, the Great Hall at Cotehele House, Cornwall, England, designed by Sir Piers Edgcumbe, retains the characteristics of the halls of earlier castles and manor houses, serving as the main living space. Only minimal furniture and window detail soften the exposed structural construction. (Photograph: © James Pipkin) **4.16** The Gothic cathedrals of the Middle Ages used masonry construction—vaulting supported by exterior *buttresses*—to create interior spaces of great beauty and spiritual impact. To an observer facing east in the nave of Exeter Cathedral, Devon, England (c. 1280–1370), the many ribs of the vaults create patterns characteristic of fan vaulting, used in several English cathedrals. (Photograph: © A. F. Kersting)

Decoration of Gothic stylistic character, with its ubiquitous pointed-arch forms, appeared in door and window moldings, around fireplaces, and in ceiling construction in a degree of elaboration that reflected the wealth and position of builders and owners. Wood furniture of increasing quality, elaboration, and functional variety began to appear. Chairs and benches with designs that seem to derive from the simple box chest were made in considerable assortment, usually with a frame of heavy members and thin inserted panels, generating the familiar appearance of *rail-and-panel* construction (fig. 4.18).

Substantial local variation in details gives Italian, French, German, and English medieval design each its own unique qualities, while the Islamic influence makes Spanish work distinctive. The Crusades carried Gothic architecture and design into the Middle East and, in return, brought back into Europe an awareness of the art, design, materials, and techniques of that region. These varied influences combined to create the foundation on which all subsequent European design development has been based.

These influences are detectable even in America since the first European settlers in the American colonies brought with them traditions of European architecture and design that were formed in medieval times. The early Colonial house in America, with its heavy braced frame, similar to the typical North European half-timber building, and its minimal windows with leaded glass in small panes, is essentially a European late-medieval structure.

Renaissance to Rococo

Various changes and developments touching every aspect of Western culture and society led Europe away from medieval ways of thinking toward the Renaissance. The Renaissance involved a new interest in the classical traditions of ancient Rome and Greece, a withdrawal from the domination of the Church and its mysticism, and a movement toward humanism, a belief in the human ability to solve problems and deal with life in a rational

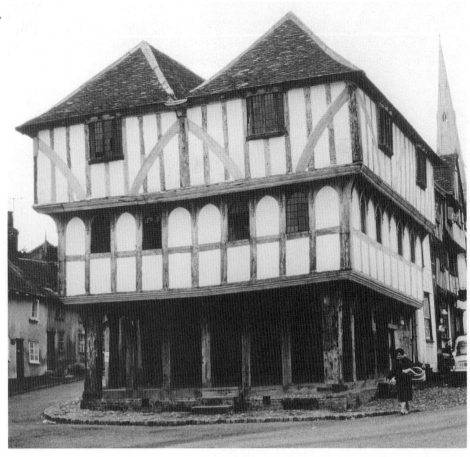

way. A new, experimental attitude led to the beginning of modern science, the voyages of the early explorers, and progressive ideas about trade and economic issues, all of which laid the foundations for the industrialized, technological society of the twentieth and twenty-first centuries.

In design, these developments had several direct results. Interest in surviving classical Roman structures and study of Vitruvius's texts on architecture resulted in the introduction of classical ideas (including the three major orders) into design. The more rational, scientific way of thinking, applied to construction, initiated a series of technological innovations that led to the modern understanding of engineering as a basis for structural design. The invention and development of firearms made medieval defensive systems obsolete, eventually causing the castle to give way to the palace, château, and England's *great house*, although the houses and shops of the vast majority of the people remained medieval in all but a few minor decorative details. The invention of printing, accompanied by an increase in literacy, accelerated the transfer of knowledge and made changes in the world of design increasingly rapid and extensive. At the same time, the changeover from the

feudal system to more modern political and economic practices increased the variety of design requirements, with an emphasis on luxury and individuality of design.

ITALY

The Renaissance began in Italy at about the beginning of the fifteenth century and gradually spread north to France and England, then to other parts of Europe, including Germany, the Low Countries, and Spain, with a time lag roughly proportionate to the geographic distance. Art history customarily divides the Renaissance into three phases: early, middle (or High), and late (Baroque and Rococo). The term *Mannerism*, borrowed from the history of painting, is sometimes used to describe the transition from the High to Baroque phases of the Renaissance in Italy.

Early Renaissance Early Renaissance work is characterized by a rather cautious application of classical Roman detail to buildings that are largely medieval in overall concept. Symmetrical planning appears in such buildings as the Florentine palaces (the Palazzo Medici-Riccardi of Michelozzo di Bartolomeo and the

4.17 The Guildhall at Thaxted, Essex, England, was built in the second half of the fifteenth century. It is a fine example of half-timber construction, in which a structure's framework is exposed. (Photograph: John Pile) **4.18** In the Middle Ages, the chair was an object with specific symbolic and ceremonial significance, denoting status or rank. This fifteenth-century French example is built up in a wood rail-and-panel construction derived from box construction. The tracery at the top relates the piece to Gothic architecture. The Metropolitan Museum of Art, New York. Gift of J. Pierpont Morgan, 1916 **4.19** In the grand salon on the second floor *(piano nobile)* of the Palazzo Massimo alle Colonne, Rome (by Baldassare Peruzzi, 1534), the Roman Ionic *pilasters*, the elaborate frieze and ceiling, and the details of mantel and door frames combine to suggest a re-created interior of ancient Rome. The classical statuary adds to the effect, while the sparse use of furniture is typical of such ceremonial Renaissance interior spaces. From *Letarouilly on Renaissance Rome* by John Barrington Bayley.

4.19 →

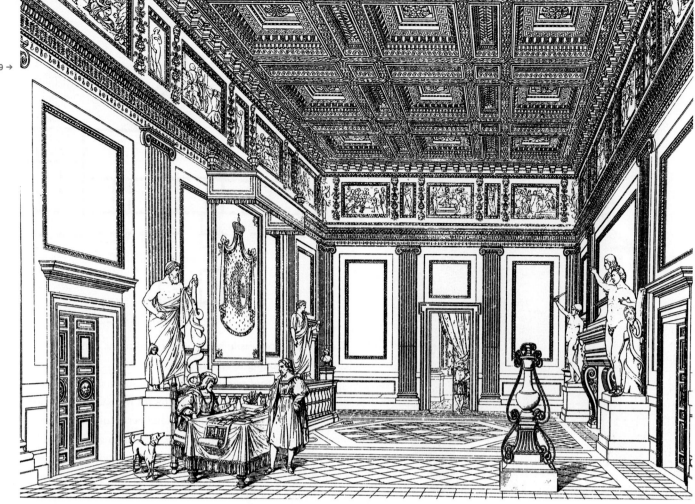

Palazzo Strozzi of Benedetto da Maiano, for example), which display a restrained use of classical moldings externally but a full use of Roman orders in the interior central courtyards. The interior of the small Pazzi Chapel (begun c. 1442; at the Church of Santa Croce, Florence), usually attributed to Filippo Brunelleschi (1377–1446), gives a clear example of the way in which the detail of rediscovered Roman classical orders was used in Renaissance design. Such cautious introduction of Roman detail appears only in exceptional (and, in their own day, trend-setting) interiors such as those of Brunelleschi.

While ordinary houses remained untouched by Renaissance ideas, the rich began to add decorative moldings, doors and door frames, and other details borrowed from Roman antiquity to the interiors of their houses and *palazzi*. Elaborate ceilings with structural beams made into patterns of squares (coffered ceilings), painted wall and ceiling decoration, and classical molding were often the main decorative elements in an otherwise simple room. Ceilings frequently included paintings, perhaps by major artists. Sculptural plaques or *rondels* (such as those of Luca della Robbia) appeared as wall decoration. Elaborate fireplace mantels began to include classical detail in their carving.

High Renaissance The fully developed or High Renaissance moved toward a more sophisticated understanding of the concepts of Roman architecture with such consistently classical projects as the plan for St. Peter's, Rome (1506), by Donato Bramante (1444–1514), which would be altered and expanded

over the following century. The modest-size Palazzo Massimo alle Colonne, Rome (1534), retains interiors in fairly complete states of preservation, while older engraved illustrations of these spaces give even more complete detail as to their design (fig. 4.19). Furniture was still used rather sparsely, in a manner reminiscent of medieval austerity, but there was a gradual increase in the variety and richness of furniture types (fig. 4.20). Classical detail, used with skill and confidence, provided wall decoration, moldings at doors and windows, fireplace mantels, and elaborately decorated ceilings.

The clarification and near-standardization of Renaissance design practice, as well as its geographical spread, were encouraged by architect-theorists such as Leon Battista Alberti (1404–1472) and Andrea Palladio (1508–1580). Both not only produced important work but also wrote illustrated books explaining their working methods. Alberti emphasized the mathematical and geometric basis of his designs. Palladio offered practical instruction along with illustrations of his own works, such as the Villa Rotonda (or Villa Capra), Vicenza (begun 1550), and the remodeled old town hall known as the Basilica (begun 1549) in the same city, and accurate drawings of Roman architecture that formed the basis of his church designs, such as San Giorgio Maggiore (begun 1566) and Il Redentore (begun 1576), both in Venice.

Palladian interiors are developed with the same sense of order and devotion to classical detail that govern the overall concepts of the buildings that house them. The churches use Roman architectural details for pilasters, cornice moldings, and door and

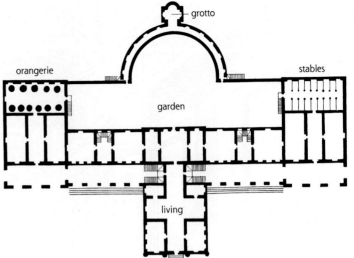

window trim, usually in gray marble to contrast with the generally white wall and ceiling surfaces, thereby accenting form. The effect suggests that Palladio was trying to re-create, or at least make reference to, the great baths of ancient Rome.

Palladio's villas include many well-preserved interiors, which give an overview of his domestic work. The Villa Barbaro, Maser, Italy (c. 1555–59), has a main living area with a spacious cruciform central hall dividing the square plan, creating four large rooms in the four corners (fig. 4.21). The spaces are architecturally simple, but the walls are richly decorated with illusionistic paintings by Paolo Veronese (1528–1588) in which architectural elements (arches, balustrades, doorways, trellises) frame scenes of distant landscapes. In the Villa Foscari, Mira, Italy (c. 1556), Battista Zelotti's frescoes include some doorways standing open with family members and servants, even a pet bird, looking in—all in *trompe l'oeil* painting (fig. 4.22). This kind of painted wall decoration suggests stage scenery.

Taken together, Palladio's work and books formed a demonstration of High Renaissance practice that became a basic model for classically oriented design for the next several centuries. Palla-

dian influence can easily be traced forward to the American colonies, continuing to appear even today.

The urge toward systematic perfection so strong in the work of the High Renaissance gave way toward the end of the period to an interest in more experimental and personally expressive ways of designing. The term *Mannerism* is often applied to the style that marks a transition from the reserve and order of the High Renaissance to the elaboration of the Baroque, the third and final phase of Renaissance design. Mannerism is exemplified by such works as Michelangelo's Laurentian Library, Florence (begun 1524), with its extraordinary entrance hall and stairway. The architect used a classical order but pressed the columns back into recesses in the walls and filled the space with a great, exuberant stairway creating a dramatic sense of movement. Other interiors, such as the Palazzo del Te (c. 1526–34) of Giulio Romano (c. 1499–1546) at Mantua, similarly employed classical detail but introduced oddities, what seem to be mistakes (but are deliberate), and curious fresco paintings.

Baroque The rich, sometimes excessive decoration of Baroque spaces led art historians of the nineteenth century to dismiss this work as decadent. Modern art historians have reinstated the Baroque as a significant phase, being especially attracted to the Baroque interest in space, movement, effects of light, and sense of drama rather than its details of decoration. While classical detail was still used extensively, it was altered, even distorted, as in the spirally twisted columns of the Baldacchino in St. Peter's Basilica, Vatican, Rome (begun 1624; fig. 4.23), by Gianlorenzo Bernini (1598–1680). In smaller Roman churches, such as San Carlo alle Quattro Fontane (1638–41; facade, 1665–67) and

4.20 Renaissance furniture developed to suit the needs of an aristocracy with new and specialized functional demands—for the storage of varied objects of value and personal significance—and a taste for elaborate surface decoration. This sixteenth-century Florentine walnut *stipo*, or cabinet, is made up of separable upper and lower sections for easy transport. The figures carved in relief are *bambocci*, or urchins. (Courtesy Sotheby's, New York)

4.21 The plan of Andrea Palladio's Villa Barbaro, Maser, Italy, appeared in a woodcut illustration in his influential *The Four Books of Architecture*, first published in Venice in 1570. The central living block houses a cross-shaped hall space with enclosed rooms (and stairs) at the four corners. The wings extend outward to farm buildings at left and right.

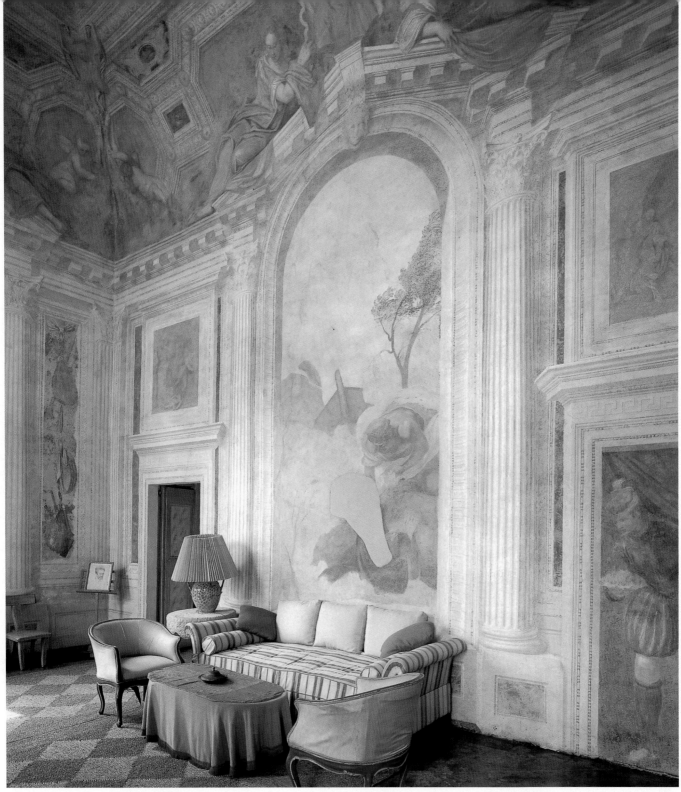

Sant' Ivo della Sapienza (c. 1642–60), Francesco Borromini (1599–1667) carried Baroque ideas of spatial complexity to a further extreme.

The simple shapes—squares, circles, and rectangles—of the earlier, more restrained phases of Renaissance design gave way to more complex forms—ellipses, trapezoids, and spirals—in Baroque design. As these forms are developed in three dimensions and overlapped and interlaced, Baroque space takes on qualities of mystery and theatricality. It gives the effect of a richness that cannot be clearly comprehended but that vividly expresses drama,

4.22 The Renaissance architecture of the interior of the Villa Foscari—also called La Malcontenta—by Andrea Palladio at Mira, near Venice (c. 1556), is elegantly simple, while Battista Zelotti's elaborate frescoes wittily introduce rich architectural detail in illusionistic perspective. Balancing the real door on the left is a painted open door at the right, from which a figure seems about to step into the room. The furnishings are modern. (Photograph: Evelyn Hofer)

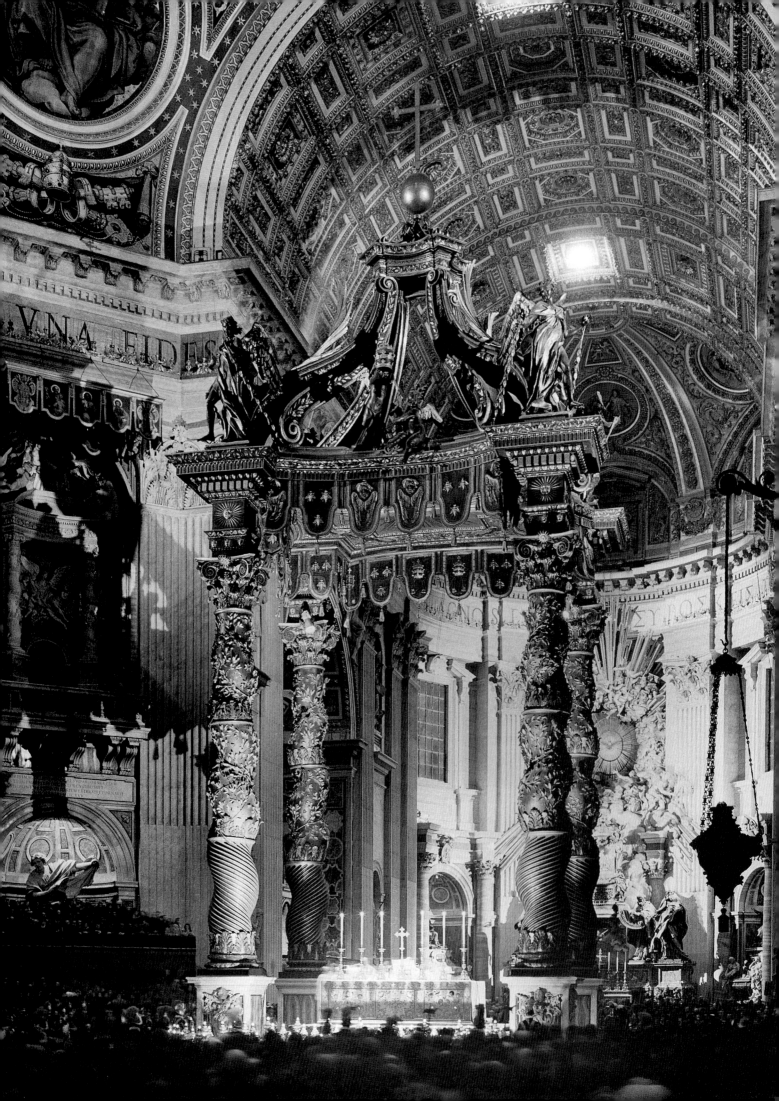

movement, and action. These design directions were encouraged and supported by the Counter-Reformation movement in the Catholic Church, where they joined with the other arts (including music) to make churchly events exciting and dramatic.

CENTRAL EUROPE

Over the next hundred years, Baroque ideas traveled north, reaching northern Italy in the work of Guarino Guarini (1624–1683) at Turin, in both churches and in secular buildings such as the Palazzo Carignano (1679–92), with its curving stairs and elliptical domed rotunda. Still later, Baroque concepts reached southern Germany and Austria and spread into Hungary and Bohemia on the east and Switzerland on the west. Baroque churches by such architects as Johann Michael Fischer (1692–1766) and Johann Balthasar Neumann (1687–1753) are astonishingly complex and elaborate. German and Austrian palace architecture at the end of the seventeenth century and the beginning of the eighteenth combined Italian Baroque influences with the comparable French stylistic development, Rococo; Johann Lukas von Hildebrandt's Upper Belvedere Palace in Vienna (1700–1723; fig. 4.24) and Neumann's Residenz at Würzburg, Bavaria (1719–44), serve as good examples of this style.

FRANCE

In France, the Renaissance passed through the same three phases as in Italy, each occurring about fifty to a hundred years later than the Italian equivalent. The Early Renaissance in France appeared first in small details of ornament, door and window frames, and fireplace mantels in châteaux that are otherwise medieval in concept. Chambord (1519–47), the giant royal hunting lodge in the Loire Valley, is full of classically derived detail and has a generally symmetrical plan, pointing toward growing acceptance of the Italian conceptual formality. The double spiral central staircase is a remarkable demonstration of geometric planning ingenuity. The much smaller château of Azay-le-Rideau is remarkable for its intact interiors, with furniture in place much as it must have been when the building was new (fig. 4.25).

With its square plan around a central court, symmetrical about both axes, the château Ancy-le-Franc, the work of the Italian architect, painter, and theorist Sebastiano Serlio (1475–1554), marks the arrival of a developed Renaissance style in mid-sixteenth-century France. By 1656 Louis Le Vau (1612–1670) was building the château of Vaux-le-Vicomte outside Paris (fig. 4.26). This building served as something of a model for the same archi-

tect's work for Louis XIV at Versailles, which was begun in 1661. Work continued there with Jules Hardouin-Mansart (1646–1708) succeeding Le Vau. The palace is a vast complex with many spectacular interiors, including a chapel, an opera house, and the famous Galerie des Glaces, or Hall of Mirrors.

Toward the end of the seventeenth century and in the eighteenth, French Renaissance design took on some of the character of Baroque design, particularly in the free and flowing use of curves. The period styles in France are usually identified with the reigns of French royalty, using the terms Louis XIV, Louis XV, and Louis XVI to identify furniture and related decorative styles. However, the last phase was more restrained in France than in Italy and Germany, meriting a different stylistic term, Rococo, to describe the elaborately decorative but classically ordered character of French Late Renaissance design. Such buildings as the Petit Trianon (1762–68) by Ange-Jacques Gabriel (1698–1782), among the finest examples of Louis XIV design, display a restraint and classical discipline characteristic of the Rococo style. The preserved salon from the Hôtel de Varengeville demonstrates how Rococo elaboration was adapted by aristocratic French society of the time (fig. 4.27).

Following the French Revolution of 1789, Rococo design shifted toward a more reserved and less florid direction (see pp. 92–94 for a discussion of Neoclassicism). The interior styles called Directoire and Empire (after the political developments of the time) introduced references to the styles of ancient Rome, partly as a result of interest in the findings of the excavations at Pompeii and, in the case of Empire work, partly to celebrate the exploits of Napoléon's era (fig. 4.28).

French Renaissance furniture and decorative elements are usually described with a terminology based on royal reigns, a reminder that these styles almost exclusively served royalty and the aristocracy, having relatively little impact on a wider public. French provincial furniture design, however, is a partial exception. In the seventeenth and eighteenth centuries, furniture makers of provincial France began to make everyday wood furniture in simplified versions of French Renaissance "high style" prototypes. Such furniture, which struck a pleasant balance between simplicity and elaboration, has remained popular in France and is still widely collected elsewhere. (Unfortunately, the style has been abused by modern mass-produced imitations of poor quality, causing the term *French provincial* to become almost meaningless.)

The term *Biedermeier* designates German and Austrian furniture of the early nineteenth century based on French Empire

← 4.23

4.23 The Italian Baroque at its most flamboyant is demonstrated in the huge *baldacchino*, or canopy (begun 1624), under the dome of St. Peter's Basilica, Vatican, Rome. Bernini's gigantic columns are twisted and covered with decorative detail that almost conceals their Roman classical derivation. The elaborate capitals of the columns are Composite capitals, combining elements of the Ionic and Corinthian orders. (Photograph: © Leonard von Matt, Switzerland)

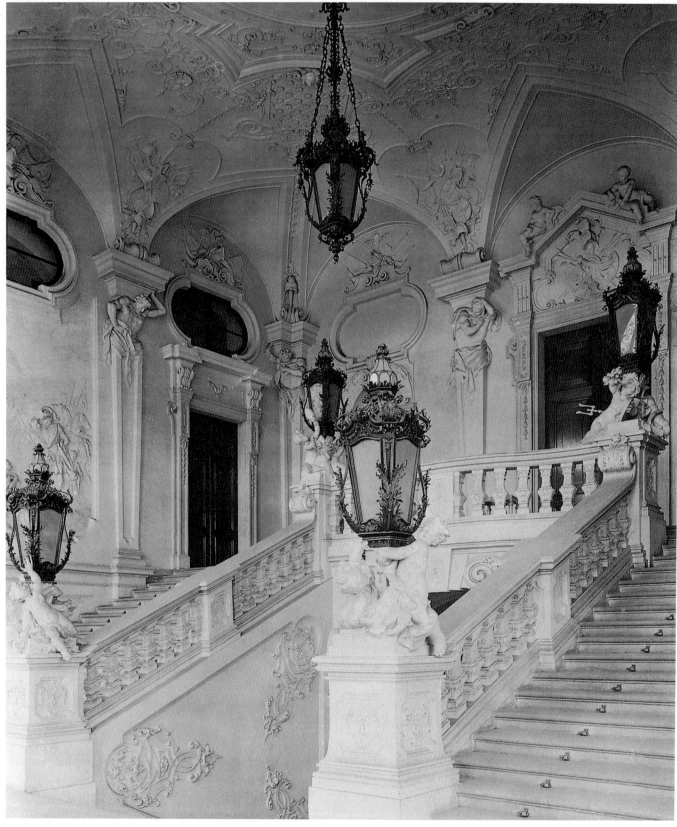

4.24 The Baroque fascination with movement and drama made monumental stairways, such as this Johann Lukas von Hildebrandt design for the Upper Belvedere Palace, Vienna (1700–1723), favorite subjects for the sculptural elaboration of architectural basics. Color is an austere white except for the blacks of the metalwork. (Photograph: Foto Marburg)

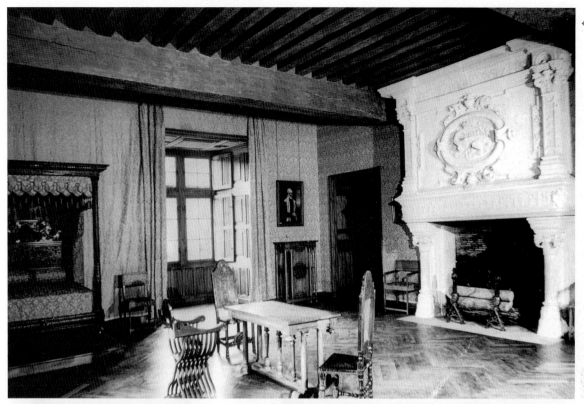

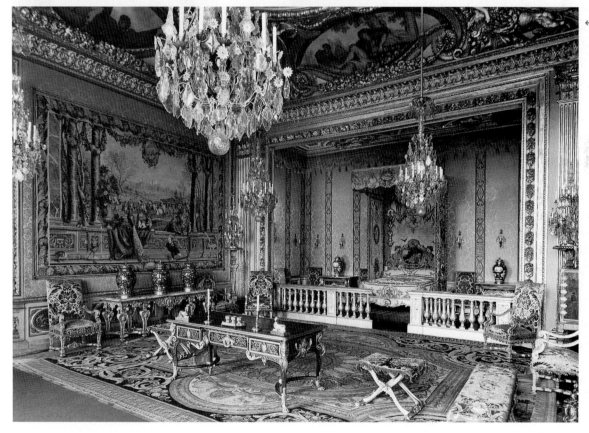

4.25 A room in the château of Azay-le-Rideau (1518–27) in the Loire Valley retains a basically simple, medieval quality conveyed by the exposed wood ceiling beams. Italian Renaissance ideas are evident in the ornately carved fireplace with its classically inspired details. Fabric-draped walls and a curtained and canopied bed represent concessions to comfort. The demountable furniture could be adapted to specific circumstances. (Photograph: John Pile) **4.26** This overwhelming, elaborately decorated bedroom was meant for the king, should he spend the night at the château of Vaux-le-Vicomte near Paris, built in 1656–61 by Louis Le Vau for Nicolas Fouquet, France's superintendent of finances. The painter Charles Le Brun and a team of plasterworkers and other artists produced an interior clearly based on Italian Baroque influences. In 1661, Louis XIV arrested Fouquet, confiscated the château, and put the talented team of architects, designers, and artists to work at Versailles. (Photograph: Caisse Nationale des Monuments Historiques et des Sites. © ARCH. PHOT. PARIS/S.P.A.D.E.M.)

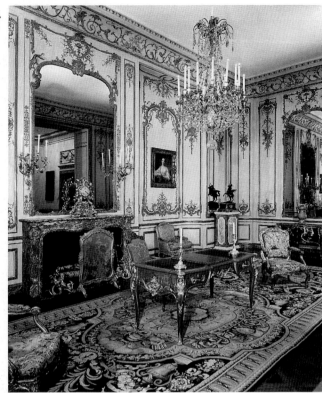

design and interpreted by local craftsworkers, who modified French design in the direction of traditional German peasant furniture. At its best, Biedermeier furniture can be simple, elegant, and handsome, with its use of various lighter woods and occasional painted (often black) detail (fig. 4.29).

ENGLAND

English design of the Renaissance developed in a series of styles identified, as in France, with the reigning monarchs. Royalty did not influence design in any direct way, but designers, cabinetmakers, and other craftspeople seem to have felt that a change of rule offered a reason for introducing stylistic change that was already in the wind. Renaissance ideas first appeared in England in the sixteenth century during Tudor and Elizabethan times. Awareness of the new design developing in Italy came to England with travelers, with Italian craftsworkers, and, indirectly, with craftsmen-designers from the Low Countries, where a somewhat modified version of Italian and Spanish design had appeared.

The great house of Longleat, Wiltshire (c. 1568–80), with its external symmetry and Italianate interiors, provides a complete example of Elizabethan Early Renaissance design. Robert Smythson (c. 1535–1614), one of several builder-craftsmen who seem to have acted as architects in this period, was probably responsible

for Hardwick Hall of 1590–97, one of the finest of Elizabethan buildings to have survived (fig. 4.30).

A more sophisticated and consistent High Renaissance direction appeared in the work of Inigo Jones (1573–1652), who had visited Italy and was familiar with Palladio's work. He used a Roman temple concept for St. Paul's Church, Covent Garden, London (1631–33), which presents an interior of classic simplicity characteristic of his other work as well.

Sir Christopher Wren (1632–1723) moved the Renaissance in England a step closer to the Baroque spirit. After the Great Fire of

4.27 This room from the Hôtel de Varengeville, a town house on the boulevard St.-Germain, Paris, is a fine Rococo interior of about 1735. The soft color of the wood paneling and the rich gilded surface decoration are typical of the style. The central table, with its *japanned lacquer* finish and

elaborate gilt decoration, was made in 1759 by the famous royal cabinetmaker Gilles Joubert 1689–1775) for Louis XV's private rooms at Versailles. The Metropolitan Museum of Art, New York
4.28 The French Empire style found its way to America with such crafts-people as the

French-born and -trained Charles-Honoré Lannuier (1779–1819), who settled in New York and is believed to be the designer of this griffon-support console table (c. 1811). It is made of rosewood and ebony, with secondary parts of pine, poplar, and ash, and has gilded ornamentation and a marble top.

The Napoleonic decorative elements (eagles, wreaths, fasces) that give the Empire style its name were readily translated into symbols appropriate to the new federal government of the United States. (Photograph: Helga Photo Studio, courtesy Bernard & S. Dean Levy, Inc., New York)

4.31 →

4.30 ↑

1666, which devastated much of London, he built a new St. Paul's Cathedral, with its famous dome, and many small city churches. For these, Wren employed the classical vocabulary in a surprisingly varied way, each one a unique study in interior space and detail. St. Stephen's Walbrook, London (1672–87), is a particularly fine example (fig. 4.31). The building is crowded in among neighbors so that its exterior is scarcely visible, but its beautifully domed interior is one of Wren's greatest successes. Wren's work also included secular buildings; Chelsea Hospital, London (1682–85), with its quiet brick exterior and handsome chapel and dining hall interiors, clearly influenced design in the American colonies.

Overall, the eighteenth century in England moved toward a more restrained and academic classicism, represented in build-

ings such as Lord Burlington's Chiswick House (c. 1724–29; interior decoration 1726–29 and new gardens by William Kent), clearly based on Palladian precedents. The eighteenth-century style called Georgian developed a restrained and elegant way of using classical detail in large houses and in rows and squares of smaller city houses as well. Interior detail and furniture design exhibited some of the most admired of all historic work.

The famous English cabinetmakers Thomas Chippendale (1718–1779), George Hepplewhite (d. 1786), and Thomas Sheraton (1751–1806) became known for their fine products (figs. 4.32–4.34). The books they published illustrating examples of their work led to the development of styles in both

4.29 An oval library table of circa 1830 in the German Biedermeier style displays the style's characteristic combination of light, yellow-toned fruitwood and black edge trim. (Courtesy Didier Aaron, Inc., New York)
4.30 The Long Gallery of Hardwick Hall, Derbyshire, England (1590–97), is a fine

example of an Elizabethan great house interior, with its tapestried walls and *strap-work plaster* ceiling. The room runs the full length of the building; the many large windows on the right flood it with light and give rise to the line from Alexander Pope: "Hardwick Hall, more glass than wall"! The architect's

identity is uncertain, but stylistic similarities to other buildings suggest Robert Smythson (c. 1535–1614). (Photograph: © 1985 James Pipkin) **4.31** In St. Stephen's Walbrook (1672–87), one of Sir Christopher Wren's many London churches, a simple rectangular space becomes complex and visu-

ally rich, as the arrangements of columns, arches, and domes transform its plan into, in rising sequence, a square, a Greek cross, an octagon, and a circle. This design may have served Wren as a preparatory study for St. Paul's Cathedral, Wren's largest and most famous work. (Photograph: Edwin Smith)

4.32 ↑ 4.33 ↑ 4.34 ↑

England and America that take the names of their originators. The Adam brothers (James and Robert), working as architects, interior designers, and furniture designers, developed a personal style within the Georgian tradition based, in part, on Roman work as it was discovered in the excavations at Pompeii. (The excavation of Pompeii in the eighteenth century attracted wide attention in Europe and led to considerable imitation, more or less literal, in the decorative design fashions of that time.) Adam interiors such as the library at Kenwood, London (1767–69), the drawing room at Home House, London (1772–73), the sequence of great rooms at Syon House, Middlesex (1760–69; fig. 4.35), and the library at Osterly Park, outside London, in their richness of color and delicate decorative detail, are among the most spectacular of eighteenth-century works.

Neoclassicism

The complexities of late Renaissance design, the elaboration of Baroque space, and the flowing decoration of Rococo surfaces led to an inevitable reaction, not so much a return to the simplicity of the early Renaissance as an effort to look back to the origins of classicism in Greece and Rome. Although the term *Neoclassicism* did not come into use until the 1880s, the work that is now so called appeared in France as early as the mid-eighteenth century. Ange-

Jacques Gabriel, mentioned above as the designer of the Rococo interiors of the Petit Trianon, turned, in the exterior of that building, to a restrained classicism, using, on each of the building's four sides, four Corinthian columns or pilasters centered between matching bays with a simple cornice and balustrade at the level of the flat roof. Gabriel's larger twin buildings that front on the Place de la Concorde in Paris have a similar classic sense identifiable as Louis XVI or Neoclassic in style (fig. 4.36). Étienne-Louis Boullée (1728–1799) is known for a number of fantastic building designs of Neoclassic character. His proposal for the unbuilt Bibliothèque Nationale in Paris as it appears in an engraving would have been a vast monumental space both austere and original (fig. 4.37).

Boullée and Claude-Nicolas Ledoux (1736–1806) have become known in recent years for works that seem to hint at the direction Post-Modernism has taken. Ledoux developed a highly personal style in which simple arch forms combine with classic columns, often with heavy *rustication*, to generate powerful masses, sometimes embellished with elements of fantasy. Images of the Royal Saltworks at the French town of Arc-et-Senans (1775–79; fig. 4.38) and the surviving tollhouses at the old gates of Paris have been sources of direction for many current Post-Modernists. A small boudoir now installed in the Victoria and Albert Museum, London, is believed to be a Ledoux interior of the 1770s or 1780s. It suggests that Ledoux, like Gabriel, could combine a Rococo and Neoclassic vocabulary as a particular pro-

4.32 This fine example of Thomas Chippendale's "ribband-back" (ribbon-back) side chair, of mahogany, dates from about 1755. The simple structure accommodates strong joints—for example, the section where the front legs meet the seat frame is larger than in other designs, allowing amply for joining. The

carving, based on Rococo influences, converts the pristine form into something rich and elaborate. (Photograph courtesy Stair & Company, New York) **4.33** George Hepplewhite made this dining chair in London about 1785, in both arm and armless versions, for a matching set of ten. The shield back is characteristic of

Hepplewhite's work and that of his followers. The chair is finished in black with polychrome decorative details. (Photograph courtesy Stair & Company, New York) **4.34** The style of Thomas Sheraton was more reserved than that of Chippendale, suggesting the Neoclassic influence of the Louis XVI style. His book

The Cabinet-Maker and Upholsterer's Drawing Book of 1791–94 helped to make his style widely known. This mahogany chair was made about 1790. (Photograph courtesy Stair & Company, New York) **4.35** The work of the Adam brothers has always been admired for its bold and attractive use of strong color

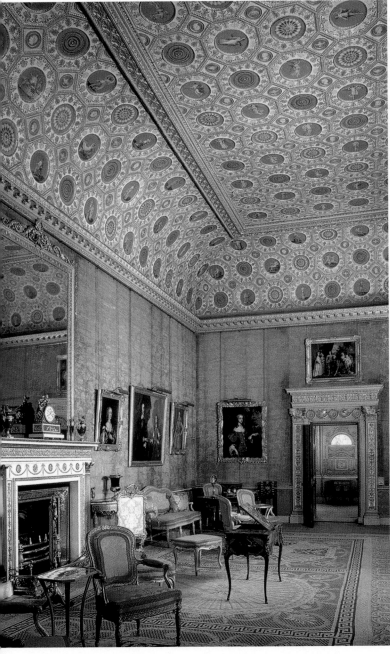

4.35 ↑

← 4.36

← 4.37

← 4.38

ject might suggest. Contemporary engravings of the interior of his theater at Besançon, France (1778–84), now unfortunately destroyed, suggest a magnificent Neoclassical space.

EMPIRE STYLE

The interior design of Charles Percier (1764–1838) and Pierre-François Fontaine (1762–1853), Napoléon's favorite architects and designers, can be described by either the period term *Empire* or the stylistic term *Neoclassical*. Their work often includes references to Egyptian and Pompeian influences, as well as preferences for certain colors, such as red, gold, and black, and motifs, such as the Roman fasces, symbol of power, which flattered Napoléon's imperial ambitions. Percier and Fontaine are sometimes called the first professional interior designers—specialists who took responsibility for every aspect of an interior from architectural features to furniture and decoration (fig. 4.39).

and its delicate decorative detail. This salmon pink drawing room with painted and gilded ceiling in Syon House, Brentford, Middlesex, admirably reflects those qualities. Originally a Jacobean building, Syon House was remodeled (1760–69) by Robert Adam in Georgian style, the English form of Neoclassicism.

(Photograph: © Adam Woolfitt/CORBIS) **4.36** The restrained classicism typical of mid- to late-eighteenth-century French architecture is evident in the twin facades that form the northern boundary of the Place de la Concorde, Paris (1753–75), the work of Ange-Jacques Gabriel. (Photograph: James Austin)

4.37 A surprisingly modern spirit infuses a Neoclassical scheme by Étienne-Louis Boullée. His drawing of this unbuilt design for a vast library hall is from 1784. (Photograph courtesy Bibliothèque Nationale, Paris) **4.38** Greek Doric columns define the entrance gateway to the monumental Neoclassical Royal

Saltworks at Arc-et-Senans (1775–79), designed by Claude-Nicolas Ledoux. This was only a small part of his plan for a town laid out in concentric circles, an urban design for Arc-et-Senans that was never constructed. (Photograph: © Wayne Andrews/Esto)

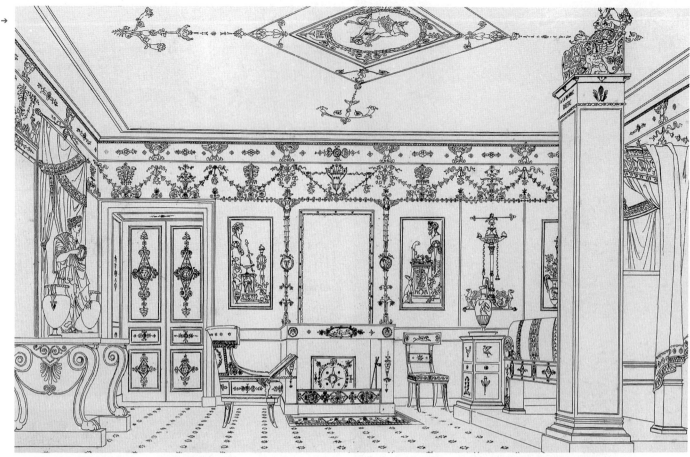

They also encouraged the awareness of their work through publication. Their *Recueil de décorations intérieures*, published in 1801 and again in 1812, contained engravings of many different rooms, all Neoclassic in character, and had a strong impact on trends developing in continental Europe and in England.

REGENCY STYLE

The work of the English Adam brothers (discussed above) incorporated both Rococo and Neoclassical tendencies. Thomas Hope (1769–1831) was an active traveler and collector who filled his house (designed by the Adam brothers) with antiques and eventually opened it to the public (for a fee) as a kind of museum; his well-illustrated *Household Furniture and Interior Decoration Executed from Designs by Thomas Hope* (1807) further encouraged the spread of the Neoclassical style (fig. 4.40). The English Regency style takes its name from the period of time (1811–20) during which George, Prince of Wales, was the Prince Regent before succeeding George III as George IV (r. 1820–1830). Regency style borrowed not only from Neoclassical design but also from other

more exotic directions, including Egyptian, Greek, Gothic, Chinese, and Moorish styles of decoration. The work of Sir John Soane (1753–1837) in the interiors of his own house (1812–13) and the Dulwich Art Gallery (1811–14), both in London, remains close to Neoclassicism. The Royal Pavilion at Brighton remodeled (1815–21) by John Nash (1752–1835), on the other hand, is an eccentric agglomeration of various exotic styles—its exterior predominantly Indian and its interior mainly Chinese—assembled to create a fantasy palace for the Prince Regent himself (fig. 4.41).

North America

COLONIAL STYLE

On the American continent, early settlers brought with them the design ideas from their former homes in Holland, France, Spain, and, of greatest importance, England. Colonial houses were generally modest and simple, almost medieval in character in that they were direct and functional with a minimum of decorative

4.39 Charles Percier and Pierre-François Fontaine are often considered the first professional interior designers. This perspective drawing of an imagined bedroom in a house in Paris is from their 1812 book *Recueil de décorations intérieures*. The Metropolitan Museum of Art, New York. Harris Brisbane Dick Fund, 1928 (28.40.1) **4.40** A plate from Thomas Hope's 1807 book, *Household Furniture and Interior Decoration*, illustrates a writing table, an armchair, and a pedestal, representative designs of what later came to be called the English Regency style. The illustration at the lower left is a side view of the writing table above. The Metropolitan Museum of Art, New York. Harris Brisbane Dick Fund, 1930 (30.48.1) **4.41** In the kitchen of the Royal Pavilion, Brighton, England, remodeled by John Nash in 1815–21, the eccentricity of English Regency design achieves its ultimate expression: although the structural columns are of iron, the tops are ornamented to look like palm trees.

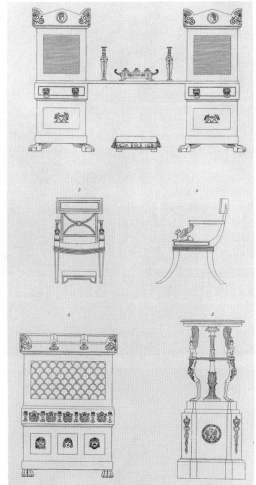

4.40 →

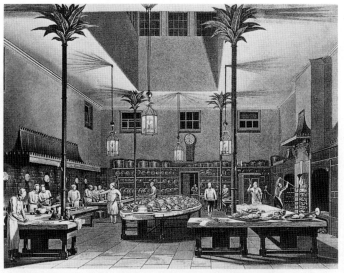

← 4.41

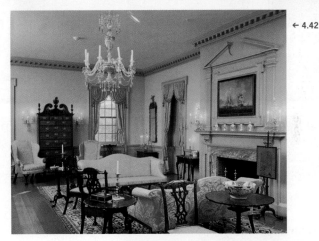

← 4.42

detail. Gradually, as the settlers became established and more affluent and were joined by newcomers of more aristocratic background, this early Colonial design vocabulary gave way to a version of more elaborate English style (fig. 4.42).

An American equivalent of eighteenth-century English Georgian design developed in which the influence of Wren and the great English cabinetmakers can be traced quite readily (fig. 4.43). Large houses such as Westover (William Byrd House, c. 1730) in Virginia, the Vassall-Longfellow house (fig.4.44) and the Governor's Palace (1706–20), Williamsburg, Virginia, and churches such as Philadelphia's Christ Church (1731–44) adhered closely to the models provided by Wren and his contemporaries (fig. 4.44). Palladian details and academic classical design, learned from books imported from England, began to appear in buildings such as Monticello, Thomas Jefferson's house near Charlottesville, Virginia (which he completely remodeled, 1796–1809), clearly based on Palladio.

← 4.43

4.42 The Port Royal Parlor, preserved at the Winterthur Museum, near Wilmington, Delaware, is Henry Francis du Pont's interpretation of a mid-eighteenth-century American Colonial room. The furniture and furnishings, of contemporary date with the yellow color scheme, give an impression of how the rooms of a wealthy family's mansion were decorated in a style having its base in eighteenth-century England. (Photograph courtesy Winterthur Museum)
4.43 This *highboy* cabinet, made in Boston circa 1725 in an American equivalent to the English Queen Anne style, is veneered in walnut and maple; the body is made of pine. The ornamental detail is restrained, but the carefully matched veneers on the drawer fronts generate flowing, symmetrical patterns. (Photograph courtesy Bernard & S. Dean Levy, Inc., New York)

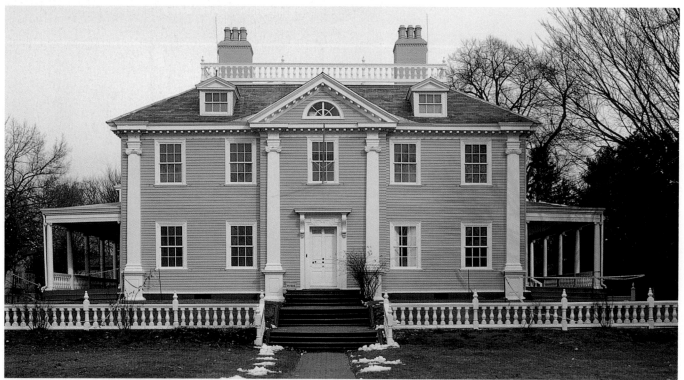

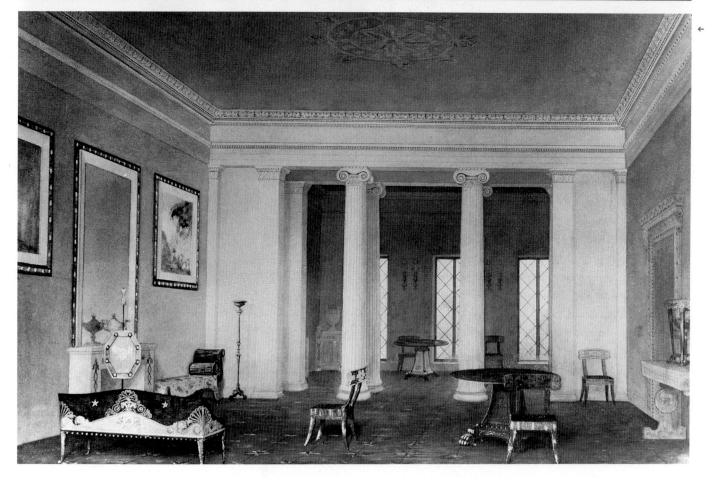

4.44 As the home of the poet Henry Wadsworth Longfellow, this building reflects the influence of Christopher Wren and his contempories.

4.45 A watercolor rendering circa 1845 by the prominent New York architect Alexander Jackson Davis (1803–1892) shows the double parlor of a New York City *row house* as it was to be furnished and decorated in the then-fashionable Greek Revival idiom. The Ionic columns and entablature have Greek echoes in the furniture; the side chairs are of the klismos form seen in ancient Greek vase painting (see fig. 4.10). (Photograph: John Pile)

4.47 →

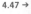

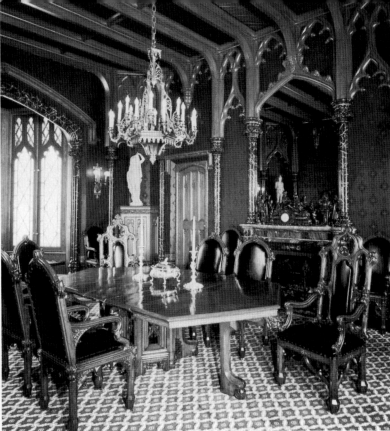

4.46 →

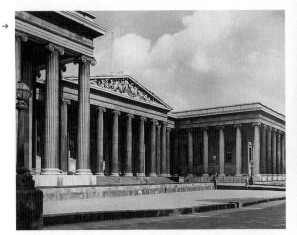

FEDERAL STYLE

The term *Federal style* describes the furniture and interior design paralleling the architectural Greek Revival style in the newly independent United States about the beginning of the nineteenth century. The people of the young nation realized their government was the first democracy since the Athens of Pericles, inspiring an interest in the design of ancient Greece. While photography had not yet been invented and travel to Greece was rarely attempted, books such as James Stuart and Nicholas Revett's *Antiquities of Athens* (1762–95) made fairly accurate information about Greek architecture available. An effort to revive Greek architecture and adapt it to nineteenth-century needs produced many templelike churches, public buildings, and even private houses (fig. 4.45). The interior design followed suit with related interior detail and furniture design suggested by images on Greek vase paintings. The American cabinetmaker Duncan Phyfe (1768–1854), well known for his designs based on the English Sheraton style, modified his pieces to reflect the Greek influence. Along with the revival of Greek architectural elements, influences from the Empire and Directoire styles in France and the Adam and Regency styles in England entered into American design. The term *Neoclassical* becomes applicable to many aspects of the Federal style.

The Greek Revival was not confined to the United States. A parallel direction appeared in Germany and in England, with the work of Karl Friedrich Schinkel (1781–1841) and Sir Robert Smirke (1781–1867); Schinkel's Altes Museum, Berlin (1822–30), and Smirke's British Museum, London (1823–47), rival one another in the display of Greek columns (fig. 4.46).

GOTHIC REVIVAL STYLE

Before long, the Greek Revival led to a desire to revive other ancient styles. A Gothic Revival in both England and the United States followed on the heels of the Greek Revival, with many of the same architects simply shifting the sources that they imitated.

While Gothic architectural styles did not look out of place for churches, their application to hotels, public buildings, and houses produced many odd results (fig. 4.47). Gothic Revival furniture and interior design tended toward the curious and quaint. Its extension into simple country building led to the naive style called *Carpenter Gothic*. The term refers to country building with supposedly Gothic decorative detail added in the interest of fashion, with results sometimes charming, often simply amusing, The forms of pointed arches, tracery, and *crockets* ornamented ordinary household furniture. Houses and barns were decorated with forms vaguely resembling Gothic tracery cut out of wood by the increasingly popular scroll saw.

4.46 The facade of the British Museum, London, by Sir Robert Smirke was built in 1823–47, at the height of the Greek Revival in England. It used an extraordinary number of Greek Ionic columns to create an impressive street front for a building whose exterior was otherwise unremarkable. (Photograph: Edwin Smith) **4.47** Lyndhurst (built 1838, renovated from 1864), a Gothic Revival mansion overlooking the Hudson River near Tarrytown, New York, is a markedly different example of the work of Alexander Jackson Davis, who designed the Greek Revival interior in figure 4.46. (Photograph: Bob Bishop)

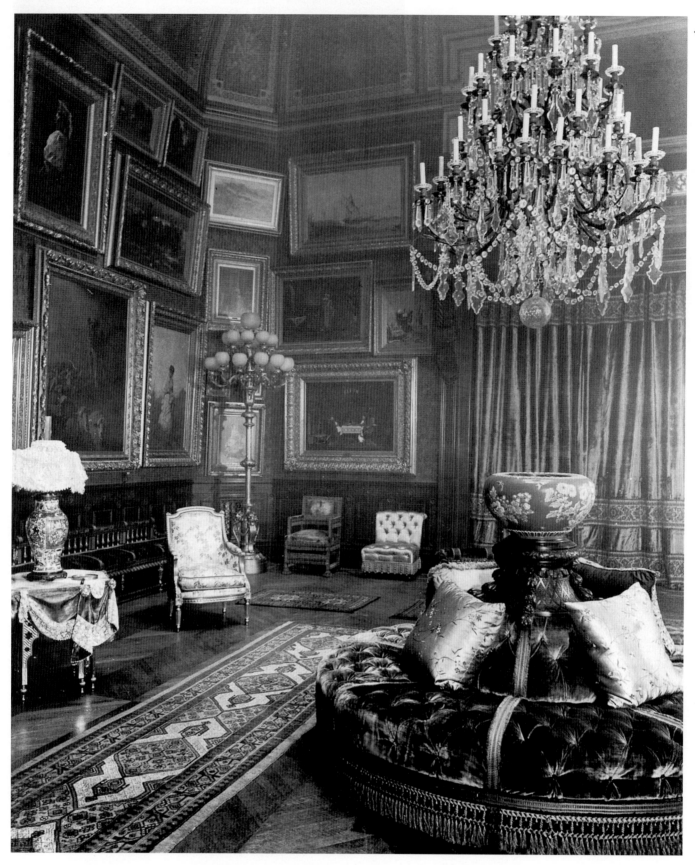

4.48 In 1894, this Victorian gallery in the New York home of Mrs. William Astor housed her collection of paintings. Far from being a neutral setting in which the art collection stands out, it is filled with lamps, a large chandelier, rugs, draperies, and furniture—all intended to create a sense of opulence. The actual paintings, displayed in tiers that rise far above eye level, seem to be no more than additional accessories. (Photograph: Museum of the City of New York. Byron Collection)

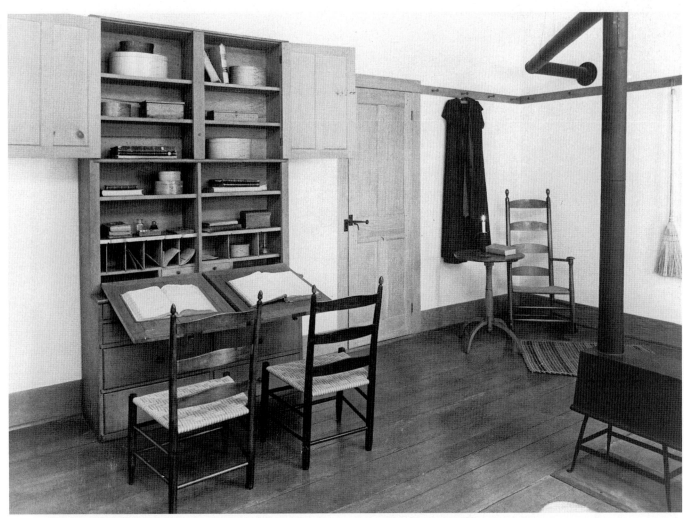

left as natural sticks or logs—even, perhaps, with the bark left on—manufactured primarily by the Old Hickory Chair Company of Indiana, founded in 1898. The stylistic term emerged from the popularity of the furniture for the rustic summer homes and lodges that were built by wealthy city dwellers in the Adirondack region of New York State.

Turn of the Twentieth Century

ART NOUVEAU IN EUROPE

In continental Europe, an aesthetic movement known as Art Nouveau surfaced at the end of the nineteenth century. Its primary bases were in Belgium, with such designers as Henry Van de Velde (1863–1957) and Victor Horta (1861–1947; fig. 4.54), and in France, with Hector Guimard (1867–1942). While the movement included art and architecture, it was particularly in interior design and in the design of furniture and smaller objects that it came into its fullest development. Art Nouveau is characterized by the abandonment of all historical references (which made it the first truly original style in a very long time), by adventurous exploration of new forms, and by the use of a rich and original vocabulary of decoration based on the curves and flowing lines of natural forms. Art Nouveau, like the

Arts and Crafts Movement in England, revealed an awareness of Japanese design in its simple, flowing lines and freedom of form.

The movement spread rapidly, becoming known as Jugendstil in Germany and the Scandinavian countries, and it influenced the work of Charles Rennie Mackintosh (1868–1928) in Scotland and the Catalan architect Antonio Gaudí Cornet (1852–1926) in Spain. Each of these men developed a highly personal style quite unlike anything else that was being produced in their respective home cities of Glasgow and Barcelona, but with visual qualities that can now be seen to parallel closely the Art Nouveau of Belgium and France.

Art Nouveau design was strongly fashion-oriented, and its sudden rise in popularity was matched by its sudden decline and virtual disappearance by the dawn of World War I. Subsequently, Art Nouveau was generally dismissed as an eccentric fad; only in recent years has it been rediscovered and become an object of study and admiration.

VIENNA SECESSION

In Vienna, a parallel new style directed toward the modern world arose. The Vienna Secession movement was begun by artists and designers who found the policies of the traditional academy too restrictive. In response, they set out to establish their own gallery. Josef Olbrich (1867–1908) designed their Secession

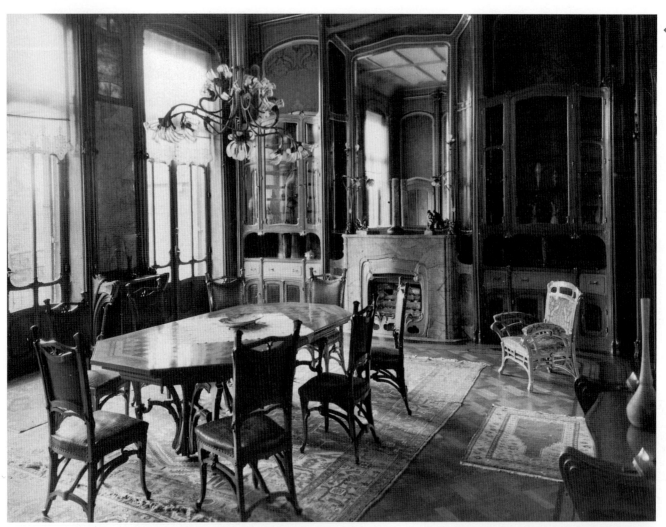

← 4.54

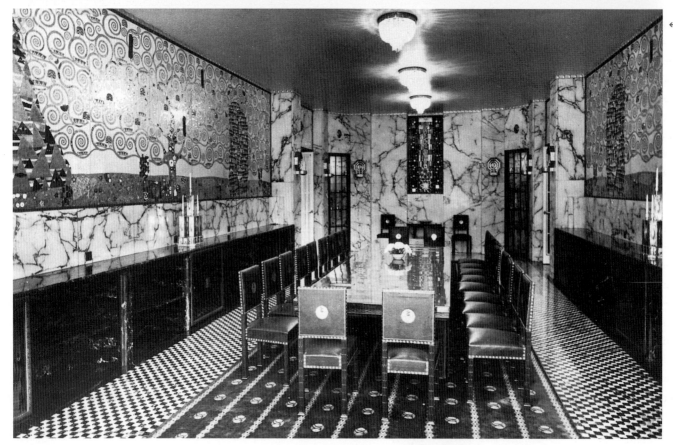

← 4.55

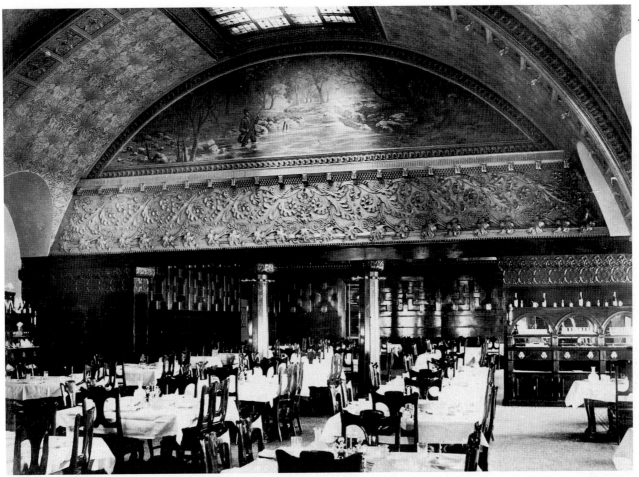

← 4.56

Building in Vienna (1898–99), in a style that mixed a certain symmetrical classicism with an original decorative vocabulary similar to Art Nouveau, although generally less curvilinear and more geometric in feeling. The work of Otto Wagner (1841–1918), Olbrich's teacher, included the Postal Savings Bank, Vienna (1904–6), with its steel-and-glass banking room. Josef Hoffmann (1870–1956) became best known for his Palais Stoclet, Brussels (1905), a large house with elaborate interiors in the innovative Secession vocabulary (fig. 4.55). Hoffmann's furniture and various decorative objects are highly original and give what is often called Vienna Moderne its special quality. Adolf Loos (1870–1933) pushed even closer to Modernism in his work, which, at least in some examples, demonstrates his much-quoted dictum, "Ornament is a crime."

ART NOUVEAU IN THE UNITED STATES

In the United States, Art Nouveau and related influences can be traced in the decorative designs (lamps and glassware) of Louis Comfort Tiffany (1848–1933) and in the architecture and inte-

rior design of Louis Sullivan (1856–1924). Sullivan holds a complex role in design history. He was viewed as the first modern architect because of his use of steel-frame construction and glass, expressed as a design element in tall buildings. (He took the maxim "Form follows function" as his guiding principle.) At the same time, his nature-based decorative vocabulary placed him closer than any other American to Art Nouveau (fig. 4.56). Sullivan employed Frank Lloyd Wright and became his mentor before Wright established an independent practice. This connection forged a close link between Sullivan and the beginnings of the twentieth-century movement toward Modernism.

Twentieth Century

Four men—the American Frank Lloyd Wright and the three Europeans Walter Gropius, Ludwig Mies van der Rohe, and Le Corbusier—are now generally recognized as the key pioneers of Modernism in architecture and design. Many others contributed

4.54 The Art Nouveau designer Victor Horta developed every element and detail of the dining room of the Hôtel Solvay, Brussels (1895–1900), in the original Art Nouveau style, with forms based on nature's flowing curves. Furniture, fireplace mantel, window frames, and light fixtures are all Horta's work, designed specifically for this project. (Photograph: Dotreville, Brussels) **4.55** The dining room of Vienna Secessionist Josef Hoffmann's Palais Stoclet, Brussels (1905), incorporates Hoffmann's own designs for rug, furniture, lighting, and ornamental silver pieces, with twin mural mosaics by the Austrian painter Gustav Klimt (1862–1918). The Wiener Werkstätte shops produced the decorative elements used throughout this elaborate mansion. (Photograph: Studio Minders, Ghent) **4.56** The Auditorium Building (so called because of the opera house at its center) of Chicago was designed by the firm of Dankmar Adler and Louis H. Sullivan (1886–89). The dining room shown here, in the adjacent hotel wing, has interior design by Sullivan himself. The floral decoration suggests an Art Nouveau influence. (Photograph courtesy Chicago Historical Society)

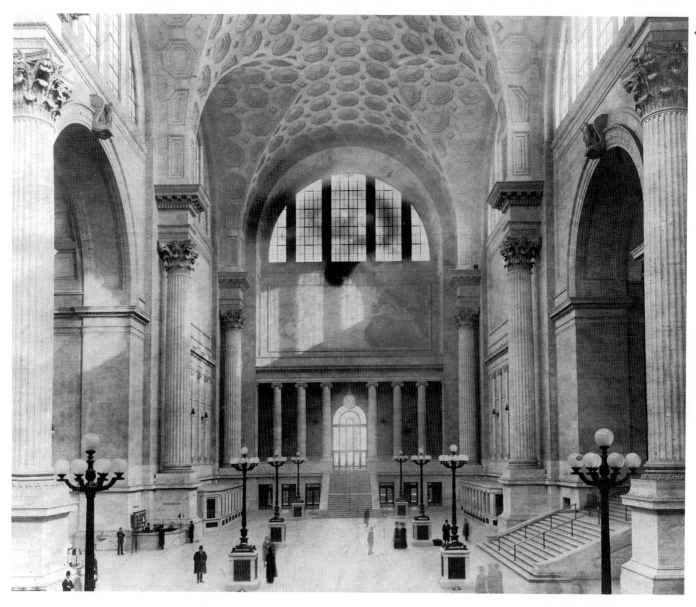

significantly to the development of Modernism, but any one of these four leaders alone might have taken design in that direction.

At the same time that they were developing their new style, most of the design in Europe and the United States followed the traditional historical styles.

ECLECTICISM

The ideas of Sullivan and Wright did not find wide acceptance in the United States of the early twentieth century. At the World's Columbian Exposition of 1893, popularly known as the Chicago World's Fair, Sullivan's Transportation Building was considered more strange than beautiful, while the other buildings, of pseudo-Roman classical design, were greatly admired. American

architects often went to France to study at the École des Beaux-Arts and came home trained to produce buildings designed in the style now called *Beaux Arts* in recognition of its origin; the Paris Opera House by Charles Garnier, built in 1861–75, is a fine example, with its rich overlay of florid, classically inspired decorative detail inside and out.

Most important buildings designed in America before World War II were influenced by the Beaux Arts imitative way of working, often called *Eclecticism*. The word means "borrowing from many sources," and this was the leading characteristic of Eclectic design. A museum or courthouse might be Roman in origin, a church Gothic or Romanesque. New York's Pennsylvania Railroad Station (1904–10; fig. 4.57), for instance, was designed by the firm of

4.57 The majestic main concourse of the former Pennsylvania Railroad Station, New York, was inspired by the ancient Baths of Caracalla, Rome (c. 211–17 C.E.). Built in 1904–10 from designs by McKim, Mead, and White, the terminal incorporated functional iron-and-glass train sheds (out of sight through the arch on the left) and eclectic borrowings from historic precedents. (Photograph: Geo. P. Hall & Sons, 1911, courtesy Museum of the City of New York) **4.58, 4.59** The pioneer professional decorator Elsie de Wolfe, in an 1898 renovation, brought about a dramatic change in the New York row house she occupied with Elisabeth Marbury. In 1896 the dining room was the picture of late-Victorian and Edwardian elaboration (fig. 4.58). With only fresh paint, some new furniture, and the elimination of bibelots, the 1898 interior (fig. 4.59) achieved the relatively clean, simple look that de Wolfe favored throughout a long career. (Photographs: Museum of the City of New York. Byron Collection)

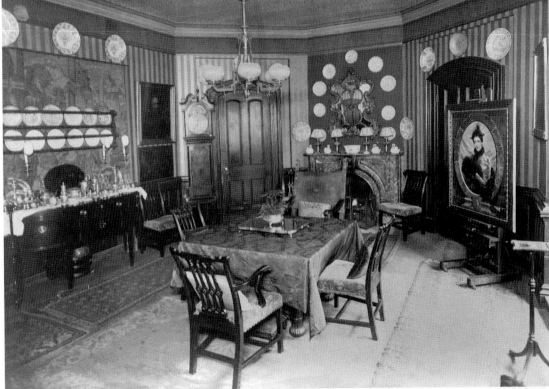

← 4.58

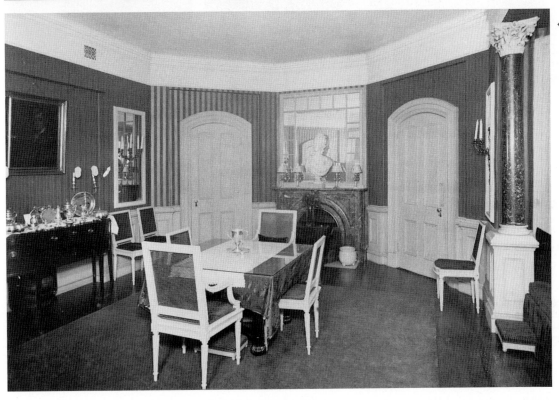

← 4.59

McKim, Mead, and White in imitation of the ancient Roman Baths of Caracalla. A style was chosen to suit each project; banks were often Greek or Roman, schools Tudor Gothic, clubs Renaissance palaces, private homes small châteaux or Georgian mansions. Modern steel structure was often concealed by the period-style exterior.

Interior design was expected to follow along, providing historically believable decoration in whatever style suited the building or the taste of the owner. The profession of interior decoration became focused on the ability to create rooms furnished with antiques (genuine or imitation) and related details in one of many styles. A diluted version of American Colonial interior design became a particular favorite in residential works.

The most positive development of the Eclectic era in interior design was the emergence of a specialized profession called, at the time, *interior decorating*. Elsie de Wolfe (1865–1950) is often considered the first truly professional decorator (figs. 4.58, 4.59). Her clients were mostly wealthy New Yorkers, her work generally confined to tasteful borrowing from the historic periods. Her 1913 book *The House in Good Taste* served to popularize her thinking, which went far beyond stylistic imitation to probe more basic questions about aesthetic goals, even suggesting simplicity as a design objective. Her work opened the way for other decorators, such as Nancy McClelland (1876–1959), Ruby Ross Wood (1880–1950), Rose Cumming (1887–1968), and Dorothy

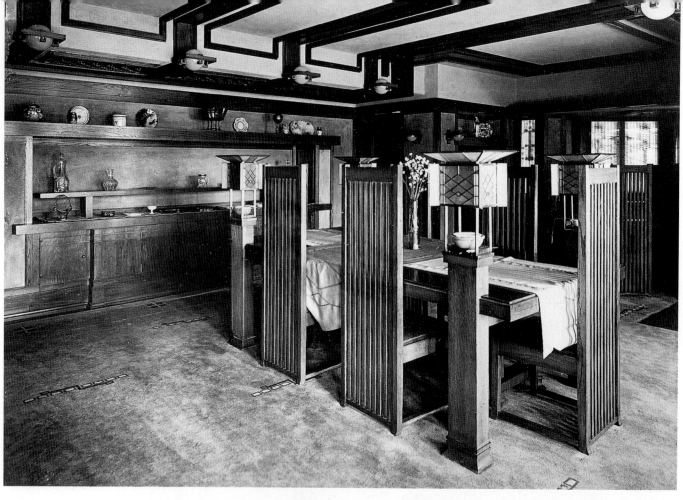

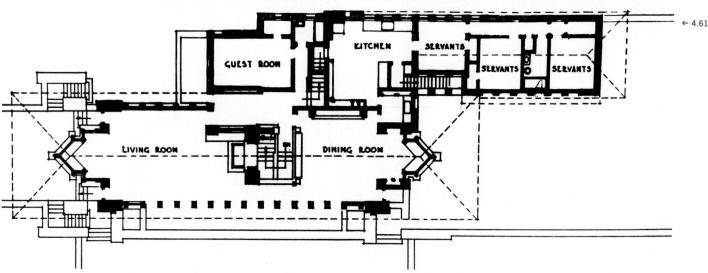

Draper (1889–1969), who similarly adapted traditional styles to their clients' modern needs. The work of such designer-decorators as T. H. Robsjohn-Gibbings (1905–1976), Edward Wormley (1907–1995), and William Pahlmann (1906–1987) in the 1930s and 1940s had its roots in the style-oriented professional practice developed by the first wave of Eclectic decorators.

FRANK LLOYD WRIGHT

Wright (1867–1959), building on the guidance of Sullivan, began early in the twentieth century to produce private residences such as the Isabel Roberts House, River Forest, Illinois (1908) and the Frederick C. Robie House, Chicago (1906–9; figs. 4.60, 4.61) that, with their rejection of historical references and

4.60, 4.61 Whenever his clients permitted it, Frank Lloyd Wright acted as his own interior designer. In the dining room of the Frederick C. Robie House (Chicago, 1906–10), his extraordinary table and chair group, built-in cabinets and shelves, lighting,

ceiling treatment, carpet, and stained-glass windows together create a harmonious unity (fig. 4.60). While this early photograph suggests a gloomy massiveness, light and bright color actually prevail. In the plan of the Robie House (fig. 4.61), the dining

room appears at one end of the main living space. A continuous ribbon of windows stretches across the front of the building; living and dining areas flow into one another, divided only by the free-standing fireplace and stairway. Decks and roofs on either

side extend the long horizontals of the building. (Photograph: Chicago Architectural Photo Co.)

4.63 →

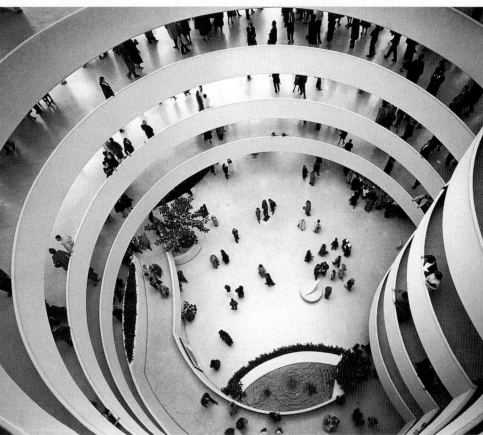

4.62 →

their introduction of open and flowing interior space, define some of the primary directions of modern design. Concerned with every detail of the interiors of his buildings, Wright designed built-in furniture and lighting and, where the client would permit, movable furniture (fig. 4.62), even rugs as well. His interest in and respect for the character of materials recall the Arts and Crafts Movement. He always used wood in a natural finish and had plaster painted in its own cream-white color tones. These colors, along with those of brick and stone (where they occur), created a soft, warm, natural color tonality, often enlivened by a strong, bright red, Wright's favorite accent color. He introduced more bright colors through inserts of stained glass in windows, in geometric patterns. Wright did not hesitate to use ornamentation in an abstract, geometric vocabulary.

Wright might be said to have had two careers, one up to 1915, when he left the United States for Japan to work on his Imperial Hotel, Tokyo (completed in 1922), the second after his return to the United States. Many of his later buildings exhibit his awareness of traditional Japanese design. He produced a large body of work, including many houses (the E. Kaufmann Sr. House, known as Fallingwater [1937], a country house near the village of Mill Run in western Pennsylvania, is probably the best known) and a variety of larger buildings with extraordinary interior spaces. The S. C. Johnson & Son, Inc., Administration Building (1936–39) and Research Laboratory Tower (1943–50), Racine, Wisconsin; the H. C. Price Company Tower, Bartlesville, Oklahoma (1952–56); and the Solomon R. Guggenheim Museum, New York (1956–59; fig. 4.63), suggest the scope and variety of Wright's later projects.

As in his earlier work, Wright controlled, insofar as possible, every detail of interior design. His interest in ornament, while it grew more restrained, set his work apart from the International Style developing in Europe, giving it a much more personal, occasionally even eccentric feeling. The selection of materials, each used in its particular natural color, still controlled the interior's overall character, with the tones of brick, stone, plain concrete, and natural woods dominating (see fig. 10.2). A strong, bright red continued to be used as an accent color. Some of Wright's furniture designs move away from the craft-related use of wood. For example, the office furniture for the Larkin Company Administration Building, Buffalo (see fig. 4.62), employed painted steel as a primary material, a striking innovation in 1904.

4.62 Frank Lloyd Wright's swivel chair designed for the Larkin Company Administration Building, Buffalo (1904), of painted metal and oak, represents an early effort to develop a chair suited to the modern office in both functional and aesthetic terms. Height

37½″. The Museum of Modern Art, New York. Gift of Edgar Kaufmann, Jr.
4.63 The Solomon R. Guggenheim Museum, New York (1956–59), is a famous late work of Frank Lloyd Wright. The great spiral ramp forms the main exhibition gallery of the

building. (Photograph: Robert Mates © The Solomon R. Guggenheim Foundation, New York)

← 4.64

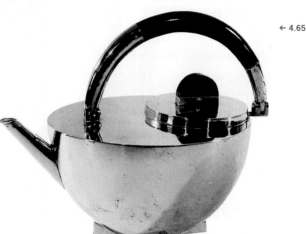

← 4.65

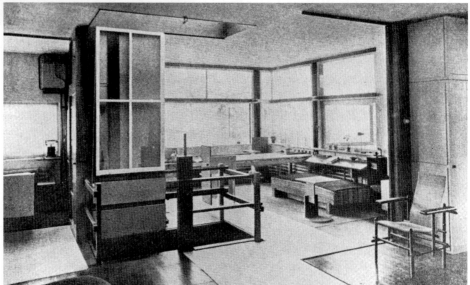

← 4.66

WALTER GROPIUS

In Europe, meanwhile, Modernism emerged in the work of three pioneers, all of whom had worked around 1911 in the office of the German pre-Modernist Peter Behrens (1868–1940) and had probably become familiar with Wright's early work through its publication in the Netherlands and Germany. Walter Gropius (1883–1969), one of this famous threesome, is best known through the influence of the German design school called the *Bauhaus*, established under Gropius's direction at Weimar in 1919 (fig. 4.64). The school moved to Dessau in 1925 and then to Berlin in 1933. The Bauhaus taught design in conjunction with modern art. In Bauhaus designs, spaces took on a quality related to the abstract character of the current painting and sculpture (Cubism and related movements). Ornament came solely from the

4.64 The director's office of the Weimar Bauhaus, designed by Walter Gropius in 1923, was furnished with a rug, wall hanging, and lighting created in the Bauhaus workshops and furniture of Gropius's own design. Here, the abstract qualities of modern art met the machine-inspired, unadorned simplicity of the Bauhaus aesthetic to create a space characteristic of the developing International Style. (Photograph: Bauhaus Archiv) **4.65** This nickel silver and ebony teapot, designed and made by Marianne Brandt in 1924 at the Bauhaus, combines the clean geometry of machine production with a craft aesthetic (in the flowing form of the handle). Height 7˝. Manufactured at the Bauhaus metal workshop, Germany. The Museum of Modern Art, New York. Phyllis B. Lambert Fund. **4.66** The upper level of the Schröder House, its main living floor, in Utrecht (1924), is one of the few complete examples of a De Stijl interior. It is the work of Gerrit Rietveld, an architect best known for his Constructivist approach to furniture design. As in a Mondrian painting, the colors are restricted to white, black, and the three

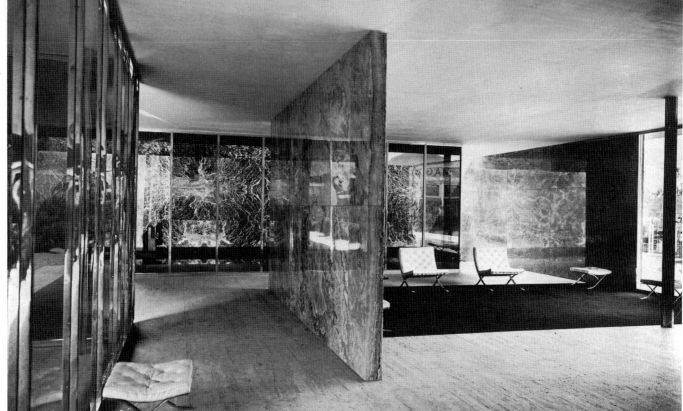

visual effects created by combinations of materials and colors. The goal was to unify art and technology, creating an aesthetic suited to the modern mechanistic world by relating materials, form, and function in an abstract visual vocabulary (fig. 4.65).

The Bauhaus was a key influence on architecture, interior design, and industrial design in the 1920s and 1930s and, through the continued influence of its teachers and students, onward into recent times. The austere and unornamented "functional" modern interior with its tubular metal furniture and color palette of black, white, neutrals, and primary colors can be traced to Bauhaus origins.

Gropius resigned his directorship of the Bauhaus in 1928 to work privately. But even after the Nazis forced the Bauhaus to close in 1933, Gropius's influence continued through his work in England and, subsequently, in the United States, as well as through his chairmanship of the architecture department at Harvard University from 1938 until 1952. Under Gropius's direction, Harvard became the first American design school to accept the ideas of the modern movement.

DE STIJL

The Dutch movement called *De Stijl* (after the name of the magazine that was its mouthpiece) defined directions similar to those of the Bauhaus and had close connections to the work of the painter Piet Mondrian and the sculptor Theo van Doesburg. Gerrit Rietveld (1888–1964) is the best-known De Stijl designer,

with his Constructivist sculptural Schröder House, Utrecht, Netherlands (1924; fig. 4.66) and his geometrically abstract furniture (see fig. 13.6). The furniture of Marcel Breuer (1902–1981), developed at the Bauhaus, seems to parallel De Stijl thinking, although there was no direct link between the two centers (see fig. 13.55).

LUDWIG MIES VAN DER ROHE

The second of the major pioneers of Modernism who knew Gropius through their shared tenure in Behrens's office was Mies van der Rohe (1886–1969); he followed Gropius as director of the Bauhaus in its final years. Mies tended to relieve the austerity of his work with rich materials, including onyx, marble, travertine, chrome-plated steel, and natural or black leather. The term *Bauhaus style* refers to either the austerity of Gropius or the richness of Mies's vocabulary of interior color, finish, and detail, or it can include both.

Mies van der Rohe's influence stemmed less from his academic positions than from his architectural design. The German Pavilion at the 1929 International Exposition at Barcelona (fig. 4.67) and the Tugendhat House, Brno, now the Czech Republic (1930), gave striking demonstrations of the modern view of interior space as open and flowing, without division into boxlike rooms, and without historical reference or applied ornamentation. Mies moved to the United States in 1937 and from 1938 to 1958 headed the architectural school at Chicago's Armour Institute,

primaries. (Photograph: Die Neue Sammlung, Munich) **4.67** Perhaps the most famous of all modern interiors, the German Pavilion (also known as the Barcelona Pavilion) at the 1929 International Exposition at Barcelona was demolished after the fair but was reconstructed from the original plans in 1986. Shown here as originally built to Ludwig Mies van der Rohe's design, the pavilion combines travertine marble floors, polished-steel columns, and screen walls of glass and polished marble, rich materials characteristic of Mies's style.

The Barcelona chair and ottoman are regarded as classic pieces of the modern era. (Photograph courtesy Mies van der Rohe Archive. The Museum of Modern Art, New York)

4.68 →

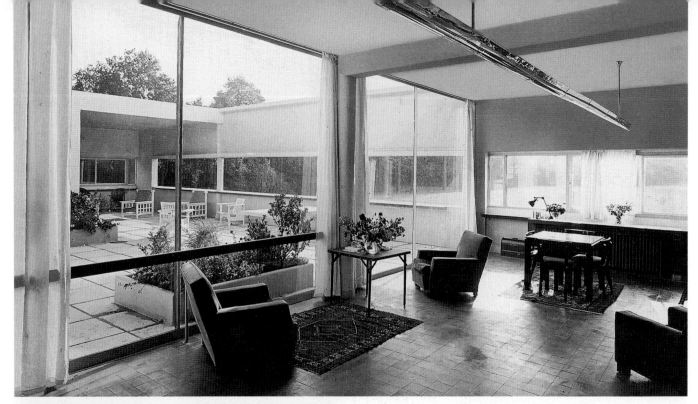

4.69 →

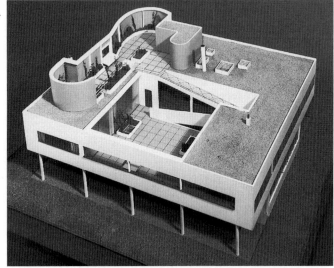
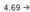

later named the Illinois Institute of Technology. His maxim "Less is more" is often quoted to summarize his design philosophy. He continued to influence modern design, producing a number of the major buildings of the 1950s and 1960s.

LE CORBUSIER

Although actually Swiss, Le Corbusier (Charles-Édouard Jeanneret, 1887–1965) is usually thought of as a French modernist since most of his career was based in Paris. His influential 1920 book *Towards a New Architecture* (translated into English in 1923) made him the primary theorist and publicist of the ideas of the

modern movement, even before he had produced any major body of work. In his work of the late 1920s and 1930s, he demonstrated his conviction that the aesthetic of engineering (of ships, airplanes, and industrial buildings) formed a sound basis for all design in the modern era. His work was always regulated by an orderly, mathematical modular system that gave a special power and dignity to his design.

The Villa Savoye, Poissy-sur-Seine (1929–30), with the main block of the house elevated to the second-floor level on columns, is a good example of his work, shocking when it was built but now a respected key monument of the modern movement (figs. 4.68, 4.69). Le Corbusier's early interiors generally shared the simplicity, austerity, and Cubist geometrics of Bauhaus design, although his use of color was somewhat more adventurous, perhaps drawing on his distinguished work as an abstract painter. He used not only strong primary colors but also tints (pink and blue) and secondaries—greens and oranges—and applied them in large, simple areas.

Because no modern furniture was available when the first Le Corbusier projects were designed, older, simple products, such as bentwood café chairs and plain restaurant tables, were often selected. Later, in cooperation with Charlotte Perriand (1903–1999), Le Corbusier developed furniture designs using steel tubing, leather cushions, and tabletops and cabinet fronts of solid color (see fig. 13.54). Some of these designs continue in production and have come to be called *classic modern*.

4.68 In the Villa Savoye, Poissy-sur-Seine, France (1929–30), Le Corbusier (Charles-Édouard Jeanneret), with Pierre Jeanneret, created a vastly influential example of International Style Modernism. The main living space unifies outdoor and indoor areas by means of a rolling glass wall that allows the resident to define the flow of space. The nondescript original furnishings in this rigorously modern building reflect the unavailability of anything more appropriate at the time the house was built. (Photograph: Lucien Hervé, Paris) **4.69** The main block of the Villa Savoye is lifted on thin columns, while the garage, entrance, and service space make up the small enclosed portion of the lower floor. A finely detailed exhibition model was made of the house, in wood, aluminum, and plastic, 25 × 22½ × 11⅛″. The Museum of Modern Art, New York. Exhibition Fund

← 4.70

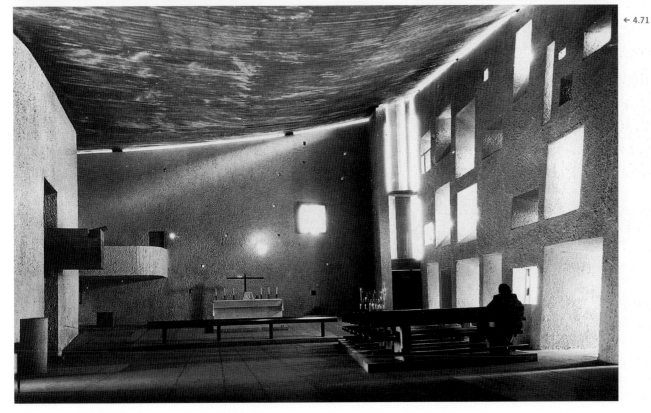
← 4.71

4.70, 4.71 The Chapel of Notre-Dame-du-Haut, Ronchamp, France (1950–54), is one of the most important of Le Corbusier's late works. The sculptural exterior, with its upswept roof and pattern of window perforations, includes a towerlike form enclosing a chapel, one of three. (Photograph: Marvin Trachtenberg) Inside, the Chapel of Notre-Dame-du-Haut is as modern as its exterior, yet it suggests earlier architectural traditions. The lighted rectangles on the right are funnel-shaped apertures in the thick south wall, each filled with stained glass. All of the interior details were designed by Le Corbusier. (Photograph: Lucien Hervé, Paris)

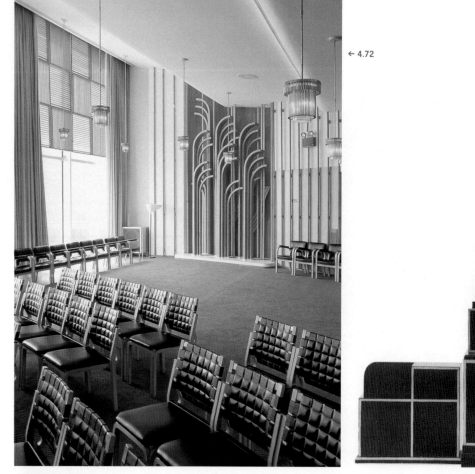

← 4.72

← 4.73

← 4.74

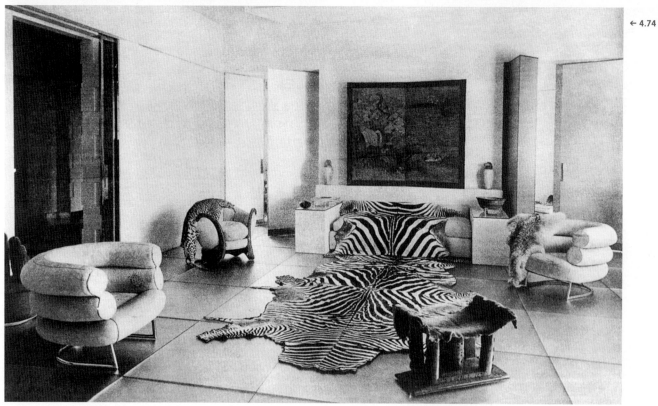

4.72 The Edgar J. Kaufmann Conference Rooms, Institute of International Education, New York, includes this large room designed in 1964 by Finnish architect Alvar Aalto. It is a fine example of his work, with an undulating ceiling and walls surfaced with strips of natural birch that also form a sculptural relief. The seating uses stacking chairs of Aalto's design; the ceiling lights are also of Aalto's design. (Photograph: Joanne Chan)

4.73 The Skyscraper bookcase, designed circa 1928 by Paul Frankl (1886–1962) in black-lacquered wood with silver-lacquered front edging, refers explicitly to the skyscraper architecture of the period in its non-symmetrical center element with active setback forms. Setback and zigzag motifs are favorite elements of Art Deco design. (Photograph courtesy Phillips, New York)

4.74 This Art Deco bedroom by Paul Ruand (Paris, 1933) is furnished with semicircular Bibendum armchairs, a cube bed, and a decorative screen, all designed by Irish-born Eileen Gray (1878–1976). With its African stool and zebra skins resting on a glass floor, the room exhibits an imaginative mix of Art Deco and more purist, abstract, geometric, modern trends.

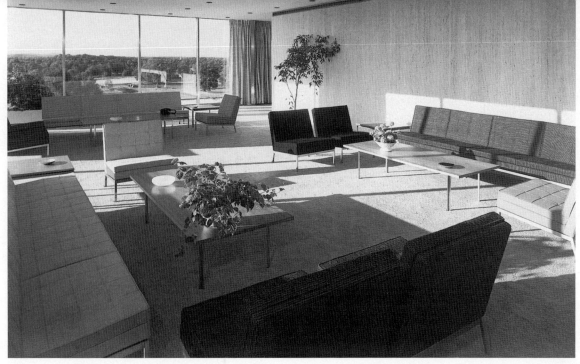

← 4.75

After World War II, Le Corbusier's work changed in character, becoming less geometric and more sculptural or organic. The Chapel of Notre-Dame-du-Haut (figs. 4.70, 4.71), the pilgrimage church at Ronchamp, France (1950–54), demonstrates this shift and also offers one of the finest religious interiors of the twentieth century. The term *International Style* came to be used for the geometrically based, unornamented, and rather mechanistic work of the European pioneer Modernists.

ALVAR AALTO

In Finland, the most important work of early Modernism was produced by Alvar Aalto (1898–1976). Aalto's work, with its flowing curves and use of the wood of Finland's forests, developed a more gentle and less mechanistic character than that of the early Modernists (fig. 4.72). The Paimio Sanatorium (1930–33) is a large complex, but its warm and pleasant interiors suggest a humane view of institutional needs. In a private house such as the Villa Mairea, Noormarrku, Finland (1938–39), and in the church at Imatra, Finland (1956–59), simple means generate spaces of exceptional comfort in both residential and public contexts. Aalto's designs for furniture remain in production, useful and beautiful (see fig. 13.8)

ART DECO

At about the same time that the International Style was developing, a more commercial and fashion-oriented kind of Modernism was appearing, now usually called *Art Deco*. It had its origins in post–World War I France, where influences from primitive art and Cubist painting and sculpture combined with modern motifs, such as electric power, radio, and skyscraper building (figs. 4.73, 4.74). Ornament was accepted, but it was a modern ornament of stepped and zigzag forms often associated with the rhythms of jazz. This style became a favorite for theaters and exhibition buildings and was often used for public spaces, office building exteriors, and apartment buildings (fig. 4.76). The Chrysler Building, New York (1930), designed by William Van Alen (1882–1954), and the structures of New York's Rockefeller Center, including Radio City Music Hall (1931 and after), designed by Donald Deskey (1894–1989) and others, are rich in Art Deco detail. This style also had some popularity in England and, to a lesser extent, in other European countries. It was the decorative style of the interiors of some of the last great ocean liners, such as the French Line's *Normandie* (1932), the *Queen Mary* (1934), and the *Queen Elizabeth* (military service, 1940; ocean liner, 1946).

Another influence in the 1930s came from the introduction of streamlining in dirigible and airplane design. The rounded shapes of streamlined aircraft were taken up by the practitioners of the new profession of industrial design and adapted to trains, automobiles, furniture, and even such unlikely objects as refrigerators and pencil sharpeners. Industrial designers produced interior design work—most often for trains, ships, retail stores, and showrooms—using some mixture of Art Deco and streamline styles.

POSTWAR MODERNISM

After World War II, professional design work by both architects and interior designers settled into a vocabulary of Modernism

4.75 In the 1950s, Modernism's diverse influences came together in America in a widely accepted idiom easily adaptable to the facilities of large corporations. Florence Knoll Bassett (b. 1917), head of the Knoll Planning Unit, designed this executive reception area (1954–57) for the offices of the Connecticut General Life Insurance Company in Bloomfield, Connecticut. Skidmore, Owings & Merrill were the architects. (Photograph: © 1957 Ezra Stoller/Esto, courtesy Skidmore, Owings & Merrill, New York)

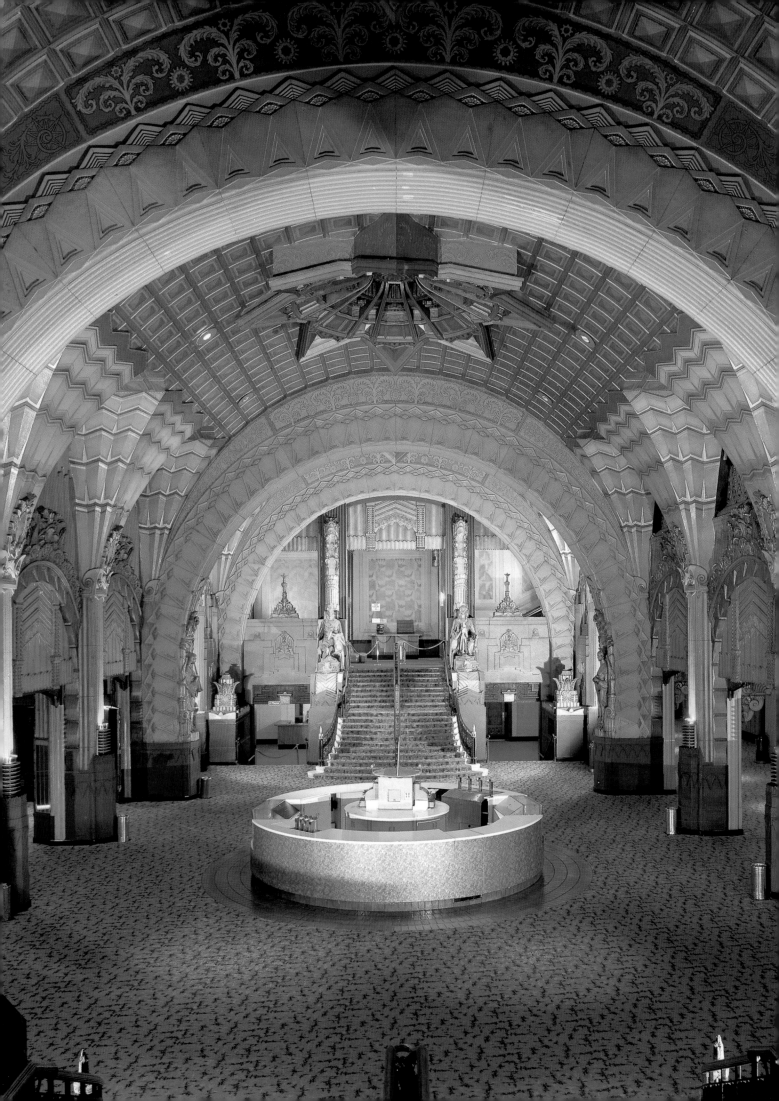

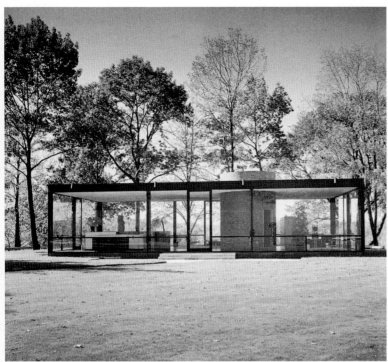

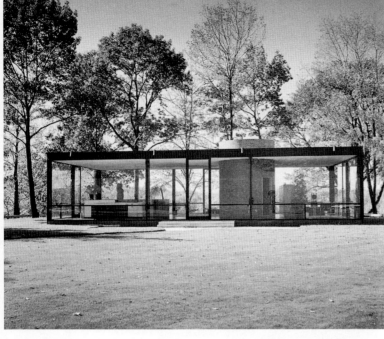

largely based on the work of the prewar pioneers. The influence of Gropius and Mies as teachers combined with a widening acceptance and admiration of modern work led to the adoption of *functionalism*, or the International Style, as the basis for most public and commercial work (fig. 4.75). The availability of furniture design classics by the European leaders and a full range of more recent furniture and related products by post–World War II designers made the modern interior readily available everywhere. The famous Glass House (with four walls of floor-to-ceiling glass) at New Canaan, Connecticut, designed in 1949 by Philip Johnson (b. 1906) for his own use, carried the aesthetic of Mies's minimalism to a dramatic extreme (figs. 4.77, 4.78). In spite of the praise granted such examples in professional circles, Modernism was not widely accepted in residential interior design, which, for the most part, clung to imitations of traditional styles, with some limited inclusion of the craft-oriented Scandinavian furniture design often called *Danish Modern*.

The work of Eero Saarinen (1910–1961) developed a variety of aspects of Modernism, including the extraordinary flowing curves of the TWA Terminal (1956–62) at New York's John F. Kennedy International Airport. Similar forms appear in Saarinen's furniture designs (see fig. 13.46), while his simple and elegant residence for J. Irwin Miller, Columbus, Indiana (1955), housed interiors that were the work of Alexander Girard (1907–1993) (fig. 4.79). In that house, Girard introduced for the first time the "conversation

pit," a sunken seating area designed as an integral part of the physical structure. Girard's work included many textile designs for the firm of Herman Miller. That company also produced furniture design by the offices of George Nelson and Ray and Charles Eames that can be viewed as the essence of 1950s Modernism.

Transition to the Twenty-First Century

In the 1970s and 1980s, several challenges to Modernism surfaced that set the direction for design today. Since this is a field for ongoing development, even struggle, it is not surprising that the differing directions in competition for domination of future design work have engendered considerable conflict and confusion. Although the rather illogical term *Post-Modernism* has been coined to describe whatever develops beyond the Modernism of the recent past, the term has in fact come to be attached to a particular direction, which is only one of several quite different approaches. Whatever term is ultimately chosen, a number of distinct directions, each developing in a lively way, can be recognized and defined.

LATE MODERNISM

Late Modernism is a new term to define the most conservative of these directions. This work is firmly based on the Modernism of the four famous pioneers, but it attempts to move forward into

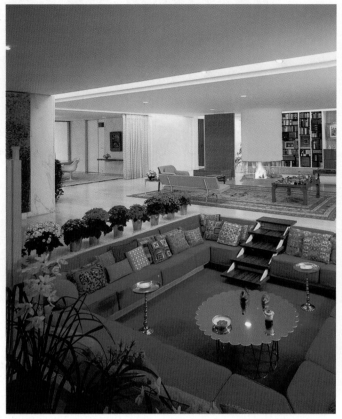

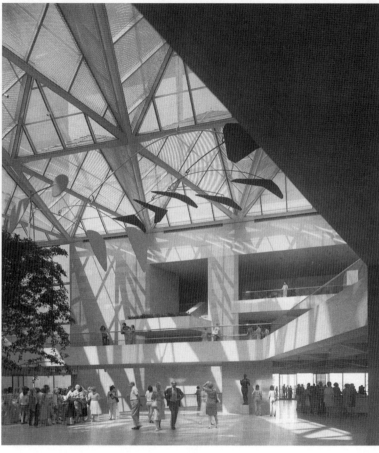

new forms, more adventurous and aesthetically more varied than the formulaic designs of the later generations of Modernists. The work of I. M. Pei (b. 1917), such as the East Building of the National Gallery of Art in Washington, D.C. (1978), belongs to this category (fig. 4.80). The houses and other interior work of Richard Meier (b. 1934; fig. 4.81) and Charles Gwathmey (b. 1938; see fig. 9.36) also fall in a direct line of development from early Modern roots.

HIGH TECH

A somewhat different direction with a basis in Modernism has come to be called *High Tech*. It places more emphasis on the exploitation and visible display of elements of science and technology, particularly the advanced technologies of the computer-oriented, aerospace, and automated industrial fields. Early Modernism was closely allied with technology in its interest in the machine and its intention to create a design vocabulary suited to the modern, technological world. Devotion to the machine has gradually come to seem somewhat dated, a rather naive and

romantic view of mechanization as the solution to every problem. High Tech design moves forward into the post–Machine Age technology of electronics and space exploration to learn from the advanced technology of those fields and to search out an aesthetic in their products.

Prior steps in this direction can be found in the work of Buckminster Fuller (1895–1983), best known for the development of the geodesic dome structure, which has been used in many ways, including as the United States Pavilion at Expo 67, Montreal World's Fair of 1967. Charles Eames (1907–1978) and Ray Eames (1912–1988) also hinted at this direction in their own house of 1949 (Eames House, Pacific Palisades, California; see fig. 5.9), assembled from industrial building components, and in the husband-and-wife team's well-known and widely popular Eames furniture designs of 1946 onward (see fig. 13.38).

The mature High Tech style uses industrial materials, furniture, and equipment of technological character, simple forms, and little decorative or ornamental details. Its identification with advanced technologies tends to make High Tech work look futur-

4.79 The living room of the J. Irwin Miller House, Columbus, Indiana, was designed by interior designer Alexander Girard in cooperation with the architect Eero Saarinen, in 1955. The lowered area of the living room was much imitated and became known as a "conversation pit."

The warm color and decorative detail are typical of Girard's work and represent 1950s design at its best. (Photograph: Balthazar Korab) **4.80** The 1971–78 East Building—popularly called the East Wing—of the National Gallery of Art in Washington, D.C., was designed by I. M.

Pei & Partners. Stairs, landings, and decks lead to the various exhibition galleries, which overlook the main entrance area and central atrium. The simple geometric forms combined in complex angular relationships are typical of this architect's work. An Alexander

Calder mobile forms a colorful focal point. (Photograph: © 1978 Ezra Stoller/Esto)

4.81 Richard Meier was the architect and interior designer for the Frederick J. Smith House, Darien, Connecticut, built in 1965–67 in the style now called Late Modernism. The simple, geometric forms and absence of ornament xemplify Modernism's continuing dynamism. (Photograph: © Ezra Stoller/Esto)

4.82 →

4.83 →

istic. Architects and designers of this style include Renzo Piano (b. 1931) of Italy and Richard Rogers (b. 1933) of Britain—their Centre Pompidou, Paris (1971–77), has become an emblem of High Tech (see fig. 9.18)—and James Stirling (1926–1992; fig. 4.82) and Norman Foster (b. 1935) in England.

POST-MODERNISM

The general term *Post-Modern* has come to identify the direction that grew from the theoretical position taken by Robert Venturi (b. 1925) in his influential 1966 book *Complexity and Contradiction in Architecture*. In it, Venturi challenged the emphasis on logic, simplicity, and order characteristic of Modernism, suggesting that complexity and ambiguity have a place in design. Following this dictum in his own work, Venturi has produced designs that sometimes seem eccentric, disturbing, or banal. Venturi's many major projects—such as the 1986–91 Sainsbury

Wing of the National Gallery, London, designed with Denise Scott Brown, his wife (b. 1931)—include references to historic classicism used in ways that serve and enhance modern uses. In the *mielparque* (hotel and conference center) of the Nikko Kirifuri Resort, Nikko, Japan (1997), whimsical and colorful decorative elements enliven otherwise simple basic space design (fig. 4.83).

Post-Modern design also departs from Modernism in its willingness to include ornamentation and elements referring to historical styles. Such traditional elements are not intended to imitate past building styles but rather to act as references used out of context, often with humorous impact. Such *metaphors*, as these designers' elements or symbols—treated almost as figures of speech—are often called, seem to question the seriousness of mainstream Modernism. If the realities of the modern world sometimes seem to approach absurdity, Post-Modernism offers us

4.82 The work of the British architect James Stirling (1926–1992) has often been described as High Tech. However, the Neue Staatsgalerie in Stuttgart, Germany, by James Stirling, Michael Wilford and Associates, architects (1984), eludes easy classification. It is unique in its combination of High Tech, Post-Modernism, and independent, creative directions. (Photograph: Timothy Hursley, © The Arkansas Office, courtesy *House & Garden*) **4.83** This ornamented skylit "village street" was designed by architects Venturi, Scott Brown & Associates as part of the *mielparque* (hotel and conference center) at the Nikko Kirifuru Resort, adjacent to the Nikko National Park, site of ancient Buddhist and Shinto shrines, Nikko, Japan. The hotel and conference center's playful Post-Modernist decorative elements are intended to evoke a traditional Japanese street lined with shops and cafés. (Photograph: Kawasumi Architecture Photo Office, courtesy Venturi, Scott Brown & Associates)

absurdities as serious creativity or, from another perspective, presents serious work that can be viewed as absurd.

The American designer best known for Post-Modern work (although he dislikes the term) is Michael Graves (b. 1934), whose early designs for witty and odd furniture and interiors were later joined by major architectural projects. His Portland Public Service Building, Oregon (1980), was one of the most controversial projects of the period, attracting both extravagant praise and bitter condemnation. Philip Johnson, long a proponent of Modernism in America, moved toward Post-Modernism in such projects as the AT&T Headquarters (now the Sony Building), New York (1979), with its references to Roman, Romanesque, and Georgian design elements (see fig 17.9).

In Italy, the group that used the title Memphis was energetic in developing furniture and interior design that shared the Post-Modern inclination toward arbitrary and whimsical uses of color and form (see figs. 1.23, 13.59). Many designers in the United States enthusiastically adopted this style.

DECONSTRUCTIVISM

The term *Deconstructivist* describes the work of a number of architects and designers whose designs are quite varied. However, when this work is shown in a group exhibition, as it was in 1988 at the Museum of Modern Art, New York, the cumulative impact is one of a distinct emerging style or direction. The characteristics shared by Deconstructivism include an emphasis on elements that seem torn apart and reassembled in an apparently illogical or chaotic manner.

In Deconstructivist projects, design elements—instead of being constructed into unified wholes—are *de*-constructed, separated, and pulled out from a whole in ways that frequently result in sharply angled, overlapping, and interpenetrating forms that deliberately deny the traditions of architectural and design aesthetics. External elements seem to break into interior space, while interiors, often not clearly bounded, break out from containment. The term *Deconstructivist* has been chosen in part to describe these qualities, in part to recall the term *Constructivism*, which in art history describes the work of a movement of the 1920s centered in the Russian avant-garde, before the Soviet government suppressed all Modernism in exchange for a propagandistic "realism." The creations of such artists and architects as Aleksandr Rodchenko (1891–1956), Vladimir Tatlin (1885–1953), and Kazimir Malevich (1878–1935) had an emphasis somewhat similar to Deconstructivism in that the assembly of elements appears disjointed and unrelated except as it is put together in a particular work.

The American architect Frank O. Gehry (b. 1929) has produced designs that have often been classified as Post-Modernist but have not fit this identification comfortably. His own house, originally a nondescript suburban building in Santa Monica, California, has since 1978 undergone a series of remodelings. Deconstructivism is suggested by the way in which spaces in the Gehry House have been torn and fractured, while elements taken from banal construction practice have been added to exterior surfaces in an effort to fragment existing forms. Gehry has produced a series of designs for museums using multiple curved forms in ways that would have been impossible without the assistance of computer-aided techniques. Of these, the most spectacular is the Guggenheim Museum Bilbao, Spain (1992–97), where the works of such artists as Robert Rauschenberg and Richard Serra are set in surroundings no less spectacular than the works themselves (figs. 4.84, 4.85)

Another American, Peter Eisenman (b. 1932), is the designer of a vast, as yet unbuilt complex for the University of Frankfurt in which units that seem ripped apart are distributed along a linking spine to create complex and disturbing relationships. In Ohio, the Aronoff Center for Design and Art/DAPP Building at the University of Cincinnati (1988–96) makes use of complex spatial forms that create interiors of amazing variety that can be viewed as both confusing and stimulating (fig. 4.86).

In Paris a park, the Parc de la Villette, is studded with a number of small pavilions called *follies* by the architect—each different but each related to the others in dimension (a small cube) and in color (bright red)—that seem to be fragments of some larger whole (figs. 4.87, 4.88). Although the forms of these follies (as the designer calls them) are eccentric and complex, their effect is playful and cheerful rather than forbidding. They are the work of the Swiss-born but now New York–based Bernard Tschumi (b. 1944). In the United States, Alfred Lerner Hall, the student activity center at Columbia University, New York (1997–99), uses ramps and walks passing through an open space with windows opening to campus in a way that ties the interior space into the entire university complex.

Underlying all Deconstructivist work is a clear challenge to any design that strives for formulas of complacent charm and acceptability. The arches and pinnacles so obligatory to the Post-Modern skyscraper and the replay of traditional elements that make so many suburban houses appealing to a large public seem, like television entertainment and junk food, too simplistic. Deconstructivism has taken up a search for more meaning and more strength.

Although not always Deconstructivist in character, the work of Dutch architect Rem Koolhaas (b. 1944) suggests new directions that hint at twenty-first-century possibilities. In 1991, his Paris house known as Villa dell'Ava shocked its neighbors with its Modernist glass and geometric solid forms topped by a swimming pool. The Maison à Bordeaux, France, is a unique design with an elevator-like space that moves through different levels of the house (see fig. 8.1). For the Educatorium, on the University of Utrecht campus, Koolhas created an unconventional building that glows at night and has a floating, slightly disembodied feeling inside. To unify a variety of social and educational functions he used a design based on one continuing line of concrete that resembles a giant paper clip partly unbent. This line begins in

4.84, 4.85 The complex and curving exterior (fig. 4.84) of the Guggenheim Museum Bilbao, Spain, was designed by Frank O. Gehry with the assistance of computer modeling. Sheathed in gleaming titanium metal, it is a dramatic image strongly futuristic in its implications. The interior of the central atrium space (fig. 4.85) is as complex and as varied as the exterior. Stairs and walks lead to upper levels while roof skylights flood the space with daylight. (Photographs: © Jeff Goldberg/Esto) **4.86** The Aronoff Center for Design and Art/DAAP Building, University of Cincinnati, Ohio (1988–96), is a major work by Peter Eisenman. Its interior is made up of a twisting central spine with many level changes that give access to various studios and rooms serving the university's art and architecture programs. The mostly white interior of complex form can be thought of as Deconstructivist in concept. (Photograph: John Pile)

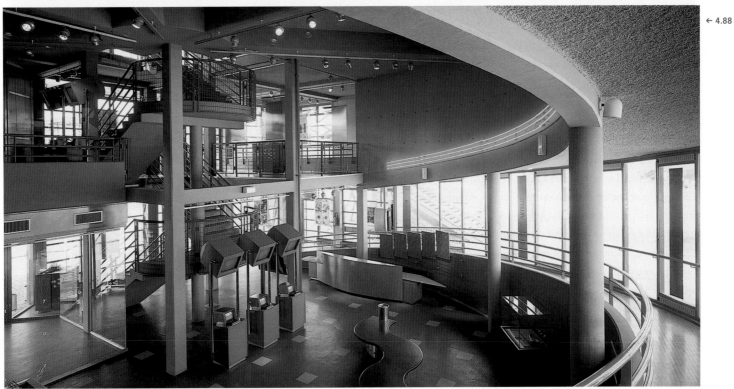

4.87, 4.88 In the Parc de la Villette project, Paris, architect Bernard Tschumi has created a series of small bright red pavilions that seem to be fragments of a larger whole. These *follies*, as he calls them—follies were eighteenth-century pavilions built in an extravagant and fanciful style—are complex and eccentric in form, as demonstrated by both the exterior (fig. 4.87) and the interior (fig. 4.88) of one pavilion. Tschumi's work is representative of the recent Deconstructivist direction in architecture. (Photographs: © Peter Mauss/Esto)

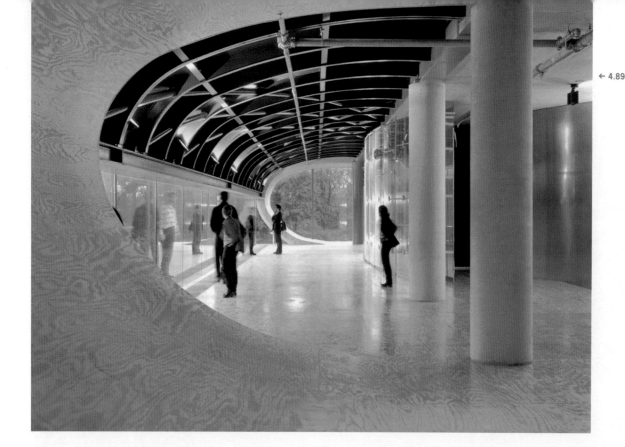

← 4.89

the lobby, runs along the ceiling of the restaurant, then becomes a curved outside wall, and eventually converges into the ceiling of the lecture halls (fig. 4.89). Many Koolhaas projects still unbuilt have impact through drawings and models that show how his work will develop in years ahead.

The variety of different and often conflicting currents now running in the design world is characteristics of a period of change in which established norms seem to have outlived their usefulness while new norms have not yet taken clear form, similar to the Mannerist developments in Italy in the sixteenth century, when the established ascendancy of classical design systems came into question while the Baroque of the seventeenth century had not fully emerged. Mannerism was a style in transition, permitting the testing of new and sometimes outrageous or extreme ideas, confusion, and rich development. If the present is also such a time, it is not surprising that untried and disturbing forms are evident.

A striking characteristic of recent design work is a tendency toward internationalism. In addition to work in their own countries, many designers are finding commissions in other countries. In America, Japanese, English, Austrian, and Dutch architects and designers have undertaken important projects. The work of Americans is now found in France, Germany and Italy, as well as in many other countries. Ease of transport and communication (instantaneous computer transmission of messages and drawings) has encouraged international practice that would have been unusual in earlier times.

Living and working in design at such a time may not be as easy as it is in the middle of a well-established period, but the level of excitement and interest is higher. Public awareness of design issues and involvement in controversy increase at such a time and make design a lively and vital field rather than a settled craft. The twenty-first century promises to become one of the most interesting of all historical design periods.

Non-European Traditions

Until the last few centuries, geographical regions separated by long distances had little means of communication. European traditions developed over the past 5,000 years, independent of remote civilizations that were largely unknown. Each of the great non-European ancient civilizations not only has a history but also a *design history* that can become a lifetime study. Here, it is possible only to provide some general comments, with emphasis on the ways in which non-European design has from time to time been valued in Europe and America and exerted some degree of influence (fig. 4.90). The cultures of particular interest for these purposes are those of Asia, of the Islamic world, and of pre-Columbian America.

4.89 For the Educatorium, on the campus of the University of Utrecht, The Netherlands (1993–1997), architect Rem Koolhaas of Office for Metropolitan Architecture unified a variety of functions by basing the design on a continuing band of concrete that is at once floor, roof, and ceiling. Inside, on an upper level, the floor rises into a curving plywood wave like the kind found at a skateboard park. This view is of a hallway that overhangs the restaurant. (Photograph: Hans Werlemann/Hectic Pictures, courtesy OMA, The Netherlands) **4.90** The Peacock Room was designed by artist James Abbott McNeill Whistler in 1876–77, when the influence of Asian art and design was at its peak in England. The painting in this detail of the room, now installed in the Freer Gallery of Art, Smithsonian Institution, Washington, D.C., is Whistler's *Princess from the Land of Porcelain.* (Photograph courtesy the Freer Gallery of Art, Smithsonian Institution, Washington, D.C.)

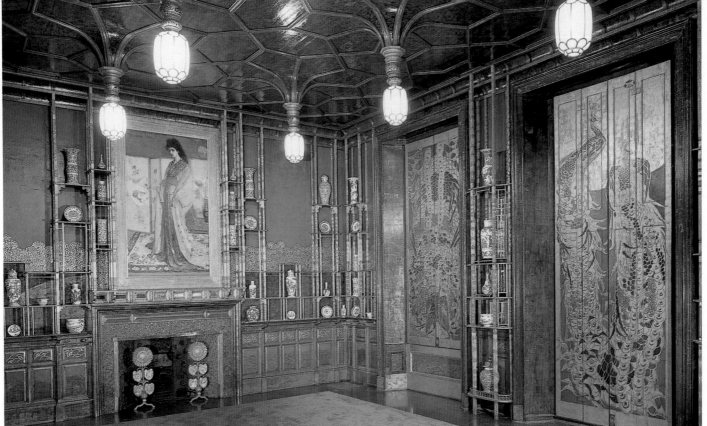

CHINA

Civilization in China developed in the Stone Age, and Chinese written history begins around 3000 B.C.E. Although Chinese artwork has survived from very early periods, our knowledge of Chinese architecture and interior design extends only a few centuries into the past. The preferred building materials, wood and bamboo, are not long lasting, so few ancient structures survive; stone, an available building material in China, has generally been used solely for platforms, understructure, and enclosing walls. Nonetheless, because Chinese culture has been, until very recent times, extremely conservative, the traditional design of the last few centuries is believed to differ little from earlier practice.

Marco Polo's visit to East Asia occurred in the thirteenth century, giving Europeans new access to Chinese art and decorative design. However, information concerning built structures remained scant until the eighteenth century, when the development of the tea trade and the importation of artwork, landscape paintings, and wallpapers illustrating Chinese architecture brought fresh knowledge to the West. Paper was invented in China, and wallpapers were made there as early as 200 B.C.E. In the first part of the sixteenth century, hand-painted papers, made in small sections (about 12 by 16 inches) and decorated with flowers, birds, and landscape motifs, began to be imported into Europe (fig. 4.91) By the eighteenth century, *chinoiserie*, a fashion for Chinese motifs based on a fascination with the exotic products of a distant culture, had become widespread in France and England. Actual imported objects—porcelains, teak tables, and other small pieces of furniture and artwork brought by the ships of the tea trade—led to the use of Chinese motifs in the furniture designs of Thomas Chippendale and other English cabinetmakers of the Georgian era. Photography, a still later development, has offered

detailed imagery of Chinese architecture and interiors only in relatively recent years. Efforts to create complete interiors in a Chinese idiom have predominantly been restricted to spaces with a highly exotic character, as in some theaters of the 1920s.

The typical traditional Chinese building uses a framework of wood posts and beams assembled into a cage structure in some ways similar to the framing of modern Western structures. The parts of a wood (or bamboo) frame were locked together with ingenious joints that required no nails or screws, generating a structure that has good resistance to earthquakes but only moderate resistance to fire, rot, and insect damage. Although often used as a base, masonry was only occasionally used for wall panels inserted between posts, somewhat in the manner of European half-timber work. Sloping roofs surfaced with thatch, shingles, or tile have been used since the earliest times, but the support of roofs does not use the Western system of *rafters* that form a triangular *gable*; instead, a beam spanning the width of an interior space supports short posts that supports a shorter beam that in turn supports another, still shorter *post-and-beam* assembly, creating a stack of diminishing rectangular units that hold the sloping roof. It is probably this system of construction that has given rise to the most obvious characteristics of traditional Chinese architecture. Roof surfaces are generally curved in a concave line that continues outward beyond the enclosed space to form broad *eaves*. Several successive levels of eaves are frequently formed, generating a highly distinctive building silhouette.

Inside, the connections between supporting posts and beams are made with complex interlocking brackets that form intricate and highly decorative patterns. Palaces, temples, pagodas, and houses were all built with variations on this general scheme. Towerlike pagodas use a succession of typical bracketed roof structures to

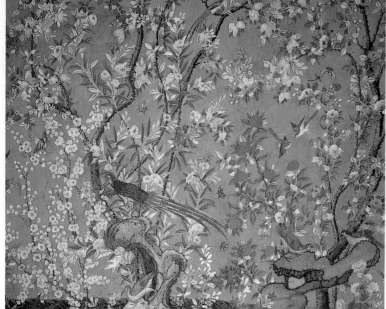

4.91 →

← 4.92

generate the picturesque multiroofed form. Interior spaces are usually open halls of varied size with the posts, beams, and brackets all painted in strong and bright colors, creating a richly ornamental effect. The favored colors are vermilion red, deep green, black, and gold. Windows, doors, and wall panels may be perforated screens having elaborate, small-scale decorative patterns.

Houses are often composed of several pavilion-like units arranged around an open court. Other plans weave open courts and garden spaces into more complex groupings. In general, strict symmetry is valued; larger temple and palace complexes are frequently made up of a sequence of larger central pavilions and paired smaller units arranged symmetrically along a lengthwise axis, most often carefully oriented along a north-south line. Movement is generally blocked along the center axis—it becomes necessary to move to one side or the other to pass a barrier and progress to the next centrally positioned pavilion.

Traditional Chinese furniture, as made for the more affluent, is of fine quality in both design and construction. Many examples from the seventeenth and eighteenth centuries are of simple but elegant form made up from wood members that combine straight lines and subtle curves. Chairs, usually with arms, are made in a variety of shapes (fig. 4.92). Tables may be square or oblong, at writing height or low. Cabinets are often beautifully decorated with lacquered surfaces and decorative hardware. Red lacquer was particularly prized.

Beds consisted of a low platform that could be covered with soft padding for sleeping but that in daytime could be used as a seating area. In the colder climate of north China, such a bed was often built of brick, accommodating an arrangement under the platform for heating by a fire that could be tended from outside

the bed. In the south, carved screening might surround such a raised bed, creating a kind of room within a room.

JAPAN

Japanese design has exerted an influence on Western practice through several lines of contact. In the nineteenth century, Japanese prints became known in England and were admired by the artistically inclined who made up the Aesthetic movement that linked fine art with the Arts and Crafts Movement. The painting of James Abbott McNeill Whistler (1834–1903) has an obvious connection with Japanese art, while his Peacock Room (1876–77), now preserved at the Freer Gallery of Art, Washington, D.C., was clearly an effort to absorb Japanese traditions into Western design (see fig. 4.90). By the 1870s, Londoners could, and often did, acquire screens, boxes, ceramics, and other decorative objects from shops specializing in such imports. In France, Siegfried (later Samuel) Bing (1838–1905) was drawn into the fashionable interest in Japanese art and design stimulated by the Japanese exhibits at the Paris World's Fair of 1878. His Paris shop, called L'Art Nouveau, opened in 1895 and included Japanese imports among its offerings. The mixture of work from the European Art Nouveau movement with actual Japanese works shows a clear intention to absorb Japanese aesthetic concepts into Western design. Awareness of Japanese architecture and interior design was developed through such publications as Edward S. Morse's 1885 book *Japanese Homes and Their Surroundings*. With the coming of Modernism in the twentieth century in Europe and America, traditional Japanese design came to be regarded as predictive of the directions appropriate to current thinking.

4.91 Hand-painted Chinese wallpaper imported into Europe and America in the eighteenth century helped fuel the Western enthusiasm for Chinese art and design. This example is from Westbury House at Old Westbury Gardens, Old Westbury, New York. (Photograph: Zindman/Fremont) **4.92** The great delicacy and elegance of traditional Chinese furniture can be seen in this eighteenth-century chair, which combines straight lines and subtle curves. The Metropolitan Museum of Art, New York. Seymour Fund, 1967. **4.93** The main building of the Inner Shrine, Ise, in southwest Honshu, Mie prefecture, Japan, was first built in the early first century C.E. and, with only a few exceptions, has been reconstructed every twenty or twenty-one years since. The structure consists of a basic frame of wood posts, beams, and rafters enclosed by plain wood planks; the roof is of thatch. (Photograph: © Yoshio Watanabe, Tokyo)

← 4.93

Although the design and architecture of Japan has early links with Chinese sources, these influences came to Japan by way of Korea. Certain Shinto shrines—built to house the spirits of deities and supernatural beings of Japan's indigenous, pre-Buddhist religion—have been rebuilt at regular intervals for nearly 1,500 years. These replicate the originals in form and material, and they display the affinity for the natural world that characterizes so much of traditional Japanese design. Izumo shrine, first built before 550 C.E., survives in rebuilt form. It is a simple single interior space defined by wood posts resting on an elevated wood platform reached by a stair. A gabled roof extends out to the edge of the platform, forming a surrounding porch. Although the structure is symmetrical, the stair and entrance are not centered but placed in the right-hand half of the structure. The Inner Shrine at Ise, originally built in the late first century B.C.E. or early first century C.E. and rebuilt every twenty or twenty-one years since, is made up of several similar structures placed within a fenced enclosure (fig. 4.93).

The basic frame of wood posts, beams, and rafters is enclosed by plain wood planks set into grooves in the posts. With no applied decoration, the austere simplicity that characterizes so much of traditional Japanese design is clearly evident.

Beginning in the eighth century, shrines, temples, and pagodas were built in a style strongly influenced by Chinese practice. Roofs with curving profiles, upturned eaves, and multiple-level "stacked" roofs; bracketed-wood interior construction; and rich decoration came into use, with the result that many of these buildings are almost indistinguishable from Chinese buildings of the same period.

The concept of a wood frame supporting a sloping roof with all structure internally exposed and with a minimum of applied decoration came to be much admired by Western visitors to Japan and exerted considerable influence in the development of modern twentieth-century Western design. A typical Japanese house has a floor raised off the ground on posts bearing a pavilion-like area with regularly placed wood posts supporting a wooden roof structure. The plan layout is *modular*, with the basic *module* the dimensions of the tatami straw mats made in a uniform size—about three by six feet. Room areas are defined by the arrangement of mats, and room arrangement is often quite free and asymmetrical, creating linked pavilions with open courts and gardens interwoven with enclosed spaces. Most walls are sliding screen panels, or *shoji*, that make it possible to open up or divide interior space at will.

Zen Buddhism, with its ideas of simplicity, its respect for nature, and its emphasis on an aesthetic developed on the basis of a philosophy that might be called minimalist, was a strong influence in the development of Japanese design traditions. The ceremonial drinking of tea was honored in special rooms in houses, and in special teahouses, where a small hearth sunk in the floor served for heating water; there was no furniture.

Traditional Japanese practice, in fact, did not call for furniture to any significant degree. Cushions were placed on the floor for seating, and small charcoal heaters called *hibachi* provided portable heat. A fixed charcoal burner called a *kotatsu*, sunk into the floor and with a low raised top, was also used; cloth quilts

could be stretched over it and over the feet and legs of those sitting around it to gain warmth. A bed could be made up anywhere by placing soft pads on the floor mats. Small drawer chests, cabinets, and low tables were normally kept put away, to be brought out only as needed and then put away again, out of sight. A clear alcove called a *tokonoma* could hold a hanging scroll painting and flower arrangements set on a slightly raised floor platform. Other alcoves could include some shelves or built-in cabinets. Shoji screens were basic and geometric in decoration or bore more complex patterns. Portable folding screens, some richly embellished with landscape or other painted art, appeared frequently. Candleholders, lanterns, and lamps using oil and wicks provided nighttime illumination. A kitchen might be no more than an area surrounding an open hearth or a fireplace where cooking could be done with simple pots and utensils. Bathing called for great wood tubs, often with an integral arrangement for heating at the bottom. A latrine was a neatly edged floor opening serving a box placed below, accessible from outside.

The patterns of wood grid structure and sliding wood-and-paper shoji, along with the openness of plan and the absence of furniture, suggest a precursor of the qualities that were to develop in the Modernism of Europe and America in the twentieth century. Certain historic examples, such as the great Katsura Detached Palace complex at Kyōto (early seventeenth century), a vast and superbly refined example of the typical traditional house, have become the focus of interest for Western moderns who find in them a special order of perfection (figs. 4.94, 4.95).

It is clear from his later work that during his long stay in Japan, Frank Lloyd Wright became strongly influenced by the culture's traditional designs.

The flow of European influence into Japanese culture has tended to overwhelm aesthetic traditions and replace them with a somewhat diluted version of Western styles. The fact that the traditional architecture of Japan never placed great emphasis on comfort and convenience—never developing any practical system of heating, for example—has probably contributed to its decline. Some modern Japanese architects have moved toward an integration of some aspects of traditional work, such as its abstract visual forms, into modern practice using Western technology. Kenzo Tange (b. 1913) is the best-known representative of this direction, while Tadao Ando (b. 1941) and Arata Isozaki (b. 1931) have developed an international practice based on a fusion of the best of Eastern and Western traditions.

SOUTH ASIA

Buddhist, Jain, and Hindu religions generated the surviving buildings of early India and Pakistan. As early as the third century B.C.E., Jain structures were cut into rock, creating cavelike interior spaces. The Buddhist *stupa* is a dome-shaped monumental structure that can be as high as 300 or 400 feet. It is a solid mass with no significant interior space. Other stupas, like that at Karli in western India dating from 100–125 B.C.E., are interior spaces cut into rock (fig. 4.96). The sides are lined with closely spaced columnnar forms topped with elaborate sculptural elephants. At the innermost end, an apsidal shape surrounds a colos-

4.94 The Ko-shoin of the complex of buildings that comprise the seventeenth-century Katsura Detached Palace, KyŌto, Japan, is an example of traditional Japanese architectural design in its most perfected form. (Photograph: Okamato Shigeo) **4.95** The Katsura Detached Palace was built in the seventeenth century, when the tea ceremony was extremely popular. Many of its design features can be traced back to earlier teahouses. Sliding screens carry delicate paintings, while the tatami mats of the floor spell out the subtle geometry that stands behind the aesthetic impact of the uncluttered space. Shown here is the Pavilion of the Pine Lute. (Photograph: John Pile)

sal solid domed stupa. The arched form of the ceiling above is carved in imitation of timber structures no longer extant.

Hindu temples dating from the ninth and tenth centuries are composed of groupings of tower or dome forms densely covered with intricate sculpture. Interior spaces are low halls for music, dance, and other ritual purposes that are grouped at the base of the tower domes, which have only limited internal space. The Jain Dilwara temple complex at Mount Abu in northwest India includes a late (thirteenth-century) columned and domed hall with white marble columns and ceiling covered with a fantastic density of intricate carving (fig. 4.97).

Surviving secular buildings are of relatively recent date but appear to repeat ancient patterns. In the tightly built cities, houses are generally three or more stories in height with brick walls built up against adjacent buildings on both sides and at the rear. A central courtyard gives light to the rooms but is narrow enough to block direct sun penetration to the floor of the court. A ground level is usually open in plan with entrance, cooking, and storage areas. The upper levels, reached by stairs, will have rooms at front and back with latticed windows overlooking the court. Elaborate carving and colorful decoration are present according to the wealth of the owner. There is generally only minimal furniture; storage chests, mats, and quilts placed on the floor serve for sitting and sleeping. Larger houses group more rooms, often in irregular arrangements around the narrow central courtyard. Oriel windows and balconies often project from the street front, providing places where women may observe activities below while remaining invisible behind perforated screens.

Many of the most spectacular buildings in India were produced under Islamic rule, which began with invasions of North India in the early fourteenth century, and are discussed below.

THE ISLAMIC WORLD

The spread of Muslim religious belief, beginning with Muhammad's revelations of 610 to 620, carried with it architectural and design ideas that became varied as they developed in differing geographical regions. The text of the Koran and the common use of Arabic established a core of consistency in spite of the variety generated in the stretch from Moorish Spain across North Africa, the Middle East, and Turkey into India and what is now Pakistan. Indonesia is Islam's most populous country. With its vast reach in both time and geography, it is not surprising that Islamic design is so diverse as to make characterization difficult. Still, certain themes can be recognized. The mosque is the significant building type on which design effort has been focused. Although mosques differ greatly in concept, as a prayer hall the emphasis is always on interior space rather than external massing. The technology of building is concentrated on arch, vault, and dome construction in masonry, with arch forms including the pointed arch, the wider four-centered arch, and, particularly in Spain and Portugal, the horseshoe arch. The tall pointed forms of European Gothic design and the directional, lengthwise orientation of the Gothic church contrast with plans that are predominantly nondirectional, grouping repeated bay units in clusters that expand in all directions, with only certain internal elements oriented toward Mecca. Buttressing is not a significant visual

4.96 The great Chaitya Hall at Karli, Maharashtra, India (100–125 C.E.), is carved into native rock. The nave is a long, forty-five-foot-high chamber with side aisles defined by lines of columns, at the far end of which is the great Buddhist stupa. (Photograph courtesy Fine Arts Library, Harvard College Library) **4.97** The richly carved columns of the pillared hall (*mandapa*) of the thirteenth-century Jain Dilwara temple complex at Mount Abu, Rajasthan, India, support small domes to create a complex interior full of elaboration. (Photograph: R. K. Vaghela/Dinodia Photo Library)

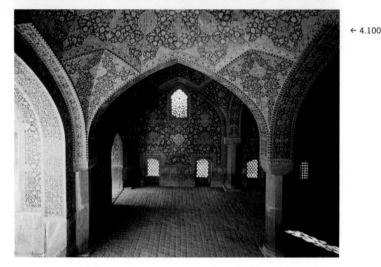

element, and great heights are rarely attempted except in minaret towers.

The Sunni rejection of the representation of living things—human, animal, and plant—encouraged the development of a vocabulary of abstract decoration, small in scale and rich in elaboration. Walls and arches were often built with alternate bands of stone in contrasting colors (most often red and white), and surface decoration in ceramic tiles and mosaics in bright and varied colors were common. The undersurfaces of arches and domes were often treated with many brackets and niches called *muqarnas* (or stalactites), forming a complex cellular surface. Although representational art was permitted in Shiite regions, building decoration remained generally abstract. The decorative use of Arabic calligraphy in Islamic art was of paramount importance. According to Muslim belief, Arabic is the language Allah chose for his revelations to Muhammad, and the Koran, to the Muslim, is the record of those revelations and contains the actual words of God. Calligraphy appears as a design element in all forms of Islamic art.

A mosque such as the Great Mosque at Damascus (706–15) is made up of an open courtyard with a vast adjacent arcaded prayer hall. The *mihrab*, a niche oriented toward Mecca, and the *minbar*, a pulpit for preaching, are the only elements that stand within a columned prayer hall. In Spain, the Great Mosque at Córdoba (786, with later additions) is made up of a court and another vast prayer hall with two tiers of arches resting on a huge number of columns (fig. 4.98). The lower arches are of the characteristic horseshoe form, while the upper semicircular arches are raised on square "stilts" that rest, in turn, on columns. The mihrab (962–66) is topped by a dome made from a complex grid of intersecting arches. Later mosques, such as that of Sultan Süleyman I at Istanbul (1550), have an open interior hall topped by a

high dome with half-domes on either end, a concept clearly based on such Byzantine structures as the church of Hagia Sophia, also in Istanbul (see fig. 4.13), which the Ottoman rulers converted into a mosque.

The palace called the Alhambra at Granada, Spain, of the thirteenth and fourteenth centuries, is a complex cluster of open courts with fountains and ponds and adjacent halls with columns supporting arches and domes, all elaborately and colorfully decorated (fig. 4.99). Although much Islamic design concentrates on interior space with minor concern for exterior form, tombs, especially those built in India, are well known for their external mass. The most famous of such buildings, the Taj Mahal (1630–53) at Agra, is made up of a central domed chamber surrounded by passages that link four smaller chambers at the corners of the symmetrical square plan. An upper dome rises to a height of almost 200 feet. Marble wall surfaces, both inside and out, are carved and ornamented with gold and color detail.

4.98 Converted to Christian use in 1236, the structure of the Great Mosque at Córdoba, Spain (begun 786), retains its Islamic character. A forest of columns support two tiers of arches in the sanctuary. (Photograph: Vittoriano Rastelli/CORBIS) **4.99** Decorative

tilework above the arches of the Court of the Lions, Alhambra, Granada, Spain, built in the 13th and 14th centuries, is characteristic of Moorish (Islamic) work in that country. (Photograph courtesy Spanish National Tourist Office)

4.100 Pointed arcades and vaults in the

Masjid-I Shah Courtyard at Isfahan. Mosaic tiles in rich colors cover the walls and surfaces of vaulting.

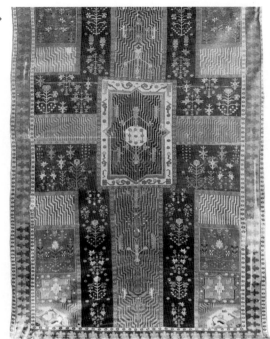

4.101 →

← 4.102

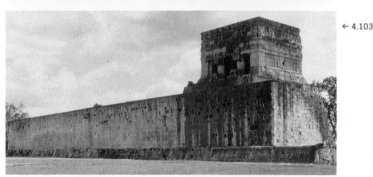

← 4.103

The characteristic arch, vault, and dome forms of Islamic architecture, and its rejection of representational forms in painting, sculpture, mosaic, and tile give it unique qualities different from most other Western architecture (fig. 4.100).

Islamic design has exerted influence on European practice through various exchanges. The Moorish invasions of southern Europe and the long presence of the Muslims in Spain exposed a wider population to a largely unknown culture. Further contacts with North African and Indian design resulted through the activities of colonialism, which reached a peak in the nineteenth century. The most direct link has turned out to be the carpets and rugs made in many Islamic regions; these products frequently exhibit the abstract forms of Islamic ornamentalism at their best. Rugs are readily transportable and have served to make this aspect of Islamic art a familiar element of interior design practice even up to the present day (fig. 4.101).

PRE-COLUMBIAN AMERICA

Although Native American design as it developed before the arrival of European colonizers is commonly known through such artifacts as rugs and pottery, these objects are generally viewed as isolated artworks to be collected or displayed, with little or no direct impact on the design of complete interiors. North American cultures either were nomadic or built with fugitive materials, so that scarcely any surviving interior spaces are available for study. In the southwest regions of North America,

Navajo, Hopi, and Zuni builders of adobe structures have left a somewhat more complete legacy of vernacular architectural forms, and here, too, interiors are of simple character, with portable artifacts the primary evidence of unique, creative achievement (fig. 4.102).

In Mexico as well as in Central and South America, the highly developed civilizations of the Toltec, Aztec, Mayan, and Inca populations created great cities that included monumental structures. The Spanish conquerors who devastated these cultures left only the great stone structures that were too massive to destroy or plunder, such as the temples at the Mayan site of Chichén Itzá dating from the fifth to thirteenth centuries. Almost none of these surviving monuments include significant interior space (fig. 4.103). Many pre-Columbian structures are covered with carved abstract and fantastic images that seem connected with religious beliefs, mythology, and magical concepts. The impact of this work on later design has thus far been minimal. Mayan or Aztec decorative detail is sometimes imitated in a superficial way to generate novelty in a theater or restaurant. The work of Frank Lloyd Wright in the 1920s (for example, in the Mrs. G. N. Millard House, the Storer Residence [see fig. 10.42], and the Ennis House in California) is sometimes related to Mayan themes; it seems more likely, however, that the use of patterned concrete block, a constructional system that Wright was experimenting with at the time, generated wall surfaces whose ornamental resemblance to Mayan precedent was purely fortuitous.

4.101 "Oriental" rugs have been popular elements in European and American interiors since the Renaissance. Pictured here is a portion of a Persian "garden rug" from Kurdistan dating 1700–1750. The Metropolitan Museum of Art, New York. Gift of James F. Ballard, 1922. The James F. Ballard Collection. **4.102** The simplicity and logic characteristic of pueblo architecture are suggestive of modern design. Photographed circa 1887–96, this cluster of houses at Taos Pueblo, New Mexico, is known as South House. (Photograph courtesy The Southwest Museum, Los Angeles) **4.103** The Mayan Upper Temple of the Jaguars at Chichén Itzá, Mexico (1000–1200), is typical of the monumental structures created by pre-Columbian civilizations. (Photograph: Jeffrey Jay Foxx, New York City)

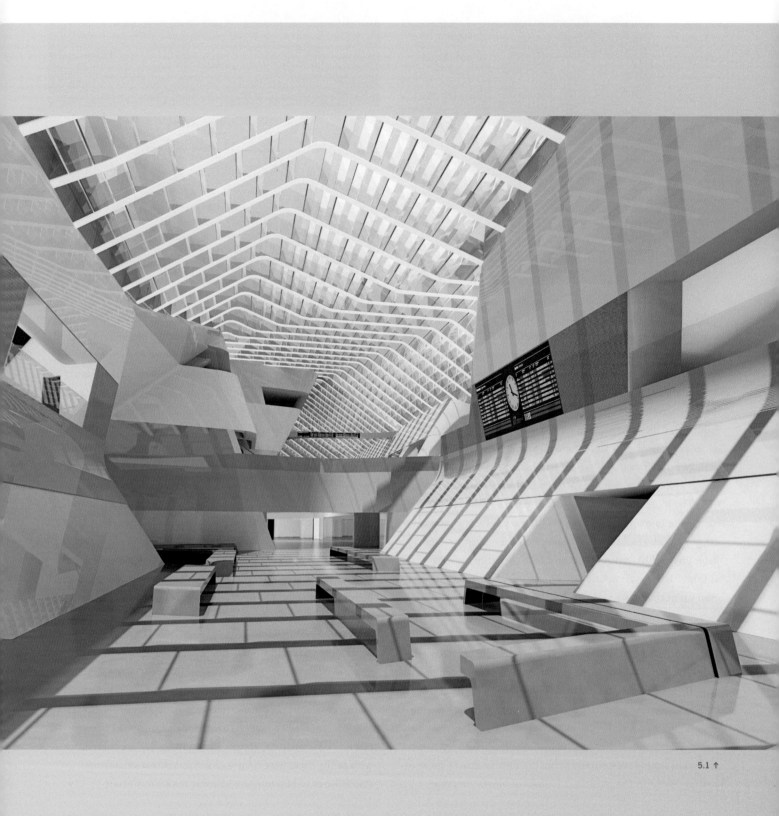

5.1 ↑

chapter five. The Design Process

When visiting an interior space or looking at photographs of completed projects (such as those in this book), it is often hard to imagine how the many elements present were brought together in an organized and pleasing totality. The ability to manage this process is one of the key skills of the interior designer, equal in importance to the aesthetic capability that determines the success of a project in visual terms. Until the nineteenth century, formal training for designers scarcely existed—designers were either trained by apprenticeship or entirely self-taught. The apprentice learned every step of the design process by working closely with a master, seeing actual projects through from beginning to end. The self-taught designer learned from experiment and mistake, with the mistakes often painful to designer and client alike.

In the mid-nineteenth century, design and architecture became subjects for formal training at the famous École des Beaux-Arts in Paris. The system of teaching devised there has, with minor modifications, become the method used in virtually all design schools. The "Beaux Arts method" is based on the simulation of an actual project as it might present itself in professional practice. A written *problem* is prepared, describing the specific requirements that a client might bring to a designer. All of the students in a class are given the problem and asked to develop a *solution* in a limited period of time, usually five or six weeks. Students work under the direction of an instructor or *critic*, who offers advice and suggestions as sketches are made and developed into formal presentations of finished drawings (and sometimes models as well), which

are then evaluated and graded by a *jury* of several professionals and instructors. The design problems assigned increase in complexity as the student advances.

This remarkably successful method of teaching is the basis for the skills of almost all currently practicing design professionals. It has, however, some obvious limitations. Each project begins with a written problem that must substitute for a relationship with an actual client. Although the space to be worked on may be real or imaginary, the student encounters it as a given condition, most often to be known solely through drawings. As the design is developed, there is no interaction with a real client; instead, the critic, a trained design professional, offers direction based on standards and attitudes that may be quite different from those of a lay client. While the completed project is presented in drawings similar to those that might be shown to a client, the reaction to it that is offered the student again comes from professionals and does not allow for the interaction, revision, and further development crucial to projects undertaken with bona fide clients.

The student project ends with the presentation and response. The steps that would be involved in moving forward to execution of the project, the details of construction, purchasing, supervision, and completion, are not experienced because there is no way to carry through these steps in the school setting. As a result, the graduating student is fully trained in a key stage of the design process yet has only general knowledge of the many steps that

5.1 A computer-generated image of the waiting room of the new Napoli-Afragola train station in Naples, Italy. (Courtesy Zaha Hadid)

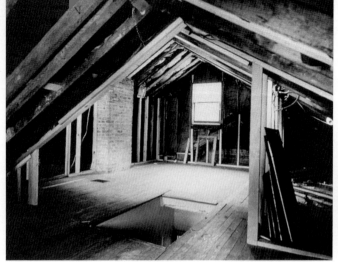

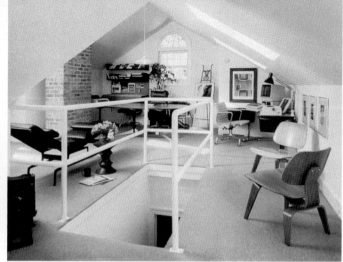

come before and after the central phase. Professional designers will usually admit that their formal training dealt with only a small part (perhaps no more than 10 to 25 percent) of the process that a real project involves. Learning about the remainder of the design process must then take place on the job, usually as an employee of a professional design firm. It is the *total* process of design projects, from beginning to completion and beyond, that is the subject of the following discussion.

Creativity in Design

All design work is, by nature, creative. It involves the development of something new, something that did not exist before. Even the smallest design projects, such as the selection of new colors for an existing room or the introduction of new furniture into an older space, are creative since they generate a new reality in an older location (figs. 5.2, 5.3). Major design projects demand a higher order of creativity if they are to rise above the routine and banal. Before moving into the steps that a design project must go through, let us explore briefly the ways in which an optimum level of creativity can be achieved.

For every human situation there are routine ways of acting that provide satisfactory results in conventional situations; it is not necessary, for example, to invent a new way of tying shoelaces or brushing teeth every day. Many design problems, in turn, can also be dealt with through routine—standard plans for houses, schools, medical offices, kitchens, and bathrooms abound. Yet a key difference between dull or mediocre design and work of real excellence is precisely the level of creative thinking that the designer has generated. Designers therefore must consider, for each project, where routine proposals will serve and where a creative approach can lead to better results.

When routine approaches dominate, a designer's work may be practical and may serve certain functional needs, but it will lack the spark that can push design work to a higher level of excellence and make a positive contribution to the lives of those who encounter it. For a designer, the excitement and satisfaction of producing outstanding work stem from the creative process.

There has been much discussion in recent years over the question of whether creativity can be learned. It is said that all human beings are born with creative abilities and that this can be recognized in the behavior of young children, who are typically highly inventive in their play, their speech, and when given the chance, their art. Unfortunately, much of education involves replacing such creativity with routines and rules. The three Rs, for example, specify correct ways to read words, form letters, and deal with arithmetic problems. Developing creativity can be considered largely a matter of rediscovering abilities that have been dormant since childhood.

Design schools have organized various courses, programs, and exercises intended to develop such abilities. Group brainstorming sessions, free sketching (sometimes called *empathic sketching*—that is, related to empathy with a particular problem), and encouragement of fantasy proposals are all techniques that can help to bring forth imaginative approaches to a given set of requirements. Our memories are stocked with images of work that is currently popular, avant-garde, or trendy, and it is easy to draw on such sources without realizing how much influence they are exerting. All designers by necessity draw on memory and on knowledge of what has already been done and proven successful. The goal is to make creative use of such knowledge without mindlessly repeating past or current routine practices.

Being creative, however, does not mean that every problem and every situation must have a totally new and radically adventurous approach. Inventiveness does not call for an effort to be

5.2, 5.3 A renovated attic in an older house greatly expands the house's useful space. An attic before (fig. 5.2) and after (fig. 5.3) conversion by Bill and Juanita Sharpe in their own home in Grand Rapids, Michigan. (Photograph: B. Sharpe, courtesy *Metropolitan Home*)

5.4 A hotel guest room designed with the intention of replication throughout the living space of the *mielparque* at the Nikko Kirifuri Resort, Nikko, Japan. The design is by Venturi, Scott Brown and Associates, architects. (Photograph: Kosuge, courtesy Venturi, Scott Brown and Associates)

← 5.4

different just to be different—that route too often leads to forced, eccentric, and pointless design. The objects that come to be regarded as classic gain that reputation because they have an excellence that bears up with much use over a long period of time. The effort to create design that has such classic excellence involves originality of a more subtle nature. It is a fortunate reality of interior design practice that, although the problems to be worked on fall into familiar patterns, no two problems are ever identical. When there are numbers of truly identical spaces—as in a hotel (fig. 5.4) or motel, for example—they constitute only one design problem. Even in this situation, rooms facing in different directions or at different floor levels may suggest a variety of designs. It is more usual to find that each project calls for new thinking. Each house, each apartment, each living room, and each office is in some way unique if only because its occupants have unique requirements. It is the discovery of the issues that are specific to a particular project that can become the starting point for a truly creative approach.

It is helpful to look for some element in any project that can serve as a springboard for imaginative thinking. It may be some aspect of the given space—its shape, structure, light, and view (or lack thereof), some special functional requirement, something about the character of the client, whether an individual or an organization—that can set off a line of thinking. Is the building old or new, handsome or unappealing? Is its structure visible and interesting; is there good daylight or none; are window views attractive or depressing? Is there something special about the intended occupants, their business, their organizational style, their tastes and interests? Noting such matters may lead to an intriguing approach to what at first may have seemed a routine problem. Might good light but an unattractive view lead to a new way to treat windows? Can the structural elements be made interesting and exciting, or should they be hidden in a clever way? Do the occupants have special interests, hobbies, collections, strong color preferences? If such matters are not simply

viewed as requirements (possibly troublesome requirements) to be dealt with but are instead exploited as a basis for an imaginative approach, creativity can be stimulated.

Rather than beginning a project with an effort to find a "solution," an acceptable plan, or an overall scheme, it is more useful to start with loose sketches, allowing free association to guide fantasy without strict concern for the practical realities of the client's needs. Letting the problem simmer, "sleeping on it," or otherwise leaving it in the back of the mind while dealing with other matters are all means to discover an approach that will be both original and realistic. The aim is to put aside the constraints that so often lead to routine approaches so that other possibilities have a chance to come forward.

Sequential Outline

Every interior design project must be taken through a number of working steps in a logical order. The size of the project and the designer-client relationship will determine what steps are necessary. The simplest of projects—a single room, perhaps with the designer as his or her own client—may hardly require any formal organization of work and may omit some steps that might seem overelaborate. Larger projects and projects that require client approval of design decisions call for more organization and systematization. The *flowchart* in figure 5.5 outlines the steps for such a project. In extensive projects involving many spaces and serving many people, orderly working methods are essential. They not only ensure efficient work processing, they also reassure corporate and institutional clients, who will certainly expect such methods.

One of the striking differences between the amateur interior designer and the skilled expert is that the amateur tends to approach the project without any work plan. Making decisions without reference to a clear sequential order leads to revisions and mistakes. The end result often looks makeshift and poorly planned.

Stage 1. PROJECT BEGINNINGS

Design Step	Communication Document
• Outline project scope	Report
• Outline time schedule and budget	Schedule, budget
• Select consultants	(letters)
• Plan designer-client relation	Contract or letter
• Schedule design work	Schedules
• Select space(s) to be dealt with	

Stage 2. PROGRAMMING

Design Step	Communication Document
• Research (background)	
• Obtain or prepare surveys	Plans, photographs
• Conduct interviews, collect data	Reports, lists
• Develop preliminary program	Written draft
• Review and revise program	
• Prepare final program	Written report
• Obtain client approval	Letter confirmation
• Develop space allocation	Lists, block diagram
• Prepare adjacency studies	Lists and charts
• Obtain client approval	Letter confirmation

Stage 3. CONCEPT DEVELOPMENT

Design Step	Communication Document
• Develop preliminary design*	Preliminary sketches
• Develop preliminary plan*	Plans and overlays
• Review with client	
• Revise preliminaries*	Revised design
• Obtain client approval	Letter confirmation

Stage 4. CONCEPT DEVELOPMENT

Design Step	Communication Document
• Make formal drawings*	Scale drawings
• Select materials*	Charts and samples
• Plan lighting (with consultant)	Reflected ceiling plan
• Select items for purchase:	
→ Furniture	List
→ Lighting	List
→ Other	List
• Select colors and finishes*	Charts and samples
• Estimate and refine costs*	Budget
• Make presentation to client*	Presentation
• Review budget with client	
• Make revisions as necessary	List
• Obtain client aproval	Letter confirmation

Stage 5. DESIGN IMPLEMENTATION

← 5.5

Design Step	Communication Document
• Prepare construction drawings	Working drawings
→ Structure	
→ Lighting	
→ Electrical	
→ Furniture	
• Prepare detail drawings	Detail drawings
• Prepare specifications	Specifications
• Gather final cost estimates	Written estimates
• Obtain bids	Written bids
• Make time schedules & issue work orders	Schedules
• Select contractors	Written contracts
• Prepare & issue purchase orders	Written orders

Stage 6. PROJECT SUPERVISOR

Design Step	Communication Document
• Supervise construction	Project report
• Coordinate work and deliveries	
• Supervise installation	
• List errors & defects	Lists
• Supervise correction	
• Supervise move-in	

Stage 7. POST COMPLETION

Design Step	Communication Document
• Make adjustments & changes	
• Prepare post move-in	Report

*Step included in a typical school design problem

5.5 A flowchart displays sequential steps of a major interior design project in graphic form. In all of the project stages, each step leads to the step that follows with a downward-pointing arrow. Revisions that may occur as part of the designer's thinking or that may be required after a client meeting are indicated by feedback loops with arrows pointing upward. Shaded items are not process steps but events that lead to legally significant documentation. An asterisk (*) indicates a step usually included as part of a design school project.

Some of the sequential steps common to many design projects may at times be omitted. Construction drawings may not be needed if there will be no new construction. Estimates and bids may not be involved when items to be purchased are few and of known price. Steps are sometimes combined—programming may include space allocation, for example—and steps are often overlapped in time sequence. Many projects present further complications when they comprise a number of units, each one of which is, in a sense, a separate design project. Various rooms of a building, for example, or floors of a multifloor project may call for individual design treatments and may be *phased* so as to progress on different time schedules.

Although many of the details in the steps mentioned above are discussed in greater detail elsewhere in this book, an overview of the entire design process as below can be beneficial.

Project Beginnings

ESTABLISHING CONTACT WITH CLIENT

Designers find clients in various ways, including reputation from previous projects, recommendations of satisfied clients, social contacts, and aggressive sales efforts. Designers and design firms are increasingly energetic in marketing efforts that include presentation of completed projects in publications—magazines and newspapers—and distribution of reprints of such publicity. Designer websites provide another means for reaching prospective clients. Offering interviews and giving talks (usually illustrated) to groups that may include possible clients are also means of making design services known to an appropriate audience.

The best situation is when a prospective client approaches a designer with a desire to assign a project. Many prospective clients contact several designers and ask them to present their method of work and examples of previous projects. The making of sketches or design proposals as a means of attracting a client is generally regarded as unethical. Ideally a degree of rapport and trust between designer and client-to-be should be established at the very beginning of a relationship.

OUTLINING SCOPE OF PROJECT

While it is the prospective client who must tell the designer what work is contemplated, the designer very often has an active role in helping the client define what is called for. Clients often have only a vague (or even mistaken) idea of what a project calls for and what possibilities exist. Discussion at this stage will form the basis for the next steps.

OUTLINING TIME SCHEDULE AND BUDGET

It is important that designer and client have a shared understanding of what is desired and what is possible in the important areas of time and money. Clients are frequently quite unrealistic in their expectations. It is generally unwise to accept goals that cannot be realized even if this seems to be necessary to obtain an assignment. Trouble will surface later if a client begins a project with expectations that seem certain to lead to disappointments.

DETERMINING NEED FOR SPECIALIZED CONSULTANTS

Most larger projects, and some smaller ones, call for the involvement of various professionals in addition to the interior designer. There may be an architect already enlisted before an interior designer is selected, or the services of an architect or engineer may be required to deal with aspects of the interior project. Consultants in the specialized fields of lighting, acoustics, and code compliance may be necessary as a project progresses. It is best to reach an understanding about how these services will be obtained and paid for at the beginning of a project. The relationship between interior designer and architect is particularly important—there must be mutual respect and a clear understanding about the areas of responsibility of each if a project is to proceed satisfactorily.

AGREEING ON DESIGNER-CLIENT CONTRACT RELATIONSHIP

Whether a standard form of contract or a simple letter of agreement is used, it is important to negotiate fees, schedule of payment, and other business matters at the beginning of a project. It is unwise to proceed with any further steps until an agreement has been reached and put into writing. Details of business issues are the subject of Chapter 18, "The Business of Interior Design"; client contracts are discussed beginning on page 561.

SCHEDULING DESIGN WORK

Scheduling is the responsibility of the designer together with whatever assistants or staff are to be employed. Target dates need to be set for beginning and ending each step, with an eye to meeting the expectations of the client. To be realistic, a schedule must consider not only the time the designer and staff will need to spend on the new project but also the time required by any other projects that may be in the works. Charts are often helpful in showing the relationship of steps that may overlap or be dependent on one another. Scheduling through the use of such sophisticated techniques as Project Evaluation and Review Technique (PERT) and Critical Path Method (CPM) can be of great assistance in large and complex projects.

In the PERT chart illustrated (fig. 5.6), numbers along the bottom of the chart indicate units of time (weeks, months, or for an actual project, calendar dates), while the horizontal bars represent estimated time for each step. Comparison of actual duration of each step with the planned time for completion provides a running check of compliance with schedule. Computer techniques for conducting such monitoring are available with printouts that indicate project status and warn of delays that require attention in order to bring the project back onto schedule.

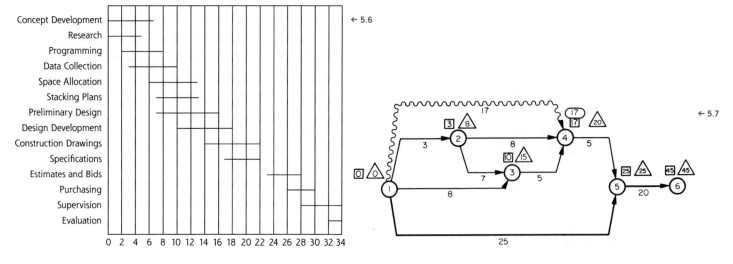

← 5.6

Concept Development
Research
Programming
Data Collection
Space Allocation
Stacking Plans
Preliminary Design
Design Development
Construction Drawings
Specifications
Estimates and Bids
Purchasing
Supervision
Evaluation

0 2 4 6 8 10 12 14 16 18 20 22 24 26 28 30 32 34

← 5.7

The illustrated CPM chart (fig. 5.7) is a very simple example of the systematic charting that is most useful for large and complex projects. The numbers in circles refer to a list giving a number to the beginning and end of each step. The number for the end of each step is also the number marking the beginning of the subsequent step. These numbered circles are called *nodes*. Above each node a number in a square indicates the total time elapsed in reaching that node by the route requiring least time. A number in a triangle above each node indicates the units of time available to reach that node along a noncritical path while still arriving at the end point at the time determined by the critical path. The difference between the number in a square a nd the number in a triangle is the so-called float, or extra time available that may be consumed before reaching the next node without delaying completion. Computer programs are available to manage scheduling using PERT and CPM and are almost essential in dealing with complex projects. ·

SELECTING SPACE(S) TO BE DEALT WITH

Selecting space is not a required step when the project is to deal with an existing space; many projects, however, begin before a space has been selected. A client who is about to rent an apartment, buy a house, or lease floors in an office building can often be helped to make a wise choice through the advice of a designer. Different possibilities may be more or less suitable to a client's needs and may involve greater or lesser costs in ways that will be more evident to the experienced designer than to the client. The selection of a particular space is, of course, a necessary step before more detailed design can begin. A more detailed discussion of this step appears in Chapter 6, "Planning."

Programming

RESEARCHING THE PROJECT

The usual first step in preparation for planning is to survey available information relating to the kind of project to be undertaken. This is particularly helpful if the project is of a kind that the designer has not previously dealt with or if it is of a highly specialized nature. It is hardly necessary to do background research in relation to such familiar material as the design of a residential space, but a retail shop, a restaurant, or a medical facility involve significant issues that go beyond the obvious. Even residential spaces may involve special requirements (for an elderly person or a person with a disability, for example) or may be intended to incorporate solar heating or an unusual facility for exercise, music, or some other activity. No designer can hold information on every possible issue in mind and keep up-to-date on an infinite number of changing materials and methods.

Research involves seeking out whatever books, technical reports, journal articles, and manufacturers' data may relate to a project. There are many good books devoted to the design of such specialized spaces as schools, hospitals, auditoriums, offices, and so on; other publications deal with such matters as barrier-free access, current lighting practices, and energy-conservation issues. A scan of relevant material and of recent magazine articles can lead the designer to a body of data relating to the project that will be fresh and readily available. Critical review of published reports of recent projects can suggest what other designers are doing in a given field, providing guidelines about what to consider and what to avoid. Visits to actual projects of a parallel nature can also be helpful. Before starting work on a hospital interior, for example, it may be useful to visit several recent hospital projects to observe their

5.6 A Project Evaluation and Review Technique (PERT) chart in bar (or Gantt) form shows the time required for the various steps of a project. Overlapping bars suggest that certain steps of the project may occur at the same time. Comparing the actual time for the completion of a step with the planned time shown in the PERT chart helps monitor the development of a project. **5.7** In this Critical Path Method (CPM) chart, lines represent activities or processes; circles, or nodes, represent the beginnings and ends of processes. Numbers indicate the duration of each step (in days or weeks). The critical path that gives the system its name is the route through the chart, from left to right, that adds up to the longest total time. This represents, therefore, the shortest possible time in which the project can be completed if each stage remains on schedule, and thus is the sequence most attentively monitored. The CPM chart also shows which other paths allow some leeway in time—the float, indicated by numbers in boxes—and are not critical. (From *Critical Path Method* by A. T. Armstrong-Wright)

successes (or limitations); on-site conversations with users can often bring out realities that are not apparent in articles and illustrations. Research can begin to make the designer an expert in a particular project type before undertaking actual design work.

OBTAINING OR PREPARING A SURVEY OF SPACE(S)

Architectural plans may be available for either an existing space or a space not yet constructed. It is necessary to check plans of existing space against the actual reality, since built space often does not comply with available plans as a result of changes made during construction or later alterations. If no plans for existing space are available, the designer must make a carefully measured survey so that drawings can be prepared. Even small projects that involve only furniture and color selection require accurate plans for intelligent design decisions. Taking photographs of existing space can make small details available visually, eliminating the need to revisit the space.

CONDUCTING INTERVIEWS AND COLLECTING DATA ON REQUIREMENTS

For simple projects, information on requirements can often be obtained from a client in some of the earlier meetings listed above. For complex projects it is usually necessary to interview many individuals, department heads, managers, workers, or typical users of the projected spaces to discover what detailed requirements may exist. It is particularly important to obtain sound information on users' needs. Unfortunately, actual users are often not consulted in developing this information. Managers and supervisors who believe they know the needs of those whom they supervise often give information that is extremely inaccurate, leading to design that proves to be unsatisfactory. In addition, the users of many projects are not available when design is under development. The patients of a hospital, the customers of a shop, the guests in a hotel will not be available until after the project is complete. Every effort should be made to interview some typical users of the projected design and to evaluate their stated needs carefully. Data collection is less of a problem in residential design because usually the client and user are one and the same. Data collection is discussed more fully on page 167.

DEVELOPING PRELIMINARY PROGRAM

Programming is a vital part of interior design work. A full discussion appears on pages 165–67. The preliminary program is a draft describing the general requirements of the project and listing the spaces called for, with their functions and specific needs. It is prepared as a basis for the next step.

REVIEWING PRELIMINARY PROGRAM WITH CLIENT

When the designer reviews the preliminary program with the client, the client has an opportunity to add or subtract information, make changes, and correct errors. If the client is a large organization, this review may be done by a committee or by a number of individuals who have detailed knowledge of particular parts of the project.

PREPARING FINAL PROGRAM

Any revisions required after the preceding step are made when the final program is prepared, so that the program becomes a "bible" to guide all further design work. Specialized consultants offer programming services independent of the work of a designer. Some clients may have commissioned such programming and may come to a designer with a complete project program already in hand. The final program should be stored in computer memory so that revisions can be made easily as new data become available. Because larger interior projects are developed over a long period of time (often years), requirements are likely to change while design work is in progress. It is important to record changes and keep records of when they are made to avoid confusion as the project continues.

OBTAINING PROGRAM APPROVAL FROM CLIENT

Confirmation of full agreement between designer and client regarding the program requirements must be secured before work progresses. In fact, client approval is necessary for any major step or group of steps in the design process.

DEVELOPING SPACE ALLOCATION

Allocating space may have been partially or completely included in the program described above. Many programs leave open the exact allocation of space. The assignment of space in terms of square-foot areas is detailed on page 167. A graphic chart or *block diagram* (see fig. 6.13) makes space allocations visually accessible.

PREPARING ADJACENCY STUDIES

Adjacency is a term used to describe the needs for closeness or distance between elements of a planning program. Spaces that must be close together have a high need for adjacency—that is to say, a need to be adjacent. A dining area and kitchen would be a typical example. Elements that may be remote from one another—such as a bedroom and a living room—have a low level of adjacency need. Drawing information from the program and possibly from additional survey data, the designer studies the relationship of spaces and charts them using matrix charts, link-value charts, and bubble diagrams (see figs. 6.14, 6.15).

Concept Development

Planning must begin with the development of *concept*—an overall view, or dominating idea, that sets apart the project under study from all others. A strong concept, an idea that can be summed up in a compact statement, is the basis for planning that will have strength and consistency. One route to design that will rise above

← 5.8

mediocrity is to search out an overriding concept, an idea, a theme that will guide thinking and bring all of the diverse parts of a design into a strong relationship. A guiding concept is not a program of detailed requirements; it is a statement of an overview—something that can be expressed in a sentence or two—written or sketched on the proverbial back of an envelope. Although the theme that guided design development may be difficult to identify in a finished project, it is invariably present in outstanding work. Students in design schools are painfully familiar with the teacher's question, "What is your concept here?" usually asked before the student can begin to describe the details that have come forward too soon and have made the proposed design a collection of unrelated elements, each perhaps valid at some level yet adding up to an indifferent scheme.

In much design that may strike us as mediocre or banal, it is a strong concept that is missing. The average retail shop, restaurant, medical office, motel, house, or apartment tends to be an assembly of routine elements selected in unrelated ways and brought together for strictly practical reasons. The resulting general impression is often unmemorable, sometimes even unpleasant. In contrast, every truly successful design project is based on an idea.

In the fine arts, it is relatively simple to identify the principles that underlie, for example, a Piet Mondrian painting, a Kurt Schwitters collage, or an Alexander Calder sculpture. The Chapel of Notre-Dame-du-Haut, Ronchamp, by Le Corbusier (see figs. 4.70, 4.71), I. M. Pei's pyramid at the Louvre, Paris (fig. 5.8), or the house that Charles and Ray Eames designed for themselves in California (fig. 5.9) are each also dominated by a concept that is recognized by any visitor, although verbal statements of such concepts may not be easy. And even when a design idea is expressed in words, interpretation remains flexible. One might describe the concept behind the Barcelona Pavilion of Ludwig Mies van der Rohe as "an open pavilion using abstract forms and rich materials," yet the built realization of that structure gives a highly specific and individualistic form to that concept (see fig. 4.67); another designer dealing with a different project might find a totally different way of realizing the identical theme.

The passage from idea to realization is usually best pursued through a series of drawings, often seemingly endless drawings of the sort that can be called *concept sketches*. Such sketches are concerned not with matters of detail but with a visual search for the ways in which a concept can be developed into a constructed reality. Most often plans, they may also be sections, elevations, perspectives, or any combination thereof. They may use color or a pasteup of torn bits in collage, or they may even be three-dimensional sketch models. All such sketching remains loose and highly abstract and may be quite meaningless to anyone other than the designer, who at this stage is primarily concerned with keeping

5.8 The Pyramid du Louvre, the glass pyramid designed in 1983 by architect I. M. Pei of Pei Cobb Freed & Partners to form a new entrance to the vast complex of the Musée de Louvre, Paris, generated extensive controversy when it was first proposed, raising questions about how it would relate to the ornate architecture of the famous building. When unveiled in 1988, however, it was clear that the architect's strong concept made the addition exceptionally successful—beautiful in itself but also an enhancement to the expansive court and its rich historical architecture. (Photograph: Owen Franken/Stock, Boston) **5.9** Charles and Ray Eames were the architects and designers for their home, built in 1949 on the Pacific Palisades near Venice, California. The use of standardized, industrially produced elements—such as the windows, doors, open-web steel-joist structure, and corrugated-steel roofing—forms the basis for a powerful design concept. (Photograph: © 1984 Henry Bowles, courtesy *House & Garden*)

Building Section Through Frankenstein

monitor screens with striking effect. Where the necessary computer equipment is not available, an alternative way to combine color scheme and design is to make a kind of color collage on the plan, pasting down swatches of actual materials or colored paper slips to furniture or other items pictured in the plan.

ESTIMATING COSTS

As decisions are made, their impact on costs can be determined. Preliminary estimates can be obtained from contractors on the basis of designs that are still subject to some revisions.

PREPARING FINAL DESIGN AND DETAILED BUDGET

With all of the decisions made in the preceding steps, final design can now be completed. Cost estimates can also be refined and incorporated into a detailed budget for presentation to the client.

MAKING PRESENTATION TO CLIENT

In design circles, the term *presentation* describes a formal showing of design proposals to a client for approval. Preparation may be a simple matter of collecting drawings and samples, or it may involve considerable special effort. Presentations must sometimes

(barring the lower two floors and penthouse). The entry to each apartment is organized freely about an island kitchen unit, which flows into a study/dining area. Both bedrooms, each with a bath, open off the gallery running along the central spine. **5.16** Cross-section of Sedgwick

Rd., Seattle, designed by Olson Sundberg Kundig Allen, Architects, completed 2005. Giant-wheeled partitions lie beneath steel roof trusses on the open-plan second floor. **5.17** Photograph of Sedgwick Rd., Seattle, designed by Olson Sundberg Kundig Allen, Architects, completed 2005.

Windowed wall panels are on wheeled bases, making it possible to create semi-enclosed spaces at will for any desired use. .

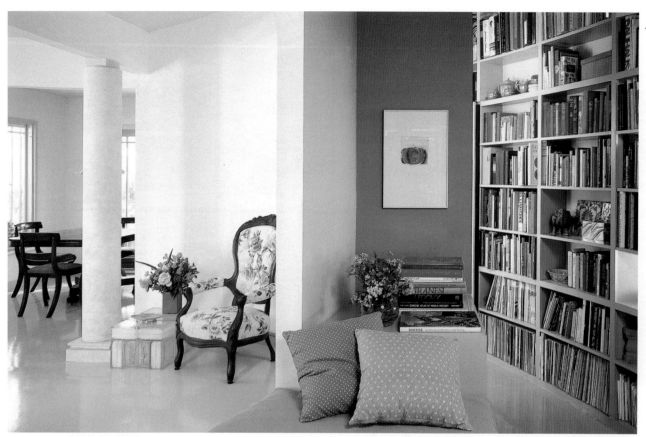

← 5.18

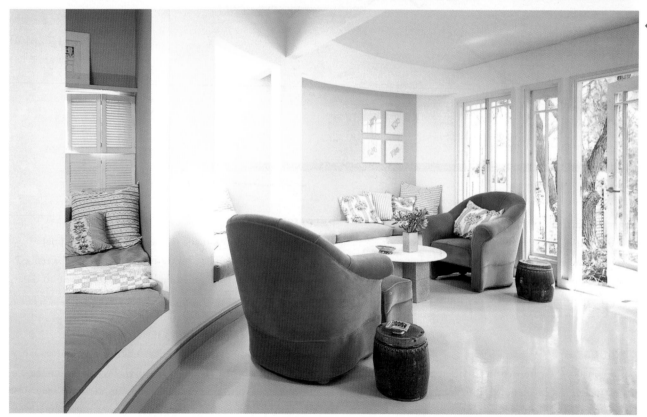

← 5.19

5.18, 5.19, 5.20, 5.21 In this interesting and complex space (figs. 5.18, 5.19), ingenious planning has provided for private and semipublic functions within a limited area. A floor plan (fig. 5.20) helps understanding of the design. Such plans are the designer's major tool. In figure 5.21, the same plan is axonometrically projected. This type of drawing enables professional—and nonprofessional—designers to picture three-dimensional relationships. The drawing is made to scale for the three axes—height, width, and depth—but with the width and depth drawn at a 45-degree angle to the horizontal. Comparing the plan, the axonometric projection, and photographs of the realized space, one can easily visualize the design and comprehend the concept behind it. Robert (Buzz) Yudell, architect, and Tina Beebe, color and materials designer, designed the space, in their own home in Santa Monica, California. (Photographs: © Henry Bowles, courtesy *House & Garden*)

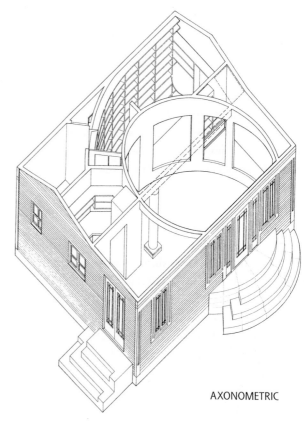

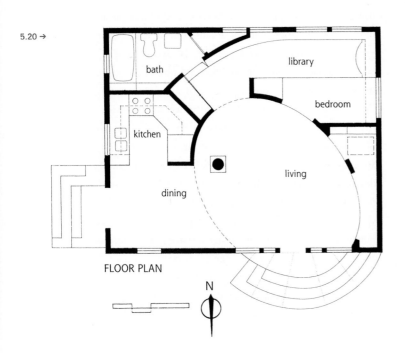

5.20 →

← 5.21

FLOOR PLAN

N

AXONOMETRIC

Drawings to Scale, Perspectives, and Axonometrics

DRAWINGS TO SCALE

In drawing to scale, whether by hand or on computer, a selected dimensional unit—for example, one-quarter inch—is chosen to represent one foot. Multiples and subdivisions of this unit are used to represent all the parts of the actual-size space being drawn. At ¼″ = 1′0″, the entire space is shown at one forty-eighth its actual size. The scales most used in interior design are ⅛″ = 1′0″ (for larger spaces or groups of spaces); ¼″ = 1′0″ (for rooms and smaller groups of rooms); ¾″, 1″, 1½″, and 3″ = 1′0″ (for details); and, sometimes, full size (1′0″ = 1′0″) for complex details and for some furniture drawings. Scale rulers, including the triangular architect's scale, are graduated in these scales and make it easy to lay out drawings in accurate scale dimensions. Construction drawings give actual numerical dimensions, however, since measuring off scale dimensions cannot be trusted to have enough accuracy for use in building.

Drawing to scale involves showing a subject by three different views that set out its three-dimensional reality on flat paper in a way that permits scale measurement of each view. This is known as *orthographic projection* because it treats the related views of an object as if they were on the same plane. The views most used to show architectural and interior subjects are the *plan, elevation,* and *section*. The *perspective* is also a popular view used to show architectural and interior subjects, but it is not drawn to scale.

Plan A plan is a view from above, looking down, as if a building, room, or rooms have been sliced through horizontally, revealing the floor levels and the parts of walls, furniture, and other elements that lie below normal eye level Also called *floor plans* or *ground plans,* plans are similar to maps and are familiar to everyone who has looked at guidebooks, real-estate brochures, and similar materials. In a plan, a space is drawn out to scale with lines representing walls, doors, windows, and columns in their proper relationships. (See Appendix 1, "Architectural Symbols.") A completed interior design plan includes furniture and any other significant elements drawn in their intended locations. The most vital of all architectural and interior drawings, plans usually come first and can convey almost all of the information about a project that needs to be drawn. A *reflected ceiling plan* shows any elements that will be present in the ceiling—typically lighting units and, possibly, air conditioning outlets.

Elevation The term *elevation* describes a view that shows one face (front, side, or rear) of its subject projected onto a vertical plane, as if the face had been transferred onto paper in scale (fig. 5.14B). Exterior elevations of a building resemble a picture of whatever face of the structure is shown. Interior elevations of rooms show one wall surface at a time in scale, usually with whatever furniture or other objects will be on or close to that wall.

Section Sectional drawings show an object, a space, or a building as if it had been sliced through to reveal internal spaces and construction (fig. 5.14C). Two kinds of sections are useful in interior drawings. The first discloses, in addition to the internal spaces and constructions, the hidden structure and materials within the thicknesses of the subject being sectioned (for example, the ducts and wiring placed between walls or above ceilings). A section of a window frame or a doorframe or a cabinet belongs to this category. The other type of section shows the hollow spaces of rooms within a building, making clear their shapes and relationships, without disclosing the composition of thickness. A variation of this type of section (sometimes called a *sectional elevation*) slices the structure so as to reveal the appearance of distant walls or any other elements that would be visible if the near or front wall were removed. Detail sections (often drawn at large scale) are particularly useful in showing how materials are to be put together in actual construction. (See Appendix 4, "Material Indications in Section.")

PERSPECTIVE DRAWINGS

A perspective drawing manipulates line on a two-dimensional surface to show three-dimensional space as it actually appears from a given viewpoint, with lines converging toward a point or points on a horizon and objects at a distance drawn smaller than those close up. Since it can give a virtually photographic view, perspective has become a favorite device in interior sketches and formal presentation drawings to indicate how a space will look when completed (figs. 5.15, 5.16). A fine-arts training usually includes some instruction in perspective, at least at the level of drawing observed space "by eye" as it is seen in perspective. To draw an unbuilt space in perspective, either from orthographic drawings or from imagination by hand or by computer, takes a special skill that is usually acquired only with some study and practice. A measured perspective can be as accurate as a photograph in depicting a space's actual appearance, and it offers the advantage of showing a space yet to be built—which, of course, a camera cannot do. Elaborate perspective renderings are usually made by specialists who devote all their time to this work. Most interior designers will find an ability to sketch and draw in perspective a valuable skill. Classroom work with a teacher and self-teaching from books are both possible ways to become proficient in perspective drawing.

AXONOMETRIC DRAWINGS

Axonometrics and the special type of axonometric called *isometric* are sometimes used in addition to or in place of perspectives. These employ a system of projection in which true scale dimensions are used for width, length, and height, with each running in a particular direction. No vanishing points are used so the effect is less realistic than in perspectives, but schematic understanding of spatial relationships can be made clear (fig. 5.21). Axonometric drawing systems are most often used to create views from above (bird's-eye views), which can show spaces with ceiling or roof removed to make an overview understandable.

be made to several groups or committees at different times. There may be a question-and-answer period of a formal sort, or more informal discussion may take place. The skill of the designer in verbal communication is an important part of any presentation. Many clients have trouble understanding drawings and rely on explanations offered in words. Notes should be taken on any suggestions or requests for revisions. If designer and client have a close working relationship, the presentation may be managed informally or omitted entirely. Corporate clients, accustomed to the presentations made by advertising agencies, generally expect a similar performance, including an element of salesmanship, from the designer. Drawings made as part of the design development stage are usually suitable for presentation. Some rendered color perspectives, possibly the work of a specialist, may be added (figs. 5.22, 5.23). Software programs are available by which the color scheme can be infinitely modified until it is exactly as designer and client wish (fig. 5.24). Color and material charts are usually carefully organized and assembled for showing. Large samples of actual materials, even examples of actual pieces of furniture, may also be shown.

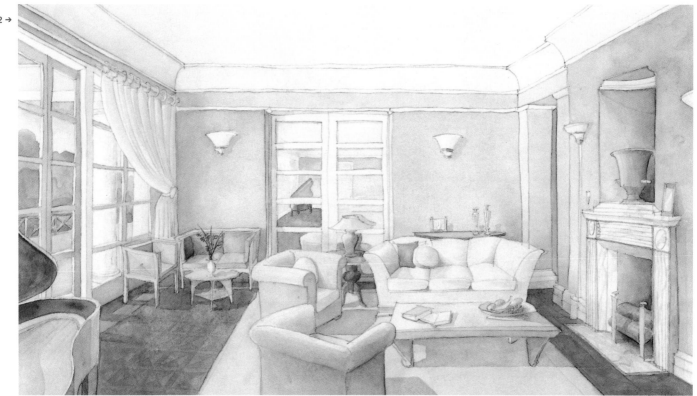

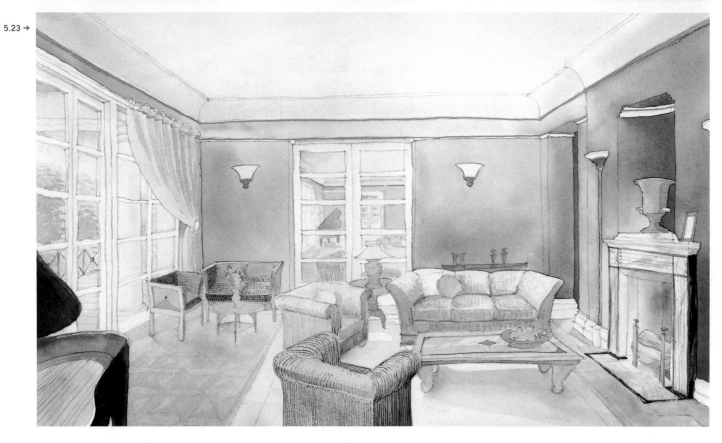

5.22, 5.23 Two watercolors illustrate alternative color schemes for a living room in Robert A. M. Stern Architects' Villa, New Jersey. The base sheet is a carefully constructed perspective drawing in pencil by Thomas A. Kligerman, the associate in charge of the project. The watercolor was then added by William T. Georgis, also of the Stern office. (Courtesy Robert A. M. Stern Architects)

← 5.24

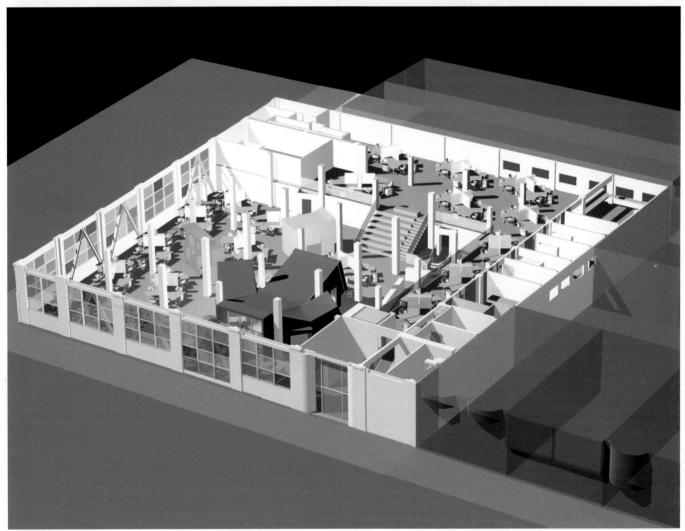

← 5.25

5.24 As demonstrated by this perspective produced with DesignCAD 3D, software developed by American Small Business Computers, computer-aided techniques can generate schematic images that simplify the design process. This luxury bathroom can be repeatedly modified on the computer screen until design, color, and details are exactly as the designer intends. (Photograph courtesy American Small Business Computers) **5.25** Model of West Office (advertising agency) interior, designed by Kirshenbaum, Bond and Partners, San Francisco, 2001. A scale model is one of the most convincing (and charming) ways to present a design, especially to clients with a limited understanding of drawings. **5.26** A model in cardboard and paper shows a grouping of custom-designed office furniture at a scale of 1″ = 1′0″. Model and design by John Pile for Cosco Office Furniture, Inc. (Photograph: John Pile) **5.27** The computer makes possible complex forms that would be extremely difficult or impossible to communicate by hand and is a powerful alternative to modelmaking,

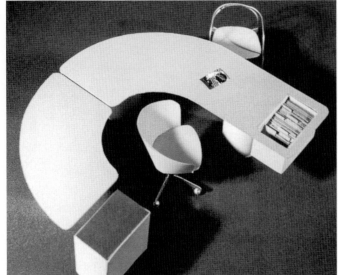

5.26 →

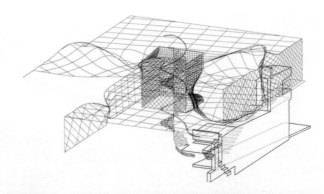

← 5.27A

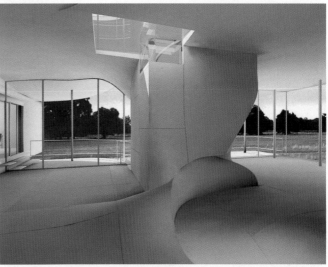

← 5.27B

Architects frequently use models as presentation elements; similarly, interior models can be effective presentation tools (figs. 5.25, 5.26). Although elaborate models can be very costly, they often prove the best means of putting across a design proposal. Some designers make their own models, others commission special model-making craftspeople.

An efficient alternative to model making is the computer generation of images that are very similar to photographs of completed spaces (figs. 5.27, 5.28, 5.29, 5.30, 5. 31, 5.32) A variety of perspectives taken from different positions and at different angles can be produced; programs are also available that permit simulated movement walk-throughs into and around spaces still under design development. Such virtual tours of planned interior space can be extremely impressive to clients—and indeed may be expected.

Designers have also continued to find it effective to make use of audiovisual techniques for presentation, particularly to groups that must approve larger projects. Slides, films, and videotapes all aid the viewer in understanding complex drawings and models. Photographs of models create an illusion of reality (and convey a certain charm, as well) that often helps to convince clients of a design proposal's success. The goal of a design presentation is securing approval to go ahead with the execution of the project.

REVIEWING BUDGET WITH CLIENT

Reviewing the budget with the client may be formally incorporated into a design presentation or it may more informally follow the presentation in response to the common question, "What will

all this cost?" It may also be the subject of a separate meeting following a generally successful presentation.

MAKING REVISIONS AS NECESSARY

Revisions may be requested even if a presentation has met with general approval. Concerns over budget frequently produce requests for changes that will reduce a total expenditure considered excessive.

OBTAINING CLIENT APPROVAL OF DESIGN AND BUDGET

It is important to obtain a clear and affirmative approval. Given that approval, possibly with some minor adjustments, the remaining steps can proceed.

Design Implementation

PREPARING CONSTRUCTION DRAWINGS

Working drawings, as they are often called (*blueprints* to laypeople), will be used first to obtain final cost figures and then by contractors

as demonstrated here. The computer-generated axonometric of the Torus House (fig. 5.27A), planned for construction in Old Chatham, New York, reveals the spatial relationships of the project, designed for two artists who needed separate sudios. The computer-

generated perspective image of the house interior (fig. 5.27B) projects the complex forms in virtual photographic reality. A series of such projections can give the effect of a walk-through. Preston Scott Cohen was the architect. (Courtesy Preston Scott Cohen)

5.28 →

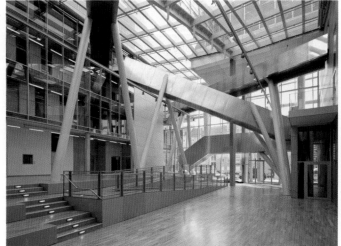

← 5.31

5.29 →

← 5.32

5.30 →

and workers constructing the project (figs. 5.33–5.36). Working drawings include scale plans, elevations, and sections, using notes and symbols together with large-scale details to spell out every particular of the work to be done. Written specifications give details of materials and methods of construction or production that drawings cannot fully show.

Interior design working drawings follow the general practice of architectural drafting; indeed, architectural and interior drawings are often combined. At this point, coordination between designer, architect, and engineer is vital to avoid duplication and conflict. At the same time, this cooperative effort extends to all the specialists involved—lighting, acoustical, and other consultants. Electrical and plumbing details and, occasionally, heating and air-conditioning details must also be coordinated. The interior designer must now prepare special charts of color chips and plans marked to show color locations for the painting contractor.

The way in which the project is to be contracted somewhat influences how complete the working drawings must be. If competitive bids are to be taken, drawings and specifications must be very complete and as precise as possible to ensure that all bidders will be figuring on an identical set of requirements, leaving nothing to the imagination. For example, the indication "wood" can refer to softwood, hardwood, plywood, or even *particleboard*. Only

5.28, 5.29 CAD and photograph of the Academy of Fine Arts, Munich, 1992/2002–2005, designed by Coop Himmelblau. The project was to expand the Academy of Fine Arts, originally built in 1876. The open configuration of buildings locked together produces a sequence of transitory spaces between the park and urban spaces: the glass facade as a media membrane, the gate to the Academy, the inner court, the studio terraces as the connecting link and gate to the park. Diagonal ramps and gangways connect the functional areas of the various parts of the building and thus the different departments. In this way, an energized complex is created, which corresponds ideally to the diversity of creative activity. The art school extension houses painting studios, sculpture studios, a media workshop, photography studios and a print workshop. **5.30, 5.31, 5.32** Plan, drawing, and photograph of the Schlesinger Library renovation, Radcliffe Institute for Advanced Study, Harvard University, designed by Venturi, Scott Brown and Associates, Inc., 2004. The architects

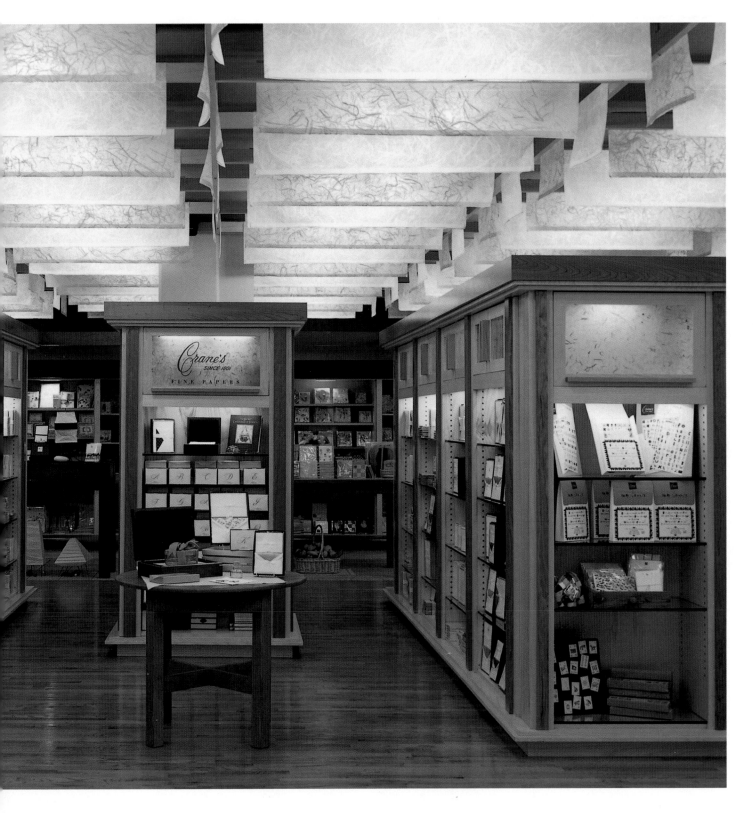

5.38 Of note in this general view of the interior of Kate's Paperie, New York, is the paper-shaded ceiling lighting used throughout the store, a witty reference to the paper products the store features. (Photograph: © Norman McGrath)

5.39 →

KATE'S PAPERIE

5.40 →

REFLECTED CEILING & LIGHTING PLAN
SCALE: 1/4"=1'-0"

LEGEND

	Poles supporting paper walls – see plan
	Halo H126 Drop Opal
	Lightolier lensed downlight, 26 watt electr 5096–CLW4–7226–H1120
	Special fluorescent fixtures per mock-up
	Halo H–4T Housing Abalite
	Alkco miniature troffer recessed fluoresce # G7248 type"G" 48"L x 5–3/4" w x 2
	Lightolier multipoint track– Matte white Lightolier Mini – swivel – 7610 Matte W 3 per track
	Alkco Twin inch #TW2106 – Translucent D 12–1/4"L x 7–7/8" W x 1–1/8"D mounted vertically
	pen display light fixture supplied by Dalco
	emergency light

KATE'S PAPERIE

Alfredo De Vido | Architects
412 East 85th Street/New York, New York 10028 Tel. 212 517–6100

REFLECTED CEILING & LIGHTING PLAN

Date: Apr. 98
Revisions: JULY 1, 1998, aug 6, 1998– A-4A
SCALE: 1/4"=1'-0"

5.39 A computer-aided drawing (CAD) of a base floor plan serves also as an electrical plan and shows placement of furniture and equipment along with electrical outlets that serve lighting in display cases. (Courtesy Alfredo De Vido) **5.40** A CAD-generated "layer" overlays the basic plan as a reflected ceiling plan to show lighting layout. (Courtesy Alfredo De Vido) **5.41** This portion of a working drawing sheet shows CAD-drafted details of the display fixtures. (Courtesy Alfredo De Vido) **5.42** The finished display fixtures as installed on-site have built-in pretzel-shaped fluorescent lighting. (Photograph: © Norman McGrath)

5.41 →

5.42 →

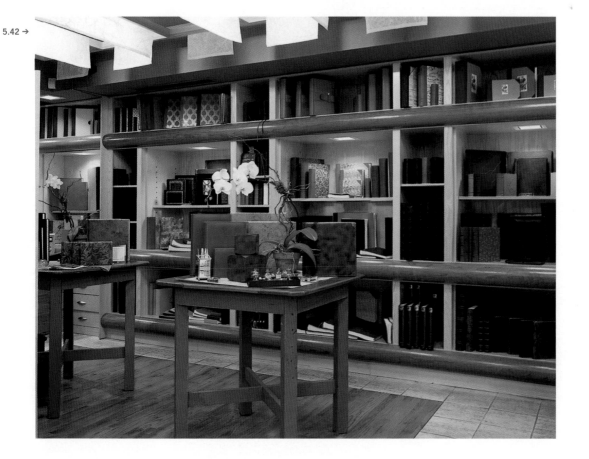

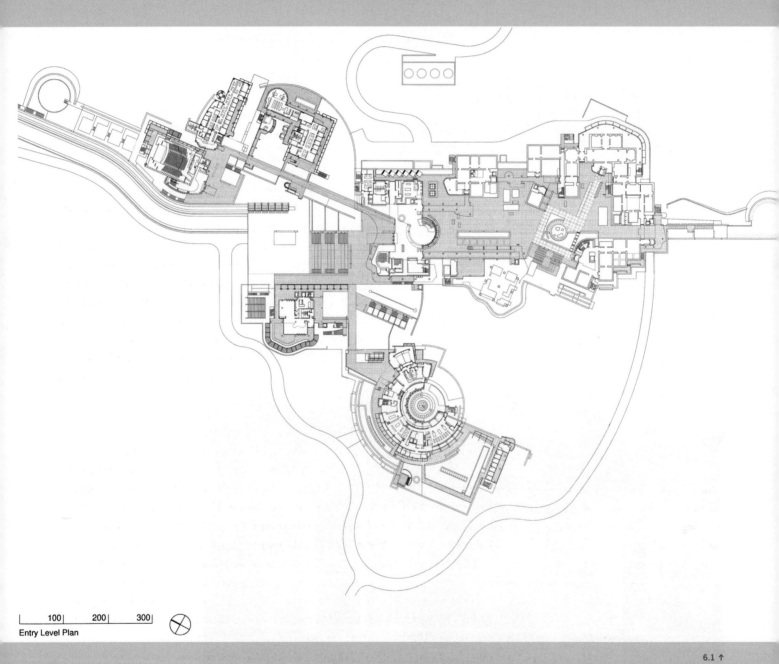

100 200 300 ⊕

Entry Level Plan

chapter six. Planning

Planning is a primary aspect of interior design. The very term *design* implies planning of a thoughtful and organized nature. Design professionals offer as one of their most important skills the ability to plan, creating spaces that will be practical and comfortable and will serve their intended purposes. Amateurs tend to use available furniture placed according to chance or habit and to rush into choices of new furniture, color, and materials without taking the time to plan methodically. Poor planning—or no planning at all—is probably the most common cause of disappointing interiors. While not as apparent as unsuccessful color or lighting, it is more fundamental to basic performance.

Preliminary Steps in Planning

Under some conditions one may begin planning freely on blank paper. However, most planning must take account of existing circumstances and other *constraints,* or limitations, such as building code requirements, that restrict what can be done. The interior designer is most often limited by the more or less fixed elements of architecture in the space. This obviously applies when the designer works with an existing space. (See Case Study 3, pages 186–89.) It also applies when architectural planning has been completed before interior design begins, even when the new construction will provide only an unpartitioned shell.

Ideally, interior design planning should begin along with the architectural planning of fixed elements. This is possible when the interior designer is part of the design process from the beginning. It can also occur when the given architectural space is open and clear, as in *lofts* and office space rented without preexisting partitions (fig. 6.2). Most houses and apartments are built from plans made before the owner or occupant, much less the interior designer, has any input. By having a house custom-built, the owner can influence the architect or builder and participate in the planning process and can also bring the interior designer into the process.

SELECTING SPACE

A designer can be very helpful before the planning process begins, when a client is looking for space—to rent an office in an office building, to rent or buy an apartment in an apartment house, or to purchase a house. The building or house may be existing or still unbuilt. A client will usually have in mind certain criteria, such as general location, size, and cost, but often finds it difficult to choose between alternatives or to evaluate an available possibility. A designer can bring a practiced eye to observe the potential strengths and weaknesses of an available space and offer disinterested advice about how well the given conditions will suit the client's requirements.

The first step is to spell out the client's requirements in a program. The term *program* in the world of architecture and

6.1 The Getty Center in Los Angeles, designed by Richard Meier & Partners Architects LLP, occupies a hilly site south of the Santa Monica Mountains. Buildings are organized along two ridges of the 110-acre site. An underground garage and a tram station reveal the public entrance to the site. The museum lobby offers views through the courtyard to gallery structures. The smaller pavilion buildings, connected by gardens, invite reflection and encourage an interplay between the interior and exterior. A 450-seat auditorium terminates the east elevation. Along the western ridge, the Getty Research Institute for the History of Art and the Humanities completes the site. The building consists of a million-volume library, study carrels, reading rooms, a small exhibition space and offices for staff. Throughout the complex, landscaping integrates the buildings into the topography with garden sequences extending beyond the enclosed volumes.

design describes a statement of objectives and requirements that is best written out to form what is sometimes called a *project brief* or *problem statement.* It is axiomatic that a good statement of a problem is basic to finding a good solution. Indeed, the solution to a problem may become almost self-evident once the problem is stated with clarity. Conversely, unclear objectives and uncertainty about requirements typically cause confusion and delays and, all too often, lead to disappointing and unsatisfactory final results.

The program lists, with as much precision as possible, these requirements: the kinds and numbers of spaces to be provided; the relationships of the spaces; any specific needs for equipment, storage, or special furniture; and other specific needs. After the space is selected, this program will form the basis for the new interior design. (Programming is discussed more fully on pages 165–67.)

Whether the designer accompanies the client on visits to different spaces or evaluates spaces, built or unbuilt, from plans, it is important for the designer to notice and call attention to such things as the following:

- *Window orientation in relation to light,* at various times of day and in various seasons: south orientation gives sunlight at all times of day, more in winter, less in summer; north provides the consistent but cool light artists value; east is bright in the early morning, less so later in the day; west offers strong light in the afternoon, often too much late in the day so that special window treatment is called for. These orientation issues may be modified by adjacent structures that obstruct light.
- *Outlook from window for good views or obstruction,* including the possibility of future obstruction.
- *Quality of plan layout,* including convenience of spatial shapes and locations. In house and apartment plans, awkward or wasteful spaces often appear. Note potential problems with noise and privacy. Check closets, baths, and kitchens for adequacy and quality of layout. In apartment, office, and loft buildings, check adequacy of elevators and stairs.
- *Possible noise problems,* from elevators or adjacent spaces or from out-of-doors. City street noise and aircraft noise are particularly problematic.
- *Elements that can or should be changed:* Can walls be added or removed and doors or windows added, eliminated, or changed to improve a space? If closets, kitchens, or baths require change or improvement, will this be possible?

Designers often note changes that will greatly improve a space at small cost. With an unbuilt structure, a change may be possible at no cost. On the other hand, some desirable changes may be very costly or even impossible. Removing a partition wall, for example, may be relatively easy, but removing a *bearing wall* or column that is part of a building's structure will be difficult and expensive, if not impossible. Changes that affect plumbing and duct work may be easy but will always be costly. They may also be very difficult or impossible where, for example, pipes come from below and continue upward into spaces occupied by other people, preventing the relocation of a bathroom or kitchen.

Legal restrictions relating to safety may rule out certain changes in layout. Window and door locations may be restricted by zoning that regulates exterior appearance. An owner might not permit some changes in rented space. All such issues are best explored before the final selection of a space.

In comparing spaces, the designer may notice that seemingly identical spaces are actually quite different. The same apartment plan, for example, may be better or worse on various floors of a building or with different orientations because of the difference in light and view. In an office building, two plans with the same area may differ in window size and location, in light and view, and in convenience of access from corridors and elevators. Identical houses on opposite sides of a street, because of their orientation, may differ greatly in terms of light, view, and privacy. Clients often fail to observe such factors, particularly when evaluating space from plans alone, and they can greatly benefit from intelligent design advice when making decisions that may be difficult, even frightening, and that often involve large sums of money.

6.2 This is the floor plan of a loft space provided by the rental agent who offered the apartment. The only fixed elements are the kitchen, bathroom, closets, and single central column. These, plus the locations of windows and door, are the design constraints. The final layout can be as open or as intricately subdivided as the new owners and their designer may decide. **6.3** Knowledgeable replanning was used to customize a space for a particular owner of a Manhattan apartment. The apartment as purchased is shown in the plan at left. As replanned (right), it now provides a two-bedroom suite, a luxury bath, and a living area for two teenagers (upper portion of plan); common rooms—kitchen, dining, and living area—near the entrance; and a bedroom, study, and luxury bath suite for the parents (lower portion of plan). A curving glass-block wall surrounds the large tub of the master bath, separating it from the living area. The designer was Bromley/Jacobson Architecture.

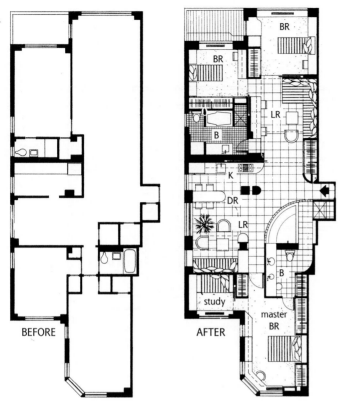

BEFORE AFTER

ANALYZING AND EVALUATING SPACE

Once a space has been selected (or if no selection is required, as when a space in current use is to be altered, renovated, or refurbished), the designer must analyze and evaluate every aspect of it. In this process, it is helpful to categorize elements or characteristics of the space:

- *Good or excellent elements*—probably the features that led to the selection or decision to keep the space—that should be retained, emphasized, and exploited in design development
- *Neutral qualities* that are satisfactory but offer no special merits or attraction
- *Problems and unsatisfactory features* that must be altered, eliminated, or at least neutralized or minimized

Such attractive features as good daylight or a fine view from windows are easy to recognize and should be exploited. Modern residential and office spaces tend to be largely neutral in character, with smooth floors, walls, and ceilings; windows and doors without ornamental detail; unobtrusive heating and air-conditioning outlets; and no fireplaces, molding, paneling, or other special details. Problems sometimes do not present themselves until planning begins—or even after moving in.

Spaces already divided into rooms usually cause more problems than open space. Since houses and apartments are laid out to suit an imagined "typical" occupant or family that may be quite different from the actual one, their plans may well be unsuitable to a particular occupant or have serious faults that would be troublesome under any circumstances.

Common problems include the following:

- Some or all of the rooms are too small. Kitchens and bathrooms are particularly likely to be inadequate.
- Rooms relate poorly to one another. For example, the dining room is not adjacent to the kitchen, or the bathroom is poorly placed.
- Rooms are badly shaped. They may be too long and narrow, have awkward notches or cutoff corners, or make furniture placement difficult.
- Corridors are long, narrow, dark, and unpleasant. This not only wastes space, it is usually inconvenient as well.
- Openings (doors and windows) are badly placed. For example, an entrance door opens directly into a major space, or openings are so placed that they take up wall space and make furniture layout difficult.
- Closets are inadequate, badly shaped, or poorly located.

Once such problems are recognized, it is possible to consider steps that will minimize or eliminate them (fig. 6.3). Moving a partition or removing it may improve a plan layout and alter room size. Doors can be relocated or blocked up. Some spaces can be enlarged by taking space away from adjacent areas. A dining room, for example, can often be eliminated and its space given partly to an enlarged kitchen and partly to adjacent living space.

At a more detailed level, poorly placed or awkwardly shaped windows can often be dealt with through drapery or blinds. The appearance of poorly shaped spaces can be improved through choice of wall colors and materials. Color and lighting (the subjects of Chapter 10 and 11, respectively) can make spaces seem larger or smaller, as desired. The size, character, and placement of furniture can help to minimize planning problems. Even a small kitchen or kitchenette can usually be made more workable with suitable choices of equipment and better layout. Corridors can often be improved through lighting and color and by using them for book storage or a gallery-like display of art.

Collecting all such information about existing conditions or other limitations constitutes the preliminary basis of planning (figs. 6.4, 6.5). The designer's main planning tool is a *scale plan* showing what exists or what is to be built, along with any other data about fixed elements. Such a plan may come from a real-estate firm or architects' drawings (see fig. 6.2). These plans can be used as a starting point, but an on-site check should be made to ensure their accuracy. Plans provided by real-estate agencies are often small in scale, unclear in details, and inaccurate, at least in minor ways (fig. 6.6). Building plans may not have been followed exactly or later changes may not be shown in the plan.

On-site with ruler and measuring tape, the designer (or an assistant) should check available plans, obtain heights of ceilings and openings that may not be shown in the plan, note any significant details, and, possibly, take some photographs for reference.

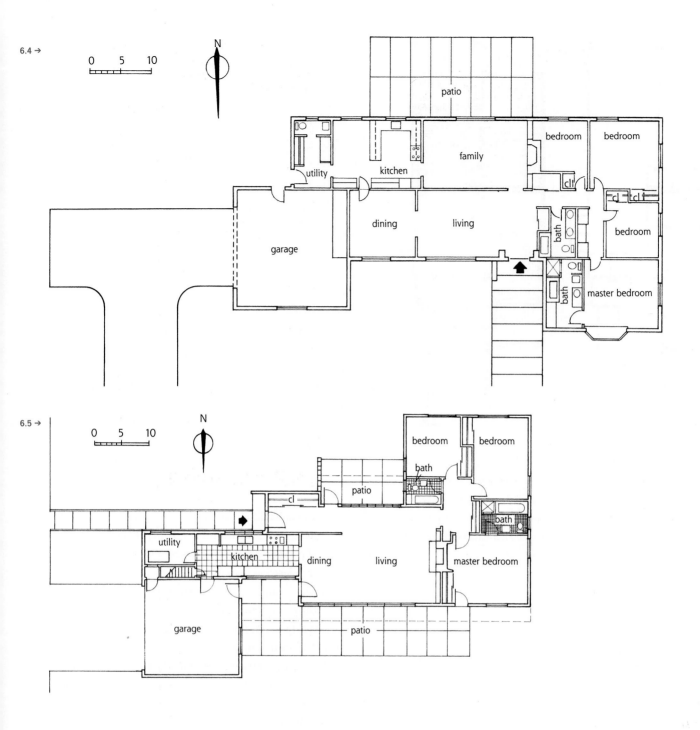

6.4 This plan of a suburban house contains a number of serious problems: several major rooms (family room, two bedrooms) and the patio face north—the least desirable orientation. Major rooms (living, dining, and master bedroom) face the street, resulting in limited privacy and less-than-ideal outdoor view. The prime southern orientation will usually be blocked by the window treatment required for privacy. The front door opens directly into the living room, with no vestibule or other transition. Access from the garage to utility and kitchen areas is only through outdoors, with no convenient access from the garage to the main living spaces. The living room contains the passage route to dining, kitchen, and family room. The traffic route to kitchen and patio goes through the family room, whose fireplace is close to the circulation path. Furniture arrangement in living and family rooms will be difficult because of traffic paths and architectural constraints. All rooms except the two corner bedrooms lack good cross-ventilation. All four bedrooms have a partition wall adjacent to another bedroom, resulting in the loss of acoustical privacy. Master bedroom closet space (in bath and hall) is poorly planned. The bay window of the master bedroom, apparently added for external effect, is poorly placed in relation to the interior. The master bath general layout and the shower placement are awkward. **6.5** This well-planned modern house displays the following desirable features: The major rooms (living room and master bedroom) face south. No major rooms face the street (on right). The main entrance is sheltered, opens into a vestibule, and is close to coat and general-storage closets. The garage has direct access to the kitchen and utility areas and easy access to the principal living space. The kitchen follows a logical corridor work-flow plan. The dining area has direct access to the kitchen and an open, natural relationship to the living space. The living area is not cut by a major traffic path. The living spaces and bedrooms all permit reasonable furniture layouts. All major rooms have good cross-ventilation. The second bath is accessible to all living spaces and to the smaller bedrooms. No two bedrooms share a partition wall or a wall with a living area, thus assuring good acoustical isolation and privacy. Enough closets are provided for each bedroom and for linens and general storage. At least two outdoor living spaces—patios or terraces—are provided. A good house plan should offer all, or most, of these advantages.

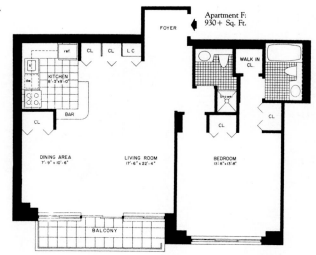

If no plans are available, the on-site job becomes larger, requiring careful measurement of the space in question so that accurate plans of existing conditions can be drawn up.

The task of *measuring up* an existing space is often the first assignment given to a junior designer. As a test of accuracy and thoroughness, it is good practice for any beginner. When only one or two rooms are being considered, this is a fairly simple matter. Plans of a whole house or larger building may take considerable time and effort to prepare, but it is vital to have accurate plans before starting design work. The usual procedure is to make a roughly drawn plan on a pad and note down complete dimensions (fig. 6.7). Back at the drafting board, these are drawn up to scale as a basis for further design work (fig. 6.8).

Planning the Space

Planning can now move to its primary task, the fitting of the project's requirements to the plan.

PROGRAMMING

If the *program* has not already been prepared in order to select space, it is prepared at this time (figs. 6.9, 6.10, 6.11). (Since the designer usually begins with an existing space to be redesigned, the program is most often prepared at this stage.) It may seem unnecessary to prepare a program for a small project (such as a living room, a kitchen, or an office), but requirements need to be specified, whatever the project size.

When work is being undertaken professionally for a client, a clear program must be developed to ensure that client and designer share a common point of view about their goals. This applies equally to individual clients and to corporations or other large organizations. In the latter case, where the designer must deal with and satisfy many people, clear lines of communication come even more important. A committee is always more difficult to deal with than an individual, and clarity of objectives is best determined through agreement on a written statement.

6.6 This apartment plan is typical of those offered in the advertisements of real-estate firms. A designer can help clients evaluate the plans of apartments that they are considering renting or purchasing. **6.7, 6.8** Rough, freehand field notes (fig.6.7) accompany the measuring that precedes the actual interior design. The data collected in the field notes are then organized into a neatly drafted plan drawn to scale (fig. 6.8). For a small area such as this, the usual scale would be ¼" = 1'0". The space is a compact, top-floor apartment in an 1830s Brooklyn, New York, brownstone.

← 6.9

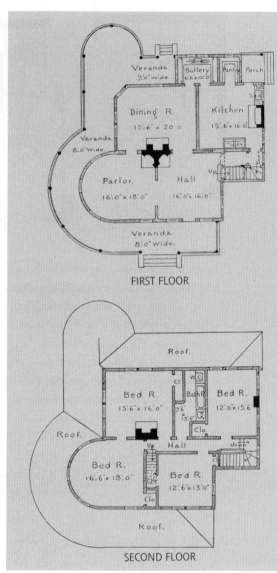

FIRST FLOOR

SECOND FLOOR

6.10 ↑

6.11 ↑

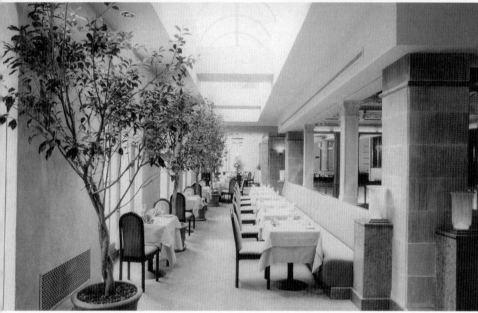

Designers typically begin programming by developing a general project statement. This may be no more than a sentence or two outlining the work to be done—its extent and purpose—in the most general terms. Designers usually follow this by a *survey* organized to collect complete specific details about the clients' requirements. Such a survey will ask such questions as the following: How many people are to be seated in a living room? Will there be books, a piano? Will the kitchen be used by one person or several? Will it be used to prepare only snacks or full dinners for a crowd? Is a dishwasher wanted? A microwave oven? A restaurant range? How is the office to be used? Does it need conference seating, files, a computer? Are there color preferences or other special

personal requirements to be taken into consideration? Even when designing for one's own use or for one's own family, it is helpful to note down all such data, in part because the process will raise questions that should be answered before planning begins.

For large, multifaceted projects, such as corporate offices, hospitals and other medical facilities, school and college buildings, and airport and other transportation facilities, programming of a highly organized sort becomes an important and complex need. Specialized consultants other than the interior designer are sometimes retained to develop a program even before a designer is hired. Other design organizations are prepared to develop complex programs using specialized personnel for that purpose.

6.9, 6.10 A mezzanine level in New York Barbizon Hotel served as a visitors' reception area from the 1930s to the 1950s (fig. 6.9). Today, the same space is mezzanine level of the hotel's restaurant" (fig. 6.10). As designed by Judith Stockman & Associates, interior

designers, with Milton Glaser as conceptual director, it has a fresh and modern feeling that replaces the older flavor of a bygone day. (Photograph of fig. 6.10: © Langdon Clay) **6.11** Older houses in sound condition often make good candidates for conversion—if the

projected result is cost-effective. Antiquated kitchens and baths and some room arrangements need replanning in order to adapt the spaces to modern life and to the new occupants' special needs. In this 1890s house, for example, a designer would provide a more modern

kitchen layout and additional and better bathroom facilities and better closets and other storage.

In projects accommodating a number of people, each must be interviewed to learn individual practical needs, habits of living and work, tastes, and personal preferences. For larger projects it may not be necessary or appropriate to interview every person involved. Department heads and a few representative individuals should be able to give data on behalf of the others. It is important to remember, however, that managers often have mistaken ideas about what their subordinates really need and want. Their information should be cross-checked by conducting some individual interviews.

In addition to ascertaining space and furniture requirements, it is important to collect data on activities and processes, asking such questions as the following: Where is privacy important, and where does interaction occur? Data may be recorded on a simple lined pad, on forms developed for the purpose, or on a laptop computer. It is wise to remind those interviewed that the designer cannot guarantee to satisfy every item on each wish list; compromises may be necessary to resolve conflicts and to accommodate budgets. Data must also be collected about general needs—for example, storage requirements and facilities for group use.

A printed form is often developed for data collection on larger projects. Data can then be entered into a computer so that a numerical count of spaces of a given type, equipment needs (how many files of a particular size, for example), and other information can be obtained as planning proceeds. Data collection will also usually include information on *adjacency* needs to help identify, for each person or each function, which other persons or functions need to be located nearby. Although it does not require a survey to know that a dining room should be close to the kitchen that will serve it, in office planning there is no way to know which people need to be near one another, who uses a conference area often and who does not, and which groups work together in teams unless this information has been collected through a survey. The uses to which this information can be put are discussed on pages 168–69. Some furniture manufacturers offer survey forms and a computerized data-collection service as aids to designers working on projects in which their furniture systems are to be specified (fig. 6.12). Use of a manufacturer's service has, of course, the disadvantage of making designer and client captive to that maker's products.

Any program is subject to question and to revision. Testing the program's validity is useful, especially when the designer was not the person who prepared the program. Items may have been included out of habit; questionable assumptions may have been made. Other elements may have been left out because no one thought about them. Such program testing can take place before planning begins and will often continue throughout the planning process. The designer must also evaluate the program's requirements and ensure that they do not lead to unwise plan-

ning. If they do, the issues should be discussed and the program revised.

With simple spaces, the preparation of the program can lead directly to designing (see page 171). In a simple project, the number of rooms and their uses probably have already been established. The designation of rooms as living room, bedroom, kitchen, and so on rarely comes into question. The designer must still decide whether to combine some rooms (separate living and dining rooms, for example), whether any rooms can or should be made larger or smaller, or whether some room uses should be changed (a bedroom to a study, or even a garage to a new living room), but such changes can usually be kept in mind quite easily. More complex projects, in which many spaces and functions need to be provided, call for several preliminary steps, including area assignment, block diagramming, adjacency studies, and stacking plans.

AREA ASSIGNMENT

Assigning areas involves estimating for each space—meaning each function or room or both—an approximate size expressed in square footage. Arriving at appropriate area assignments is partly a matter of common sense and experience and partly a matter of consulting various data handbooks that list commonly accepted area rules for various functions. (See Table 2, "Room Areas in Square Feet," page 168.) One can work out an appropriate area for a bedroom, for example, by evaluating similar rooms. The minimum size for a bathroom is found in many handbooks. Suggested sizes for offices of various sorts are often listed in tables. Areas for an auditorium, a conference room, or a restaurant can be calculated on the basis of the number of seats to be provided and the type of use.

Once footage has been estimated, a list of spaces and their proposed areas, with allowances for circulation spaces, storage, and so on, can be prepared, and the total area added up. The aim is to match the total area available fairly closely. If the mismatch is too great, area assignments may have to be adjusted or the available space reconsidered.

For larger projects that will occupy two or more floors, it is next necessary to assign each functional unit to a particular floor. This step is called *stacking,* meaning the preparation of a *stacking plan* or diagram. (Stacking is discussed in detail on pages 170–71.) For projects on one level, work can proceed to the following steps.

BLOCK DIAGRAMMING

Once area assignments have been made, each area is drawn to scale in the form of a block or a box of arbitrary shape, usually a convenient rectangle, unless a more special shape is called for by the function of the space. This is known as a *block diagram.* A requirement of 4,800 square feet, for example, is drawn as a block of 48 by 100 feet, or perhaps 40 by 120 feet, to scale. All of the blocks representing all of the required spaces make up a

Table 2.
Room Areas in Square Feet (Typical)

ROOM	SMALL	AVERAGE	LARGE
RESIDENTIAL:			
Living room (or space)	150	400	800
Dining room (or space)	75	250	400
Kitchen	50	125	450
Bedroom (master)	120	200	500
Bathroom	30	60	200
OFFICE:			
Executive	250	350	600
Managerial	100	200	250
General office staff	55	100	120
Clerical (minimum)	50	80	100
Circulation space (as percent of total)	10%	15%	25%
HOSPITAL ROOM	75	90	125
HOTEL/MOTEL ROOM	100	175	400
AUDITORIUM (per person)	6	7.5	9
RESTAURANT (per person)	7	12	24
ELEVATOR	20	55	120
GARAGE (one passenger car)	150	200	250

chart that gives a clear usual idea of how the space requirements relate in size.

ADJACENCY STUDIES

Adjacent means side by side or adjoining. In interior design, the term has been extended to describe a full range of relationships from close to far apart. Rather than describing adjacency needs terms of yards or feet, the designer usually makes a scale that gives simple numbers or letters to different levels of closeness.

Such a scale might be:

1	=	Adjoining
2	=	Near
3	=	Medium distant
4	=	Far
5	=	No contact

The designer next makes a chart showing all of the spaces to be planned, arranged as in a map mileage chart so that a blank is shown for each relationship of one space to another. This is called a *matrix chart*.

For example, a house or apartment made up of

LR	=	Living space
DR	=	Dining area
K	=	Kitchen
BR 1	=	Bedroom 1
BR 2	=	Bedroom 2
B	=	Bathroom

would be charted thus:

	B	BR 2	BR 1	K	DR
LR					
DR					
K					
BR 1					
BR 2					

As the designer decides the suitable level of closeness between each pair of spaces, she or he assigns it a corresponding number from the scale and places it in the appropriate box of the chart.

The chart above might be completed in this way:

	B	BR 2	BR 1	K	DR
LR	4	4	5	4	2
DR	4	5	5	1	
K	4	5	5		
BR 1	1	3			
BR 2	2				

6.12 This programming questionnaire was administered to collect data for the design of a large corporate office facility. (Courtesy J. F. N. Associates) **6.13** A matrix chart shows the desired relationships among the spaces of the block diagram. **6.14** This is an adjacency diagram, preparatory to discussion and review with the client. The house plan in figure 6.5 is derived from this diagram.

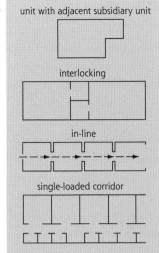

unit with adjacent subsidiary unit

interlocking

in-line

single-loaded corridor

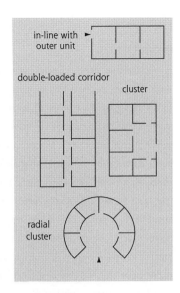

in-line with outer unit

double-loaded corridor

cluster

radial cluster

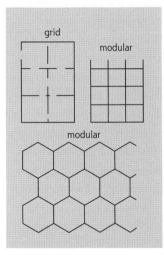

grid

modular

modular

overlapping grids

free

above, freehand sketches may be made on any medium and may include floor plans, sections, elevations, or perspectives. Preliminary design can also develop mentally, without any drawing, but such design thinking can be hard to hold in memory, and it is often misleading in the way it relates to real spatial limitations. Design ideas are best put on paper or entered on the computer as soon as possible so that they can be looked at, compared, and saved as design progresses.

Exactly how the planner arrives at a completed design is difficult to describe. It seems to involve a special talent for visualizing geometric possibilities. The planner looks at the space available and at the information about needs embodied in block diagrams and adjacency charts and derives from this a rough solution, which is sketched out on paper or on the computer (figs. 6.17, 6.18). Then the first proposal is evaluated and improvements suggested. This leads to a next proposal, and a next, and so forth, until a plan emerges that seems to resolve the space allocation problem.

In real situations, this process is modified by any number of pressures that contend with one another for dominance. What elements will be given locations with good daylight and view? What spaces must be close to the point of arrival? How are the conflicting needs of residents, visitors, workers, and other identifiable groups

to be reconciled? These concerns, while typical of large and complex problems, come up in small projects as well. How large should the kitchen be when every foot allocated to it must be taken away from some other space? Is an extra bathroom worth its cost in space and in money? If necessary, rooms can be combined and doors can be moved, closed up, or cut out, but are such steps worth their cost and complication? The planner must consider all these issues while developing a basic plan assigning space locations, sizes, and purposes and positioning walls and openings to achieve a completed project that works well and is visually satisfying.

PLAN TYPES

Although any conceivable arrangement of spaces may be considered in developing usable plans, it is often helpful to consider some typical ways of grouping spaces. A plan may be based on one of these arrangements, may use different types in different areas, or may use combinations of types within a particular grouping. The units making up a plan may be rooms, spaces more or less open to one another, or functional units within an entirely open space (fig. 6.19).

Arrangements in frequent use include the following:

- *Unit with adjacent subsidiary unit.* Typical examples include a living room with adjacent dining area, a dining area with adjacent kitchen or kitchenette, a bedroom with connected bath or dressing area, and an office with adjacent lavatory or storage area. Smaller subsidiary spaces can often be placed in an inter-locking arrangement that works well for rows of hotel, motel, or hospital patient rooms.

- *In-line (linear) bands of spaces.* A line of rooms each opening into the next is a frequent arrangement of the galleries of a museum or for an exhibition where visitors are to follow a planned circulation path. An in-line arrangement with a parallel corridor is typical for rows of offices and hotel or hospital rooms. Rooms with adjacent subsidiary units are most often placed in line with parallel circulation.

- *Single-loaded corridors* have the spaces they serve on one side only, often with services on the other side.

- *Double-loaded corridors* serve rows of in-line spaces on both sides. Double loading is space efficient since one corridor serves two rows of space but, where daylight is desired for the primary spaces, is possible only within a building unit of the appropriate width.

- *In-line inner and outer units.* Units placed in line may be made up of an outer space that must be passed through to reach an inner space, a common arrangement for private offices accessible only through an outer secretarial space, waiting space, or both.

- *Clusters.* Spaces grouped around a common area that may serve for access or another significant function are called *cluster arrangements*. Private offices are often grouped around a central clerical space. Work that involves team cooperation is well

served by cluster arrangements that may be made up of bands of in-line units around a shared space or may be in a radial relationship around a compact center. A radial grouping may take circular form, but it can also be developed in straight-line patterns. A cluster may be open to other spaces on one side or may be entered through a circulation path. An entire floor plan may take a cluster form, as in a museum where galleries open off a court or an atrium. The cluster arrangement was the basis of the typical ancient Greek and Roman courtyard house plan, as well as of some similar modern houses.

- *Grid plans.* This organizational form packs spaces together in patterns that involve groupings of either similarly or variously shaped areas. Museum or gallery plans that offer visitors free or flexible circulation are often of this type. When openings between elements of a grid are limited, a grid plan can generate complex and confusing patterns of circulation. An irregular grid of various spaces packed together with irregularly placed openings can become a labyrinth of complexity. A grid, used as a basis for controlling the plan, does not need to be apparent in the finished design. It helps to establish the placement of elements, but the grid lines need not be visible in any actual constructed or placed realities. An almost totally open space may still be the result of planning on a grid.
- *Modular planning.* The use of a grid of regular geometric elements, such as squares or rectangles, can create a unit or *module* to be repeated throughout a design in a way that creates rhythmic order. Modular planning is a basis for organization greatly favored in architectural design. Structural design tends to call for repeated identical units (*bays*) that are economical to construct and that establish an orderly basis for planning. On a modular grid, spaces may be laid out in any of the arrangements discussed above, with elements of the plan falling on the modular lines or relating to them (at half, third, or fifth points, for example). Elements may also depart from the module in some positions while still maintaining a relationship to its pattern.
- *Overlapping grids.* A means of introducing complexity and enrichment to plans that have a regular module, overlapping grids can offer subtle variations on the geometry of a simple grid without total abandonment of a geometric basis.
- *Open, or "free" plans.* Elements are placed within a space that may be totally unobstructed or that may be based on a structural grid that is unobtrusive. Such classic Modernist plans as that of the Barcelona Pavilion of Mies van der Rohe (see fig. 4.67) place *screen walls* within an open area in a way that modulates space without enclosure or obvious pattern. The modulating elements may be set in rectilinear patterns (as in the Barcelona Pavilion) or in more irregular geometric or free relationships. Open plans are often adopted for gallery or exhibition spaces and are the cornerstone of open, or "landscape," office planning.

CIRCULATION

A matter that needs special attention in planning, *circulation* is an aspect of any layout. People using a built space do not stay fixed in unchanging locations. They move about, and the ease and convenience of their movement have a very strong impact on the sense of comfort that a space provides. When moving from one place to another, a simple and direct route feels better than a roundabout and awkward path. Squeezing through narrow openings and bumping into furniture when moving about is unpleasant and irritating. The more frequently a line of movement will be followed, the more important it is that the route be direct and ample. A space that will hold a number of people needs routes of movement that interfere with each other as little as possible and that have generous paths. A space serving few people allows a more minimal passage that will serve one person at a time.

An *overlay circulation diagram* aids the planner in resolving circulation patterns (fig. 6.20). In this chart, lines are drawn to show the paths of movement that will be followed most frequently. The planner may vary the line thickness to indicate frequency of movement or the number of people expected to follow each path. A circulation diagram makes it easy to spot problems. A good circulation pattern will show short, direct routes, particularly for the most used paths. A problematic pattern will generate a complex and confused circulation diagram, with winding and contorted paths passing through bottleneck points of constriction. When using a built space, one does not ordinarily think about circulation patterns as an abstract concept, but the success of circulation planning will make itself felt in the space's sense of ease and comfort, as compared with other spaces that arouse annoyance and discomfort.

Circulation patterns can be described as falling into a number of types that can be used alone or in various combinations. They interact with space-plan arrangements to generate, ideally, plans at organize spaces well and provide logical access and movement.

Typical circulation patterns include the following:

- *Straight-line.* The most common pattern is a direct route from an access point to destination(s) at an end, on one or both sides of the line of movement. Its end may be an exit or alternative access point. Although the line may not actually be straight—it may turn corners or curve—the movement remains along a single route.
- *Line with branches.* This elaboration of the linear pattern offers alternative paths that branch off or fan out to give access to various possible destinations.
- *Radiating circulation.* Here alternative paths move out from a central access point.
- *Ring circulation.* A circular path moves through the spaces it serves and returns to a starting point. It provides two alternative paths to any destination and can provide access or exit at two or more points. It has special value where safety regulations require two exit routes.

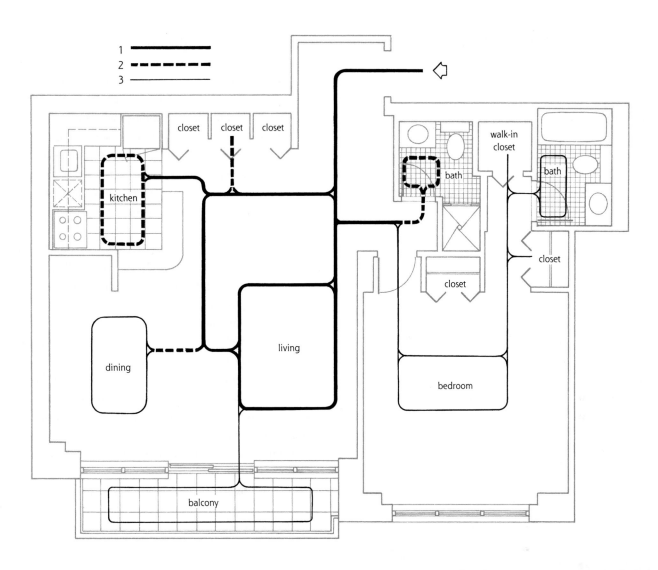

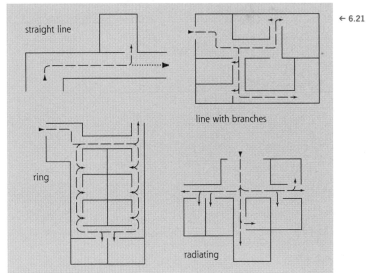

Circulation patterns within a single space also need study. In planning any room it is useful to make a diagram of the way in which movement can take place from any access point to any destination. Are the available routes direct; do furniture groupings obstruct movement; will circulation routes cut through furniture groups in a way that will be inconvenient to those moving about or disturbing to those using any group? A plan with diagrammatic lines tracing usual paths of movement is the best test of circulation patterns (fig. 6.21). All lines of circulation should ideally be direct, as short as possible, visually obvious, and independent of other cross-traffic lines of circulation, as well as free of conflict with functional groupings that call for cohesion.

In any planning, spaces located at a dead end, where circulation is brought to a stop by the absence of any further possible destination, have a special value. They imply privacy and a sense

6.20 A circulation diagram drawn over a plan often helps to evaluate the plan's practicality and can serve for the design of the furniture layout as well. This plan of a rental apartment was provided by a real-estate firm. The projected normal circulation has been diagrammed clearly and neatly, with varied line weights (thicknesses) indicating the anticipated level of traffic along each path. A poorly planned layout, by contrast, exhibits a confused and tangled circulation pattern with many points of overlapping cross-traffic. **6.21** The dotted lines on these plan layouts represent typical circulation patterns.

Table 3. Furniture Planning Checklist

USING SPACE
- Normally
- Maximum

NUMBER TO BE SEATED
- Upright
- Lounge
- Reclining

TABLES
- Low
- Work
- Conference
- Dining
- To seat (number)
 - Normally
 - Maximum

DESKS OR OTHER WORK SURFACES
- Size (s)

STORAGE NEEDS
- Clothing
 - Hanging
 - Folded
- Books
- CDs, tapes, DVDs, records
- Dishes, silver, other tableware
- Other

SPECIAL EQUIPMENT AND STORAGE
- TV, VCR, CD and DVD player, sound system
- Film/TV projection system
- Music (instruments, music stand, printed music, etc.)
- Bar and serving needs
- Files
- Telephones
- Computer equipment
- Other

BEDS
- Single
- Double
- Queen
- King
- Convertible
- Other

BATHROOM
- Toilet
- Sink
- Bathtub
- Shower
- Bidet
- Vanity
- Linen storage

KITCHEN
- Refrigerator
- Freezer
- Range
- Sink
- Dishwasher
- Work counters
- Dry food, equipment, and utensil storage
- Table
- Chairs or stools

LAUNDRY
- Washer
- Dryer
- Storage
- Table

OTHER REQUIREMENTS
- Display
- Artworks
- Hobbies
- Plants
- Workshop
- Miscellaneous

of arrival and offer a feeling of repose or containment. A private office, a residential bedroom, or a private dining room can all provide this special quality. It is often noted that people at a party tend to move toward such dead-end spaces and group there, sometimes at the expense of crowding, even when other more generous spaces are available. It is not uncommon to find a crush of people in a kitchen, for example, while the dining and living spaces are quite empty. The feeling of arrival at a destination seems to have an attraction that is lacking in a space that is also a circulation route to other spaces beyond.

FURNITURE LAYOUT

Furniture layout, a form of detailed planning, usually follows more general space planning, but it is wise to have furniture placement in mind while planning spaces. Most people can come up with examples of rooms almost impossible to furnish because of their basic plan: the bedroom with no wall broad enough to permit placement of a bed; the living room with so many doors and windows that furniture has no place to rest. When an interior design project involves a room or rooms that are not to be changed, planning begins with furniture layout. Wherever it fits in the sequence of planning, furniture layout must follow a pattern comparable to that of space planning.

The first step is to list the furniture required. The designer returns to the program to learn what activities are to take place in the space in question and then decides what furniture clusters will serve those activities. Many other questions arise: What are the needs for storage or for the display of objects? Are there existing pieces of furniture (a treasured antique, perhaps, or a favorite chair or sofa) to be retained? Will any or all existing pieces be appropriate to the new space? Will new built-in units be best for dealing with some furniture needs, such as placement of books, TV, VCR, DVD, and sound equipment, and kitchen utensils? How many people will use a particular space and how many will need to be seated, both in normal situations and on special occasions? All such questions need to be explored in an effort to arrive at furniture planning decisions that will serve user needs at the best possible levels of satisfaction. A short checklist, such as that shown in Table 3, "Furniture Planning Checklist," left, will often prove useful.

In completing such a checklist, additional details about sizes and any other specifics that may be significant should be noted. While many entries may seem obvious, it is surprising how often a methodical review of such a list will reveal needs not previously recognized. Like the program and earlier charts, this is another tool to clarify the client's needs and desires and the designer's approach. Using it can avoid future problems and misunderstandings.

With a list of furniture requirements in hand (or in mind), the designer can place the necessary pieces on the floor plan in drawing or on a computer screen. The guiding basis or placement must be an understanding of the activities being provided for and a consideration of people's movement into and

around the space. The program will list these activities, both everyday and special.

When drawing furniture in plan, it is important to use correct sizes, properly scaled. With practice, it becomes easy to draw furniture to scale without measuring or consulting catalogs for dimensions, but developing this skill takes some effort. Templates with cutouts to scale representing commonly used furniture types in typical shapes and sizes are available for various spaces (home, office, kitchen, and bathroom). While some furniture types are nearly consistent in size (chairs, sofas of given capacity, beds, file cabinets), others vary greatly. Tables and office desks come in a range of sizes and in various shapes. Even pianos range from up-right to concert grand.

Exact sizes of existing furniture can be obtained by measurement, while sizes of new furniture are given in manufacturers' catalogs and price lists. A chart of sizes drawn to scale, such as the one provided in Appendix 2, "Furniture Symbols," can be photostatted to any desired scale and kept at hand to aid in drawing. It is sometimes suggested to amateur home decorators that they cut out pieces of paper or cardboard, possibly color-coded, at scale sizes to represent furniture. These can then be moved about on a plan, represent furniture. These can then be moved about on a plan, representing different arrangements. Computer programs can provide similar possibilities. Experienced designers prefer to work with drawing directly, regarding cutouts as an unnecessary planning aid.

FURNITURE ARRANGEMENT

Placement of furniture needs to be influenced by anticipated patterns of circulation. Diagramming plans the probable movements of people, making use of furniture and space. It will suggest the need for clearances and avoidance of awkward blockages. Seating must consider space for legs and feet, and avoidance of corner placements where people seated at right angles find their knees in conflict.

The concept of *proximity,* the relationship of closeness or distance, is of particular importance in planning furniture placement. Users of furniture will have personal needs to be close to or far from others. People seated in order to have a conversation need to be close enough to make hearing and observation of facial expressions easy. A typical living-room seating group calls for this kind of proximity. In a public space such as a hotel lobby, however, individuals or small related groups will prefer to be at a considerable distance from strangers. Members of a group sharing

← 6.22

a meal will want to be close, but excessive closeness in a public dining space can interfere with a sense of privacy. Crowding of some degree has come to be accepted in city restaurants, where the resulting noise level is thought to compensate for a degree of proximity that would otherwise be unacceptable.

Residential Spaces The following notes offer some suggestions for furniture planning for the most frequently encountered residential space functions.

- *Living area.* The living area varies widely, from the formal parlor-like space used only for an occasional ceremonial event to the all-purpose space of a studio apartment. In almost every case, the primary uses will call for a furniture grouping suitable to conversation and various types of entertaining (fig. 6.22). Conversation demands seating that will accommodate an adequate number of people arranged at suitable distances and in comfortable configurations. A sofa on one side of a room and chairs far away on the other side make communication awkward. Distances between 4 and 10 feet are most comfortable for normal conversation. A primary seating group for four to six people is the normal core, usually arranged around a low coffee or cocktail table. Larger numbers of people tend to break up into separate groups. Movable seating works best in such situations.

6.22 Frank O. Gehry was the architect for a renovation of his own 1930s-vintage clapboard house in Santa Monica, California. The living area is organized in a conversation grouping, but books, telephone, and stereo equipment are also at hand. Note the open framing and the seemingly unfinished studs and joists that give the space an almost improvisational quality, typical of Gehry's work. (Photograph: Tim Street-Porter)

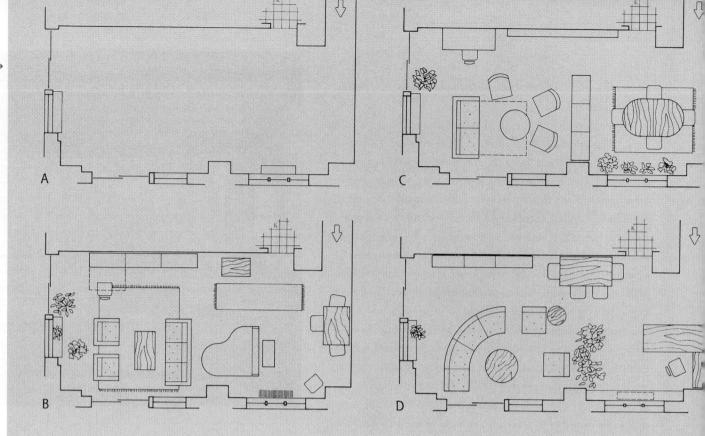

6.23 →

The same seating will probably serve for music listening and television watching, for one person or several, making the location of the audio equipment and TV screen controls important. A fireplace, even if it is rarely used, becomes an important focal element. During the third quarter of the twentieth century, the television had come to replace the traditional fireplace as a focus of attention in the living space. However, it is now common to relegate the TV to a special viewing area, perhaps in another room, or to conceal it when not in use. Windows with an attractive view offer an alternative focal point. In any case, windows will probably influence furniture layout according to their placement and the amount and intensity of light they admit.

Many living areas are expected to serve secondary functions as well, for example, as library, office, study, music room, or guest sleeping room (fig. 6.23). The combined living-dining room demands furniture for the dining function, often a minimal everyday provision that can be expanded for an occasional larger gathering, which leaves more space for the living area's other functions, such as entertaining large numbers of people. Circulation is of special importance at large gatherings, especially if there will be buffet service of food and drink. If normal furniture place-

ment does not allow easy movement, an alternate arrangement should be planned for such occasions (fig. 6.23 E–F).

- *Dining area.* Whether located in a separate room or in an alcove or other part of a general living space, dining spaces call for a table of suitable size to meet the range from minimum to maximum number of diners to be seated with the appropriate number of chairs available. It is particularly important to leave sufficient space around the table for chairs to be pushed back for access and for serving. Table shape—rectangular, square, oval, or round—strongly influences the degree of formality that will be associated with dining. Circles and squares, having no obvious head or foot, favor informality, while rectangles and ovals are the norm for formal dining. In the larger or more formal dining room, a *buffet, sideboard,* or other extra serving surface and provision for storage of dishes and serving pieces may be considered.

- *Family room.* Family rooms—or media rooms (fig. 6.24), recreation rooms, or playrooms—have become common in larger houses, particularly for families with young or teenage children. Such an extra room permits the living room to retain some formality and relieves it of an excess of multiple functions, as well as giving children their own social space. The

6.23 This series of furniture plans shows the same living-dining area planned in several ways. **A.** This plan shows the unfurnished space; the entrance is at the upper right, indicated by an arrow; the kitchen access (labeled K) is close to the entrance. Two sets of sliding doors

(upper right and lower left) lead to two different terraces. **B.** The dining table at far right can be opened up to seat as many as six. In the living area, the seating group is placed to relate both to windows and views and to the unit along the upper wall that houses a music

system, a bar, and a small drop-front desk. The piano is an obvious visual focal point. **C.** A room divider is used in this plan to create a separate dining area. The table will seat two to six as placed and can be extended to seat eight. The convertible sofa is situated so as to be

opened easily to become a guest bed. There is a large desk or worktable along the upper wall, as well as a long shelf upon which to display art. **D.** In this plan, primary lounge seating is imagined as a curved sectional group with related chairs. The wall unit and dining table

ture: to omit a separate dining room, for example, or make do with existing furniture, in order to provide a spacious living room, an all-new kitchen, or a valuable oriental rug. Ultimately, such decisions rest with the owners, clients, and users, but the designer can aid the decision making by articulating the choices and by proposing one or more solutions, often in plan form.

At another level, all design involves making choices that imply points of view about what is important and what is not. Although owner, user, or client can contribute to many such decisions, the designer must accept responsibility for making a vast number of small decisions in which the values to be taken into consideration are hardly major enough to be thought about as separate issues. When the sofa is placed here or there, a few inches forward or back, the decision implies some view about the relative importance given to the ways in which the sofa and the space around it are to be used. Every plan is based on innumerable decisions of this sort, and the plan's success reflects the quality of such decisions.

Evaluating the Plan

Effective planning is aided by another special skill that all designers need to develop. This is the ability to visualize in three dimensions what is being drawn out in plan, to imagine a completed space, even though the details have not yet been considered, and to live in that space in the imagination. This skill can be practiced when looking at plans published in books and magazines or plans drawn by others. One can imagine oneself a tiny person existing at the scale of the drawing and enter the space. When actually planning, each proposal can be tested by this kind of mental visit to the place that exists, at this point, only on paper. The aim is to make of the mind something like a motion picture or television camera that makes it possible to see—and to feel and sense in every way—what the built space will be like. In this kind of mental visit to the unbuilt space, the designer can enter, look about, move along the various possible lines of circulation, turn right and left, stop, perhaps even sit down where some real occupant of the space might do so. This permits the designer to make a running evaluation of appearance, convenience, and practicality. "How would I like to be here, move thus, sit in this location?" These questions and their answers form a critique of the sketched plan.

In making such a mental visit to a proposed space, a number of points call for special attention. It should become habitual to check these issues as a plan is being drawn, even to consider them when planning ideas are just forming in the mind. Computer programs are available that permit a virtual visit to a space, aiding evaluation of many of the issues discussed here.

Not every issue will apply to every project, but the following are the more important:

- *Entering the space.* The moment of arrival in a space, the transition from being outside to being inside a house (fig. 6.28), an apartment, a suite of offices, or a room, is always significant. First impressions are, traditionally, of major importance, and repeated arrivals at the same location only intensify the impression. How does the arriving person move? What does that person see? How are the practicalities (removing coat, placing packages, umbrella, and so on) dealt with? In a home, the impact of the entry is mostly visual and spatial. Everyone knows a house where the front door bursts into the midst of a living space or where there is no convenient place to hang coats. A public space such as an office, shop, or restaurant may require a reception control point, waiting space, or directory information to aid orientation. A cramped waiting room with a tiny wicket window guarding a receptionist is an all too familiar and depressing introduction to many professional offices. A handsome, spacious, and suitably furnished reception area suggests, in contrast, a well-organized and confidence-inspiring organization.

- *Moving into destination space.* This is the next step of experiencing a space. Are there halls, corridors, stairs, elevators, lobbies, doorways to be passed through? How will they look and feel to a first-time visitor, to a regular visitor or user, to a resident or owner? Going down a long, narrow, twisting hall is not the best introduction to a living room, classroom, office, or guest room. While familiarity can blunt the impact, an unpleasant access still leaves a negative impression. Passing through a low, narrow, or dim transition space can be offset by arriving at a large, bright destination space, the contrast heightening the favorable experience of arrival. Most often, direct, simple, and open access, with its implications of ease and welcome, is best (fig. 6.29).

- *Arrival at objective and activity provision there.* In a living room, where and how does the arriving person greet others or find a place to sit or stand? What is seen as one looks about? Comparable questions can be asked of a dining location, a bedroom, an office, or a shop. Is it possible to move about comfortably? Does the space offer different situations to suit different times, people, moods?

- *Utility spaces.* Kitchens, bathrooms, workshops, and other such spaces need to be planned to make the activities that go on in them as efficient as possible. How easy is the movement in these spaces? Do they offer a sequence of satisfactory visual impressions? Too often, a kitchen planned for strict efficiency turns out to be cramped and inflexible. A workshop need not be less pleasant than a living area in order to be practical.

- *Circulation.* Not simply a matter of abstract planning charts, circulation is a sequence of experiences, visual and kinetic, that can be imagined while studying a plan. Have the circulation patterns that may apply to the resident, the visitor, the employee, and other kinds of users, all of whom may use the

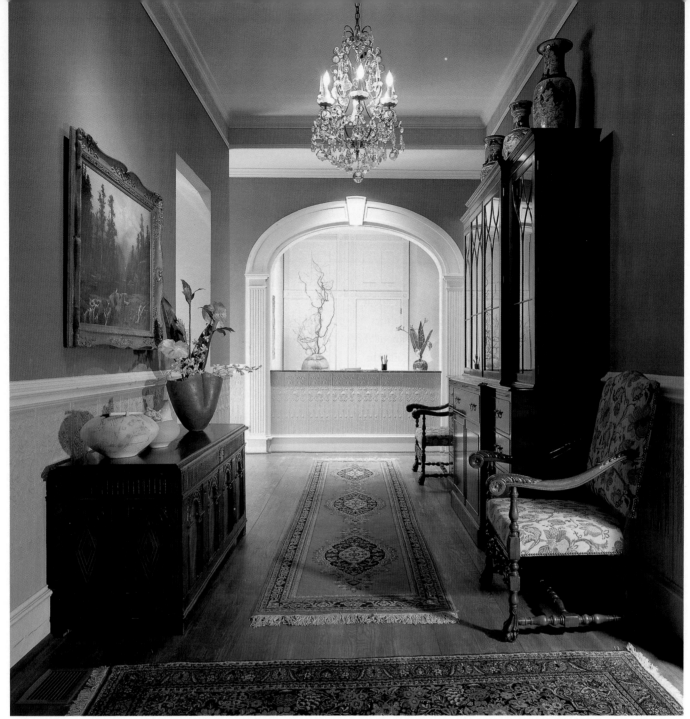

← 6.28

same space in different ways, been taken into account and any conflicts resolved? In planning a hospital or an airport, the experiences of many different kinds of users, each with different patterns of movement and varied needs, should be traced in order to discover and minimize conflicting patterns.

- *Daylight and view.* A designer needs to take daylight and view into consideration. Windowless spaces, while common in many modern buildings, generally present problems. Where will light and view be available? How can their absence be offset? On the other hand, glare can be unpleasant, and a view, under some circumstances, can be distracting. Have these situations been controlled? Wise planning to avoid awkward relationships between people and window areas works best.
- *Dead-end location.* While people value freedom of movement within a space, a quality that good, open circulation provides, they also seek out and enjoy cozy spaces at the end of move-

ment paths. Such dead ends, or *culs-de-sac,* where no further movement through is possible, may suggest some sort of primitive security or stability and will suit certain spaces, including bedrooms, private offices, and bathrooms. Have any dead ends been intentionally planned to serve some of the social inclinations of the space users?
- *Acoustical issues.* Usually thought of in technical terms of materials and even electronic devices, acoustical issues actually respond best to sound planning. Have sources of noise, such as a family room with TV, VCR, or DVD player, or sound system, been placed as far away as possible from bedrooms or other places where quiet will be important? If this cannot be done, have barriers of some sort, such as a wall of closets in between two adjacent bedrooms serving users of different age levels, isolated the noise to some extent? In offices, layout can do more to provide *acoustical privacy,* that is, inabil-

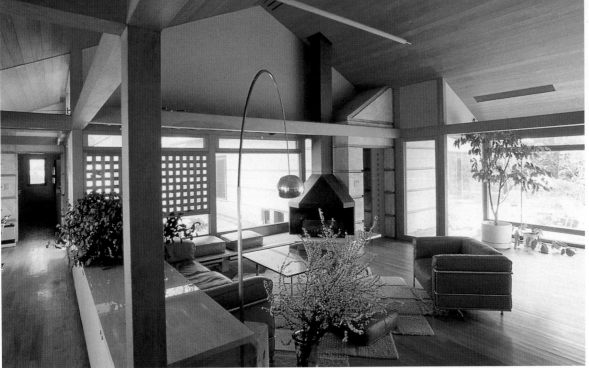

ity to hear conversation from one space to another, than any available materials. Has the planner, by placing elements so that sound must either travel a long distance or be blocked by natural sound-absorbing barriers, eliminated the most troublesome acoustical problems (see pages 468-72)?

- *Safety and security.* Control of access, surveillance, and safe exit routes, often thought about only after problems appear, are all best dealt with through planning. A few minutes spent imagining various emergency situations (fire, vandalism, theft, and so on) will suggest simple ways to minimize what can otherwise be difficult problems to control. Has sufficient attention been paid in terms of safety to such elements as glass doors and partitions, steps, stairways, and ramps, and in such high-risk areas as bathrooms? When imagining the problems that might arise with these elements, the designer should seek to envision the experiences of children, the elderly, and people with disabilities (see also Chapter 7, "Human Factors and Social Responsibility," and Chapter 8, "Interior Design for Special Needs").

Building codes deal with a number of elements that relate to safety. Fire safety is involved in selection of materials, zoning of areas to prevent the spread of fire, and requirements for safe routes of egress in case of fire. Such code requirements must, of course, be adhered to, but they only define the minimum and do not guarantee levels of safety that may be desirable. Also, fire safety codes have little bearing on safety against accidents, and most building codes offer little guidance in this area. A thoughtful critique of planned spaces will include visualization of worst-case possibilities, including use of spaces by children, older occupants, and those with disabilities, and situations created by crowding in public areas. Moreover, security issues have come into new importance through widely publicized incidents in which hazards have been created by deliberate acts. Consideration of such issues while planning can often offer improved safety and security at minimal cost and reduce the need for special equipment that cannot, in itself, achieve optimum levels of success.

All of these points may seem obvious, and thinking about them can—and certainly should—be second nature to the skilled planner. Nevertheless, our everyday observation of the interior spaces we use makes it clear that good planning for all of the building users' needs cannot be taken for granted without serious repercussions.

Planning is too often viewed as a matter of applying familiar formulas or of staging formal visual effects, whether or not these really serve intended purposes. Consider how many houses have a front door that is seldom or never used, while family and visitors alike go around to the side or back. How much space is given to formal parlor living rooms, used once or twice a year, while normal life is crowded into a family room often located in a dark basement? Public buildings are equally given to main entrances leading to little-used lobbies, while most visitors come from underground subway concourses or parking garages. Good planning avoids these absurdities and concentrates on serving real needs with both efficiency and elegance.

6.28 In a sedate and traditionally formal entrance hall, oriental rugs and a crystal chandelier relate to period furniture in this residential setting in Austin, Texas, designed by Kenneth Jorns. (Photograph: R. Greg Hursley) **6.29** Flowing space, warm colors, and a strong relationship with the outdoors work together in this living room of a house in Okusawa, near Tokyo, Japan. Note the open access at the left to the living room. The classic upholstered chair and sofa—nine designs by Le Corbusier—and a modern lamp by Joe Columbo seem well suited to the spirit of the place, designed by architect Mayumi Miyawaki. (Photograph: Gilles de Chabaneix)

case study 3. Office Floor in a City Building

FORBES-ERGAS DESIGN ASSOCIATES, INC.,
INTERIOR PLANNING AND DESIGN
WHEEL-GERSZTOFF ASSOCIATES, INC.,
LIGHTING CONSULTANTS

A full floor in a Manhattan loft building was developed for Wheel-Gersztoff Associates, a lighting design firm with a staff of sixteen. Fixed elements included stairwells, window location, plumbing, and supporting columns (fig. 6.30).

Because most of the firm's clients are architects or designers, a strong design quality was important, both to display the firm's design standards and to demonstrate excellence in lighting design (figs. 6.31, 6.32; see also fig. 6.34). The flavor of the original 1890s building is maintained in hardwood floors and the metal ceiling (fig. 6.33), which recalls the pressed-metal ceiling characteristic of the period—although this is, in fact, a modern reproduction in cast Aluminum.

The overall impact of the space is modern and elegant, yet simple and efficient. It serves the partners and staff well while so signaling an appropriate message to visiting professionals and their clients (fig. 6.34).

6.30 →

chapter seven. Human Factors and Social Responsibility

It is generally taken for granted that all design is concerned with the creation of objects and places that will satisfy the uses to which people will put them. Designers, without even realizing they are doing so, often assume they know how to do this on the basis of personal experience, thinking that their own requirements are typical of those of all others or that their observations of people provide an adequate foundation for deciding what "most people" will need. Some designers may become so focused on abstract concepts of form or on technical issues of function that the realities of human needs are neglected or forgotten. To avoid the mistakes that such attitudes can engender, the design professions have become increasingly involved with the methodical study of the specific ways in which their work affects individual people and the public at large.

Such studies can be divided into two major areas. The first, known as *human factors*, deals with the needs of individual people. In interior design this involves the many issues that directly influence the comfort and convenience of those who will be the occupants and users of the spaces being designed. The second, designated as *social responsibility*, is concerned with both the immediate and long-term impact of design on society. Although these two areas are closely connected, each deserves thoughtful consideration. While many aspects of life impact on the health and comfort of human beings and on the larger concerns of environmentalists, interior designers have an especially close relationship with these issues. In the past, design often seems to have

been concerned solely with aesthetic issues in ways that ignored consequences to the human needs of both individuals and the society as a whole. It is easy to think of examples of uncomfortable, even dangerous stairways, endless long passages, and buildings with a voracious appetite for electric power and fuel. Population growth and worry about the earth's capacity to sustain its human populations has led to new concerns about such issues.

The designer is always in a position to make decisions and to lead clients to support decisions that are favorable to human use and to the concerns of social responsibility. This chapter offers an overview of the ways in which an interior designer may engage these issues.

Human Factors

Since all buildings are designed to serve some human purpose, it may seem strange that the study of human factors in relation to design has become a specialized field. Many buildings and many interiors, however, including some by skilled designers, fall far short of serving human needs in an optimal way. This can hardly be considered a recent problem. Throughout history, there have been cold and cramped cottages, depressing and comfortless temples and churches, and mansions and palaces that must have been miserable to live in. Such problems, long viewed as inevitable evidence that "nothing is perfect," have been accepted more or less without complaint.

7.1 The office, manufacturing, and distribution building for Miller SQA, a subsidiary of furniture manufacturer Herman Miller, Inc., Holland, Michigan, was developed with special concern for green issues. Natural daylight pours in to offices and production areas through huge sky-lights, reducing the cost of lighting and the need for heat in winter. Motorized shades from Media Shades Systems control natural sunlight, providing insulation and less need for air-conditioning, while photo sensors regulate artificial light to further reduce energy consumption. William McDonough + Partners were the designers and architects. (Photograph: Tim Hursley. Courtesy of Herman Miller, Inc.)

Over the years, a number of forces have emerged in protest of antihuman design. One such force, the theoretical school on which modern architecture is based, is *functionalism*. First developed in the 1930s, functionalism insists that the serving of function is the primary goal of all design efforts. Oddly, it has been the failure of many projects designed in the name of functionalism to deliver the promised satisfactions that has stirred up a new interest in understanding the relationship between human beings and the buildings that they build and use.

Several related disciplines, each with a highly specific interest in designing for human needs in a more careful and methodical manner than has been common in the past, have pulled together in recent years. Their first task has been to study existing buildings, in order to see how they work or, more often, fail to work for their users. Many modern offices, shops, restaurants, apartments, and houses are inconvenient, uncomfortable, or unsatisfactory in one or more ways (for example, poorly lighted, badly ventilated, or noisy). More and more stories circulate about widely published projects that photograph well—that even win awards—but have turned out to be unsatisfactory in use, some even bitterly disliked.

The causes of such failures are varied and often difficult to pin down. In some cases, design simply has not caught up with the complexities of modern building technology, or technology may have been relied on for performance beyond its current capability (as with windowless buildings totally dependent on less-than-perfect air-conditioning and other environmental controls). In other cases, design may have been directed by people or agencies with little awareness of the actual needs of users. Modern apartment houses and office buildings are designed more for the profit of the developer than for the satisfaction of occupants. Economic forces that run counter to users' needs (for taller buildings, perhaps, or smaller rooms) exert formidable pressures, and mistaken assumptions about "what the public wants" take the place of genuine information about actual requirements.

A particularly disturbing accusation suggests that designers are often more concerned with using projects as vehicles to further their own careers than with designing for users' needs. In a world in which media exposure has become vital to success, there are certainly temptations to try for startling, spectacular, or glamorous effects, whether or not they coincide with the goal of serving real human needs.

Increasing criticism of the design professions, from both without and within, has stimulated a new level of attention to the aspects of design that directly affect the user. The design profession has become open to the studies of other professions that deal with human needs, particularly to research findings from psychology, sociology, anthropology, and other disciplines that tend to be more rigorously scientific in their approaches than the largely empirical world of design. Since, however, this is not as yet a defined field but an interdisciplinary approach

drawing on a number of specialized fields, there is some confusion of terminology. Such terms as *environmental psychology, architectural psychology, ergonomics, spatial behavior*, and *proxemics* have come into use, each defining one way of investigating the relation of design to human use.

The term *human factors* is something of an umbrella term intended to include all such specialized studies, which share the realization that human beings are powerfully affected by their environment and the related conviction that human behavior is in turn influenced by the environment in which it occurs. Although it is widely believed that people feel, work, rest, eat, and think better in some spaces than in others, there is surprisingly little exact knowledge of what makes one place so much more satisfactory than another. Precise scientific knowledge about any issue generally comes from research involving carefully controlled experiments in which only one factor is varied while all other factors are kept constant. Controlled research of this sort is rarely possible in the complex situations of built environments, where too many factors interact and prove difficult to control.

For these reasons, research in human factors is usually based on observation and such techniques as surveys rather than on controlled experimentation. While the results are therefore less precise, they yield general guidelines that can significantly aid the designer in avoiding serious mistakes and increasing user satisfaction. Many of the insights in the area of human factors research have come from sociology and psychology, fields that work in similar ways in much of their methodology. At the same time, the movement called *consumerism* has increased public awareness of the need to evaluate the performance of products of every sort, including buildings and their interiors, in terms of both service to and protection of consumers.

Every designer should be familiar with the studies of such pioneers as anthropologist Edward T. Hall and psychologist Robert Sommer, as well as with the constantly growing literature that examines the relation between designed artifacts and spaces and their human users. Hall, in *The Hidden Dimension*, studies the ways in which different cultures have developed differing attitudes toward space between human bodies in various social contacts. He extends this to the ways in which people use rooms and furniture. (See Table 4, "Personal Distances," opposite.) In various articles and several books, including *Personal Space* and *Tight Spaces*, Sommer has related similar observations more directly to the planning of buildings and rooms. His observations of territorial behavior in public and private spaces have provided new insights for designers. In addition, ergonomic data provide more specific details about human bodily dimensions, muscular and sensory functioning, safety and security matters, and the special needs of certain segments of the population. (Children, the elderly, and people with disabilities present particular requirements for the designer; for a dis-

Table 4. Personal Distances

KIND OF RELATIONSHIP	CLOSE	FAR
Intimate	0″–6″	6″–1′6″
Personal	1′6″–2′6″	2′6″–4′
Social	4′–7″	7′–12′
Public	12′–25′	25′ and over

The four terms are fairly explanatory in defining kinds of relationships. *Intimate* indicates the closest of personal relations—family members or lovers. *Personal* contacts are one-to-one conversational relationships. *Social* contacts are those at parties, conferences, business meetings, typically with more than two people involved. *Public* contacts are those between speaker and audience, teacher and class, and similar person-to-larger-group relations.

— Based on E. T. Hall, The Hidden Dimension, 1966.

cussion of these special needs, see Chapter 8, "Interior Design for Special Needs.")

The ways in which a designer may use the study of human factors will vary with the nature and scope of individual design problems, but some typical applications can be listed to suggest the range of possibilities.

BACKGROUND

Traditionally, design education has focused on aesthetic issues, frequently relegating functional matters to a secondary role. Even the designs of avowed functionalists more often seem aimed at creating a strong visual effect than at serving specific user needs. The study of environmental psychology or any other discipline in the field of human factors directs design attention to the specific ways in which design affects human life and makes the union of aesthetics and practical service a design goal.

Visually exciting design that runs counter to human needs is wasteful, harmful, and destined to failure when put to use. The notorious Pruitt-Igoe housing project in St. Louis won design awards when it was built in 1956 but was demolished only sixteen years later, in 1972, in response to its disastrous inadequacy as a living environment for its residents. A handsome building may contain offices or laboratories that are inconvenient and inefficient. A fine winding staircase may be the scene of dangerous accidental falls.

On the other hand, users' efforts to make spaces comfortable by rearranging furniture, introducing personal clutter, and similar modifications can undermine the visual quality of a designed space. Occupants are often quite content with houses of banal exterior and interior design. The thoughtful designer will make every effort to create a space that works for its users without sacrificing visual quality.

USER PARTICIPATION

In the phase of design work known as *programming*, the specific needs that a design project is meant to serve are spelled out in detail (see Chapter 6, "Planning"). Too often, this is done without direct contact with end users. Managers of businesses and organizations may assume that they have sufficient knowledge to develop programs without any firsthand exploration of user needs. This leads to housing that is hated by its occupants; offices that are depressing and inconvenient to workers; hospitals that frustrate patients, visitors, and medical staff; schools and colleges that act as inhibitors to learning; and airports built for aircraft and airlines rather than for travelers.

Better programming demands the methodical observation of existing projects of a comparable nature to discover what aspects work well and where problems and failures occur. Surveys can go directly to users to discover what real needs and desires exist (see fig. 6.12). Office workers will often have specific complaints about noise, lack of storage space, poor lighting, and similar issues. Vandalism and crime in a housing project have many causes, but design that avoids dark, hidden spaces and provides access routes in full public view has a favorable impact on such problems. It is, of course, not possible to reach every future user of a hospital, airport, or office building, but some sampling of potential users can be undertaken.

Since surveys can only discover opinions and desires based on the experience of those surveyed, their results require interpretive study. Motivations should be questioned and unrealistic desires separated from genuine needs. A desire for "more closets," for example, may indicate a need for other kinds of storage that will be more serviceable. A wish for a windowed corner office may come less from any practical need than from a desire for heightened status—a value that may or may not deserve consideration. All needs and desires must be brought into some realistic relationship not only with the project's budget and priorities but also with the underlying economic forces.

User participation in design, accomplished through review groups, worker committees, or sessions with sample groups of potential users or all of these forms of participation, will often aid design by discovering real needs in detail and sorting these out from assumed requirements. It may even lead to better design and direct economies. Just as worker participation in factory management has been found to improve production, user participation in design can contribute to developing projects that improve the user's quality of life.

Participatory design depends on establishing a relationship between designers and users in which each educates the other. The resulting design should satisfy many sets of values. While participatory design can take some extra time and trouble, it has proven worth while in many projects. Among its benefits is the higher level of users' acceptance of the end result. When compromises must be made (for example, between desires and economic

72"

58"

70"

66"

44"

25"

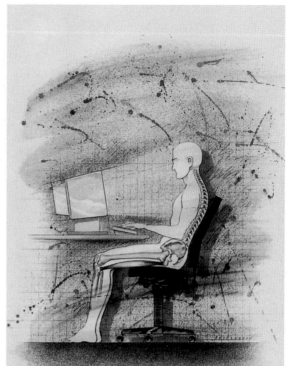

← 7.3

realities), users involved in the process find it easier to accept the result than if they had simply been presented with a solution over which they had no influence.

Giving choices of equally satisfactory alternatives is another technique through which participation can improve user satisfaction. Choosing a color scheme, furniture, or furniture arrangement makes users feel that the resultant space is their own in a way that a fixed scheme mandated by remote authority does not. Designers' work is often defeated or sabotaged by users who resent having had no input into what is provided; involvement in some aspect of the design process can disarm such hostility.

USE OF RESEARCH DATA

Many design decisions can be aided or guided by information developed by researchers in the fields dealing with human factors. *Anthropometric* data deal with bodily dimensions to establish clearances, heights of tables, counters, and shelves, and similar useful guidelines (figs. 7.2, 7.3). To this, *ergonomic* data add a concern with body mechanics and sensory performance, thereby guiding the designer on such issues as seating comfort and ease of seeing and hearing, and thus lighting and acoustics as well (figs. 7.4–7.6). (It is important to remember that the data concerning averages for the general population, so often used as bases for design, ignore the reality that most people are *not* average: the

unusually large or unusually small; the very young or very old; and people with temporary or permanent disabilities constitute major segments of the total population. The design issues that consideration of these facts generate are the subject of Chapter 8, "Interior Design for Special Needs.") *Experimental psychology* is the study of sensory perception and deals with the ways in which spaces are experienced and the impact of color and light on both senses and emotions. *Anthropology* and *sociology* involve the study of human behavior in various cultures and contexts.

Even studies in animal behavior have been useful in understanding human attitudes toward privacy and communication and have aided understanding of territoriality, the desire for space defined in terms of individual and group privacy. *Proxemics* deals with the impact of spatial realities on social grouping and behavior. For example, crowding is known to increase levels of irritation and frustration, leading to interpersonal friction, arguments, and even crime. Human beings require suitable levels of privacy for work, meditation, and rest, as well as adequate settings for personal contacts, in both work and social situations. Appropriate spaces, walls, doors, and furniture selection all contribute to making daily life comfortable, satisfying, and productive.

Research in all of these fields is quite specialized, often pursuing observation or study of specific, narrow questions. Many designers seem impatient with such studies, feeling that they do

7.2 This diagram shows typical human dimensions for an adult male 70 inches in height. Average dimensions for people of other heights can be determined by multiplying the figures given here by the person's height (in inches) and then dividing by 70. **7.3** Ergonomic furniture

is designed through careful study of human body mechanics. This drawing of an office chair designed by a Swedish physician, Dr. Johan Ullman, for Medical Innovations reveals that the seat and the back are each made up of two planes, slightly angled so as to permit the user to

move into varied positions while maintaining a balanced back. An unusual feature of this chair is the tilted seat, which takes pressure off the lower back. Both the angle of the chair back and the height of the seat can be adjusted. (Courtesy Johan Ullman, M.S./Medical

Innovations Ltd., Sweden) **7.4** Office tasks involving computer operation call for furniture thoughtfully sized and preferably adjustable to make the workplace ergonomically suitable. **7.5** This diagram illustrates the basic dimensions required for satisfactory seating.

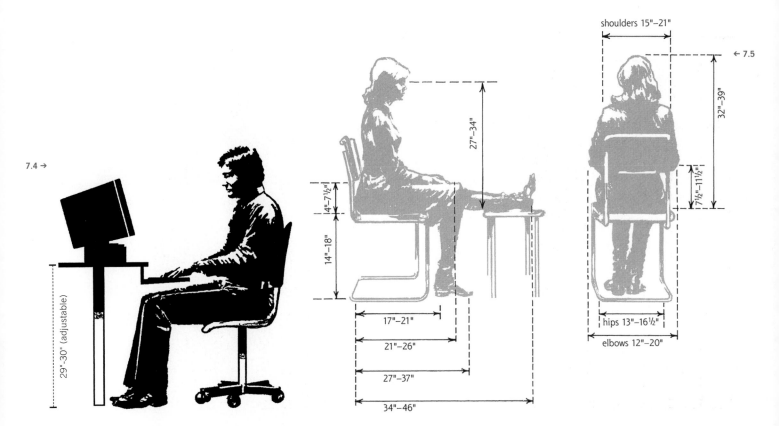

7.4 →

29"–30" (adjustable)

27"–34"

4"–7½"

14"–18"

17"–21"

21"–26"

27"–37"

34"–46"

shoulders 15"–21"

← 7.5

32"–39"

7½"–11½"

hips 13"–16½"

elbows 12"–20"

not deal with practical questions relating to particular projects. Actually, some studies have yielded very precise and useful how-to information concerning, for example, the design of good lighting and physiologically satisfactory seating. In other areas, such as the emotional impact of color or the role of space in influencing behavior, research data can only have a more general impact in promoting better understanding of these matters.

It is not unusual to find that research data yield findings that may appear to be obvious; everyone knows something about the impact of warm versus cold colors or can guess that avoiding dark, hidden spaces in public areas will discourage crime and vandalism. Still, even such seemingly obvious issues are so often ignored that it seems important to focus attention on them. Designers also find that in presenting design proposals to clients and committees, documented research findings offer support when the obvious becomes a matter for dispute.

EMPLOYMENT OF CONSULTANTS

In many larger projects it is helpful to employ specialists in the fields of environmental psychology, sociology, or ergonomics. This transfers some responsibility from the designer to an expert with greater experience and more specialized knowledge in areas that lie somewhat outside the normal concerns of the designer. Just as specialists in engineering, lighting, or acoustics can be helpful to the overall success of a project, the specialist in human factors can function as a kind of spokesperson for a particular set of considerations.

Scanning the available literature for studies and data germane to a project, setting up and conducting surveys or interviews, organizing user participation in design—these are all functions that a specialist can be expected to perform with a concentration that the designer can rarely achieve. Finding consultants who

have expertise in their special fields as well as an adequate understanding of the goals and problems of design is not always easy, but current interest in this field is encouraging more and more qualified people to enter it.

The increasing use of interdisciplinary teams in the design of larger projects opens the way for including a specialist in environmental psychology as one of the team. Some localities legally require such a specialist, and this trend may well become general before too long. In the meanwhile, and in working on smaller projects, designers will have to continue to rely on their own knowledge and judgment about when to call on specialists.

PERFORMANCE EVALUATION

It is a curious reality that after design projects are put into use, they are seldom evaluated in any methodical way. Interesting projects may receive publication, commentary, and even criticism in the design press, but such comment is usually concerned primarily with aesthetic values. Furthermore, it is often based on information gleaned from drawings and photographs, sometimes supplemented by a brief visit to a space too new to have developed any clear user points of view. Designers themselves tend to move on to new projects, losing interest in jobs already completed. They may even avoid asking for evaluation for fear of stimulating complaints and criticisms that would otherwise be overlooked or suppressed.

This pattern has tended to inhibit the process of learning by experience, a process that has the potential to improve the levels of satisfaction delivered by the work of a particular designer and the work of the design professions collectively. The environmental fields have begun to make a practice of taking a formal evaluation after a project has been in use long enough to weed out problems related to the stresses of moving in and the resistances often set up

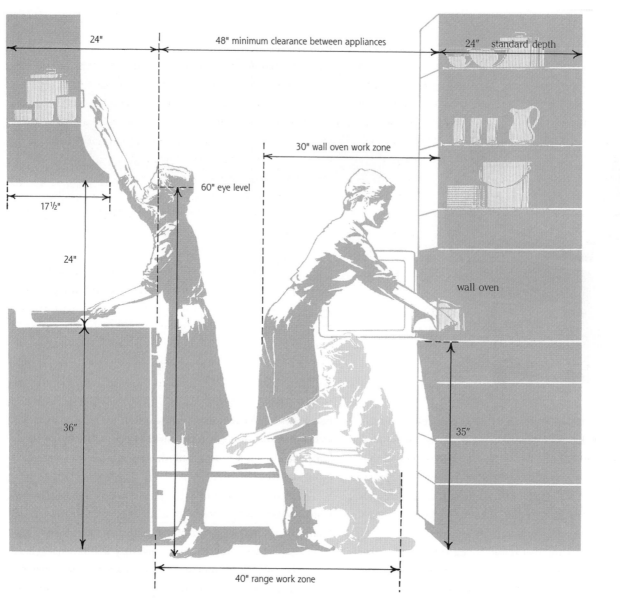

by the strangeness of a new place. Making an evaluative study at intervals such as six months or one year can generate information about what has worked well and what has not that provides a foundation for future improvement in design performance.

An evaluative study can be made on the basis of questionnaire or survey techniques, a more informal observation and report by a consultant with some experience in such evaluations, or firsthand observation and interviews undertaken by the designer. The last approach has the obvious disadvantage of introducing the possibility of bias on the part of the designer, who is more likely to accept favorable comment than unfavorable criticism—although it is the latter that is more important in limiting future mistakes. Ideally, evaluation reports on a wide variety of projects should be made

available to the entire design community, enabling all to learn from a common and growing pool of experience. At present, such general availability is unusual. However, from time to time journal articles provide some evaluative information of greater depth and seriousness than the rumors that frequently travel in design circles.

IMPORTANCE IN SMALLER PROJECTS

The need for formal and specialized study of human factors issues is greatest in such projects as airports, hospitals, housing projects, and large design organizations, in which direct user-designer contact is difficult and the bureaucratic management style adopted from conception to completion results in a rather inhuman organizational routine. Human factors issues are, how-

7.6 These clearances, applied to kitchen design, are derived from studies of human proportions and movement, such as reach.

ever, every bit as important in small projects, even down to the design of a single room.

While room designations such as *living room* or *bedroom* or project descriptions such as *private office* or *cafeteria* may suggest a full and detailed program of "usual" functions, probing real user needs may lead to the discovery that the intended use is not at all standard. A living room may be used as a studio, a place for group meetings, or a conservatory for growing plants—or it may hardly be used at all, but kept as a showplace or parlor. A bedroom may also serve as a study, a TV room, or an extra living room; it is vital to learn how many people will use it and what their relationships are. Many offices are conference rooms, TV-viewing rooms, or studios as well as offices. A cafeteria will often serve as a social club and lounge as well as for regular meal service.

While the design of spaces should respond to their intended use, it may also influence what the actual use will be. A dining room may impose formality or encourage relaxation. A cafeteria may impose a sense of rush, permit some ease and comfort, or turn into a hangout to what may be an undesirable degree. The planning of home kitchens has been found to be a factor influencing family relationships for better or worse. A cramped layout in which two people who share meal preparation constantly collide and get in one another's way puts nerves on edge and can even cause arguments, while a more accommodating layout might encourage cheerful cooperation.

Members of a family need to have suitable privacy and suitable gathering places to support pleasant relationships. Furniture arrangement can aid and encourage conversation or inhibit it. Color and lighting establish moods in a space and influence the events that take place there in subtle ways that often go unrecognized.

Many such issues may seem to be only what any competent designer would consider in the normal course of a design project. It is, however, the long history of their neglect that has made the subject of human factors a special field. In small projects, where elaborate research and the employment of consultants is out of the question, the designer has a particular obligation to remember that the aesthetic aspects of a design must be related to the practical aspects that users will have to live with.

SPECIFIC ISSUES

In addition to the general planning and design considerations related to human factors, a group of more technical issues deserves attention. Both large and small projects can benefit from a concentrated review of the issues involving ergonomics, safety, security, health hazards, and noise.

Ergonomic Furniture Interest in human factors has lead to an increase in the development of furniture that can be described as *ergonomic*. Such furniture is designed with special concern for the dimensions and movements of the human body and usually provides for adjustments that adapt to the proportions of a particular

user. Development of ergonomic furniture in the United States lagged behind Europe until recently, but most American furniture manufacturers now offer products that take full account of ergonomic concerns. Office furniture, since it is used by a particular user on a continuing basis, and furniture to suit the needs of elderly and disabled individuals have received more attention to ergonomic needs than general household furniture. Office chairs and work surfaces are now available to provide a variety of adjustments in response to individual to physical form and other special needs (see fig. 7.3). Further discussion of ergonomic furniture can be found on pages 406–9.

Safety Indoor accidents, particularly at home, are a major cause of injuries and death. Stairways and steps pose real dangers (see page 284). Bathrooms, with their slippery surfaces, hard projections, mirrors, glass, and hot water, are notorious accident locations. Kitchens, with open flames, gas or electric elements, boiling water, heated fats, and sharp objects, present other risks. High locations, balconies, windows, and platform edges need the best possible guardrails or bars, marking, and lighting. Glass always poses a danger, particularly in the form of large windows and doors that can sometimes be virtually invisible (fig. 7.7). Polished floor surfaces are a hazard, especially outdoors or near entrances where water, snow, or ice can add to the risk. Nonskid surfaces will minimize these risks. Small rugs and mats and the edges of larger rugs can cause falls. Furniture edges, projecting legs, and objects that roll or overturn easily are also involved in a surprising number of accidents.

Fire safety is a special matter that calls for the observance of building code regulations concerning exit routes and equipment such as smoke detectors, fire alarms, extinguishers, sprinkler systems, and hose connections, and for the choice of materials for maximum fire-resistance. Many designers feel that fire-safety consideration stops at the minimal observance of legal requirements, yet code compliance is not in itself assurance that all safety issues have been fully addressed. Reports of actual fires make it clear that a far higher standard of fire safety is both easily obtainable and highly desirable. Many modern synthetic materials present risks because they give off toxic fumes when burning that can be more deadly than the fire itself. The dangers are multiplied by modern closed spaces with artificial ventilation, often on high floors where rescue access is difficult. More detailed discussion of safety issues as dealt with in code restrictions is included in Chapter 15, "Mechanical Systems," beginning on page 476.

Security As an issue closely related to safety, security is an increasingly important consideration, particularly in areas where social conditions have given rise to robbery, vandalism, and even terrorism. Design cannot control every aspect of such problems, but both basic planning and suitable details and equipment can help to minimize risks. Dark halls and hidden areaways invite

trouble, while open and visible access points are to some degree self-protecting. Oscar Newman's book *Defensible Space* explores the ways in which design and planning can discourage crime and vandalism in apartment buildings and public housing projects. Most of the recommended steps may seem obvious, commonsense precautions, but a systematic review of the risks that are inevitably present and the design steps that can be taken to control them is a commendable routine. Table 5, "Safety and Security Problems," pages 200–201, outlines the major safety and security hazards and the precautions a designer can take.

Health Hazards In addition to safety hazards that create possibilities of injury, building interiors can create other problems that may impinge on occupants' health. Many materials in common use, as well as certain practices, can have an unfavorable impact on air quality within a building. Asbestos, long a favorite insulation material and an ingredient in various building products, is now well known as a carcinogen. This and other hazards associ-

ated with specific materials are discussed in Chapter 9, "Materials and Their Uses." The recirculation of air in air-conditioned interiors may favor both the short-term danger of infection and the long-term risks related to continued exposure to low levels of air pollutants. Tobacco smoke is an air pollutant being brought under control by increasing regulation of indoor smoking.

Concern has recently developed for hazards that may be associated with exposure to electromagnetic fields (EMFs). Such magnetic fields are created wherever electrical devices are in use. Where small currents are involved, the strengths of the fields are not great and their levels fall off short distances from the sources. The large currents that flow through high-tension power-transmission lines and transformers, however, do create electromagnetic fields of significant levels. The discovery of concentrations of cancer cases and other related illnesses among people who have had long exposure to strong electromagnetic fields has led to the investigation of possible EMF dangers. Although there is strong disagreement among researchers about the levels of risk involved in EMF exposure, prudence suggests that exposure to this possible hazard should be minimized until there is a resolution of these disagreements. Avoidance of proximity to outdoor high-tension power lines is an obvious precaution. Less obvious are the underground lines, power feeders in larger buildings, and the transformers that are used in many buildings to convert high-voltage currents to service voltages. Building occupants should not use spaces close to these EMF sources for extended periods of time. Compact meters are available that measure levels of EMF in terms of the gauss unit. Checking suspect locations with such a meter allows easy identification of potential dangers.

Detectors are also available to guard against carbon monoxide (CO) pollution. CO can come from defective combustion devices (such as furnaces and water heaters) and from automobile exhaust gases.

Other health hazards have been traced to the presence of formaldehyde in various products and to lead in paints and in water that comes from pipes or plumbing devices, such as faucets that contain lead. This danger is of special concern in projects where children will be users or occupants or both. Radon gas in interior air and even very small amounts of mercury that might come from fluorescent lighting tubes or from discarded batteries are additional sources of health problems associated with interior occupancy. Health hazards related to the deprivation of full-spectrum light resulting from the use of many types of modern artificial lighting are discussed on page 350.

7.7 Glass doors tend to prevent collisions between people entering and exiting but can become dangerous when certain lighting conditions render the glass virtually invisible. Here, a decorative pattern of dots on a frameless glass door solves the problem. The entrance to the offices of A. G. Becker, Inc., New York, was designed by Jack L. Gordon Architects. (Photograph courtesy Jack L. Gordon Architects)

Noise Noise, defined as unwanted or excessive sound, can be a source of major discomfort. Moderate levels of sound appropriate to a particular space use are tolerable and may even be desirable. The buzz of conversation in a restaurant and the low-level hum of activity in a large office space are not objectionable, but when such sounds rise to an excessive level they set up reactions of irritation and strain that can be tiring and unhealthful. In spaces intended to be quiet, such as a bedroom, even very low levels of unwanted sound can be objectionable. A neighbor's radio or late-night music practice can be profoundly disturbing. Mechanical noises from air-conditioning equipment or other machinery within a building can also introduce what has sometimes been called *noise pollution*. Outdoor noise from traffic or aircraft operation provide additional examples of sounds that need to be minimized. The discussion of acoustics (see pages 468–72) deals with some of the problems associated with noise control.

Social Responsibility

Buildings consume land and air space, materials, and energy for construction. In use they continue to consume energy and produce waste products. They exist to provide the interior spaces within, the spaces that interior designers plan, detail, and furnish. Interior designers and architects have traditionally understood their obligations to serve the needs and desires of their clients but have tended to feel that their responsibilities end at that point. For projects where the commissioning individual, family, or organization will be the only occupant or user, this assumption may seem valid. It ignores, however, the reality that every project, no matter how small or how personal, as it consumes space, resources, and energy and generates wastes, affects society as a whole. A project that is used by a population beyond the owners who commissioned it has a further social impact. The students in a school or college and their teachers; a hospital's patients, staff, and visitors; the workers in an office; the customers in a store; the guests and staff of a hotel; and the patrons and workers in a restaurant are all users of interior spaces they do not own and did not commission (fig. 7.8). What is the responsibility of designers to these people and to society in general?

In a commercial society, a large proportion of the projects that call for designers' services are generated to make a profit for their owners and developers. Certainly, providing a useful service need not conflict with generating a profit for the project's developer and owners, but the goal of maximizing profit can readily come into conflict with some of the interests of both a project's users and the general public. Primary responsibility in these matters must lie with owners and developers, who decide what is to be done and who have veto power over every aspect of the projects they initiate. Designers, however, as they carry out the wishes of their clients, have numerous opportunities to influence the ways in which a project will relate to the concerns of both users and the public. To

exert influence in the direction of responsibility, to find ways to resolve possible conflicts between the interests of clients and the public, and to avoid involvement in actions that are grossly irresponsible are obligations that every designer must accept.

It is helpful to summarize the issues facing designers that embody elements of social responsibility; although some may be quite obvious, others are subtle and easy to forget or to ignore, and yet others are complex or troublesome to deal with.

QUALITY VERSUS PROFIT

The clients who employ architects and interior designers, who accept or reject their proposals and finance the execution of designed projects, are frequently not the users and occupants whom such projects will serve. Projects generated for profit demand that the designers minimize costs in order to optimize profitability. Excellence in uses of space, in structure, in selection of materials and finishes, and in provision of convenience and comfort is commonly more costly than inferior provisions. Minimal space allocations result in crowding; shoddy structure, materials, and equipment reduce user satisfaction and may contribute to actual safety and health hazards. While higher standards are adopted for many projects, this is most often true of luxury facilities that serve a limited, affluent population— the VIP lounge at an airport terminal, for example, contrasts strikingly with the typical city bus terminal. So-called affordable housing is inferior to luxury housing not only in luxuries that may be regarded as optional, but also in the basics of space, convenience, and accommodations for the occupants' well-being.

The pressures to minimize costs through design decisions that favor economy over excellence affect nonprofit-sponsored projects as well. Public housing is a notorious case in point. The clinics and hospitals that serve a less affluent public differ markedly from private hospitals and medical-office facilities. Legal requirements regarding structural solidity and safety establish bare minimums that are regularly accepted as adequate standards in public and other nonprofit institutional projects.

ENVIRONMENTAL OR GREEN CONCERNS

The terms *sustainable design, eco-design,* and *green design* all describe design with concern for the impact of designed environments on the sustainability (and often, renewability) of the resources they consume or minimization of their use. The word *green*, with its relationship to natural growth, has caught on as the most popular designation for these matters. Its use in political contexts, particularly in Europe, has made it the favorite term to sum up these complex issues. The term has come into use to identify a group of concerns that have to do with ecology and with the impact of human activities on the natural environment.

Interior designers are involved in many decisions that can exhibit a surprising level of involvement in environmental and related issues. Some of these are quite obvious, but others may seem insignificant until given careful consideration.

Table 5. Safety and Security Problems

	TYPE OF HAZARD	DESIGN PRECAUTIONS
FALLS	Slippery flooring	Avoid slippery materials, especially near outdoor access.
	Small rugs or mats	Avoid when possible. Use rubber antislip underlay.
	Bathrooms	Provide grab bars and use nonskid surfaces. Consider positioning the door to open outward in order to easily reach an injured person who may be blocking the door.
	Steps	Avoid level changes and single step if possible. If not, mark level change clearly through contrasting colors, material, or design. Provide rail or safety light or both.
	Stairways	Plan moderate (normal) angle of slope. Break long runs with landings. Provide handrails on both sides and, for wider stairways, in the center as well. Provide good lighting. Avoid slippery materials. Provide nonskid treads or nosings or both. Avoid winders. Mark beginning of stairway clearly through design.
	Windows	In high (upper-floor) locations, consider safety bars or rails. Use window type that restricts opening (but see fire safety problems below). Avoid low sills.
		Balconies, roofs Provide adequate railings. Restrict roof access.
	Kitchens	Place all provisions and materials within easy reach if possible; if not, provide a secure step stool. Store knives and sharp objects well out of reach.
	Darkness	Provide adequate lighting and emergency light at key locations. Provide double switches at top and bottom of stairways. Install a light switch near the bed in bedrooms. Install a night-light in bathrooms. Consider placing proximity or sonic switches in appropriate locations.
FIRE	Prevention	Avoid highly flammable materials. Store dangerous substances in fireproof enclosures. Use fire-safe materials near fireplaces, heating stoves, and kitchen ranges. Provide adequate and safe electric wiring.
	Control	Provide extinguishers, smoke alarms, alarm signals, or bells where appropriate. Consider providing hose cabinets and sprinklers, particularly for high-floor locations, exit routes, and high-risk areas.
	Exit and escape	Provide safe exits, including two independent routes for upper floors and hazardous locations. Provide ample exits from public spaces using out-swinging doors with panic-bolt hardware. Provide exit signs and lights. Provide fire-company access (avoid fixed windows and fixed window bars). Consider outdoor escapes, ladders, and so on. Provide emergency lighting.
ELECTRICAL	Fire	Provide adequate and safe wiring. Also see "Fire" above.
	Shock	Avoid placing outlets near water. Provide ground-fault interrupt circuitry for bathroom and other wet locations.
WATER	Bathrooms	Provide safe (thermostatically controlled) mixing faucets for tubs and showers. Avoid slippery floor surfaces (see "Falls" above), tubs, and shower bottoms.
	Pools	Control access. Consider installing railings or antiskid flooring.

	TYPE OF HAZARD	DESIGN PRECAUTIONS
AIR QUALITY	Smoke	Provide adequate ventilation. Use smoke venting for enclosed meeting spaces. For spaces that carry special hazards (restaurant kitchens, theaters, and so on), consider smoke venting for use in case of fire.
	Cooking	Provide hoods and vents to remove cooking fumes.
	Chemical, carbon monoxide, bacterial	Check ventilating and air-conditioning systems to avoid retention and spread of pollutants. Provide adequate ventilation. Provide carbon monoxide alarms. Provide natural ventilation as backup in case of failure of mechanical HVAC systems.
	Materials	Avoid materials that may give off air pollutants (plastics and other synthetics call for particular care). Avoid materials that produce toxic fumes when burning or smoldering.
MATERIAL	Glass	Avoid glass and mirror in locations where collisions are possible. Mark or pattern glass walls and doors to aid visibility. Avoid sharp edges and corners in furniture applications. Avoid glass shower and tub enclosures. Consider use of tempered or shatterproof glass or nonshattering plastic alternatives where appropriate.
	Metals	Avoid sharp edges and corners in hazardous locations.
	Other	The location of all hard materials (tile, slate, stone) and rough materials (exposed concrete, rough wood boards) should be carefully considered, as well as all their possible safeguards.
MISCELLANEOUS	Furniture	Avoid small, low, and easily overturned furniture items, including chairs. Consider safety issues for movable furniture (on casters or rollers) such as low tables, plant stands, and so on. Furniture with rounded or padded edges and corners is safest.
	Children	Check bars and railings on stairways, furniture, and so on to avoid spacing that may catch a head, arm, or leg or allow the child to slip through. Steps, stairs, windows, and balconies all require safeguarding to prevent falls.
	Garage	Isolate to prevent possible exhaust pollution. Provide fireproof enclosure and good ventilation. Provide carbon monoxide alarm.
	Elevators and escalators	Check safety provisions, emergency stop, alarms, and control of access.
SECURITY	Intrusion	Provide suitable locks, gates, bars, and so on. Consider TV surveillance, intercom, or computerized access control systems when appropriate. Plan to avoid hidden (blind) corridors, stairways, and vestibule locations, and light these areas well.
	Burglary	Provide suitable locks, bars, automatic lights, and so on. Consider installing an alarm system.
	Pilferage and theft	Provide lockable storage, locking for individual rooms, and access and exit control points. Consider magnetic or other merchandise control systems for shops and stores.
	Vandalism	Consider use of resistant materials. Plan for maximum surveillance of risky locations.

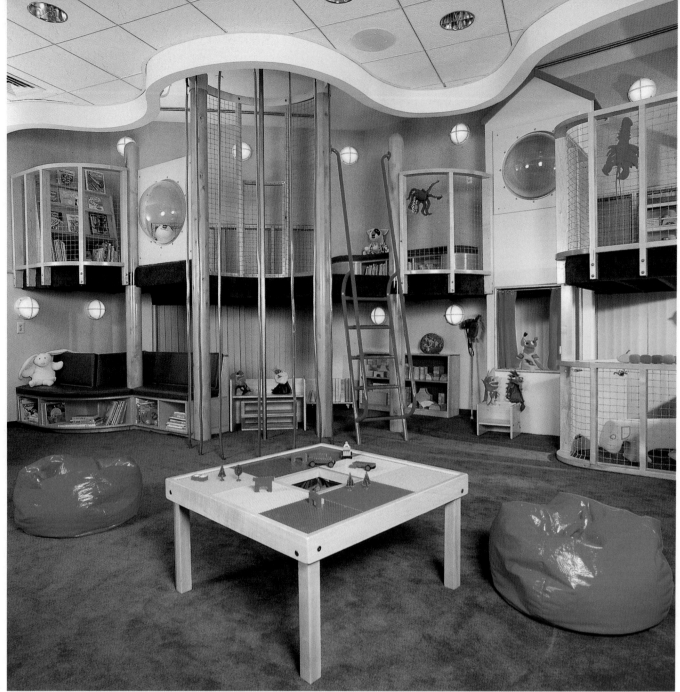

Many recent developments related to the work of architects and designers reflect the growing concern with green design issues, including the following:

- A year 2000 convention of the American Institute of Architects (AIA) adopted a resolution stating the intention to make sustainable design an issue for its members in all their practices and procedures.
- The State of New York has introduced an incentive for developers of real-estate projects that offers tax deductions in the form of a "green building credit" where certain procedures are followed.
- The International Interior Design Association (IIDA) has introduced concern for sustainable design into its current strategic plan.
- The Forest Stewardship Council (FSC), based in Oaxaca, Mexico, has introduced standards for forest management and for manufacturers of products that use forest materials leading to "certification." Products carrying the designation FSC meet these standards.

7.8 Social consciousness combined with enlightened self-interest has persuaded many businesses to provide day-care facilities for the children of their employees. The investment banking firm Goldman, Sachs & Co. retained Sherry Robbins of SDR Design to develop this children's center. In the preschool and school-age area shown in figure 7.8, nets provide safety at the balcony edge, as well as create a sense of openness. (Photograph: © Howard Barash Photography 1993, courtesy Goldman, Sachs & Co.)

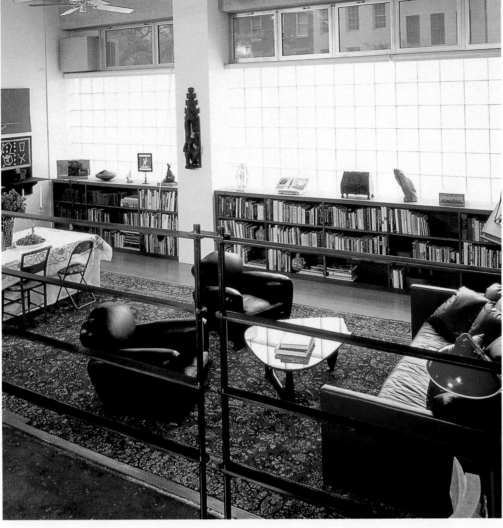

Victorian and later periods, with ideas of comfort and convenience closer to present-day standards, are less problematic. Victorian kitchens and baths may have outmoded equipment, but otherwise they are often quite practical, permitting modernization without much visual change. Gas lighting can be electrified (it often already has been) without greatly changing its appearance.

Whatever its age, the historic interior has probably been subjected to some unfortunate changes. Over the years, different owners remove fireplaces, alter windows, paint over woodwork, damage plasterwork and wood moldings, and destroy other period details while making repairs. Decisions about what to restore, replace, or simply accept depend on an evaluation of the space's condition, budget limitations, and practical issues. Fortunately, many new techniques and products make it possible to restore old detail, remove inappropriate finishes, and generally refurbish historic interiors to the limit of the owner's desires and budget.

Many difficult decisions remain. Should furniture be genuine antiques, which tend to be rare, expensive, and not the most practical choice; antique reproductions, which are also expensive and cannot avoid a quality of artificiality; or modern, which carries the danger of clashing with the space's period? The last alternative often works out surprisingly well, with the modern movable objects forming a pleasant contrast with the period background. Should dark Victorian woodwork be preserved and complemented with dark and florid Victorian wallpaper, or should brighter modern colors and finishes be used? There are no absolute answers. The judgment and taste of the owner and designer will enter into the resolution of every such question that arises in a particular project.

Nonresidential Projects Nonresidential historic buildings present some other problems, depending upon the building type (figs. 7.13, 7.14). Houses of worship can usually be preserved or restored without much change, except to heating and lighting systems. Introducing modern levels of lighting without resorting to inappropriate fixtures or excessively dramatic effects requires discretion and judgment. Theaters and auditoriums often need improved and more comfortable seating, but care must be taken not to harm acoustics when making changes. Safety requirements dealing with

7.12 The former loading dock of a beer warehouse in Brooklyn, New York, is the unlikely setting for this project. Daylight floods into the living room through windows at the top of what were once entrances to the shipping docks. Mary Evelyn Stockton and Frank Lupo were the architects for their own home. (Photograph: © Andrew Garn, courtesy *Metropolitan Home*)

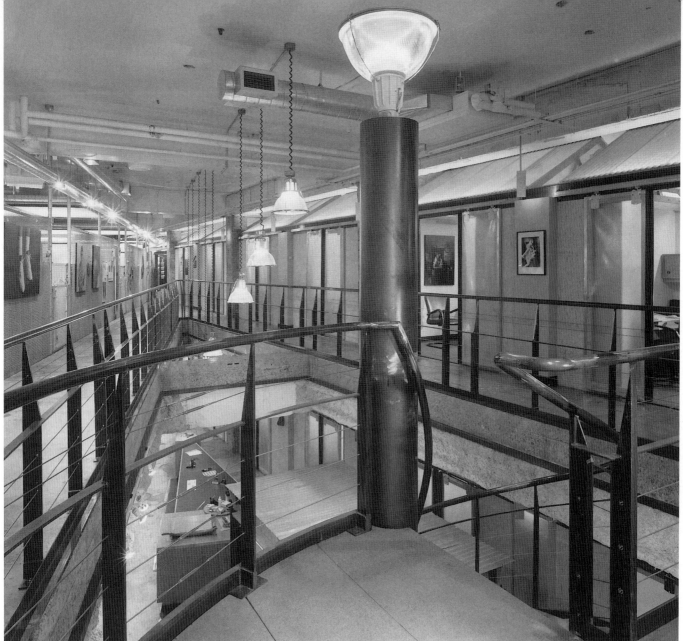

← 7.13

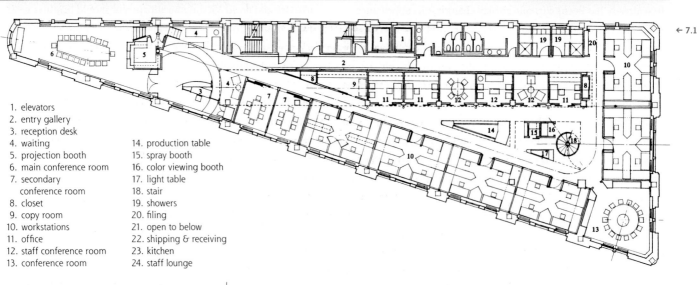

← 7.14

1. elevators
2. entry gallery
3. reception desk
4. waiting
5. projection booth
6. main conference room
7. secondary
 conference room
8. closet
9. copy room
10. workstations
11. office
12. staff conference room
13. conference room

14. production table
15. spray booth
16. color viewing booth
17. light table
18. stair
19. showers
20. filing
21. open to below
22. shipping & receiving
23. kitchen
24. staff lounge

MAIN LEVEL

0 5 10 25 50

7.13, 7.14 Adaptive reuse has turned an unusual triangular space—formerly a printing and production facility for the *Seattle Times*—into highly original offices for the firm of Herring/Newman. The floor plan (fig. 7.14) shows the lower level, seen in figure 7.13 through the open well from the floor above. NBBJ Architecture Design Planning were the designers for this project in Seattle, Washington. (Photograph: Robert Pisano, plan courtesy NBBJ Architecture Design Planning)

exits, stairs, and certain materials may also be an issue.

Many public buildings include large and monumental spaces that may seem depressing (creating a gloomy atmosphere that can be corrected by improved lighting) or simply wasteful in terms of modern economics. How to deal with such spaces in courthouses, post offices, and banks, for example, is a special concern, but it is clear that making new ceilings, carving out commercial shop space, and similar courses of action can be destructive and unwise. Some building types—such as the railroad station—have become largely obsolete. An appropriate new use must first be found for them before design issues can be addressed. Many good examples of intelligent adaptive reuse are appearing (fig. 7.15).

Role of the Designer

Confronting these large and difficult issues, it is easy for any designer to feel discouraged, even hopeless. Even with the best of intentions, what can one do that will have any significant impact on so many intractable problems? It may be helpful to sort the issues into categories of responsibility that suggest differing approaches.

MATTERS WITHIN DIRECT CONTROL OF THE DESIGNER

Many design decisions related to issues of responsibility are entirely within the designer's domain. Planning the placement of elements in relation to windows, for example, can determine how much lighting and ventilation can be naturally provided and how much must be dependent on energy-intensive artificial systems. The choice of materials, normally made on the basis of aesthetic preference, can be modified by an awareness of which materials are drawn from resources subject to rapid depletion. The extent of demolition and reconstruction as compared to preservation and reuse is very much within the field of designers' recommendations. The designer's willingness to investigate and consider the needs and preferences of actual users and occupants, instead of relying on assumptions that may be inaccurate, will have a positive effect on the project's social responsibility.

One of the most difficult positions for a designer may be the decision to refuse involvement in a project that seems too drastically at odds with concepts of responsibility. The rejection of an assignment that appears destined to lead to an irresponsible product may be a hard choice when it seems clear that others will be only too happy to take on the work. The justification that "If I turn it down, someone else will do it anyway" is all too often the excuse offered for proceeding with questionable efforts. Each designer must confront such issues at one time or another and make his or her own decision. In the long run, involvement with projects that are hurtful to broader social goals does nothing to enhance the reputation of a designer. The extra effort involved in acting responsibly, on the other hand, can draw favorable attention and will certainly contribute to any designer's sense of self-esteem.

ISSUES REQUIRING COOPERATION BETWEEN DESIGNER AND CLIENT

Even the decisions that a designer may make alone demand at least the passive approval of a client before they are put into execution. Many larger decisions come to a client's attention in very specific ways: Where will a project be located (where will a building be built, or what rental space will be occupied); what space allocations will be established; what weight will be given to the needs and preferences of users and occupants? In all such areas designer and client must arrive at agreement about the level of responsibility that will be acceptable. Designers can find that their role becomes that of an educator. It is often feared that green design will be costly. Clients may resist proposals that seem unusual in fear that they will lead to excessive expenditures. It is important that designers be prepared to deal with this myth and offer assurances that they will take care to work within budgets and may often be able to point to savings related to green design proposals. Natural light and ventilation cost less than their artificial equivalents. Reuse of an older structure is almost always less costly than new construction. Irresponsibility often comes forward in the guise of economy. Bad lighting costs less than good, and crowding and discomfort may seem economically favorable when compared with the expense of adequate space and superior levels of comfort and convenience. Fortunately, there is extensive evidence to support the idea that "better" is often advantageous as compared to "worse" in the long run. Many socially responsible courses of action can even be shown to be financially beneficial in immediate terms. Often, materials that are recycled or from new sources are less costly than their traditional counterparts. Efforts to limit levels of energy consumption are almost certainly economical since energy in the form of electricity, oil, or gas are inevitably expensive because they use diminishing resources. Natural light and ventilation cost less than their artificial alternatives. Reuse of older structures is frequently a better bargain than new construction. Workers' efficiency rises—and absenteeism and turnover decline—in facilities planned responsibly, with consideration for workers' needs, health, and well-being. Insurance rates drop and liability suits are less likely in facilities that are safe, afford universal access, and reduce health hazards. Responsible design is also likely to increase the life span of a project, minimizing the need for costly upgrades to new standards as they become accepted and legally mandated.

Although many of these concepts become obvious to any thoughtful designer, they may seem strange to individual clients and to client organizations that tend to focus on limited goals and the lowest possible first cost. Preparing a detailed summary of specific savings related to green objectives—including life-cycle costing and calculation of payback periods for energy-efficient appliances, equipment, and design—can be helpful in reassuring clients that there will not be an excessive bill for doing what can readily be seen to be the right thing. There is a clear obligation on the part of every designer to make a case for

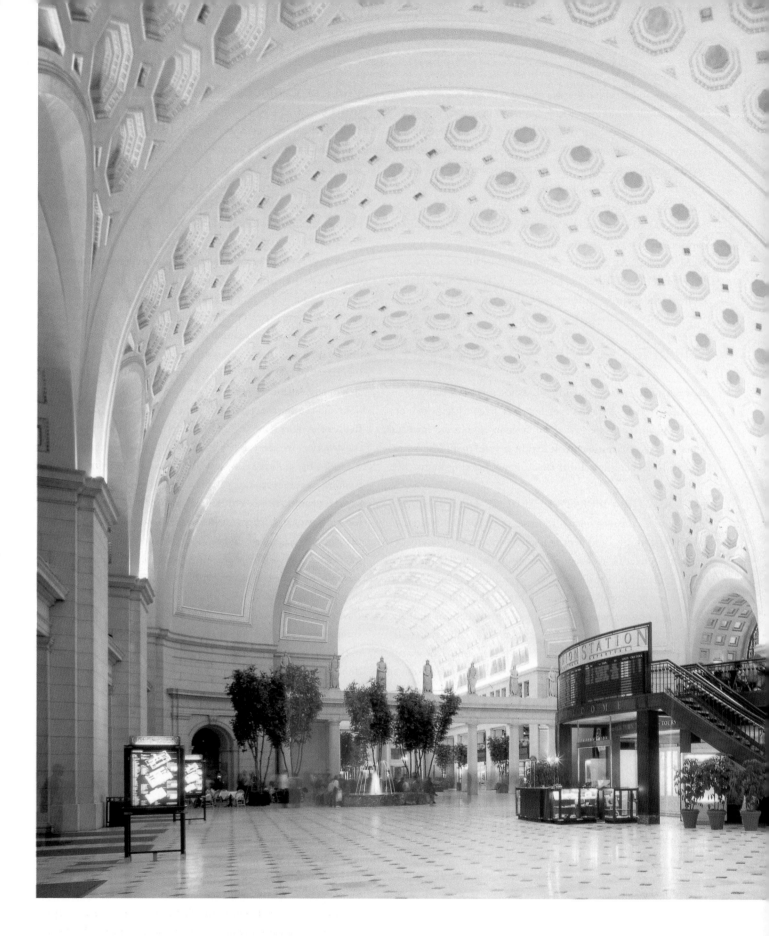

7.15 Union Station in Washington, D.C., a monumental building designed by Daniel H. Burnham in 1908, was rescued by historic preservation and adaptive reuse. The vast spaces of the old station had become underutilized as rail travel decreased in recent years. With the introduction of new retail spaces and a variety of restaurant facilities, the building has been converted into an attractive and popular commercial center while retaining its usefulness as a station. Harry Weese Associates with Benjamin Thompson & Associates were the architects and designers for this project. (Photograph courtesy Osram Sylvania)

7.18 The handsome arched windows of the original building give the office space a distinctive visual character, while new frames allow for the opening of windows for fresh-air circulation in suitable weather (Photograph: © Jeff Goldberg/Esto) **7.19** Lighting, heating, ventilation, and air-conditioning provisions are explained through diagrammatic arrows and related legends in this sectional drawing of a typical perimeter office of the Audubon project. (Courtesy Croxton Collaborative Architects) **7.20** An internal stair connects the skylit circulation space on the eighth (top) floor to the floor below. Throughout the building, the use of natural light is maximized and the need for artificial lighting minimized. (Photograph: © Jeff Goldberg/Esto)

7.18 →

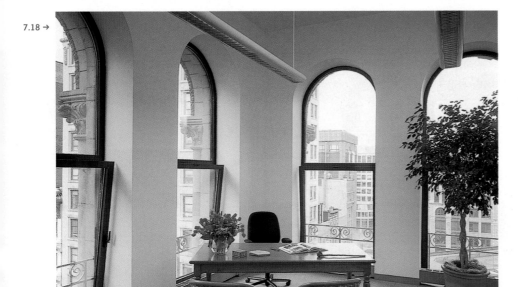

7.19 →

← 7.20

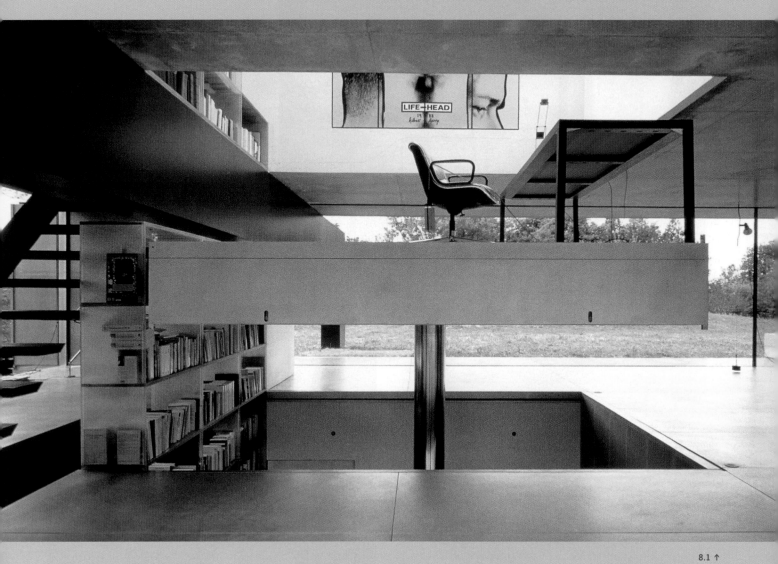

8.1 ↑

chapter eight. Interior Design for Special Needs

Until quite recently interior design—in fact, all design—was based on the idea of serving most people, meaning average people or those close to average. Throughout history, widths of corridors, dimensions of doors, heights of steps, and sizes of furniture have all been determined by the beliefs that people are generally similar and that whatever will serve any one person will serve everyone else equally well. Convenient as this assumption may be, it is obviously false; no one person is average in every way—height, weight, strength, and health. People who are significantly larger or smaller than average in physical size and weight, including infants and children; people weaker than average in some way, including the elderly; and people experiencing either temporary or permanent physical disability are those most likely to be ill-served by design solutions generated for the public at large. People fall into at least one of these special-need groups for some portion of their life spans, making awareness of these needs essential to good design. (See Chapter 7, "Human Factors and Social Responsibility," for the many considerations affecting design for the "average" person.)

Many essential guidelines for meeting the needs of people with physical handicaps are set forth in the code of standards known as ANSI A117.1, developed by the American National Standards Institute. These recommendations have become the basis for most state and national codes dealing with accessibility and accommodation of the disabled. The Americans with Disabilities Act legislation discussed below makes these standards mandatory in a wider variety of situations.

Americans with Disabilities Act

The Americans with Disabilities Act of 1990 (generally known as ADA) stipulates that all commercial and public facilities be *barrier-free*, providing access to people with disabilities. Employers with fifteen or more employees may not discriminate against persons with disabilities who are otherwise qualified for a particular job and must accommodate the disabilities of these employees unless doing so will result in undue hardship. State and local governments also may not discriminate against qualified persons with disabilities, and new construction and alteration of existing structures must provide access for disabled people. By mid-1995, buses, trains, and their stations were to be made barrier-free. Public facilities such as hotels, restaurants, theaters, museums, stores, doctors' offices, and day-care centers may not discriminate in their hiring of employees on the basis of disability, and both new construction and alterations of existing public structures must be made barrier-free.

Since its passage, evidence of the impact of ADA has become widely visible. Rest rooms with space for wheelchair access and handholds for chair users, special elevators in transit facilities, buses with wheelchair lifts, and ramps at steps where no elevator access is possible have become familiar features of American life. The vastness of the effort required to comply with ADA requirements has meant that not all of those requirements have been fully met in every situation, but compliance has been, on the

8.1 The Maison à Bordeaux, Bordeaux, France, has an elevator platform "room" that moves up and down so as to give access to bookshelves on any of three floor levels, an accommodation for the wheel-chair-using owner of the house. Architect Rem Koolhaas was the designer. (Photograph: Hans Werlemann/Hectic Pictures, courtesy OMA, The Netherlands)

whole, surprisingly extensive and has not introduced any of the many anticipated problems. Designers, as they face new projects and renovations of older facilities, are at the forefront of the effort to make ADA compliance complete.

In projects that are private and therefore outside of the jurisdiction of ADA law, concern for special needs is more erratic. Where members of a family are aware of special needs within their group, designers are expected to adjust their proposals accordingly (see Case Study 5, pages 232–33), but where no overt problem exists, it is easy to forget special needs issues. A thoughtful designer can remember that almost everyone becomes at least temporarily a special needs candidate through injury, illness, or simply aging. Since provisions for special needs usually present no problems to those without such needs, making provisions offers a kind of bonus if and when special needs develop.

Clients can be brought to understand the merits of countertop heights that relate to varied human dimensions and to appreciate avoidance of dangerous level changes that offer no benefit and present potential hazards. Even a client indifferent to such issues can benefit from unobtrusive steps that the designer can take toward recognition of an approach to universal design.

Universal Design

In response both to the provisions of ADA and to the growing awareness of the needs of the large percentage of the population currently disadvantaged by so many existing facilities, the concept of *universal design* has emerged. The term refers to the idea that all facilities, all spaces, and all products (from vehicles and furniture to appliances and tools) should be designed to accom-

modate all people with special requirements; in striving for this goal, the needs of the total population will surely be better served. There are, of course, limits to the degree of success possible (at least within the boundaries of present knowledge and technology) in making truly universal design a reality. Nevertheless, it is possible, for example, to make vehicles accessible to the blind; to provide elevators, lifts, and ramps usable by those in wheelchairs; and to make kitchens and bathrooms practical for those with a wide variety of disabilities. It is a reasonable design goal to press for maximum progress in these directions.

An interesting demonstration of universal concepts is embodied in the universal kitchen prototypes developed as a school project at the Rhode Island School of Design (figs. 8.2, 8.3). In a minimum kitchen (really a *kitchenette*) suitable to a small apartment or studio and in a larger kitchen suitable to a larger house or apartment, a variety of proposals are suggested for barrier-free use. Work surfaces can be raised or lowered as most convenient, the dishwasher rises from below counter level to a convenient height for loading and unloading. Refrigerator doors are clear to permit seeing the contents on revolving shelves before the doors are opened. Ventilation hoods move to locations close to the cooking operations that require their use. Another interesting prototype, called a supine workstation (fig. 8.4), provides a reclining seating surface connected to a computer keyboard and monitor arranged to make work practical for a user unable to occupy the usual upright position for office work.

While such proposals are aimed at encouraging similar developments in manufactured products, an office furniture system of comparable originality is now in production that includes an Interactive Tower (fig. 8.5), with full-range height adjustment for a work surface, computer monitor and keyboard, and adjustable

8.2, 8.3 The MIN (fig. 8.2) and MAX (fig. 8.3) versions for the Universal Kitchen Project were developed at the Rhode Island School of Design to demonstrate the ways in which design can serve the needs of users with various physical problems. The entire MIN unit can be raised or lowered to bring work surfaces to the height that best suits the user. The refrigerator door is transparent, and the shelves within rotate for easy access. The dishwasher and waste-disposal units are in swing-out bins at the base. The entire MIN unit can be closed up when not in use. In the MAX version, the *island unit* and its cooktop can be raised or lowered, while a rising unit above contains ventilation hoods and gives access to the dishwasher below, which can also rise for easy loading and unloading. The corner oven has clear space below for easy wheelchair access. (Photographs: Mark Johnson, courtesy Rhode Island School of Design) **8.4** A supine workstation provides computer support and adjustable seating to serve the needs of users with various disabilities (**A**). Even a fully reclined position (**B**) is possible while keyboard and

8.4A →

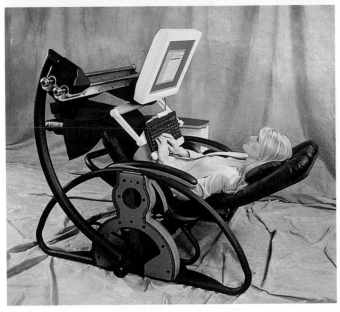

8.4B →

8.5 →

Economic Considerations of Universal Design Codes

Granted the acceptance of universal design goals, businesses, institutions, government agencies, and private individuals tend, as clients of designers, to focus on the added expense of realizing these goals. Elevators cost more to build, maintain, and operate than do stairs. Wide corridors, ramps, and clearances for wheelchair movement require extra space, which is inherently expensive. The price of meeting the requirements of the Americans with Disabilities Act falls equally on all affected and must be accepted as inevitable if our society is to eliminate the needless limitations placed on so large a part of the population.

Projects on which the ADA does not bear, such as private homes and other nonpublic facilities, require designer and client to determine together the degree to which the objectives of universal design should apply. Ignoring these issues may not in the long run be functionally or economically advantageous. A house designed with no consideration of these issues may be serviceable for average adults, but it may cease to be habitable if one of the occupants suffers an injury or illness that creates special needs. An accident to a child or an elderly visitor may not only be an unhappy disaster but costly as well when medical treatment, nursing-home stays, or paid caregivers—even possible liability damage suits—are considered. Before such matters are dismissed as either insignificant or impossible to resolve, it behooves designer and client to review any applicable special needs, which are discussed in this chapter and further enumerated in Table 6, "Checklist for Special Needs," page 230.

display panel all combined into a mobile unit on wheels that can be easily moved about with the flexibility that modern office organization often demands. (See "Economic Considerations of Universal Design Codes," above.)

Children

Everyone begins life as a child and spends a number of years with a body smaller and lighter than that of the average adult. As young children develop from crawlers to walkers, their needs

screen move to usable angles. Julius T. Corkran and Alan Harp of the Design Group at the Center for Rehabilitation Technology, Georgia Institute of Technology, were the designers. (Photographs: Alan Harp, Industrial Designer, courtesy Georgia Institute of Technology) **8.5** This fully adjustable workstation, called an Interactive Tower, is part of the Levity Collection designed by Richard Holbrook and produced by Herman Miller. Surfaces for a computer monitor and keyboard and holders for reference materials are all fully height- adjustable by the user, who can even work sitting on the floor if desired. The unit is totally mobile and folds for easy travel. (Photograph courtesy Herman Miller, Inc.)



differ quite obviously from those of adults, and even well into the preschool years their small and constantly changing body size creates additional concerns relating to safety and comfort that are often overlooked, in part because the remarkable adaptability of young children is often viewed as part of a normal learning process. The phrase "the burnt child dreads the fire" may express a certain truth but ignores the possibility that the burn may be dangerous and quite preventable. Young children cannot articulate their needs in detail, and older children, in their eagerness to achieve adult status, tend to deny such needs, leaving to adults the responsibility to recognize the problems and hazards that children face in the complex modern world.

Particular considerations for children are those related to safety and comfort. When the designer is planning a residence, whether a house or an apartment, with a client whose family makeup is a known factor, the need for appropriate bedrooms, privacy, suitable storage, and other comfort issues is usually taken into account. When residences are developed for rental or sale, assumptions are made about the number and age of the probable occupants. The near certainty that children will be among the occupants of almost any residence at some time, present or future, suggests that thought be given to their requirements.

The issue of safety centers on stairways, railings, gates, windows, and doors, where falls are a hazard to the young child learning to walk, as well as to the older child who runs and jumps and may be tempted to try risky adventures. Stairways with long uninterrupted runs, changes of level, and transitions with just one or two steps are all obvious problems. Railings on stairs, balconies, or decks present risk of failure, the danger of slipping through or catching small heads between supports, and temptations for climbing or other gymnastics. Sharp corners and the hard edges of steps and adjacent walls and railings can be elements of risk. Glass and mirror, especially in large areas close to steps or in places, such as bathrooms, where hard and slippery surfaces are common, are also dangerous to children. Children need to be protected from open fireplaces, heating stoves, and electrical devices, wires, and outlets. Kitchen-stove controls and bathroom faucets and handles must be located with safety in mind. Medicines and other hazardous items, including chemicals for cleaning or hobbies, guns, and so on, need to be stored in safe, enclosed areas.

8.6 Rooms and furniture for children must be designed with the user's size in mind. Clear, bright, usually primary colors are generally considered the most appropriate to children's visual orientation. The United States Child Center, Lemoore, California, was designed by Naomi Hatkin and Pamela Helmich of GHI Architects. (Photograph: Brenner Vandouris)

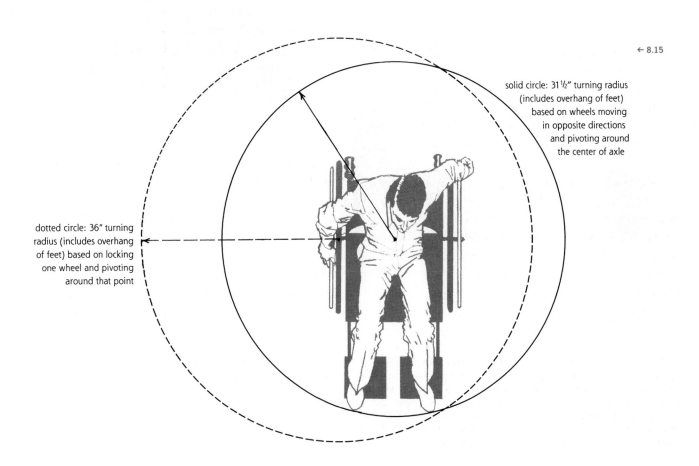

25"

42"

32" min. doorway width

31" maximum forward reach

48½" high reach to shelf

46¾" head to floor

22" maximum side reach

18¼" easy forward reach

16" easy side reach

45½" reach above floor

31" underside of table

38" full reach to high shelf over obstruction

22"

29"

4½"

8¾"

18¾" full reach to low shelf

solid circle: 31½" turning radius (includes overhang of feet) based on wheels moving in opposite directions and pivoting around the center of axle

dotted circle: 36" turning radius (includes overhang of feet) based on locking one wheel and pivoting around that point

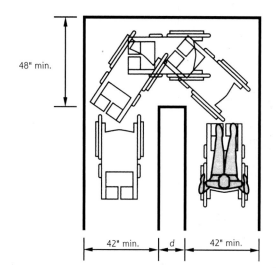

48" min.

42" min. d 42" min.

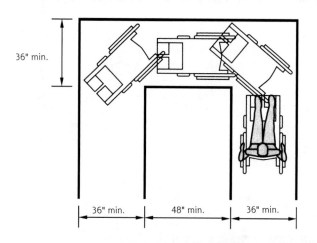

36" min.

36" min. 48" min. 36" min.

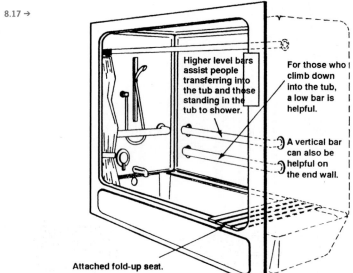

Higher level bars assist people transferring into the tub and those standing in the tub to shower.

For those who climb down into the tub, a low bar is helpful.

A vertical bar can also be helpful on the end wall.

Attached fold-up seat.

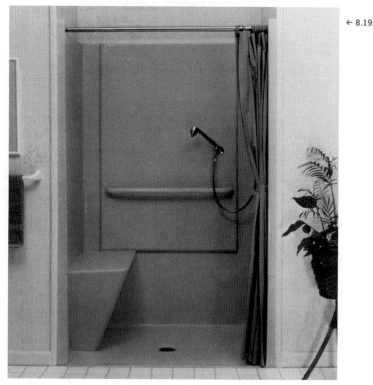

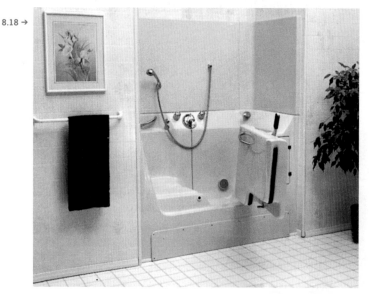

tions, that can be made practicable through design adjustment (fig. 8.22).

The impairment of manual functioning—the use of arms and hands—demands greater emphasis on the selection of specific details than on overall planning. Door hardware, for example, often consists of knobs, handles, thumbplates, and other elements that can be quite problematic for people with a hand or arm that is stiff, paralyzed, or missing. Getting through a closed door can be a difficult challenge for a person thus disabled and can prove impossible if wheelchair use and impairment of hand or arm

8.16 This diagram illustrates wheelchair clearance standards for movement through corridors. **8.17** Grab bars provide tub and shower access for disabled users. This diagram illustrates the various standards and requirements for the design of grab bars. (Courtesy Lasco Bathware) **8.18, 8.19** Many conventional facilities that would be difficult or impossible for a person in a wheelchair to use can be made practicable through design adjustments. Two products of the Silcraft Corporation— a side-access bathtub with handheld shower (fig. 8.18) and a barrier-free shower unit (fig. 8.19)—were designed for users with disabilities. (Photographs courtesy Silcraft Corporation)

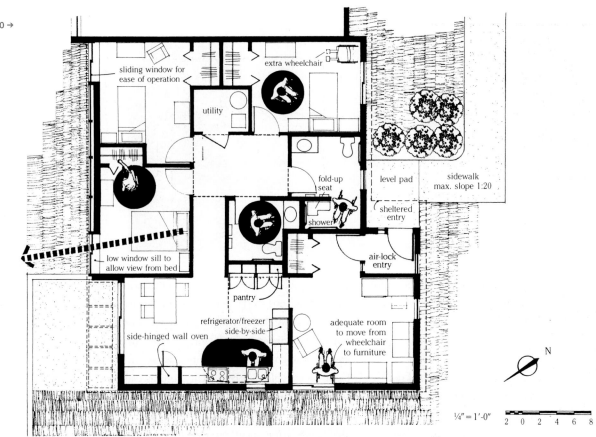

sliding window for ease of operation

extra wheelchair

utility

fold-up seat

level pad

sidewalk max. slope 1:20

sheltered entry

shower

air-lock entry

low window sill to allow view from bed

pantry

refrigerator/freezer side-by-side

side-hinged wall oven

adequate room to move from wheelchair to furniture

N

¼" = 1'-0" 2 0 2 4 6 8

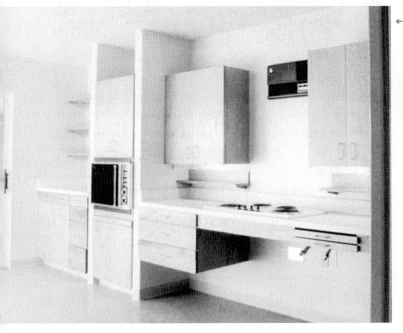

functions are combined. Suitable hardware is helpful, but a full solution to complex disability may require a mechanized opening device. Similarly, the many knobs and buttons that control innumerable everyday functions need to be chosen with antici-

pated problems in mind. Light switches, elevator call buttons, telephones, thermostats, and appliance controls frequently are placed too high for wheelchair users and are too small or awkward to operate with limited or absent hand function. Sound- or

8.20, 8.21 The floor plan (fig. 8.20) illustrates barrier-free strategies in a residential apartment designed to accommodate a person with a disability. The shaded central zone indicates a circulation path for wheelchairs. The Nutting Apartments for Disabled Persons,

Amherst, Massachusetts, was designed by Juster Pope Associates Architects and Planners. In an interior of the Nutting Apartments, the kitchen area (fig. 8.21) is designed to make appliances and work surfaces easily accessible to residents in wheelchairs. A low oven (left) comes

equipped with a pullout shelf below, to facilitate use by a person in a wheelchair. The two-handled work surface (right) pulls out from the counter to allow wheelchair clearance and provide a comfortable working height. (Photographs courtesy Juster Pope Associates) **8.22** Well-

designed alternatives to standard appliances can often accommodate the needs of users with disabilities. A horizontal refrigerator by Penguin Products offers improved accessibility to people in wheelchairs. (Photograph courtesy Penguin Products)

proximity-activated electric switches may be the best solution for certain locations. In addition, the selection of bathroom faucets and drain controls must be made with care.

A number of safety issues require special attention to the needs of those with disabilities. Fire exits are often poorly located, narrow, and may use stairs or ladders—difficult if not impossible for the disabled to negotiate. Even mild sight impairment calls for signs and lettering large and clear enough to make reading easy; blindness renders standard emergency-exit signs and lights totally ineffective. Signs and labels, such as the floor numbers of elevator controls, can be composed of braille numerals or other markings that convey information through touch (fig. 8.23); audible signals also offer assistance. Objects protruding from a wall or other support pose a hazard to the visually impaired. Projections should not exceed 4 inches, unless the object extends to below 27 inches above the floor, making it detectable by walking cane. Overhead obstructions must be no lower than 80 inches above the floor. Flooring at the edges of such hazards as stairs and other level changes not protected by railings (including platforms and driveways) must have a surface that is noticeably rough, grooved, or otherwise textured to contrast with surrounding surfaces. The handles of doors that open into hazardous areas must be distinguishable by touch from other handles. Emergency warning systems require both audible and visual signals. Details such as the location and workability of fire-alarm boxes, as well as the practicality of exit-door hardware, demand thoughtful consideration and a thorough understanding of current legal requirements (fig. 8.24).

The extent to which barrier-free design can serve every type of disability varies. The provision of ramps, escalators, and elevators, the avoidance of needless level changes, and the allotment of space for wheelchair movement are all now required by law in the design of public places. These accommodations also turn out to be advantageous to the general public. Other aids for disabled users may have little value to people without physical problems but cause no inconvenience. Tactile labeling of directional signs and elevator controls, for example, assist blind users yet are barely noticeable to others. Still more specialized arrangements, such as kitchen counters, appliances, and cabinets set at heights accessible to wheelchair occupants or bathroom fixtures with variable height adjustments (see figs. 8.9–8.11), are not feasible for every situation but can be made available where it is known there will be a user who can benefit from such equipment. In practice the designer can expect to provide legally mandated and intelligently conceived accommodations for disabled users in every project to the maximum extent that current techniques allow. Further measures to deal with specific problems may be considered when a prospective occupant has special needs that can be defined and dealt with on an individual basis, as with a residential project for a person with a disability—a blind person, perhaps, or a wheelchair user. (See Case Study 5, page 232.) A private office could be similarly planned to offer optimum conditions for an occupant with specific requirements. Such individualized design for special needs can achieve a remarkably high level of accommodation to disability problems (fig. 8.25).

Home Nursing

The staggering costs of hospital and nursing-home care, together with the inevitable discomfort and unhappiness associated with such facilities, have led to a new interest in maximizing home care for health and disability problems. This usually involves personnel—family members, hired aides, or, in many situations,

8.23 Directional signs can include equivalent legends in braille to aid sight-impaired visitors. Such signs are mounted at a height of 60 inches from floor to centerline (an ADA standard) to make location by touch easy. The sign shown here was designed by Vignelli Associates Designers for the Solomon R. Guggenheim Museum, New York. (Photograph courtesy Vignelli Associates Designers) **8.24** Fire safety is an important consideration in designing for elderly or disabled persons. The Lodex manual fire-alarm system, an invention of Kevin Jameson, can be adjusted to a height of 48 inches to meet the standard forward reach of a wheelchair user. Its name is derived from the words *low* and *dexterity*. (Photograph courtesy Kevcor Limited)

part-time attendants—who can deal with the needs of elderly or disabled persons or both in a home setting if suitable facilities are available. Interior design becomes a factor in providing those accommodations.

The typical basic requirements for satisfactory home care include a room with easy access; an appropriate bed and additional furniture, such as a chair suitable for long periods of sitting; conveniently located appliances, such as lighting, telephone, and television; and a bathroom with close and easy access fitted with suitable fixtures. Food-preparation, serving, and cleanup areas must also be available. An extra room, such as a den or guest room—if location, access, relation to bath, and so on, have been considered—can greatly facilitate home care, as living space either for the ailing person or for a live-in nurse or other care-

giver. Because the need for home care often arises unexpectedly (after an accident or sudden illness, for example), suitable interior arrangements may be difficult or impossible to prepare on short notice, suggesting that some degree of contingency planning in residential projects may be wise. The concept of adaptable housing is a step in that direction.

Adaptability

To make every residential unit fully accessible and usable for the entire range of special needs, no matter how desirable this might be, would involve arrangements that in practice would come into use in only a small percentage of cases. Houses that are not

8.25 Planning for a sight-impaired client, the architects selected various flooring materials and strong wall textures that change from level to level or space to space, providing tactile information on location, while the flowing mahogany railing serves as a guideline. The sighted members of the family can enjoy the visual effect of these design details. The circulation and stair core of this house is also a conservatory, adding other sensory touches. The house, near New York City, was designed by Charles Moore and Richard B. Oliver, architects. (Photograph: © Norman McGrath)

Table 6. Checklist for Special Needs

ACCESSIBILITY

- Doors easy to open and close
- Storage accessible to limited high and low reach (upper shelf edge at maximum of 48" above floor)
- Heights of switches, thermostats, alarms, and so on accessible to limited high and low reach
- Controls made childproof or positioned out of child reach as needed
- Stove, oven, and other appliances, as well as cabinet doors, workable for users with disabilities
- Work-surface heights appropriate or adjustable for users with disabilities
- Sinks and washbasins accessible to wheelchair users (30″-wide clear space under obstacles)
- Bathroom fixtures usable by people with disabilities (with grab bars as appropriate)

MOBILITY

- Barrier-free passage for those using crutches, walkers, and wheelchairs (36″ passage, 60″ double-passage width)
- Door-opening clearance for wheelchairs (32″ minimum)
- Clearance for wheelchair turns and turnarounds (60″–78″ diameter)
- Rails (34″–38″ height above floor or stair nosing) and grab bars where required
- Floor surfaces smooth (free of obstacles) but nonslip
- Avoidance of trip hazards (edges of rugs, door saddles, small rugs and mats)
- Edge markers (visual and tactile) at edges of steps and other drops
- Avoidance of steps and stairs where possible
- Provision of ramps (36″ minimum width, 1:12 maximum slope, 30″ maximum rise for one run, 60″ flat platform, and 90-degree turn)
- Stairs and steps of moderate slope, short runs between landings but greater than a single or only a few steps (7″ maximum riser height, 11″ minimum tread width), no winders, spiral stairs, or open risers
- Elevators with wheelchair clearance (36″ minimum door width, 51″ minimum depth, 68″ minimum width, or 80″ with centered door)

USABILITY

- Door hardware easily operable by users with disabilities
- Faucets and drain easily operable by users with disabilities
- Kitchen appliance controls easily operable by users with disabilities
- Mirror heights set low (bottom edge not above 27″)
- Windows easily operable by users with disabilities

VISION

- Adequate light levels
- Auditory signals to supplement visual signals
- Warning signals (markings and alarms) in a form effective for visually impaired
- Edge markings for stairs and other drops (strong color, tactile edgings)
- Lighting adjustable to provide needed intensities and avoid discomfort
- Braille or other tactile markings where needed
- Signs and labels with adequate size and typography

HEARING

- Visual signals to repeat auditory warnings, alarms, telephone bells, and other signals
- Acoustical controls to limit excess background noise and "cross-talk" interference

SAFETY

- Emergency exit paths, doors, and stairs usable by people with disabilities
- Emergency markings, signs, lights, and so on visible or audible or both to people with disabilities
- Emergency signals, fire-alarm boxes, and so on usable by people with disabilities
- Fire hazards minimized (upholstery, mattresses, and carpets flameproofed)
- Passive fire alarms and control devices provided (smoke- and heat-sensitive alarms, carbon monoxide alarms, automatic sprinkler systems)
- Sturdy rails at all appropriate locations (balconies, deck edges, and so on)
- Ground-fault interrupters at all electrical outlets with proximity to grounding (water pipes and faucets)
- Safety glass or impact-resistant plastic wherever glass breakage may occur
- Markings on glass doors and transparent wall surfaces to prevent accidental collisions

Table 8. Interior Materials

KEY
- Structural use (light)
- Nonstructural use (frequent) (medium)
- Nonstructural use (occasional) (dark)
- Empty position: Unsuitable or rarely used

			FLOORS	WALLS	COLUMNS	CEILINGS	STAIRS	DOORS	WINDOW FRAMES	WINDOW TREATMENT	MOVABLE FURNITURE	BUILT-IN FURNITURE	BATHROOM FIXTURES*	KITCHEN FIXTURES*	FIREPLACES	MANTELS	TRIM	HARDWARE
WOOD		Soft	●●	●●	●●		●●	●	●		●	●	●	●		●	●	
		Hard	●	●		●	●	●	●		●	●	●	●		●	●	
		Paneling		●				●										
		Plywood	●	●		●	●	●			●	●	●	●				
		Boarding	●	●		●		●										
MASONRY	STONE	Fieldstone	●●	●●											●●			
		Limestone		●●											●●			
		Travertine	●	●			●				●							
		Marble	●	●	●●		●				●		●		●	●		
		Granite	●	●●			●●				●		●					
		Slate	●				●						●					
	CONCRETE	Mass	●●															
		Reinforced	●●	●	●	●	●								●●			
		Block		●											●●			
	GYPSUM	Block		●●														
	BRICK		●	●●	●●		●								●●	●		
	TILE	Ceramic, vitreous	●	●	●							●	●		●		●	
		Porcelain		●	●													
		Quarry	●				●											
		Mosaic	●	●	●							●	●					
		Terra-cotta		●	●													
	TERRAZZO		●				●											
METALS	STEEL	Mild			●●		●●	●	●		●	●	●	●	●			●
		Stainless				●					●		●	●				
		Enameled		●		●							●	●				●
	IRON	Cast		●	●										●			●
		Enameled											●		●			●
	ALUMINUM	Cast				●					●						●	●
		Extruded							●		●							●
	BRONZE					●												●
	BRASS										●							●
	COPPER					●											●	●
	DIE-CAST																	●

Table 8. Interior Materials (continued)

		FLOORS	WALLS	COLUMNS	CEILINGS	STAIRS	DOORS	WINDOW FRAMES	WINDOW TREATMENT	MOVABLE FURNITURE	BUILT-IN FURNITURE	BATHROOM FIXTURES*	KITCHEN FIXTURES*	FIREPLACES	MANTELS	TRIM	HARDWARE
GLASS	WINDOW							●				●					
	PLATE							●		●		●					
	TEMPERED		●				●	●				●					
	MIRROR		●	●	●					●	●	●					
	BLOCK		●														
PLASTIC	TRANSPARENT		●					●		●							
	LAMINATE		●	●			●			●	●	●	●				
	SHEET WALL COVERING		●	●													
	EXTRUSION					●		●		●	●		●			●	
	TILE	●	●			●											
TEXTILES	DRAPERY		●				●		●								
	UPHOLSTERY		●							●	●						
	WALL COVERING		●														
	CARPET	●	●			●											
MISCELLANEOUS	LATH AND PLASTER		●	●	●												
	DRYWALL		●	●	●												
	ACOUSTIC TILE				●												
	LINOLEUM	●	●			●								●			
	ASPHALT TILE	●				●											
	CORK	●	●														
	RUBBER	●															

The word fixtures includes plumbing and appliances.

electricity consumed in the refining process. Energy production consumes coal, gas, and oil, all resources destined for depletion if present rates of consumption continue. Energy production and consumption result in by-products that contribute to the formation of acid rain, with resultant damage to plant life and the ecosystems dependent on it.

POLLUTION AND WASTE

Among the by-products of the processes of energy generation and manufacturing are air pollution and other wastes. Atomic energy plants are an obvious source of nuclear waste that has no known practical means of disposal. Materials put into use in structures and products will generally turn to waste as the uses made of

them become obsolete. Although the materials of surviving great historic buildings remain in use, many modern buildings have short lives and are demolished to make room for replacements. Demolition turns a large share of the materials of a structure into waste—a steel frame may be worth selling for scrap and so is recycled, but the glass, concrete, smaller wood, and synthetic elements typical of modern buildings are often ground up, burned, or transported to landfills where space is running out. Fine antique furniture hundreds of years old retains the use of the wood from which it was constructed, but tables and chairs only a few years old are commonly scrapped, with their materials—metals, wood, and plastic—adding to landfill overload. Other waste is developed at construction sites when materials are cut and assembled and packaging (used to aid shipment from production factories) is removed and discarded. Disposal of construction waste is costly and troublesome, adding to the overuse of landfills and incinerators, while the latter in turn contribute their share to air pollution.

INTERIOR ENVIRONMENT IMPACT

Materials can also influence interior air quality in potentially undesirable ways. The odors associated with many familiar materials—the smell of freshly cut wood, of fine leather and other natural materials—are reminders that materials give off fumes and vapors over long periods of time. Fortunately, the vapors coming from the traditional natural materials are generally harmless, but modern synthetics, plastics, and solvents used in paints, other finishes, and adhesives can be insidious and harmful, especially in spaces without ample ventilation, such as the typical sealed interior common to many modern buildings.

Contemporary sealed interiors, unfortunately, are all too likely to make use of a high percentage of synthetic materials. Wall paneling of manufactured boarding; plastic fibers in carpets as well as drapery and upholstery fabrics; plastic foams in upholstery; and many synthetic finishes for floors, walls, and ceilings have all been found to give off fumes over a long period of time in a process called *off-gassing* that pollutes interior air. Air-conditioning systems in these buildings commonly recycle air to limit energy consumption, so that the so-called fresh-air supply is actually recirculated air in which a concentration of pollutants gradually builds. Bacterial concentrations may accrue in ducts and other parts of air-conditioning systems, encouraging the spread of infectious diseases. Many complaints of nose, throat, and eye irritations, headaches, and other less specific ailments have been traced to pollutants in the air of enclosed spaces. Formaldehyde, a chemical much used in adhesives and in the making of particleboard and similar construction materials, has been found to have a direct relationship to various physical ailments; its use is now generally forbidden by various health codes. Benzine, xylene, and toluene are also carcinogens often present in wall and floor coverings and in the adhesives used with them.

Many older materials have been found to be associated with health hazards little suspected when they were in widespread use. Removal or containment of such materials is a continuing and expensive problem in the renovation of existing building interiors. Lead, until recently the most common base for paint pigments, is a hazardous substance that can cause brain injury, particularly to young children. Removal of lead-based paints and avoidance of lead pipe or other lead plumbing parts (such as faucets) is an important environmental concern. The mineral asbestos, long a favorite material for insulation and fireproofing, is a highly dangerous carcinogen. Although the disastrous health risks experienced by asbestos workers have brought about a general ban on asbestos in most uses, it remains present in pipe and duct insulation in numerous older buildings. Asbestos was also extensively used in the making of floor tile and various sheet products, flat or corrugated, that were popular several decades ago. Removal or containment of asbestos is essential, but the very process of removal can be extremely hazardous.

Fire risks involve additional concerns discussed more fully in Chapter 15, "Mechanical Systems." Most of these hazards arise when materials give off highly toxic fumes during smoldering or burning. Although fire-control systems are a primary defense against such dangers, the selection of materials that resist ignition, do not support combustion readily, and give off less harmful combustion by-products is prudent. Certain interior spaces, such as the passenger cabins of aircraft, are particularly problematic because of the prevailing use of all-synthetic interior materials in an environment where accidents are often accompanied by fire. In such accidents, toxic fumes may account for more fatalities than other bodily injuries.

SICK-BUILDING SYNDROME

The phrase *sick-building syndrome* has come into popular use to describe buildings in which indoor air quality is so unsatisfactory as to cause serious illness and lesser physical complaints among users or residents. The term is somewhat misleading, since it is not, of course, the building itself that is sick but rather the occupants who suffer from problems created by the environmental maladies that the building generates.

The best defenses against sick-building syndrome are removal of all known hazardous materials, care in specification of new materials to avoid potential pollutants (natural materials most often are the least offensive), air-conditioning and ventilation systems that offer ample input of outdoor air (ideally six changes of air or more per hour, with an intake of outdoor air in a ratio exceeding 24 cubic feet per minute), and wherever possible, windows that can be opened to permit free air circulation. In general, minimizing the use of synthetic materials, care in checking the health certification of all materials, and provision of ample ventilation and air cleansing are the principal lines of defense against material-related hazards. (Further discussion of these issues can be found on pages 460–62.)

Types of Materials

While all materials originate from natural sources, human needs impose certain levels of modification on materials as they are found in nature.

The following are the three levels of processing these materials:

- *Natural materials.* Except when they need to be superficially modified for use, natural materials remain unchanged. Stone and wood, for example, can be used in their natural forms, but they are usually cut into standard shapes. Quarried stone is most often cut into blocks, in which form it is called *ashlar*, and trees are cut first into logs, then into boards, or lumber, of standardized forms and sizes.
- *Processed materials.* The result of converting natural materials into special forms for practical use is processed materials. The natural material clay takes on different properties and uses when fired into brick and tile. Sand and small stones (called *aggregate*), when bonded together with *cement*, form concrete, a kind of artificial stone that can be poured in mass, reinforced with embedded steel rods, or made up into blocks similar to cut stone. Wood may be sliced into thin sheets of veneer, and layers of veneer may be glued together to form plywood. All metals require processing to extract them from ore, refine them, and possibly combine them into alloys. Then they are formed into sheets, tubes, rolled sections, castings, or other shapes.
- *Synthetic materials.* These do not exist in nature but have been brought into being, or manufactured, through artificial processes. Glass is an ancient synthetic made from sand and various other elements fused by heat. Plastics, the most familiar of modern synthetics, are made from various chemicals, most of them derived from petroleum. Synthetics themselves can be combined, leading to the creation of hybrids, such as fiberglass.

In practice, many materials result from combinations of these levels of processing. A natural fiber such as wool may be processed through spinning and weaving to make a textile. A core of solid wood may be surfaced with a synthetic plastic laminate. Rolled steel beams or columns may be enclosed in poured concrete and covered in turn with metal lath and plaster, plasterboard, solid wood boards, plywood, tile, or any number of other materials.

Wood

STRUCTURAL

Timber is the most widely available, simplest, and most familiar of structural materials. Wherever there are trees, the use of wood for building becomes commonplace. Wood is limited by its source, trees, to a lengthwise strip material. This in turn limits timber building structure to a *frame*, that is, a cage or grid of long

← 9.3

members put together with diagonal bracing members to form a sturdy structural support for whatever wall and roofing materials will be used. Walls and roofing may also be wood (in the form of vertical planks, clapboards, or shingles) or other materials, such as plaster and rubble for walls, tiles or tar paper for roofing.

Wood makes a reasonably durable, but not permanent, building material, being subject to decay, rot, insect damage, and fire. Wood buildings over a few hundred years of age are rare, and none from ancient times survive, although we have knowledge of wood construction in ancient Egypt, Greece, and Rome from secondary sources such as paintings, written materials, and physical evidence in ruined structures.

Because of its lengthwise structure and comparatively light weight, wood was a favorite material for floors and roofs even when walls were made of stone or other more lasting materials. Many ancient ruined structures exhibit surviving masonry walls and columns, while wood roofing has been lost through one or another form of damage. Surviving wood roofing used for medieval barns, churches, and other large spaces often displays large wooden members assembled into triangular arrangements called *trusses* in order to span spaces wider than the longest available beams. The frames of heavy timber used for many smaller medieval structures are often exposed externally, creating the visual patterns of *half-timber* construction (see fig. 4.18). In America, since exposed framing proved impractical because of climatic conditions, such framing in Colonial houses and other buildings was usually hidden by an external covering of shingles or boarding (see fig. 4.44). However, if it was not covered by paneling or plaster, the framing was often visible inside.

The development of power saws and planers in more modern times has led to the practice of converting timber into neatly cut and sized units, referred to as *lumber.* Modern wood construction uses sawmill-cut lumber for the heavy framing or, for smaller

buildings, smaller members placed close together to form a light but strong frame. Small houses are commonly built with a structure of 2-by-4-inch studs placed 16 inches apart to form wall framing. Joists for floors and rafters for roofs are also 2 inches thick but 8, 10, or 12 inches deep. They are also placed at the same 16-inch spacing. An outside sheathing and an interior finish together create a hollow "sandwich" assembly that provides reasonable strength with minimum material and labor costs. This system, called *balloon* or *western framing*, is characteristically American and is still in very common use for the construction of small houses (fig. 9.3). *Braced framing*, using horizontal beams mortised into heavy, full-frame-high timber posts, with one-story vertical posts between, usually diagonally braced, also continues in use and has become popular with modern architects to form the structure for houses and other small buildings, particularly where large areas of walls are given over to glass.

The industrial processing of wood has added plywood and particleboard to the list of timber materials. Both of these convert wood into large sheets that minimize solid wood's tendency to warp, shrink, and split. Plywood is made up of layers of thin wood veneer, particleboard of wood chips and sawdust bonded together with an adhesive and pressed into flat sheets. Both materials make economical use of wood, and both are most useful for sheathing walls, roofs, and floors rather than as primary structural materials.

Although its use as a major building material is limited in modern practice by the combination of rising cost (resulting from diminishing supplies) and restrictions introduced to reduce fire risks, wood seems assured a continuing role in the architectural construction of smaller buildings and as a secondary material in building that uses other materials for primary structure. Although wood structure is usually hidden, it influences the location and size of openings. When wood-frame members are exposed, they may become major visual design elements (fig. 9.4).

INTERIOR

Along with its role as one of the primary materials of architectural construction, wood is used in many interior applications as well as for furniture construction (see pages 418–24; see also Table 25, "Characteristics of the Most-Used Furniture Woods" in Chapter 13, "Furniture"). All wood has characteristics connected to its origin in the trunks of trees: a lengthwise grain, limitations on available length and width, and visible grain patterns that relate to the ways in which logs are cut to produce usable lumber.

The following general information is applicable to wood in all of its many uses:

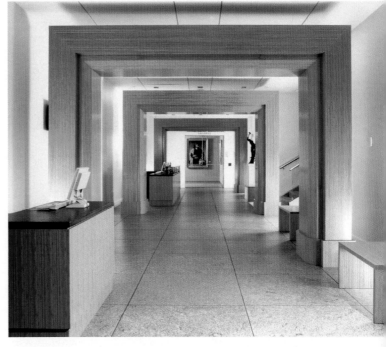

9.4 ↑

Softwood The term *softwood* refers to the woods of evergreen trees (conifers) that are generally fast growing and therefore sufficiently "soft" to cut with a handsaw and be assembled with hammer and nails. Pine, spruce, fir, and other softwoods are the materials of carpentry. Redwood and cypress are valued for their oil content, which allows them to last well out-of-doors even when left unpainted. Wide-board floors, some interior paneling, and the *tongue-and-groove* boarding often used for *wainscoting* and other wall surfacing, and the moldings used for the majority of trim are of softwood milled into standard forms readily available at lumberyards. Natural finishes, stains, or paints are usually applied to softwoods to provide surface protection.

Hardwood The wood from deciduous trees, including fruit and nut trees as well as others that lose their leaves annually, is denser and "harder" than the softwoods. Hardwoods are of good appearance and take finishes well, rendering them suitable for fine cabinetry and furniture making. Birch and maple are often used for wood flooring and for furniture. Mahogany, oak, and walnut are familiar hardwoods in wide use. Other hardwoods are less available, and their use is confined to furniture and decorative applications. Cherry, ash, hickory, satinwood, zebrawood, and ebony are used in limited applications for decorative effect. Poplar is frequently used in concealed locations, as in a plywood core. Table 9, "Status of Tropical Hardwoods," page 244, lists the major hardwoods that are endangered or threatened by over- or unregulated harvesting of tropical forests.

9.3 The structural system of wood framing known as balloon framing was developed in Victorian America. Small, lumberyard-sawed wood pieces are assembled in a frame that is easy and economical to construct. When they are vertical, these elements are called *studs*; when horizontal, *joists*; and when roof supports, *rafters*. 9.4 The materials used for the interior design of the Dahesh Museum in New York, completed in 2003, include a liberal use of bamboo for corridor arches, cabinetry and trims. The heavy arches shown here lead the eye down the corridor, suggesting both depth and containment.

Table 9. Status of Tropical Hardwoods

TRADE NAME (Scientific name in italics)*	SOURCE	MAIN USES/COMMENTS
ENDANGERED		
Afrormosia (Pericopsis elata)	Africa	Furniture
Ebony (Diosporos spp.)	Africa, Southeast Asia	Musical instruments, inlay, brush backs
Iroko (Chlorophora excelsa, C. regia)	Africa	Veneer, furniture
Mahogany (Khaya spp.)	Africa	Furniture, paneling, turnery, doorframes
Paduak (Pterocarpus soyauxii, P. spp.)	Africa, Southeast Asia	Joinery, veneer, furniture
Rosewood (Dalbergia stevensonii, D. nigra, D. latifolia)	Latin America, Southeast Asia	Joinery, handles, musical instruments, furniture
THREATENED OR OVEREXPLOITED		
Sapele (Entandrophragma cylindricum)	Africa	Veneer, furniture, cabinetry, joinery
Mahogany (Swietenia macrophylla)	Latin America	Furniture, paneling, turnery, doorframes
Teak (Tectona grandis)	Southeast Asia	Shipbuilding, joinery, furniture, flooring
Utile (Entandrophragma utile)	Africa	Veneer, cabinetry
Lauan/Meranti/Philippine mahogany (Shorea spp., Pentacme contorta)	Southeast Asia	Plywood, furniture parts, light structural work
Ramin (Gonstylus spp.)	Southeast Asia	Furniture, interior joinery, moldings, plywood, picture frames
Okoume (Aucoumea klaineana)	Africa	Furniture components, joinery, paneling
LITTLE OR NO FOREST DAMAGE		
Rubberwood (Hevea spp.)	Malaysian plantations	Furniture: Good replacement for ramin
Teak	Javanese plantations Hard to distinguish from other teak.	Shipbuilding, joinery, furniture, flooring:
Virola (Dialyanthera, Virola spp.)	Amazonian swamp forests	General utility: No road building required; not managed but regenerates well

** Some family names contain numerous species (spp.).*

Plywood A widely used material, plywood is made by bonding together a number of layers. Veneer plywood is made of many thin layers, most often of fir. The outer layer of *veneer-core plywood* may be fir (suitable solely to utility applications) or it may be a veneer of better appearance, such as birch or walnut. *Solid-core plywood* is plywood made with a core of solid wood (often poplar) plus two outer layers, cross-banded with the grain running across that of the core, and a surface layer of attractive face veneer. Both faces of plywood must have the same layering in order to achieve balanced construction and discourage warping. Particleboard can also be used as a core for plywood, requiring only one layer of face veneer on both sides.

Veneer Wood can be cut into very thin slices (usually (⅛-inch thick), making sheets that are somewhat flexible. Successive layers sliced from one log or slab form a *flitch*, with each layer repeating the grain pattern of the adjacent layers. When veneer is glued to its backing or core, the arrangement of adjacent strips can create various patterns, including the symmetry of *book matching*, the repetition of *slip* or *end matching*, and the diamond shape of *diamond* or *quarter matching* (fig. 9.5).

Particleboard A sheet material made by pressing together wood chips and sawdust with an adhesive to make a board or panel, particleboard has most of the qualities of wood but is grainless. A similar board made with higher pressures to create greater strength and smooth surfaces is called *hardboard*; Masonite is a familiar trade name of a brand of hardboard.

Lamination Strips of solid wood can be laminated together to make large surfaces, such as the widely used *butcher block*.

Bentwood Strips of certain woods, when subject to steam heat and moisture, can be made sufficiently flexible to be bent around forms. When dried and cooled, the bent shapes are retained. The

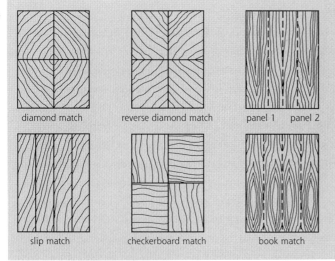

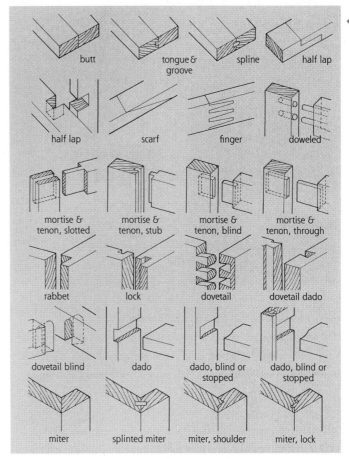

furniture manufacturer who developed this process, Michael Thonet (1796–1871), created in his Austrian firm an extensive line of bentwood furniture during the mid-nineteenth century (see fig. 13.39). Bentwood furniture remains popular today.

Molded Plywood If layers of veneer are pressed between molds while being glued together to form plywood, the finished product will retain the form of the mold. Molded plywood is often used for parts of furniture, including chair seats or backs.

Because wood is available in boards or sheets of limited size, most applications for the material require the assembly of a number of separate pieces. The term *joinery* describes the great variety of wood joints that are used in making furniture, paneling doors, and manufacturing windows and other items of *millwork* (fig. 9.6).

Wood joints and other woodwork details have been developed over hundreds of years to deal with the following issues:

Shrinking and swelling. Changes in humidity cause wood to shrink and swell making it necessary for larger expanses of wood to be put together with some allowance for movement, as in *rail-and-panel* construction.

Warping. Turning and twisting out of shape is also largely controlled in rail-and-panel construction, as thicker rails hold thinner panels flat.

End grain. The exposed surface where wood is cut across the grain is of unsatisfactory appearance and takes finishes poorly. *Miter joints* and special edge treatments are used to hide not only end grain but also the layering of plywood and core panels.

Glues. Some adhesives, particularly older types of glue, may not hold joints when stressed. Many joints are intended to hold

parts together through interlocking so that glue need not be depended upon. Although modern resin glues usually develop joints of high strength, traditional joints are often still used both for their good appearance and their usefulness in holding parts in place while glue is drying.

Many wood joints have an attractive appearance and can enhance the aesthetic quality of objects where they are used. *Dovetails, mortise-and-tenon* joints, and exposed *dowel* joints are among those that can be ornamental and suggestive of fine craftsmanship.

Wood requires finishing to seal open grain structure and create attractive and durable surfaces. Various paints, varnishes, lacquers, and oils can be used to create finishes of varied appearance. (For a brief description of the most popular finishes for wood and other materials, see Table 11, "Interior Primers and Finish Coatings," page 266.) Wood is an attractive material for many uses in interior design. It is widely available and a renewable natural resource in spite of the way in which excess tree cutting is gradually reducing availability (see page 205). Its design implications suggest warmth and comfort, so that wood floors, walls, and other

9.5 When veneers are sliced from a solid block, the successive sheets laid to make up a flitch have virtually identical grain patterns. The arrangement of veneers can generate a wide variety of patterns, some of which are shown in this chart. (Drawing courtesy Hardwood, Plywood & Veneer Association) **9.6** Woodworkers have developed many ways of joining wood to aid strength and govern appearance. Some commonly used woodworking (often called millwork) joints appear in this chart.

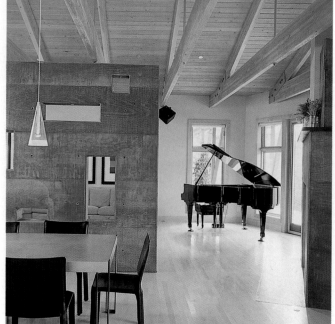

elements seem pleasant and natural in many contexts (fig. 9.7). The use of wood in visible areas tends to reduce any suggestions of coldness that may arise from the use of masonry, metals, and glass. Criticisms of early Modern design as cold and unhuman arise, in part, because of the avoidance of wood in favor of glass and metal, considered "modern" in the early years of the International Style, whereas wood appeared to be "traditional." Recent practice avoids such thinking, though it is now necessary to be watchful over uses of rare and exotic woods that may be endangered through overuse and resultant forest depletion. The Forest Stewardship Council (FSC) has set standards for forest management. Products carrying the designation FSC meet these standards.

Masonry

Masonry is the general term for a family of materials that played a major role in historic building and that continues in modern use. The term refers to construction with stone and manufactured materials such as brick, tile, concrete block, and gypsum block—even the mud brick used in some ancient and indigenous buildings. With the exception of mud brick, masonry materials offer excellent durability. The oldest surviving buildings and ceremonial structures are all of stone (for example, the pyramids of Egypt, see fig. 4.3, and Stonehenge), and the ruins of ancient structures are usually the remaining stone portions of buildings that used timber roofing.

Use of stone requires available quarry resources and involves the tools and labor required to cut, transport, and erect this heavy material. Bricks and tiles are invented materials that have many of the qualities of stone, except that they can be made when and where needed and in sizes convenient to handle.

Masonry materials as selected by interior designers tend to suggest strength, stability, and permanence because they are usually either structural or related to structure. There may also be an implication of richness and luxury associated with the known high cost of such materials as marble. Introduction of masonry within nonmasonry structures can seem forced and may be impossible. It is not reasonable to introduce a stone wall partition in a carpenter-built house. The popular marble bathroom is often a forced attempt to introduce luxury. A brick floor over wood structure may be possible but is of questionable suitability. Certain masonry materials, such as tile, can be used almost anywhere and offer the sense of solidity associated with masonry along with a vast range of texture and color choices.

Masonry materials offer good strength under *compressive loads* (as in walls and columns), which tend to squeeze or crush the material in use. However, they have poor *tensile strength* for resisting stretching and are therefore not very satisfactory for use as beams or rafters in floor or roof construction. A *beam* is a structural member stressed in bending by the loads placed upon it. Bending stress combines compression at the top of a simple beam with tension at its bottom. Materials such as wood and steel make good beams because they are strong in both compressive and tensile stress. Masonry materials are strong only in compression.

A short stone beam called a *lintel* may be used to span a door or window opening in masonry construction, but the opening must be kept narrow in order to prevent the lintel from cracking under its own weight and the weight of the wall above. *Post-and-lintel construction* (fig. 9.8), in which columns are placed fairly close together to support lintels, creates an enclosure with the internal space filled only with columns, as, for example, in the hypostyle halls of Egyptian temples. Ways to roof over large open spaces with masonry did not come into wide use until the ancient Romans developed systems of *arches* and *vaults* that made possible the building of such structures as the Roman baths or the Pantheon (see fig. 4.11). Domes and vaults remained the only feasible and durable structural devices for enclosing large spaces until the development of the modern materials discussed below (fig. 9.9).

The building techniques of both domes and vaults require carefully cutting stones into complex shapes; using a temporary (usually wood) structure called *centering* to support the masonry structure while it is under construction; and erecting massive walls or buttresses to resist the outward pressure, or *thrust*, exerted

9.7 The richly hued wood floors, window and door surrounds, and exposed-beam ceiling in the Caswell House, Hillsboro, California, warm the coldness of the sparse, dramatic furnishings and the masonry fireplace and freestanding wall that divides the living and dining areas. MacCracken Architects were the designers. (Photograph: Mark Darley/Esto) **9.8** In the most basic structural system, post-and-lintel (sometimes called *trabeated*) construction (A), vertical posts, or columns, support horizontal members (the lintels). When the material used is wood, the system is described as post-and-beam construction. To enclose a space with a ceiling or roof, a series of post-and-lintel groupings can be used to support slabs of stone or planks of wood (B). (Drawings: © Farrell Design Associates) **9.9** Curved, triangular masonry surfaces called pendentives form the transition between a dome and the supporting walls or columns. Pendentives make it possible to fit the circular form of a dome over a square space (*bay*) with supports at its four corners. **9.10** The construction of

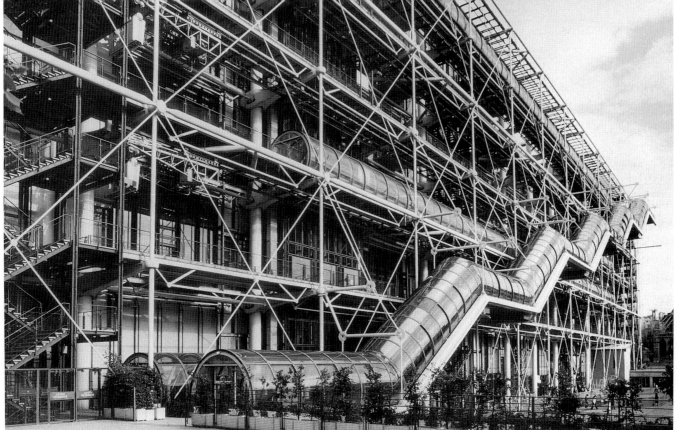

← 9.18

the same in both systems. The architectural and engineering drawings used in the construction of all major modern buildings will, of course, reveal what structural system is in use.

Such striking open and flowing building forms as Frank Lloyd Wright's Solomon R. Guggenheim Museum in New York (see fig. 4.63) or Eero Saarinen's TWA Terminal at John F. Kennedy International Airport, New York, could hardly have been conceived without the availability of reinforced concrete.

Metals

STRUCTURAL

In the nineteenth century, the Industrial Revolution brought metals into wide use to make machinery. Iron in both cast and wrought forms began to be employed for bridge building, for columns in mill structures, and then as a major structural material for the frames of train sheds, market halls, and other utilitarian buildings. Iron finally began to replace masonry in many types of large buildings and was itself replaced by stronger *steel* (iron alloyed with carbon) as the latter became generally available. The high strength and moderate cost of steel made it an ideal material for railroad rails, engines and other machinery, and shipbuilding. Toward the end of the nineteenth century, it was recognized as the best available material for the structural frames of tall buildings.

The *skyscraper* came into being with the rising values of city real estate, but its technical realization depended on the development of the elevator and the use of steel framing. In steel construction, walls do not ordinarily carry any weight (they exist strictly to provide enclosure), while columns at the wall line or standing freely support a grid of beams and girders that in turn support floor and

roof-deck materials (fig. 9.17). The familiar I or H shapes of steel members provide a maximum of material where maximum compressive and tensile stresses at the top and bottom of beams occur, while the thin connecting web uses a minimum of material. Steel structural members are cut and drilled at the mill and assembled on site with rivets or welding with surprising speed and seeming ease. While steel will not burn, the heat of a fire can soften it enough to lead to structural failure. Therefore, in multistory buildings steel is always fireproofed by covering it with masonry, concrete, or, in modern practice, sprayed-on insulating material.

In addition to forming a cagelike frame construction, steel can be used to make roof trusses to span wide openings. It is also the material for other types of constructions, including domes and space frames, roof structures in which many small members create a grid using the rigidity of triangular forms to provide high strength with minimal material. Steel is a key material for some new and still experimental structural techniques, such as suspended structures using steel cable to support roofing in much the same way that cables of a suspension bridge carry a roadway over a wide open space.

Steel is currently the primary material for the structures of large buildings and is often used in small and light forms for parts of smaller buildings. *Open-web joists*, using steel rods to connect top and bottom steel elements, commonly form the roof structures for one-story garages, shops, warehouses, and factories. In small houses, steel may show up as a single floor beam or in the form of the tubular columns often used in a basement to support a main floor beam. Steel construction offers minimal obstruction to interior space and has been a primary force in the increased openness of modern planning (fig. 9.18). The only major rival of steel in modern building is reinforced concrete.

INTERIOR

In low buildings metal structural members may be visible elements in an interior. Many small items of trim and details make use of metal, generally in a manufactured or prefabricated form. Metals can be worked in many different ways to produce materials for additional fabrication or to make finished objects. Rolling, stamping, casting, extruding, and machining are among the processes used in working with metals. Connections can be "mechanical," using rivets, screws, nuts and bolts, or threaded elements, or they can be welded, by applying heat or electric power to bring about partial melting to fuse parts together. Metal as selected by interior designers offers an impression of modernity linked to technological aspects of the modern world. All metals in current use involve industrial production and tend to present the smooth and perfect surfaces that result. Metals require finishing; the gleaming shiny surfaces that most often result are appropriate in some contexts, not in others. Paint and other finishes that hide metals may work where strength, economy, and fire-resistance are desirable but where the metallic qualities of coldness and hardness are not. Metals in general interior use include steel, iron, aluminum, brass and bronze, and copper.

Steel Many small elements such as doorframes, doors, window sashes, handrails, and items of hardware are made of steel. Most steel requires a protective finish, such as paint, or plating with a nonrusting metal, such as chromium. Stainless steel resists rusting but, because of its high strength, is difficult to cut and work.

Iron Wrought iron is sometimes used for decorative railings and *grillwork. Cast iron* is an economical material formerly used for structural and decorative parts of buildings. Its poor tensile strength makes it brittle and easily damaged. It may be found in historic buildings and in furniture (or parts thereof) of the Victorian era.

Aluminum The light weight and resistance to rusting characteristic of aluminum have made it a popular material for many architectural details, such as storefronts, window frames, and exterior wall cladding. It can be made into continuous ribbons of varied form by the process of *extrusion* (squeezing through a die that determines cross-sectional shape). Detail elements such as handrails and hardware are often made of aluminum, which will develop a gray oxide surface unless finished by *anodizing* (a form of plating) or with some other coating. Anodizing can produce a color tone while preserving the surface glitter of aluminum.

Brass and Bronze Nonferous alloys, including brass and bronze, are much used in decorative detail in historic design. Brass has a yellow gleam that makes it a popular material for hardware and trim. Bronze has a deeper brown metallic color and will weather to the green tone, the *patina* familiar in statuary.

Copper The special orangy metallic color of copper is well known for its decorative possibilities. Copper must be protected with a lacquer coating if it is not to turn a green oxide color, frequently seen as the tone of copper roofing. Interior uses in hoods over fireplaces, stoves, or bar counters are not uncommon.

Glass

Although glass is most valued for its transparency, it can also be produced in opaque and mirror form. Glass is most often used in windows, doors, and partitions where transparency is essential; it has also come into use as a primary material for buildings where *curtain walls* (nonbearing exterior walls between columns or piers) of windows become the exterior sheathing of the entire structure (figs. 9.19, 9.20). Although production of glass had been known since ancient times, only small pieces could be made so that windows had to be made of many pieces held together with lead strips or with wood. The development of industrial techniques for making large sheets of glass ("plate glass") made possible large areas of unbroken glazing. Modern architecture was quick to recognize the possibilities of whole walls of glass and, eventually, entire building exteriors as in the now-familiar glass tower high-rise buildings that have become so ubiquitous.

The use of glass in interior design offers an intriguing set of possibilities for introducing barriers to movement and sound transmission while permitting passage of light along with or without vision. Glass can also offer decorative possibilities through color and pattern. When used in large areas, particularly in combination with metals, glass suggests modernity and openness. Much glass may seem "cold" in situations where such implications are to be avoided. Modern architecture has tended to make extensive use of glass in ways that contribute to its openness and ease of relationship with its surroundings.

The inherent fragility of glass must always be kept in mind. Common *window glass* and *plate glass* are subject to easy breakage, introducing a variety of hazards when used in walls, doors, or furniture. In addition, they transmit heat and cold easily. Special types of glass have been developed to limit such problems and to produce some other pleasing effects.

9.19 The glass portions of an outside wall open up an unconventional space in a Los Angeles, California, house to light and views. Every level of the curving stair provides glimpses of the outside. The seating is from Dialogica; the coffee table was designed by the architect Eric Owen Moss. (Photograph: © Scott Frances/Esto)

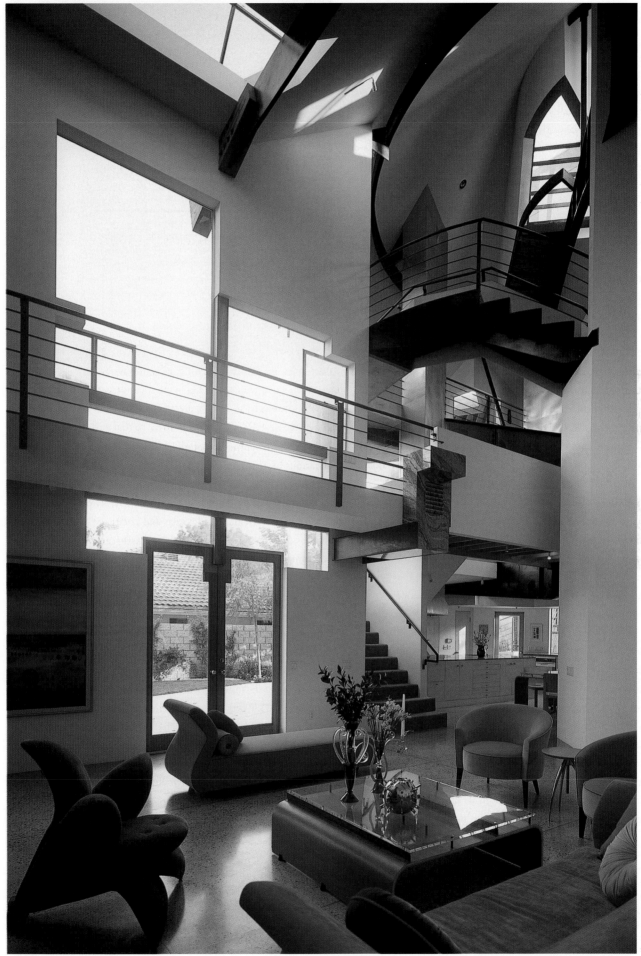

These special types of glass include the following:

- *Laminated or safety glass.* One or more layers of a plastic sheet are sandwiched between sheets of ordinary glass to create a material that resists the tendency of plain glass to shatter into sharp-edged shards.

- *Tempered glass.* Glass is treated by heat processing to gain extra strength. Tempered glass is resistant to breakage and shatters into small, harmless pieces. It is a favored material for frameless glass doors, shower doors, and similar applications. Tempered glass cannot be cut and must be factory produced in desired sizes and shapes.

- *Wire glass.* Made with an embedded mesh of wire that holds a sheet of glass together even when breakage occurs, wire glass is particularly useful for its ability to resist shattering from fire heat. It is therefore a code requirement in locations where a fire barrier is needed.

- *Thermal glass.* A number of glasses with special insulating properties are available. Some offer heat limitation by means of multiple layers with air space between, some feature resistance to heat transmission through coloring that blocks infrared radiation, and others block heat by means of semimirrored reflectivity.

- *Suspended-particle-device (SPD) glass.* Glass (and some plastics) can be made with a layer of suspended-particle-device (SPD) film to provide variable transparency. When an electrical voltage is applied, the film can be varied from clear to fully opaque. A rotating knob similar to a dimmer permits variation of the applied voltage, allowing adjustment to a desired degree of transparency, including total blackout as required in rooms using screen-projected images. Alternatively, control can be provided by light-sensing photocells (see photo sensors, pages 369–70) that adjust degree of transparency in response to ambient light. Such "smart window" glazing offers simple control of both light input and levels of privacy.

- *Mirror.* Glass silvered on one side creates a reflective surface, or mirror. Partial mirroring makes one-way glass that, when lighting is appropriately balanced, permits vision in one direction but blocks it in the other.

- *Decorative glass.* Glass can come in a wide variety of textures and surface treatments that permit light passage but distort image transmission. Glass is also made in a full range of colors, clear or textured, suitable to many decorative uses, among them the well-known *stained glass* in which separate pieces of glass are joined with metal strips to generate patterns.

← 9.20

Plastics

Plastics are all synthetic materials made by chemical combination of various basic ingredients, most derived from petroleum. A type of plastic may be known by several names—a generic or chemical name and one or more trade names given to it by manufacturers. *Acrylic* is a generic name, Plexiglas and Lucite are trade names for acrylics. The character of a particular plastic can vary greatly according to the way it is processed. Nylon, for example, appears to be totally different when knitted into a stocking, woven into carpet fiber, or made into a solid glide or roller. Plastics offer a wide range of possible uses to the interior designer but also have acquired a reputation as cheap substitutes for superior, traditional materials. For this reason, plastics are most often used in ways that do not emphasize their synthetic qualities. Floor tiles, plastic laminates, and plastics used as wall coverings or in upholstery, for example, provide practical applications while not asserting their actual nature. The ease with which plastics can simulate other materials presents a temptation to introduce *faux*, or false, materials that generally convey a sense of shoddy quality. (See "Genuine Materials versus Imitation," page 256.) Plastics have found successful applications in many modern furniture designs and as substitutes for glass where safety is a special concern.

9.20 In this Apple Store in Soho, New York, designed by Bohlin, Cywinski, and Jackson, the transparency of the structural glass stair against the etched structural glass floor creates a composition that is whimsically light, fluid, and reflective. The image of the sponsoring company as based on advanced technology is furthered by the use of glass as a dominant material.

Architects and interior designers must take into consideration that the synthetic elements used in the manufacture of plastics are subject to emission of pollutants (off-gassing) that can present health hazards along with unpleasant odors. Floor coverings and some wall surfacing materials as well as upholstery foam and covering are particularly subject to these problems. Manufacturers are becoming increasingly alert to these issues and provide data and labeling where assurances can be given that no problems will exist.

There are two main families of plastics—*thermoplastics* and *thermosetting plastics*—and they differ in their basic qualities.

THERMOPLASTICS

Soft and moldable when heated, thermoplastics become stiff and solid when cooled. Thermoplastic objects are made by molding, rolling, or extruding the heated material. Familiar groups of thermoplastics include acrylics (transparent and clear, colored or opaque), *polystyrenes* (much used for household items), and *vinyls* (common as floor tiles and as alternatives to leather in upholstery).

THERMOSETTING PLASTICS

Some plastics are made from a liquid resin and a second liquid called a *catalyst* that when combined and subjected to heat harden and become solid. Once formed, objects of thermosetting plastic cannot be softened or melted. Thermosetting plastics can be processed by rolling, molding, or foaming to make sheets, objects of complex forms, or light foam slabs of varied densities ranging from soft cushioning to firm board. The *melamines* are a strong thermosetting plastic. *Phenolics* (Bakelite is a well-known trade name) are weaker but inexpensive and good insulators. *Polyesters* and *urethanes* are used to make foams, soft or rigid. *Glass fibers* are embedded in polyester to make the hybrid, high-strength material usually called by the trade name Fiberglas. *Plastic laminates* are made from layers of special paper bonded together and surfaced with melamine plastic to make a thin sheet material of great strength and excellent resistance to scratching or other damage. Plastic laminates are generally bonded to an understructure of plywood or particleboard.

New Materials

Within recent years, a vast variety of new materials has become available. Most are not totally new but are new combinations of older materials or new processes of working materials that make them usable in new contexts. Some examples of new materials having possible uses in interior design follow:

Carbon fiber This is truly a new material in which pressed graphite is combined with plastic resin to produce elements of very high strength, combined with thermal and electrical conductivity. It is used for furniture parts whose strength is superior to wood, or metal.

Cement Cement is used to produce precast tiles for flooring, self-leveling floor surfacing, and fiber-reinforced material of superior strength. It is also used in a poured form for countertops. A curvable wall panel is made with a cement base.

Glass Glass is used in many new products such as a glass sheet that varies in transparency with a wire-applied electrical current, in "graffiti-proof" tile. Recycled glass is used in many products such as floor and tall tiles. Woven fiberglass makes a highly durable wall covering.

Steel and aluminum Steel and aluminum are produced in many forms of perforated sheets for walls and ceilings, and are used for sound control. Honeycomb panels of aluminum are available in many forms. Aluminum foam is used in various forms, and can be made from recycled aluminum.

Bamboo Bamboo is not a new material but has found new uses for flooring, paneling, and veneers. Fiberboard is now made from sunflower seed, with a base of straw.

Leather Leather is used as woven flooring, and as floor tiles.

Synthetics such as PVC and other plastics are often used in recycled forms for flooring and textiles, many having flame-resistant characteristics. Recycled rubber and cork with plastic binders form floor tile. Seamless floors poured in place are made of various resins and aggregates. Graffiti-resistant coatings are available for wall surfaces.

Material Selection

For any given use, a short list of widely accepted materials will usually come to mind, making selection of the specific material for a particular purpose a matter of common usage, personal preference, or habit. Unfortunately, this often leads to unimaginative or cliché selections, to the neglect of less familiar possibilities that may offer real advantages, or, at worst, to downright mistakes when a chosen material fails to perform as desired. Many of the most common complaints about interior projects relate to materials that fail in one way or another—that break, wear out, attract dirt, prove hard to clean and maintain, or in some other way create problems that could have been avoided.

EVALUATING MATERIALS

Problems such as those mentioned above can be guarded against by using a mental (or actual) checklist in evaluating each choice. Materials are usually chosen to satisfy their primary role—a floor material to be practical to walk on; a window material to admit light; a door material to provide closure. Problems are most

Genuine Materials versus Imitation

The idea that materials should be what they appear to be has wide acceptance as a basic value in design. Some designers even insist that *all* materials be used only in their own natural color; they develop color schemes through choosing materials with their natural colors in mind. This may be problematic in the case of synthetics. Plastic laminate, for example, can hardly be said to have a "natural" color; its use requires acceptance of an artificial color and perhaps of texture or pattern as well.

Most designers prefer to avoid materials that attempt to imitate some other material in an artificial way. Fake materials tend to degrade the quality of the space where they are used. Many modern materials are made with the specific purpose of mimicking some other, usually superior (and more expensive) material. Linoleum is produced in patterns that imitate tile, wood boards, parquet, or marble. Wallpaper can be found that imitates wood boards, marble, tile, or brick. Some plastic sheeting is embossed to imitate the texture and mortar joints of brickwork. Imitation wood beams of plastic can be glued to ceilings to suggest structure that does not exist. Serious design work of good quality rejects all such imitations as cheap, shoddy, and generally of such poor appearance as to fool no one.

Every designer has to make decisions about where to draw the line on the issue of imitations. Is a plastic laminate that imitates a wood veneer satisfactory as a tabletop or desktop material? Are paper-thin wood tiles that imitate parquet acceptable since they really are made of wood? Is a plastic material that imitates leather a satisfactory alternative to the real thing? What about false wormholes in the distressed

finishes applied to some antique reproductions? Such questions may have to be decided on a case-by-case basis, but it generally makes sense to minimize or avoid imitations wherever possible, especially if originals are within the project budget.

Some imitations can be seen in another light. We know that painted imitations of marble were often used in Baroque churches and that Early American floors were sometimes painted in patterns to suggest tiles. The aim in these instances, however, was not so much to deceive as to elicit delight in the maker's skill, as is the case with trompe l'oeil painting (see figs. 4.22, 9.38) and the art of theatrical scene painters.

If plastic is to replace leather, a plain surface or texture is preferable to one that tries to mimic pigskin or elephant hide. Laminates come in plain colors and in patterns that are purely geometric rather than imitative. Plastic butcher block or knotty pine, linoleum marble or flagstone, simulated brick and tile, fake fireplaces, and plastic plants have no place in a well-designed interior.

On the other hand, the changing of color through dying or staining (of wood and similar elements) and the changing of a surface through materials such as paint and wallpaper have come to be widely accepted. Most surface materials have appearance characteristics that make it clear that they are surface. A tiled wall does not suggest that the wall is tile all the way through. Wood paneling looks very different from structural woodwork. Even stone used as a surface material (in large, thin sheets) looks quite different from the smaller blocks of actual stone construction. The idea that structural and surface materials should look different has been a recognized design principle for many years.

likely to arise in connection with secondary criteria, which may be overlooked if one focuses on primary function and appearance alone. An otherwise satisfactory floor material may become dangerously slippery when wet; an attractive wall surface may become marred easily and be hard to clean; carpet selected for its surface appearance and color may show dirt and wear. It is an important part of the interior designer's work to be alert to such issues and to deal with them by learning all of the characteristics of the materials chosen. (See Table 10, "Checklist for Material Selection," page 259.)

These matters are interrelated in complex ways, making judgment and selection difficult. For example, the desired appearance may conflict with the material's functional practicality or cost. The relative importance of various criteria will change with the intended use. Fire safety may be of minor importance in a one-story residence but significant in a high-rise office or hotel. The presence of a sprinkler system can reduce fire safety to an incidental value. The impact of cost will vary with available budget,

while lifetime cost will weigh more strongly on a project planned for long use than on one destined to have a shorter span of usefulness. Vandalism, a factor in public spaces in modern cities, rarely impinges on a private home or office. Acoustical qualities may be vital in a concert hall, significant in an office or home, but of little importance in a shopping center. Durability can influence aesthetic values, as some materials wear or age in a way that is visually acceptable (wood, wool, natural leather) while other materials grow unattractive and shabby long before they actually wear out (some carpets of synthetic yarns).

The cost of materials must inevitably be considered in all material selection. In projects where there is an unlimited budget, cost offers no restriction and, in some cases, costly materials may be selected deliberately as a means of displaying wealth. The use of rare woods and rich marbles are ways of showing the freedom with which money has been spent. In most situations, designers must have cost constantly in mind and must be prepared to check the price level of one material against that of

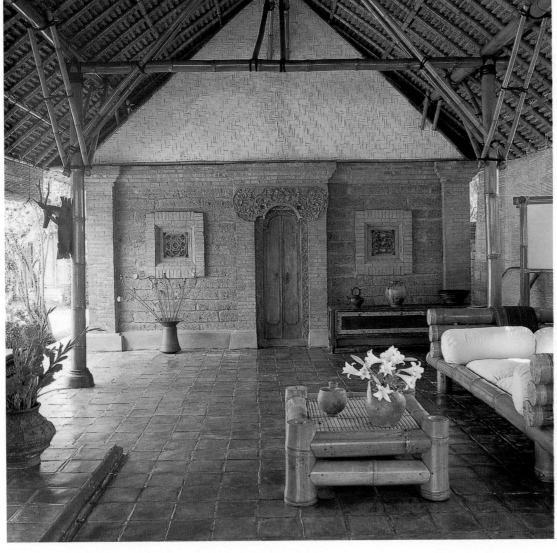

another as decisions are being made. When costs run over budget, the most common way of making adjustments is to make substitutions of materials. First cost is only one aspect of economic impact, however. Cost of maintenance and the length of the service life of a material are also factors to consider.

MATERIALS IN THEIR SETTING

Along with all the practical matters involved in material selection, some intangibles affect the concept of appropriateness. One of these is the concept of whether the material is genuine or an imitation. (See "Genuine Materials versus Imitation," page 256.) If imitation is undetectable, the viewer will react as if genuine material was in use. However, imitations are often not totally convincing and tempt the designer to excessive or poorly placed uses. Imitation fieldstone, for example, will seem unconvincing in a high-floor modern apartment. The impact of climate, regional traditions, and location, for instance, can also be strong influences (figs. 9.21 9.22). Rough white plaster walls, tile floors, and a

wood-beamed ceiling suggest a Mediterranean or other semitropical location. Sliding screens, mats on the floor, and austerely simple forms and natural colors suggest Japan. A country cottage or farmhouse calls for material choices different from those customary for a town house or city apartment. It is possible, of course, to create the look of a Mediterranean villa in a northern city high-rise or a Scandinavian modern space in California or Mexico City, but such unexpected concepts raise questions about their suitability.

There are also traditional uses for materials in relation to certain spaces. Dark wood paneling, with its air of sober formality, has often been adopted for a conservative boardroom or law office or for the library in a rather formal home; for the same reasons it would seem out of place in a children's playroom or a fast-food restaurant. Glittering materials (brass, mirrors, crystal) suggest a casino, an opera house, or a shopping center; in a library, a hospital, or a country cottage they would seem inappropriate. While it is important to avoid cliché material choices, total disregard for widely accepted traditions of usage may lead to bizarre results.

9.21 Regional traditions lead to design developed around locally available materials. Bamboo is an exotic material in Europe and America, but in this house near Sanur, Bali, Balinese designer Putu Suarsu makes it the dominant material, giving the space its special character. The natural materials tile and brick add their warmth to the space. Many of the objects are antiques from the Indonesian islands. (Photograph: Tim Street-Porter)

9.22 ↑

← 9.23

Materials in Relation to Their Uses

Each element, whether structural or nonstructural, is composed of one or more materials. As previously mentioned, the structural elements in a space are usually the result of architectural decisions over which the designer has little control.

Nevertheless, since elements can be modified through surface treatment, which can make drastic changes in appearance, the designer has a wide range of choices:

- *Leave material exposed* in its natural, unfinished state or, if already covered, uncover to expose it. (Brick, stone, wood, even concrete are often used in this way.)
- *Treat exposed, natural materials* with a finish chosen to preserve their natural appearance while protecting against wear and dirt. In practice, such natural finishes will change the color and appearance of the material to some degree, usually darkening the color somewhat. (Typical finishes of this kind are wax, oil, and various clear varnishes and lacquers.)
- *Coat exposed materials* with a finish that covers and seals the surface and hides it with a colored pigment (usually paint). Even when the color is changed, the texture of the material shows—that is, a red brick wall painted white (or any other color) still looks like brick. Paint tends to hide construction details, such as mortar joints, and may change texture.
- *Completely cover over materials* with a layer of a second covering material. (Examples are wood veneered or covered with plastic laminate; wallpaper or plastic sheet material on walls; carpeting on a floor.) In many situations a basic, often structural material is hidden by another structural layer. Such a covering layer of material may then be finished with still another coating material. (In a wooden house, the wood studs and joists of wall, ceiling, and roof construction are usually covered by lath and plaster or, in modern practice, plasterboard, which is then finished with another material such as paint. Steel structural columns are wrapped with an insulating material for fire protection, which is in turn covered by a material chosen for its finished appearance.)

The following survey discusses the major interior elements, and the most common materials and finishes used for each.

9.22 Designed by Bernard Tschumi Architects, almost everything in this Beijing unit is made of bamboo, including floors, ceilings, and these space-dividing, sliding partitions. **9.23** The gleaming marble of the majestic Ionic columns echoed in the carved fireplace mantel, the hardwood parquet floor, the generous reading tables, and the Windsor armchairs all set a tone of dignity consistent with the main reading room of the New York Bar Association library. The building was originally designed by Cyrus L. W. Eidlitz in 1895. James Stewart Polshek and Partners, Architects, were responsible for the renovation that introduced lively wall colors and modern lighting. (Photograph: © Elliott Kaufman) **9.24** The cool gray of concrete and the warm colors of natural wood set off the spectacular landscape surrounding a bedroom of the Post Ranch Inn a luxury resort in Big Sur, California. Mickey Muennig was the architect and Janet Gay Freed the designer. (Photograph: © Larry Dale Gordon 1992)

9.24 →

Table 10.
Checklist for Material Selection

FUNCTIONAL CRITERIA
 Primary
- Suitability to basic utilitarian purpose
 Secondary
- Durability in anticipated use
- Ease of maintenance, repair, cleaning
- Resistance to damage and vandalism
- Safety characteristics (accidents, fire)
- Acoustical performance

AESTHETIC CRITERIA
- Availability of desired natural or applied colors
- Textures
- Possibilities of pattern
- Visual suitability to intended function

ECONOMIC CRITERIA
- First cost
- Lifetime cost in relation to expected durability and estimated cost of maintenance, cleaning, repair, and future replacement

Walls

LOAD-BEARING WALLS

Since load-bearing walls support floors and roofs, they must be of considerable structural strength. Their material has usually been determined by the architectural design of a building. The primary material, often covered and concealed by finish materials, can be an important interior element when left exposed. Common examples are the following:

- *Brick*—exposed or painted.
- *Concrete block*—exposed or painted. It is usually left exposed only in utilitarian spaces such as garages or basements.
- *Concrete*—mass or reinforced.
- *Stone*—available in varied colors and textures. Fieldstone (see fig. 9.11) is laid up, or constructed, in a variety of ways, from very rough to more regularly patterned *courses*, or layers. *Ashlar*, neatly cut stone, is often used in monumental architectural spaces.
- *Wood*—large frame members and planking of post-and-beam construction, exposed or finished. Most common, carpenter-built construction is usually concealed.

PARTITION WALLS

Partition walls (or simply, *partitions*) typically have an inner, hidden support structure and an outer surface that, in turn, may be covered with a surface finish. The same combination of materials

that makes up a partition is often used to line (and thus conceal) wall-bearing materials.

Wood Studs

Wood strips, usually 2-by-4-inch studs spaced 16 inches apart and running from floor to ceiling, are the most common partition structure in nonfireproof construction. They provide space for pipes, wiring, and ducts. Where drainpipes are to be run within a partition, 2-by-6-inch studs are used. A double wall with two separate sets of studs can improve acoustical isolation between spaces.

Metal Studs

Steel studs are used in place of wood to offer improved fire-resistance while still providing hollow space within a partition's thickness for pipes, ducts, and wiring.

Gypsum Block

A light masonry material, used only in partition-wall construction, gypsum block gives superior fire-resistance and acoustical control and provides a sturdy surface for plaster or other surface treatment.

Concrete Block

(Usually cinder-concrete block.) A masonry block even heavier and more solid than gypsum block, concrete block is used for spaces that need particularly good isolation, such as fire stairs, elevator shafts, and machinery rooms.

Lath and Plaster

The traditional partition surface of older construction is wood lath supporting a covering of plaster applied by hand, wet, in several coats. More modern lath may be a perforated gypsum board or an expanded metal mesh. Metal lath is usually used over metal studs to provide good fire-resistance. Lath and plaster may be used to line bearing walls as well. Plaster may be applied directly (without lath) to gypsum or concrete block. High labor costs and slow drying time have tended to discourage the use of plaster walls.

Drywall

The term *drywall* is given to the most common alternative to lath-and-plaster partition construction. Studs (wood or metal) are covered with sheets, usually 4 by 8 feet, of plasterboard, a factory-made sheet composed of gypsum plaster sandwiched between sheets of a special heavy paper. This wallboard can be cut and nailed in place quickly and easily. Joints are covered with a special tape and both joints and nailheads are covered with a plasterlike compound, producing a fairly smooth wall. Drywall partitions often show some bulges or waves, and the

← 9.26

marks of joints and nailheads may also show up. Cracking is, however, less likely than in lath and plaster surfaces.

Movable Partitions

Movable partitions are factory-made products available as complete systems that incorporate doors, glass panels, and, usually, provision for wiring. The prefabricated elements can be taken apart and reused in new locations and arrangements as necessary. Metal or metal and glass are the most usual materials. Movable partitions are most widely used in office installations (fig. 9.26).

Folding Partitions

Also factory-made products, folding partitions use panels or accordion-folding elements that slide on ceiling or floor and ceiling tracks to make it possible to combine or separate adjacent spaces at will. Both appearance and acoustical performance of folding partitions tend to be problematic, but their use is common where a special functional need requires this kind of flexibility, as in making dining or conference rooms larger or smaller to suit the needs of various groups.

Toilet Partitions

Partitions for toilets are another factory-made system product. They provide panels and doors for the stalls and screen elements used in public toilet facilities. Metal with baked

← 9.25

9.25 Interesting results can be achieved when materials are used in unorthodox ways, as in this balcony railing made of perforated steel, a material typically associated with High Tech design. A kitchen can be seen in the background. Hodgetts + Fung Design Associates were the architects and designers for this California residential project. (Photograph: Tim Street-Porter) **9.26** The massive gray element in this illustration is a movable display divider in the art gallery area of Forbes Silicon Valley Bureau, Burlingame, California. The divider provides a surface on which to hang artwork but also rolls on casters in floor tracks so as to vary the relative sizes of the meeting rooms within the gallery and to enable the gallery to be used as a party space. The surface material is perforated stainless steel. Brayton & Hughes were the designers (Photograph: John Sutton, courtesy Brayton + Hughes Design Studio)

enamel finish is the most usual material, although slate and marble were once common and are still used occasionally.

Glass In addition to its use in movable partitioning, glass can be used with wood or metal framing to create walls that offer transparency or translucency in varying degrees (figs. 9.27–9.29).

Glass is available in a wide range of colors and textures and in shatterproof form. Walls of curving and angled glass, clear or otherwise, are possibilities for introducing free forms that avoid the boxlike character of conventional rooms (fig. 9.30). Glass partitions can also be built up of *glass block*, a masonry-like material providing translucency and a unique appearance (figs. 9.31, 9.32).

9.27 Sliding glass doors can convert a space from an open garden pavilion into an enclosed room. A new owner required that an existing (1955) house by the famous architect Ludwig Mies van der Rohe be expanded to provide entertaining and guest rooms. Peter

L. Gluck and Partners, architects for the project, left the original house untouched, adding instead a two pavilion complex adjacent to the original building. In his Tugendhat House of 1930 in Brno, now Czech Republic, Mies himself set the precedent for entire walls of

sliding doors. (Photograph: © Paul Warchol)

INTERIOR FINISH COATINGS

FINISH	DESCRIPTION	FREQUENT USE
Semigloss		
SEMIGLOSS ENAMEL	Alkyd-based product with good gloss retention, also grease and alkali resistance.	Woodwork, trim
SEMIGLOSS LATEX	Has moderate hiding power, ease of application and clean-up, rapid cleaning, low odor.	Drywall, plaster, wood, plywood
DRY FALLOUT SPRAY SEMIGLOSS	Provides a moderate gloss level.	Walls, ceilings
Flat finishes		
ALKYD FLAT	Superior to latex paints in hiding power and washability. Odorless, but should be used in well-ventilated areas.	Drywall, brick, wood, metal, plywood
LATEX FLAT	Good hiding power, spreadability, odorless. Requires special primers prior to application on porous surfaces. Do not apply in extreme temperatures.	Plaster, drywall, brick, masonry

TRANSPARENT FINISHES

FINISH	DESCRIPTION	FREQUENT USE
Varnishes		
FLAT OR SATIN	Flatting agent added that makes it less glossy in finish than glossy varnishes. Mar-resistance is inferior to gloss varnish.	All types of wood surfaces
COUNTER OR BAR VARNISH	Dries very hard and is resistant to alcohols. Made from polyurethanes and polyesters.	Bar tops
PENETRATING SEALERS	Very thin varnishes that are applied and rubbed out while the surface is still wet. Fair resistance to marring.	All types of open-grain woods
SHELLAC	Often used as a "wash" coat on wood surfaces before final sanding. Fast-drying, light-colored, but has a poor resistance to abrasion, water, and alcohols.	Wood, plaster, drywall, brick, plywood
Laquers		
STANDARD	A coating material with high nitrocellulose content that is modified with resins and plasticizers. Good durability but little resistance to chemicals. Dries quickly and is easy to repair. Increases flammability of surfaces.	Wood furniture and paneling
CATALYZED	Superior to standard lacquer in resistance to chemicals.	Wood furniture and paneling
Vinyls		
CATALYZED	A clear converting catalyst vinyl coating. Fast-drying and highly resistant to abrasion.	Wood furniture and paneling

Tile A vast variety of tiles, from tiny mosaic to large squares and rectangles, in many colors, textures, patterns, and materials, can be used as wall surface treatments. Tile is particularly suited to wet, humid locations with water splash and steam, typically kitchens, bathrooms, areas around pools, and similar spaces. Decorated and painted tiles can approach an art form. Spanish or Dutch painted tiles suggest specific periods and countries; at their best, they are objects of collectors' interest. Wall tiles of leather are available in a variety of colors and offer a softer and warmer tactile sense and a softer appearance compared with ceramic tile (fig. 9.35).

Mirror This form of glass, one side of which is coated with metal or some special preparation, has a special interest as a wall material because of its ability to create the illusion of increased space. Floor-to-ceiling and wall-to-wall mirrors double space visually (fig. 9.36). Parallel mirrors placed opposite each other generate an illusion of endlessly continuing space. Tinted, *antique* (naturally or artificially showing the effects of age), and small squared mirrors create other visual effects. Because mirror has been overused and misused, its selection should be considered carefully.

Metal Although rarely used, a metal surface can function as wall covering. Copper, brass, aluminum, and stainless steel are possible materials. Stainless steel is very difficult to cut and work and

so is a particularly rare choice for this application. An occasional use is for the interior walls of elevator cabs, where its high resistance to damage and vandalism is advantageous.

Plastic Vinyl and other plastic sheet materials are in wide use as wall coverings, both for their ability to resist damage and for the variety of color and textural patterns they offer. Many plastic wall coverings simulate other materials, such as grass, cloth, canvas, suede, even metals. Once damaged, plastic materials are more difficult to repair than painted surfaces. The material itself and the adhesive used for application need to be carefully checked to ensure avoidance of harmful VOC emissions. Plastic wall covering made without polyvinyl chloride (PVC), a notorious source of air pollution, is now being manufactured.

A recently introduced hybrid product with the trade name Imago sandwiches a textile fabric between layers of a plastic resin. Sheets of the material can be used as wall surfacing as well as for other applications, such as tabletops and window covering. Various patterns, embossed or matte, are manufactured in a variety of colors. The material is shatterproof and resistant to scratching and marring (fig. 9.37).

Fabric A traditional material for wall covering, fabric offers a fine variety of colors and textures. Silks, satins, and brocades were often used in luxurious interiors of traditional design. Simple

9.35 These wall tiles of leather from York Street Studio are water-resistant and come in many sizes and colors. (Photograph: Tony Cenicola/NY Times) **9.36** Large areas of mirror visually repeat an interior, effectively doubling its space. This high, narrow room appears more spacious than it is, with the glass-block wall and marble-topped desk extending into their mirrored doubles. Gwathmey Siegel & Associates were the architects for this executive office for the Evans Partnership, Montvale, New Jersey. (Photograph courtesy Gwathmey Siegel & Associates Architects)

9.37 Imago is a hard-surface material composed of textile fabric sandwiched with resin to form a sheet material for both vertical and horizontal applications, such as wall panels and tabletops. The examples shown here, Progeny and Mercury, are in use as screen panels. The material was developed by Suzanne Tick, design director for KnollTextiles. (Photograph courtesy Knoll) **9.38** This medieval, nail-studded door is, in fact, a fantastically successful trompe l'oeil done on an ordinary plain panel. David Fisch was the artist. (Photograph: © Jeff Blechman)

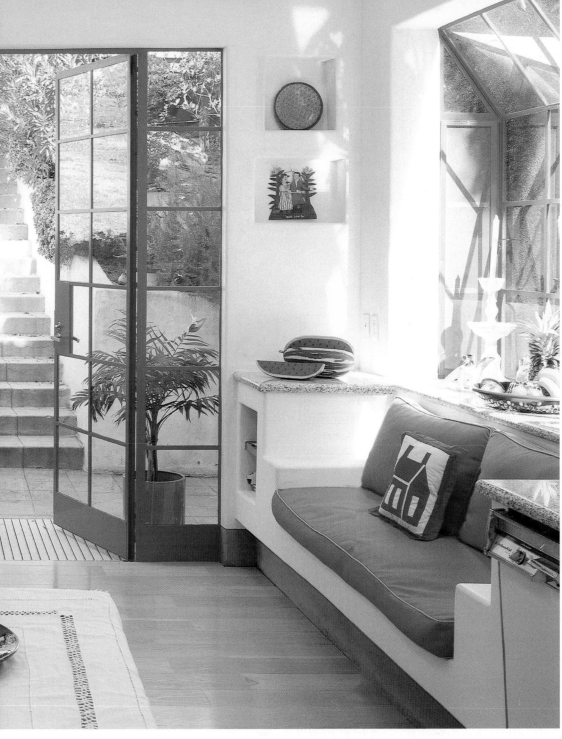

← 9.40

different planes. Special hardware permits setting paired sliding doors flush when closed and then angles the tracks slightly to allow the doors to slide. Aluminum-framed sliding doors are popular for outside window-door uses. Sliding shoji screens, adapted from traditional Japanese practice, can be considered a form of sliding door that permits a flexible subdivision of space.

French Doors Actually long *casement windows* that extend to floor level, French doors are simply double, hinged doors of framed glass (fig. 9.40).

Louvered (or Jalousie) Doors Usually made of wood, louvered doors permit air circulation. They have become popular for closets that require some ventilation.

Accordion Folding Doors A kind of compromise between swinging and sliding doors, accordion folding doors permit full opening but when open do not project into adjacent space as far as conventional swinging doors do.

Revolving Doors Doors that revolve are widely used to control drafts and loss of heat at entrances that handle large numbers of people. They are usually standardized factory-made products and come in many different designs and with varied details.

Gates Gates may be regarded as a special type of door. They come hinged or sliding and of various materials and designs. Special forms of roll-up and sliding gates, available for security closure, are often used in addition to more conventional door types.

9.41 → *WINDOW TYPES*

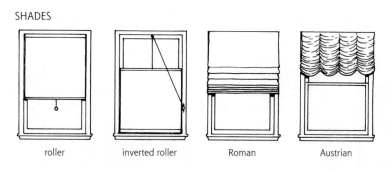

double hung awning fixed glazing arched top casement combination casement/fixed glazing bay sliding

9.42 → *WINDOW TREATMENTS*

SHADES

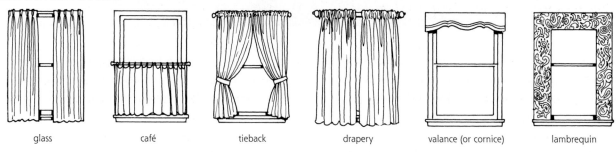

roller inverted roller Roman Austrian

BLINDS SHUTTERS SCREENS

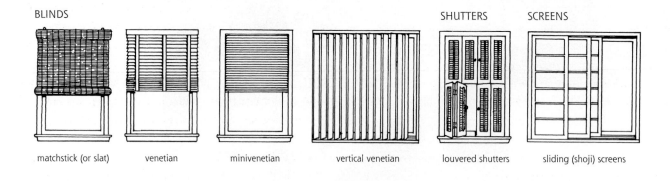

matchstick (or slat) venetian minivenetian vertical venetian louvered shutters sliding (shoji) screens

CURTAINS AND DRAPERIES

glass café tieback drapery valance (or cornice) lambrequin

9.41 Various types of windows are shown in elevation above, with the architectural plan symbols that represent them below. **9.42** Various types of commonly used window treatments, both hard and soft.

Windows

An important element in basic architectural design, windows are also important elements in the interiors that they serve. Since windows greatly influence the nature of an interior, designers often change or replace them as part of their design schemes. This alteration concerns both the window itself and the *window treatment*, any additions to the window, such as shades or curtains, that can modify both the appearance and the function of the actual window.

Glass is obviously the primary *glazing* or transparent window material, in the form of *window* (thin) or *plate* (thicker) glass, clear or patterned or *obscure* (not transparent). Virtually unbreakable Lexan plastic has come into use as a glass substitute where breakage is a major problem.

WINDOW TYPES

Types of windows can best be classified according to how they are framed to hold glass (fig. 9.41).

Fixed Glazing Windows Windows that are fixed into place and cannot be opened require only simple frames and are widely used where opening capability is not required, as with shop windows and windows of air-conditioned spaces, or in combination with windows that open. Fixed glazing requires consideration of means for cleaning, of impact on fire safety (access and escape), and of provision for alternative ventilation in the event of mechanical ventilation system failure.

Double-hung Windows Windows that are double hung use the most familiar sash, two up-and-down sliding units, giving a 50 percent opening in any combination of top or bottom or both.

Casement Windows Casement windows swing outward or inward like small doors and most often appear in pairs. *French windows* (listed above as doors) are casement windows that extend to floor level.

Awning and Projected Windows Windows that project or have awnings have framed units hinged horizontally to swing in or our in various configurations.

Jalousie Windows A special form of awning window, jalousies use many small hinged louvers of glass.

Sliding Windows Windows that slide move sideways on top and bottom tracks. Floor-to-ceiling versions opening to the outdoors are widely used.

All of these window types may use frames of wood, steel, or aluminum. Double-hung and casement windows may use large panes of glass filling each movable unit or have a number of smaller panes set into small frame members, called *muntins*. The pattern of windowpanes has a strong impact on the visual effect of windows and can suggest a particular style or period of design. For example, the small panes of Colonial windows are very different from the plate glass of Victorian windows.

Windows are, by their nature, interruptions in walls, generally exterior walls. They have a major role in transfer of heat and cold from outside into interiors and from interiors to the out-of-doors. Glass (or the plastic that is sometime substituted) transfers heat more readily than most wall materials. This means that in winter, interior heat is lost to the outside, with resulting energy costs and the discomfort associated with cold surfaces and drafts. In summer, this situation is reversed, with exterior heat transferred into the interior by contact with warm outside air and by direct radiation from sunlight with resultant extra demands on air-conditioning. Efforts to minimize heat transfer in both directions has led to the development of many special types of glazing (see page 252). Familiar examples are tinted glass and partially reflective glass that resist heat transfer, particularly the entrance of solar heat where windows are oriented toward the sun at part or all of the day. Double or triple glazing with dead air space between layers (the principle of the thermos bottle) is provided by such glass products as Thermopane. The use of SPD "smart window" glazing (see page 252) offers control of heat transfer and light level as well as of privacy and outward view.

The effectiveness of special glazing can be aided by choice of window treatments using traditional materials or a number of recently developed techniques, some discussed below.

WINDOW TREATMENT

Window treatment (fig. 9.42) serves a variety of purposes, including the following:

- Control of excessive light, sun, and glare
- Screening of the blank nighttime "black-glass" effect of exposed windows
- Limitation of heat gain from summer sun
- Limitation of winter heat loss to cold glass surface
- Screening of indifferent or unpleasant view
- Screening for privacy of occupants
- Hiding or modification of unsatisfactory window shape, location, or detail design
- Improvement of bare or unfinished-looking window opening
- Introduction of desired color and texture

Most window treatment calls for adjustability to deal with night and day, summer and winter, and changing conditions of use. A wide variety of blinds, shutters, curtains, and drapery techniques have been developed to deal with these problems. Some of the most useful include the following:

← 9.44

9.43 →

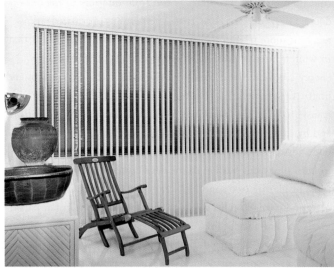

← 9.45

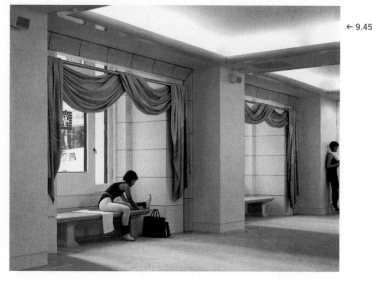

Roller Blinds (or Shades) A piece of cloth or heavy paper on a spring roller, these usually pull down from the top. Variations exist that pull up from the bottom or that have a roller suspended by pulleys, permitting any desired opening, top or bottom. Special roller blinds effectively block out light, making them a good choice for spaces used for slide or film projection or where daytime darkening of a bedroom is desired. A number of materials with heat-resistant characteristics are available for use as roller shades. Thermo Shade and Thermo Veil are trade names for shade fabrics with energy-conserving properties that also permit some see-through vision. Roller shades can pull down from above or upward from a bottom roller, the latter of particular value for ground-level windows where privacy is desired and for other windows where there is the need to protect furnishings from fading caused by the sun's rays. Electrical operation is available with or without automatic solar control.

Roman and Austrian Blinds These types, which pull up with a cord into accordion folds, are well suited to some traditional interiors.

Matchstick or Slat Blinds Blinds of thin bamboo or wood strips, which can be pulled up by cord into a roll, make a somewhat informal, as well as inexpensive, simple window treatment.

Horizontal Venetian Blinds These familiar and useful controllers of light and view come with slats of wood, plastic, or aluminum in a wide variety of colors and finishes. Heat- and light-limiting/conducting materials can be added as an energy-conservation measure. Contemporary design has favored minivenetian blinds with very narrow slats (about ⅜ inch), which give a particularly neat look.

Vertical Venetian Blinds Widely used in modern interiors, these blinds pull to the side (fig. 9.43). Their louvers come in various widths, materials, and colors.

Accordion-Pleated Shades These shades are constructed from a stiffened fabric that is folded in a pleated, bellows like configuration, which opens out as the shade is lowered and closes up in a compact stack when raised.

9.43 Levelor vertical blinds are used in the guest bedroom of a Coconut Grove, Florida, apartment. The designer, Juan Montoya, explained that he used the blinds "to create blades of light and shadows at night." The construction of the Italian beds allows slipcovers to be easily removed for cleaning. The chair is a replica of the deck chair used on the French liner *Normandie* of the 1930s. (Photograph: Norman McGrath, courtesy Juan Montoya) **9.44** Multiple membranes trap dead air in these "honeycomb" shades, providing significant insulation from heat in the summer and cold in the winter. **9.45** Simple swags of drapery frame windows and introduce overtones of opulence and tradition into an otherwise simple, even austere space. Robinson Mills & Williams of San Francisco were the designers for San Francisco's Fairmont Hotel. (Photograph: Nick Merrick, Hedrich-Blessing)

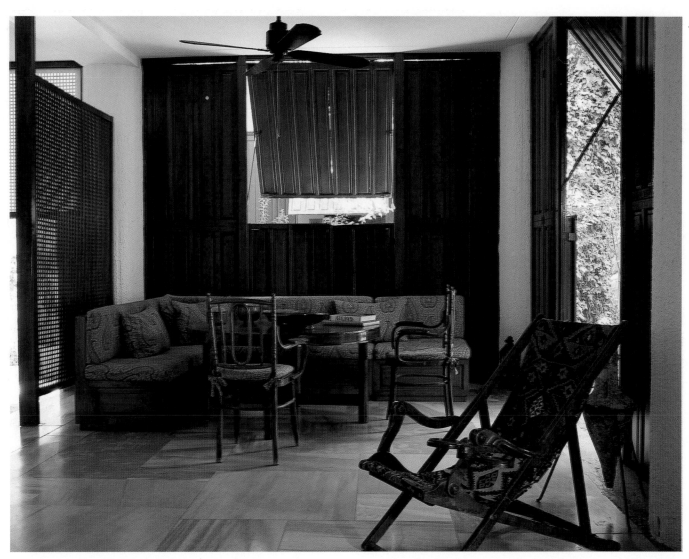

Honeycomb Shades A degree of thermal insulation is provided by these cellular shades made up of layers of fabric pleated to form hollow cells when the shade is lowered. Single and double cell types are available. The air trapped in the cellsforms an insulating layer. The outward face is white to reflect sunlight, while the inward face can be of any desired color (fig. 9.44).

Drapery This refers to loosely hung fabric, usually heavy and opaque, that can cover an entire window or extend from floor to ceiling or wall to wall. A vast range of fabrics can be used, and fabrics in combination with linings can provide the desired degree of light and privacy control. Sheer fabrics permit light transmission and some degree of see-through vision. Several layers of drapery make different levels of light and view control possible. Since drapery introduces textiles at window openings, it offers color, pattern, and various kinds of trim, making possible a great variety of aesthetic effects (fig. 9.45). (See Appendix 5, "Estimating Material Requirements.")

Curtains A more modest form of drapery, curtains are usually placed within the window frame, possibly attached to the actual window sash. Simple sash, café, lace, and net curtains offer limited light and vision control, often in ways appropriate to historical stylistic treatments.

Shutters Often also called blinds, shutters come solid or louvered and appear in many traditional interiors (fig. 9.46). They can be used alone or in combination with shades, curtains, or drapery.

9.46 The complex arrangement of shutters in this dining room, in which the upper section can be tilted outward to control daylight, is a traditional Turkish window treatment. The owner-designer of the interior in Bodrum, Turkey, was Mica Ertegün of MAC II, New York.

(Photograph: Marianne Haas, courtesy *Elle Decoration*)

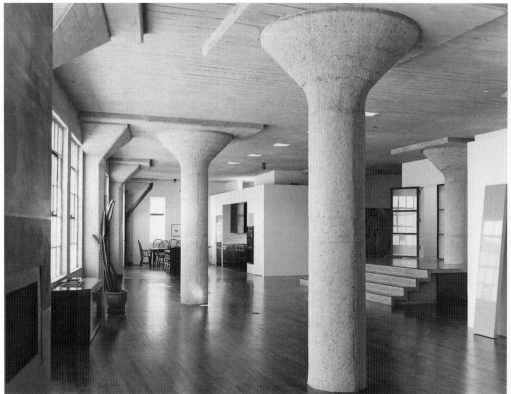

Shoji Screens Screen panels sliding on tracks not only function as shades but also give the window area a special character.

Metal Chain Drapery Links or beads in long strands provide some degree of security protection in the event of glass breakage. SPD glazing (see page 252) offers a means of control integral with the glass of a window, making additional window treatment for functional performance optional.

Columns

Totally bearing-wall structures, including most houses and small buildings, do not require columns. In large modern buildings with frames of iron, steel, or concrete, structural columns that carry the building's weight often stand free in interior spaces. They can be hidden by partitioning, but the large open spaces of stores, offices, lofts, and similar large interiors often leave them exposed (fig. 9.47).

Columns in older buildings often make use of decorative motifs from historic architecture. Whether plain or decorative, columns invite various treatments, ranging from simply painting the exposed column to wrapping it with materials that cover the original, changing its form and providing it with a surface of any desired materials, textures, and colors.

Steel columns, most often tubular or of H-shaped cross section, may be exposed only in buildings where strict fire-protection rules do not apply. Otherwise, they must be enclosed in insulating materials, which gives them a simple boxlike appearance similar to that of concrete columns. Wood columns (or *posts*) and brick piers also have simple rectangular or square shapes. Their surfaces may be left exposed or covered or wrapped as desired. Many of the techniques for wall treatment apply to columns as well, including paint, wallpaper, wood paneling, metal sheathing, and combinations of such treatments. Columns are sometimes covered with mirror to minimize their visible impact, although the resulting glitter may make the column appear *more* rather than less important.

Floors

Along with ceilings, floors represent the largest shares of area in an interior. Since a space's users come in direct contact with floors, they are usually far more important than ceilings as major design elements. Floors are ordinarily flat, but they may

9.47 A 97-foot-long loft space, now a residence in a reinforced-concrete loft building, gains a special quality from the gargantuan mushroom columns. The columns, typical of warehouse construction, have *bushhammered surfaces* that exaggerate their integral texture. The panel leaning against the wall at the right is an acrylic plank sculpture by John McCracken. Frederick Fisher and Eric Orr were the architects for this Los Angeles project. (Photograph: © Timothy Hursley, courtesy *House & Garden*)

include level changes created by raising a false floor in some areas or by depressing floor areas as a part of basic construction. This has been an accepted way to provide a sense of separation between spaces and to introduce spatial variety for aesthetic reasons.

Changing the floor level can present problems, however. A dropped area will reduce the height of the same space in the floor below and is therefore usually practical only in new construction or in total renovation. In the latter case, it is also likely to be costly, since the old floor must be removed and replaced at the lowered level. A raised area is less problematic, since it requires only the building of a false raised floor on top of the existing floor. There must be sufficient ceiling height to give satisfactory headroom after the raised level is in place.

All floor-level changes require steps or ramps at access points, making them potential accident spots. Small level changes of one or two steps, because they are easy to overlook, cause the most accidents. These should be avoided in public spaces and wherever crowds of people gather. Railings, edge markings, lights, and similar devices at level changes and at edges of raised floor areas offer some protection from accidents.

Access floors are a means for providing space for electrical and communication cables in spaces where use calls for such services in dense quantity. The term refers to systems that raise a floor by a few inches or more above basic floor level in order to generate a hollow space or *plenum* under the working floor level. The floor is then made up of panels that can be lifted to give access to the under-floor space, where cables can be run from connections at building risers (see fig. 15.24). Computer rooms and the trading rooms of brokerage and banking firms make frequent use of such systems. The floor surface can be of any usual material: hard, resilient, or carpet.

FLOOR MATERIALS

Most floors are composed of a basic structural material such as wood or concrete, which may be left exposed, treated, or totally covered with a special flooring material. Some heavy flooring materials, such as stone, brick, terrazzo, and ceramic tile, are suitable only to ground-level locations or over heavy subfloors, such as concrete. Lighter floor materials may be considered in almost any location, with selection determined by functional and aesthetic considerations. Widely used flooring materials include concrete, masonry materials (including terrazzo), wood, and tile.

Concrete Concrete is the basic structural material of floors in most modern buildings, including the slab on grade ground floors of many houses. Bare concrete can be troweled to a smooth surface, but is still generally regarded as acceptable only in utility spaces. Concrete floors are usually surfaced with one of the floor coverings or other treatments listed below.

Masonry Materials Masonry materials are widely used to give floors a hard and durable surface. These materials are usually laid over concrete or another subfloor that provides structural support. Typical materials include brick, slate, flagstone (see fig. 9.7), marble (including travertine), and granite.

Terrazzo A special form of masonry floor surface, terrazzo uses marble chips mixed into a cement mortar. The mix is then ground and polished to a smooth surface after setting. Metal divider strips subdivide areas to discourage cracks and to create patterns or designs. A wide variety of color and textural effects is possible.

Wood A common flooring material, wood may be used as the basic construction and left exposed; as a subfloor and covered with another material; or as a surface material applied over a subfloor. Although not very durable, softwoods are often used for simple board floors, including the admired wide-board floors of old buildings, and can be painted or finished to expose natural color and texture.

Hardwood floors may be simple strips of maple or birch or tongue-and-grooved strips made up for the purpose, most often of maple or oak. *Parquet* flooring is composed of small blocks of hardwood fitted together in patterns, often using woods of two or more contrasting colors.

Factory-made units of parquet make it possible to lay a parquet floor in a manner similar to tile. Thin, prefinished wood floor tiles simulate parquet with somewhat limited success.

Tile A flooring material with a long history of acceptance, tile is particularly suited to use in kitchens, bathrooms, near pools, and in other locations where water will often be present. Besides being waterproof, its hard surface promotes good sanitation.

Tiles of baked clay, such as the popular quarry tile, are similar to masonry materials and require a sturdy subfloor. Ceramic tile, in a range of sizes, shapes, colors, and textures, permits a great variety of color and pattern treatments (fig. 9.48). Very small tile, usually called *mosaic tile*, promotes textural and patterned effects.

WOVEN FLOOR COVERINGS

Carpets and rugs are among the most commonly used coverings. Although they are actually textiles, they are discussed here as materials rather than in Chapter 12, "Textiles".

RUGS The term *rug* describes a movable unit of carpet, usually smaller than the room in which it is used. *Area rugs* are often used to help group items of furniture within a larger space, thus defining an area for conversation, dining, or other activities. Rugs are made in a great range of sizes, from very small (often called *mats*) up to room size. Many popular types of rugs come from particular regions and are made in locally characteristic styles and colors.

CONSTRUCTION		CHARACTERISTICS
Woven	Wilton	Woven on a Jacquard loom, permitting up to five or six colors in a pattern design. Top-quality construction, particularly when woven of worsted yarn. Density (and quality) are defined by the number of warp lines per inch, called the pitch. Older Wilton was woven on a 27-inch loom with 256 warp lines, called full pitch. Warp lines (rows or wires per inch) may vary from 13 for top quality to 8 for medium quality. Cut pile is normal. A Wilton with an uncut pile may be called a *Brussels carpet*. Broadloom widths have been produced.
	Axminster	An industrial weaving technique (now obsolete) permitting great variety in color and pattern, with some similarity to handweaves. Quality is defined by the weft count, given in rows to the inch. The range is from 11 rows (top quality) to 5 rows (lower quality) per inch. Widths up to 12 feet (broadloom) have been produced.
	Velvet	Normally a cut-pile carpet industrially produced in varied color and pattern. (A similar uncut pile weave is called *tapestry*.) Quality is similar to Axminster, but inferior to Wilton weaves.
Tufted		This is now the most widely produced type of carpet. Industrially produced in broadloom widths with yarn pushed up through a backing to form tuft loops, which may be cut or left uncut. A latex backing may be added to secure the tufts. The density of the yarn and the height of the pile influence appearance and durability.
Needlepunched and Needlebonded		A manufacturing technique using hooked needles to insert fibers into backing. First developed for production of kitchen, bath, and outdoor carpeting of polypropylene fiber, now also used for general-purpose carpet.
Knitted		Construction superior to tufting in durability, but inferior to weaving. Multiple needles knit pile and backing together, usually with an added latex backing. Loop pile in solid color or tweed is most common.
Flocked		Short fibers are stood on end electrostatically and adhered to a backing. Surface resembles a cut-pile velvet. Patterns may be printed on flocked carpet. An economy construction producing carpet of inferior wearing qualities.
Handmade	Knotted or tied	The construction of oriental rugs, in which the yarn is tied into a woven backing with individual knots. Up to 800 knots per square inch are used in high-quality orientals. The ends of knots may be cut off to form a pile or the surface may be formed of knots, giving a flat, durable surface.
	Woven without knots	Kilims and *Soumaks* are fine oriental weaves handwoven without knotting. Kilims are thin and light but durable. The Soumak adds a third element to the warp and weft and forms a smooth surface. Soumaks are also sometimes called *Cashmeres*.
	Hooked	Tufts of yarn are pushed through a woven backing to form a pattern or pictorial design. A traditional craft technique producing durable rugs or mats, usually of traditional design types.
	Braided	Developed as a means of using discarded fabric remnants by braiding narrow strips together into strips that can be sewn into rugs or mats. Often called rag rugs. A traditional handcraft technique capable of producing work of lively color and charm. Commercially produced imitations are also available.

of carpets in current use, as well as the guidelines for estimating yardage. (See Table 13, "Carpets and Rugs, pages 282–83, and Appendix 5, "Estimating Material Requirements.")

Carpet selection presents a complex problem in which cost and durability must be balanced against one another and related to aesthetic decisions about color, pattern, and texture. The high cost of wool as a fiber has encouraged the acceptance of synthetic fibers, with new forms constantly appearing. New fibers have not had a chance to demonstrate durability over time, but the performance of synthetics has been, to date, disappointing in terms of wear, resistance, ease of cleaning, and the ways in which appearance changes with use. Fire-safety issues also are a cause for concern with many synthetics. In evaluating costs, it is wise to consider life-span cost, including maintenance and repair costs along with estimated durability, before accepting substitutes for wool on the basis of assumed economy. For large projects, laboratory and use testing is advisable before specifying a particular carpet.

FLOOR COVERINGS

Floor coverings are laid over a structural floor of concrete, wood, or other material. Wall-to-wall coverings can be used over a subfloor of unfinished appearance, while rugs that occupy less than a total floor area require a subfloor of finished appearance. Woven soft floor coverings are discussed above. The most-used hard floor coverings are paint and various kinds of resilient flooring.

Paint Usable over concrete or wood with an endless variety of color and patterns, paint wears rapidly and must be renewed regularly. It is therefore a poor choice where heavy traffic and usage are anticipated.

Resilient Flooring The term *resilient flooring* covers a range of manufactured products available in sheet form or in tiles, usually in squares of 9 or 12 inches. The common resilient materials are linoleum, asphalt and asphalt mixtures, vinyl plastic, cork, and rubber (fig. 9.51). An extensive variety of color and pattern choices is available, and designs can be created with arrangements of tiles or with inlay strips in sheet-flooring installations.

Steps and Stairways

Steps and stairways can be considered a special form of flooring, since they make use of many of the same materials and surface finish techniques (fig. 9.52). Stairways may be constructed from wood, concrete, or steel, in accordance with the overall structure of the building in question. Steel stairs may have treads of cement or *composition*—material composed of various ingredients and often taking the place of more expensive or uncompounded

material—and exposed surfaces can be covered and finished to suit the intended use. Many steel stairs are factory-made and supplied in prefabricated form for installation on site. Spiral stairs (fig. 9.53), a favorite for fitting a stair into a limited space, are also available in prefabricated form.

DESIGNING STAIRWAYS

Where new steps or stairs are to be constructed, it is necessary to observe the basic dimensional limitations that control the convenience and safety of all stairs. A step is made up of a riser (the vertical surface between stepping surfaces) and a tread (the horizontal step surface). The riser and tread dimensions together establish the slope of the stair (fig. 9.54) and, therefore, the ease and convenience of its use. (See "Establishing the Slope of a Stair," page 287.)

Having established the slope of a stair through tread and riser calculation, the width must be established and the overhead clearance worked out. One person using a stairway needs a width of at least 26″; a stairway permitting two users to pass needs at least 44″, although a wider dimension up to 68″ is more comfortable. Stairways wider than this must be subdivided by railings so that every user has a rail to grip. Headroom calls for at least 84″ of clearance. The length of a *stairwell*, or the floor opening through which a stair passes, is determined by the line of headroom as it passes through the structure of the floor above.

All stairways need railings (figs. 9.55, 9.56). Stairways that are open at the side require some form of rails or banisters that prevent people from falling. Rail or baluster elements should be carefully spaced so that young children can neither slip through and fall nor catch their heads between elements. Long runs of more than 20 to 24 risers should be broken up into shorter runs with *landings*. *Winders*, the wedge-shaped treads used in curving stairs, have such a bad record in causing accidents that they are best avoided, especially in public spaces. Objects of breakable materials such as glass and mirror should not be placed close to stairs, and materials that can be slippery, in normal circumstances or when wet, should not be used on or near stairs. Nonslip nosings and tread materials can minimize the risk of slipping.

Building codes include many rules that affect stairway design. Widths of stairs in public places, requirements for landings at intervals that avoid overlong runs, heights and placement of railings are all matters dealt with in many codes. In addition to code requirements, designers should consider additional safety issues. A single step level change is notoriously dangerous, as are all short runs (a few steps) unless carefully marked, lighted, and provided with adequate railings. Barrier-free requirements demand that all stairs should be augmented by ramps or mechanical lifts that are wheelchair accessible and so available to people with physical problems that make stairs difficult.

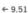

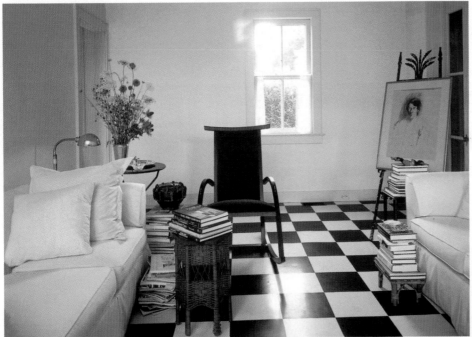

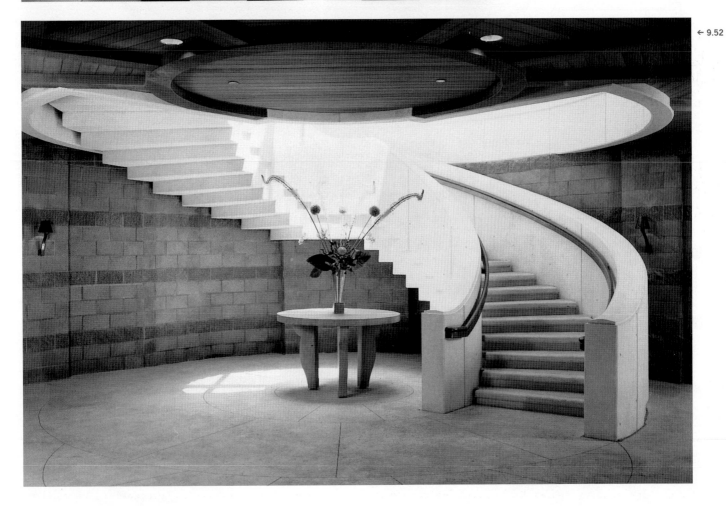

9.51 In this living room in the Long Island resort town of East Hampton, New York, the checkerboard pattern of the linoleum flooring acts as a foil to the simple furniture and the white walls. The painting is by Jack Ceglic, who also designed the room. (Photograph: © Mary Harty/Peter DeRosa, courtesy *House & Garden*)

9.52 In the central rotunda of the Opus One Winery, Oakville, California, a winding stairway provides access to the caves on the lower level. Light pouring into the upper level of the space dramatizes the transition to the cool, dim areas below. The designers were Johnson Fain and Pereira Architects and Planners. (Photograph: Tim Street-Porter)

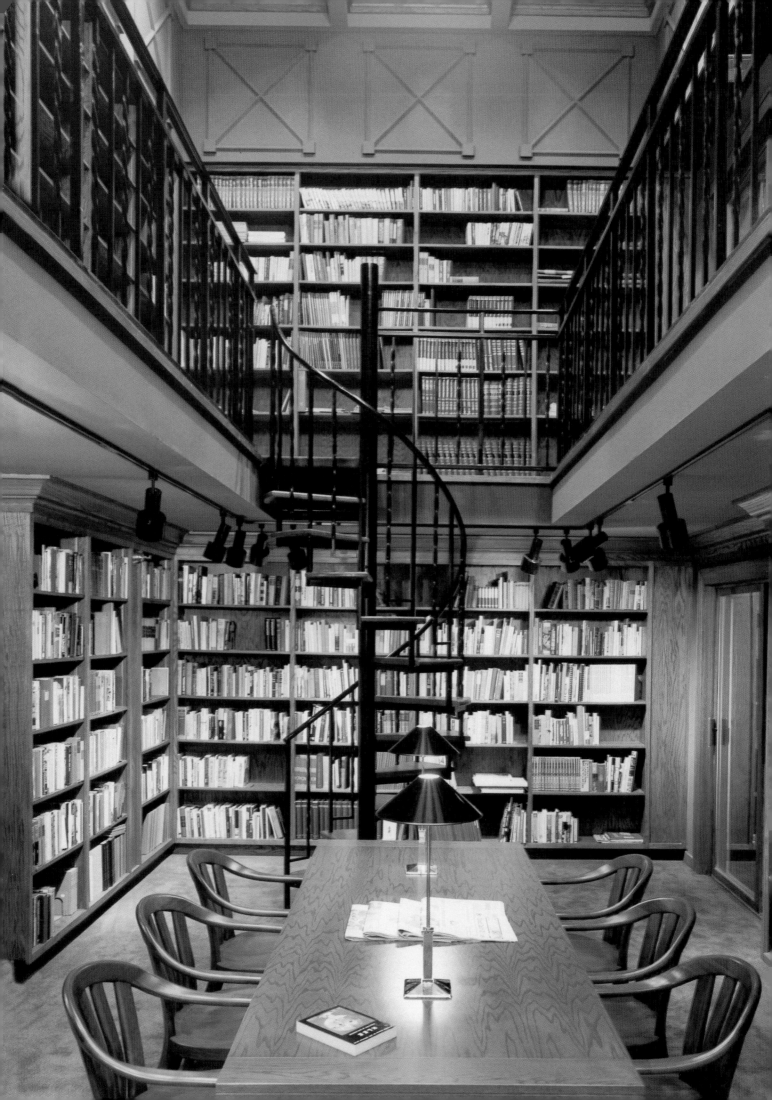

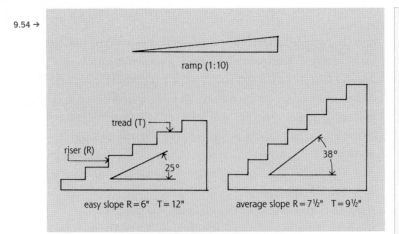

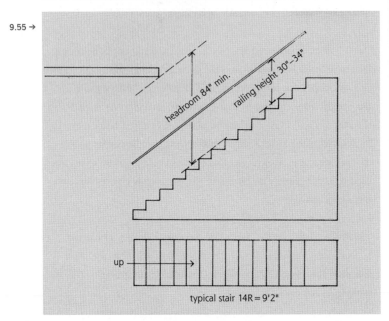

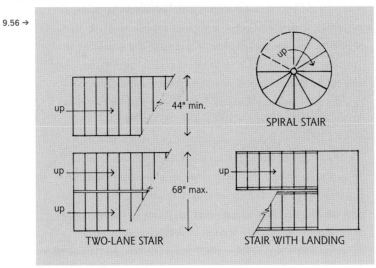

9.54 →

ramp (1:10)

tread (T)

riser (R)

25°

easy slope R = 6" T = 12"

38°

average slope R = 7½" T = 9½"

9.55 →

headroom 84" min.

railing height 30"–34"

up →

typical stair 14R = 9'2"

9.56 →

up →

44" min.

SPIRAL STAIR

up →

up →

68" max.

TWO-LANE STAIR

up →

STAIR WITH LANDING

← 9.53

9.53 A spiral stair forms a visual accent in a double-level library at 1666 Coffman, Minneapolis, Minnesota. Interior designer Gary Wheeler of the architectural firm Perkins & Will was the designer. (Photograph: Saari & Forrai Photography, courtesy Gary Wheeler/Perkins & Will)

9.54 Slopes and riser and tread dimensions for a ramp and typical stairways are given here. **9.55** Railing height and headroom clearance for a typical stairway are shown. **9.56** These drawings represent architectural symbols for several stairway examples.

Establishing the Slope of a Stair

Riser height should fall within a range of 6″ to 9″, 7″ being desirable. Since all risers in a *flight* (or *run*) of stairs must be equal, the exact riser height is determined by dividing the total level change into equal units. For example:

- Given a level change of 9′8″ (116″) and trying to get a riser height close to 7″, divide 116 by 7:

$$\frac{116}{7} = 16.57$$

- Since the number of risers must be a whole number, either 16 or 17 risers might be selected:

$$\frac{116}{16} = 7.25 \quad \text{AND} \quad \frac{116}{17} = 6.82$$

- This gives the choice of a riser 6.82″ high or 7.25″ high.
- The lower riser will yield a stair that is easier to climb.
- The 7.25″ riser will produce a slightly steeper stair, but it will take up less space because the fewer risers will require fewer treads.

The number of treads is always one less than the number of risers, since the topmost riser requires no tread.

Tread dimension is determined in relation to riser dimension. Old rules of thumb for this relationship (which are still in general use) are:

- Riser plus tread should equal 17″ to 17½″.
- Riser multiplied by tread should fall between 70″ and 75″.

In the example above, if a 7.25″ riser had been chosen:

$$17-7.25 = 9.75 \quad \text{AND} \quad 17.5-7.25 = 10.25$$

$$\frac{70}{7.25} = 9.66 \quad \text{AND} \quad \frac{75}{7.25} = 10.34$$

Applying the first rule yields a tread dimension between 9.75″ and 10.25″, while the second rule gives between 9.66″ and 10.34″. Averaging this out, a tread of 10″ (a comfortable tread length) might be selected. The total length of the run of stairs, or the amount of space the stairway will actually use, would then be 16 (the number of risers) minus 1, or 15 (the number of treads) times 10″, or 150″ (12′6″). Treads are often designed to overhang the riser below with a projection called a nosing. This overhang dimension is not considered in calculating stair dimensions.

Ceilings

Inevitably, ceilings form an important aspect of all interiors, at least in terms of square footage. Many ceilings are simply blank, neutral areas, often, like the sky out-of-doors, providing a simple overhead for more complex elements at eye level and below. However, thought and design effort may make the ceiling a more active part of an interior.

A simple and basic issue in ceiling design involves the decision to keep a ceiling as a single plane or to introduce lowered areas (usually called *soffits*) in portions of a space to contrast with areas of full height. The term *cove* is often used for a curved transition from wall to ceiling or for a curved profile where a lowered ceiling makes a transition to a higher ceiling level. A cove is often formed in a pocketlike profile, providing a space where *cove lighting* strips can be concealed to form a source of indirect lighting. Ceiling planes can also slope at an angle, as seen in many attic spaces and spaces with *dormer windows*. The term *cathedral ceiling* is a rather misleading designation for ceilings that are high and introduce sloping surfaces.

The ceiling plane establishes the height of a space and therefore its volumetric proportions. A maximum height is usually established by structure, but a lower ceiling, called hung or *furred*, can be introduced down to whatever level may be considered minimum, headroom (8 feet 2 inches is a commonly accepted minimum, although heights as low as 7 feet 2 inches will not create any physical problem). In setting ceiling height, it is often necessary to consider what is to be placed above the ceiling, since the space between ceiling and structure is commonly used to house ducts, wiring, and plumbing (including sprinkler pipes, when they are used); in addition, many architectural lighting fixtures are recessed up into the *plenum*, or cavity above the ceiling. Dimensional clearances must be sufficient to avoid any interference between these elements and any structural elements, such as beams and girders.

The visible ceiling surface may be smooth and blank, but it may also be studded with such functional elements as lighting fixtures, air-conditioning outlet louvers, sprinkler heads, and audio loudspeakers. It may also take on the functional demands for specific acoustical performance. Ceilings of open louvers, slats, or *egg-create* create a visual overhead plane while permitting easy access to ducts, sprinklers, and other functional elements for economic or technical reasons. Another approach, which finds particular favor in interiors of High Tech character, is to expose all piping, ducts, and other technical elements, possibly painting them with strong colors to make them decorative features rather than offensive necessities to be hidden (see Chapter 15, "Mechanical Systems").

For purely visual reasons, a ceiling may be ornamented with peripheral moldings, one or more decorative rosettes, or even rich sculptural and painted decoration, as in many historic inte-riors. Structural elements such as beams may be exposed and, in turn, decorated. Coffered ceilings (with a wafflelike pattern of squares) and the varied and often complex patterns of vaulting, domes, and modern shell structures all form alternative kinds of ceilings. In spaces under the roof level of a building, *skylights* can be introduced into ceiling design for both practical and visual reasons.

CEILING MATERIALS

A listing of widely used ceiling materials includes plaster, Sheetrock or wallboard, wood, acoustical ceiling materials, integrated ceiling systems, metal, and glass:

Plaster Plaster is a primary traditional material applied wet on lath to achieve both plain and decorated ceilings (fig. 9.57). Paint and wallpaper are common finishes. Plaster moldings and trim are important elements in many historic interiors. As with walls, the scarcity and high cost of the plasterer's skilled labor combined with the plaster's slow drying time discourage its use in modern practice. Moldings of wood or plastic are now sometimes used to patch, repair, or simulate the decorative elements characteristic of plaster.

Sheetrock or Wallboard For plain, smooth ceilings similar in appearance to plaster, Sheetrock or wallboard is now the most common inexpensive material. Its treatment is similar to the same material on walls.

Wood Wood appears as a ceiling material when the beams or joists and planks of wood construction are left exposed. Natural or painted finishes are possible. Wood paneling similar to wall paneling is occasionally used in more traditional interiors. An unusual but effective ceiling results from the use of narrow tongue-and-grooved boards of the sort supplied for hardwood flooring, normally used with a natural finish.

Acoustical Ceiling Materials Special ceiling tile and panels of pressed paper, fiber, and mineral composition have holes or pores that trap and absorb unwanted sound (fig. 9.58). Small tiles (usually one foot square) may have clearly visible round holes or a less noticeable texture of pores suggestive of travertine stone. Bevel-joint lines accentuate the pattern of tiles; flush joints are less visible and suggest a smooth ceiling plane. Similar materials are also made in larger panels (commonly 2 by 4 feet) for use with a system of support structures that can coordinate with lighting fixtures and heat, ventilation, and air-conditioning (HVAC) outlets on the same dimensional module.

Ceiling Systems Panel materials (usually with acoustical value), supporting structure, which may be visible or hidden, and,

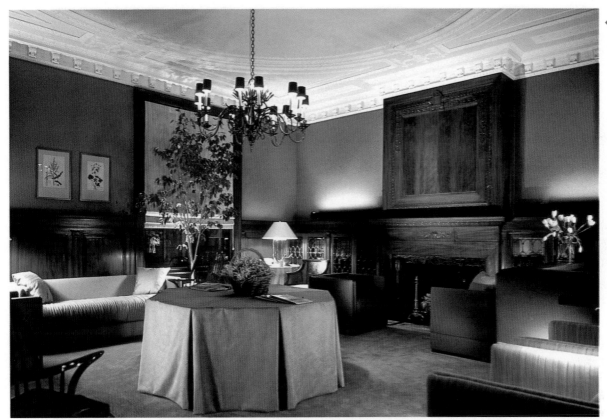

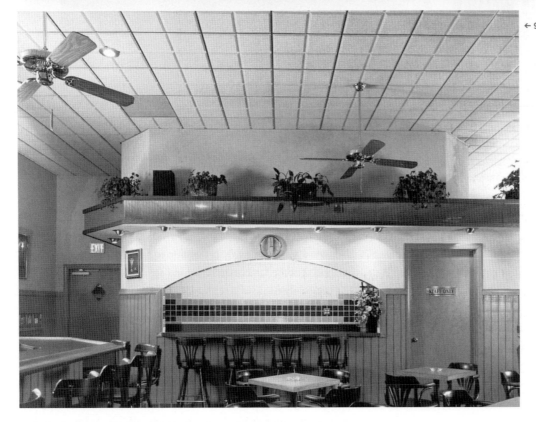

9.57 In converting a large mansionlike town house in New York City into a group of medical offices, interior designer John F. Saladino retained the ornamented plaster ceilings. The waiting-room interior displays a compatible, traditional, and rich character in dramatic contrast to the usual drabness of doctors' offices. (Photograph: Peter Vitale) **9.58** Acoustical ceilings absorb noise in spaces where sound may otherwise reach disturbing levels. In the Merchant & Main Bar & Grill, Vacaville, California, designers James and Robert Tooke used a system ceiling: A grid of metal supports holds squares of sound-absorbent material, which reduces restaurant noise generated by hard, sound-reflective surfaces to a comfortable level. (Photograph courtesy Chicago Metallic Corporation)

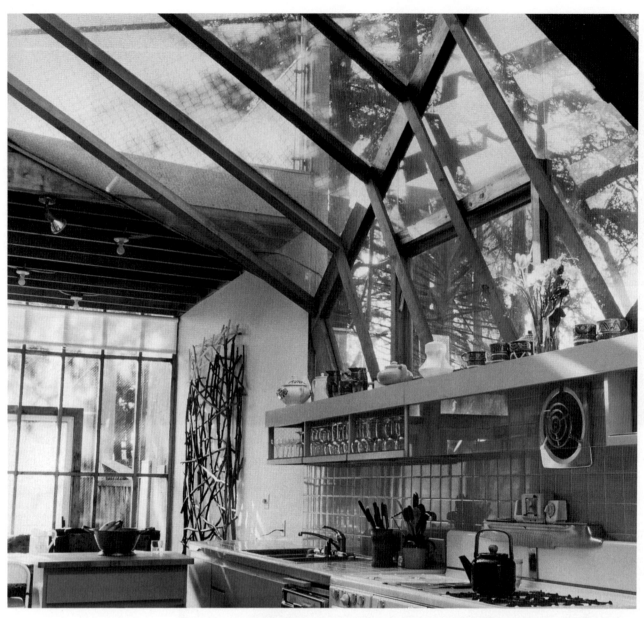

often, lighting and HVAC elements are all integrated into a factory-made product system. It may include visually striking elements such as coffers or other forms. Such integrated systems most often find use in office and other contract or commercial interiors.

Metal Ceilings Some systems use spaced metal strips with the intervals open to the acoustical material above. Metals such as stainless steel, aluminum, copper, or bronze also find occasional use as surface materials for ceilings. Pressed-metal ceilings (erroneously called *tin* ceilings), once popular Victorian elements, have now been rediscovered.

Glass The usual material for skylights, glass is normally set in a framing of wood or metal (fig. 9.59). As skylighting expands to become a total ceiling, it is possible to speak of a glass ceiling—a feature of some famous architectural structures. Glass, mirror, or a plastic substitute as a ceiling material can create spectacular and startling visual effects.

Miscellaneous Elements

Of the surprising number of components in an interior, many may seem minor or incidental, but each calls for design attention

9.59 The entire ceiling of a kitchen has been turned into a skylight. Cooking thus becomes an almost outdoor activity, particularly pleasant in the southern California climate. Frank O. Gehry was the architect for this Los Angeles project. (Photograph: © 1986 Tim Street-Porter)

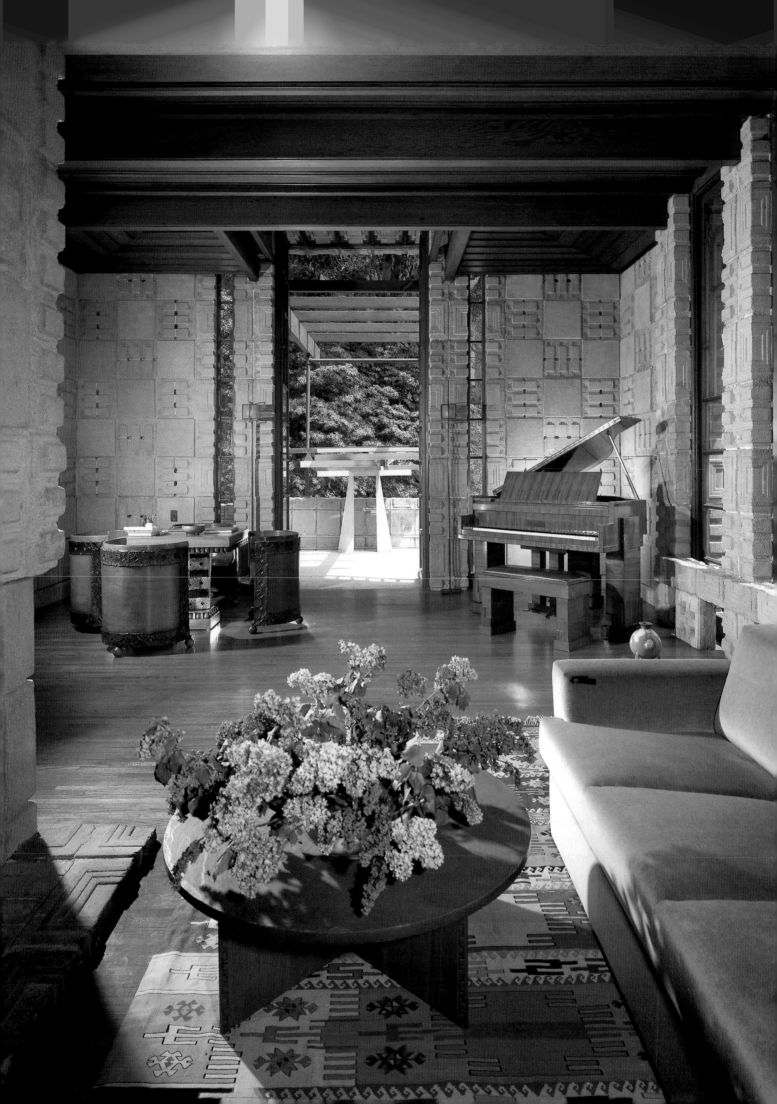

← 10.3

Table 14. Checklist of Basic Color Steps

LIST FACTORS THAT WILL INFLUENCE COLOR SCHEME
Physical
- Orientation and extent of windows or other daylight source
- Type and location of artificial light used
- Hours that space will be used and for what purposes
Atmospheric: calm, restful, stimulating, dignified, playful, etc.
- Personal color preferences of users
- Residential design: by querying the occupants
- Public design: by observation of common regional color usage
Geographical
- Climate
- Regional preferences in color usage

ESTABLISH CHARACTER OF THE COLOR SCHEME, IN WORDS OR ALONG WITH COLOR IMAGES
- Choose among warm, cool, or neutral
- Select theoretical type: analogous, complementary, etc.
- Decide dominant hue or hues
- Gather color samples, photos of existing interiors, or other color materials

SELECT COLORS FOR ONE OR MORE LARGE MAJOR AREAS: FLOORS, CEILINGS, WALLS

NOTE AREAS OF PREDETERMINED COLOR
- Existing furniture to be retained
- Material of a known color: brick, stone, natural wood, etc.

ADD COLOR FOR SECONDARY ITEMS AND AREAS
- Furniture, drapery
- Other elements with significant color impact

ADD SMALL AREAS OF ACCENT COLOR
- Strong values of an already selected color or of a contrasting color
- Materials of a special nature that will impact the total scheme: metallic elements, tinted glass, mirror, etc.

ALL-NEUTRAL COLOR

An approach using all-neutral color has much in common with the all-natural color approach but is arrived at without specific concern for the natural colors of materials. It is a type of monotone or monochrome scheme (see pages 318–319) based on the idea that neutral colors, those close to the central gray axis of the Munsell color solid, are always safe and nonclashing, generally acceptable in any situation. A neutral scheme may be based on true neutral grays in the white-to-black range or may be warm, using beiges and tans as dominant colors (fig. 10.3), or cool, using grays of greenish, bluish, or violet tint. Of all the neutrals, white is probably the most useful and most widely used. Whites, too, can be cool or warm or, with colored pigment added, tinted toward cream, as in the many paint colors offered with names such as off-white, linen-white, or oyster-white. Schemes using white, grays, and black are of this type.

The notion of *neutral-plus* adds to the neutral scheme some limited areas of strongly chromatic color, often one or more true primaries. Such schemes were favorites of early Modernism, suggesting the paintings of Piet Mondrian and the work of various designers connected with the De Stijl and Bauhaus movements. White and neutrals plus primary accents remains a useful for-

10.3 Although all the colors in the Jean-Georges Restaurant, in the Trump International Hotel and Tower, New York, are close to neutral, the total effect is strongly colorful. The panels above the open kitchen are etched silver-leaf. Adam Tihany was the interior designer. (Photograph: Peter Paige)

mula for color schemes that can hardly go wrong while offering possibilities for varied color through the use of strong color tones in the accent areas. An all-neutral scheme with only plants as a source of accent color is also frequently adopted.

FUNCTIONAL COLOR

Probably the approach most widely used in developing color schemes is functional color. It is based on an analysis of what color is expected to do for the interior space in an active sense. Overall color tonality is chosen to enhance or offset environmental factors of climate or orientation. Warm color is welcome in cold climates or spaces with a northern orientation that will never receive direct sun. Cool colors are helpful in hot and sunny locations. Difficult spatial shapes can be modified, with small spaces made to look larger, oddly shaped spaces made more reasonable through color distribution, based on the known facts of color perception. Elements can be emphasized or visually diminished through color, and messages can be subtly conveyed through selection of colors that attract, repel, or express specific attitudes. A white door in a white wall will seem to disappear. A bright red door invites attention and suggests importance.

In general, a functional approach to color permits, even encourages, a very free use of color elements, demanding only that every color decision be purposeful in some way. Functional use of color can interlace with the concepts of color theory and can overlap neutral and natural color use. It is particularly appropriate to modern concepts of overall design rooted in functional intentions.

Color in Specialized Interiors

Although the basics of developing color schemes apply to every type of interior space, it is possible to define recommendations suitable to specific interiors. Considerable research has been done in an effort to discover the "best" color schemes for various space functions, with highly inconclusive results. Because many variables interact with color in complex ways, no fixed rules can be established for dealing with color use. The sizes and shapes of spaces, the anticipated duration of typical occupancy, the impact of climate and local (or national) traditions—not to speak of changing tastes and styles—all lead to the often contradictory suggestions developed by researchers and writers. Out of this confusion, however, arise a number of generalizations and a few specifics that can be helpful in planning color schemes for assorted types of occupancy.

OFFICES

Commonly occupied for long periods of time on a daily basis, offices deserve color schemes that will be of optimum help to their users. For many years recommendations for the use of a bland buff or tan, or the green tones thought at one time to be "eye-savers," led to office interiors with a depressingly institutional character. Modern practice suggests the use of livelier colors in limited areas with related quiet tones for larger spaces. Because it is important to limit brightness contrast within the field of vision of the office worker (see page 334), dark tones and black become problematic and work surfaces need to be of fairly light tones to minimize contrast with task materials, typically print on white paper. Floor colors should not be so dark as to introduce excessive brightness contrast between tasks or work surfaces and floors. Intense colors such as bright reds, yellows, purples, or violets are best restricted to secondary spaces passed through briefly, such as corridors or service areas. For the milder colors appropriate to work spaces, it is generally believed that cool colors encourage concentration whereas warmer colors best suit activity. Southern orientation with natural light and warm climate locations support the use of cool colors, while colder climates and north orientation suggest warm color tones. In multifloor office projects, each floor can be given an identifying color tonality, with strong color in lobbies, corridors, and entrance points and quieter versions of related hues in general office areas.

Private offices tolerate more aggressive color schemes, especially when occupants can be identified and personal color preferences considered, as with many executive offices. Office personnel may change or be moved about with the passage of time, however, rendering overly personal or eccentric color schemes generally inappropriate even in private offices. Natural color schemes, discussed above, featuring the tones of materials such as wood, leather, and masonry, are usually successful.

The popular "modern" color practice of using white for walls, a neutral tone for floors, and accents of intense, saturated, primary or near-primary color is regarded as unacceptable by many researchers, who find the white surfaces to be sources of excessive brightness, contrast, and glare. Studies indicate that user-occupants are frequently dissatisfied with such color schemes, regarding them as harsh and cold. Black, white, and sharp colors are thus best used in lobbies, corridors, and other spaces that are not occupied for long periods of time (fig. 10.4).

SCHOOLS AND COLLEGE FACILITIES

Typically afflicted with drab institutional color schemes, educational facilities are well served by many of the same criteria that apply to offices. Students in a classroom alternate attention between desktop tasks and forward vision toward teacher and chalk-board. Mild color schemes for floor and side walls, cooler or warmer in tonality as orientation and climate may suggest, can be relieved by stronger color on the end wall related to or contrasting with chalkboard color. The black of the traditional chalkboard, which in practice actually appears as a medium gray,

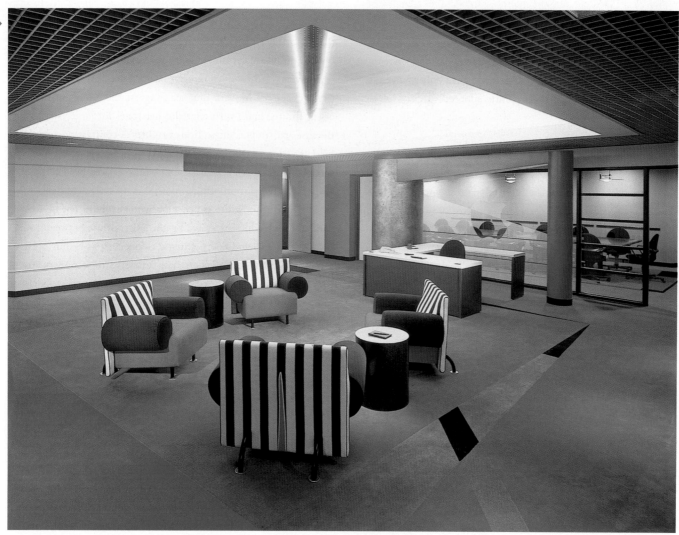

is less satisfactory than other chalkboard tones now available. The intense green chalkboard and brown tones of many tackboard surfaces also take on an institutional drabness that can be avoided or relieved through the use of contrasting color surrounds.

Classrooms for young children profit from the use of brighter colors, usually in warm tones; the use of primary colors, however, is an undesirable cliché. Auditoriums, gymnasiums, and large lunchrooms are best served by light tones, especially warm colors that minimize brightness contrast. Corridors and stairway areas can use stronger colors to offer variety and stimulation during transitions from one area to another.

RESTAURANTS AND OTHER FOOD-SERVICE AREAS

A restaurant offering excellent food and service can fail if color and materials generate a depressing or unpleasant atmosphere. Grays and black as well as stronger tones of blue and violet are not advisable, and yellow-greens have unappetizing implications. Although red and other warm tones tend to stimulate appetite and create a cheerful atmosphere, they are best used with restraint and with stronger accent colors that may be analogous or complementary. Floor coverings are frequently chosen in tones that tend to hide dirt; fussy patterns in dull colors, however, can be unappealing. Good maintenance is preferable to hiding soil. In restaurants where they are used, table linens contribute an important color element within the diner's field of vision and need to be selected in relation to the overall color of the restaurant.

Various traditional associations of color with style of food service can provide valuable suggestions for restaurant color as long as they do not lead to cliché treatments. Natural wood for floors and tabletops—possibly for walls as well—relates well to seafood cuisine. The national colors of red, white, and green in an Italian

10.4 Brilliant color is generally most appropriate in spaces that are passed through quickly. In this reception area in the Computers, red blue, and black are all present in saturated intensity. Simon Martin-vegue Wiinkelstein Moris were the designers. (Photograph: Charles McGrath)

10.5 The Jade on 36 restaurant and bar, Shanghai, 2005, designed by Tihany Design, takes traditional elements from China's everyday life and re-interprets them in a different medium, scale and context. The emperor's gown becomes the inspiration for an intricately "folded"

ceiling feature in the main dining room. Oversized interpretations of miniature glass perfume bottles are backlit—acting as lighting fixtures—and are located within the deep rich brown tones of the macassar ebony wood wall panels. (Courtesy Tihany Design)

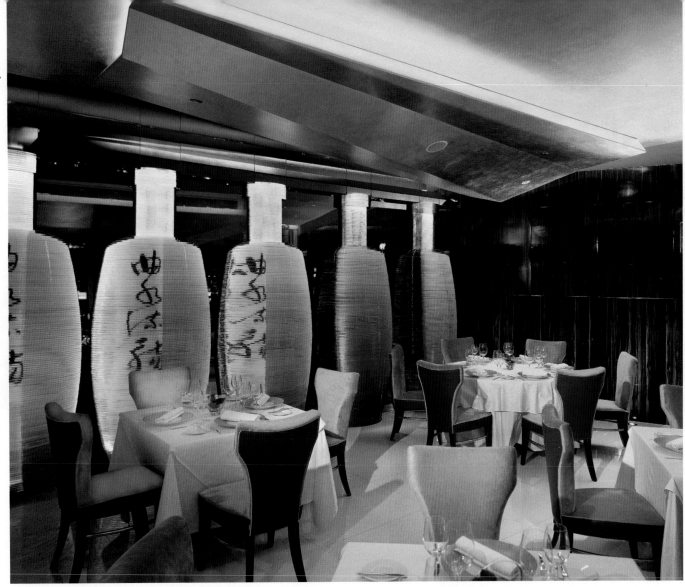

restaurant, red and white in a Danish dining room, or blue and yellow where Swedish food is offered are acceptable if not presented in overpowering excess. Softer warm tones suit luxury restaurants serving traditional menus; the glitter of silver and glassware supplies a lively accent to the restrained color, which suggests a leisurely pace.

Cafeterias and dining accommodations provided in office or industrial facilities can use brighter colors to stimulate a rapid pace and to provide contrast with the colors of work settings. Black, gray, strong cool colors, and yellow-greens are to be avoided. In fast-food outlets intense color is often deliberately adopted to encourage quick customer turnover since a brisk pace is one of the attractions of these restaurants.

In these as in all food-service facilities the level and type of lighting are critical (see pages 346–47). Restaurant color schemes must always be developed under the type of lighting that will be used in the completed facility.

Patrons' memories of a particular restaurant include reactions to the spatial design, the color, lighting, and the degree of good service. Together they will generate a sense of comfort and satisfaction in combination with memories of the food. A pleasant meal involves all of these elements. Patrons will remember just one unsatisfactory element.

STORES, SHOPS, SHOWROOMS

Retail and sales facilities present color problems similar to those of restaurants. Choice of color must be favorable to the goods on display and must relate to the price levels, pacing, and general character of the store. Acceptance of certain traditions helps customers to feel right in a particular shop and thus to find selection and purchase of goods easy. Menswear, for example, is appropriately offered in settings of brown wood tones and subdued color, while women's shops benefit from pastels and warm tones. The High Tech vocabulary of white, black, and chrome (possibly with bright accent colors) befits products with technical associations, such as electronic or photographic gear; bright colors in general suit sports equipment; and restrained color complements the sale of expensive jewelry.

In many shops the colors of merchandise and packaging furnish so much color that a neutral, noncompeting setting may serve well. In an automobile showroom, for example, the strong colors of the cars on display provide all the color needed. Discount outlets and clothing shops featuring "plain pipe racks" use little color and bright lighting to create a neutral environment appropriate to an image of fast pacing and low prices.

Retail food stores call for color coordinated by area to the various kinds of food for sale. Because of its associations with

freshness and cleanliness, white suits the display of dairy and frozen-food products. Meats show well in either white surroundings or with blue or blue-green tints that accent the red tones. Special warm-tone lighting is also often used to accent the color of meat both on display and at service areas. Bright accent colors can become part of an overall color theme that aids the identification of supermarkets and other chain retail outlets. Signs, packaging, and advertising materials, if color coordinated, assist each other in projecting the character of a particular business to encourage customer satisfaction and loyalty.

MEDICAL AND HEALTHCARE FACILITIES

The complex, interrelated needs of doctors, nurses, patients, visitors, and staff—groups with overlapping but varied relationships to the spaces they use—present special problems in color selection. Patients enter a hospital with concerns and worries, and their stays will include periods of discomfort and boredom. Visitors have another set of concerns as they come to cheer, observe, and attend to the patients they see. Doctors and other staff put in long working hours that can be tiring and stressful. Of these groups, the needs of patients should be primary, and, fortunately, serving these needs generally will be advantageous to each of the other constituencies. In terms of color, the basic requirement is schemes that will be at once restful and calming while projecting a level of optimism and good cheer that supports recovery and health (fig. 10.6).

A number of research studies have reported findings suggesting that environmental ambience plays a significant role in the rate of recovery among hospital patients and in the well-being of nursing-home occupants. The specific elements that can make a favorable difference include visual contact with the out-of-doors and the use of warm color tones along with materials, such as natural wood and fabrics, that relate to residential interiors. White, institutional green, or tan contribute to a depressive atmosphere. Cool colors, although believed to be calming, are of questionable value in patients' rooms because they can also be interpreted as depressing; strong greens or blues are best avoided. Patients' bathrooms call for mild, warm colors that flatter users' skin tones when reflected in mirrors.

In intensive care units, cooler colors, which offer a calming ambience, are appropriate. Bluish green has become a standard color treatment for operating rooms because it provides visual relief from the brightly lighted red tones of blood and tissue that occupy the visual field of the surgeon and other personnel at work. Examination and treatment areas may use cooler colors wherever a calm atmosphere is indicated and warmer tones in areas such as dermatology and obstetrics; in all cases color should be restrained to avoid any possibility of environmental color reflection interfering with patient diagnosis (fig. 10.7). Nurseries, for example, should not use strong colors because they may distort evaluation of infants' skin color and impede appropriate care.

10.6 The warm tones of simple wood details enliven a patient's room in the Reisman Building of Beth Israel Hospital, Boston, Massachusetts. Design was by Rothman Rothman Heineman Architects with Crissman Solomon Bauer Architects and Lloy Hack Associates. (Photograph: © 1984 Steve Rosenthal) **10.7** Color is a welcome relief from the white and neutrals typical of a medical examining room. Although the pink-red of the stool and the green of the examining couch are limited in area, they bring the room to life. The room is in the Prudential Health Care System's facility, Lithonia, Georgia. Quantrell Mullins & Associates were the architects. (Photograph: Brian Robbins)

Hospital corridors, with their heavy use by many, sometimes conflicting types of traffic, are problematic. Active color schemes can add to a sense of confusion and clutter, while white, buff, and institutional green contribute to a depressive tone. Mild warm tones for side walls, with stronger accent colors for end walls, doors, and any other locations that can provide relief from monotony, may be considered. Lobby and reception areas can use stronger color schemes developed to project a sense of quality and good organization. Laboratories, staff offices, lounges, and cafeterias in hospitals can be approached in the same ways that such areas are treated in other contexts.

Environmental circumstances have a strong impact on the behavior and recovery of patients in psychiatric hospitals and the psychiatric-care facilities of general hospitals, where lengthy stays are common. Attractive color treatment has been shown to have a favorable effect in such conditions. In general, color schemes suggesting pleasant residential environments, colorful and warm but calming rather than overactive, are most beneficial. Strong tones of blue (depressive) and of red and orange (exciting) are best avoided, and violet, purple, and black should never be used. Highly reflective finishes can generate images that may be disturbing to some patients, making polished floor surfaces, shiny tiles, and gloss paints inappropriate.

Nursing homes call for color treatment paralleling that of general hospitals. Because patients are often long-term residents, emphasis on a calm and homelike atmosphere is important. Medical and dental offices, clinics, and group-practice facilities can follow color recommendations for office systems in combination with those for hospital treatment, laboratory, and other work spaces. Medical-office waiting rooms are notorious for their unpleasant character, the result of shabbiness and neglect or, in a misguided effort at betterment, overdecoration with excessive color and pattern. These reception and waiting areas deserve special attention, as patients must frequently endure long waits in states of tension and anxiety; a pleasant and optimistic tone can be conveyed through the use of lively color, either warm, cool, or a balanced combination thereof, as climate and orientation may suggest.

HOTELS AND MOTELS

In addition to providing lodging for their patrons, hotels and motels can offer an element of entertainment. Even the business traveler who must use a city hotel hopes for some degree of pleasure in the stay. Although the public lobbies of hotels are occupied only briefly by a guest, they make a first impression that sets the tone of a stay and is reinforced with each entrance and exit. Color is a significant element in expressing efficiency, dignity, luxury, relaxation, playfulness, or any combination of such qualities. The dark woods and rich marbles of many older hotels suggest solidity and tradition, whereas the bright saturated colors and whites of a resort hotel imply informality and entertainment.

Hotel dining rooms are in effect restaurants and can use color with the care discussed above.

Guest rooms, because they are temporarily a private home to their occupants, are notably demanding of color that will please and cheer the occupants. Hotel managers must decide on whether to adopt a standard scheme for all guest rooms of a particular type (making for economy and efficiency) or whether to use a number of varied schemes for similar rooms. The latter approach ensures that repeated stays in a certain hotel will not be monotonously uniform and allows the arriving guest to make a choice among rooms to favor personal taste.

This strategy is particularly favored by *boutique hotels*, small hotels with luxurious appointments. Offering choices, however, can complicate the assignment of rooms. When an assortment of schemes is offered, each must be sufficiently agreeable to any reasonable guest.

The general suggestions for selecting color on the basis of climate and room orientation (warm or cool dominant tones as appropriate) can be enlivened by the introduction of colors characteristic of a particular location or region. This is especially applicable to resort hotels in exotic locations, where the guest has come with a desire to experience "local color." Brightly colored tiles and fabrics combined with white or near-white wall surfaces may suggest a tropical island; textiles or wall coverings in small patterns using red and green typify the coziness associated with British residential interiors; and natural teak, white, and bright (probably red) details distinguish Danish modern. Although such color schemes may be used in the actual locations mentioned, they may also be used elsewhere to evoke a particular style and atmosphere. While an emphasis on high style or fashion color might suit some big-city hotels, a more modest and homelike character may be more appropriate to a tourist motel.

An estimated average duration of guests' stays can guide color selection: in facilities where guest stays are relatively brief, more aggressive color can be used to make an impression that will not have time to become boring; where longer stays are typical, as in many resort locations, color that is pleasant but calm will be less likely to become a source of irritation to any guest. Strong accent colors in bed coverings and draperies, rather than in more fixed elements, allow replacement from time to time to adjust to changing fashion and to inject an element of freshness.

An interesting approach to hotel and motel guest room color calls for the use of lighting that can alter the color ambience of the room. Stage lighting has long made use of colored light to alter the appearance of a scenic set, but such techniques have seemed too complex for other uses until recently. The introduction of fiber optics (see pages 351–52) has made it possible to deliver light of modified color to selected locations. The walls of a guest room that are actually white or of neutral color can be given any color when flooded with colored light. Such lighting can then be made controllable by the room

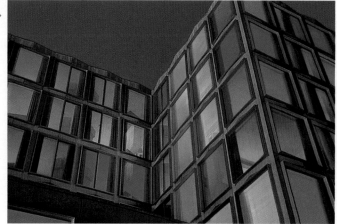

occupants much as dimmers make it possible to control brightness. The hotel guest can choose to make the room pink, green, blue, or violet according to personal preference or time of day (fig. 10.8).

RETIREMENT LIVING FACILITIES

As special-purpose living places suited to elderly occupants become increasingly available—often called *retirement villages* or *assisted living facilities*—designers are called upon to produce suitable color treatments for such projects. In many ways the realities of hotel and motel practice as discussed above are applicable, but certain differences require attention. Hotel and motel guests are generally in residence for only a short time—as little as one night but rarely more than a week or ten days. In retirement living, occupants may live in a particular space for years. This might suggest that personal preference should be given special consideration, and this is often done. However, it should be noted that prospective occupants often have little experience in color selection and will gravitate toward expressing preferences based on habit or perhaps some timidity. Designers also can fall into assumptions based on cliché beliefs about what will be suitable to the elderly. Unfortunately, this tends to lead to bland color, assumed acceptable to conservative tastes, or to an emphasis on warm but pale color that is thought to be homelike.

Recent research has shown that with advancing age, color perception weakens, causing colors to appear less bright than their actual hue and value suggest. When timid colors are viewed with dimming eyesight, the effect can be needlessly depressing. The use of stronger color than might seem normal is now suggested as being suitable for aging occupants. Strong brightness contrast helps vision, and colors of bright hue and strong saturation, used with discretion, make for an environment more suited to an elderly population than the more routine color approaches that tend to seem institutional.

INDUSTRIAL SETTINGS

Frequently cluttered with equipment, machinery, and materials, industrial settings can profit from the use of color in setting the tone of work spaces to reduce fatigue and annoyance and to promote efficiency and safety. As with offices, brightness contrast needs to be carefully considered to ensure that materials and tools in use are readily distinguishable from backgrounds but that excessive contrast does not promote eye fatigue. Glossy surfaces that produce reflected glare are undesirable. Areas of bright, pleasant color that offer relief from eye strain may be strategically located. Problems associated with various work processes can to some extent be offset by appropriate color choices. Excessive heat, for example, is countered by dominant areas of blues or greens. Conversely, warm reds and oranges reduce discomfort associated with cold. Irritation generated by high noise levels can be lessened by the presence of light colors, especially greens.

Color used to aid safety in industrial settings has come to be widely accepted. Greens are commonly used as a general color for machinery and equipment, forming a background for contrasting color according to the following rules:

- *Yellow* indicates potential hazards, including moving equipment such as forklifts and cranes.
- *Red* indicates fire-safety equipment, containers of dangerous materials, and control switches and buttons on machinery.
- *Blue* indicates electrical controls and repair areas.
- *White* indicates trash containers, drinking fountains, and food-service locations.
- *Black and white striping* indicates traffic areas, aisles, and stairway locations.

Another color code is used to identify piping according to function. The bright colors of the coded pipes often inject a lively color element into industrial settings.

Working Method

Putting together a color scheme at the drawing board involves making color charts and material charts. These convert color scheme ideas into visual forms that can be evaluated and, when accepted, realized.

COLLECTING COLOR SAMPLES

The process requires a readily available stock of color samples that can be placed in trial relationships and then pinned down to form visual records of schemes as they develop. Preparing a collection of such samples is a key preliminary step in color work (fig. 10.9).

It is generally most convenient to work first with abstract color schemes, that is, representing all colors with flat paper swatches devoid of texture, pattern, and other special characteristics of real materials. Colored papers, which come arranged in systems (see page 312), offer a suitable medium. Available index

10.9 →

A B C

D E F

10.10 →

SCHEME A FLOORING

- ■ FRAME
- ■ FRONT & REAR
- ■ WORK TOP
- ■ ACCENT
- ■ END PANELS

SCHEME B FLOORING

BOWERY SAVINGS BANK COMPUTER ROOM
110 EAST 42 STREET N.Y., N.Y.

POOR, SWANKE, HAYDEN + CO
277 PARK AVENUE, NEW YORK, N.Y.

10.11 →

booklets of such color paper systems are an ideal means of bringing a full range of color to the worktable.

The color stock can be augmented with large sheets of color papers and color paper samples cut from packages, printed brochures, advertisements, and any other sources that may turn up. The habit of clipping and filing colored papers and cards leads quickly to a highly useful collection of samples ready for use in working on color schemes. Metallic papers, glossy flint papers, and textured papers can be added to a sample collection to increase its range. In addition, one can mix colors (using tempera, gouache, or designers' colors) in small quantities and brush the mix onto cards to create additional color samples. With modern color systems in general use, this method has become a last resort.

PREPARING COLOR CHARTS

With an adequate sample collection at hand, it is a simple matter to begin making up any desired color scheme by grouping together sample swatches to represent the chosen colors (figs. 10.10–10.13).

Using Colored Paper Samples It is important to lay out the paper samples so that each color covers an area roughly proportionate to the actual space it will take up, so that large areas of sample paper represent large areas, appropriately small swatches stand for small accents. Again, it is essential that the work of color charting be done under light having the same color characteristics as the light that will be normal in the real space, including all the types of light to be used, alone and in whatever combinations may occur in the actual space.

Insofar as possible, color samples should be arranged in the same order that they will occupy in the actual space, that is, floor color should go at the bottom of the chart, walls above, colors for furniture and other objects in corresponding relationships, and ceiling color on top. It is important to include samples of *all* colors that will be present; a white ceiling, for example, should not be ignored but should be represented with an appropriate area of white sample. As it is developing, the scheme should be viewed against a neutral background—white, black, or, best of all, a neutral gray. Samples should be placed side by side, leaving no background visible between them. As a scheme is brought together into a final color plan, samples can be glued down to a mount to form an established record (fig. 10.11). Such an abstract color chart can be used for review with a client or as a basis for color sketching or rendering.

10.8 An exterior view of Saint Martin's Lane Hotel, London, displays the many guest rooms with different colors created by colored lighting. Controls accessible to the individual guest make it possible to vary the room's color to suit individual taste. Philippe Starck and Anda Andrei designed the interiors with lighting designer Arnold Chan and Gary Campbell of Isometrix (Photograph: Scott Eberle, courtesy Rubenstein Associates) **10.9** One of the initial steps in working with color is to collect material samples as demonstrated by Martin-Senour Paints. Here materials are organized to illustrate various types of color schemes: (A) monochromatic, (B) analogous, (C) complementary, (D) split-complementary, (E) tetrad, and (F) neutral with accents. (Photographs courtesy Martin-Senour Paints) **10.10** A color "board". Part of a presentation for an office planning project. Samples for two schemes ("A" and "B") are shown as a basis for discussion in a client meeting. (Courtesy Swanke, Hayden, Connell, Architects) **10.11** Color board by Stockman

10.12 →

Another method of color charting uses a floor plan, usually at ¼″ = 1′0″. An extra print of the furniture layout plan works best as the basis for a color chart. Actual colors of flooring, furniture, and built-in elements are shown by pasting down samples cut to fit the plan indication of the element in question (fig.10.13). Wall colors and the colors of drapery and other materials on vertical surfaces are indicated by diagrammatic color lines (in pencil or marker), which are then keyed to sample swatches placed adjacent to the plan. In this way, color is seen more or less in position, as it will occur in the real space.

Plan and elevations can both become the basis for pasting in color samples (or pencil or marker indication of colors), displaying all colors in correct relative location and area. By cutting out such a plan and elevation drawing chart and folding the wall elevations up into a vertical position, a kind of abstract model of the space, called a *maquette*, is created. Traditional decorators often made such a color presentation by rendering (usually in watercol-

ors) the floor plan and each wall surface. While lacking the full three-dimensionality of a model, this maquette is often helpful in visualizing how colors will actually relate in the completed space.

Still another technique of color charting uses a perspective drawing, usually only a geometric layout without detail, as a basis. Color samples cut to fit the areas in the layout are pasted down to form a collage color chart that approximates the appearance of the constructed space as seen from a certain viewpoint. Computer programs can assist this process and are increasingly used, even in small firms. (See "Computer-Assisted Color Charts," page 305, and figs. 10.14, 10.15.)

Using Actual Materials The color chart can be taken a step further by translating the abstract colors into real materials and finishes (see figs. 10.12, 10.13). Once again, a collection of samples is extremely useful. Wood and laminate finishes available from fur-

10.12 Actual samples of the materials to be used in the intended colors are assembled here into a sample chart that gives a strong impression of the color character of the planned space.
10.13 The same scheme is shown here in a pasteup, or collage, floor plan.

Fabrics are cut out and fixed in place to represent upholstered furniture. Papers are used to show the floor color; the colors of furniture materials (wood, marble), and other elements (such as walls) are usually indicated in colored pencil. This type of plan does not portray

the total, three-dimensional impact of wall, ceiling, drapery, and other colors, and it should be studied along with other color charts for a balanced impression of overall color. Nevertheless, it helps to analyze the effect of color on certain key features of a space.

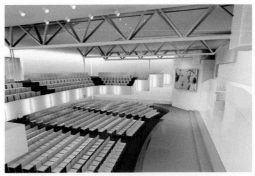
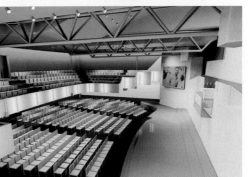
Computer-Assisted Color Charts

Computer programs make possible a number of techniques that use the ability of modern crt and flat screens to display a wide variety of colors. In theory, available systems can produce as many as 16.7 million colors; however, since the human eye is only able to distinguish about a million colors, programs offer a more limited but still vast number of colors on-screen.

Designers can use such computer programs to produce drawings without hand drafting. Plans, isometrics, and perspectives generated by CAD and similar programs (see pages 551–52) can be realized in full color, and the color can be varied instantaneously at the designer's wish (figs. 10.14, 10.15). Developing a color scheme can be greatly aided by rapid review of a variety of alternatives, and various alternative schemes can be saved and printed out for evaluation and discussion.

A screen displaying a colored image can be photographed in color or conveyed digitally to a printer or a projector for display on a screen. Such techniques are useful in developing visual presentations and in showing alternative color schemes to a client. Computer-produced color also can be documented in forms useful in translating designs into production. Specification of material and paint colors can be developed in relation to computer-generated color in ways that offer remarkable accuracy and convenience.

niture makers and samples of basic material colors (brick, concrete, terrazzo, metals, woods, and so on) are needed along with samples of tiles, floor coverings, and other materials. For materials not easily kept on hand, such as brick, stone, and other bulky materials, color illustrations may be substituted. It is important to have samples of the actual carpet and textiles in order to take into account the impact of textures and patterns. Large samples of carpets, textiles, and other major material areas should be viewed together because tiny samples, viewed only at the drawing table, tend to be misleading.

Large *memo square* samples of textiles, usually a yard of whatever width the fabric is produced in, large samples of carpet, and panels of wood finish are available from manufacturers. It may be necessary to carry the more portable materials to a showroom where a more bulky item is on display in order to observe the relationship. Textiles, carpet, and paint color samples, for example, might be taken to a furniture showroom or to a sup-

plier of brick or marble. Larger design firms often operate a sample room storing large samples of frequently used materials, which can be spread out on a table and viewed under suitable lighting.

SAMPLE BOARDS

Charts called *sample boards* can be made using real materials along with color swatches representing paint and other solid color areas. Such charts, like the abstract charts, should show materials in areas proportional to their real use and in appropriate relationships. The accepted chart becomes a record of the color selections for items to be purchased and for paint and other colors to be applied on site. A written record of pattern and color numbers should be made and a set of samples should be put away in a folder or envelope representing the scheme settled on for each space of a total interior project.

REALIZING THE COLOR SCHEME

Realization becomes a matter of placing orders for products (furniture, draperies, and so on) with correct color specifications, relaying specification information for materials and items that are built-in (architectural materials, hardware, and light fixtures), and, for the painter, preparing a plan color chart showing where each color is to be applied, with a key to a set of sample swatches.

10.14, 10.15 Computer software can simplify working with color, enabling the designer to try out various color schemes on a realistic perspective without having to render the perspective from scratch each time. In the computer-generated perspective of the Love Fellowship Tabernacle, Brooklyn, New York, shown here, designers Weisz & Yoes began with a predominantly blue color scheme (fig. 10.14) then added vermilion for a more dynamic effect (fig. 10.15). (Courtesy Weisz & Yoes)

Table 15. Dealing with Common Color Problems

Problem	Color choices appear random.
Solution	Relate color to a carefully thought out plan.
Problem	Colors are too many or too varied.
Solution	Use restraint in the number of colors, particularly the number of strong colors.
Problem	Color in large area is too intense.
Solution	Lower the intensity of the chosen color; confine intense color to small areas and to areas used only briefly.
Problem	Color in large area is too contrasty.
Solution	Let one or the other color dominate, not both; restrict one of the two contrasting colors to a smaller area.
Problem	Color is drab and monotonous.
Solution	Use strong color accents to enliven the restrained scheme.

Specially Mixed Colors It is important to remember that color choices are not limited to the available standard colors offered by the makers of paints, fabrics, carpet, and other products. Carpets and textiles can be dyed to order, paints mixed to match any sample swatch. Ready-mixed paints are usually limited to a range of banal tints, although some paint color systems offer a much wider range, including strong colors often identified as decorator colors. A competent painter can mix color to match any requirement, except, perhaps, color desired at an extreme level of intense saturation (very high or full chroma). Dyeing carpet and fabric to order offers only the limited risk that a large area matched to a small sample may be a visual surprise—for better or for worse.

Evaluating Color On-Site In following a project on-site, it is important not to be upset by the impression given by one or another color or finish before all the related elements are in place and seen under the specified lighting. Colors influence one another so strongly that it is quite common for some one color, perhaps a painted area or a floor color, to look all wrong until the other elements that make up the total color scheme are in place. Some on-site adjustments of color can be made, although only to certain elements, the most flexible being paint color. A prime coat can be viewed and changes considered before a final coat is applied. Still, it is important to remember before making adjustments to paint color that the color areas to be delivered later (carpet, upholstery) will influence the

way painted areas will appear. Hasty changes and adjustments made on-site when the total scheme is not yet in place are often unwise. In general, if a well-proportioned color chart viewed under appropriate light has seemed satisfactory, the finished space will probably look as good. Sticking to a well-conceived plan until all elements are in place is usually the sensible course of action.

Common Color Problems

There are a number of common color problems that can lead to disappointing results. (See Table 15, "Dealing with Common Color Problems," above.) An example of such problems is the random acquisition of items and the making of color decisions without relationship to a carefully conceived color plan. Too much or too varied color in schemes using many hues is also a problem. Restricted schemes are usually safe, while full rainbow schemes using many hues tend to appear chaotic and random, arrived at without planning. Too-intense color used in large areas is another problem. Although it may work in an area that is used only briefly, it is likely to become tiring over time in an area that receives extensive use. Yet another problem is too much contrast in large color areas. In complementary schemes, in particular, colors of near equal intensity set up a tension that is unpleasant if not uncomfortable. High-intensity colors work best when they are in small areas near larger areas of lesser intensity.

Drabness and monotony are problems at the opposite extreme from those mentioned above. Color schemes using institutional green, beiges, tans, and browns may seem safe but can produce depressing results. In restricted color schemes, strong accents can avoid problems of this type.

Successful color depends, above all, on the planning of a total scheme with all elements, in swatches or samples of whatever sort, viewed in relationship to one another in proportional areas and under appropriate light. The amateur's failure to create a well-conceived color relationship is usually the result of piecemeal color decision-making. Whether the planned scheme is derived from some form of color theory or simply improvised intuitively, it will have a basis in systematic coordination. This is the only reliable way to approach color planning.

Light and Color

Human vision depends on the presence of light, and the effect of color results from some special properties of light. Light is a form of radiant energy. The eye distinguishes different wavelengths of the radiant energy, or light, and interprets them, in the brain, as different colors. The brain further interprets color as having particular characteristics. Thus, red is not only understood as different from any other color but also brings with it implications of

400 500 600

WAVELENGTH IN NANOMETERS

warmth, liveliness, and, perhaps, relationships with fire and blood. Light energy at the extremes of wavelength—infrared at the long end and ultraviolet at the short end—becomes invisible.

THE COLOR SPECTRUM

Daylight, or white light, is a random mixture of light of all wavelengths. (Artificial light that appears to match the color of daylight is also called white light, although it usually has a somewhat different color makeup.) When white light passes through a glass prism, its different wavelengths become sorted into colors, creating the familiar rainbow, or *spectrum*, arranged according to wavelength (fig. 10.16). The longest is red, followed by orange, yellow, green, blue, and violet. Their measure in nanometers (formerly designated millimicrons), or one-millionth of a millimeter, is generally assigned as follows:

Red..700–650 nanometers

Orange...640–590 nanometers

Yellow..580–550 nanometers

Green...530–490 nanometers

Blue...480–450 nanometers

Violet...440–390 nanometers

The various wavelengths of daylight are not always balanced. At dawn or sunset, daylight tends to be short of blue-green components, thus appearing reddish. Incandescent lamps share this characteristic. On cloudy days, daylight is weak in red-orange, so it appears bluish. In such situations, the brain introduces a compensatory bias. The mind soon adjusts to the varying tints of daylight and the quite different color content of artificial light sources (firelight, candlelight, incandescent light, or fluorescent light), quickly accepting them as "normal," so that colors appear quite recognizable under any of these different kinds of light. This effect is known as *color constancy* and explains why colors can be distinguished even when seen through the tints of sunglasses. Some forms of light (sodium or mercury vapor) do not contain a full spectrum but only light of certain frequencies. Under these lights, colors are not visible in normal relationships since only a few spectrum frequencies are present.

ADDITIVE COLOR

Colored light, produced by filtering white light so that only one color can pass through the filter (a colored glass or gelatin), makes normal color vision inoperative: everything appears as a tone of the colored light. For example, in pure red light, white

10.16 When white light passes through a prism, it is broken up into a spectrum, or rainbow, of colors—red, orange, yellow, green, blue, and violet— whose order is determined by the wavelengths of the radiant energy they represent. (From *Theory and Use of Color* by Luigina De Grandis)

and red objects appear bright red, green objects almost black, and other colors as intermediate tones of red. Colored light is used in stage lighting and sometimes in lighting displays but rarely in lighting interiors, since it distorts real color and the single color soon becomes irritating and monotonous.

Color mixing of light, used mostly in the theater, is called *additive* color, because mixtures are obtained by adding together the wavelengths that represent the three colors considered *primary* since they cannot be made up by mixing other colors (fig. 10.17). Any other color can be produced by mixing any two of the three additive primaries—red, blue, and green (yellow is produced by adding red and green, for instance). All three additive primaries mixed at one time will produce white or normal light.

SUBTRACTIVE COLOR

In interior design (as in painting, printing, and any other situation using pigments and dyes as the colorants), one is usually working with *subtractive* color. That is, the object or material absorbs, or subtracts, all the colors of light except the color of the object, which is the color we see. A red object is actually one that absorbs all colors but red and reflects back only red light. If we mix two colors, for example red and yellow, as paint or pigment, the red pigment is subtracting all but red light reflection, the yellow all but yellow, so that the mixture reflects back some red and some yellow, producing the visual impression of orange color.

THE COLOR WHEEL

When dealing with subtractive color, the colors that cannot be produced through mixing turn out to be red, yellow, and blue. Given these three *primaries* of subtractive color (fig. 10.18), any other color can be produced by mixture. On the color spectrum, with the band of colors arranged according to wavelength, the primaries alternate with *secondaries*, which can be mixed from the primaries that are their neighbors on either side. The spectrum begins with red. Its neighbor, orange, results from mixing red with the next color of the spectrum, the primary yellow. Yellow is followed by green, a secondary made from yellow and blue, the next primary. The visible spectrum ends with violet (or purple), a secondary that can be made by mixing blue with red, the color at the beginning of the rainbow band.

This has led to arranging the band in a circle, so that its end meets its beginning. In the resulting *color wheel* (fig. 10.19), the primaries and secondaries are equally spaced, with each secondary between the two primaries that can be mixed to create it. This wheel

arrangement is the basis for the various color systems that organize the confusing realities of color into an understandable entity.

Color Systems

Color systems are extremely helpful in any discussion of color because they clarify the terminology used in everyday conversation about color and suggest organized ways of arriving at visually satisfying color schemes.

Once ordinary color names go beyond the primaries and secondaries, they become more and more imprecise. Modifiers such as light, bright, deep, dull, and dark are used in various and confusing ways, and many color names, such as tan or buff, suggest a wide range of color tones. Color names drawn from real objects are equally imprecise. Just what color is rose, cream, or sky blue? Manufacturers of paints, textiles, and other materials deepen the confusion by designating their products with such names as flame, champagne, and colonial blue, which defy precise identification.

Efforts to understand color in a systematic way go back at least as far as the German poet Johann Wolfgang von Goethe's study of color in the early nineteenth century. Modern systems vary somewhat in detail, but each provides an organized way to arrange and name colors. The best-known systems are those

10.17 *Additive color* is the term used to describe the mixing of colored light. The primary colors of light are red, green, and blue. Yellow results, as demonstrated here, by adding red and green light. All three primaries combine to form white light. **10.18** The three primaries of subtractive color—blue, yellow, and red—are here shown as blocks and arranged in a color wheel. Blending each pair of primaries generates the secondaries, orange, green, and violet. When each of these is placed between the pair of primaries that creates it, the six-color wheel results—the spectrum in its natural order. **10.19** Mixing each primary and the adjacent secondary produces an intermediate, tertiary color. The six shown here as blocks—violet-red, red-orange, orange-yellow, yellow-green, green-blue, and blue-violet—make up a spectrumlike band that has shifted slightly from the primary-secondary position. When the tertiaries are placed between their components, a twelve-color wheel results. **10.20** In the Ostwald system, a central axis is a scale of grays, from white at the top to black at the bottom. A color wheel

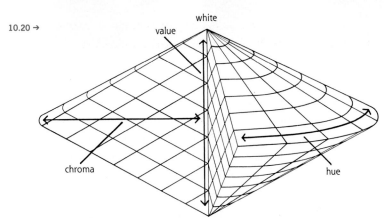

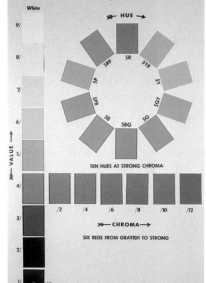

white

value

chroma

hue

black

developed by the German chemist and Nobel Prize winner Friedrich Wilhelm Ostwald (1853–1932; fig. 10.20) and the American painter Albert Henry Munsell (1858–1918). The Munsell system, widely used in dealing with colors produced by dyes and pigments, is the system most generally accepted in interior design work and forms the basis for the following discussion.

MUNSELL COLOR SYSTEM

In the *Munsell* system, any color is described in terms of three attributes: hue, value, and chroma (fig. 10.21). By noting these three qualities according to a standardized system, any color can be exactly described and specified. Understanding the three dimensions of color is the key to dealing with color problems in an organized way.

Hue The first (and most obvious) characteristic of a color is its position in the spectrum, the quality that gives it its basic name. In the Munsell system, this is called *hue*, and it is designated by a letter identification. Munsell chose to recognize *five* basic hues, a decision that goes against the normal understanding of primaries and secondaries. In practice, the Munsell system is usually modified to use six hues, three primaries and three secondaries, which can be identified by the letters R, O, Y, G, B, V (red, orange, yellow, green, blue, violet). Intermediate hues between these six are then identified by two-letter combinations: RO for red-orange, OY for orange-yellow, and so on. These hues are often called *tertiaries*. Still finer gradations of hue (*quaternaries*) can be inserted between the first twelve with three-letter designations (OOY, OYY, YYG, and so on). This subdivision can be continued indefinitely.

Value The second characteristic of any color is its lightness or darkness, called its *value*. The value of a color depends upon the amount of light it reflects (lighter) or absorbs (darker). Adding white, which reflects all light, lightens a color without changing

is arranged around it, with each hue's maximum chroma, or saturation, at the circumference. The hues become gradually less saturated as they near the central axis, where they reach neutral gray. Above and below the wheel, the hues parallel the gray value scale (upward

for tints, downward for shades) in disklike steps. These circles become smaller as the number of steps to maximum saturation decreases toward the upper and lower points. When all the possible colors are placed, forming a geometric solid, the result is a symmetrical figure—a

pair of identical cones meeting at the center plane. (Courtesy U.S. Department of Agriculture) **10.21** In an illustration from the most recent version of the Munsell color system, a value scale of grays at the left runs from white at the top to black at the bottom. From a middle

gray, a line of steps runs to the right in increasing levels of saturation for a particular hue—in this case red, the hue at the top center of the color wheel, as shown. (Courtesy GretagMacbeth, New Windsor, New York)

TINTS

SHADES

its hue; similarly, adding black, which absorbs all light, darkens a color without changing its hue. Munsell measures value by means of a scale of tones ranging from light to dark (fig. 10.22). White, placed at the top of the scale, is designated 10; black, at the bottom, is designated 0. The value scale between them has nine equal steps of grays ranging from dark to light. The value of any color can be found by matching its lightness or darkness with one of the steps of gray. In mixing color, a sample of a particular hue can be moved upward on the value scale by adding white or downward by adding black. Light values, above the middle of the scale, or 6 through 9, are called *tints*; dark values, below the middle, or 4 through 1, are *shades* (fig. 10.23).

Values strongly affect the perception of a color. The same color, or hue, placed at opposite ends of the value scale has greatly different effects. For example, the lightest tint of violet, often called lavender, is a delicate, light color that might be used in a summer home. Its darkest shade is a very deep purple that might appear heavy and oppressive in the same setting.

In the Munsell system, the value number of a color follows the hue designation. For example, YG/7 is a yellow-green with a value matching step 7 of the gray scale.

Chroma The third aspect of color is its intensity or purity, called *chroma* in the Munsell system. *Saturation* is also a commonly used term for this quality. Steps of chroma are numbered up to 14, from low chroma to maximum chroma, although different hues reach maximum chroma at different step numbers (fig. 10.24). Maximum chroma signifies a particular hue in its purest form. Adding the hue opposite to it on the color wheel lowers the chroma, making the color less pure and intense. Mixing equal amounts of the colors opposite to one another on the wheel produces a neutral gray, identified as chroma 1. The intensity of a color usually affects its value as well. In Munsell's notation of colors, the chroma number comes last. Thus, YG/7/4 indicates a yellow-green hue at a value of 7 and chroma of 4.

The Color Solid Arranging colors using the gray value scale, which is neutral, as a central axis, the circular arrangement of hues as a ring with the axis at its center, and all possible steps of chroma connecting the axis (low chroma) with the hue on the rim of the wheel (high chroma) like spokes gives a three-dimensional cluster, or *color solid*, with every color in a logical place (fig. 10.25). Because various hues reach maximum chroma at different

10.22 The gray scale of values from white to black in ten tones is shown adjacent to a value scale of reds, with the clear primary near the center. Adding white to produce the lighter tints or adding gray or a complementary to produce darker shades reduces the chroma of the pure

color. The equivalent gray tone is shown adjacent to each color tone. It is not possible to produce a tint as light as pure white or a shade as dark as solid black.
10.23 When tints and shades become discernibly different from the pure colors on which they are based, they are given

new names. Pink, cream, and beige (above) are tints of red, yellow, and orange. The shades (below) may be called tan, olive, and taupe. They are derived from yellow, green, and orange. **10.24** Here a scale of chroma moves in seven steps from the fully saturated pure color

to a least saturated neutral, while maintaining the entire scale at a constant value.

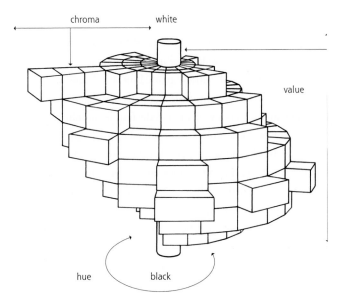

chroma | white | value | hue | black

value levels, the Munsell color solid does not form a neat sphere or any other perfect geometric shape. Yellow, for example, becomes most intense at a high-value level, blue and red at a lower value. The color solid is therefore somewhat irregular and lumpy. Some color systems force a perfectly symmetrical color solid by imposing different ways of spacing and annotating actual color specimens.

Although the Munsell system is generally recognized as the most useful and practical color system for interior designers' use, a number of other systems are of interest for the differing ways in which they organize the complexities of color relationships. A simplification of the Munsell color wheel with its five hues into a wheel of three primaries and three secondaries has already been mentioned. The logic of this approach can be understood in two ways:

1. In the color wheel, the secondaries orange and green are positioned between the primaries that, when mixed, create them. Violet is positioned at the end of the spectrum, beyond blue. If the spectrum is bent into a circle with violet placed next to red, violet then falls between red and blue, the primaries that make it, and a logical color wheel emerges.

2. A second basis for the logic of the six-hue color wheel arises from the physical measurement of the wavelengths of colored light. The colors at the ends of the visible light spectrum, red and violet, have wavelengths of 700 and 400 nanometers, respectively. If this range of 300 nanometers is divided equally into five parts of 60 nanometers each, the resulting values of 640, 580, 520, and 460 will be found to correspond with the

hues orange, yellow, green, and blue, indicating that the primaries and secondaries of the color wheel are spaced in accordance with their measured wavelengths. Various names have been given to this six-part color wheel since it was first defined by Goethe in 1810. When intermediate steps are added between the six primaries and secondaries, these tertiaries generate a twelve-step color wheel sometimes referred to as the *Brewster system* (after Scottish scientist Sir David Brewster, 1781–1868, who invented the kaleidoscope) or the *Prang system* (after the Silesian-born American Louis Prang, 1824–1909, who developed a four-color printing process known as chromolithography, used to print America's first Christmas cards).

OTHER COLOR SYSTEMS

The Commission Internationale de l'Eclairage (CIE) is an international scientific organization concerned with establishing standard means for expressing color characteristics of light sources and the reflection and transmission of light by objects in numerical terms. The *CIE system* is of primary use in scientific applications dealing with the precise matching of colors, taking into account both light sources and the color qualities of materials and objects. It offers a level of exactitude beyond the needs of practical applications, suitable only to laboratory measurements.

The Deutsches Institut für Normung (DIN) offers a system that classifies colors in terms of hue, saturation, and relative lightness. The *DIN color wheel* is divided into twenty-four parts, with the four basic (or primary) hues of red, yellow, green, and blue. About nine hundred standard colors are identified in this system.

The *Gerritsen system*, first presented by the Dutch color theorist J. Frans Gerritsen in a book published in 1975, is based on the color-perception behavior of the human eye. Because the cones of the human retina sense and distinguish red, green, and blue, these hues are designated as primaries, while the hues magenta, cyan, and yellow, each sensed by two of the three primary receptor cones, are designated as secondaries. In practice, this corresponds to the phenomenon of additive color in which the addition of red and green generates the secondary yellow. The Gerritsen system arranges the three primaries and three secondaries in a circle. Two intermediate colors are then developed between each pair of the basic six, creating a ring of eighteen colors. Additional intermediate steps produce a ring of fifty-four colors, approaching continuous hue variation (fig. 10.26). Values are defined in steps created by reducing the intensity of the primaries. Any color at any level of value can be defined in these terms. Because of its use of the

10.25 An arrangement of all colors takes three-dimensional form because each color has three dimensions. This form is referred to as a color solid. In the color solid of the Munsell system, hues are arranged in a circle, values are stacked vertically from light to dark as a center pole or axis, and chroma (saturation) is arranged in steps from the neutral center outward. The irregular form of the color solid results from the way in which different hues vary in their value steps and chroma.

The *Swedish Natural Color System* (NCS) is based on studies of color perception, by Ewald Hering, that define as "natural" the six color sensations of red, yellow, green, blue, black, and white. A color wheel of the four chromatic colors is developed with nine intermediate steps between each of the four basic colors (fig. 10.27). For each hue, colors are arranged in a triangle with the basic hue, black, and white placed at the vertices. The sides of the triangle are divided into ten steps, making a scale from hue in tints to white and in shades to black. A grid of colors in intermediate steps fills the triangle (fig. 10.28). There are forty such triangles for forty steps of hue, ten steps between each of the four chromatic hues. Each triangle contains sixty-six colors, for a total of 2,640 colors, each with a specific identification. Of these colors, 1,412 have been made available as colored papers, convenient for designers' use. A *Standardiseringskommissionen* (SIS) color atlas based on the NCS system identifies each sample with a notation on the relative presence of the four chromatic hues plus whiteness and blackness. The atlas offers samples in forty hues and five gray scales described as achromatic, yellowish, reddish, bluish, and greenish.

A number of other systems have been developed by manufacturers of such color-related products as paints, printing inks, and textiles. The system developed by the Container Corporation of America (CCA) is based on the Ostwald system. It incorporates loose-leaf pages holding small, removable sample chips of colors, each with an identifying notation. Replacement chips can be obtained, allowing chips to be removed for inclusion in color charts or for the use of suppliers or contractors. Paint manufacturers offering color systems include Martin-Senour (Nu-Hue Custom Color System) and SCM Glidden Coating and Resins (Glidden Professional Colors), among others, each providing a large variety of color samples suitable for interior designers' use with specific instructions for mixing paint to give accurate matches for the samples. Although the specification of colors through the use of such systems has obvious advantages of convenience, it requires becoming "captive" to the products of a particular manufacturer. Other color systems, such as the Color-Aid system of papers and the Pantone system of papers and transfer transparencies, relate to the uses of colored inks or papers.

COMPLEMENTARY COLORS

In practice, it is most useful simply to bear in mind the concepts of value and chroma while working with any color wheel that places the strongest possible chroma of each hue in the rainbow-order ring. In this arrangement, each hue will be directly opposite

light sensitivities of the eye as the basis for establishing primaries, the Gerritsen system is more adaptable to work with colored light (as in stage lighting, for example) than to work with dyes and pigments. In this system, the complementary pairs (see discussion below) are blue and yellow, green and magenta, red and cyan. It is interesting to note that the three chromatic hues used in color printing are yellow, magenta, and cyan (black is the fourth ink color), the three secondaries of the Gerritsen system.

In the *Kuppers system*, developed by Harold Kuppers, six primary colors are defined: red, yellow, green, cyan, blue, and magenta. These six primaries arranged in a ring are, of course, quite similar to the basic color wheel of the Brewster or Prang system. Kuppers also makes use of a "color solid" in which all possible colors are arranged in a six-faced form similar to a cube but with faces of diamond rather than square shape. As with Gerritsen's work, the Kuppers system attempts to account for the phenomenon of additive color and thus is more appropriate to work with color lighting and color printing than to interior design.

The Optical Society of America (OSA) has developed the *Uniform Color Scales* (OSA-UCS) based on a theoretical color solid in which spheres of colors are packed together in contact with other spheres most similar in color sensation, so as to build up a three-dimensional polyhedron. This OSA-UCS system has been used to generate 558 standard sample colors intended to be spaced in uniform steps of difference in terms of each color attribute. The theoretical basis of this system is complex and difficult to visualize, although its practical application does not differ greatly from that of the Munsell system.

10.26 The Gerritsen color system is represented by a color circle from the 1975 *Theory and Practice of Color* by J. Frans Gerritsen. Each color in the wheel (and outer ring) relates to the small diagrams that show the relative presence of the additive (light) primaries used in this system. (Courtesy Uitgeverij Cantecleer bv, The Netherlands) **10.27, 10.28** The NCS system of the Scandinavian Color Institute of Stockholm is presented in the *Natural Color System Color Atlas*. Sheet 2, reproduced in figure 10.27, shows samples of high chromatic values—one of each from a range of forty specified hues. Sheet 9 from the NCS atlas (fig. 10.28) gives color notation within one of the forty specified hues. (Photographs: Reproduced with permission of the NCS-Scandinavian Color institute, Stockholm)

(across in a straight line from) a hue that we think of as opposite in character: red across from green, orange from blue, yellow from violet. Thus each primary stands across from a secondary made up by mixing the two other primaries. Such opposite colors are called *complementary*. Mixing two complementaries—in effect, adding together the three primaries—results, in the subtractive color of dyes and pigments, in a neutral gray. (In reality, the actual color may be a brownish or bluish neutral rather than the theoretical neutral gray of the color systems.)

WARM AND COOL COLORS

Looking at the color wheel in figure 10.19, we see that the circle is divided through its center into two families of color that make strongly different impressions. Red, orange, and yellow are described as *warm* colors; green, blue, and violet as *cool*. A clear mental association between the colors themselves and the temperature sensations of hot and cold has been established. Warm colors actually seem to raise the apparent room temperature, making spaces feel cozy and pleasant indoors in winter, while cool colors provide relief on a hot day or in a warm climate. Notice that a complementary pair is always made up of one warm and one cool color.

Neutral grays, black, and white are neutral in relation to the warm-cool range, as one might expect from their position as the central axis of the Munsell color solid. Tints and shades close to neutral, located near but not at the axis, can be spoken of as

warm or cool according to which side of the color wheel they lie on. They are sometimes hard to identify in terms of hue, partly because we use different color names for colors of low values and low chroma. A dark red or orange of low chroma will usually be called a shade of brown. A blue in a similar position in the color solid will be seen as a cool gray. Colors with names such as tan, olive drab, or taupe at the darker end of the scale or pink, cream, or beige at the lighter end are examples of hues given new names when of low chroma and either high or low value.

Psychological Impact of Colors

It is widely recognized that colors have a strong impact on human moods and emotions (fig. 10.29). Even some physical sensations can be modified by the presence of colors. However, the exact nature of these influences is not well understood, and the confusion is compounded by the complex ways in which color interacts with spatial perception, as well as the ways in which colors influence each other.

It is generally agreed that warm colors convey a sensation of warmth, both physical and emotional. Well-documented cases demonstrate that complaints about inadequate heat have been silenced by a change of color scheme, with no change of actual air temperature. The idea of a cozy room is strongly identified with

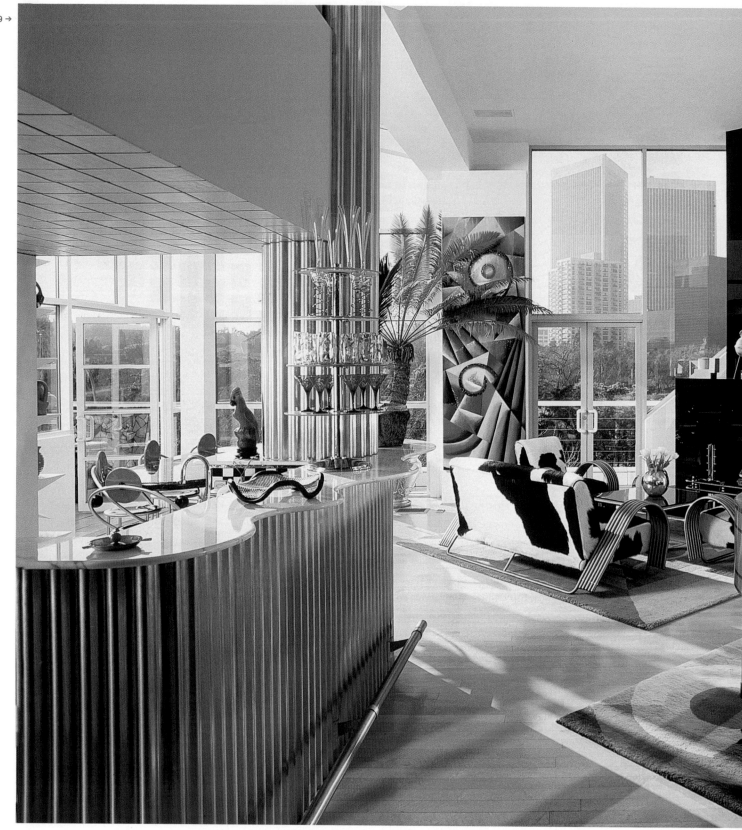

10.29 Bold colors—contrasting in both value and hue—create an atmosphere that is vibrant, active, even aggressive. Frank Gehry, architect, remodeled the Los Angeles home of artist Miriam Wosk, who created the interior design. (Photograph: © Grant Mudford, courtesy *House & Garden*)

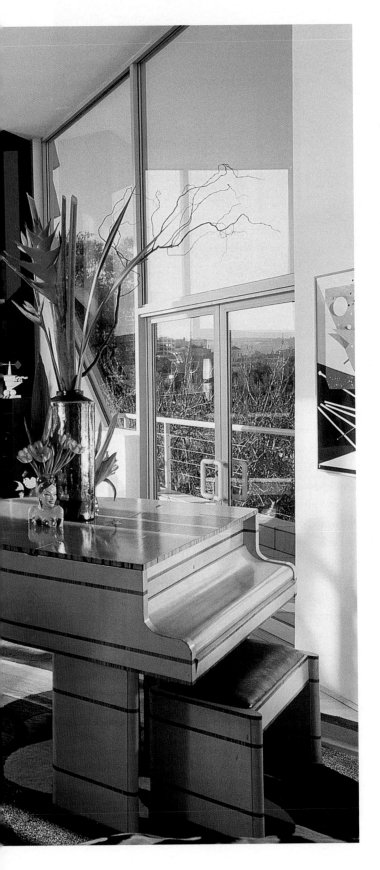

are innate or cultural. The response may also differ according to the context. Red is commonly associated with danger and the meaning stop, yet it is used for exit signs that indicate a route out of danger to safety. A color that may communicate excitement of a pleasurable sort in one context may be irritating in another; a hue that is calm and soothing under one set of circumstances may be depressing in another. With these cautions in mind, it may be useful to review the generally accepted associations for the various hues:

Reds are seen as warm, even hot, exciting, and stimulating. They are associated with tension and danger (heat and fire). Limited amounts of red can augment and balance blues and greens in a color scheme, adding life and cheer. Strong reds and greens together in large areas can generate unpleasant tensions.

Oranges share the qualities of reds to a slightly reduced extent. Small areas of red-orange are a useful, stimulating modifier in otherwise neutral or cool color schemes.

Yellows, the mildest of the warm colors, are usually associated with cheerfulness, even humor (in theater lighting, it is traditional to use yellow for comedy scenes). They give a strong effect of brightness while suggesting less tension than reds and oranges. Yellow tints (creams and beiges) are known as safe colors, with no negative implications, but their overuse subjects them to insipidity.

Greens are the cool colors closest to warm. They have become a favorite for balanced color schemes seeking to be calm and restful, peaceful and constructive, associations stemming from green as the color of grass and leaves. The color theorists of the 1930s so successfully promoted green as the best color for offices, classrooms, and hospital interiors that its overuse has made "institutional green" an objectionable cliché. However, green remains a good color to impart serenity, especially when used with limited areas of red or red-orange to counter any sense of drabness.

Blues are the coolest of the cool colors, suggesting rest and repose, calm and dignity. Overused or in too strong a chroma, blues can generate depression and gloom, as evident in the phrase "to have the blues." Intense blue in small areas can be a helpful accent in warm and warm-neutral color schemes.

Violets, along with their stronger versions called purples, have a reputation as problematic and unsafe colors. At the borderline between cool and warm, they seem to convey uncertainty (in contrast to borderline green, which communicates strength from both families). Violets are often seen as artistic, suggesting subtlety and sensitivity but at the risk of conveying ambiguity. Purples even more strongly intimate tension and depression, although they also project dignity (the "royal" purple). Violets can be highly expressive but must be used with caution.

Neutral colors—grays, more or less warm, cool, or exactly neutral, as well as browns and tans—tend to convey, in milder form, the impressions of the hues that they contain in dilute form. The truly neutral grays make good background colors, easy to live with over long periods. However, they are subject to dullness and an impression of monotony. When used with limited areas of more

the use of warm color and lighting that emphasizes the warmth of the colors present (see fig. 10.42). In contrast, cool colors suggest formality and reserve and communicate a sense of physical coolness as well (see fig. 10.36).

Many attempts have been made to identify the impact of the various hues, but it cannot be ascertained whether these reactions

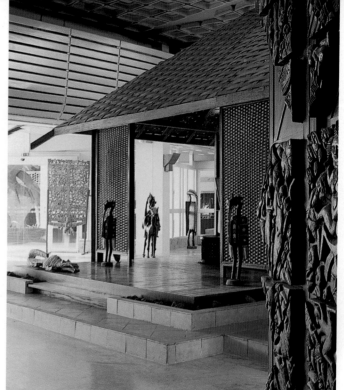

chromatic color, grays can be very useful. Browns and tans, which are actually somewhat neutralized reds and yellows, have a traditional association with a snug, clubby atmosphere. They appear homelike in their milder tones, masculine in their heavier values.

Whites and near-whites suggest clarity, openness, and brightness. White is always a safe color and can be used in large areas to highly satisfactory effect if offset with small areas of chromatic color. The association with cleanliness and sanitation is an obvious one. All-white schemes can seem forced and empty, but whites used with appropriate accents imply modernity and high style, perhaps in part because whites were so widely used by early Modernist designers.

Black is a powerful accent color, depressing if used to excess. It suggests weight, dignity, formality, and solemnity. Extensive use of black is best limited to spaces occupied for brief periods of time (elevator cabs, vestibules, bathrooms). As dark grays share some of these qualities to a reduced degree, they can be used more safely where strong, dark accents are required.

Recent research suggests that the impact of colors is less determined by hue than by intensity. Thus, a strong red or green has similar interpretive value as exciting and stimulating, while softer pastels of any hue have implications of calm and restraint. The significance of the various hues may be somewhat overstated in view of this finding, while the significance of intensity (or chroma) may sometimes have been neglected.

While these generalizations seem to have considerable value, it must be remembered that colors are rarely used alone and that colors used together interact in ways that are very complex. One cannot simply mix a bit of red for excitement, some black for dignity, and some green for calm and expect to achieve a scheme with all of those qualities. Almost any color can work in certain situations, and almost any combination can be successful, given balanced relationships of hue, chroma, and value and sound choices of location, area, texture, and other variables. In practice, all of the systematic knowledge of color reviewed above is best absorbed as background for creative work that proceeds in ways that have no dependence on formula or routine.

Cultural Symbolism of Colors

Although the psychological impact of various colors as outlined above is widely understood, it must be noted that different cultures understand color differently. It is well known, for example, that whereas in Western usage death and mourning are associated with the color black, in China and other Asian civilizations the color of death is white. Cross-cultural studies have discovered that in Japan, blues and greens are understood as "good," while the range from red to purple is seen as "bad," in contrast to the Western understanding of red, yellow, and green as "good" and purple and orange as "bad."

Sensitivity to such cultural issues can be significant in interior design in two important ways. First, with the modern ease of intercontinental communication and transport, designers are increasingly likely to work on projects located in geographical sites far from their home base. A North American designer working on a project in a foreign country must be able to make color decisions in light of the cultural context of the project's distant location. Intense warm colors, for example, that may seem "too hot" for use in the North American climate may be welcome in the tropical regions of Central America and parts of China and Africa in a way that might, at first, seem illogical. The designer needs, therefore, to make an effort to identify with the color usage of the region where a project is destined to be sited (figs. 10.30, 10.31).

Another way in which regional color practices can be put to use is in creating an ambience suggestive of a distant location. The feeling of Morocco might, for example, be created in Florida or Boston; a Greek or Mexican ambience can, to a degree, be generated in any location through the use of appropriate color. This use of color has long been familiar to the designers of restaurants, where a regional cuisine can be reflected in the interior design of

10.30 In the lobby of this Club Med Resort, Senegal, the color of the pavilion—a range of brown and tans—reflects the tonality typical of this region of West Africa. Design was by Jean-Pierre Heim. (Photograph: Fabrice Rambert)
10.31 Used together, strong red and blue suggest excitement and activity in this house in Mexico designed by George Woo, architect. Though the interior is contemporary, the use of strong color is characteristic of Mexican culture. (Photograph: © Balthazar Korab, courtesy *House & Garden*)

10.31 →

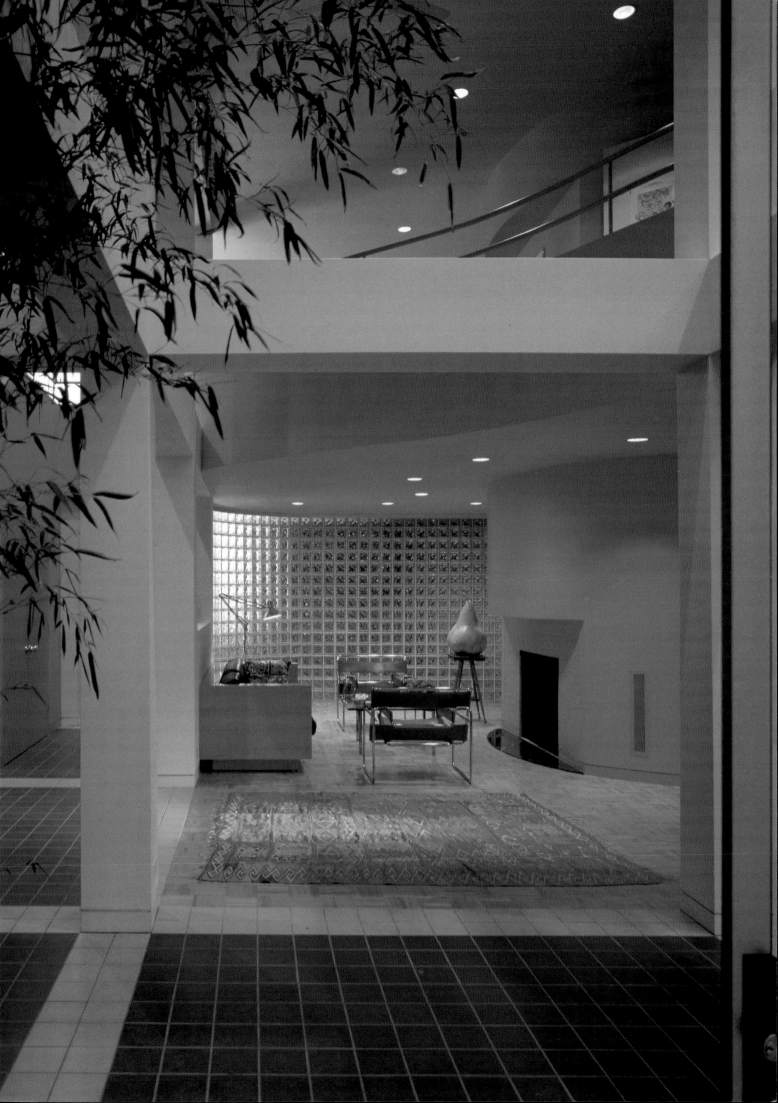

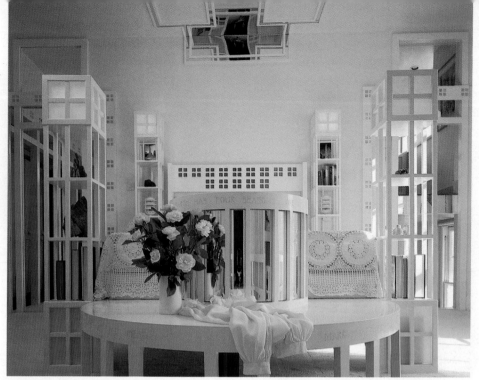

10.32 →

the space where that food will be served. The color symbolism appropriate to a Japanese, Mexican, or Danish restaurant can be readily imagined, and it is obvious that color is not fully interchangeable in each context. A similar but more subtle use of color symbolism can be applied to the design of residential, commercial, and business interiors, where occupants may find hints of a particular geographical usage pleasing or stimulating.

Many other forms of color symbolism can be discovered in regional, national, religious, and other contexts. While awareness of such associations is useful, it must be remembered that any color may have varied meanings according to its context, so that the designer needs to be sensitive to, but not intimidated by, the many meanings that any color may have. Among religions, for example, the colors white, red, green, and purple symbolize the seasons of the church year for many Christian denominations. Green is the color of Islam, while blue and white (symbolizing heaven and earth) are the colors of the Jewish prayer shawl. The yellow-orange of the Hindu Krishna sect's robes is a familiar color symbol, as is the brown of monks' robes. The red of Communist party flags has led to the term *red* being used to describe every aspect of communist thinking. In the theoretical system called *feng shui*, colors have specific meanings relating to compass directions (red = south, green = east, black = north, and so on) and to such concepts as knowledge and fame. Design awareness of such varied color implications can be turned to use in developing color schemes with meaning appropriate to the particular interior space under consideration.

Color Schemes

The concept of *color harmony* is one of the keys to understanding the theory that lies behind the development of various color schemes. This concept has its origins in a comparison of colors with musical tones. It is well known that certain musical notes sound well together, while others make a discordant or clashing sound. There is a basis for this in the physics of sound, which explains the reasons for harmonious chords in music. The physical basis of color harmony is not so easily explained; nevertheless, it is commonly observed that some colors clash in a harsh relationship, while other combinations, whether soothing or exciting, subtle or aggressive, are pleasant.

Planned color schemes can be classified into a number of types, regardless of the actual hues used or whether warm or cool colors dominate. These types are discussed here in order of complexity, beginning with the simplest. Not unexpectedly, this parallels the order of difficulty involved in producing a successful scheme. The most complex and difficult types can be extremely beautiful, but putting them into practical use takes more experience and skill (or perhaps special talent) than working with the simpler types of scheme.

MONOTONE (NEUTRAL) COLOR SCHEMES

Monotone schemes use a single color of low chroma in one value or a very limited range of values (fig. 10.32). Typical colors used are grays, tans, and tinted whites. It is almost impossible for such a scheme to fail through harsh or clashing effect, but monotony—as the name

10.32 In the bedroom of their Thematic House, London, the architect Charles Jencks and the designer Maggie Keswick have restricted color to a monotone except for a few small accents. The result is attention focused on the symbolic motif of this "Foursquare Room"—repeated in ornamental details in the design of the ceiling, mirrors, lighting elements, and the four-poster bed. Although the color is limited to tones close to ivory white, the effect is still richly colorful. (Photograph: © Richard Bryant, courtesy *House & Garden*)

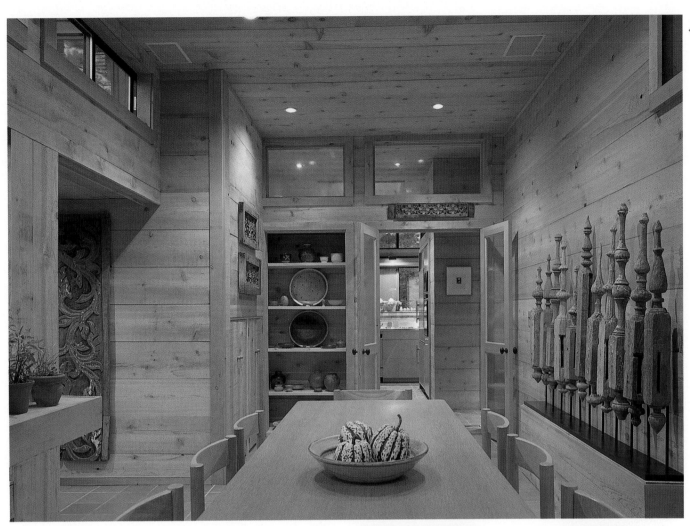

suggests—is a risk. Monotone schemes are ideal for situations where strong color will enter in some transitory way—in the costumes of occupants, the display of colorful art or merchandise, or dramatic views through large windows. In practice, the monotone scheme is often modified by the introduction of some stronger color in minor accent elements. A strictly monotone scheme can seem somewhat forced, as in the case of the all-white-room, which has become something of a decorating cliché. All-beige or almost all-beige schemes are very safe and, if monotony is relieved by some changing element not strictly a part of the scheme, can be fully satisfactory.

MONOCHROMATIC COLOR SCHEMES

Similar to monotone schemes, monochromatic color schemes use a wider range of chroma and value in a single hue. The familiar ideas of a red or blue room exemplify schemes of this type. Such schemes can also be developed using the natural colors of materials that fall in a narrow range, such as red-orange tones ranging

down through browns and tans, all of the same hue (figs. 10.33–10.35). Like monotone schemes (which may be considered a special case of monochromaticity), these schemes tend to be easy, since harsh clashes are almost impossible. Monochromatic schemes likewise risk monotony or a certain artificiality.

10.33 The dining room in the East Hampton, New York, home of the architect Alfredo De Vido, is monochromatic in color. There is almost no exception to the range of browns and tans that dominate the room. When the room is in use, the color of foods and serving pieces contrasts pleasantly with the restricted color palette. (Photograph: Norman McGrath) **10.34, 10.35** In the color chart (fig. 10.34) for the monochromatic scheme in figure 10.33, the browns and tans move to a near black for the decorative collection of spindles and the shelf on which they are mounted. On the color wheel (fig. 10.35), all the color tones are close together in the orange sector, although the actual colors are the deep and somewhat desaturated forms of the chromatic color.

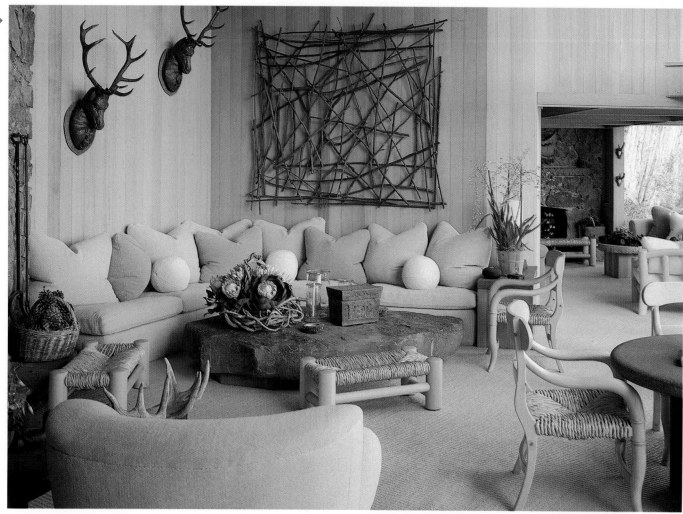

Problems arise when every item—carpet, walls, furniture, curtains—is given a strong version of the chosen hue, such as a particular blue. Rooms with a single strong color can be dramatic and often look good in photographs, but they can be hard to live with over an extended period of time. Such schemes may work best for spaces that people occupy only briefly.

ANALOGOUS COLOR SCHEMES

Analogous schemes achieve harmony by using hues that are close together on the color wheel (fig. 10.36). The typical analogous scheme uses one primary or one secondary plus the hues adjacent to it on either side. Two examples are blue with its neighbors blue-green and blue-violet and green plus blue-green and yellow-green. An adjacent primary and secondary plus the tertiary hues between them (blue and green plus the blue-greens between them, for example) also generate an analogous scheme. In each case, the hues included fall within a segment of the color wheel that spans no more

← 10.37 10.38 ↑

than about 90 degrees. As long as hue is restricted to one-quarter of the wheel, a range of varied value and chroma may be used.

Once again, because of its restriction, the analogous scheme (fig. 10.37) virtually guarantees harmony. Because of its greater color range, monotony is less of a hazard than with monotone and

10.36 The color scheme for this living space in a Lake Tahoe residence is described as analogous because the colors used are adjacent in the spectrum—primarily a range of blue and its neighbor green, the green reaching over to its other neighbor, yellow, in the yellow-tans of the wood and rush chairs, stools, and wooden wall finish. It is also, by virtue of the dominant blues and greens, a cool scheme, suitable to a hot climate. Michael Taylor was the designer. (Photograph: Timothy Hursley, © The Arkansas Office, courtesy *House &*

Garden) **10.37, 10.38** The strongly chromatic colors in the scheme illustrated in figure 10.36 are all blues and greens; the more neutral tones are tans and beiges, or desaturated yellows. The color chart (fig. 10.37) thus shows a range from blue-gray through blue and green to yellow. When mapped on a color wheel (fig. 10.38), all tones are adjacent, staying within one-third of the full spectrum.

monochromatic schemes. Complementaries from across the color wheel (fig. 10.38) are often introduced as accent colors; however, if these become important elements in the scheme, it is no longer truly analogous but a species of complementary scheme.

COMPLEMENTARY COLOR SCHEMES

As the name implies, complementary schemes use contrasting hues from opposite sides of the color wheel: reds with greens, oranges with blues, yellows with violets (fig. 10.39). The basic hues may be more subtle intermediate colors rather than primary or secondary colors, as long as they face each other across the wheel (figs. 10.40, 10.41). Complementary schemes, which tend to seem bright and balanced, are generally well liked when skillfully assembled. The danger in complementary schemes is that they may become over-bright, even garish. Flags, sports costumes, display advertising, and some stage design make good use of such sharply contrasting complementaries, but interiors in strong bright reds and greens or

← 10.40 10.41 ↑

blues and oranges may appear unpleasantly harsh or tiring.

Successful complementary schemes usually use a color of low chroma and either high or low value (tints or shades) from one side of the wheel to cover large areas and stronger colors from the opposite side of the wheel for smaller areas. Neutralizing each

10.39 The complementary colors blue and orange are used in relation to the near-neutral tones of floor and ceiling and the black of furniture elements. The space is a circulation area in the offices of SBK Entertainment World, New York, and was designed by Gwathmey Siegel &

Associates Architects. (Photograph: Elliott Kaufman) **10.40, 10.41** In the color chart (fig. 10.40) for the scheme illustrated in figure 10.39, the salmon-orange of the door and adjacent wall are complementary to the blue-gray of the near wall. Except for the nonchromatic

black, other tones are near-neutrals slightly tinted by the chromatic colors. On the color wheel (fig. 10.41), the blue and orange are almost exactly opposite and so are clearly complementary.

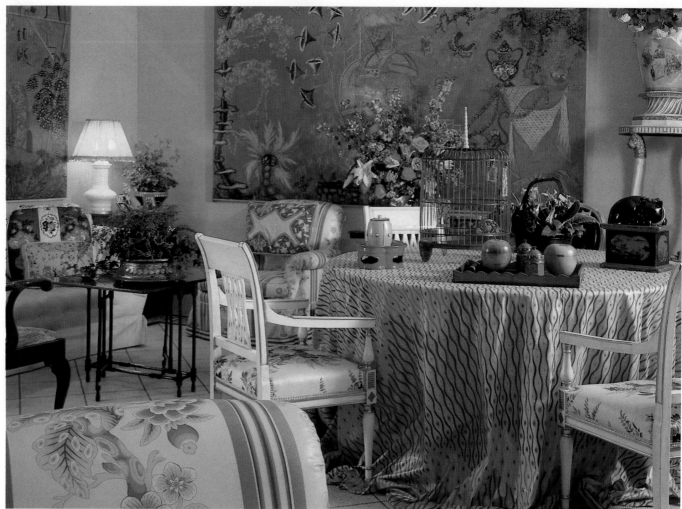

← 10.43 10.44 ↑

color by adding the complementary to it helps to unify complementary schemes. For example, a room might have floor and wall areas of a light green, grayed (reduced in chroma) by the addition of red. Some objects, perhaps upholstered furniture, would display the complementary red in strong but not full chroma, reduced by a small addition of green.

Complementary schemes are more difficult to plan than the simpler scheme types discussed above, especially if one considers the range of variations on basic complementary color. It is possible to widen the band of hues used on either one or both sides of the color wheel while still maintaining a complementary balance. Both red and the adjacent red-violet on one side of the wheel might be used with the slightly yellowed green opposite or with a range in the yellow-green to green band. Once again, such schemes require care and subtlety to avoid garishness.

A further variant of complementary schemes, sometimes classified as a totally different type, is the *split-complementary* scheme (fig.

10.42). In this scheme, a hue on one side of the wheel is used with the two hues that fall on either side of the directly opposite complementary (fig. 10.43, 10.44). With red, for example, both yellow-green and blue-green could be used, omitting the true green between them (hence the term *split*). This scheme also works best

10.42 Split-complementary colors were chosen by Mrs. Henry Parish II, designer with the firm of Parish-Hadley, for her own home in New York. Such schemes are rich in color and, when warm tones dominate—as they do here—endow a room with an inviting, comfortable charm.

(Photograph: Oberto Gili, courtesy *House & Garden*) **10.43, 10.44** The strong orange and yellow tones that compel one's attention in the space shown in figure 10.42 are balanced by smaller areas of color from the opposite side of the wheel in this split-complementary

scheme. The color chart (fig. 10.43) demonstrates that the greens of the painted panels, however, are close to yellow, while those of the plants—a significant element in this scheme—are closer to blue; the result is a split-complementary scheme. The dark brown

wood finishes may seem to fall out-side the main color range, but they are, in fact, very deep tones of orange. On the color wheel (fig. 10.44), the split tones are slightly shifted from a position exactly opposite one another.

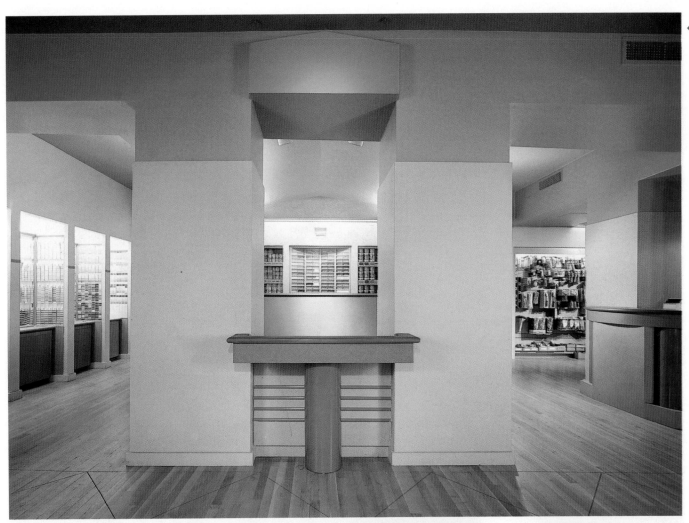

← 10.46 10.47 ↑

using lower levels of chroma for the hues from one side of the wheel in larger areas and more intense color from the other side in smaller areas and accents. Effective split-complementary schemes look lively and colorful. They make a subtler and more varied impression than simple complementary schemes.

TRIAD COLOR SCHEMES

Choosing three hues approximately equidistant from one another on the color wheel—red, yellow, and blue; orange, green, and violet; or slightly shifted versions of these combinations—creates triad schemes (figs. 10.45–10.47). These are the most difficult of all the color schemes discussed so far, and the most likely to slip into harshness and confusion. Successful triad schemes generally employ reduced intensities of all hues or all but one hue. Triad color is often used in small areas in an otherwise mostly neutral scheme. An interior following this scheme might have mostly white surfaces, with flooring in one hue of the triad at

reduced value and chroma plus accents in the other two hues of the triad.

TETRAD COLOR SCHEMES

Tetrad schemes use four hues equally spaced around the color

10.45 A triad scheme uses chromatic colors that are more or less equally spaced around the color wheel. The most common, or major, triad is red, yellow, and blue. Shown here is a minor triad, made up of the secondaries orange, green, and violet. Because they are based on saturated hues, triad schemes tend to have great impact—so it is not surprising to find this example in the showroom of a paint company, Janovic Plaza, New York, designed by Voorsanger & Mills Associates, Architects. (Photograph: © 1982 Peter Aaron/Esto) **10.46, 10.47**

The triad scheme in figure 10.45 is illustrated here in chart form (fig. 10.46). A neutral color acts as back-ground for the triad. The three secondaries that make up the dominant chromatic colors are about equally spaced on the color wheel (fig. 10.47).

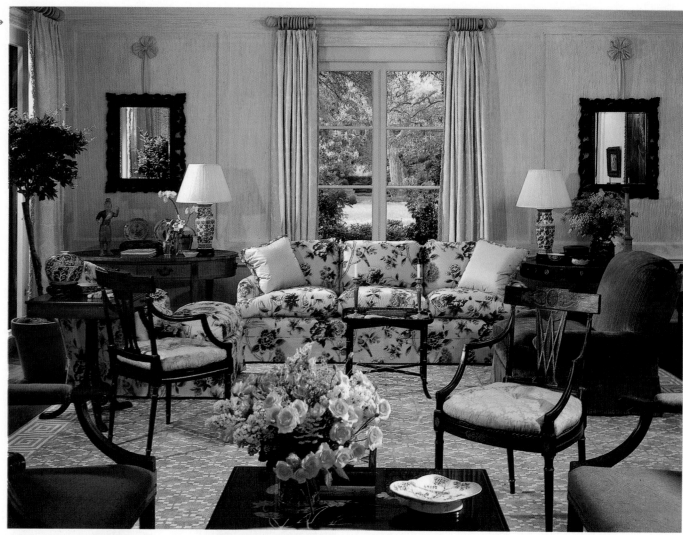

← 10.49 10.50 ↑

Special Color Effects

A number of circumstances alter the appearance of color. In the theoretical consideration of color schemes, all colors are thought of as uniform, solid, and *flat* (nonglossy). In practice, real materials have characteristics that modify the way color is seen. A glossy finish often alters the apparent color of an object due to its high reflectance. Light reflected from its surface tends to dilute and weaken the visible color, while adjacent colors (such as floor color) reflected on it may actually cause a shift in its apparent hue.

wheel (fig. 10.48–10.50). The comments offered for triad schemes are even more strongly applicable to tetrad color. Examples are, in practice, fairly rare, but, difficult though they may be to produce, lively and satisfactory schemes of this type remain a possibility.

EFFECTS OF TEXTURE, PATTERN, METALLIC MATERIALS

Texture, pattern, and metallic materials can alter the appearance of color.

10.48 A tetrad color scheme is composed of four hues equally spaced around the color wheel. In this living area in a Houston home, built circa 1919–21 by Harrie T. Lindeberg, Mark Hampton used a subtle tetrad scheme in a more recent remodeling to generate a feeling of ease in familiar, traditional terms. (Photograph: Feliciano, courtesy *House & Garden*) **10.49, 10.50** Although the color tones are muted, the four hues that form a tetrad scheme in figure 10.48 are distinct in the chart form (fig. 10.49). The greens of the upholstery and the blue of the rug are prominent values. The red and pink of the sofa and the browns of the wood finishes represent the third hue, while the creamy yellow lampshades and the beige-tan of the painted wall surfaces complete the tetrad. The tetrad color scheme diagrammed on the color wheel (fig. 10.50) shows the four hues at even intervals around the circle.

Texture Textured surfaces alter apparent color by introducing shadow or gloss at a microscale. Under a microscope, the texture may by seen as tiny hills and valleys, a series of pores, pits, flakes, shreds, or slivers that may have glossy surfaces, or may cast shadows or do both. The color seen is then the color of the material modified by these textural elements. Because of these effects, many textured materials will shift color when observed at different angles or when rubbed or stroked in one direction or another. Suede, many solid-color carpets, and textiles exhibit the latter effect. Even wood, if it is left unfinished or is finished to preserve its natural color and texture, may change color according to the angle of view and the angle of lighting. Textiles and carpets with strong texture shift the visual appearance of the actual dye color in ways that are hard to predict. Textures of surfaces (plaster, brick, stone) can alter the appearance of paint color. In order to take texture into account, color effects should be judged from actual samples of the material to be used.

Pattern Color also appears in patterns, from the slight pattern of some woven fabrics up to the large-scale, highly visible designs of some printed textiles and wallpapers. When viewed at a distance, small-scale patterns appear as a solid color, the result of visually mixing the colors that make up the pattern. Larger patterns should be categorized as sets of colors grouped together, each component having a separate identity.

Metallic Materials Metallic materials show color in a way that can be confusing. Polished metals act as mirrors, reflecting adjacent colors. The white metals—namely, silver, stainless steel, aluminum, and chromium—reflect colors back with little change. Brass, gold, copper, and other colorful metals act much as a tinted mirror, tinting the adjacent colors they reflect back yellow, orange, or reddish brown, according to the metal in question. This effect is also influenced by the finish. Glossy, or mirror-polished, finishes have a very high reflectance. Textured metallic finishes (also called *satin* or *brushed*) combine the reflectivity of polished metals with a microtexture (of tiny roughnesses) that breaks up sharp or smooth reflectivity. Metallics, like patterns, can be considered special cases, best evaluated in actual or simulated samples. Metal foils, metallic papers, and plastic sheeting are often convenient substitutes for actual pieces of metal that may be unavailable or too difficult to use in color planning.

COLORS IN RELATION TO EACH OTHER

The family of color effects or optical illusions called *simultaneous contrast* results from the effort of the brain to interpret perceived color. Any visible color area may change in appearance as a result of the other colors that surround it. The studies of Josef Albers in his book *Interaction of Color* are demonstrations of such effects. In practice, it can be noted that a neutral tone will seem tinted by the complementary of its surroundings. A white doorway, for example,

will appear pink when set in a wall of bright green, while the same door will appear pale green when set in a red wall.

The physical space will also influence how colors appear. When seen against a larger background, small areas of color may change in both value and hue. Light colors will appear lighter than they are when seen against a darker background, darks become darker against a light background (fig. 10.51). A medium tone can be made to seem either light or dark through contrast with its surroundings (fig. 10.52). Similarly, hues will seem to shift in relation to surroundings. A neutral gray will appear warm when placed on a blue background and cool when placed on red (fig. 10.53). Stronger colors will seem to shift in hue in relation to background, with a small sample seeming to move toward the complementary of the background color. For example, a small area of strong green will seem more intensely green when placed on a reddish (pink) background; placed on a violet background, its hue will seem to shift toward yellow-green.

EFFECTS OF COLOR ON SPACE

Conversely, color itself creates some surprising spatial effects. Warm colors are said to *advance*, that is, appear closer than they actually are, while cool colors *recede*, appearing farther away. Light colors make objects look larger and lighter than they are, while darker colors make them look smaller and heavier. Placing sharply contrasting hues—that is, one advancing, one receding—together can cause a sense of vibration along their edges as the colors seem to move in opposite directions (fig. 10.54). This is another in the family of color effects known as *simultaneous contrast*.

These effects can be used to advantage in interior design. A small space can be made to seem larger, an oddly shaped space to seem better proportioned by a judicious use of colors in ways that exploit these effects. A long, narrow room, for example, will seem more normally shaped if the end walls are of a strong, warm color while the sides are lighter and cooler in tone, so that visually the ends seem to come closer and the sides move away. A dark ceiling will tend to seem lower than the same ceiling in a light tone. A dark floor and ceiling can greatly reduce apparent height and may even seem oppressive. A door painted to match the color of the wall around it or a window curtained in a tone matching its surround will blend into its environment. The same element treated in a contrasting color will be emphasized.

Similarly, furniture can be made recessive or prominent according to whether it matches or contrasts with its background. An ebony black grand piano will be striking on a light floor with a light wall behind it. It will appear smaller and less assertive against a floor and wall in dark tones. Trim moldings (baseboards, cornices, window frames and doorframes) stand out and define form when painted to contrast with walls in hue, value, or both. Trim painted to match walls tends to be less noticeable, deemphasizing the shape and contributing to an effect of spaciousness.

OPTICAL MIXTURE

The color effect of optical mixture comes about when two different colors, say red and blue, are present in areas too small or too far away for the eye to distinguish separately and so they are perceived as a third color, purple, obtained by the eye mixing the original two colors. This effect was exploited by the Pointillist painters of the nineteenth century and is the basis for modern color printing techniques such as four-color halftone. Only three chromatic colors (plus black, which is the absence of chromatic color) are used to produce images in a full range of color.

Examination of a printed color photograph under a strong magnifying glass will show that tiny dots of the three primary colors are producing effects of virtually any color. In interior design, optical mixture is most significant in woven textile design, where threads of several colors when woven together create an optical mix that appears as a color different from the colors of the separate threads.

EFFECTS OF LIGHT ON COLOR

For every use of color, it should be remembered that color and color effects are influenced by the presence of light, which is what makes it possible to see color at all. When working with color in developing interior schemes, it is important that the light used match the light that will be normal in the actual built space. An effect called *metamerism* can bring about a shift in color perception as a result of the coloration of *ambient*, or general, light. Two samples that seem perfectly matched in color under one light source can appear strikingly different under another type of light. Color matching is usually done under daylight in an effort to avoid such surprises arising from this effect. Working at the drafting table with daylight illumination when the built space will normally be artificially lit can lead to some distressing surprises. Conversely, a desk lamp can falsify a scheme that will most often be seen in daylight. Many interiors must serve with both daylight and artificial light. In such cases, proposed color schemes should be evaluated under both types of lighting and under combinations that simulate the light that will be present in the real space.

Daylight and incandescent light have enough in common to be almost interchangeable, keeping in mind that incandescent light is warmer, making cool colors appear more neutral and warm colors stronger than they appear in daylight. The human eye and brain accept this shift quite readily, since the relationship of colors remains otherwise unaltered. Fluorescent lights, *high-intensity discharge* (HID) lights, and other light sources are much less predictable in their impact on color. Inspection of a scheme under the actual light source is essential when such illuminants are to be used.

10.51 A small sample of a light tone on a dark background appears lighter than a larger sample of the same color. Similarly, a small, dark sample on a light background appears darker than a larger sample. **10.52** A dark background with a medium-light sample appears darker because of the contrasting tone than the same background with a dark sample. **10.53** Identical neutrals look different when placed on different backgrounds. The red makes the gray seem cooler and darker, while the blue background shifts the gray to a lighter, warmer tone.

10.54 Because the eye cannot focus simultaneously on an intense green superimposed on an intense red, the edge where the colors meet appears to vibrate. Since strong complementaries juxtaposed tend to produce this phenomenon, known as simultaneous contrast, they are usually used only when an effect of intensity and tension is desired.

NORMAN DIEKMAN, DESIGN AND DRAWINGS

It is not unusual for designers to develop concepts and preliminary design without any thought about color. Color can be a dominant element in design, and in this example it has been considered a primary issue in design development.

The clients, sponsors of the American craft movement, were a couple who own houses elsewhere and wanted a city base where they could keep and display objects in their collection. They selected this condominium apartment in a Manhattan high-rise building primarily for its twenty-fifth-floor location, which provides a flood of afternoon light and spectacular day- and night-time city views from the ample windows.

In his design work, Diekman makes use of an unusual number of drawings, which exist as an aid to developmental thinking as well as a medium of communication with a client. Introduction of color as a key concern at every stage of design, rather than as an afterthought, is a vital part of the design process, as demonstrated here (figs. 10.55–10.58).

← 10.55

10.55 A floor plan in color (here reproduced in black and white) explains the space layout but also gives hints as to materials and color. The color tones used are partly realistic, partly expressionistic. (Courtesy Norman Diekman)

10.56 →

10.57 →

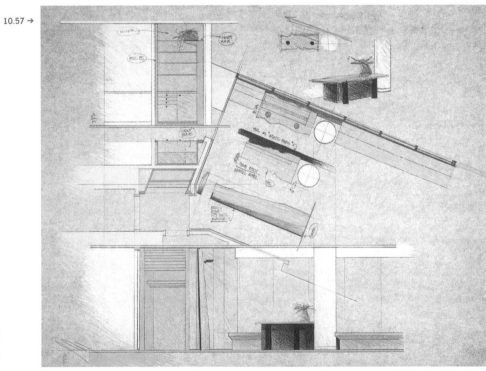

10.56 A perspective looking into the inner end of the living space emphasizes the specially designed table that can seat up to eight for dining but also can be used for display and contemplation of craft objects from the owners' collection. (Courtesy Norman Diekman) **10.57**

Detail studies in elevation and plan focus on the entrance area. Color serves to sort out elements of the drawing, just as it will work in the finished space. (Courtesy Norman Diekman) **10.58** In this view of the main living area (with the table omitted for clarity), the theme of a

summer pavilion in the sky is supported by the delicate tones of white and light neutrals for large areas, and yellows, greens, and one small red cushion as a contrasting accent. Without the color, the drawing would not have communicated the character of the space as it will be

seen in built reality. (Courtesy Norman Diekman)

← 10.58

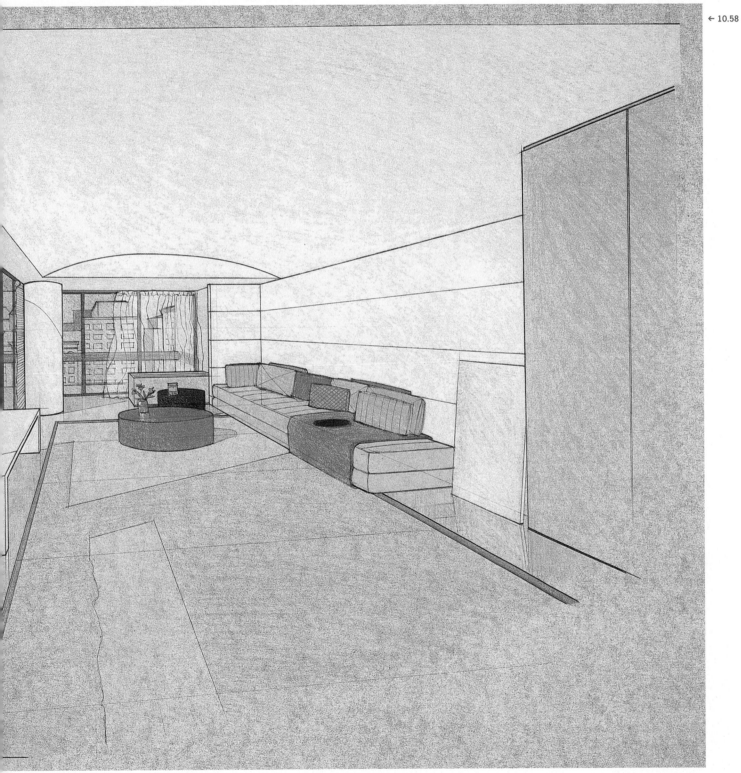

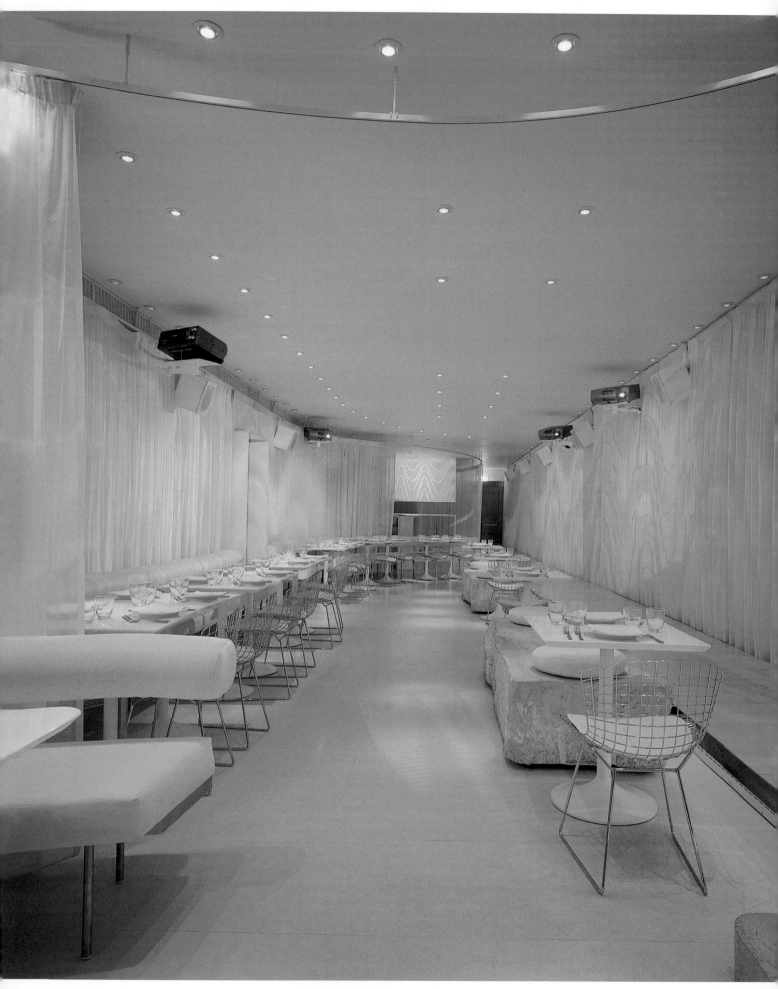

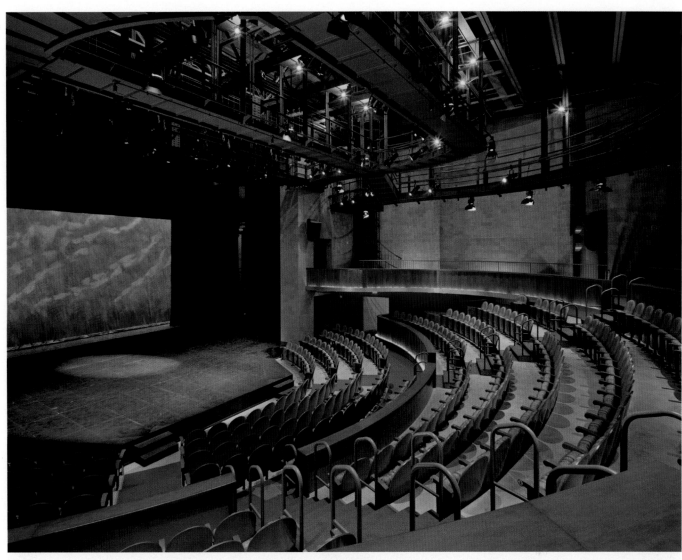

otherwise dim ceiling. Both situations are common because they provide a high level of light economically.

One special form of glare, called *veiling reflection*, comes from looking at somewhat glossy material placed so as to reflect a source of illumination, such as a window or lightbulb. A person reading print on glossy paper will move the paper around in an effort to find a position that kills the glare. Special efforts to deal with this problem (discussed on pages 344–45) are called for wherever reading, writing, or other close seeing will take place for an extended time.

Contrast and Diffusion Shade and shadow emphasize form but conceal detail in the shaded areas. Light that comes from a concentrated source, or *point source*, tends to create strong shade and shadow, while *diffused light*—light that is distributed evenly through the scattering of rays—tends to diminish or block out

shading. The sun, a point source, casts strong shadows that make objects look crisp and sharp. A cloudy sky gives a soft, diffuse light that reveals detail in shade but may seem dull or depressing in mood. Actually, sunny daylight is a mixture of point-source direct sun and diffuse light from the sky. A pure point source, such as a theater or photo spotlight, accents form by creating even sharper shadows, but its light may seem harsh.

High-contrast point-source lighting draws attention and accents form and texture. Diffused light promotes good general vision (see fig. 11.5) but in some settings may seem drab and characterless. The absence of shadows can make some tasks harder because shadows aid three-dimensional depth perception. When writing or drawing, the shadow of pen or pencil as it is lifted and lowered aids in seeing and control. For most situations, a suitable mix of point-source and diffused light will serve best.

11.4 The human eye is the receptor that natural and designed lighting serves. The iris varies the size of the pupil, controlling the amount of light that reaches the retina, thereby enabling the eye to adjust to a wide range of conditions. The cross-sectional drawing is by Giorgio Brunelli.

(From *Theory and Use of Color* by Luigina De Grandis) **11.5** The Two River Theater, Red Bank, New Jersey, completed 2005, is situated in a former industrial area. The design of the theatre responds to its context and is a study in opposites: raw and finished, interior and exterior,

transparent and opaque, geometric and organic. The large proscenium provides a flexible environment for scenic designers.

Economic Issues Daylight is free, but windows and skylights are not. Moreover, windows and skylights admit summer heat and allow winter heat to escape, effects that must be offset with mechanical equipment costly to provide and operate. Artificial light requires the purchase of lamps, fixtures, and wiring, as well as the ongoing cost of maintenance, replacing bulbs and tubes, and using power. In addition, the heat generated by lighting calls for additional summer air-conditioning, which is rarely balanced by comparable savings in winter heating. This is usually a minor factor in residential lighting design but a major concern in stores, offices, and factories, where artificial light is required on a nearly full-time basis. Given the present high cost of energy, it becomes important to design lighting that offers the best possible results with the minimum first cost and operational expenses.

Daylight

Although it costs nothing, daylight varies with the season, weather, and time of day, and it requires building design that places windows (or skylights) to make light available where needed (fig.11.6). Still, in many ways, daylight remains the most attractive form of illumination. It is the lighting for which the eye was developed, and its variability actually helps to make it pleasant and satisfying. Interior designers often seem to neglect the possibilities of using daylight, first, because they take windows for granted as a given condition of interior space and, second, because they think of windows as elements to be "treated" in some decorative way rather than made functionally useful.

11.6 The rooftop remodelling of a law firm on Falkestrasse in Vienna, designed by Coop Himmelblau, suggests a lightning bolt reversed and a taut arc. This space-creating arc is both the steel backbone of the project and its posture. The open, glazed surfaces and the closed, folded or linear surfaces of the outer shell control the light and allow or restrict the view. Both directions of view, that from outside and that from within, define the complexity of the construction's spatial relations. The constructional system, which is a cross between a bridge and an airplane, translates the spatial energy into constructional reality. (Courtesy Coop Himmelblau)

ADMITTING DAYLIGHT

The nature of daylight in the interior is determined by the architecture of the space, as well as by the location and orientation of the building. It is worth while to study those given circumstances and to consider how they might be exploited to make the best use of natural lighting. Older buildings constructed before modern electric lighting had come into general use were planned so that every room could have windows. This meant that plans of U, E, or H forms were often used to permit light courts (see fig. 11.6) to make windows possible for inner rooms. It was still necessary to provide some artificial lighting for dark days and late hours, but gas light and early electric lamps were of limited value. When such older buildings are preserved and adapted to modern use, the availability of daylight helps make them both pleasant and environmentally efficient. Windows vary in size and shape, in details of framing and opening. Latitude and climate affect the light they admit, as does external shading (through overhangs, sunshades, awnings, nearby trees, and other buildings). Skylights, encountered less often in existing buildings, are subject to some of the same variables. Where the space under consideration is already built, it is wise to observe and make n ote of the way windows perform—in what direction they face, their height and position, what view and shading they offer, and, incidentally, if they present problems with noise, heat loss or gain, or privacy. Where design work concerns a space not yet built or undergoing a major renovation, the same issues must be considered based on the facts available from drawings and on-site observation.

Windows can be changed—blocked up if badly placed, enlarged, combined, or reshaped—although this is likely to be a costly step. The effect of any changes on the exterior of the building must, of course, be considered, and permission must be obtained when the building owner is not the tenant of the space. Major changes in windows may require the help of an architect to deal with structural details and any applicable building code limitations. In general, changing frames or glazing within a window opening is fairly simple, as is cutting the wall below a small window to make it larger (or to make it into a door). Cutting an opening for a new window of moderate size is also usually fairly simple. Large windows present more problems because the new opening requires supporting structure above it. Combining several windows, greatly enlarging a window in width, or making an entire window wall, while costly, may be worth considering. Modern architecture has favored large windows not only for stylistic reasons but also because they give more light, of a more uniform quality, to spaces within (fig. 11.7). Small windows tend to be bright spots in a dark wall, while a full window wall floods a space with even light.

Skylights, too, can be removed, relocated, enlarged, or introduced where they did not previously exist. For both skylights and windows, problems with heat loss and gain can be controlled by multiple glazing, heat-controlling glass, and, most effective of all, consideration of orientation.

CONTROLLING DAYLIGHT

Multiple Glazing Multiple glazing uses two, sometimes three, sheets of glass factory-assembled into a sandwich. The dead-air spaces between the layers minimize heat loss, much as *storm windows* do. Special glass tinted to filter out heat energy while permitting most light to pass through can be obtained. While multiple glazing defends against winter cold, light-controlling glass minimizes summer heat gain. A good orientation—ideally, facing south, with appropriate exterior sun shading—makes a difference in both summer and winter. Unfortunately for interior designers, these matters usually lie beyond the normal areas of interior design concern. Nevertheless, the impact of orientation merits thought and attention, as it influences both newly planned and existing situations.

Orientation The pattern of the sun's movement is determined by latitude and season. In the temperate zone of the Northern Hemisphere, the sun appears to travel across the sky each day from east to west in a path south of the zenith; the farther north the location, the lower the path for a given date. The altitude of this path changes with the seasons, being lowest in winter, highest in summer. These natural laws influence the way in which daylight penetrates interior space (fig. 11.8). Openings facing north, which never admit direct sun, generally receive cool but consistent light from the north sky, the traditional north light of the artist's studio. East-facing windows admit strong sunlight early in the morning and lose the sun sometime before noon. West-facing windows receive later afternoon sun, sometimes too much sun on summer afternoons. South orientation has the advantage of receiving sun consistently for most of the day, at an angle that changes with the season. In winter, the low sun angle gives maximum heat and light, while in the summer the high angle reduces the sun's penetration. Careful planning of sun shading can control sun penetration precisely, a technique used as a basis for the design of solar houses that exploit the sun's energy to a maximum. Since sunlight is not available on cloudy days, only north-facing openings can offer consistent lighting. A south orientation is generally considered the most favorable in terms of light, pleasantness, and controllability.

Given a particular orientation and opening of known size, shape, and location, it is possible to predict the light patterns in summer and winter, at different times of day, and on sunny or dark days. This information will aid in determining window treatments, artificial light backup, and, sometimes, furniture placement and color schemes.

Window Treatments While windows can provide excellent light, direct sun can be a problem and must be controlled. With east or west orientations, early morning or late afternoon conditions

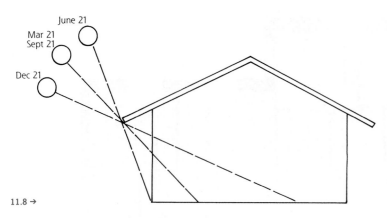

11.8 →

always call for sun control. Shades or blinds, with or without curtains, offer fully controllable adjustability, which curtains alone cannot give. (See pages 272–75, for a full discussion of window treatment.) Using daylight requires artificial backup light, even in spaces used by day only, for dark days and winter afternoons. For spaces used at night, the artificial lighting planned for that use will usually serve as the daytime backup.

When placing furniture, it is important to keep bright windows out of the field of vision of a person doing any task involving close work, such as reading, sewing, or computer and other desk work. Seating for visual tasks with the back to the window can also cause problems because of the shadow cast forward or bright light reflecting onto or otherwise impeding the viewing of computer monitors. Thus, the traditional "light coming from over the left shoulder" remains ideal, although light from the right is also satisfactory for most tasks and best for left-handed people.

Artificial Light

Barring remote wilderness cabins and atmospheric candlelit restaurants, artificial light in the modern world means electric light. Since Thomas Edison introduced his pioneering invention, a wide variety of electric light sources and lighting devices has been developed, making electric light marvelously useful and controllable. To the designer, artificial light has the potential advantage of being totally controllable in terms of brightness, color, placement, and quality. For these reasons, it is actually preferred in many situations (for example, restaurants, stores, showrooms, and exhibition spaces). At its best, it can compete favorably with daylight when used in offices, residential spaces, and many special-purpose spaces such as classrooms, waiting rooms, and many work spaces.

Planning Lighting

Planning lighting for an interior normally means planning the electric lighting. Since daylight is at best a part-time source of lighting, artificial light is generally planned to do a total job.

Many people tolerate lighting planned on a hit-or-miss basis, following habitual routines—they accept a central ceiling fixture in each room and plug an occasional lamp into some convenient outlet. Good results are hardly to be expected from this approach. Good lighting for a given space depends on careful planning, starting with an analysis of needs, followed by the intelligent selection of lighting devices to suit those needs, and ending with fixture spacing and location to achieve the lighting levels and effects desired. Observing lighting installations in use, both good and bad, will build up a memory stock of examples to follow and errors to avoid.

The following are typical planning steps:

- *Define the general aims in terms of character and atmosphere.* Is the space to be businesslike, efficient, restful, cozy?
- *Consider the specific purposes for which lighting is required.* Is the space used for working, dining, reading, watching television? Does it combine several purposes, necessitating varied or changeable lighting? Most people want their living spaces to be pleasant and relaxing, but they also demand good light for reading or writing, as well as efficient light for cleaning. A store must use lighting to set a tone suitable to its style and quality level and to flatter and feature merchandise.
- *Ascertain the intensity levels for proper vision and balance these against energy and first-installation costs and other factors to decide on lighting type.* Efficiency plays a major role in determining lamp type and fixture location, particularly in large installations. For example, the efficiency of fluorescent light favors its use in factories and other large spaces requiring bright light. However, it is important to plan carefully to avoid the visual and psychological problems associated with its use.
- *Select fixtures based on general aims and specific needs.* Once a decision is made to have brightness in one place, subtlety in another, variety for stimulation, or uniformity for efficiency, actual products should be chosen to create those effects, such as ceiling lights fixed in place for general illumination, indirect lighting for softness, concentrated spot lighting for emphasis and variety, and portable lamps for local accent and easy individual control.

← 11.7 **11.7** Besides admitting an appreciable amount of sunlight, this window wall establishes a spectacular presence in a residential space. The duplex apartment in Chicago was designed by Richard Himmel. (Photograph: Feliciano, courtesy *House & Garden*) **11.8** In the temperate zones, the sun's path across the sky is low in winter, high in summer. Properly shaded, southern exposure admits the light and warmth of the deep winter sun but blocks the strong summer sun—thereby reducing air-conditioning costs.

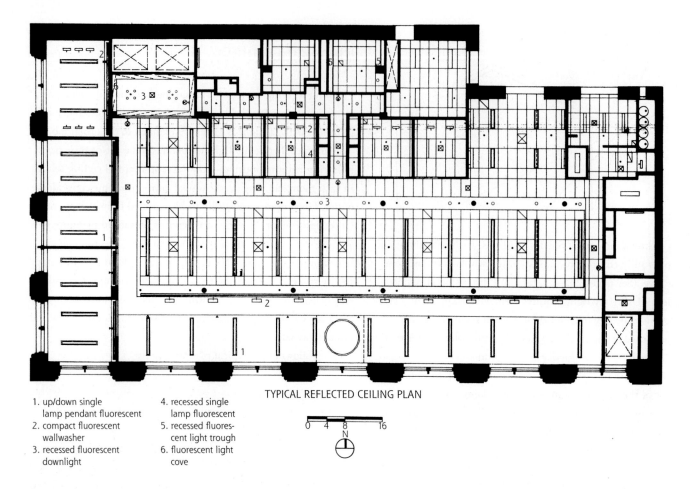

TYPICAL REFLECTED CEILING PLAN

1. up/down single
 lamp pendant fluorescent
2. compact fluorescent
 wallwasher
3. recessed fluorescent
 downlight
4. recessed single
 lamp fluorescent
5. recessed fluores-
 cent light trough
6. fluorescent light
 cove

0 4 8 16

N

- *Place fixtures.* This can be dealt with on an ad hoc basis in typical residential projects and similar situations where variety and atmosphere outweigh efficiency. In most larger projects, such as offices, restaurants, and stores, placement is determined by calculation, using formulas that yield the desired light levels along with the satisfactory quality of light.

Lighting is usually planned on overlay sheets placed over floor plans. A *reflected ceiling plan* (fig. 11.9) is the usual final drawing in which most lighting is indicated, although portable lamps are indicated on furniture plans. Plans and drawings detail the specifics of lighting location, but they give no idea of the *visual effect* of lighting. This remains an aspect of interior design almost impossible to present visually in advance of actual installation. Efforts to develop computer programs that will produce images illustrating a space as illuminated by a particular lighting installation have met with considerable success (fig. 11.10). In general, however, the informed imagination of the designer is the primary means for planning and predicting how lighting will really look.

Lighting Needs

The first step in making a lighting plan is an orderly assessment of lighting needs. These will normally fall into three categories:

1. *Task lighting*, or light for specific visual functions. This means providing adequate and suitable light for every activity that depends on good vision. The following are the typical tasks that call for special light:

 Reading and writing
 Using computer
 Drafting
 Sewing
 Food preparation and cooking
 Eating
 Dressing
 Washing, shaving, and applying makeup
 Bathing and showering

 In addition, there are any number of special tasks that may arise in a particular home environment (music practice, for

11.9 A typical reflected ceiling plan shows the layout of ceiling tiles for the central areas, as well as the location of all lighting fixtures. Symbols indicate the different types of fixtures, which are identified by a number key. The plan is for a floor of the National Audubon Society Headquarters (see Case Study 4, pages 212–15), designed by the Croxton Collaborative. (Courtesy Croxton Collaborative Architects) **11.10** In this computer-generated perspective, the effects of both artificial and natural lighting have been simulated through the use of a software program known as Lightscape. (Courtesy Autodesk)

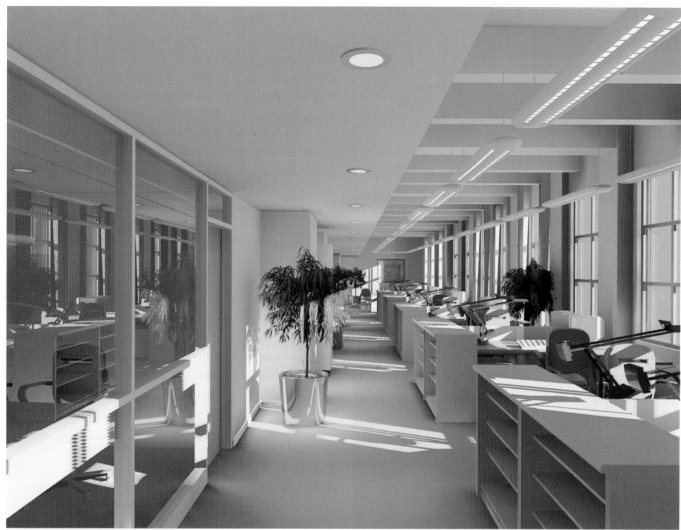

example), in workplaces such as offices, factories, and hospitals, or in such special-purpose interiors as theaters, museums, galleries, gymnasiums, or pools.

2. *General lighting*, which provides a comfortable level of light for finding one's way around a space, locating objects, and seeing people and objects. This general or background lighting, often called *ambient light*, should be strong enough to avoid excessive brightness contrast between it and bright task lighting.

3. *Special lighting*, which focuses attention on specific objects or areas and generates variety and contrast to make a space lively and interesting, even to add aesthetic impact. Attention is always drawn to brightly lit areas and objects, a phenomenon exploited in store and showroom display lighting. This is often called *accent lighting*, to describe the strong light concentrated on a painting, a display of objects, or simply on a wall.

LEVEL OF ILLUMINATION

Once the kinds of light needed in various locations have been identified, it is helpful to gain an idea of the desired light levels. Lighting measurements are based on a unit called a *candlepower*, the amount of light given by a standard candle of controlled size and composition. To avoid the seemingly inexact concept of a standard candle, a unit called the *candela* has been created for use in technical studies of lighting. A candela is defined as an international unit of luminous intensity equal to one-sixtieth of the luminous intensity of one square centimeter of a blackbody surface at the solidification temperature of platinum. For all practical purposes, one candela is equal to one candlepower. The level of light delivered to a surface one foot away from a standard candle is designated as one *footcandle* (fc). Light meters measure light levels in terms of this unit. A laboratory light meter gives very precise readings but is an expensive device. Many photographic exposure meters measure footcandles with sufficient accuracy for most practical purposes. (The meter known as the Sekonic Studio Deluxe Model L-398 is particularly suitable for use as a footcandle meter; it is an excellent exposure meter as well.)

Tables of recommended illumination levels for various purposes appear in lighting handbooks. For many years, recommendations have tended to move upward, but, in view of rising energy costs, reevaluation has led to lower light level recommendations, with the increasing understanding that other factors may be more important than the simple intensity of lighting.

Carrying a light meter to measure the footcandle level in familiar situations leads to the surprising conclusion that a very wide range of levels can be acceptable for many tasks. One can

Table 16. Recommended Light Levels

TASK	RECOMMENDED FOOTCANDLE LEVEL
Movie theater (during picture)	1 fc
Passages and storage areas	5 fc
Stairways, shipping areas, TV watching	10 fc
Cooking, washing, cleaning, playing games	10–20 fc
Intermittent reading or writing	20 fc
Reading fine type (for example, a newspaper)	25 fc
Word processing, bookkeeping	30 fc
Prolonged reading, study, computer operation, close work	50 fc
Drafting	50–100 fc
Sewing black thread on black material	500 fc
Performing surgery	2,000 fc

11.11 →

see reasonably well with as little as a footcandle level of 5, although somewhat more will help with demanding tasks (reading fine print or sewing on dark materials, for example). At the other extreme, full daylight can reach levels of 6,000 footcandles without causing discomfort. Light level recommendations should, therefore, be regarded as no more than a general guide or suggestion. (See Table 16, "Recommended Light Levels," above.)

11.11 This diagram illustrates the inverse square law: the light of one candle falls on one square foot at a distance of one foot, but from two feet away, the same pyramid of light falls on four square feet—providing one-quarter the intensity of light.

While light levels are usually selected to be provided throughout a space, the surface brightnesses at any particular location are more critical in determining the resultant conditions for satisfactory visual comfort. The overall light level in an office, for example, is not as significant as the light available at a task. Desktops typically call for more light than surrounding floor areas.

A *light source*, that is, a lamp of a certain wattage, has a light output measured in *lumens*. The lumen is the unit of light that will deliver a level of one footcandle to a surface one foot square at a distance of one foot. Illumination level varies with the distance from a light source, in accordance with the inverse square law familiar in many physics experiments. A light source that delivers 20 footcandles to a surface two feet away, when moved to a distance of one foot, will deliver not twice as much light, as might be expected, but four times as much, or 80 footcandles. When moved farther away, to four feet, illumination will fall to one-quarter the level, or 5 footcandles (fig. 11.11). In practice, the illumination level delivered by a particular source will also be influenced by its age and cleanness, by the design of the fixture used, and by the characteristics of the space where it is located. White or light-color surfaces nearby reflect and conserve light; dark surfaces or open space do not.

BRIGHTNESS CONTRAST

Another important lighting issue involves limitation of brightness contrast, mentioned above. When the eye adjusts to the general level of light in a given field of view, it can tolerate some areas brighter and some dimmer than the average, but extremes of contrast are uncomfortable; for comfort, therefore, the brightness of what is in view needs to be limited.

The brightness of any visible surface is influenced by the light that falls on it and by the percentage of that light that it reflects. Even in bright light, for example, a black or dark brown surface will appear dark, while white paper or paint will seem bright. The quality of surfaces that controls the appearance of brightness is called *reflectance*, which can be measured as a percentage. If 80 footcandles fall on a surface but only 60 footcandles are reflected back, the surface has a reflectance of 75 percent, or .75.

Footcandles refer to the level of light arriving on a surface; the light reflected back is measured in *footlamberts* (fL). The footlambert, named after physicist Johann Heinrich Lambert (1728–1777), is the unit of measurement of brightness. The brightness of the surface mentioned above would be 60 fL (fL = fc × percentage of reflectance or, for the example, 80 × .75 = 60).

To see comfortably, it is important that the brightness of surfaces within the field of vision be kept within certain limits. The following are suggested ratios:

- Between a visual task and its immediate surround, no more than 1:3
- Between a visual task and its more distant (general) surround, no more than 1:5
- Between a visual task and a remote dark surface, no more than 1:10

To reach these goals and keep brightness contrast to acceptable levels, surface reflectance in interiors should be limited to the following ranges:

Ceilings .70 to .90
Walls .40 to .60
Furniture (top surfaces) .25 to .45
Office equipment .25 to .45
Floors .20 to .40

Charts citing samples of typical surface finishes, with their reflectance values shown as percentages, are available. Some paint charts, for example, show this information for various paint colors. If the standards listed above are accepted, ceilings painted in dark colors and walls paneled in dark wood are ruled out. While this is probably reasonable in offices and other working environments, exceptions can be made for certain residential spaces and locations where visual comfort may be secondary to aesthetic considerations.

LIGHTING FOR THE AGING POPULATION

Visual acuity declines with advancing age, and vision problems become more common among members of older age groups. The recent increase in the average age of the general population, combined with the trend toward older people's remaining active both in the workforce and in their homes, calls for an awareness of adequate light levels to serve the needs of older people and of the visually impaired of any age.

With increasing age, the ability of the eye to adjust to varied levels of brightness slows, so that looking from dim to bright areas in quick succession, or from bright to dim, becomes difficult. This suggests that brightness contrast should be limited in locations where older users will normally be present. Avoidance of glare and veiling reflections, as discussed below, is of particular importance for this population.

Light levels in selected locations that can be adjusted on demand can deal with some of the needs of older and visually impaired persons in an economically and environmentally sound manner. One simple and obvious possibility is the provision of lighting devices that will accept lamps of varied wattages. A reading light normally lamped with a 60- or 75-watt bulb, for

Table 17. Fluorescent and Comparable Incandescent Energy Requirements

COMPACT FLUORESCENT	COMPARABLE INCANDESCENT
12 watt a type	40 watt
15 watt	50–60 watt
18 watt	75 watt
20 watt	75 watt
23 watt	85–95 watt
28 watt	100 watt
28 watt square	100 watt
30 watt circle	100–150 watt
12 / 18 / 29 watt 3-way	30 / 70 / 100 watt
55 watt double circle	250 watt
72 watt (32w + 40w)	200 watt

example, can be given increased output with substitution of a 100-watt bulb. Substitution of one of the newer compact bulb-shaped fluorescent lamps can provide increased output with no increase in wattage and related power consumption. (See Table 17, "Fluorescent and Comparable Incandescent Energy Requirements," above.) An even simpler approach is the increased use of lighting devices that can be moved within close proximity for specific visual tasks. An ordinary table lamp might be replaced by an adjustable lamp with a lamp head that can be pulled close for reading, writing, or sewing tasks. In many situations, it is appropriate to supply fixtures and switching that permit multiple tiers of light level—"normal" for general use and "high" for those with special needs.

While such arrangements may be difficult to provide in many public areas (such as stores, restaurants, and hotels), they are appropriate to workplaces and residential locations where visual tasks may be demanding and where the probability of older or sight-impaired users is high. Certain environments virtually guarantee a user population with a need for higher light levels, including hospitals and other medical establishments, retirement-community residences, and social-service facilities for the elderly. In these accommodations, light levels should be set higher than the "normal" recommended in standard references.

Elevated light levels should also be planned for areas with special safety problems, such as stairways and bathrooms, where use by older people is anticipated (fig. 11.12). Provision of extra lighting activated by automatic switches (*proximity switches* operated by sound or movement sensors) should also be considered. Manual switches for extra lighting should be located at a lower position appropriate for wheelchair users.

Special-Purpose Lighting

OFFICES

Because modern office buildings often allow little or no daylight to reach major interior areas, artificial lighting becomes the primary illumination source. In the past, it was considered satisfactory to simply provide overall lighting adequate to deliver a desired standard desktop level. Tests showing that increased levels of lighting tended to improve efficiency (speed of work and reduction of errors) gradually led in the 1950s and 1960s to the acceptance of very high levels for office lighting, generally supplied by ceiling-mounted fluorescent fixtures. In recent years it has been recognized that such standard office lighting is far from ideal.

High levels of uniform lighting, often delivered from fixtures of poor design, tend to create glare both from fixtures and from reflections on task materials at desktop level. Such lighting is also wasteful of energy and therefore costly because areas that have no need for high light levels (such as seating, circulation, and storage spaces) are receiving the same levels as actual work surfaces.

Recognition of such problems has led to the development of such alternative approaches as *task-ambient lighting*, in which higher levels of light are provided at desktop or "task" areas, while overall or "ambient" light is set at much lower levels (fig. 11.13). This lighting approach is now available in many office-furniture systems, with *task lighting* set close to work surfaces and *ambient lighting* supplied indirectly from fixtures aimed upward to reflect off the ceiling or from ceiling fixtures that provide only the lower levels of lighting needed for circulation and other nontask areas.

The effects of glare from ceiling lights can be eliminated by the use of fixtures incorporating lenses or parabolic reflectors that cut off light exiting the fixtures at certain angles, which would otherwise appear as bright spots in a ceiling. Suitable fixtures appear as dim or dark when viewed by workers seated at work surfaces. Glare can also come from task lights, especially in the troublesome form known as veiling reflections, where glossy materials—papers and even pencil lines on paper—reflect light sources in a way that "washes out" the material being viewed. When the angle of view toward task material is equal to the angle of incidence of the lighting in use, such veiling reflections

11.12 Lighting can play an important role in minimizing safety hazards. On this winding stairway, in addition to a sturdy handrail and a nonslip carpet to reduce possible hazards, lighting units are placed low to illuminate the wedge-shaped stair treads, known as winders. Stanley Tigerman was the architect of this residence in a northern suburb of Chicago. (Photograph: Howard N. Kaplan © HNK Architectural Photography) **11.13** Strong task lighting above work surfaces and a much lower level of ambient (general) light provide comfortable visual conditions at minimal energy cost. These New York University library study carrels are by Voorsanger & Mills Associates Architects. (Photograph: © 1983 Peter Aaron/ESTO) **11.14** When angle B (the angle of a sightline to a work surface) equals angle A (the angle from that surface to a light source), glare and veiling reflections will result at the task area, making seeing difficult. Control of this problem involves the proper placement of lighting fixtures or the shielding of light sources with suitable louvers or lenses—or both proper placement and shielding.

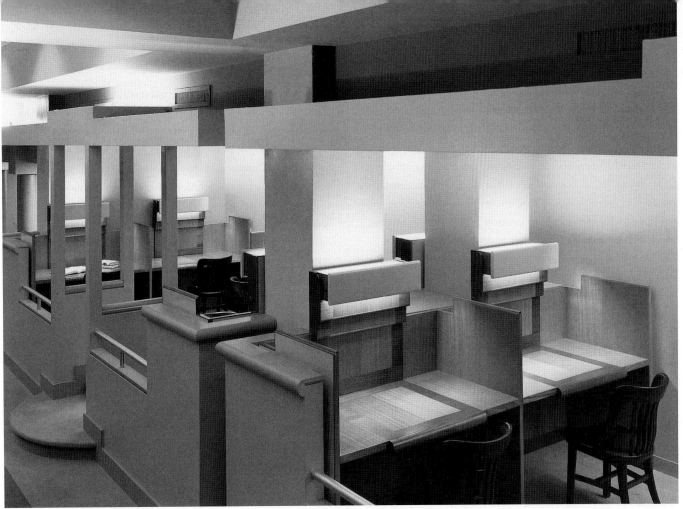

occur (fig. 11.14). Positioning of task-lighting sources at the sides of work surfaces or the use in fixtures of special lenses made up of tiny prisms that direct light sideways can reduce or eliminate reflected glare. Task lighting can also be locally switched so that lights remain off at workstations that are not occupied, resulting in energy savings.

The computerization of modern offices has made *video display terminals* (VDTs), comprising keyboard and screen, ubiquitous items of office equipment, often in continuous use throughout working hours. Visual comfort at computer workstations is extremely important in minimizing work stress and physical complaints among office workers, and proper lighting is a key factor in avoiding such problems. Lighting that creates glare on the glass of screens is a common problem that requires careful placement of fixtures and shielding the screen from glare. Light levels must be carefully set, or made adjustable, at individual workstations to ensure that the brightness of the screen and of related visual materials are balanced. The brightness level of nearby surroundings and of task materials close to a VDT screen should be no more than three times that of the screen itself.

Controls are now available to permit varying the intensity of light from ceiling-level fixtures with the aid of individual controls at workplace level. This makes it possible for an office worker to set the light level at the work surface to suit personal need as well as to adjust for the varied light from windows where they are an available light source. Task lighting incorporated in the workstation can also be provided with dimmer control. Other

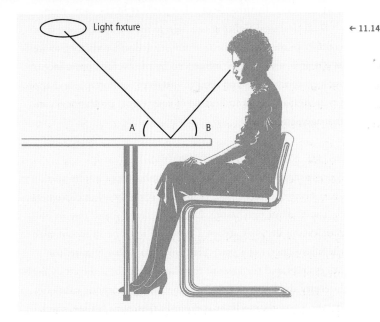

Light fixture

A () B

controls now in use include photo sensors that read light levels and adjust the intensity of light accordingly and proximity switching that turns off light at unused workstations or in empty offices as an aid in minimizing energy consumption. Equipment for these functions is discussed on pages 369–70.

Private offices and conference rooms require the same attention. In these spaces, as well as in general offices, some accent light is often desirable to relieve monotony by providing an alternative visual focus so that a brief look away from work materials offers visual relaxation and stimulus.

HEALTHCARE FACILITIES

Lighting in hospitals, clinics, and medical offices involves a complex variety of issues concerning the comfort and well-being of patients and visitors and the working needs of doctors, nurses, and staff. Waiting areas and circulation spaces require moderate light levels (30–50 footcandles), while medical-office consulting rooms, like other private offices, are best served by similar ambient light levels with increased desktop levels (60–100 footcandles). Examination and treatment rooms require higher levels (100 footcandles or more) with additional high-intensity lighting available for specific examination and treatment routines. Surgery requires very high light levels from specialized fixtures designed exclusively for operating rooms. Nurses' stations need 100 footcandles or more of illumination at work surfaces.

Patients' rooms, often illuminated in older facilities with drab general lighting at low levels, actually call for lighting adjustable to several differing intensities. A low level of lighting is suitable for nighttime, and a second, medium level (30–50 footcandles) is needed for daytime. In addition, a higher level should be available, from portable or otherwise movable light units, for examination and treatment. Reading lights are also needed for the use of patients in bed. In semiprivate rooms and wards, separate lighting controls should be placed at each patient's area to assure only minimal disturbance of other patients in the same room.

Well-designed lighting can help to reduce anxiety and discomfort in medical facilities. Families and other visitors, as well as patients, are strongly influenced by the overall appearance of such establishments and tend to interpret comfortable and appropriate lighting as an indication of competent, professional care management.

RETAIL STORES AND SHOWROOMS

Store managers understand that the ambience of a store and the appearance of merchandise on display strongly affect customers' decisions about purchasing. Lighting plays a major role in communicating the character of a store and must be in accord with the sales policies of a particular firm. Shops that feature low prices and rapid turnover of merchandise are best served by high-intensity light levels with little concern for aesthetic subtleties. Bright, even glaring light is typical of discount houses, supermarkets, and similar mass-merchandising facilities. A basic level of 100 footcandles is common, with special displays using levels as high as 500 footcandles supplied by directed spotlighting.

In stores offering increased customer assistance and an emphasis on better-quality merchandise rather than bargain prices, a moderate level of ambient light is appropriate (50–70 footcandles), with possibly lower levels for circulation spaces and higher levels for merchandise on display. Brightly lit accent displays combined with the lighting of perimeter walls and displays (100–300 footcandles) help to enliven the character of selling spaces and can focus attention on items featured seasonally or in special promotions.

Specialty shops stressing style and quality are best served by lower light levels, approaching those of residential lighting. The desired atmosphere may suggest a private club or fine hotel. General lighting of 20 to 40 footcandles is appropriate, with higher levels (up to 60 footcandles) on actual merchandise. Here, too, focal displays can use higher light levels (up to 100–200 footcandles).

In addition to these generalizations, one must consider the specific merchandise to be displayed in order to choose suitable light sources and fixtures. Uniform general lighting can wash out high-lights and make goods look soft, even dull. Point-source lighting tends to develop highlights and emphasize texture. Although some highlighting is desirable for almost any merchandise, it is especially favorable to products that glitter. Jewelry, photo equipment, and small appliances look best under high-contrast, concentrated lighting (fig. 11.15). Furniture and rugs are better served by softer lighting, although rugs and textiles (including the fabrics of clothing) look most attractive when a "wash" of higher-intensity light falls on surfaces from above or from the sides to emphasize texture. The lighting of automobile showrooms is a particular problem since the glint of highlights is an important factor in making the forms of car bodies appear handsome and exciting. Point sources, as well as other fixtures, must be placed so that they can be adjusted and directed to provide the gleaming effects that make new cars attractive.

The color of the illuminants selected also serves to make merchandise look its best. Fluorescent lighting, although economical, is unflattering to colors. The economical "daylight" fluorescents are often tolerated in bargain outlets where the bright glare of bare tubes is associated with the low prices implied by pipe racks and massed merchandise. While fluorescent lights with better color correction are serviceable in many merchandising situations, incandescent, halogen, and *high-intensity discharge* (HID) lighting (see page 351) are usually more flattering to merchandise in which color is a significant element. The attractiveness of displays in supermarkets and other food shops depends largely on the color quality of the lighting. Meat displays are notably sensitive to light-color characteristics. Because standard fluorescent light makes meat look gray and unappetizing, special warm-color lights are often installed over meat counters to bring out the pink and red tones associated with freshness. Outdoor daylight, of course, is the most flattering lighting for most of products, and an effort to simulate it in both color and direction is a sound decision in almost all merchandise display.

RESTAURANTS

Restaurant lighting parallels store lighting in many respects, with the character of the lighting playing an important role in communicating price level, quality, and speed of turnover. Restaurant selection is strongly influenced by appearance, and the level of customer satisfaction, although obviously affected primarily by the food and service, is also determined by visual impressions, among

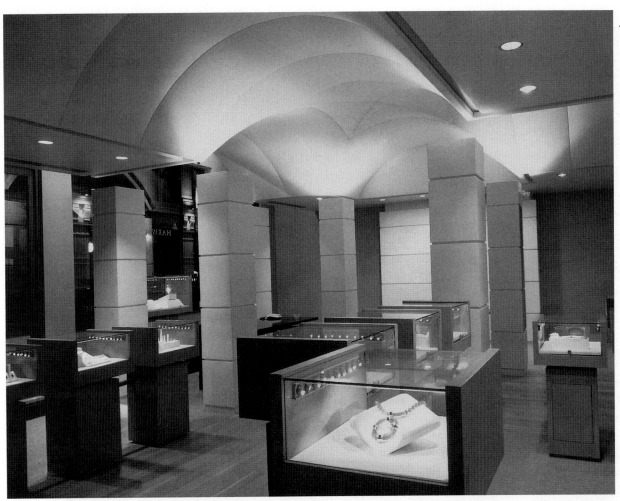

which lighting is of ultimate importance. Bright, uniform light suggests a briskly paced atmosphere usually associated with luncheonettes, diners, and fast-food chain outlets where speed and low prices take priority over quality and service.

In restaurants with table service, a midrange ambient light level (30–50 footcandles) makes circulation easy and is adequate for table illumination. Hotel dining rooms and mid-price-level restaurants are generally well served by such overall lighting. *Dimmers* make it possible to alter lighting levels as the season and time of day suggest. Fluorescent light, unflattering to both food and patrons, is best avoided in favor of incandescent and halogen sources.

More expensive restaurants featuring specialized cuisine and gourmet quality are most advantageously lit at lower levels to suggest an elegant or romantic atmosphere. Stronger light levels at tables will help to avoid an atmosphere so dim as to be inconvenient to diners. An ideal balance results when lighting can be directed onto the table (to aid menu reading as well as food consumption) while leaving the seated diners in dimmer light.

Unfortunately, this may be possible only for booths or *banquettes*, where fixed table positions are assured (fig. 11.16). Wall illumination can raise the ambient level of light while preserving a mood of restraint. Wall decoration is helpful in establishing restaurant character, and its illumination can also add accent and variety in an otherwise low-level light ambience. Candlelight is traditionally associated with romantic dining and can be effective in a space with dim ambient light; in actuality, however, it is often quite uncomfortable in terms of the diners' real need to see. Small lamps with appropriate shading are sometimes used as an alternative, although this approach presents problems in providing outlets and creates inconvenience in table setting and clearing.

Bars and backbar areas invite strong lighting directed onto the bar top and backbar displays, where the glitter of bottles and glassware generated by point-source lighting adds to a milieu of lively but intimate comfort. Auxiliary strong lighting should be provided in any dimly lit restaurant for cleaning and maintenance work done before or after serving hours.

11.15 Peter L. Gluck and Partners used a variety of lighting types in the New York City shop of Stuart Moore Jewelers. Concentrated light from tiny spots in cases, recessed ceiling lights, and indirect lighting spilling over the curving ceiling surfaces work together to create atmosphere and to focus attention on the displayed items. (Photograph: © Norman McGrath)

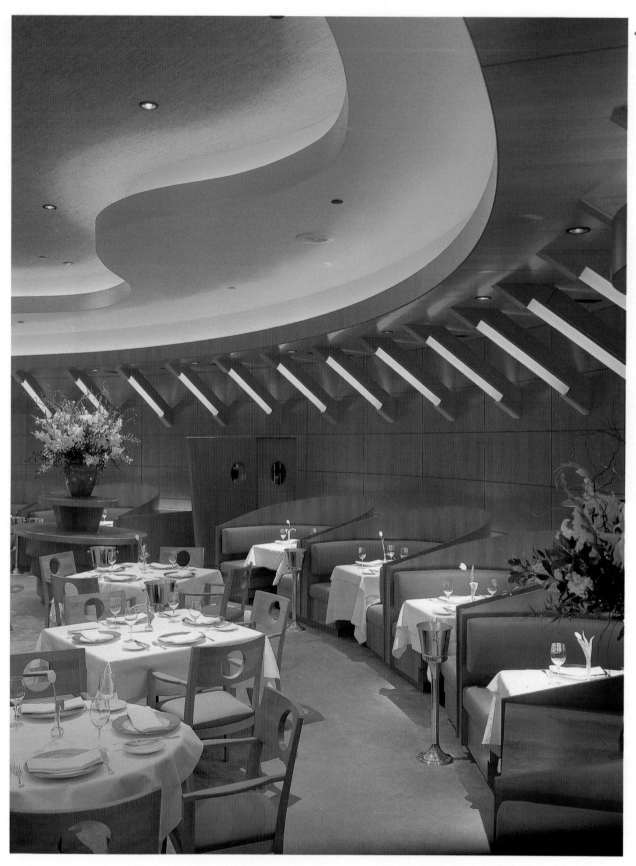

11.16 In the Opus Restaurant, Santa Monica, California, ambient light comes from coves wrapped around columns, while sharper accent lighting is provided by exposed tubes angled from walls to ceiling. The soft green of the upholstery serves as a contrast to the warm color of the pearwood walls. Grinstein Daniels were the architects of the project. (Photograph: Tim Street-Porter)

11.17 Incandescent (tungsten) and tungsten-halogen bulbs and tubes (both called *lamps* in the industry) are available in a variety of sizes and shapes. The standard industry system for designation of incandescent lamps uses a letter to indicate shape and a number to indicate size (diameter, in eighths of an inch).

A-19 A-23 B-10½ BT-37 C-7 DC-17 F-15 G-40 PAR-38 R-30 S-11 T-6 T-10 MR-16 T-4 Mini-Can T-4 D.C. Bay T-6 R.S.C. T-4 R.S.C.

Selection of Lighting

The selection of lighting devices involves several decisions, all of which entail choosing among a vast range of possibilities. The basic light source—called the *bulb* or *tube* by laypersons but known professionally as the *lamp,* the term that will be used here—may be any one of a number of types, including incandescent, fluorescent, and HID. It may be mounted in any one of a wide variety of fixtures, which may be located and spaced in many different ways. Controlling intensity, contrast, glare, and visual effect while juggling these variables in combination can become quite complex.

Selecting lighting devices begins with consideration of the type of light source, the lamp to be used. The most familiar sources are the incandescent bulb and the fluorescent tube, both in wide use and both available in a great variety of sizes, shapes, and types. In recent years, several other sources, less familiar to the general public but increasingly used in architectural lighting, have become available, in bulbs or tubes and in portable lamps. These sources include cold cathode, neon, fiber optics, and, particularly useful, the family of sources called HID. Each of the basic source types has its own set of advantages and disadvantages.

INCANDESCENT LIGHT

Incandescent, or *tungsten,* lamps, invented by Thomas Edison, are the oldest and most familiar of sources (fig. 11.17). Incandescent light is by nature a point or near-point source, which tends to cast sharp shadows and form bright highlights. These characteristics can be modified to offer some diffusion, by frosting the lamps, by using certain shapes such as the T or tubular form, or by employing various shades or fixtures. Like sunlight, candlelight, or oil-lamp light, incandescent light has a continuous spectrum that includes all colors of light to form a white. However, the white of incandescent light contains more red and yellow and less green and blue than daylight, making it much warmer. This warm color tends to be attractive, flattering to human coloring, and suggestive of coziness and comfort.

Incandescent lamps called *full spectrum* are also available. The light output color balance is adjusted to reduce the warm yellow emphasis of standard incandescents and increase the output in the green, blue, violet, and red range so as to match the color of daylight as closely as possible.

Incandescent light can be made to serve virtually all lighting needs, but it presents economic problems. It uses much of the electrical energy it consumes to produce heat as an unwanted byproduct of light. This makes it costly in terms of power consumption per lumen produced and can also create an extra load on summer air-conditioning. As a result, it is rarely used in factories, office buildings, and other structures that require large amounts of electricity. Smaller consumers need not be as concerned with economic factors, so incandescent light is popular for most home uses. It is also widely used in places that benefit from its point-source characteristic, as in store displays, where it is flattering to merchandise; in restaurants, where it renders both people and food maximally attractive; and in other locations where aesthetic considerations take precedence over economics.

Tungsten-halogen lamps are a special type of incandescent lamp that gives a higher light output than standard incandescents for a given wattage. They are made in several forms (bulbs, tubes, and mushroom-shaped reflector types) and are generally very compact in relation to their output. They operate at high temperatures and therefore usually use a quartz-glass (heat-resistant) envelope. Because of their high heat-output, their need for protective shielding to guard against possible injury in case of breakage, and the unusual size and shape of the lamp envelopes, halogen lamps are usually not interchangeable with standard types and require a specially designed fixture or lamp holder.

The typical tungsten-halogen lamp is a small quartz-glass tube in wattages from 50 to 5,000. The halogen gas that fills the tube retards the burning of the filament, so that high-temperature operation is possible with long lamp life. Reflector-type halogen lamps—parabolic aluminized reflector (PAR) lamps—use a halogen quartz tube within a reflector surround to project an intense, directed spotlight beam. They are widely used in display lighting because their small size and easy directional adjustability make them convenient for highlight illumination of merchandise. Low-voltage halogen lamps are very small reflector units in 20- to 75-watt sizes. They provide a highly concentrated and compact source of light with cooler color quality than other incandescent and halogen sources. A transformer is required to provide the low-voltage operating current. Halogen lighting generally shares the continuous-spectrum characteristics of incandescent light, with slightly cooler color that is closer to daylight than other incandescent types. Halogen light is flattering to foods, people, and most types of merchandise. Its somewhat better efficiency, compared with incandescent sources, places it between fluorescent and incandescent light in terms of cost versus quality of light.

FLUORESCENT LIGHT

Developed in the 1930s for general use, fluorescent lighting is a highly economical alternative to incandescent light. Its power

FLUORESCENT LAMP BULB SHAPES

PREHEAT RAPID-START

T-5 miniature bipin

T-8 medium bipin

T-8 medium bipin

T-12 medium bipin

T-17 mogul bipin

twin-tube double twin-tube

Circline 4 pin T-9

U-shaped T-12

U-shaped T-8

OCTRON U-shaped T-8

HIGH-OUTPUT

T-12 recessed double-contact

T-14½ recessed double-contact

SLIMLINE

T-6 single-pin

T-8 single-pin

T-12 single-pin

COMPACTS

20W triple

15W spiral

20W reflector

globe

square tube

consumption for a given light output, at about one-third to one-quarter that of incandescent lamps, soon pays off the higher cost of the lamps and their fixtures to produce major economies. This has made fluorescent lighting the norm for factories, offices, and classrooms, and for restaurants and stores that strive for lower operating costs (fig. 11.18).

The typical fluorescent lamp is a long tube and therefore gives off diffuse, shadowless light. While this promotes good general vision, it makes certain kinds of detail harder to see and tends to create a bland and monotonous lighting effect, rather like outdoor light on a cloudy day.

Fluorescent light has another troublesome characteristic, its color quality, which does not receive as much attention as it deserves. Part of the light from a fluorescent tube is full-spectrum light, that is, light with all colors present. However, this is true only of the portion of light output that comes from the glowing phosphors on the inside of the tube that fluoresce to give the source its name. The gases in the tube (mercury vapor, xenon, and others) emit light of a single, pure, one-frequency-number color. When viewed with a laboratory instrument called a spectroscope, this can be seen clearly as a dim rainbow band with superimposed brilliant lines of sharp color. While giving the illusion of normal white light, this spectrum does odd things to color perception, distorting the natural coloring of many objects. This makes fluorescent light aesthetically unpleasant—and possibly the source of various physiological discomforts. (See also the discussion of full-spectrum lighting, pages 354–55.)

This problem has been addressed by introducing fluorescent tubes in a great variety of white colors, such as *warm white* and *deluxe warm white,* some of which certainly improve color rendition. Unfortunately, when fixtures are relamped, there is no guarantee that the maintenance staff will use a particular color tube. Most often, they install the basic daylight tube, which is the cheapest, most widely available, and least desirable tube, generating the cold, blue-greenish "daylight" that makes people and objects take on an unattractive color cast.

To provide fluorescent light in forms readily interchangeable with conventional incandescent bulbs, manufacturers have introduced a variety of lamp types with compact shapes and integral transformers, or *ballasts,* so that the new units can be simply screwed into a regular lamp socket. These *compact fluorescent lamps (CFLs)* are available in types, including units with two or three U-tubes, three and four twin tubes, quad (four-tube) units, as well as circular and square shapes. There are also three-way U-tube units, interchangeable with regular three-way incandescents, and three-way circular and rectangular units, which also screw into a conventional socket but may not fit some lamps and fixtures because of their height. Spiral tube configurations are also available to fit into existing lamps and fixtures with limited clearance for other types. Compact fluorescents are also made in integral reflector form to replace regular incandescent reflector floods. Shapes similar to conventional A-shape, reflector, and globe bulbs can be found, too.

The major advantage of all of the compact fluorescents as incandescent alternatives is energy saving, with a reduction in power consumed of about 73 percent being typical. Long life in a range of 6,000 to 10,000 hours is also typical, leading to additional significant savings despite the generally higher cost of the lamps. (See Table 15, "Fluorescent and Comparable Incandescent Energy Requirements," page 343.)

In general, compact fluorescents, like conventional tube fluorescents, are not dimmable, although 15-, 18-, and 25-watt spirals are now found also in dimmable form. Among other versions are a straight tube mounted on a compact strip that includes the ballast (ideal for closet and undercabinet lights). Most of these lamps have an improved, warm-color output visually close to that of incandescent lighting despite the fact that they share the discontinuous-spectrum component of fluorescents. Newly developed fluorescents called Tri-color lamps—tri-phosphor coated tubing with a blend of three narrow-band phosphors (red, blue, and green)—offer an improved color balance and are available as four- and eight-foot tubes directly interchangeable with regular fluorescents and as compact fluorescents, discussed above.

Conventional fluorescent lights use special starters of several types. The familiar preheat starting requires pressing a special switch for a short interval before the cathode heats sufficiently to permit the lamp to light. *Instant start* (also called Slimline, after the tubes used in this circuit) requires no separate starter and lights at once, like incandescents. *Rapid start,* widely used in large office and commercial installations, requires no starter and lights after a very brief delay.

All fluorescent lights require an auxiliary device called a *ballast* to convert normal house current to the current required by the fluorescent lamp. Older ballasts (called *magnetic*) use a transformer to make this conversion. A humming sound and a possible effect of flicker (caused by 60-cycle current) and heat output are associated disadvantages. Newer fixtures make use of an electronic ballast that avoids these disadvantages to a large extent. Ballast failure leads to inconvenient and costly service. The heat generated by a fluorescent tube and associated ballast is directly proportional to the wattage consumed, so that, in view of the less-wattage-for-equal-light-output equation, fluorescent light is inherently economical. Still, in estimating lifetime cost, the first cost of fixture, tubes, and ballasts as well as the cost of relamping, cleaning, and repairing fixtures and ballast should be taken into account.

In spite of the problems associated with fluorescent lighting, its economic and related ecological advantages keep it in general use. Where it must be used for economic reasons, lamping with tubes of improved color characteristics, selecting good fixtures (which means avoiding the least expensive tube and fixture), and whenever possible, mixing its use with incandescent light or daylight will help to make fluorescent light a more satisfactory choice.

HIGH-INTENSITY DISCHARGE (HID) LIGHT

High-intensity discharge (HID) lighting combines some of the advantages of incandescent and fluorescent light. The lamps, of bulb shape, give point or near-point light; the economy of operation is excellent; and it offers lamp types with acceptable color characteristics—not, however, full- or continuous-spectrum light. First cost is high for both lamp and fixture, the latter of a special type, with a bulky and expensive transformer. HID lights have a slow starting characteristic, coming up to full light output only gradually over some minutes.

HID lamps have a long life (15,000–24,000 hours), and their poor color characteristics can be offset by pairing the mercury vapor and high-pressure sodium types, effectively balancing their respective cold and warm color characteristics.

Available HID lamps are of three types:

- *Mercury vapor* in 40- to 1,000-watt sizes, with 20–60 lumen-per-watt efficiency ratings but with cold color quality, somewhat improved in deluxe white and deluxe warm-white versions, albeit with some loss of efficiency.
- *High-pressure sodium* in 50- to 1,000-watt versions, with superior (50–125 lumen-per-watt) efficiency, but with an orange-yellow color quality.
- *Metal halide* in 15- to 1,500-watt lamps, with a 100 lumen-per-watt efficiency; these have the best HID color quality and, in smaller sizes, are suitable for a greater variety of interior uses.

HID lighting is now in extensive use in public spaces, as an ambient (general or background) light source in offices, where it is often installed in special upward-directed fixtures to provide indirect light reflected from the ceiling, and in portable lamps and uplight fixtures for home and other general uses.

FIBER-OPTIC LIGHT

Strands of glass or acrylic fiber can transmit light internally, much as water can flow through pipes. Bundles of such fibers can pipe light from a central light source, called an *illuminator,* to one or more remote locations, where the light emerges from the fibers. Most fiber-optic cables are made up of strands of acrylic fiber because glass fiber is less flexible and more fragile. The number of fibers in a cable can vary from as few as three to several hundred according to the intensity of emitted light wanted. The fiber-optic cables can be very small. At present, they can be made up of many strands bound together into a ⅟₁₆-inch to ¾-inch bundle or can be a thicker solid core of ⅛ -inch to ¾-inch diameter (fig. 11.19). In either case, the transmitting band is flexible—when thin, very

11.18 Fluorescent tubes (lamps) are made in a variety of shapes and sizes, including a number of types that can be directly interchanged with incandescent units. Most commonly used shapes are illustrated in this chart. **11.19** The diagram shows two arrangements for fiber-optic illumination. The light source is in the box at right, called the illuminator, which contains a metal halide lamp. Fiber-optic cables carry light from the illuminator to remote locations, small points of light in a ceiling (top) or ceiling-mounted downlights (bottom).

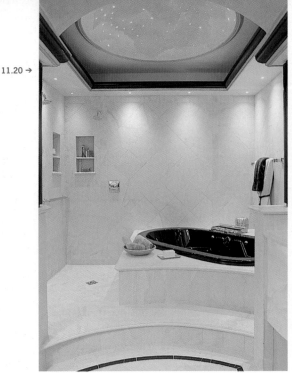

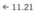

flexible—so that it can be fitted into confined spaces and bent at sharp angles. At the point of delivery, the cables can provide a tiny point of light, a larger outlet comparable to a conventional light fixture, or a linear ribbon of light. The illumination source can be placed where it will be convenient in an enclosure that must be accessible for relamping and ventilation to remove heat produced by the lamp. For thin-strand cable, the illumination source is usually a tungsten halogen lamp of 50 to 183 watts. In larger installations, a metal halide source is usually used with an intensity range from 68 to 400 watts. In either case, color filters can be added to control the color of the light, with the possibility of color change through remote control (see fig. 12.10). Dimmers can be added as well to vary light intensity. Along the fiber-optic cables there are none of the problems of insulation against shock or fire hazards associated with normal electrical wiring because the cables do not carry heat or electricity, just light.

There is always some loss of light as it is transmitted, so distance from the light source is usually limited to about fifty feet, although some installations accept lengths up to a hundred feet where a glowing ribbon is desired. In such long lengths light may be fed in from both ends of the lighted ribbon.

Fiber-optic lighting is most useful where the location of desired light makes relamping of conventional fixtures difficult, where space limitations make conventional bulbs or tubes impractical, where ventilation to extract heat is difficult to provide, and in outdoor locations where there are safety concerns regarding wetness. One illumination source can feed light to as many as twelve down-

lights, for example, or can illuminate many tiny spots of light, each fed by a different cable (fig. 11.20). Fiber-optic lighting is a particularly good alternative to neon (see below).

The cost of fiber-optic lighting is higher than that of conventional ways of providing light by a factor of 30 to 50 percent, so the technique is usually used where other lighting is impractical or where an effect is desired that would be otherwise difficult to obtain. Ceilings dotted with tiny starlike points of light, for example, stairways with individually illuminated steps, or displays and other decorative elements illuminated by slim ribbons of light or a "spray" of tiny lighted strands are uses where fiber optics can avoid the complications of placing and wiring many small bulbs (fig. 11.21; see also fig. 17.31). Continuing development is rapidly increasing the possibilities for fiber-optic use in new applications.

LIGHT-EMITTING DIODE (LED) LIGHT

Full-spectrum *light-emitting diode (LED)* lights have become familiar in use for small signal lights in many electronic devices, where their tiny size and bright red glow combined with extremely long life (up to 100,000 hours compared with 1,000 hours for the average incandescent) and low current consumption have made them useful. LEDs are in increasing use in larger applications, such as automobile stoplights and traffic signals, where they can replace incandescent lamps with greatly increased efficiency. Improved LEDs now available provide high intensities of green and blue light as well as the familiar red. Combining the output of red, green, and blue LEDs can produce a white

11.20 The remodeled bathroom of a 1930s Tudor estate, Orinda, California, is lit by fiber optics. The downlight of the perimeter soffit as well as the tiny points of light in the central dome are illuminated in this manner. Since fiber optics require no electric connections, there are no problems caused by the heat and moisture generated in a bathroom. The lighting designers were Brian Fogerty and Dana L'Archevesque of Axion Design, with fiber-optic consultant Don Liberman of Fiber Creations. (Photograph: David Duncan Livingston) **11.21** This corridor in a residential loft interior in New York's Greenwich Village is lit by the soft glow from fiber-optic strands running lengthwise overhead. Lighting consultant Jim Conti assisted Weisz & Yoes Architecture on this project. (Photograph: Paul Warchol)

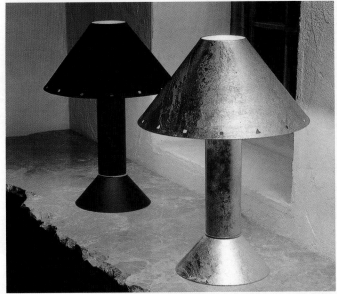

ing. Cloth, plastic, and paper shades call for regular cleaning and tend to have a shorter life. The making of lampshades can become something of a craft activity, generating many decorative designs, painted or otherwise, made to offer varied color and texture. Shades can be custom-made using almost any textile fabric to coordinate with other elements of room decoration. Lining is often used to limit the penetration of light outward or to increase the direction of light downward through reflectance or both. Shades of appropriate shape can also be used on hanging light units (such as those suspended over dining tables) to direct light downward and eliminate glare from bare bulbs.

Desk Lamps Desk lamps are a special category of portable lamps designed to give good light for desktop tasks. Older designs include the traditional student lamp (originally an oil lamp with a tank for its fuel) and the gooseneck lamp, which used a flexible conduit for both support and power supply to the bulb. Modern versions of these older types are useful and of good appearance. Highly functional desk or drafting table lamps use mechanical ways of providing adjustability. The family of designs usually given the name Luxo (after the first such example to appear, the L-1 architect's luminaire, developed in the mid-twentieth century by the Norwegian firm Luxo) uses an extensible pantograph arrangement to give a wide range of cantilever movement. The Tizio lamp, an ingenious arrangement of movable arms and counterweights, is a famous desk lamp designed by Italian designer Richard Sapper. It has inspired a number of similar, generally less successful variants (fig 11.34).

with an open top has the virtue of directing strong light downward for reading and other tasks while permitting an upward "spill" of light to contribute to general, ambient light. The shade itself can be solid or translucent to either totally hide or obscure the brightness of the bulb. Many lamps are designed to include a shade, but shades can also be purchased separately for placement on any lamp that has appropriate attachment hardware. Simple lampshades are often made with a clip that can be slipped onto any bare bulb of the right size. Shapes include cylindrical (drum shapes), reverse tapered, semispherical, oval, square, and rectangular. Metal shades, painted or metallic, are practical and long last-

11.28 Light fixture types in general use are shown here. Standing types are at left; wall-mounted fixtures are pictured above right; and ceiling-mounted fixtures appear below right. **11.29** This silicone table lamp, designed by Carlo Forcolini, uses 60-watt incandescent bulbs and is manufactured by Luceplan, Italy. **11.30** The Zink lamp, while decorative in its design, has sufficient light output to provide foreground illumination for a variety of tasks. The zinc-galvanized steel table lamp is a design of Ron Rezek Lighting & Furniture.

(Photograph courtesy Ron Rezek Lighting & Furniture)

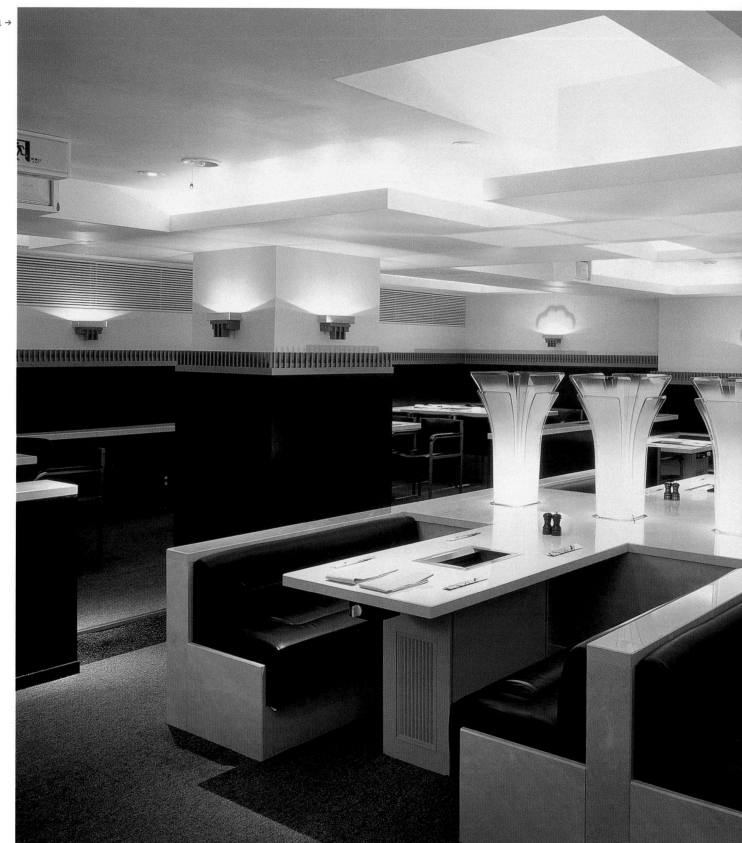

11.31 In Tokyo's Hanajuban Restaurant, sconces are used in combination with table uplights and ceiling-mounted lighting, creating a well-lit but soft effect. K. I. D. Associates Co., Ltd., designer, (Photograph: Yoshio Shiratori)

← 11.52

lights to give general illumination can be placed according to local needs. More complex projects use formulas to determine spacing and location.

CALCULATING NUMBER AND LOCATION

Where uniform lighting is required throughout a space (as in a general office or classroom), fixtures are usually regularly spaced. The required spacing of fixtures to assure a desired level of illumination is arrived at by using a calculation that takes into account a number of factors. With architectural lighting, the anticipated level of illumination, or brightness, can be calculated quite accurately. (See "Calculating the Illumination Level and the Number and Spacing of Light Fixtures," page 371.) This cannot easily be done with portable lighting, since lamps may be moved and wattages changed and since an even illumination level is not usually sought. In residential and other less formal spaces, experience (which can be aided by the use of a light meter) rather than calculation usually guides the placement of lighting.

SWITCHES

Any lighting installation will require switching to provide control from convenient locations. This can be provided by switches at individual fixtures, multiple switches for a single fixture, switching from remote locations or central panels, or, in special cases, multiple switching or switching controlled by clock or light sensors. Switching controlled by sound- or heat-sensitive proximity switches turns lighting on when people are present and off when people leave.

An infrared wireless control can dim lights without a wired connection so that ceiling lights can be controlled by the user of an office workplace to suit personal preference. All the lights in a room can be controlled at once with use of a similar control. Centralized control switching can control all the lighting in a house or other building from a central panel. Preset controls can switch lighting according to a prearranged schedule.

Light switches are normally provided at the entry to each room or space. A space that can be entered from two or more directions calls for multiple (upstairs-downstairs) switching. Convenience outlets along walls should be spaced so that an outlet is always available within 6 feet. Wall switches are routinely placed at a height of 50 inches, outlets at 12 inches from the floor. Although they are minor elements, switches, switch plates, and outlet plates should be selected by the interior designer to complement the design of the space, not left to the whim of the electrician, who merely installs what he or she has on hand, regardless of its design appropriateness.

DIMMERS

Dimmers, a further modification of switching, permit a range of light levels from very low up to the maximum available, and provide them in a smooth transition. When incandescent lights are dimmed, they become warmer in color. This effect of coziness is favored in residential spaces and in dining areas generally. Special dimmers are required to control fluorescent lights that are available in dimmable versions. Dimmers can also be used with electronic and magnetic low-voltage lights, such as the popular low-voltage track lights. As with simple switching, dimming control can be remote, centralized, and preprogrammed. Small dimmers are available for installation on an electric cord to control a single lamp. Automatic dimmers can alter light levels gradually, in response to time, outside light levels, or an arbitrary program.

PHOTO SENSORS

Photo sensors are electronic devices that control light fixture output in response to the level of light detected by the sensor. They can take over the adjustment of light levels ordinarily provided by the action of occupants of a space. Light adjustment is often neglected by occupants who tend to ignore light-level changes except in cases of excessive brightness (direct sun entering a window, for example) or extreme dimness (at day's end). Occupants

may also be absent leaving lighting fully on unnecessarily. Switching and dimming controlled by photo sensors has energy saving as its primary benefit, but it can also contribute to user satisfaction by its automatic establishment of suitable light levels (fig. 11.52).

Photo sensors can provide feedback control in which ambient light level is sensed and used to make adjustments to achieve desired levels of light. *Open-loop feedback control* does not sense the light level that it controls. It is typically used to sense external daylight levels and adjust interior lighting to suitable levels in response. This usually means adjusting artificial lighting with dimmer controls, but it can also be used to control mechanically operated window or skylight shades or blinds. *Closed-loop feedback control* senses the light level in a particular space or area and adjusts the lighting to desired levels accordingly. This type of control responds to any daylight present as well as to the artificial light under photo-sensor control. Moving window blinds up or down, for example, in accordance with occupant desire for privacy or to obscure an outside view will cause the artificial lighting to respond with appropriate adjustment. The primary benefit of such feedback control is energy saving, which results when artificial lighting output can be reduced when ample daylight is present.

Codes and Regulations

Various legal codes have some, usually limited, impact on lighting design. There are assorted rules in city building codes that require lighting for emergency situations, for signs and other indications of routes to fire exits, and for related passages and stairs. Such lighting may have to be connected to special circuits that are independent of general electrical service, supplied either by back-up battery or by generator circuits that will survive overall power failure.

Another set of requirements deals with minimum levels of lighting required for certain spaces, such as school classrooms, where a minimum level of light—50 or 60 footcandles at desktop—is mandated. Such lighting codes unfortunately take no note of lighting quality, and meeting the code at minimum cost often leads to the selection of poor-quality fixtures, which in turn leads to excessive brightness contrast (glaring ceiling fixtures) that results in unsatisfactory seeing conditions in spite of code compliance. Well-designed lighting will comply with such codes and will far exceed their demands in terms of lighting quality. Where codes establish a minimum to be met, it should be recognized that this is merely a floor below which no lighting installation should drop.

Some building codes, particularly in urban areas, now impose restrictions that are opposite in their impact. These are regulations intended to control excessive energy consumption. They establish limits on the electrical consumption that lighting may require in new or renovated construction. Such limits are expressed in terms of watts per square foot that are permissible for a given installation. A common limit is 3 watts per square foot, but some codes have moved to levels as low as 2 or 1.5 watts per square foot. Office lighting of some years back commonly exceeded these limits by a wide margin. Task lighting is an important tool in meeting such codes. When ambient lighting is kept low and higher levels are delivered only at actual workplaces with sources located close to work surfaces, overall energy consumption falls well within such code limits. Designers must be aware of whatever restrictions apply to the lighting design for a specific project. Compliance with regulations will generally not conflict with other design requirements and often results in superior lighting design.

Codes and regulations vary widely among different states and cities and are subject to frequent revision. Professional designers find it worth while to become familiar with current regulations applicable in their own communities. When working on a project in another area, it is usually best to consult with a designer or firm active in the location in question to arrange for filing and approval of plans, taking bids, and other aspects of a project, including whatever rules and restrictions apply to lighting.

ISO 9001 is a code of standards adopted by the International Organization of Standardization (IOS) that outlines standards for management systems that include lighting. The UL label that indicates compliance with standards and tests provided by the Underwriters Laboratories is a well-known indication of compliance with certain safety standards. The Canadian Standards Association (CSA) provides testing and certification of compliance with safety standards for devices intended for use in Canada. Building codes and fire safety codes impinge on lighting since electrical supply is the basic energy source on which lighting depends. In efforts to arrive at some uniformity among building codes, the Uniform Building Code, the Building Officials & Code Administrators International (BOCA) National Building Code, and the Standard Building Code each offer a model for local authorities to adopt. Standards set by the National Fire Protection Association (NFPA) also impact to a limited degree on lighting.

The complexity of lighting as a technical matter and the constantly increasing variety of lighting sources and devices may tempt the interior designer to turn over all lighting problems to a specialized consultant. Nevertheless, the consultant, however expert, is primarily a technical aid. It remains for the designer to suggest the character, atmosphere, and visual effects desired. The more knowledgeable the designer is about technical issues, the easier it will be to communicate with a consultant, and the greater the probability of a satisfactory result. For modest projects that cannot include the services of a consultant, the designer must accept full responsibility for planning lighting that will balance technical performance with pleasant visual impact.

Calculating the Illumination Level and the Number and Spacing of Light Fixtures

It is possible to calculate the level of illumination that a proposed installation of light fixtures of a known type and spacing will give. The same formulas can, in reverse, suggest the number and spacing of fixtures needed to produce a desired level of illumination. The relationship basic to all such calculations is:

$$\text{Illumination (in footcandles)} = \frac{\text{lumens supplied (lumens per watt} \times \text{wattage)}}{\text{area in square feet to be lighted}}$$

Here is the approximate lumen output of various lamp types:

TYPE OF LAMP	LUMENS PER WATT OUTPUT
Incandescent	20
Mercury	5
Fluorescent	80
HID	85

To arrive at, for example, 60 footcandles throughout an area of 6,000 square feet with fluorescent light:

$$60 \text{ footcandles} = \frac{80 \times \text{required wattage)}}{6,000 \text{ square feet}}$$

$$\text{or} \quad 60 = \frac{80 \times \text{wattage}}{6,000}$$

giving

$$4,500 = \text{wattage required}$$

The wattage could be provided, for example, by 112 40-watt tubes installed in 28 four-tube fixtures placed at regular intervals to provide even coverage of illumination in the space. This calculation is oversimplified, however, because it takes no account of the design of the fixture used, its state of cleanness as time passes, nor of the characteristics of the space, such as its shape and paint color tones, that will affect the lighting to be installed. These factors are taken into account through two steps:

1. The arbitrary lumen-per-watt figure given above is replaced by a figure given in the manufacturer's specifications for the particular fixture selected for use.
2. This figure is multiplied by a *coefficient of utilization* (CU), also obtained from the manufacturer's literature, which takes into account the size and shape of the space and the reflective values of wall and ceiling surfaces. This CU can be further modified by factors to take into account the lamp depreciation (the average dimming of the lamp over its useful life) and a factor for dirt depreciation to allow for dimming caused by dirt buildup.

The restated formula becomes:

$$\text{Footcandles delivered} = \frac{\text{lumen output} \times \text{CU} \times \text{lamp depreciation} \times \text{dirt depreciation}}{\text{area in square feet}}$$

This formula can be used to determine the illumination level that a proposed layout of a given fixture will provide or the number of fixtures of given wattage that will be required to deliver a desired light level.

For example, suppose that a level of 75 footcandles is desired in a space having an area of 8,000 square feet. The fixture chosen uses four 40-watt fluorescent tubes with a lumen output of 3,200 per lamp (tube). The manufacturer's literature gives the following data:

CU for the space in question	.56
Lamp depreciation	.80
Dirt depreciation	.75

The formula can now be used to find the area that one fixture will light satisfactorily:

$$75 = \frac{(3,200 \times 4) \times .56 \times .80 \times .75}{\text{area in square feet}}$$

This gives an area of 57.34 square feet covered by each fixture. The total area would then require:

$$\frac{8000}{57.34} = \begin{array}{l}139.52 \text{ or, rounding off,} \\ 140 \text{ fixtures}\end{array}$$

These might be arranged in ten rows of 14 fixtures, five rows of 28 fixtures, or a different layout suited to the shape of the space. Calculation of this sort is most useful in planning the overall lighting of offices, factories, classrooms, or similar uniformly lighted spaces. Simpler calculation of the same kind can predict the illumination level to be expected from a single lamp or light fixture.

case study 7. A Duplex City Apartment

MAYA LIN STUDIO WITH DAVID HOTSON,
ASSOCIATED ARCHITECT,
ARCHITECTURE AND INTERIOR DESIGN
RENEE COOLEY, LIGHTING CONSULTANT

This duplex apartment in New York City for a couple with children is entered at an intermediate level, with stairs leading downward to a main living area and upward to bedrooms. The simple, almost Minimalist, interiors are enlivened by creative, unusual, and carefully planned lighting.

From the apartment entrance at the intermediate stair landing, backlit translucent panels of sandblasted glass are visible ahead, forming a link between the two floor levels (fig. 11.53). It is surprising to find that these panels are actually walls of the bathrooms on both levels.

On the lower level, the main living area receives limited daylight from a rear courtyard skylight. To compensate, artificial light comes from wall-washers that light one wall, while the fireplace opposite is lit by six downlights carefully spotted in a random pattern to avoid any suggestion of a regular grid (figs. 11.54, 11.55).

In the kitchen-dining area, light comes from overcounter lights concealed in the bottom of the cabinets above. A small television imbedded in an overcounter cabinet provides visual interest (fig. 11.56). Wall-washers and randomly located downlights illuminate the dining area (fig. 11.57).

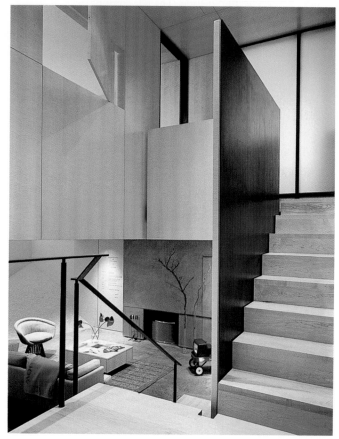

← 11.53

11.53 In this view from the intermediate-level entrance landing, the stair upward faces a backlit sandblasted glass wall of illumination. Down the stairs on the left the living room with its fireplace wall is visible. The pivoted panel above opens on the master bedroom. (Photograph: Michael Moran) **11.54** In the living area, wall-washers light the wall and paintings. The sofa looks toward the fireplace, out of sight on the left with one of the random placed downlights visible above. Beyond the illuminated glass wall can be seen on the left while the opening to the kitchen area is farther ahead. A glimpse of the dining area can be had on the right both above and below the stair landing. (Photograph: Michael Moran) **11.55** A CAD-drafted reflected ceiling plan shows the skylight over the court (top left) and locates the ceiling light fixtures of the lower level. The kitchen-dining area is at the bottom of the plan. (Courtesy David Hotson, architect)

11.54 →

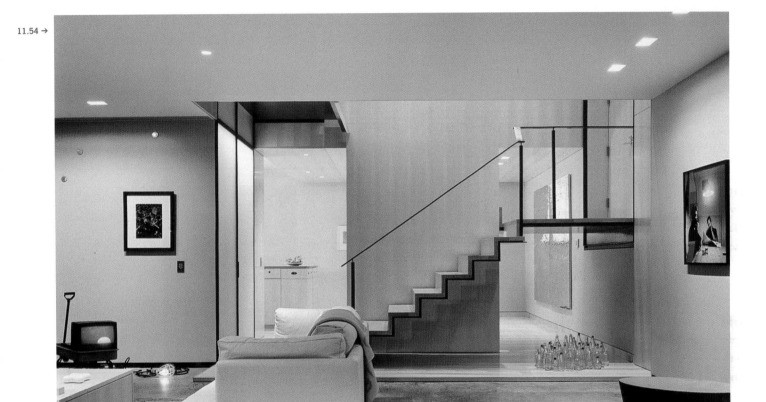

← 11.55

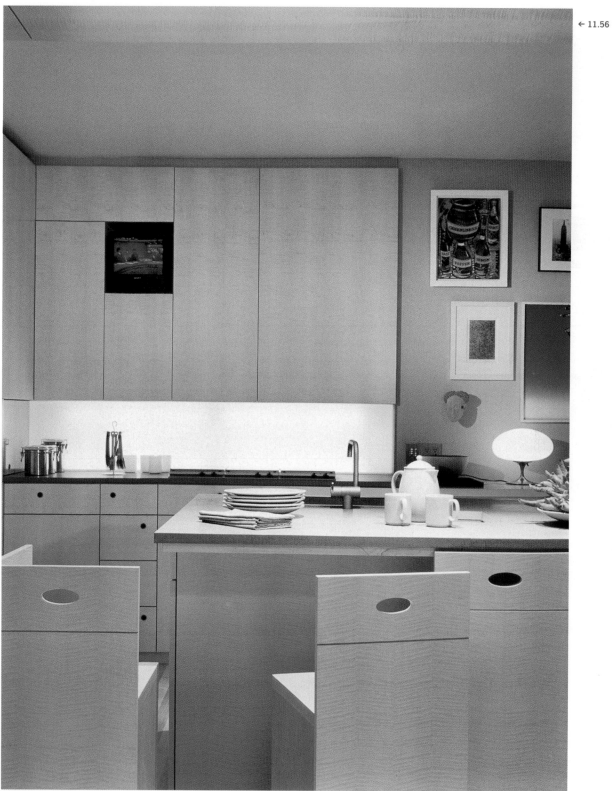

← 11.56

11.56 In the kitchen portion of the kitchen-dining space light comes from the bottom of the overcounter cabinets. Note the small television screen affixed above. The island counter unit in the foreground holds several chairs that fit snugly to become invisible when not in use but can pull out as shown when needed. (Photograph: Michael Moran) **11.57** When looking from the dining area past the stair and landing and through to the living area beyond, the illuminated glass wall is on the right. The skylight is barely visible beyond the living area. (Photograph: Paul Warchol)

11.57 →

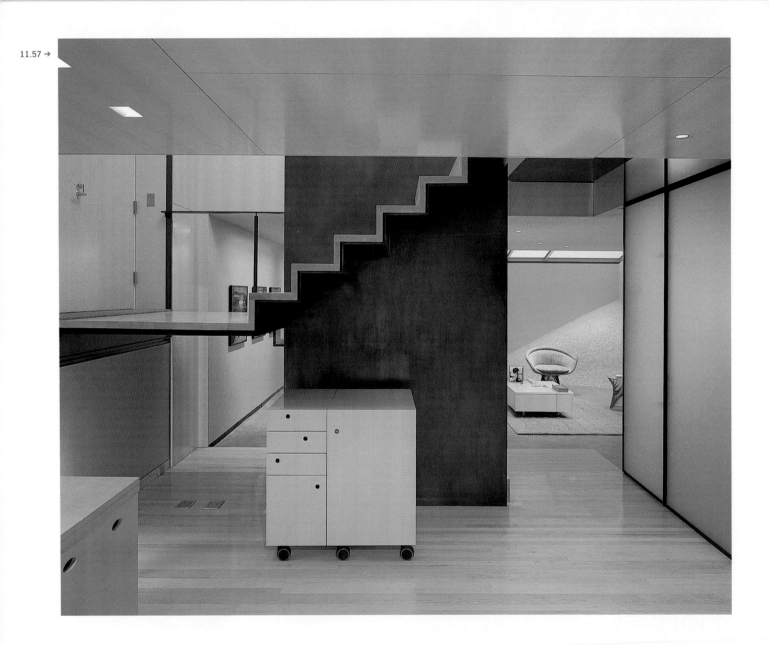

← 12.1

chapter twelve. Textiles

Among the many materials that contribute to the design of a complete interior, textile fabrics have a particularly important role. They introduce a sense of softness, curvature, and flexibility into a space, making a hard- or bare-looking room seem soft, comfortable, and humane. With their vast range of colors, textures, and qualities, they offer unlimited design possibilities.

Fabrics most often appear in interiors as upholstery cover materials for chairs, sofas, and cushions; as bed and table covers; and in window treatment, usually called by the traditional term *drapery*. Fabrics also appear as *woven floor coverings*, which refers to carpets and rugs (floor coverings are discussed on pages 277–84). Lesser uses include curtains in locations other than windows (at door openings, for example) and as wall-covering material, among others. (See Table 19, "Textiles in General Use in Interiors," pages 379–81.")

In comparison with the basic construction materials (brick, concrete, stone, wood, and plaster) that are likely to line a raw space, textiles are less durable. While this may appear to be a disadvantage, it turns out to be a major reason for textiles' significance to the interior. Since, like paint, they require periodic renewal and are easy to change, they regularly provide an opportunity to do over a space with new color and texture. Indeed, the phrase "to redecorate" implies new paint and new fabrics as the primary means of renewal.

It is probably because of this sense of textiles' impermanence that designers feel free to be somewhat adventurous in their choice of fabric colors, textures, and patterns. This, in turn, has encouraged designers and manufacturers of textiles to offer a tremendous variety. Fabric design has a close relationship to the world of fashion and shares its constant search for newness and change. Some fabrics, especially prints and other patterned materials, enjoy a brief popularity and then disappear because they come to look dated and out of style. Textile lines reflect changing tastes in terms of color and weave as well. On the other hand, certain basic fabrics will always be available, and any color can be produced on special order, even if color lines change. Fabric selections should always be made after a fresh review of what is currently available. It may be because of their inherent decorative possibilities that textiles have generally been selected almost entirely on the basis of their aesthetic qualities.

As interior design has become increasingly responsible and professional, realization has developed that textiles play structural and functional roles no less important than those of any other materials. Designers are now aware of a large number of characteristics of textiles that impact their selection. Intended structural use of textiles can include these obvious categories:

- Drapery (window treatment or other)
- Upholstery covering
- Wall covering
- Floor covering
- Panel surfaces
- Bedding
- Toweling, bath, and washing services

12.1 The textile in the foreground is recycled polyester. Horizontal and vertical warp-faced lines converge to suggest concentric squares, transparent mazes loosely aligned in rows. The middle-ground textile is also recycled polyester. It features a range of yarn sizes, types, and colors, including a heavy bouclé. The background textile is 60% worsted wool and 40% viscose. A custom-dyed striped warp is used to paint the fabric with a complex arrangement of seven sophisticated colors. The repetition of certain colors in alternating and varying stripes creates an even larger scaled tonal rhythm. All the textiles are heavy-duty and were designed by Rachel Doriss and the Pollack Studio, USA.

Among the functional performance characteristics of fabrics in any of the above uses are the following:

- Green issues
- Useful life
- Maintenance requirements
- Color stability (resistance to fading)
- Shrinkage resistance
- Resistance to moth damage
- Fire resistance
- First cost
- Useful lifetime cost

Many of these concerns are now the subjects of systematic testing and rating standards that can aid designers in making sound selections.

Selecting Textiles

The selection of textiles often ranks with the choice of furniture, hard floor coverings, and paint colors as a key element in the designer's contribution to a design project. Textile selection may seem deceptively simple—a matter of casually choosing some attractive colors and textures—but the subject is actually complex and merits more careful attention. For this reason, textiles occupy a full chapter in this book, while other materials are dealt with in the context of their use or in Chapter 9, "Materials and Their Uses."

GREEN ISSUES

Textiles have a generally minor to moderate impact on green issues. Natural fibers produced from plants, such as cotton and linen, have constantly renewable sources, as do many materials with animal origins, such as wool, horsehair and goats' hair, leathers, and silk. Only the products obtained from endangered animal species—furs and certain skins, such as leopard and zebra, and the now-outlawed ivory from elephant tusks—threaten the natural world through possible extinction of wild animal populations. Synthetic fibers are not major consumers of irreplaceable resources and make modest energy demands for production and eventual disposal. Recycling of materials from textile and nontextile sources is coming into increasing use.

Although some fibers and chemical finishes can have an impact on indoor air quality, the role of textiles is generally minor in this regard. However, adhesives used with textiles for wall or panel covering and particularly adhesives used for carpet installation can present serious problems of off-gassing that merit special attention. Textiles used as window treatments, if chosen with green issues in mind, can have a favorable impact on energy requirements through their ability to provide some degree of insulation from heat and cold.

COLOR

It is most practical to make fabric selections while the color scheme is being developed. This can be approached in two ways. One way is to select approximate colors for the fabric, using colored papers or any other color medium to represent the desired fabric color, while leaving the selection of the actual material to a later time (when visiting various showrooms, for example). However, this creates an extra step when the process can be dealt with all at once. (It is also often difficult to locate a close match for a sample in a particular kind of fabric.) The other approach—making a final fabric selection when developing a color scheme—saves the extra step but presents other difficulties. It requires having on hand a library of samples large enough to include almost anything that might be desired. Large design firms usually maintain extensive files of samples from the manufacturers they favor, but the individual designer will probably have a much more limited selection on hand.

Dealing with this problem requires building up a sample file large enough to contain at least a few examples of almost anything that may be needed. This involves visiting the showrooms of textile manufacturers in major cities to collect samples. A list of the best-known sources for decorator fabrics can be compiled from advertisements in design magazines. Many furniture manufacturers are also textile distributors, providing fabrics not only for their own products but for general use as well, often offering drapery in addition to upholstery fabrics. Some will provide complete sample swatch sets on request or at a small charge.

The designer can usually tell quickly from a showroom visit if it is a source of strong interest. After making a selection of fabrics according to color and other qualities, the designer may request sample swatches, which can be put on file for reference when a scheme is being planned (figs. 12.2, 12.3; see also fig. 12.19). Swatches, usually small (three or four inches square), are attached to a card identifying the manufacturer and pattern number and giving other data such as width, fiber content, and price. While small samples give a poor indication of the appearance of large-scale patterns and prints, and may even misrepresent basic colors and textures, the swatch remains a primary selection tool because of its convenience, availability, and low cost. Manufacturers will loan out samples of a square yard, called a *memo square*, of prints and larger patterns. If the scale of the project or the fabric's intended use warrants it, memo squares can be purchased.

Since color is usually the starting point in selection, most designers file samples by color, although they can also be filed under such categories as manufacturer, fiber, or appropriate use. Drapery and upholstery textiles are often filed along with other upholstery cover materials (such as leathers and simulated leathers) and sometimes with other decorative materials, such as plastic wall coverings, window shade and blind materials, and wallpapers. (Because of their greater bulk, carpets and rugs are usually filed separately.) It is often convenient to file favorite fabrics in duplicate so that a file record will remain when a sample is

← 12.4

made from that particular fiber. The list of natural fibers in traditional use is fairly short, but modern invention has added many fibers, while the possibilities of combining fibers have become almost limitless. The most widely used fibers can be grouped into a few categories: natural fibers, artificial fibers made from natural and synthetic polymers, mineral fibers, and fiber blends. (See Table 21, "Fibers," opposite.)

YARN

Yarn is the term for the long, continuous strands or threads made from fiber to prepare it for construction into fabric by such common techniques as weaving or knitting. The yarns themselves can be of various constructions (fig. 12.4); those most frequently encountered include the following:

Monofilaments A single strand of material, all of the same substance, is a monofilament. The most familiar monofilament yarns are those extruded from a plastic (like the much-used fishing lines) and those made by slitting flat plastic sheet. Horsehair can be considered a natural monofilament yarn.

Multifilaments Several monofilament yarns twisted or piled together make a single multifilament yarn. Multifilaments may be used alone or may be spun with other synthetic or natural fibers.

Spun Yarns Using a traditional technique, a continuous strand is made from short natural fibers such as cotton and wool. Hand spinning is the ancient way of making such yarns. Spinning machines that took over this function were among the first important inventions of the Industrial Revolution. Synthetic multifilaments cut into short lengths have been blended with natural fibers in an attempt to combine the best qualities of both fiber types.

Twisted Yarns Spun yarn may be twisted, which increases the strength of the yarn. The tightness of the twist influences the fabric's texture and appearance.

Plied Yarns Several yarn strands wound together increase thickness and strength and produce varied textures and appearance. Multiple strands may be plied together. Using strands of more than one color creates special visual effects.

Slub Yarns Irregular in diameter, slub yarn may be produced either by spinning yarns that have not been combed or by

mechanically introducing deliberate irregularities. It gives the fabric a special texture.

Stretch Yarns Yarns that stretch return to their original length after stretching. They may be constructed with the fiber wrapped around a stretchable core (of latex or similar material) or may be the result of new processes in which synthetic fibers are crimped, giving them a springy, coil form. Fabrics made from stretch yarns, used widely in apparel, are useful in certain upholstery applications.

CONSTRUCTION

Construction refers to the way in which fiber is made into a cloth or textile. The most familiar constructions use yarn as a basic element, but constructions that do not require fiber in yarn form also exist. A list of the most-used fabric constructions follows.

Felt Fibers, usually wool, that have not been made into yarn can be worked together through pressure, heat, chemical reaction, or other means to produce a homogeneous sheet of tangled-together fiber strands called *batting*. Some synthetic fibers can be felted with the aid of an adhesive.

Films Synthetic materials such as the plastics polyester and polyvinyl chloride (PVC) can be made into a continuous sheet, familiar in such uses as shower curtains. Films may be laminated over woven fabric to produce plastic sheeting that can be cut and sewn with ease. Plastic wall-covering materials and imitation leathers are often of this construction.

Woven Fabrics The dominant type of textile is a woven fabric. These come in a variety of constructions (fig. 12.5, 12.6). Most are of the sort called *two-element weaves*, constructed with the familiar technique of the over-and-under interlacing of a lengthwise *warp* and the horizontal *weft*, or *filling*. The strands are normally at right angles, with construction taking place on the weaver's equipment, a loom. The loom holds the warp strands in place and provides a way of lifting some (often alternate) warp strands to open a *shed*, or space, through which the weft strands

12.4 From upper left, the following yarn constructions are pictured: monofilament, one-ply, and two-ply; from upper right: three-ply and, below that, multiple (or cable) ply.

← 12.5

A B C

D E F G

can be passed, one strand at a time. In hand weaving, the weaver passes the weft strands through the shed, while power looms do this mechanically. Variations in the arrangement of over-and-under strands and in yarn texture and color make possible a vast variety of patterns in woven fabrics (figs. 12.7–12.9).

Weaves may be of two, three, or four elements, each element being a particular kind of yarn. *Two-element weaves* are the most common, the warp and weft each forming one element. In *three-element weaves*, an additional yarn element is added to either the warp or weft. *Four-element weaves* may be constructed with three warps and one weft, but most are double cloths made up of two warps and two wefts. Within each of these weave types, the pattern of over-and-under interlacing of the elements can vary. The name of a cloth refers both to the number of elements and the pattern of weave. Weave patterns are described as *plain, twill*, or *satin*.

Plain weave is the simple and familiar over-and-under interlace (fig. 12.10). A one-to-one (warp thread to weft thread) interlace produces *gingham, taffeta, monk's cloth*, and *muslin*. A two-and-two interlace (or *basket weave*) is characteristic of *canvas* and *duck*, while *sailcloth* employs a one-to-two relationship. All of these are two-element weaves.

Adding a third element produces *brocades* and the *pile weaves*, which include the cut piles—*plush, velour*, and *velvet*—and the uncut piles—*terry (terry cloth)* and *velveteen*. In pile weaves, the third element projects above the plane of the basic weave, forming loops. These are the uncut piles. When the loops are cut, leaving individual standing strands of yarn, the typically velvety

← 12.6

fuzzy surface of the cut piles results. *Corduroy* is also a three-element plain weave. Four-element construction in double plain weave produces *double cloths*, which are, in effect, two separate cloths woven at the same time and held together by strands that intermittently cross from one surface to the other. The two faces may have different patterns and colors. *Matelassé* combines single and double cloths with doubled areas stuffed to produce a quilted appearance.

Twill weave is produced by passing weft strands over one or more and under one or more warp strands in a shifting sequence to produce an appearance of diagonal pattern. Two-element twills include *cheviot, denim, drill, gabardine, herringbone*, and *houndstooth check (hound's-tooth)*. Three-element twill brocades and velvets and four-element double twill can be produced.

12.5 The following weaves are illustrated: plain (A), twill (B), satin (C), leno (D), and pile (E). The last two show weft-knit (F) and warp-knit (G) constructions. **12.6** A complex fabric woven in Ireland, Academia by Jack Lenor Larsen is suitable for both upholstery and drapery.

The recessed squares are of platinum-colored-metallic yarn with a surround of natural-color *worsted* in a double-twill weave. The fabric can be coordinated with a related design in a *Wilton carpet*. (Photograph courtesy Jack Lenor Larsen, Inc.) **12.7** The contributions of Vienna

Secessionist Josef Hoffmann (see page 105) to the Wiener Werkstätte craft shops retain a surprisingly contemporary look. Designed in 1908 but once again in production is his Zickzack fabric, among others, of viscose, or rayon, and cotton weave. (Photograph courtesy Bachausen,

Vienna) **12.8** The fine, open casement-weave fabric lends itself well to use as curtains or draperies. This one is made from Egyptian cotton, goat hair, and a gold *guimpe*. (Photograph courtesy Jack Lenor Larsen, Inc.) **12.9** This wall covering of polyolefin, a synthetic textile,

Satin weave describes a construction in which the warp is carried over four, five, or six weft strands and under one in a staggered pattern that avoids the diagonal patterning of twills. *Satin, sateen,* and *damask* are cloths of satin weave.

Diagonal weave is a rarely used construction in which the weft threads are at an angle (such as 45 degrees) to the warp instead of the usual 90-degree right angle. Interesting angular patterns result.

The term *Jacquard weaving* refers to a mechanical method of controlling a power loom in order to produce woven pattern by means of cards with holes punched in them that control the interlace of strands. Brocades, damasks, velvets, *tapestry weaves,* and matelassés are often Jacquard-woven.

Other Constructions Another fabric construction in current use is *knitting,* which is not a weave using warp and weft but a kind of knotting technique in which a single strand is looped or threaded together, in the way hobby knitters make scarves, sweaters, and laces, but now usually produced on complex modern knitting machines. Knits may be of either single- or two-element construction.

Malimo is a modern fabric construction in which many weft strands are laid across the warp and anchored down by a stitch of a third yarn element mechanically knitted into place. *Leno,* or *marquisette,* is a variation on plain weave in which pairs of warp threads cross between strands of weft to discourage the individual strands from slipping. The technique is often used to create open, casement, or drapery fabrics of good strength.

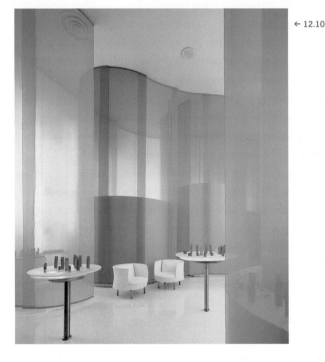

FINISHING

The term *finishing* refers to the various processes that follow basic fabric construction to prepare the textile for use. Many finishing processes, such as boiling, carbonizing with acid, shearing, *calendering* (pressing between rollers), and *fulling* (a controlled shrinking), are parts of production that need not concern the designer. *Glazing* polishes a cloth surface, familiar in the glazed cottons such as *chintz.* Various finishing processes promise soil-repellency, mothproofing,

has been made into a plasticized sheet for excellent stain resistance and easy maintenance. The weaves illustrated are, from top to bottom: plain weave, two plain basket weaves, a twill, and a herringbone twill. The product is called Tek-Wall. (Photograph courtesy Maharam Fabrics)

12.10 Organza is a lightweight, translucent, plain-weave fabric usually reserved for window treatments. In the Qiora Store and Spa on Madison Avenue, New York, however, architects Adam Yarinsky and Stephen Cassell of Architecture Research Office, aided by

curtain consultant Mary Bright, used organza's sensual qualities to define space. A unique suspended system of curvilinear organza panels creates a continuity of space that invites the customer to enter and explore. Freestanding spa cabins are concealed

behind the organza drapes and lined with Ultrasuede. Display fixtures with fiber-optic uplights that cycle through shades of white and blue give a softness and flow to the merchandise. (Photograph: David Joseph, courtesy Architecture Research Office/www.aro.net)

and resistance to wrinkling. Widely advertised treatments with trademark names such as Scotchgard and Zepel aid in resisting soiling, while other treatments tend to repel water. In recent years, various finishing processes have been developed to aid fire resistance through a chemical treatment that discourages the spread of flames. Antistatic treatments that reduce the buildup of electrical charge that occurs with some synthetic fabrics have also been developed. The availability of such finishing processes is generally clearly recorded and explained in manufacturers' specifications and advertising. Backcoating of upholstery fabrics with acrylic latex reduces seam slippage and generally improves abrasion-resistance and dimensional stability. (See Table 22, "Textile Finishes.")

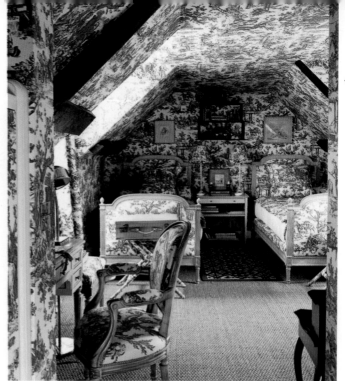

← 12.11

COLOR

Dyeing Dyeing is a primary means of introducing color in fabric, which otherwise has generally neutral gray or grayish tones. (In the trade, *greige goods* refers to undyed or unfinished fabrics or both.) Piece dyeing of woven textiles is a finishing process that produces a solid color. Dyeing yarns before weaving them permits color variation and pattern when variously colored yarn strands are woven together. Traditionally, dyes were made from various natural sources, most of which produce soft colors or colors that tend to be pleasant and harmonious even when more intense. Modern chemically manufactured dyes produce a much wider range of colors and color brightness but tend to be harsher and more garish. Since natural (undyed) yarns and natural dyestuffs rarely produce objectionable effects, they contribute greatly to the excellence of so many traditional woven materials.

Dyed materials are subject to fading from the effects of sun and other light and to fading and running in washing and cleaning. The *fastness*, or lasting quality, of dye color is a significant characteristic that needs to be tested or checked when making fabric selections. Some fading, running, and deterioration through wear is inevitable. These effects are least noticeable when colors are soft rather than bright, patterns are subtle rather than harsh, and textures are rough or coarse rather than smooth. Medium tones are less likely to show fading and wear than very light or very dark shades. However, if a fragile textile subject to rapid wear or fading also has a unique appearance, its use may be justified.

Printing Printing onto a fabric is another widely used way to add color and pattern to textiles. Traditional techniques include *resist printing*, in which a wax or starch applied to the fabric blocks coloring when the cloth is dipped in dye. Afterward, the resist

material is washed out. It may be reapplied and the cloth dipped again, and so on, to create complex patterns with several colors. This is the technique of *batik*, a well-known craft process. *Block printing*, in which individual woodblocks are coated with color and applied to the cloth, was once an important fabric-printing method in Europe. Its dependence on skilled handwork and the development of modern mechanized printing methods have rendered it generally obsolete in the industrialized world.

Roller printing involves mechanization similar to that of modern printing on paper. Rollers with the pattern for the fabric design embossed onto it are made, one for each color. As the cloth is passed under each roller in turn, the roller prints its color in the proper pattern onto it. The design will repeat on a dimension equal to the circumference of the roller. Fine detail and shading similar to that of imagery printed on paper are possible with roller printing. Although a modern mechanical technique, this method is also passing out of use in favor of screen printing.

In *screen printing*, as in silk-screen printing on paper, a screen of finely woven fabric is used for each color. The screen has blocked-out areas where the color is not to appear. Color is squeezed through the unblocked portions of the screen onto the fabric being printed. Printing may be done by hand, with fabric placed on a flat table; mechanically, onto flat fabric; or with a rotary technique, in which the screens are in roller form, the fabric rolling past printing cylinders for each color required. This is a fast and economical technique for quantity production.

Print design has developed in relation to changing historic

12.11 The use of matching textiles for window treatments, upholstery, and other elements is a popular device for developing a sense of unity among diverse elements. This mansard-roofed guestroom of a William and Mary-style manor house near Newbury, England, uses a blue-and-white cotton toile print called La Villageoíse by Braquenié to that purpose. Sally Metcalfe of George Spencer Designs, Ltd., London, was the design consultant. (Photograph: François Halard. Originally appeared in *House & Garden*.)

Table 22. Textile Finishes

Antibacterial, Antiseptic, or Bacteriostatic Chemical treatment to inhibit the growth of mold, mildew, other fungi, and rot.	**Moth-repellent** Chemical process to resist moth damage.
	Preshrunk Treated to limit shrinkage when wetted.
Antistatic Chemical treatment to reduce static electricity or conduction. Trademark names include Microfresh, Biofrest, and Slygard, among others.	**Sanforized** A particular preshrinking process limiting shrinkage to 1 percent or less.
	Scotchgard The trademark name for a chemical process to make textiles resistant to stains.
Fireproofing Fiber or chemical treatment providing noninflammability.	**Soil-release finish** Chemical process making textiles resistant to soiling.
Fire-retardant Chemical treatment to resist ignition and retard flame spread.	**Soil-repellent** Chemical process that coats fibers to make soil removal easier.
Flame-resistant Chemical treatment to resist ignition.	
Glazing Surface-coating treatment to give high-gloss surface (often used for chintz or *cretonne*).	**Teflon** The trademark name for a chemical process to aid resistance to soil and staining.
Mercerization Chemical process used only on cotton to improve strength, luster, and receptiveness to dyes.	**Zelan** The trademark name for a process to make cotton and rayon water-repellent.
Mildew-resistant Chemical process to resist development of mildew, mold, and fungus growth.	**Zepel** The trademark name for a process to increase the stain resistance of textiles.

styles. Today, many traditional designs are still available, in their original or adapted forms (figs. 12.11–12.13). Floral prints and prints incorporating many kinds of imagery abound. Modern print design includes more geometric and abstract patterns, along with new versions of more representational imagery.

A single design can be varied by altering the colors chosen, by adding or omitting certain color elements, and by changing scale through enlargement or reduction. A print design, usually limited in area, is extended to cover an unlimited yardage through *repeats* of the same design. These are generally planned so that the *match line*, where one repeat ends and the next begins, is unnoticeable. Print designs have come under copyright protection in order to cut down on the *piracy*, or imitation, of designs by manufacturers unwilling to pay the expenses and take the risks of commissioning new designs.

SPECIAL CHARACTERISTICS

Various specialized forms of textiles also deserve note. These include *embroidery* and *needlework*, familiar as handwork techniques but now most often mechanically produced, and *quilting*, also best known as a craft technique for layering together several fabrics, possibly with a filling between layers (figs. 12.14, 12.15).

Mechanical techniques for quilting are in current use. *Tufted fabrics* are made on a cloth base with tufts of fiber needled through the base and anchored on the back with a coating.

In *coated fabrics*, a surface material is spread over a woven base, as in *oilcloth*. Coating is now used to make plastic upholstery materials, which often simulate leather or some other material. These offer good durability at low cost. Coated fabrics have also come into wide use as wall-covering materials more durable than paint or paper and available in a range of textures, in imitation of materials like grass cloth, wood, or even metals, or of original design and texture.

Textiles can be called on to provide special functions relating to energy conservation. Many window treatments reduce heat transfer inward (solar heat) or, in winter, outward from a heated interior. Some fabrics have been developed to achieve exceptional results in this service. For example, a fabric called *solar cloth*, designed by Jack Lenor Larsen, uses a heat-set warp-knit polyester that is coated with aluminum powder to achieve a 60 percent reduction in heat transfer in either direction. The honeycomb cellular construction that traps dead air between layers of fabric is another means of using fabric for reduction of heat transfer at windows (see discussion, page 275).

12.12 *Toiles*, cotton with patterns printed from copperplates, first appeared in 1752. Prints from a mill at Jouy, France, near Versailles, came to be known as *toiles de Jouy*. This example, using designs inspired by a pattern book of Robert Sayers of about 1772, is a modern version printed on linen. The material, produced by Schumacher, is called Toile Orientale. (Photograph courtesy Schumacher) **12.13** This is a handsome printed chintz, a traditional fabric still in wide use, particularly for draperies, curtains, and upholstery. (Photograph courtesy Brunschwig & Fils) **12.14** Textiles dominate the space in relation to the spectacular seventeenth-century Flemish tapestry in this drawing room of a Georgian house in Old Chelsea, London. The pillows are covered in nineteenth-century needlework. Interior designer Alidad was responsible for the imaginative treatment. (Photograph: Jacques Dirand/The Interior Archive. Originally appeared in *House & Garden*)

Identifying Textiles

Several alternatives to textiles may be considered in situations where textile fabrics are most often selected. These include leather and suede and various synthetic sheet materials that are similar to leather. (See "Genuine and Simulated Leather," page 392.)

The vast variety of materials and manufacturing techniques used in making textiles and the complex terminology used in describing fabrics can seem intimidating and confusing. By checking manufacturers' suggestions and directly assessing such qualities as texture, weight (density), and feel (or *hand*, as this quality is called in the textile trades), the designer can find a range of fabrics appropriate to the intended use. These choices can be further narrowed down by balancing the fabric's aesthetic qualities of appearance, such as color, pattern, and texture, against its practical qualities, such as durability, strength, and colorfastness, and against its price.

While a detailed knowledge of fibers and weaves is not essential to interior design, the designer who wishes to become an intelligent specifier will learn as much as possible about textile technology. It can be an interesting exercise (which can become a

useful habit) to take small cuttings of fabrics and pull out the woven strands to identify the fibers and yarns and determine the weave or other construction used. To make a systematic study, the cutting can be attached to an index card and full information entered on the card. For example:

Fiber(s)	• Warp
	• Weft
Yarn(s)	• Type
Construction	• Number of elements
	• Type of weave or other construction
Finish	• Dye (yarn or piece and type)
Print	• Manufacturer or supplier
Width	
Price per yard	
Other data	

The tags that manufacturers attach to samples give some of this information (the name and number of the fabric, width, fibers, finish, and, sometimes, price); further information must come from inspecting the fabric and questioning knowledgeable salespeople who represent the manufacturer.

12.15 Handmade quilts such as this are among the finest products of American vernacular craft. Scraps of fabric are cut, assembled, and quilted, following one of a myriad of time-honored patterns; the result is both unique and traditional. The quilt here covers a four-poster bed of circa 1850 in a 1949 cottage, Castroville, Texas. (Photograph: © 1985 Michael Skott)

Genuine and Simulated Leather

Leather has had a long tradition as a favored material for upholstery covering (fig. 12.16; see also fig. 13.13). Its rich appearance and good resistance to soiling and damage make it a popular choice in spite of its high cost. Suede, a form of leather with a soft surface, is less used in upholstery because it is subject to having the color rub off. Both leather and suede are sometimes used as wall-covering materials, while leather is also a possible desktop and tabletop surface material. Leather and suede are available dyed in a wide variety of colors. Although it wears well, leather eventually cracks, tears, and crumbles after years of service, particularly if it is not cared for with regular application of dressings.

Leather, since it is an actual animal skin, is not available in yardage of standard width. Instead, it is sold in the form of *hides,* each an actual animal hide (from horses, cattle, or deer) having an area of about 25 square feet or slightly less. Leather from smaller animals (lambs, calves, and goats) is only available in smaller units called *skins,* with an average size of about 9 square feet.

Use of leather requires recognition of the dimensional limits of hides or skins and design measures to deal with the stitching required to create larger dimensions. Upholstered furniture specifications usually give, along with yardage requirements for a particular piece, a figure indicating number of hides required for leather covering.

The high cost of leather and suede has encouraged the development of a number of simulated leather materials, sometimes called *leatherette.* Vinyl, PVC, and polyurethane sheet materials are available with smooth surfaces (similar to *patent leather*) and with various leatherlike textures embossed into their surfaces. Strength and practicality in upholstery use makes it necessary for such materials to be bonded to a textile fabric backing to ease cutting and sewing. Suede is simulated by a process of flocking in which short fibers (called *flock*) are adhered to the surface of the plastic sheet material. The lower cost of these simulated materials and their availability in continuous sheets of standard width has made imitation leather and suede widely popular, although they never fully match the qualities of the genuine materials.

FABRIC TESTING

Although the evaluation of textiles by visual inspection and feel is an adequate guide for aesthetic judgments and offers some hints as to durability, the careful designer may also want to obtain data from testing of a more systematic sort. Durability, susceptibility to fading in sunlight, and resistance to ignition when exposed to flame are among those characteristics of textiles that can be evaluated through standard tests.

12.16 ↑

Standardized tests are provided by several organizations, including the American Society for Testing and Materials (ASTM), the American National Standards Institute (ANSI), and, for fire safety, the National Fire Protection Association (NFPA). The results of tests conducted by these organizations are available in their regular report, but, as a practical matter, it is the results of tests on a particular fabric under consideration for use that are most useful. Many manufacturers, particularly those concentrating on contract markets, provide test results routinely or on request, aiding designers who are making selections and preparing specifications. The Association for Contract Textiles (ACT) has developed a set of standards relating to flammability, color-fastness to *crocking* (the transfer of color from one fabric to another through surface rubbing), color-fastness to light, physical properties, and abrasion resistance, each with a symbol for use on a textile sample to indicate compliance with the related standard.

Durability There are several methods for testing durability. A *Wyzenbeek testing machine* rubs a fabric sample in two directions with a cloth- or wire-mesh-covered roller. Fifteen thousand cycles of rubbing without breakdown is considered an adequate level of abrasion resistance. A *Taber test* applies the action of two abrasive wheels rotating in two directions. The number of revolutions before the yarns begin to break is the sample's test rating. A rather crude test for floor coverings involves temporarily mounting an untested sample along with a sample of a material of known durability in a high-traffic area so that both will be walked on equally. By observing the samples at regular intervals over a period of weeks or months, the performance of the unproven material can be compared with the control sample. Similar *use testing* can be devised for upholstery fabrics by placing samples on seating units that will be subjected to heavy wear. While continuing a test to breakdown will take an excessive period of time, comparative observation after a period of weeks or months will give a reasonable indication of expected durability.

Fading Fading is tested with a device called a Fade-Ometer. A sample is exposed to ultraviolet light at controlled levels of humidity and examined for fading after successive periods of twenty hours.

"Materials and Their Uses," but they are touched on in this chapter as well, where they are matters specific to furniture.

Preliminary Furniture Decisions

In a typical design project, planning takes place before furniture selection is considered. One plans with function in mind and indicates furniture in a generalized way, using average sizes and forms to designate desk, table, chair, sofa, bed, and so on. Templates with such average size forms cut out at various scales help the beginning designer with this task. Most experienced designers become adept at drawing the plan forms of familiar furniture pieces at the commonly used scales without help from templates or scales.

BUILT-IN VERSUS MOVABLE FURNITURE

Some furniture types that impose constraints at the planning stage must be considered beforehand. This is the time to make decisions about built-in versus movable furniture. Built-ins tend to be neat and efficient, to save space, and to contribute to a modern look (fig. 13.2). In addition, they may be the most economical way to provide certain functions, such as the storage of books or quantities of other objects. In rented spaces or where long-term occupancy is uncertain for other reasons, movable furniture has, of course, the advantage of being readily transportable to a new location. It also permits easy rearrangement as needs change, or simply to satisfy the desire for change for its own sake. Certain functions, those of dining chairs, for example, require mobility (although fixed booth seating and banquettes are not uncommon in restaurants).

SYSTEMS FURNITURE

The use of what has come to be called *systems furniture* should also be considered in advance of planning. The systems developed largely for office use consist of elements linked together in clusters. Some of the elements provide spatial subdivision in addition to their primary functions. Each available system has its own dimensional characteristics and may influence plan layout by favoring certain arrangements or making others impractical or impossible.

REUSING FURNITURE

Whether or not to reuse existing furniture is another decision to be made before planning begins. This decision may be based on reasons of economy or on a client's desire to retain well-liked or treasured pieces. In residential design, it is probably more common to reuse at least some existing furniture than to start out with everything new. The designer typically inventories and measures existing furniture, noting which pieces *must* be reused and which might be considered for reuse as design develops. New furniture specifically chosen falls into a similar category. A desired seating group or a new grand piano must be planned for as if they already were on hand.

← 13.3

Layout and Planning

Arranging furniture in plan is a vital part of interior-design work. (For a detailed discussion, see Chapter 6, "Planning.") When this can best be done depends on a number of variables. Usually, basic architectural planning comes before furniture layout. When a project is to occupy existing space, where wall locations as well as room sizes and shapes are predetermined, furniture planning will usually be the first design activity. This is typical of residential projects where a house or apartment already exists and no major architectural changes are contemplated. When the space to be planned is not predetermined, either because architectural planning has not been completed or because the space is an open area without partitions (as on the floors of modern office buildings), some furniture planning can precede final layout of the partitions that will define rooms. In fact, there are situations where furniture planning must come before any other step.

An auditorium, a lecture room, or a classroom, for example, can be planned in detail only when an appropriate area has been established. A decision about the number of seats and their layout is a first requirement. The layout of auditorium seats in suitable rows with aisles establishes the general shape and size of the room. In restaurant design, the number and size of tables and chairs and their spacing are key factors in the economic planning that will determine the possibilities for profitable operation. In other projects, the layout of certain spaces may be strongly influenced by furniture layout. The size and shape of a file room, of library stacks, or of stock storage areas are developed by the layout of the required furniture. Hospital rooms and even residential bedrooms must take into account the number and size of the beds to be accommodated. A hotel or motel is planned on the basis of typical room plans, which are, essentially, proposed furniture layouts. Such furniture-first planning does not demand firm decisions on the particular furniture designs to be used—the given dimensions and shapes of the furniture serve as the basis for their layout, with room shapes and wall locations following in turn.

The reverse situation, in which partition locations have set room sizes and shapes, may be more common. It is certainly typical of many projects where the designer must work with a plan that cannot be changed or that will permit only minor revisions, as for an existing house, apartment, yacht, or suite of offices (fig. 13.3). In such projects, furniture layout must adjust to given circumstances.

Many designers choose to make plan layouts on the basis of square-foot areas assigned to various functions, into which

13.3 Despite functional demands and limited space, the galley of the yacht *Mary P* includes a large island, plenty of deep cabinets, and a dining area that seats six. Refrigerator drawers pull out from under the counters. A walk-in freezer is at right. Judy Bell-Davis was the designer of this interior. (Photograph: Neil Rabinowitz)

furniture is fit. This approach works best where spaces are not packed with furniture, as in a museum or gallery or in a gymnasium or other sports facility, where furniture is incidental.

Whatever the situation, the designer needs to have in mind the standard sizes and shapes of the furniture types to be used and estimates (or even exact counts) of the numbers of each type to be accommodated. In a large office, for example, it is usual to begin with a listing of personnel (simply by numbers, in groups by function, or even by individual name identity) and then to add to the listing the furniture requirements for each workstation or each group of similar workstations. Workstations are often classified in types designated as A, B, C, and so on, according to size and furniture required. A determination that a certain number—say, 20—of "type B" workstations are called for, each with one desk, three chairs, a credenza, and a file cabinet, makes it possible to establish a typical layout for such a workstation and then to group and place the workstations as work patterns may require. The detailed design of workplace furniture in its range from conventional office desks to sophisticated systems is discussed in more detail on page 415.

In a restaurant, the number of tables for two or for four or more and the number of booths, tables, or banquettes can be converted to typical layouts for each type as a basis for general planning. In every case, the grouping of furniture clusters must allow for adequate circulation space. Decisions to crowd furniture closely with minimum circulation space or to provide generous spacing will influence the final character of the interior. Ample circulation space and open spacing tend to be convenient and to suggest luxury; close spacing leads to intimacy and, in some situations, to a sense of excitement that may be desirable.

Although some furniture groupings are obvious and inevitable—dining tables and chairs, desks and chairs, or beds and bedside units—other groupings need to be planned with careful thought. The placement of furniture in a living room has a strong impact on how the room will be used—where conversation will be comfortable, how people will form into one or several groups, where quiet reading, listening to music, or watching TV will be most comfortable. A floor plan with furniture roughed in can be evaluated by imagining how life will be in the completed space. How will people move about? Where will they sit? Will the situation be convenient and comfortable, and will it be pleasant visually? Are the objects chosen satisfactory in ergonomic terms? Do they present any safety problems? Do they take account of the environmental factors stemming from their use of materials and the ways in which those materials affect indoor air quality? These are issues that call for special attention on the part of the designer since they are often given little thought by clients and end users. Designer and client can each study furniture plans and try to visualize the reality that they suggest. Only when such layouts seem fully satisfactory is it appropriate to move on to the selection of specific furniture.

Selecting Furniture

With a basic plan of the interior space completed, furniture selection can begin. Another decision—which may apply to an entire project or be taken on a piece-by-piece basis—then confronts the designer. Should any furniture for the project be custom-designed and -built, or should it be purchased ready-made from shops, showrooms, catalogs, galleries, and dealers? The pros and cons of these two approaches deserve some discussion.

SPECIALLY DESIGNED FURNITURE

Furniture that is specially designed can be tailored to suit the precise needs and desires of users and can give an interior a unique visual quality (fig. 13.4). However, it involves some element of risk; if the finished product turns out to be unsatisfactory in some way, it may be difficult and expensive to change or replace.

In general, special furniture is likely to be more expensive than standard, available products, not only more expensive to produce but also more expensive in terms of design time. Designing a piece of furniture is a major project that cannot be dealt with in a few minutes or hours. Built-in furniture, almost by definition, is specially designed. Simple shelving presents no problem to the designer, carpenter, or cabinetmaker. Other cabinetry, such as dressing-room fittings, a room divider, or special kitchen or bathroom cabinets, can range from fairly simple to extremely complex and costly.

The process usually begins with simple sketches, moves to drafted elevations and cross sections, and ends with construction drawings for the shop or cabinetmaker that will build the piece or pieces. Scale models are helpful to the design process; even full-size mock-ups are often made before going ahead with a special design. Designing seating is very demanding; chairs in particular have gained a reputation as being difficult to design. The challenge they pose may explain why the design of a special chair has come to be regarded as the signature of a master designer. The designing of a chair proceeds as described above, except that a full-size mock-up or prototype that can actually be sat in is almost essential in order to test for comfort, strength, and stability.

Many fine historic interiors are largely furnished with specially designed elements. An Adam brothers room, an Art Nouveau interior, a Frank Lloyd Wright house can hardly be separated from the special furniture that they contain (see figs. 4.35, 4.54, and 4.60). Many designs now in production originated as specials for a specific project. Most of these date from times when fine craft labor was cheaper and more available and budgets more generous than today. The modern tendency is to avoid special furniture design except for simple built-ins or an occasional single piece when no acceptable stock alternative is available. Economic pressures and a client's desire to see a sample before

making a decision are probably equal factors in limiting the development of special designs.

Specially designed furniture also includes handcrafted furniture by artisans and furniture by artists (see fig. 13.63).

READY-MADE FURNITURE

Ready-mades can include fine antiques, simpler old furniture, modern furniture that has become *collectible*, and any other furniture that is already a valued possession for reuse. However, most selections will be made from furniture in regular production. It can be inspected in a shop, store, or showroom. Manufacturers' catalogs illustrate available pieces and give fairly complete data on dimensions, construction, and available finishes and often include suggestions about planning and layout as well. *Production furniture* comes in a wide range of quality and price levels and in a vast variety of styles.

Using a reputable manufacturer and dealer offers some assurance of quality and of repairs, service, and replacements over a period of time. The possibility of both viewing and trying out an actual sample in a shop or showroom before making a purchase can safeguard against unhappy surprises, giving both designer and client or user security about a decision that can involve large expenditures.

In exchange for these advantages, one gives up having furniture exactly fitted to specific needs and accepts the closest available standard solution. One must also accept seeing the same designs in other places, in some cases to the point of boredom with what may be a current cliché. Manufacturers do their best to minimize monotony by offering a maximum variety of designs, optional details, and finishes.

MODULAR, KNOCKDOWN, AND ECONOMY FURNITURE

While any furniture not built into a fixed location is movable, some furniture is designed to permit change by assembling parts in various configurations. Such *modular furniture* is made up of standard units that can be put together in numerous ways. Modular seating, for example, offers individual seats, arms, and often corner and end-table units that can be combined to create sofas or more complex seating groups, including corner and serpentine clusters. Modularity makes it possible to reconfigure groups as needs change or to suit a move to a new location. Modular storage offers similar possibilities for composing a specific arrangement to suit unique needs without turning to custom construction, with the potential for rearrangement as a bonus.

Much office furniture is modular; desktops, drawer pedestals, and accessory elements are available separately to be assembled into workstations that can be modified as needs change or totally dismantled and reconfigured when a major reorganization takes place.

Knockdown or *KD* furniture is usually modular but is made and shipped disassembled. Since many furniture units are, when assembled, so large and clumsy as to make shipping and moving difficult, KD construction leads to major savings in costs for warehousing, packing, and shipping. It is most often used for residential furniture of reasonable cost, sold in knocked-down packages that purchasers can take home in a car. Design of KD furniture is frequently of surprisingly high quality, tending toward simplicity in general form and in detail.

When budgets are limited, furniture products that are well designed and functionally serviceable yet inexpensive are essential. Although it is a common complaint that "good design is too expensive," much expensive furniture is, in fact, poorly designed. Many products of fine design quality at reasonable prices are available. The best sources are neither the mass-market furniture and department stores nor the showrooms that service designers and architects but, rather, certain specialty good-design firms that sell directly to consumers. Many such firms offer mail-order catalogs and websites, and many specialize in KD products. Other good sources lie outside normal supply routes. For years many designers have found economical solutions to their own furniture needs through improvisation. A flush door placed on demountable horses, for example, makes a serviceable table or desk. Steel file units available in larger office-supply shops can substitute for horses to provide more storage. Shelving and storage systems produced for industrial applications can solve problems of storage as an alternative to lumberyard planks cut and assembled with hardware-store brackets and supports. Simple bentwood chairs and inexpensive versions of such classics as the Breuer Cesca chair (see fig. 13.55) are of excellent design at minimal price levels. Slipcovers can make secondhand chairs and sofas presentable, and a basic mattress on springs can take on whatever character its cover establishes.

A newer source is Internet auctions, where a designer can bid on furniture items offered for sale by private individuals and possibly get a classic piece at a bargain if not outbid. With some thought and ingenuity, inexpensive furniture can yield both functional and aesthetic results in no way inferior to those in projects with unlimited budgets.

← 13.4 **13.4** Furniture specially designed for an interior can have a strong effect on the atmosphere of the space. In the Moon Soon Restaurant, Sapporo, Japan, a project of Iraqi-born London-based architect and designer Zaha M. Hadid, the unconventional furniture helps to set the mood. (Photograph: © Paul Warchol)

CRITERIA FOR CHOOSING FURNITURE

The primary goal in choosing appropriate furniture, whatever its source, is *quality*. It is an unfortunate fact that the most widely available furniture tends to be mediocre; badly designed and poorly made, it is intended to sell quickly and serve briefly before being discarded, either because it goes out of style or it physically disintegrates. Furniture only a few years old can be observed in trash piles almost every day, while good furniture can last for a very long time, as demonstrated by antiques still serviceable after hundreds of years. Evaluating furniture quality involves several issues, many easy to evaluate, others more difficult. The primary issues are the same that apply to the evaluation of all design—function, structure and materials, and aesthetics (see Chapter 2, "Design Quality")—but with more particular bearing, as detailed below. An additional consideration is cost.

Function *Function* relates to the furniture's purpose. Almost all furniture has a practical use, and good furniture serves that use effectively and reliably. Different uses call for specific qualities and characteristics. For example, storage furniture must be sized to hold whatever it will contain efficiently and conveniently, and its drawers and doors must work well and continue to work well over years of use. Chairs and other seating and reclining furniture must fulfill the requirement of providing comfort.

Secondary function is a term sometimes used to describe matters that do not relate to the primary, or main, purposes of an object, but rather to aspects of its performance that may surface only under special circumstances. Safety is not an issue that comes readily to mind as a major concern when evaluating furniture. Tables and chairs seem benign compared to automobiles or firearms. Nevertheless, a surprising number of injuries result from circumstances relating to furniture. Chairs can tip over, tables can trip the unwary, and large pieces can overturn with unfortunate results.

The hazards relating to furniture can be listed in a number of categories:

- *Sharp corners and edges*. Bumping into the corner of a table or cabinet can lead to a bruise or a cut. Soft or rounded edges or corners are safer. Metals are harsher than wood or plastics. Glass is the most hazardous of furniture materials. Glass-topped tables, especially those with sharp corners, are well known to present risks of serious injuries.
- *Chairs*. Those that can be easily overturned present dangers. Chairs on casters are especially risky because they can be overturned more easily when tipped. Three-legged chairs are notably dangerous. Four-legged chair bases are now frequently replaced by the safer bases that have five points of floor contact.
- *Fire safety*. All furniture with fabric covers and upholstery presents this concern. Beds are notorious firetraps for smokers. Cover fabrics that do not flare up or support combustion

reduce fire hazards. Cushion and mattress materials that do not burn easily and that do not generate toxic fumes when burning reduce fire-related risks. Special processing to achieve fire safety must be considered in many contexts.

- *Children and the elderly*. These two segments of the population are particularly vulnerable to furniture hazards. Small objects that are easily tipped over, as well as sharp edges and corners, are dangerous to older people with reduced visual acuity and physical agility. Children are active, careless, and of a size that often contacts tabletop edges at eye and head levels. Some furniture, such as cribs and chairs, may have spaced members that can catch a child's head in a dangerous grip.

Although total safety is most likely beyond human grasp, it is wise to look at furniture selections in relation to intended use. What might be acceptable in an executive office (a table with a large plate-glass top, for example) may be questionable in a home with young children or in a public lobby where crowds of people may congregate. Fire hazards are most significant in the closed spaces of high-rise buildings or in such special installations as the seating in aircraft. Concern over such issues is more valid than the indifference that until recent years has been the norm.

Universal design is a term that has come into use to suggest a goal that would make every designed situation serviceable to those (children or adults) who are very small, those who are taller or otherwise larger than average, and those who are temporarily or permanently physically impaired. This includes those who are on crutches, sight-impaired, or with other limitations that make standard heights of chairs and tables, locations of cabinets, heights of beds, and placement of furniture problematic. It is usually true that furniture that accommodates people with disabilities will serve the general population equally well. Considerations of function in furniture should include issues that extend to the full range of human form and performance. (For further discussion of universal design, as well as design for special needs, see Chapter 8, "Interior Design for Special Needs.")

Structure and Materials *Structure and materials* concern how the furniture is made. Good furniture is well made of appropriate materials. Examining the broken furniture left on garbage heaps often reveals slick or showy finishes covering flimsy materials and slipshod construction. Since inexpensive furniture of good quality exists, it is clear that the poor quality of such materials and construction stems only partly from an effort to maintain low prices. The difference lies in the maker's awareness of and attention to the kind of construction the furniture calls for and an effort to use affordable materials honestly and to their best advantage. It also lies in the purchaser's awareness of and regard for such factors. Minoru Yokoyama's table is a good

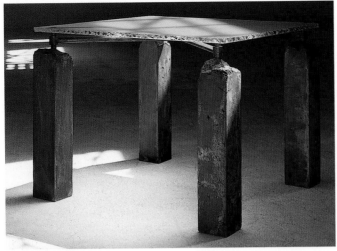

13.12 →

13.13 →

13.14 →

restaurants, and theaters ideally will provide access for those with physical limitations to the maximum extent practical.

- *What are the physiological requirements?* Comfort is too often judged on the basis of a quickly formed first impression. This tends to favor the softness of thick padding and deep cushions. Actually, the body is better accommodated by firm support at certain key points where weight is transferred and by limited softness at other locations. The pleasant sensation of "sinking into" a soft seat soon leads to unexpected discomfort—the feet fall asleep and the sitter becomes restless—and can contribute to physiological problems. Long periods of sitting in chairs designed without regard for physical needs can give rise to back ailments and may contribute to such major physical problems as varicose veins and heart and circulatory ailments.

- Recent concern with issues relating to human factors has greatly increased, and many seating designs described as *ergonomic*, that is, suited to human body mechanics, have appeared (fig. 13.16). Most such designs are intended for use in office or home work situations and provide adjustments in height, spacing of parts and movements (often with adjustable spring tension) to accommodate body size, proportion, and movement. This approach assumes that the chair in question will be used by one user whose needs can be taken care of by such adjustments. Seating that must serve many users (dining chairs, seating in waiting rooms and lobbies, and transportation seating) presents the more difficult problem of ergonomic suitability to all, or at least most, users. Seating that is truly ergonomic, whether or not so described, will provide comfort in long-term use and will minimize physiological damage that poor seating postures can cause. Many traditional designs from simple wood stools to old-fashioned rockers are ergonomically successful, while much "luxury" seating is far less satisfactory.

In selecting seating furniture, then, appropriate comfort with the best possible ergonomic performance is the primary consideration. Suitable size and shape for a particular use follow.

Seating Types Seating products are available that offer a wide variety of special-purpose features, such as rolling, swiveling, tilting or reclining, stacking, folding, and even conversion to other use—most often in the familiar convertible that makes up into a bed.

Multiple seating has developed a terminology of its own that can be confusing. *Sofa* is the generic term; *two-seater* and *three-seater* are self-explanatory. *Love seat* is a charming synonym for

The concept of universal access for persons with physical disabilities presents a further consideration. Transfer from a wheelchair to other seating calls for a corresponding seat height and form with minimal arm obstruction. Seating in public places such as waiting rooms (at airports or in hospitals, for example),

that can fold down to serve as a table (as shown). Kolatan/Mac Donald Studio were the designers. (Photograph: Michael Moran). **13.12** A small table by Bruce Tomb and John Randolph comprises an unpolished ¾-inch-thick glass top on a sandblasted-steel frame supported by four

legs of rough, stonelike poured concrete. A larger version is available as a conference table. (Photograph: © Paul Warchol) **13.13** The Eames lounge chair (with ottoman) designed by Charles and Ray Eames in 1956 is probably the most famous and most imitated of all

the Eames designs, perhaps because it is a modern design that offers lasting comfort as well as excellent form. Molded rosewood plywood units with fitted leather cushions are supported by a cast-aluminum base. (Photograph courtesy Herman Miller, Inc., Archives)

13.14 A chaise designed by John Mascheroni for Swaim looks back to 1930s precedents. (Photograph courtesy Swaim)

Table 24. Table Selection

FUNCTION

- Dining
- Conference
- Coffee/cocktail
- Side/end
- Bedside
- Special purpose (writing, computer, projector, TV, and so on)
- Mobile

SHAPE

- Rectangular
- Square
- Round
- Racetrack (rectangular with semicircular ends)
- Boat-shape (curving sides with straight ends)
- Elliptical or oval
- Hexagonal
- Irregular or free-form

SUPPORT STRUCTURE (BASE)*

- Four legs, at or near the corners
- Three legs (note possible instability)
- Center pedestal
- Two or more pedestals
- Trestle
- Complex structure

HEIGHT**

- Coffee: 12–18″ (15″ average)
- Low conference/dining: 25–28″
- Standard conference/dining: 29–30″
- End/bedside: 15–26″

SURFACE DIMENSIONS (WIDTH BY LENGTH)***

- Coffee: 15–24″ × 30–60″ rectangular; 24–60″ round
- Conference/dining: 24–30″ edge per seated person
- Seating 2: 24–30″ square or round; 24 × 30″ rectangular
- Seating 4: 30–42″ square; 36–42″ round;

48–54″ × 30–40″ rectangular
- Seating 6: 40 × 48–54″ rectangular ; 42–48″ round
- Larger: allow 24–30″ edge per person

SURFACE MATERIAL***

- Solid wood (subject to warping and splitting)
- Plywood or other core with wood veneer or plastic laminate surface
- Glass
- Marble, slate, tile

BASE MATERIAL

- Wood
- Aluminum
- Steel

EDGE TREATMENT

- Shape: thickness, square, half-round, irregular curve
- Corner: square, radius (curved)
- Material: *self* (same material as top surface), veneer, solid wood, metal edging, plastic edging

SPECIAL FUNCTIONS

- Stacking, nesting
- Extension: inserted leaf or leaves, contained (fold-out) leaf
- Drop leaf (with pull-out or swing-out supports)
- Gateleg (with extra leg that swings out to support leaf)

* In addition to dimensions, it is important to consider leg base locations in determining comfortable seating patterns at a table. Besides making sure that seats fit under the table edge, the designer must verify that occupants can sit without their knees or legs coming in contact with the table legs or base.

**Wheelchair access to table presents a problem. Wheelchair arms require a clearance of 29-30" under a tabletop. This forces a height of 30-32", too high for other users. It appears best to set a top height of 29-30" and to expect that wheelchair occupants can remove their chair arms when drawing up to a table.

***When determining table sizes, it is important to consider clearances for chairs both when they are occupied and when they are moved away from the table for access. Distances to walls and other tables and suitable circulation space for access and service may be factors of importance.

In restaurants, the size and spacing of tables affect the character and atmosphere of the space. Extreme crowding is, oddly enough, desirable in some situations (city nightclubs, for example), while generous table sizes and spaces may convey a sense of luxury in other circumstances.

two-seater (fig. 13.17). As most sofas have arms, *armless* is used to designate the occasional exception. Other terms sometimes used include *Chesterfield* for an overstuffed sofa with padded arms; *Lawson* for sofas with arms lower than the back; *tuxedo* for sofas with arms the same height as the back.

Modular seating refers to the *sectionals* that appeared in the 1930s and continue to be popular. These are single units that come armless, with a single arm at right or at left, and as corner units. Several can be assembled in a variety of ways, including straight or angled sofalike groupings, and they can be rearranged to suit changing needs or locations. The term *modular* is also used for modern seating systems with a continuous base structure that supports individual seat sections. Arms, corner units, even end-table elements or *planters* may be added to the basic unit to make up groupings uniquely planned for a particular location. Some modular systems use units less than one seat in width and include tapered units, enabling the formation of curves, circular shapes, and S-shaped groupings. Large modular seating assemblies are particularly useful in public spaces such as lobbies and lounges that call for a large number of seating spaces (fig. 13.18).

Folding and stacking chairs are special designs that offer the functions implied by their names. Folding chairs of simple design and low cost are familiar utility products widely used to provide temporary seating or extra seating wherever needed. While the most basic of folding chairs are often of poor quality and unattractive

appearance, many better designs are available, including some that fully equal fixed-chair types. The familiar *director's chair* is a folding unit that has become something of a classic, often used even when the folding feature is of secondary importance. Other folding types carefully disguise their portable function with designs that match those of conventional chairs. Any folding-chair design should be checked for its sturdiness in the open position, its compactness when folded, and its ease of opening and closing.

Stacking chairs are designed so that a number of units can be stacked vertically for easy movement or storage (fig. 13.19). The

13.15 Chairs by Vico Magistretti (in the foreground) make dramatic gestures that echo those of Robert Longo's wall piece and contrast with the more sedate forms of the 1950s-vintage Diamond wire chair by Harry Bertoia, visible to the right of the fireplace. Art and furniture-as-art give the room, in a renovated 1950s California house, its character. Brian A. Murphy, designer. (Photograph: © 1986 Tim Street-Porter) **13.16** The Aeron chair is a fully engineered task chair designed by Don Chadwick and William Stumpf for Herman Miller. The mechanism permits smooth transition from forward to rearward tilt. The seat and back surfaces use pellicle web upholstery that distributes weight and permits air circulation. (Photograph courtesy Herman Miller, Inc.) **13.17** This love seat was handmade of willow, or twig, in a traditional method of simple furniture-making that continues today. It is particularly suited to rural, informal settings. (Photograph courtesy La Lune Willow Collection)

best stacking chairs are of fine design and ideal for meeting rooms, ballrooms, and other places where many chairs are needed in a form that can be put away in limited storage space when a clear floor is required. Some stacking designs feature extreme compactness, as does the 40/4 chair designed by David Rowland that permits forty chairs to be placed in a four-foot-high stack. Such stacking makes it possible to store all of the chairs from a large hall under a stage or in a small closet or storeroom. The design of stacking chairs has a substantial impact on the ease of the stacking process. Some types require that each successive chair placed in a stack be lifted up over the top of the last chair added. This can be a significant physical chore and, as a stack grows taller, sets a limit on the height of the stack. The best designs allow stacking from the front, lifting each chair only by the small amount necessary to clear the chair below, usually one inch or less. Such designs are best suited to applications where more than a few chairs are to be stacked.

With many stacking chairs a wheeled dolly is available for use to support the bottom chair at an angle so that the stack will consistently rise vertically rather than tilt forward. Some stacking chairs that are less compact than others may offer additional comfort through padding or cushioning. When only a small number of removable chairs are needed (about four to eight), such units may be considered. Most stacking chairs are available with arms to separate users within rows of chairs, with tablet arms for classroom use, and with hardware details that permit *ganging*, that is, the locking together of adjacent chairs to make temporarily fixed rows. The best stacking chairs are of sufficient design quality to be considered for uses in which stacking is not a significant requirement.

Special chair types include the *rocking chair*, a traditional favorite offering comfort through movement that is physiologically highly desirable, particularly for older or infirm persons (see figs. 13.39, 13.62). Various traditional rocking chairs, some of attractive design, are still in production, and several modern chairs of fine design quality have been produced in rocking versions (a Charles and Ray Eames design, unfortunately no longer in production, has become a classic).

Adjustable lounge chairs with tilting backs, and often with leg support, are available in many designs. The traditional *Morris chair* with an adjustable back positioned by moving a metal rod from notch to notch dates back to the 1860s. Modern adjustable chairs commonly use a concealed mechanical linkage that makes it possible to adjust position by simple body movement. Such chairs are great favorites in family or TV rooms, where television viewers may sit for hours watching a screen. Although many designs are distressingly massive and loaded with unnecessary details, a number of versions are simple and reasonable in appearance.

The *wheelchair* is a highly specialized type of chair, rarely selected by a designer but essential to the mobility and convenience of those with temporary or permanent physical disabilities. Many wheelchairs are of excellent functional design, offering adjustments that would make them highly satisfactory to users with no physical problems. At present there is a certain prejudice against the wheelchair that has blocked development of universal designs that would serve disabled and normal users equally well.

SLEEPING FURNITURE

Furniture for sleeping can range from simple pads placed on the floor through *futons* and platform beds to elaborate bedsteads with head- and footboards and auxiliary elements such as bedside stands, lamps, and electronic controls and gadgets (fig. 13.20). A mattress on a spring unit, varying in size from a narrow single up to roomy king-size, mounted on a scarcely visible metal base, often called a *Harvard frame*, has become a near-standard form of bed. The *platform bed* (*mattress* or mattress and *box spring* on a box-like base) has become a popular alternative. As with seating, comfort and physiological serviceability are complex issues that require research and thought. In general, harder beds are probably better than softer, which can cause or aggravate back problems, and simple systems of construction are likely to be more durable than complex inner- and box-spring systems. Such innovative approaches as air-inflated and water-filled beds have not had a very good record of success in continued use. Foam mattresses, on the other hand, which came into wide use with platform beds, continue in occasional use. In spite of

13.20 →

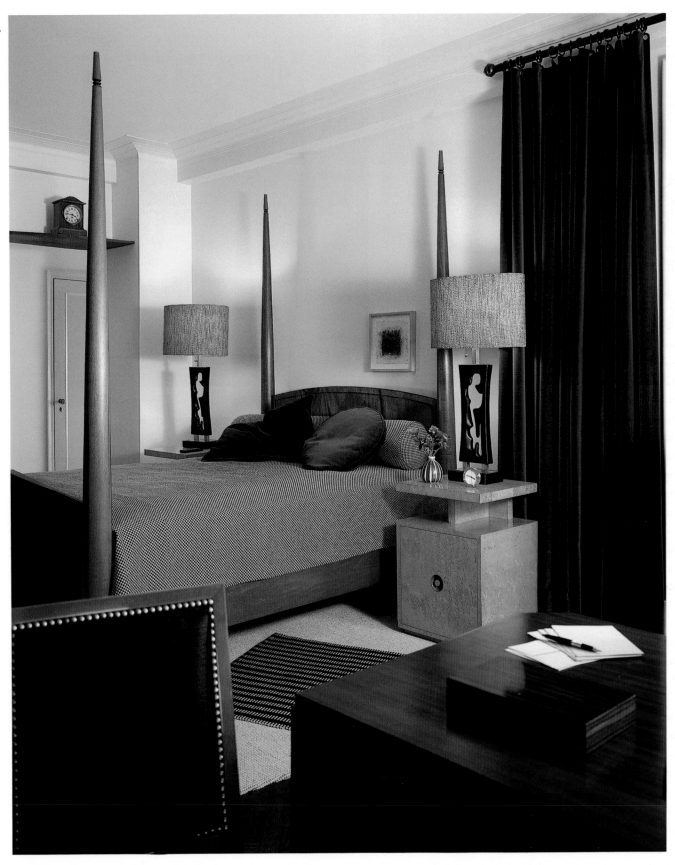

13.18 This type of modular seating is suitable to public spaces, particularly those outdoors. Mounted on a tubular steel support, the contoured, ergonomically designed seats can be grouped as desired with tabletops and other elements in straight-line or curved combinations.

The metal parts are coated with weather-resistant polyester. (Photograph courtesy Landscape Forms, Kalamazoo, Michigan)

13.19 The elegant, lightweight Handkerchief stacking chair by Vignelli Design has a seat-and-back shell of molded plastic supported by a steel frame. It is available with or without arms and with or without an upholstered pad. (Photograph: Mikio Sekita, courtesy Knoll International)

13.20 An interesting mix of furniture appears in a New York apartment bedroom, a project of Thad Hayes Design. The modern interpretation of the traditional four-poster is Hayes's own design. The night tables, typical of American Art Deco, were designed and made by Andrew Szoeke of Long Island City, New York, circa 1934. The lamps are also from the 1930s; the desk is an English antique. (Photograph: Michael Mundy)

the variety of beds available, the differences between them are mostly superficial. There is probably less variety of basic design in sleeping furniture than in any other furniture type.

Convertible sofa beds are a widely used solution to the furniture problems presented by a studio apartment (which typically consists of a main room, kitchenette, and bathroom). Seeing that the designers of such furniture must always compromise the needs of the two functions, it is surprising how well such products, at their best, serve the conflicting needs. They must, of course, be evaluated for both uses. *Fold-up* or *wall beds* also known as *Murphy beds*, once also a popular solution to the space problem, seem to have been largely displaced by improved convertibles, although they have recently become available in a variety of styles and systems (fig. 13.21).

Other types of sleeping furniture include the *loft bed*, that is, a bed on a raised platform that frees the space beneath it for other use; the *bunk bed*, particularly adaptable to children's rooms; and the *trundle bed*, which is an extra bed hidden under a larger bed.

Hospital beds, commonly used in nursing homes and other healthcare facilities in addition to hospitals, are built very high to make it easier for attendants to care for patients and provide a number of adjustments to increase patients' comfort. The adjustments may be manual (with cranks) or powered by an electric motor. Unfortunately, the high mattress position makes access

difficult, particularly for people with injuries or disabilities. (Conventional beds with very low mattress levels present the opposite difficulty.) Ideally, powered height adjustments should be included on hospital-type beds intended for home use. Such products, which are becoming increasingly accessible, encourage home care as an alternative to nursing homes for those with physical problems that can, with proper equipment and help, be dealt with in a residential setting.

STORAGE FURNITURE

Storage furniture is logically selected to suit the kind and quantity of materials to be stored. Open shelves (figs. 13.22, 13.23) and various cabinets with hinged or sliding doors and arrangements of drawers in many sizes and shapes are available in various combinations to suit specific needs. *Storage systems* offer standard related components that can be grouped together to suit a particular set of storage needs (see fig. 1.22).

Modern storage systems often incorporate elements to serve other special purposes, such as desk use, the service of food or drinks, or housing for TV and other electronic devices (see fig. 14.7). Storage can also offer possibilities for display, either for ease in locating specific items, as with open bookshelves, or simply to offer protection while making collections of objects of interest or beauty visible.

13.21 A room divider containing a fold-up (Murphy) bed designed by Harry Allen and named La La Salama ("Peaceful Sleep" in Swahili) is a classic device to gain space in constricted quarters. Several storage compartments are camouflaged by hidden doors; on the other side are a mirror and shelves. (Photograph courtesy Dune)
13.22 In the designer's own home in Guilford, Connecticut, Warren Platner has used built-in furniture extensively. Glass shelves store books in the landing space. The house is by Warren Platner Associates Architects. (Photographs: ©

Ezra Stoller/Esto) See also figure 13.23.
13.23 Built-in shelves and seating line the hallway of the Guilford, Connecticut, home of architect-owner Warren Platner. (Photograph: ©Ezra Stoller/Esto)

13.23 →

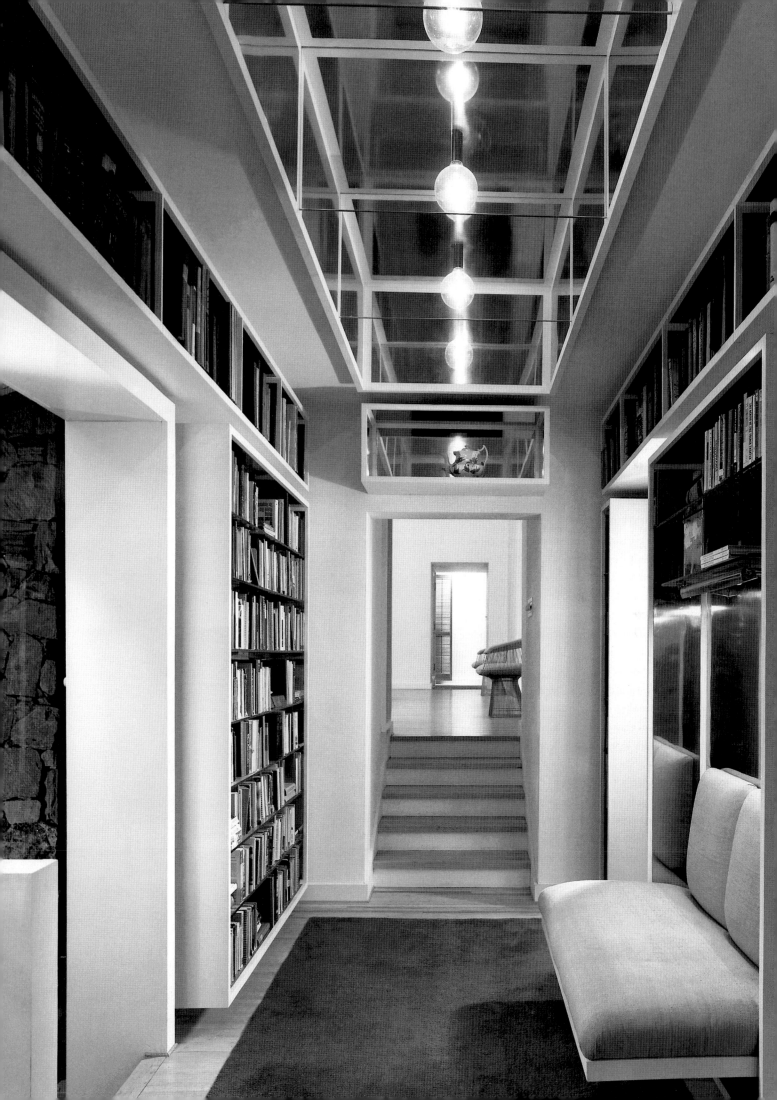

Modular or *system* storage furniture is particularly well suited to making up storage walls and room dividers. *Storage walls* are assemblies of connected storage components that fit from floor to ceiling, often using a custom-fitted insert at the top. They serve the function of a partition wall while providing storage accessible from one or both sides. A storage wall may separate adjacent living and dining spaces, two territorial areas in a shared children's bedroom, or two adjacent office spaces. *Room dividers* serve similar uses but do not extend to the ceiling or, in most cases, from wall to wall. They divide a large room into two sections while preserving its sense of unity and providing storage at the same time (see fig. 13.21). Dividing living and dining spaces is one of the most common uses of a room divider. The living side can accommodate books, records, TV, and stereo equipment, while the dining side can hold dishes, glassware, silver, and linens. (See also Chapter 16, "Special-Purpose Spaces.")

Storage is often available in multiuse designs that combine storage with some other function. Examples include sofas that incorporate shelving for books or other objects (fig. 13.24), beds with drawers incorporated into their bases, consoles with drawers or cabinet space (fig. 13.25), and such familiar designs as window seats or benches with lift-lid seats giving access to space otherwise unused as possible storage compartments.

COMPUTER FURNITURE

The constantly increasing use of computers in homes has led to the emergence of a variety of designs that fall between conventional desks and office workstation products. Such computer furniture ranges from simple stands, often on casters for easy movement, to more elaborate designs that are close to conventional desks with special modification to accommodate desktop computer hardware. In both residential and nonresidential spaces, the increasing popularity of the laptop computer has led to the introduction of special shelves or trays connected to seating furniture (fig. 13.26) and to the appearance of small stands of the sort formerly offered as tray tables for drinks or snacks now recommended as ideal for laptop computer support.

CONTRACT DESIGN FURNITURE

Contract design calls for many specialized types of furniture designed to satisfy specific needs. There are special lines of furniture tailored to the requirements of hospitals and healthcare facilities, offices, libraries, hotels and motels, restaurants, theaters and auditoriums, and retail shops, to name a few of those most widely available. Among these, the most highly specialized types, such

13.24 ↑

← 13.25

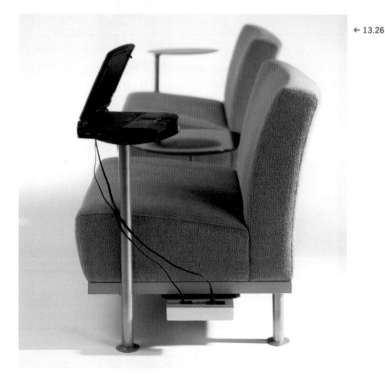

← 13.26

13.24 Tamu is a sofa with surrounding shelving designed by Marco Zanuso, Jr., for Driade. (Photograph courtesy Driade) **13.25** A console designed in 1933 by Louis Süe is typical of the 1930s Modern style, now usually called Art Deco. It is of burl ash veneer with an aluminum structure. (Photograph courtesy Christie's, New York) **13.26** This sofa incorporates a power and communication module and an adjustable shelf to hold a laptop computer. It is part of the Palette lounge series designed by Wolfgang C. R. Mezger for Davis Furniture Industries.

(Photograph courtesy Davis Furniture Industries)

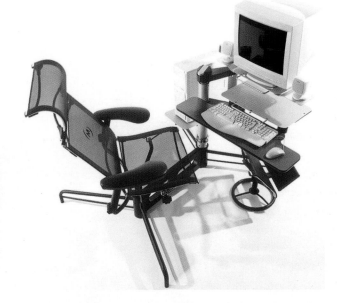

as hospital and laboratory equipment, need only be noted here as areas served by product lines developed to fill such needs.

Other contract furniture products have more varied uses. Theater seats, for example, may also be used in school and college auditoriums and lecture halls. Stacking chairs may be specified for auditoriums, ballrooms, lecture rooms, cafeterias and dining rooms, conference rooms—wherever changing uses call for closely spaced seating at times and clear space at other times. Restaurants demand special tables, attractive and durable when tabletops are left exposed, simple and unobtrusive when tablecloths will virtually conceal whatever is beneath. Banquette seating may be a standard product or may be built to order.

Office furniture has become a very important specialty as office work has become a major part of modern working life. The simple desk and chair continue in wide use, but systems furniture has come more and more to replace the freestanding desk with a complex of work surfaces, screen panels, and storage units that serve as partitioning as well. The *workstation* is supplanting the conventional office room, occupying less space while, at best, providing

better function (figs. 13.27, 13.28). The constantly changing nature of office work has led to the introduction of office systems that emphasize flexibility both within the individual workstation and in the grouping and regrouping of workstation clusters. The increasing emphasis on team organization in office work has meant that emphasis on privacy has, in many contexts, given way to cluster groupings that focus on the need for easy voice and visual communication among the members of a team group (figs. 13.29, 13.30).

The typical office workday of long hours spent sitting in a chair has led to the development of ergonomic chairs offering improved comfort and physiological impact through shape, dimension, and adjustments that minimize muscular stress (see fig. 13.15). Conventional file cabinets have been augmented by *lateral files* (in which the filed material is stored side by side instead of front to back) and special equipment for microfile materials. Computers require special stands and tables for their keyboards, screens, and printers, all of these connected by wires and cables that must be accommodated in suitable furniture

13.27 This workstation is described as "point-based" and is part of a "constellation" that branches at 120-degree angles to place the computer-using worker at a center point among reachable elements. Design by Ayse Birsel for the Resolve system, produced by

Herman Miller. (Photograph courtesy Herman Miller, Inc.) **13.28** Microsphere, a workstation with a futuristic look, has an adjustable, fully engineered chair and an equally adjustable computer support with separate and adjustable keyboard and monitor shelves. Accessory elements

include additional work surfaces, telephone support—even cup holders. (Photograph courtesy Microsphere) **13.29** Conceived in the late 1990s by Italian designers Studio Kairos, adapted by British designer Tim Wallace, AbakEnvironments is an office system of

many components suitable to use in open-plan or partitioned offices. (Photograph courtesy Hermann Miller)

units. Arrangements for wire and cable distribution vary with access from floor level or ceiling level and with distribution to the individual workplace or to horizontal channels incorporated into workplace system panels or other elements (fig. 13.31).

Office-furniture systems have been developed under the influence of open or *landscape* office planning, in which partitioned private offices are avoided in order to open up communication and allow easy rearrangement of workplaces. Early open office plans often limited privacy too severely by placing conventional desks in totally open space. Most systems now provide for some form of screening to create both visual and acoustical (auditory) privacy. A typical office system offers a continuum ranging from total openness to something approaching a walled private office. Systems can be categorized into two general types depending on the way this flexibility is supplied. Panel or *panel-hung systems* use the panels that provide privacy as their primary structure, with work surfaces and storage components hung from the panels. *Freestanding systems* use desk and storage units similar to conventional furniture as their basic elements and provide panels or screens that can be attached to establish privacy (fig. 13.32). Many systems offer assorted types of panels of varied height and transparency, some even with doors, to make possible a maximum number of arrangements. Some systems also allow work surfaces to be set at differing heights to suit the physical needs of the individual user. Work surfaces and storage elements set lower than standard heights can be very helpful to workers of less than average height. Others may find it helpful to have work surfaces set at heights for standing work positions. When such flexibility is available, installation must be performed with full instructions about the requirements for each workplace.

The proliferation of electrical equipment in the modern electronic office has created the need for extensive wiring to be carried to each workplace. Task lighting (see Chapter 11, "Lighting") is a useful and often necessary element of an office-system installation that requires not only additional wiring and switching but also careful consideration of the quality of lighting that will be delivered at each work surface. Most office systems include ingenious provisions for wiring, with arrangements for concealment, easy service and replacement, and excellent safety ratings (fig. 13.33).

Planning with systems furniture requires a full understanding of the particular systems to be used because the dimensions of available units determine the possible sizes and shapes of workstations. While some preliminary planning can be done on the basis of typical or generic furniture, an early decision to use a specific system will make it possible to plan realistically and to avoid troublesome later adjustments. Thicknesses of panels and details of how panels and other components meet at corners influence the dimensions of rows or clusters of workstations as well as the practicality of arrangements of components within worksta-

13.30 Haworth Inc. introduced their new a_con™ conference table in 2005. This high-end table combines smart furniture design with the most sophisticated multimedia support tools. An electronic, extendable media projector and plug-in media ports rotate according to users' needs, allowing them to plug in with their laptops, handheld PDAs (personal digital assistants), IT connections, and other communication tools.

13.31 →

utility pole →

upper beltway →

lower beltway →

beltway covers ↑

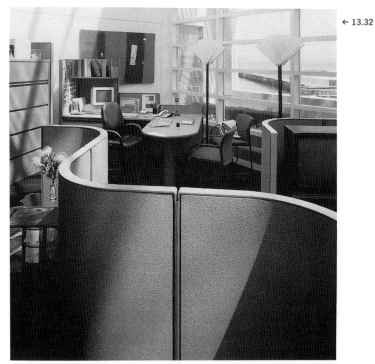

← 13.32

← 13.33

← 13.34

tions. Manufacturers generally provide excellent planning manuals to aid the designer; they also frequently offer a planning service that can take on a considerable share of the detailed planning process. Some firms supply computer programs as well to efficiently aid planning and to assist in the production of drawings, specifications, and ordering information on an integrated basis (see fig. 18.16). The selection of a particular system and the use of such aids unfortunately make the purchaser something of a captive buyer who cannot readily change to an alternative system either at bidding time or in the future when additions or changes to a facility are contemplated. It is desirable to select a manufacturer with a good record of continuing support to users of its products and with excellent prospects for long survival. A system made by a manufacturer who no longer produces that product group or who has gone out of business leaves users orphaned, which can be both inconvenient and costly.

Other contract uses require special versions of ordinary home furniture. Motel and hotel furniture, drawer chests, desks, beds, and bedside tables differ from home equivalents only in having more durable surface finishes, heavy-duty mattresses, and sturdy casters on the bed frames to facilitate movement for bedmaking. Chairs for restaurant service need to be strong and to have spot-resistant cover fabric (fig. 13.34). Public lounge furniture is similar to living room furniture except that it, too, demands extra sturdiness and wear-resistant properties. On the other hand,

13.31 In the Pathways workplace system manufactured by Steelcase, overhead power distribution is through "utility poles" that lead wiring into horizontal beltways within the panels that provide space division and privacy. (Drawing courtesy Steelcase) **13.32** The curvilinear panels of the 9000 series office-furniture system by Steelcase can be used to control traffic-flow patterns while also relieving the rectilinear quality typical of most office layouts. (Photograph courtesy Steelcase, Inc.) **13.33** The "if" office furniture system from Haworth includes a "utility chain," a flexible tube that integrates power and other wiring supply from floor, wall, or ceiling as needed. (Photograph courtesy Haworth, Inc.) **13.34** Contract furniture demands a higher level of durability than furniture designed for residential uses. The indoor-outdoor aluminum furniture from the Toledo Collection, designed by Jorge Pensi for Knoll, would be suitable for restaurants and other public spaces. (Photograph courtesy The Knoll Group)

transportation seating (for buses, trains, and airplanes) is of a very special type that must meet exacting performance and safety standards established by the federal government. The interior designer confronting a specialized contract assignment for the first time will usually need to spend some time visiting special furniture showrooms, talking with salespeople in the field, and collecting a library of current catalogs devoted to suitable furniture products. Some industry manufacturers' associations have established quality standards that are an aid in evaluating available products. The Architectural Woodwork Institute (AWI), for example, produces a quality standards manual that defines three levels of quality, designated as *economy, custom,* and *premium,* in detailed specifications. Although meant for built-in woodwork, the same standards are useful in evaluating any wood furniture. The Business and Institutional Furniture Manufacturers Association (BIFMA) has published similar standards for performance tests to be used by its member firms.

CHILDREN'S FURNITURE

Although children manage to adapt themselves to adults' furniture, their smaller size and varied degrees of strength and mobility make special furniture desirable to improve children's comfort and even aid their physical well-being. Infants require a special bed or crib and, if possible, a unit for bathing. The cradle, popular in earlier times, seems to have disappeared from modern use. As children grow, high chairs and playpens are needed. Interior designers rarely have responsibility for selecting these items, which are thought of as equipment for temporary use, usually more or less portable and, unfortunately, often of poor quality. When a home includes a room designated as a nursery or child's room, however, it must be furnished with some thought and care. Cribs and playpens may pose a safety problem if their fencelike bars are spaced so that a child's head can be caught. Units using screen mesh in place of bars avoid this problem. Cribs of excellent design are available, including some foldable types that can be stored or passed on for reuse. A well-made high chair of fine design quality can serve successive generations.

As children grow, an appropriate bed becomes a necessity—bunk beds are a favorite provision for two children close in age. Simple shelving, storage chests, and eventually a table or desk round out the basic furniture for a child's room. A number of manufacturers offer furniture that can be adjusted to the changing needs of children as they grow: tables or desks that can be adjusted in height, storage units that can be expanded or rearranged. Designs have been developed that place seat height low for a young child but, when inverted, become appropriate for an older age. Scandinavian designers have been particularly successful in developing home furniture suitable to child use, and some of their lines are available as imports.

In childcare facilities, nursery schools, and elementary schools, special furniture sized to suit appropriate age groups is essential.

A number of manufacturers provide lines of school furniture with chairs, tables, and desks in graduated sizes of sturdy and durable construction. Some products are available with adjustable-height units so that smaller and larger children within a particular age group can be comfortably accommodated.

Furniture for children's use is sometimes best accommodated with built-in units that a designer may wish to detail for custom building. In home situations, shelving, clothes storage, and units that combine storage and desk space are candidates for custom detailing, often more economical than purchasing factory-made products. Similarly, in school interiors, built-in shelves, *cubbies,* and wardrobes may be detailed to fit a given space, suit a known user group, and still be economical to construct.

Children seem to appreciate furniture that is designed to take into account their sizes and needs, and adults often find that furniture designed for children has a special charm that makes it welcome in whatever setting it may be put to use.

Structure and Materials

Quality of materials and technique in furniture construction has a major impact on both its durability and its proper use. Furniture is made in many ways from a great variety of materials. Generally, the details of construction are at least partially concealed in the finished product. The reputation of a particular manufacturer, published specifications (when available), and price are all clues to the quality of construction.

Well-made furniture need not be expensive, but cheap duplicates of high-quality products are almost certainly the result of some skimping on materials or details. When evaluated over its useful life, quality furniture is often a better bargain than cheap substitutes. An inexpensive dinette table that must be replaced in five years may, over the long run, end up costing more than a high-priced table that will still be serviceable (and perhaps more valuable) after a hundred years.

The examination of an actual sample, along with some simple testing in the form of shaking, bouncing, pushing, and pulling (particularly if done in comparison with several similar objects), can give some idea of constructional quality. Good furniture is not weak, fragile, or shaky when new and will not develop weaknesses with normal use over long periods of time.

Just how sturdy a piece of furniture needs to be depends on its intended use. Many fine antiques that have held up over centuries are actually quite delicate, but they have been used, as intended, only under conditions that do not impose too much rough usage. In general, home furniture need not be as rugged as furniture used in institutional and public spaces. Delicate materials and finishes can survive in private living spaces or in executive offices better than in hotel rooms, dormitories, or where young children will be regular users. Whatever its intended use, good furniture

Table 27. Furniture Finishes

FINISH	CHARACTERISTICS AND USE
PAINT	Usually brushed on, hides the color and grain of wood and so is most often used on inexpensive furniture and built-in cabinetry. Several coats are required to hide grain and imperfections. Gloss or semigloss surfaces are best for resisting dirt and abrasion.
ENAMEL	A special type of paint, usually gloss or semigloss, best applied over one or more priming coats. It hides wood color and grain and provides a tough surface that resists abrasion and can be easily cleaned.
BAKED ENAMEL	Can be used only on metals. It is generally sprayed on and then subjected to sufficient heat to fuse its components into a very hard, glossy surface. It is commonly used on kitchen cabinets, appliances, and bathroom fixtures.
PLASTIC COATING	Used on metal parts, is factory-applied by heating the part and then dusting it with plastic powder, which melts and fuses on the metal surface. The resulting leatherlike texture is tough and abrasion-resistant.
CHROMIUM PLATING	A metal surface treatment used for the legs and frames of furniture. It is factory-applied and provides good protection against rust and damage. A silvery metallic finish, a satin grain, or a mirrorlike surface are most often used, although gold, brass, or black are also possible.
LACQUER	A general term for a number of quick-drying synthetic finishes that can be brushed on but are usually sprayed on in several coats, often with heat used to accelerate drying in factory production. Clear lacquer finishes allow the color and grain of wood to show. Fillers are often used to fill the open grain of some woods. Lacquers are also available in a full range of colors that hide wood color and grain.
BLEACH	Can be used to lighten the color and reduce the grain of wood before applying a clear finish coating. Some woods can be bleached sufficiently to become almost white while still showing a grain pattern. Lacquer is the usual surface coating for bleached wood.
STAIN	Can be used to darken or color wood before applying a transparent surface finish. Because stains penetrate into woods to some depth, they help to conceal scratches or other damage to the surface coating. The rich colors associated with mahogany are produced by reddish stains; *ebonizing* is achieved by using a black stain.
VARNISH	A gum dissolved in a solvent. As the solvent evaporates, it forms a transparent coating with a brownish color tone. A number of thin coats are usually used to generate a surface that is matte, semimatte, or, most often, glossy. Varnish is used on many antiques and antique reproductions.
SHELLAC	A gum dissolved in alcohol that leaves a light-colored, clear coating as the solvent evaporates. The finish may be satiny or high-gloss. Shellac finish is easily damaged and will show water spots and marks of other liquids. It is often used as a sealer before applying other finishes or is used in combination with other finish materials, such as oil.
OIL	Finishes that penetrate into wood and also form a surface coating. Linseed, tung, and other oils can be used alone or in combination with a solvent to aid application. Oil finishes darken wood somewhat, but they allow grain and color to show through, thus preserving a "natural" surface appearance. Oil may be applied by brushing, spraying, or dipping. Several coats are usually applied, wiped off, and hand-rubbed to the desired level of gloss. Oil finishes are easily damaged but are easy to repair by recoating.

Table 27. Furniture Finishes (continued)

FINISH	CHARACTERISTICS AND USE
FRENCH POLISH	A term for a traditional furniture finish using oil, shellac, and alcohol applied with cloth pads and hand-rubbed. A variety of mixes and finish processes are used to produce handsome but generally delicate finishes on fine woods.
WAX	Can be used on wood to provide protection while preserving a natural appearance, although with slight darkening. It is also often used over other finishes (such as shellac, varnish, or oil) to provide protection and aid development of a high gloss.

long life of hard use, will stand up against considerable abuse, and consequently will be heavy and correspondingly expensive.

PLASTICS

A relatively new material for furniture construction, plastics come in so many varieties that generalization becomes difficult (figs. 13.45, 13.46). Price increases of recent years (most plastics are petroleum-based substances) have somewhat set back earlier expectations that plastics would become the primary material for furniture making. Still, many modern designs use plastic parts, and certain plastics are widely used for special applications. Its most visible application in furniture is probably as sheet laminate, used as a tough surface material (see above under wood furniture).

Plastic Laminates Laminates are composed of layers of heavy paper impregnated with melamine resin. Plain colors, patterns, and imitations of wood grain are common surface finishes. The thickness of the laminate shows as dark brown or black at the edges unless they are trimmed in some way. Some recently developed laminates, of uniform color throughout their thickness, do not create edge-appearance problems.

Acrylics Acrylics (such as Plexiglas and Lucite, to mention two well-known trademark names) resemble glass in their transparency. They also can be made translucent and colored. While less subject to breakage than glass, they scratch more easily and attract dust and lint with static electrical charges. Acrylics can be bent and molded into curved shapes and are used mostly to make transparent parts and occasionally entire pieces of furniture.

Molded Plastics Molded plastics, such as styrene, polyethylene, nylon, and vinyl, are often made into small parts for special purposes, such as glides, rollers, edge trim, and drawer pulls. The only other plastic sufficiently strong and moderate enough in cost to be usable for major furniture parts is fiberglass, a hybrid material in which glass fibers are embedded in a molded polyester resin. It is commonly used to make custom auto-body parts and small

boat hulls. Fiberglass chair shells can be molded to body-conforming shapes that are very strong and durable when well designed. The plastic may be exposed, painted, or covered with upholstery padding. Fiberglass chair shells can be tested for strength with deliberate rough handling, in testing machines, and through observation of chairs in regular use. The sight of broken plastic shells is common in public spaces, which impose the harsh tests of heavy use and, sometimes, deliberate vandalism. Chair shells made of plastic softer than fiberglass, used in many designs, cannot be expected to stand up to this kind of heavy usage.

A fair test of any plastic chair is to kneel in the seat and try to tear loose the back by pushing back and pulling forward. Also, test leg or base connections to the chair body; they should be unbreakable in any reasonable form of rough treatment.

Foamed Plastics Foamed plastics have become favorite materials for cushions, mattresses, and padding in upholstery. Foam takes the form of slabs, thin sheets, or molded parts shaped into cushions or fitted to entire chair forms (see fig. 13.46). Upholstery foams vary greatly in degrees of softness, durability, and resistance to fire. Poor-quality foams do not hold up well, and some foams produce toxic fumes when burning. The quality of foams can be verified only through manufacturers' specifications and guarantees, since testing calls for laboratory techniques.

Plastic foams can also be made stiff enough to be called rigid. Combinations of soft and rigid foam are used in some modern upholstery, either alone or with embedded frames of wood or metal or with bracing panels of wood, metal, other plastics, or fiber. Evaluating such hybrid plastic furniture is somewhat difficult, since the construction is concealed in the finished product. Testing for comfort, durability against hard use, and similar characteristics can be done fairly easily by sitting in each piece, moving in it, and deliberately trying to break it. Durability in service over a long period can be tested only by the product's service record, so any new construction material should be approached with caution.

Given a structural framework of a stronger material, such as wood or metal, rigid foam, with a plastic surface finish, can also

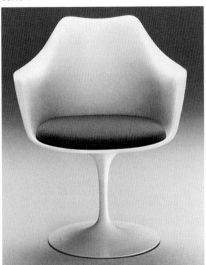

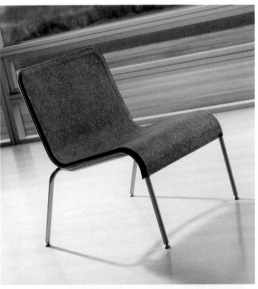

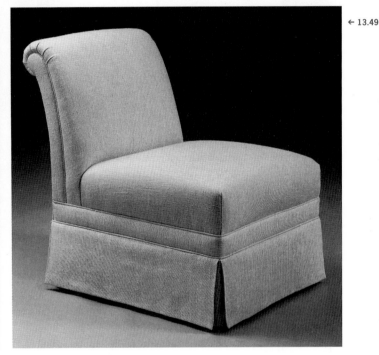

be used as the primary material of storage furniture. This technique is currently used to create mass-produced furniture of minimal quality with surfaces colored to simulate wood. Its potential for use in well-designed furniture of higher quality will probably be developed eventually.

Furniture consumes many materials. It also often has poor durability, so both the materials and energy are wasted as poor quality furniture is discarded after a short period of use. In a desire to meet environmental standards, new designs are appearing with a dedication to survivability. The very simple lounge chair designated "PET" is an example of a design produced with a steel frame, and a seat and back of molded plastic felt, both materials fully recyclable (fig. 13.47).

UPHOLSTERY

Upholstering is a technique using a variety of materials to create softness in seating and reclining furniture (figs. 13.48, 13.49). Upholstery can range from a thin pad added to a hard seating surface to a complex construction that provides excellent comfort. Since a covering of fabric, leather, or plastic usually conceals all

13.45 Danish furniture designer Verner Panton took full advantage of molded plastic's malleability in this flowing, strikingly sculptural stacking chair, made as a single unit (1959–60). (Photograph courtesy Herman Miller, Inc., Archives) **13.46** Eero Saarinen designed this graceful pedestal-base armchair in 1956. The shell of molded plastic, reinforced with fiberglass, is supported by a cast-aluminum base. The shell has a lacquer finish, the base a finish of fused epoxy plastic. The removable cushion is of foram foam. (Photograph courtesy Knoll International) **13.47** The PET lounge chair, developed by Brian Kane and Turnstone, is made by compressing two sheets of felt onto a steel frame and reducing the fabric to an ⅛-inch thickness. **13.48, 13.49** Simple and timeless examples of conventional upholstery, the Mayfair Looseback chair (fig. 13.48) and the related Slipper chair (fig. 13.49) offer excellent comfort in neutral styles that can be adapted to many different situations. (Photographs courtesy Brunschwig & Fils)

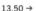

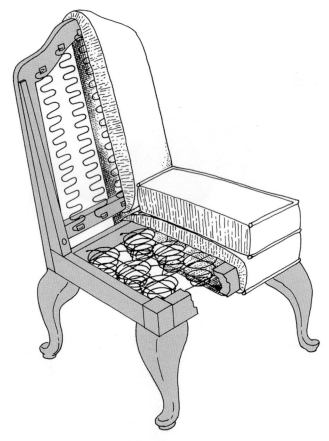

trial. Durability is, again, harder to evaluate. Upholstered furniture made with good workmanship using good materials can have a long life, but upholstery using shortcut methods and cheap materials can be a doubtful economy, leading to the dismembered examples so often seen discarded after a short life. The reputation of a particular manufacturer is again the best guide to quality. Appendix 5 includes a discussion on using the customer's own material (COM).

Furniture Design

Furniture design tends to follow the trends in architectural and interior design. Historically, a furniture style displays both the general concept and specific details of its own period (fig. 13.51). The furniture of the Middle Ages exhibits Gothic details, that of the Renaissance elements from classical antiquity. Typical Victorian furniture has a vertical proportion and elaborate and fussy details, while modern furniture generally appears simple in both form and detail.

The terminology of furniture styles can be confusing, as some terms referring to historic periods and other terms describing an approach to design are used in ways that overlap. The modern habit of reproducing furniture designs from the past generates some of this confusion. The term *Colonial*, for example, describes both actual antiques from the Colonial era and modern reproductions of Colonial designs. *Modern* logically means nothing more than recently produced, but the term has come to designate a particular style as well. Sorting out this tangle demands careful use of the terms discussed below.

ANTIQUES

The term *antiques* refers only to furniture made over a hundred years ago (according to the definition used by U.S. Customs) in the particular style then current (figs. 13.52, 13.53). Dealers and galleries that deal in antique furniture usually reserve the term for examples of good quality, often called *fine antiques*. As the years go by, old furniture that was once scorned often comes to be appreciated and valued.

Country antiques can still be found at reasonable prices, and good antiques are sometimes, surprisingly, no more expensive than reproductions. Truly fine antiques, considered to be of museum quality, have become very costly; they are selected and bought as much for their investment potential as for their use as furniture. These should be purchased only from reputable dealers, galleries, or auction houses.

upholstery construction, its techniques and quality are hard to evaluate. Inspecting an upholstered unit before it is covered or watching the upholsterer at work in the shop are the best ways to become acquainted with upholstery techniques.

Traditional upholstery, still used in many quality products, begins with a frame, sturdily made in hardwood, with strong joints (fig. 13.50). This establishes the outer form of the finished unit. The open bottom is laced with an over-and-under weave of heavy webbing. Onto this, a number of coil springs (16 to 25 per seat) are tied and sewn to be pulled down into a partially compressed position. Canvas is placed over the springs and a cushion added on top. The cushion may be a removable unit or sewn down in place. The back is similarly treated, often without the coil springs. Padding is placed on arms and edges, and the whole is covered with the material that will be visible in the finished product. (See Appendix 5, "Estimating Material Requirements.")

Traditional upholstery, which depends on skilled labor, is slow and costly to produce. Most modern variations stem from efforts to reduce this labor cost. For example, flat, sinuous springs or elastic webbing often take the place of coil springs. Plastic foam (discussed above) may replace older cushioning materials, such as down, felt, or cotton, or various grades of foam may make up the entire upholstery construction. The resulting comfort can be evaluated by direct

13.50 This diagram illustrates the construction of conventional upholstered seating as it is now most commonly produced. Coil springs are used for the seat, while the more economical modern alternative, sinuous—No-Sag—springing is used for the back. Rubberized hair or foam has generally replaced the traditional cotton felt and horsehair cushion stuffing.

13.51 →

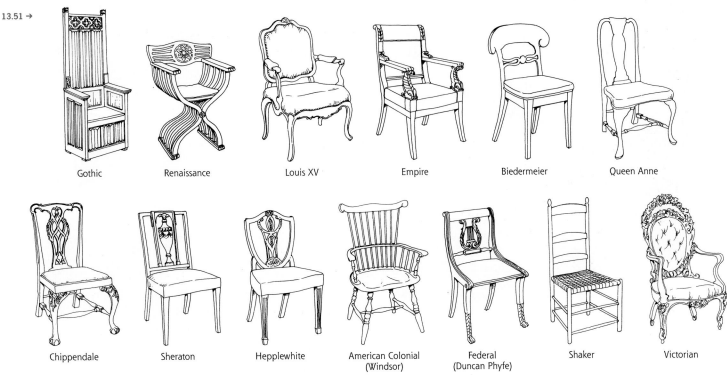

Gothic　　Renaissance　　Louis XV　　Empire　　Biedermeier　　Queen Anne

Chippendale　　Sheraton　　Hepplewhite　　American Colonial (Windsor)　　Federal (Duncan Phyfe)　　Shaker　　Victorian

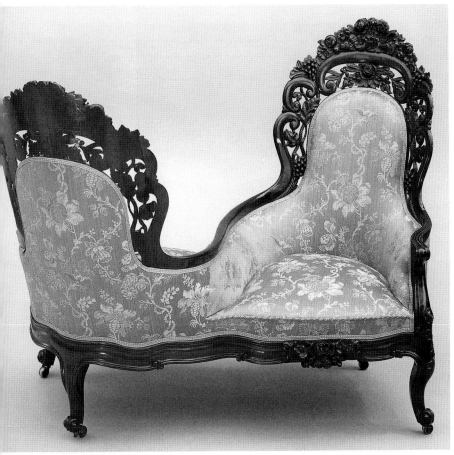

13.52 ↑

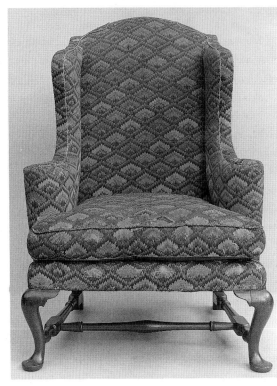

← 13.53

13.51 Furniture styles display both the general concepts and the specific details of the architecture and interior design of their period. Chairs seem to be the most clearly differentiated representatives of successive historical styles. **13.52** This Victorian tête-à-tête is an American antique piece of circa 1850. The frame is of rosewood, elaborately carved in keeping with the taste of the time. 44½ × 52 × 43″. The Metropolitan Museum of Art, New York. Gift of Mrs. Charles Reginald Leonard, 1957, in memory of Edgar Welch Leonard, Robert Jarvis Leonard, and Charles Reginald Leonard. **13.53** A Queen Anne–style antique wing chair of circa 1725, in walnut and maple, is a product of a New England shop. The cover fabric is the original needlepoint. 46¼ × 31½″. The Metropolitan Museum of Art, New York. Gift of Mrs. J. Insley Blair, 1950.

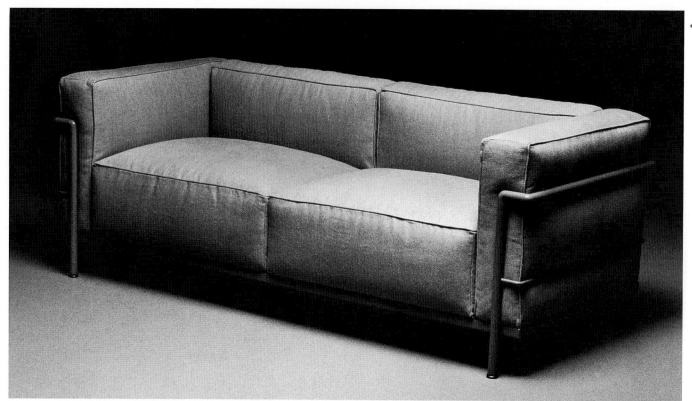

← 13.54

Many excellent designs made less than a hundred years ago may be highly valued and sought after. These are generally covered by the term *collectibles*, which also applies to a great variety of old objects, including both very costly one-of-a-kind pieces and inexpensive mass-produced items.

REPRODUCTIONS OF ANTIQUES

Reproductions are recently made objects that reproduce the design of antique originals, more or less accurately. Good reproductions are extremely accurate copies of particular examples of fine antiques. Makers sometimes go so far as to create finishes (called *distressed* in the trade) that imitate the effects of wear, down to such details as false wormholes.

Many designers frown on the use of reproductions, regarding them as a form of fakery that is dishonest when it truly deceives, foolish when it fails to deceive. Designer and client must judge this issue according to a particular context. For example, reproduction captain's chairs in a restaurant designed in a particular style may seem easier to accept than a brand-new imitation Chippendale *breakfront* in a living room.

Whatever may be said of quality reproductions, bad reproductions, often called *imitations*, which are far more common, are an insult to any sensitive observer. Crude designs labeled "Colonial

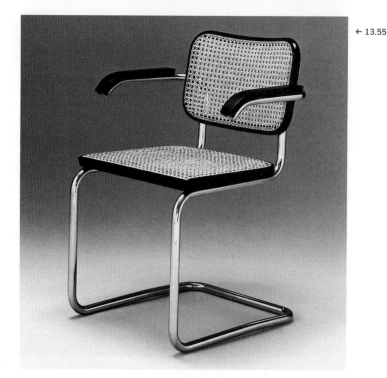

← 13.55

maple," television cabinets of Baroque design reproduced in plastic, and the furniture of nonexistent "periods" such as "Mediterranean" are unacceptable for use in interiors of any genuine design quality.

13.54 A classic modern sofa of 1928 by Le Corbusier is part of a group that includes an armchair, an extended, or wide, armchair, and a love seat. Polished-steel tubing supports rubber straps with surrounding steel springs for the seat and back, which hold the inserted seat, back, and arm cushions. In modern production, the cushions are of polyurethane foam, latex, and rubberized cocoa fibers and are covered in fabric, vinyl, or leather. 28⅜ × 61⅛ × 24¾″. (Photograph courtesy Cassina) **13.55** The Cesca armchair, a famous classic modern design of 1925 by Marcel Breuer, is usually considered the first tubular-steel chair. It is said that on a visit to a bicycle factory, Breuer was impressed with the possibilities of using steel tubing—a strong, economical, and easily manufactured structural material—for furniture. The photograph shows a modern (1968) reproduction currently available. The seat and back frames and arm pads are of hardwood, the seat and back surfaces of handwoven or machine-made caning. 31¾ × 22⅝ × 21⅞″. (Photograph courtesy Knoll International)

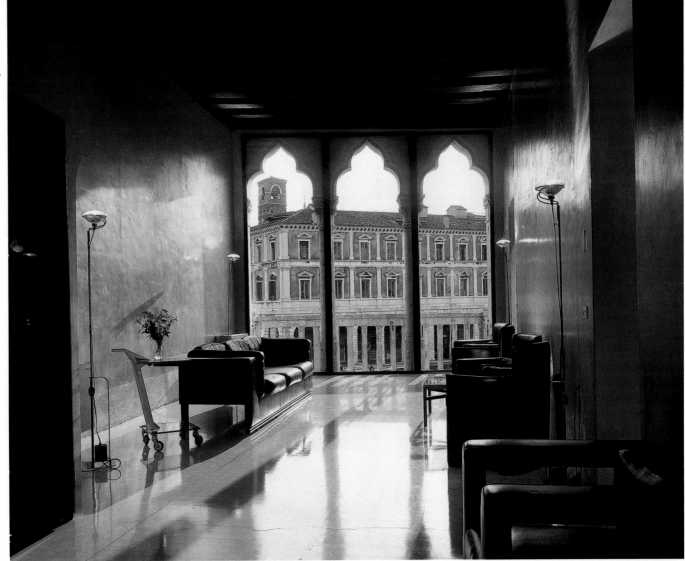

MODERN

Logically, the term *modern* should mean anything new or recent, but it has come to refer to design that is new in concept, particularly the design of the twentieth century related to modern art and committed to simplicity, functional performance, and technology. More specifically, Modern identifies the stylistic directions (also called *International Style*) exemplified by the Bauhaus. Increasingly, we hear the terms *early Modern* (1900 to the 1920s or 1930s) and *classic Modern* (for certain famous designs that have lasted for many years; figs. 13.54, 13.55) to distinguish them from truly recent designs.

Modern furniture (that is, furniture new in concept) has come to be widely used in commercial, institutional, and office interiors. Its residential design use in the United States is still limited to professionals in the design fields and a small public with an aesthetic and intellectual interest in modern art and architecture. After decades of being exposed to it, however, the general public has become increasingly accepting of Modern design, as evidenced by the products illustrated in consumer magazines and sold in retail furniture stores (fig. 13.56).

Early Modern design (of the 1920s and 1930s) is the source of many of the designs now described as "classic." The Modernism of the 1950s, which had gradually fallen out of favor, has recently been rediscovered and is collected, admired, and in some cases put back into production (fig. 13.57). It is interesting to observe the cycles of taste, in which some designs pass out of fashion only to be rediscovered after many years have gone by. It is generally designs of a high level of excellence that find a second life in this manner.

CONTEMPORARY

The simple meaning of *contemporary* is "of or in the style of the present or recent times." It should be an umbrella term to refer to whatever is being made now, but it is generally used to refer to designs that, on the one hand, do not reproduce antiques, and

13.56 Resolutely modern furniture and lighting provide a striking contrast with their Venetian setting. The Palazzo Remer, a fifteenth-century building, has become a hospitality center for the Swiss furniture firm DeSede, whose pieces are displayed here. Paolo Piva was the architect for the building renovation, as well as the designer of the sofa and chairs. (Photograph: © Durston Saylor)

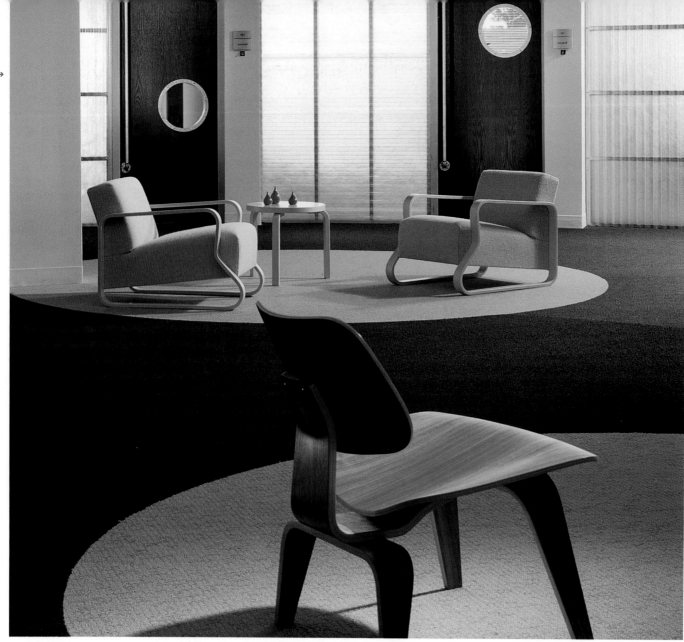

on the other, do not belong to the category known as Modern (fig. 13.58). In the furniture trade, it usually means a current design with no strong stylistic character, furniture that can blend in with almost anything else. The term *transitional*, also sometimes used, is misleading since such designs are not truly between any two identifiable stylistic directions.

POST-MODERN

As a term and a design concept, *Post-Modern* remains somewhat vague. It refers to whatever design trends follow the Modern style discussed above, but so far the new directions explored by designers have led to separate paths rather than a coherent center. More specifically, *Post-Modern* refers to the recent design trend that rejects the strictly functional and logical criteria of the Modern movement in order to introduce elements of whimsy, variety, and, at times, absurdity (figs. 13.59, 13.60, 13.61). References to historical precedents in a contemporary vocabulary or context are not uncommon.

DECONSTRUCTIVIST

Since the development of Post-Modernism called forth a variety of furniture designs, it is reasonable to ask if there will be a similar outpouring of Deconstructivist designs. There are already a number of designs that hint at the broken, torn-apart quality of Deconstructivist architecture (see pages 121–24). Frank O. Gehry has been an active furniture designer, and his recent works have an inevitable association with Deconstructivism.

13.57 Furniture developed in the 1950s or before has returned to popularity and continues in use. Here, lounge chairs and table by Alvar Aalto and a molded plywood chair by Charles and Ray Eames are at home in the entry lobby of a cutting-edge telecommunications firm, Nokia IPRG, San Francisco, as designed by Gensler & Associates Architects/San Francisco. (Photograph: Christopher Barrett © Hedrich Blessing)

His lamps, perhaps more than his chairs, seem to relate to the Deconstructivist urge. The work of Philippe Starck, with its sharp points and willful twists, can also be thought of as having connections with this turn in design thinking It is hard to visualize ways in which the mundane needs of home furniture or office systems and other contract furniture products might be influenced by the Deconstructivist direction, but past experience suggests that every development in architectural thinking finds its way into interior design, whether in furniture or in other products.

CRAFT AND ART FURNITURE

Recent years have seen an upsurge of interest in furniture designed and made by craftspeople, either by hand or with limited shop equipment (fig. 13.62). Their furniture displays a wide range of construction and design. Of course, even the finest craft skills do not assure good design skills. At its best, craft furniture is both useful and interesting, and may take on some of the qualities of an individual work of art as well. This latter quality comes to the fore when artists choose to make objects of furniture vehicles for artistic creativity (fig. 13.63). The level of usefulness varies, as does the quality of the artistic expression involved. While furniture as art is generally costly and often individualistic to the point of eccentricity, it opens up a relatively new and adventurous channel of artistic expression for the interior.

13.58 The Stuart sofa, an example of contemporary-style furniture, is in current production but has no characteristics of the modern, or forward-looking, style. On the other hand, it imitates no particular historic period. It is simply graceful and comfortable in appearance and in performance. (Photograph courtesy Brunschwig & Fils) **13.59** Nathalie du Pasquier's Royal couch is a classic example of the Memphis orientation, one of the many design trends that are considered Post-Modern. The surfaces are of plastic laminate in various patterns; the cotton fabric that covers the cushion and armrest is a design by George J. Sowden. (Photograph courtesy Memphis/Milano) **13.60** An armchair and ottoman, experimental designs by Frank O. Gehry named by him "Striped Beaver", explore the use of corrugated cardboard as a material for seating furniture. They were produced in a limited edition by Vitra 2005. (Courtesy Vitra)

13.61 This "Late Sofa", modular clipping system, and lamp were designed by Ronan & Erwan Bouroullec and manufactured by Vitra and Belux. **13.62** In this handcrafted walnut rocking chair, Sam Maloof of Alta Loma, California, displays both a woodworker's skill and a designer's sensitivity. 45 × 27¾ × 46″. Museum of Fine Arts, Boston. Purchased through funds from the National Endowment for the Arts and the Gillette Corporation. **13.63** Furniture is sometimes custom-times custom-designed for a specific space by artists or sculptors whose interest in expressive form transcends the merely utilitarian. These tables and chairs, designed by artist and designer Lisa Lombardi, are fantastic elaborations of vegetable motifs. The interior in Santa Monica, California, was designed by Brian A. Murphy.

(Photograph: © 1986 Tim Street-Porter)

case study 8. A Table Supported by Two Pillars

MINORU YOKOYAMA (CONCERTINO, TOKYO), DESIGNER

In traditional Japanese architectural and interior design, furniture plays little part. Interiors are usually empty except for objects that are brought out temporarily for a particular use. With increasing contact with Western ways, Japanese design has turned to development of furniture that combines Japanese traditional thinking about materials and crafts with study of what furniture might be. In this project, Minoru Yokoyama has approached the design of a table as an essay in aesthetic values and craft techniques.

In Japanese design, the development of wood joints serves both practical and aesthetic goals. Joints are designed to avoid the use of screws, nails, or glue, and are exercises in both ingenuity and artistic expression (fig. 13.64). Yokoyama's table uses a glass top that can be placed at the low height favored in Japan (fig. 13.65) or at the standard Western table height (fig. 13.66), or at a high position for standing users.

Two columns rise from a black granite base. A horizontal wood bar and two short cross bars are placed at the desired height. A top of either clear or frosted glass is lowered into place with the support pillars passing through holes cut in the glass. The vertical columns are made up of separate pieces, as many as needed for the selected height with ingenious lock-together joints between the sections. The long horizontal bar is made from two pieces with another ingenious carved joint. The horizontals pass through mortises (holes) in the columns and are locked in with wood wedges.

The beauty of the joinery (figs. 13.67–13.69) and the overall proportions of the assembled table combine to make an object of great elegance as well as a table available for practical use.

← 13.64

← 13.65

← 13.66

13.64 A rough sketch shows the concept of the table as it first emerged. (Courtesy Minoru Yokoyama) **13.65** In this technical drawing the tabletop is in the low (Japanese) position. The drawing was prepared by Sakura International Inc. for the production version of the design.

The notes are in Japanese, the dimensions metric. (Courtesy Minoru Yokoyama) **13.66** A detail drawing shows the interlock joint for the sections of the vertical column. The interlocking positive and negative forms are cut at a 45-degree angle, making the joint rigid

both front-to-back and sideways. (Courtesy Minoru Yokoyama)

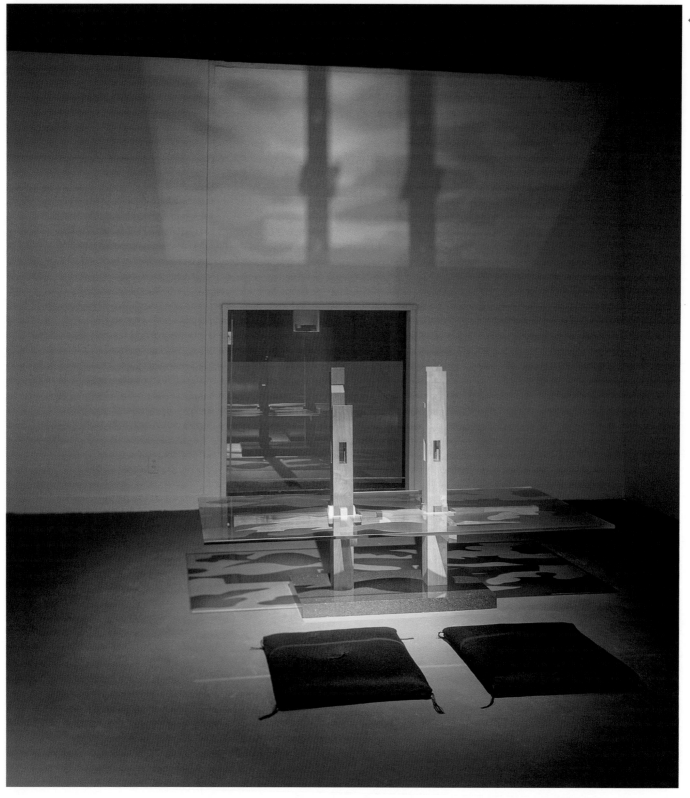

← 13.67

13.67, 13.68 These two views show the completed table with the top set at the Japanese height (fig. 13.67) (Photograph: Tomo Isoyama, courtesy Minoru Yokoyama) and at standard Western height (fig. 13.68). (Photograph: ANJU, courtesy Minoru Yokoyama)

13.69 This detail shows the intersection of vertical pillar and horizontal bars with wood wedges locking the joint. (Photograph: ANJU, courtesy Minoru Yokoyama)

13.68 →

13.69 →

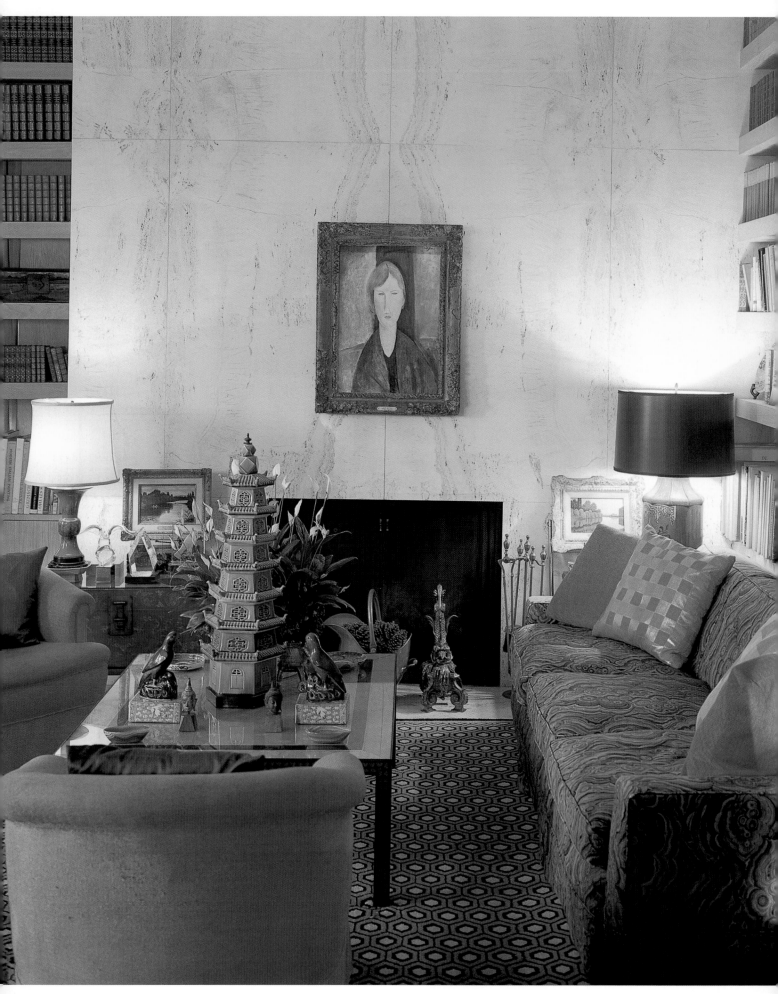

chapter fourteen. Accessories, Art, Signage

A completed interior of outstanding design with all materials, furniture, and equipment in place will often seem in some way incomplete, in a sense, unoccupied. Spaces come to life with the addition of elements expressive of individual character—the character of the users or occupants of the space or the character developed by the designer to express the less personal individuality of an organization, corporation, or institution. These elements can generally be identified as belonging to one of two classes: accessories or works of art. The dividing line is not absolute; some things fall into an overlapping area.

The term *accessories* covers a vast variety of objects, usually smaller in scale than furniture, that may be introduced into a space to serve a practical purpose (figs. 14.2, 14.3) or for ornament or display or for some combination of these purposes. Stage designers fully realize the importance of appropriate accessories in making a theatrical set express time, place, and character. Photographers photographing interiors often provide their own accessories and make a point of moving—or removing—small objects in order to show the space at its best.

Works of art are most familiar in the form of mural paintings or two-dimensional pictures hung on walls, but three-dimensional sculpture, bas-relief or in the round, can be fully integrated into interior space. While painting is regarded as the primary art form of a two-dimensional nature, the other two-dimensional mediums, such as the various printmaking techniques, weaving, photography, and other types of graphic art,

are probably more often used than original painting to bring visual variety and interest into interior spaces.

In residential interiors, owners or occupants introduce objects or possessions that may be familiar and beloved or simply necessary and useful. The results vary from charming and interesting to cluttered and messy. The interior designer can affect the outcome by acting as an advisor, helping with placement, perhaps selecting new and different objects, and frequently suggesting the elimination of objects that cannot be successfully placed or that detract from the visual effect of the space because of poor design quality. This last function calls for special tact and persuasive ability.

Although public spaces such as lobbies, restaurants, and shops do not involve such personal issues, providing decorative objects or art is an important way to add warmth. The interior designer may play a role in selecting or suggesting art, as well as useful accessories. Private offices fall in a middle ground between public and personal spaces, with occupants often eager to differentiate their spaces from identical units by personalizing them. Motivated by a sense of responsibility and pride in a job well done, the designer will usually direct and control the choice and placement of accessory and art elements rather than leave all this to the occupants. Many clients want and appreciate help with these matters.

Accessories and works of art are often treated as incidentals added almost as an afterthought. This approach may work when only a few practical necessities are required, but it is usually wise to give more design attention to these elements. A major work of

14.1 In the sitting room of the Ducommon House in Bel Air, California, an Amedeo Modigliani painting asserts itself as a primary focal point. Many accessories and two small paintings play supporting roles. Tony Duquette was the interior designer. (Photograph: Tim Street-Porter)

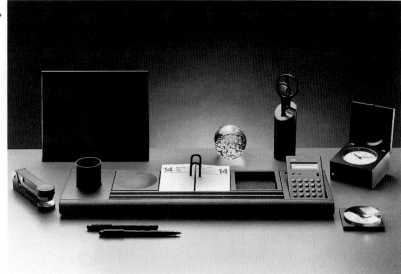

art can dominate a space and influence all other design decisions (about color, materials, and furniture placement) (see fig. 14.1). An art collection can have a similarly important role, or it can be displayed as a more incidental, background contribution to the totality of a space.

Accessories, especially items such as wastebaskets and vases, are more likely to play a background role, although a large collection of objects or a single object of strong character can also become a major design focus. A handsome clock, a ship model, or a framed map or chart can, like an artwork, dominate an interior.

Of all the elements of an interior, accessories and artworks are among the easiest to relocate, remove, or replace: a ship model can be replaced by a clock; new vases can replace old; a painting can be relocated or removed. Such flexibility makes decisions about these objects less binding—but no less important than decisions about more lasting elements.

Dealing with accessories and artworks involves several interrelated concerns. It is helpful to anticipate various practical needs and provide for them in order to avoid makeshift and unattractive solutions later on. For example, it is possible to include such items as umbrella holders, coat racks, calendars, bulletin boards, signs, and displays in ways that enhance a design. If these are not planned for, ad hoc approaches to dealing with such needs can be unfortunate.

It is important to provide for specific objects of a personal or sentimental value that occupants of spaces want on view in a way that satisfies their owners without compromising the design. These may include inherited pieces, trophies, or souvenirs that may or may not have aesthetic merit. A collection of shells, boxes, or toys, a hunting or fishing trophy, or a framed document

can usually be fitted into an interior if planned for. If not, it may later be inappropriately placed, creating visual clutter.

The introduction of well-chosen accessories and artworks can add to the interest and aesthetic quality of a space while reducing a sense of bareness or incompleteness. Making good choices in these areas is part of the designer's job. A well-chosen artwork placed in an inviting space satisfies those who see it. At the same time, it preempts a less appropriate display.

Accessories

The term *accessories* refers to the incidental objects, useful, decorative, or both, that may be added to the interior over and above basic furniture and equipment. Such objects are usually portable and subject to frequent change. Many of the items in this class are small, even trivial, so that discovery of sources for well-designed examples may take some searching. Sources may include consumer retail outlets (department stores, mail-order houses, and computer on-line businesses and auction sites), craft shops, and galleries, as well as reputable, design-oriented showrooms. It is helpful to build up a file of sources with brochures, advertisements, printouts, and magazine tear sheets. The most serviceable file will include a wide range of stylistic types in every object category. Some interiors, especially true period rooms, demand accessories that match their styles and periods (fig. 14.4). On the other hand, in many modern interiors, smaller objects from earlier traditions may fit very well. Vases and candlesticks, clocks, or ship models from some past era can

14.2 Designer Roger Zenn Kaufman's Becker desk organizer turns the familiar desktop clutter of calendar, calculator, pencil, pen, and clip holders into an ornamental and positive object—perhaps a bit of a status designator as well. (Photograph courtesy Sointu, New York) **14.3** Many modern designers have come to view minor, functional accessories as worthy territory for the introduction of creative ideas into general circulation. This magazine rack, by Dutch designer Ann Mae, has an active, sculptural quality that enhances its simple utility. (Photograph courtesy Sointu, New York) **14.4** In an authentically traditional interior, period accessories, such as the teapot and porcelain ware, create a consistent character. This is easier to achieve in a museum display than in an environment in daily use. The Federal period room illustrated, from the Phelps-Hathaway House, built circa 1765 and redone in 1788–89, in Suffield, Connecticut, preserves its original architectural details and wall treatment. It is now installed at the Henry Francis du Pont Winterthur Museum, Winterthur, Delaware. (Photograph: Lizzie Himmel)

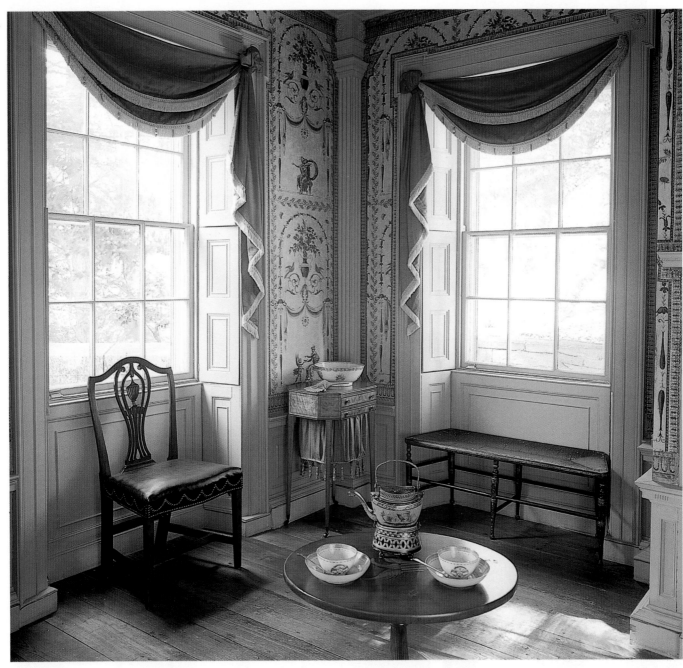

be made very much at home in an otherwise contemporary interior (see fig. 14.17).

PRACTICAL ACCESSORIES

Practical accessories, such as cooking equipment, should be considered in relation to the particular functions of each space in which they will be placed. The designer has an obligation to aid in the selection of items that will be fixed in place or built-in and will often have a role in choosing things that will be movable but in regular use. Other, more transient objects may or may not come under the designer's province. The selection of linens, tableware; and bathroom accessories, for example, often an important part of a restaurant's design, may become the designer's responsibility, while residential clients may want to make their own choices of these items, may already own these objects, or may want design help in selecting them (figs. 14.5, 14.6).

Reviewing a checklist of accessory items for various kinds of spaces may help to make such objects a planned part of the design rather than intrusions in a space. (See Table 28, "Accessories Checklist," page 445.)

DECORATIVE ACCESSORIES

Decorative accessories other than works of art exist in infinite variety, often combining some degree of usefulness with a primarily decorative role (figs. 14.7–14.13). Objects may be modern, antique, indigenous, or of craft origins, and they need not always match the style of an interior. Choices may be based on the preferences or interests of the occupants (as with personal collections, trophies, and heirlooms) or may relate to the character and use of the space. A collector of old toys or tools may want to display some or all of a collection (see fig. 14.21); an enthusiastic gardener will want vases and other containers for cut flowers. A ship

14.5 →

14.6 ↑

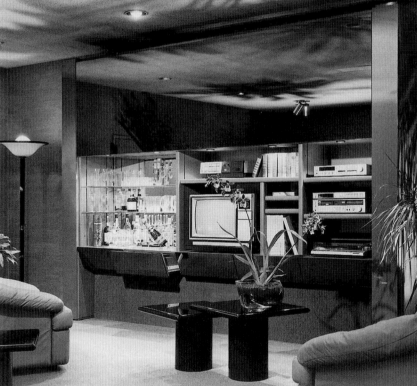

← 14.7

14.5 In a bathroom of the Middleton Inn, Charleston, South Carolina, Clark & Menefee Architects have converted a rather austerely architectural environment into an inviting space by realizing the potential aesthetic value of familiar bathroom accessories. As arranged here, towels, a basket of washcloths, and the soap and soap dish are vehicles for bringing color and texture into the room. (Photograph: © Tom Crane) **14.6** The equipment of dining, particularly formal dining, belongs to a special class of practical accessories that are also decorative. In this table setting for two attractive groupings of plates and napkins, glassware and silver, candles and flowers make it clear that the meal to come will be a special occasion. (Photograph courtesy *Gourmet*) **14.7** Wall systems contain and organize the various odds and ends that modern living calls for and that may otherwise turn into clutter. Audio equipment, TV, books, bottles, and glassware become decorative when they fit into the planned wall system made by Cy Mann Designs. (Photograph courtesy Cy Mann)

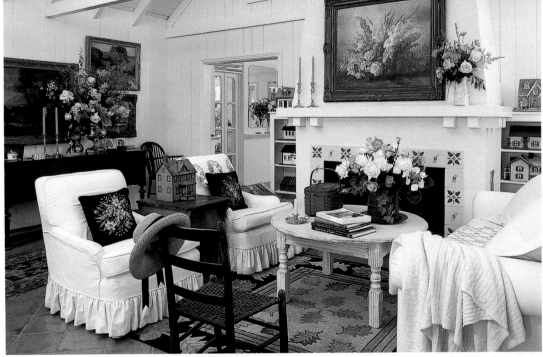

← 14.8

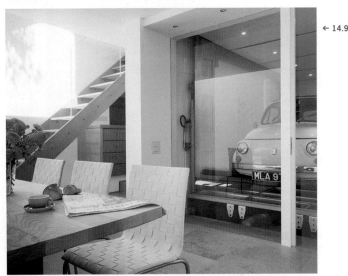

← 14.9

model might be appropriate in the office of a shipping or engineering company; restaurants often display objects that relate to a national or regional style of cookery or to other menu elements.

PLANTS

Live plants are a particularly attractive decorative accessory (figs. 14.14, 14.15). Even one small plant in a room tends to make the space seem pleasant and civilized. Larger plants, groups of plants, even growing trees can find a place in larger spaces. The provision of containers, planters, plant boxes, even whole greenhouse or conservatory areas is a normal part of the designer's work. Plant selection may be done by the designer alone, by the designer and client together, or by a specialized consultant. (See Table 29, "Indoor Plants," page 447.) The dryness or humidity of the interior needs consideration.

The obvious aesthetic values of plants are augmented by an increasing realization that they also have a favorable impact on health and the environment. Plants absorb ("breathe in") carbon dioxide and gases considered air pollutants and give off oxygen. It has been shown that a single plant can maintain an atmosphere free of formaldehyde (a common interior pollutant) for each 1,000 cubic feet of enclosed interior space. Plants are also excellent non-mechanical humidifiers, releasing moisture vapor derived from the water they require to survive. A few plants have leaves or berries that can be injurious or toxic if ingested by children or pets and thus are best avoided in residential interiors.

Plants must be located so that they receive light of the intensity and duration appropriate to their species. Each plant type can be classified according to how much daylight or artificial light it requires. Fluorescent light or special *grow lights* can substitute for natural daylight, and many species require only limited light. It is the designer's responsibility to see that light provided, plant location, and species are adjusted to particularities of the interior to ensure plant growth and survival.

Arrangements must also be made for proper and consistent watering. In placing plants, it is important to be sure that watering and maintenance will be practical. Plants placed up high or hanging must be made accessible for watering and other care in some way, possibly with an adjustable suspension so that out-of-reach containers can be lowered for service and returned to their normal positions, much as light fixtures can be lowered and raised for relamping.

14.8 In a renovation of a 1929 cottage in Malibu, California, artist Andrea Dern has used a variety of decorative accessories, including cushions and paintings with floral motifs that relate closely to the cut-flower arrangements. (Photograph: © Chris Mead, courtesy *House & Garden*) **14.9** An automobile in the dining room of a house must surely be the most remarkable decorative accessory imaginable. In this mews house in London, designed by Seth Stein Architects, the client was a car collector and welcomed a room that was, in fact, an elevator large enough to hold a car and move it to the living space levels in the house. (Photograph: © Arcaid/Richard Bryant)

← 14.10

14.12 ↓

14.11 →

When plants are used as design elements in a corporate interior, it is frequently best to arrange for the services of a special supplier who will not only sell plants but also provide regular care, rotating or replacing plants as necessary. Such a service may lease the plants or sell them outright while providing a contract for continuing maintenance. Plant suppliers can furnish lists, illustrations, and examples of various species along with information about size range, light, and water requirements. The advice of experienced suppliers can usually be trusted when the supplier will also be performing maintenance. Occupants of a corporate space often wish to buy or bring plants of their own; care must be taken that plant diseases or parasites are not introduced to the detriment of healthy plants already in place.

Artificial plants and flowers are usually regarded as unacceptable in well-designed interiors. Arrangements of dried flowers, leaves, or grasses are sometimes effective as decorative elements,

14.10 The studio of the Italian writer, soldier, and political leader Gabriele D'Annunzio is crowded with possessions that had special meaning for their owner. Their quality and the obvious concern with which they have been collected and displayed turn them into a fascinating reflection of personality. A similar density of accessories of lesser quality, chosen at random, would make a space look crowded and busy. (Photograph: © Robert Emmett Bright, Photo Researchers, Inc.) **14.11** Designed by the owner, a collection of small carved-ivory objects and an ivory model of a ship become a decorative display set out on tables, with a ceramic tureen and candlesticks as background and a framed hunting scene above. (Photograph: Lizzie Himmel, courtesy *House Beautiful*) **14.12** In the home of a professional musician designed by Melvin Dwork, musical equipment plays an essential role. The handsome piano is an important piece of furniture, surrounded by music recording apparatus. The library of music scores strikes a decorative note; the seating furniture is angled for listening. (Photograph: Jaime Ardiles-Arce)

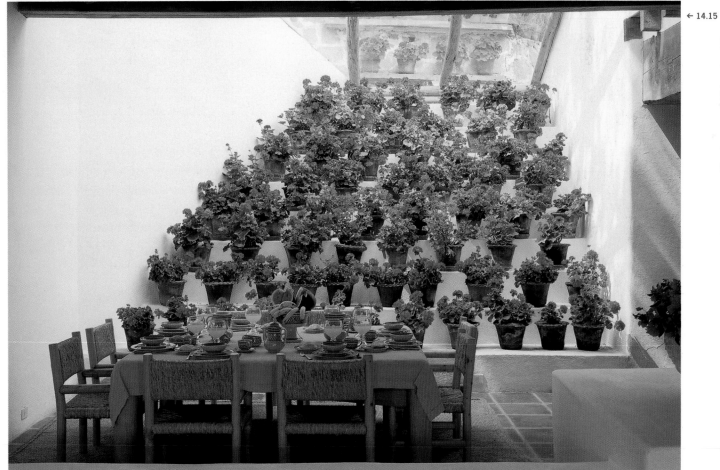

14.13 In the Santa Monica, California, home designed by Charles Eames, his wife, the designer Ray Eames, arranged the placement of a fantastic collection of objects, which, along with rugs and textiles covering seating and cushions, made of the house a virtual museum. The display constantly changed as the Eameses found new and beautiful things to look at and love. (Photograph: Tim Street-Porter, © 2002 Eames Office)

14.14 Flowering jasmine and orange trees are a striking foil to all-white furnishings in the orangerie of designer Holly Hunt's light-filled, high-ceilinged apartment, Chicago, Illinois. (Photograph: Melanie Acevedo. Originally appeared in *House & Garden*)

14.15 Live plants often provide decorative accents in an interior. In this dining room an extraordinary display of plants in a pyramidal arrangement becomes the primary visual element. The project in Valle de Bravo, Mexico, was designed by José de Yturbe. (Photograph: Tim Street-Porter)

Table 28. Accessories Checklist

ENTRANCE AREAS

- Coatracks or hangers
- Umbrella and overshoe and boot holders
- Protective mats or runners for the floor
- Bell pushes, intercom plates, closed-circuit TV
- Mailboxes or trays, message boards
- Signs, bulletin boards
- Nameplates

LIVING SPACES

- Small tables or stands
- Stools, hassocks
- Cushions
- Bookshelves or racks
- Music and video components; record, tape, cassette, CD, and DVD storage
- Ashtrays
- Wastebaskets
- Flower containers
- Planters and plants
- Clock
- Frames or other display devices
- Telephone, intercom
- Answering machine

DINING SPACES

- Serving cart, trays
- Placemats and tablecloths
- Flatware and hollowware
- Dishes and serving pieces, glassware
- Candlesticks or candleholders
- Trivets or hot pads

KITCHEN AND PANTRY SPACES

- Storage/display for cooking pots and utensils
- Storage or display or both for staples, bottled items
- Canisters
- Storage or display or both for dishes, glassware, and other tableware
- Racks or other holders for towels, potholders
- Cutting, rolling, mixing boards
- Scales
- Spice rack

- List and memo pads
- Cookbook storage
- Clock, radio, TV
- Telephone
- Small and larger appliances
- Special plumbing hardware

BEDROOMS

- Bedcovers, quilts, blankets, and so on
- Pillows, cushions
- Bedside stands or tables
- Clock
- Radio or TV or both
- Mirror(s)
- Dressing accessories (brushes, combs, and so on)
- Telephone

BATHROOMS (PRIVATE)

- Towel rack(s)
- Soap dish(es), toilet-paper holder, toothbrush and glass holder
- Medicine cabinet
- Mirror(s)
- Scale
- Towels, mats

BATHROOMS (PUBLIC)

- Paper-towel dispenser, discard container
- Liquid-soap dispenser
- Coat hooks

OFFICES

- Desk accessories (pads, holders for pens, pencils, paper clips, scissors, and so on)
- Telephone(s) or intercom unit or both
- Clock
- Calendar
- Computer and associated equipment
- Printer, paper shredder, and other electric or electronic business equipment
- Tackboard/chalkboard
- Letter trays
- Address and phone number directories
- Radio or music and video components

GENERAL (ITEMS THAT MAY BE CONSIDERED FOR ANY SPACE)

- Portable lighting (lamps: task, ambient accent)
- Telephone and directories
- Ashtrays or sand urns
- Wastebaskets
- Flowers and vases
- Plants and planters
- Terrarium
- Tack (pin-up) surfaces
- Storage (books, magazines, papers, records, tapes, CDs, DVDs, special purpose)
- Fireplace tools, fire screens, wood basket
- Display pedestals (plaster or glass cases, panels)
- Mirror
- Clock
- Computer
- Printer

SPECIAL-PURPOSE SPACES AND PUBLIC SPACES

- Directory, signs, location plan
- Graphic materials (brochures, menus, wine lists, printed forms)

CHILDREN-CENTERED ITEMS

- Toys and toy storage
- Play equipment

PET-CENTERED ITEMS

- Birdcage
- Aquarium
- Bed
- Litter box
- Scratching post
- Dishes

MUSIC-ORIENTED ITEMS

- Instruments
- Music stand
- Music storage

ming aralia

schefflera

aspidistra

column cactus

Janet Craig dracaena

benjamina ficus

fiddle-leaf ficus

bamboo palm

rubber plant

snake plant

yucca

Boston fern

jade plant

heartleaf philodendron

Norfolk pine

pothos

spider plant

Table 29. Indoor Plants

	PLANT NAME	HEIGHT*	WIDTH*	POT DIAMETER*	LIGHT REQ'D**	WATER REQ'D***
FLOOR PLANTS AND TREES	Aspidistra	18–40	12–36	6–14	L	M
	Cactus (Candelabra)	4–30	8–18	6–14	M	D
	Cactus (Column)	4–20	6–18	6–17	M	D
	Dracaena (Janet Craig)	16–60	12–28	6–17	M	M
	Ficus (several varieties)	18–240	12–60	6–48	H	M
	Ficus (Fiddle-leaf)	36–84	12–30	10–17	H	W
	Ming Aralia (*Polyscias fructicosa*)	12–48	8–24	6–14	H	M
	Palm (Bamboo)	14–28	8–24	8–21	M	M
	Palm (Dwarf Date)	24–54	18–42	8–21	H	W
	Palm (Kentia)	36–72	12–24	10–17	M	M
	Palm (Lady)	26–120	20–60	10–21	M	W
	Rubber plant	24–96	18–40	6–16	M	M
	Snake plant (*Sansevieria trifasciata*)	12–36	8–16	6–14	M	D
	Schefflera	18–96	10–48	6–17	M	M
	Yucca	15–96	8–24	6–17	M	D
SMALLER TABLE AND HANGING PLANTS	Ferns (various)	12–28	12–36	6–12	H	W
	Ivy (Grape)	6–10	R***	6–10	M	M
	Jade plant	12–30†	12–28	5–10	M	D
	Philodendron (Heart-leaf)	6–10†	R***	6–10	L	W
	Pine (Norfolk)	12–30†	10–24	5–10	M	M
	Pothos	6–10†	R***	6–10	L	M
	Spider plant	variable size			M	W
	Flowering plants (various)	variable sizes, range, and requirements				

* Heights, widths, and pot diameters are given in inches. ** Light requirements: L = 50–75 fc (footcandles), M = 75–100 fc, H = 200 + fc
*** Water requirements: D = less than average, M = average, W = more than average. ****R = runner plant, variable width and form. † Can grow into full-size tree.

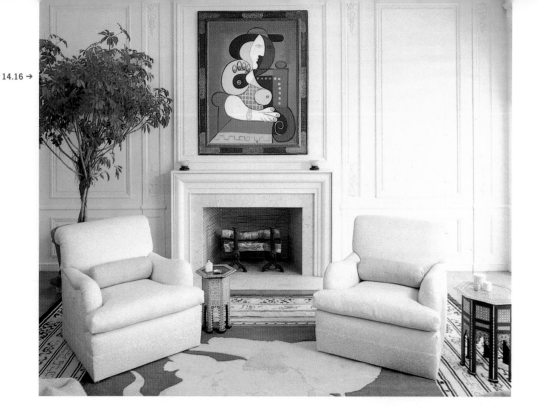

14.16 →

although they offer none of the health benefits of growing plants. Cut flowers make attractive accessories, yet because they are transient they rarely come within the concern of an interior designer. Occupants of an interior may select and place flowers, of course, with the aesthetic effect determined by their taste and budget and the flowers available at local sources. In some spaces a regular program of cut-flower display is established, making the flowers a clear design element in spite of their brief life and need for constant replacement. The presence of flowers can have a strongly favorable impact on a sense of style.

A list of decorative accessories could be endless, and choices are not generally specific to any particular functional use. Arbitrarily introducing decorative accessories for no reason other than to fill space or add interest may well add nothing more than clutter. In doubtful situations, it is usually best to omit display. Errors of omission are far less common than errors of excessive inclusion. Inclusion should perhaps be reserved for times when occupants demand certain objects on display or when the projection of a particular atmosphere or spirit calls for visual support.

Art

The practice of including works of art as integral parts of interiors has a long history. Prehistoric cave paintings, the wall paintings and bas-reliefs of Egyptian tombs, the wall paintings at Pompeii, and the great frescoes of the Renaissance all bear witness to the continuing human urge to make art an important element of our surroundings. During the Renaissance, the framed easel painting became the most popular form of artwork in interiors, and it has remained so, with murals, sculpture, and a wide variety of art forms other frequent choices.

It seems to be widely felt that an interior is not really complete until the process of "hanging some pictures" has filled up any blank wall areas. In practice, the habit of putting up indifferent or bad works that have no special value or meaning for the occupants of a space often does nothing but add pointless clutter to the visual scenes. Bare walls can be handsome and restful, and a truly fine work of art is usually seen to best advantage displayed in uncluttered surroundings (figs. 14.16, 14.17).

SELECTING ARTWORK

The selection of artwork generally follows one or both of two patterns. When works are already on hand—owned, borrowed, or previously chosen for purchase—further selection may be necessary to decide which to display, which to store, which to dispose of. Works to be displayed must then be placed, although available display space may well influence the choice of certain works. Alternatively, works are selected and purchased for specific locations.

The first situation arises when the occupants of a space are art collectors, who may own far more than can possibly be put on view at one time. Other occupants want to display works they are

14.16 A truly fine, major work of art such as this Picasso is generally best given an important location in a simple and uncluttered setting. The painting clearly dominates and sets the character of this otherwise subdued, traditionally detailed space, with furniture designed by Emily Landau placed to emphasize the importance of the work. (Photograph: © Henry Bowles, Courtesy House & Garden)
14.17 Plain walls and large windows define the space in this modern Italian building. The paintings, rugs, small ancient Asian sculptures, and other decorative objects create warmth, liveliness, and interest and show up particularly well in the otherwise reserved setting. (Photograph: Guy Bouchet)

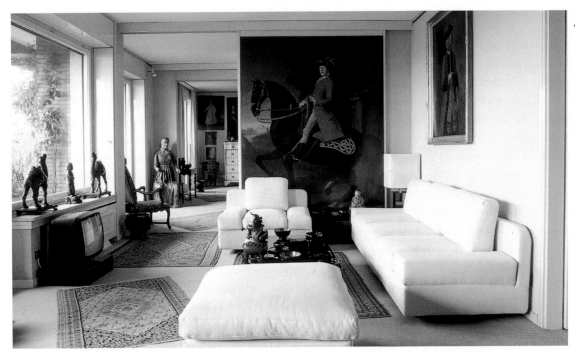

← 14.17

attached to, such as family portraits, works by a friend or relative, or simply favorites, aside from their artistic merits. In the corporate world, such works as portraits of a founder or former officials, a view of important buildings or events, and similar materials, valued for historic or sentimental reasons over aesthetic merit, may be selected by the client for display.

In private homes or private offices, it is usually possible to find locations where such materials can be put on view to the satisfaction of the occupants. If the spaces are used by visitors or the general public, the designer may try to discourage, exercising ingenuity and tact, display of inferior materials. Failing this, it may be possible to turn such material into something of a historical exhibit rather than an art display. Fortunately, many modern corporations have become major collectors of high-quality artworks. In this case, it is usually easy to place good works in prominent locations and to find more obscure placement for less attractive works that still are wanted on display.

When art is to be specifically acquired for a particular interior project, designer and client must work together to make choices and plan placement. Specialized consultants can help to steer a course through the often-confusing world of art markets, both in terms of finding suitable works and giving advice related to costs and budgets. Such consultants may assist significantly in developing a major collection of valuable works. In any case, it is extremely important to verify the consultant's credentials, since the art world, like all businesses, has its share of unscrupulous practices.

Paintings A great variety of artworks may be considered for acquisition and display. Paintings often come to mind as the most suitable works for wall hanging. Certainly, almost any subject matter, size, shape, color tonality, period, or style can be found amid the vast output of artists who have worked or are currently working in this form. Major works by important

artists, whether old master or modern, have become very costly. They are sold through art auctions, well-known galleries, and eminent dealers. While no guarantees can be given, they may turn out to be excellent investments.

Works of less well known artists, secondary historic figures, and younger living artists who have not made major reputations are more likely to be available at affordable prices. As investments, they carry an even more uncertain future. Even so, modestly priced works selected for their visual merit rather than for name value and price will often be a more workable choice, especially if an unlimited budget is not available.

There is also a seemingly endless supply of inferior work, banal, glibly illustrative, and cliché-ridden. This all too often appeals to the unaware who simply want a spot of color to fill a given space. One can learn to distinguish good art from bad by studying high-quality work directly in museums, major galleries, and through reproductions in books. This does not mean that all the work of unknown artists is bad, but those who have no background in art might do well to avoid the unknown in favor of artists backed by a reputable gallery or by critical approval. This applies to works of art in all other mediums as well.

Drawings and Prints Works on paper, usually classified as drawings even if they are in watercolors or pastels, are generally smaller in scale and more delicate in character than oil paintings. They are entirely suitable to smaller and more intimate interior spaces. They tend to cost less than larger works by the same artist; in fact, drawings by artists of major reputation are sometimes priced at levels accessible to medium-level budgets.

Prints, or, as they are now often called, *multiples*, are works in one or another medium that permits the making of many copies of a work through some printing technique. Original prints are made from a printing medium such as the copperplate of the engraving

and etching, the crayoned stone or metal plate of the lithograph, or the stencil screen of the silk-screen print worked directly by the hand of the artist or under the artist's direct supervision. The artist signs and numbers each perfect print with figures that indicate the total number of copies printed (the edition) and the order in which the particular print was made (for example, 30/100 indicates the thirtieth impression in an edition of one hundred). After printing, the plate, stone, or screen is destroyed so that additional, possibly inferior, prints cannot be made. Editions are usually small, in the range of 50 to 500 copies. Prints of lesser quality are sometimes produced in large numbers without the participation of the artist, without a signature, with a signature printed from the plate or stone, or even with a forged signature.

A print's monetary value largely depends on the number and signature, but the visual value can be determined by simple inspection. Prints produced in large volume, reasonably priced, are often an excellent choice for spaces such as hotels or large office projects that need many artworks. People of average means who wish to start an art collection do well to begin with prints since works of good quality at affordable prices are available and because an extensive collection can be compactly stored in a small space. Such collectors may put a few works on display in rotation.

Photography is another medium that produces prints. The investor should again look for signed and numbered originals printed by the photographer or under direct supervision in limited editions. While photography is a relatively young medium, its practitioners already include a great many established artists whose work is of serious merit, as well as an increasing number of young photographers working in creative ways.

Reproductions All of the methods of producing original works, whether unique or in multiples, must be distinguished from *reproductions*, versions of an original in which the artist had no role. These are usually different from the original in size, medium, and technique. In quality, they range from very inferior to quite good. One method of reproduction is the hand copying of known paintings, often by artists of some skill. The results are nevertheless generally of disappointing quality and should not be considered worthy of display except, possibly, as a kind of theatrical prop in some commercial spaces—restaurants or bars, perhaps, where a particular character is sought.

The more common form of reproduction is by modern photomechanical means on color printing presses, usually in large quantities. The original work is photographed, and plates or films are made with a screen, which creates the tiny dots of halftone printing. Full-color printing requires four color inks, each printed from its own plate or film. Such color reproduction, commonplace in books and magazines, is used to make the cards and reproduction prints sold in museum shops and other art outlets. The process can always be easily identified by looking through a magnifying glass for the halftone dot pattern.

Reproductions relate to original artworks much as records or tapes relate to live musical performance. They may be of excellent quality and make works accessible for study and enjoyment at any place or time, yet they are undeniably different from the original they reproduce and can never successfully pretend to be anything but reproductions. When and if reproductions should be used for display in an interior is a somewhat debatable question. There is a certain absurdity in framing and hanging a reproduction of a major work: if bad, it makes a poor substitute for the original; if excellent, it involves a level of pretense best avoided.

Reproduced art certainly can offer beauty and satisfaction, but it should always be used in a way that makes its status clear. This may be why posters that reproduce an artwork often seem the most attractive form of reproduction. Those produced by museums and galleries are usually graphically well designed. A poster with its printed legend included also may serve as a reminder of a trip, an exhibition visit, or some other event that connects the artwork with personal experience. Posters have become collectors' items, with prices ranging from modest sums for modern posters to substantial sums for old and rare examples.

Other Artworks Many other kinds of artwork can be considered for interior display. Some functional objects of superior visual quality become art-worthy when they are displayed in a way comparable to other art forms.

The following list suggests some of the many possibilities:

- Advertisements (for example, posters)
- Architectural drawings
- Architectural ornaments
 Iron or bronze
 Stone
 Terra cotta
- Arms and armor
- Autographs, letters, documents
- Blankets (for example, Native American)
- Implements (industrial, agricultural)
- Indigenous artworks
- Manuscripts, music
- Maps and charts
- Quilts
- Rugs
- Sculpture
 Ceramic
 Glass
 Metal
 Mixed materials
 Mobile
 Stone
 Wood
- Tapestries

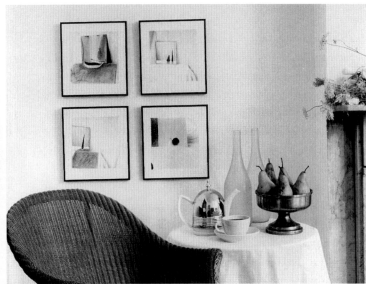

- Technical (engineering) drawings
- Textiles
- Tools (antique)
- Weavings

When art purchases of any magnitude are contemplated, it is wise to seek advice from disinterested experts. The art world is not immune from dishonest practices. Traps for the unwary to guard against include unscrupulous dealers who try to pass off copies, prints, reproductions, and other works of little value as originals and the buying of forgeries or stolen works. Even expert collectors and major museums are sometimes taken in by frauds. Expert opinion is the buyer's best protection, including a second opinion when called for. Besides art consultants, museum curators and collectors with a good knowledge of a particular field and its prices are qualified experts.

FRAMING AND PLACING ARTWORK

In addition to a role in selecting and possibly purchasing art, the designer is likely to be involved in decisions about mounting and framing art. The way museums and galleries frame and hang works provides guidance in these areas. Historic art is often displayed with framing contemporary with the work, often of considerable, even excessive, elaboration. With modern art, the tendency is to use simple, even minimal, framing or to omit frames entirely in favor of the simple edge strip or a frameless mount. Art-supply shops stock many different types. A number of systems offer frames in standardized sizes that serve very well for framing smaller works, including prints, drawings, and photographs. If mats and backing

are used, they should be of acid-free paper, which will not damage the displayed item. Better frame shops are also helpful in suggesting suitable framing for a work and can aid in the selection of mats and similar details. The recommendation of a gallery or dealer is often the best way to find a good framing shop.

Choosing the location, background, and hanging position for artwork is very much part of the interior designer's work. Traditionally, art was often hung on elaborate backgrounds of cloth or wallpaper, crowded together to show a maximum number of works, and placed too high for comfortable viewing (see fig. 4.48). Modern practice, beginning early in the twentieth century, is to allow generous wall space around each work and to provide a neutral background that will not compete with the art. White or other light neutral colors and smooth or unobtrusive textures are preferred. Standard hanging height today brings works down, with their center, in most cases, near average eye level (figs. 14.18, 14.19). If the space has good general lighting, no special lighting is necessary, although special concealed lights or track lights like those used in many galleries might be considered to emphasize the work. Individual lights attached to the tops of frames are now rarely used.

Hanging works from a picture molding or a modern concealed hanging strip is one way to avoid nail holes in a wall, especially if pictures will be rotated. Arrangements of works in symmetrical groups of three or in stepped rows, a traditional placement, now appear forced and unattractive. It is acceptable to cluster a large number of small works together into a kind of mosaic, which serves to display many works in a limited space. Another way to display art in a limited space is to provide a location, perhaps with a ledge or shelf, where individual pieces can be

14.18, 14.19 In an interesting comparative study, four small drawings have been placed in matching frames and hung as a group: In figure 14.18, the usual rule of hanging at eye level has been followed, with the result that the works seem to float off upward, unrelated to the other objects. In figure 14.19, the same four works have been lowered to a position closer to the chair and table, where they become easy to view from a seated position and enter into a relationship with the real objects placed on the table—the bottles, teapot and cup, and dish of fruits—which are more transitory accessories. (Photograph: Michael Luppino, courtesy *Metropolitan Home*)

interchanged from time to time (fig. 14.20). This also avoids putting nail holes in the wall.

Sculpture and other three-dimensional works, if they are small, may be simply placed on a table, shelf, or other horizontal surface. If the work is too large or it requires protection, a glass or plastic case, which tops a pedestal base of some kind, may be used (fig. 14.21). Generally, the simplest of frameless cases looks best, with similarly simple boxlike pedestal bases. The moving sculptures called *mobiles* must be suspended, usually from the ceiling, and need to be located to prevent a possibly dangerous collision that could damage either the mobile or the colliding person. This entails hanging the work beyond human reach or providing a barrier (furniture or a railing) that makes contact impossible. Here, too, the practices of major museums and better galleries are a good guide.

Positioning works of art involves relating the spaces available, the objects to be displayed, and the desired level of viewers' attention. A major work, especially if it is large, calls for a focal location—for example, centered on an uncluttered wall (see figs. 14.1, 14.16). Certain locations, including the chimney breast above a fireplace mantel or the blank wall above a low chest or bookshelf, seem to invite the display of art. Works placed in these locations will tend to draw attention and can even dominate a room. Less important works may be best fitted into locations that draw less attention, such as smaller wall areas, the walls of corridors, or other incidental spaces, or may be grouped so that no one work has a dominant position. A collection can be seen to advantage in a circulation space, where objects come to attention in a planned sequence as the viewer walks past (fig. 14.21).

Another possibility in acquiring artwork that has not yet been discussed is the commissioning of work for a specific place. The practice boasts a noble history. Some of the great masterpieces—including the Sistine Chapel frescoes by Michelangelo, the metopes of the Parthenon (now part of the British Museum's collection known as the Elgin Marbles), and Henri Matisse's stained-glass windows in the chapel at Vence—are works commissioned to occupy a particular location. Today, commissioned artwork is most often created for important public spaces; some public buildings built with public funds are even legally required to have it. Occasionally, competitions, more or less formal, are undertaken to select an artist or a work in such situations.

A specially commissioned work always involves some element of risk, since there is no sure way to predict how the end result will actually look in the space until it is complete. Commissions are usually granted on the basis of an artist's reputation and, often,

after a preliminary small-scale sketch or model has been considered and evaluated. Murals painted to fit a given space and monumental architectural sculpture are almost always commissioned. They may be executed on site or, when the scale and medium allow, in the artist's studio, to be delivered to the intended location and installed. A specially commissioned work calls for understanding and cooperation among artist, designer, architect, if involved, and client. It may happen that the results disappoint the commissioning individual or agency, possibly leading to conflicts.

While designers expect to have an important role in the selection and placement of artworks and accessories in typical projects, in some situations the user may have preferences quite different from those of the designer. This pattern arises in large projects where there are many private rooms, including office projects, dormitories, and spaces, such as school classrooms, where users actually produce art and other decoration. In such cases, it is best to provide locations where art and objects can be placed according to the occupants' wishes without doing either physical or aesthetic damage to the space. A tackable surface and an empty horizontal shelf or other surface allow placing a picture without damaging a wall and holding a favorite snapshot, a potted plant, or a souvenir.

Since the desire to have such things about in any space that can be regarded as personal territory seems to be nearly universal,

14.20 In the living room of a house on Long Island, New York, framed antique prints rest on a ledge above a vintage sofa by Angelo Donghia. Since these pieces are not hung, they can be easily rearranged, replaced, or removed without worrying about wall damage from nail holes. An Indonesian banana-leaf-and-shell box serves as an occasional table. Sherri Donghia was the designer. (Photograph: © William Waldron, courtesy *Elle Decor*)

14.21 This amazing display of collected objects is in a vacation house in East Hampton, New York. The floor and lower shelves hold antique lawn sprinklers. Above are ship models in bottles, decoy ducks, and various toys. The top shelf holds Victorian glass vases. In the foreground on a pedestal is a sculptured torso wearing a T-shirt. The variety of objects suggests the highly personal interests of the owners and most likely provides a source of entertainment and basis for conversation with guests. (Photograph: © Susan Pear Meisel, Courtesy Louis K. Meisel Gallery, NY)

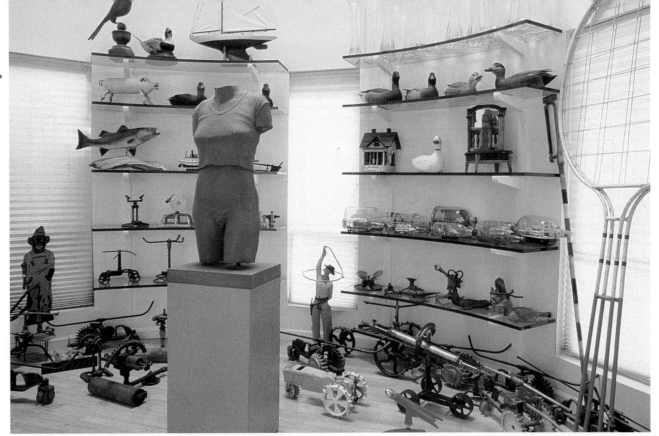

the wise designer accepts this reality and supports it, whether the actual selection and placement are part of the project or are left to the inclinations of occupants.

Signage and Graphics

Rarely of significance in residential projects, signs and other graphic elements can be of considerable importance in commercial, office, institutional, and other contract interiors (fig. 14.22). When this material is neglected by the designer, improvised signs will proliferate, ranging from indifferent and awkward to amateurish and unattractive. Many interiors are badly marred by makeshift signs and labels that occupants have created out of necessity.

When well designed and appropriately placed, good graphic elements can enhance an interior aesthetically. Several classes of graphic components can be recognized:

- *Major identification signs*, exterior and interior, aid first-time visitors in identifying their destinations. A house or room number is basic, along with—for most nonresidential projects—a name identification. For business establishments the name identification can also be an effective advertising element. Even if not within the formal responsibility of the interior designer, coordination of exterior signage (even a rooftop sign) with interior character and interior graphics is important.
- *Interior signage* may include directories giving locations and room numbers for departments, individuals, or specific functions. Simplified floor plans are often helpful as sign elements in large and complex projects, such as corporate office groups, hospitals, and other institutional facilities, as well as hotels or cruise liners, where strangers can easily become lost. Directional signs are helpful in locating elevators, stairs, rest rooms, information counters, and offices that serve the public. The first-time users of an airport or bus terminal, an auditorium or healthcare facility need signage to locate counters, stairs, baggage-claim areas, parking access, buses, taxis, and any number of other possible destinations (fig. 14.23). Clarity and legibility are of vital importance, as is neat and attractive appearance.
- *Code regulations* and common sense both require signage to serve emergency needs. Exit signs defining routes to doors and stairs that provide fire exits are mandated by fire codes. Although their size, coloring, and—in many locales—illumination are specified by code, exact placement and detailed design fall to the designer. Location of such emergency equipment as fire-alarm boxes, fire extinguishers, and hose cabinets must also be identified by appropriate signs. New regulations (as well as a sense of responsibility to the public) call for sign designations of locations where circulation and facilities to serve persons with disabilities can be accommodated. Certain signs and labels useful to those with disabilities also call for modifications or additions, as in the case of elevator floor-call buttons that are made accessible to wheelchair users when placed at appropriate heights and to blind persons with the addition of braille numerals.
- *Graphic symbols* that replace verbal messages with visual images conveying information clearly and concisely have been developed for many frequently used signs and labels (fig. 14.24). The popularity and ease of international travel would indicate that such signage should be considered in place of, or in addition to, verbal message signs. The use of graphic symbols is particularly appropriate wherever an international user group can be anticipated, as at a major airport.

A. INTERIOR SIGNAGE
directories
 illuminated
 nonilluminated

B. PRIMARY SIGNAGE
illuminated
 exit indicators
nonilluminated
 exit indicators

C. DIRECTIONAL SIGNAGE

D. SECONDARY SIGNAGE
plaque signs
panel signs
window signs
frames
fixture signs

E. DESK AND COUNTER SIGNS
information display
poster holders
tackboards
changeable letterboards
literature organizers
perpetual calendars

Provisions for adjustability and revision are important if signage is to maintain its designed quality and accuracy over a period of time. Functions of spaces vary, people change offices or leave, and new names surface. Within a good signage program, directories can be updated and nameplates can be moved to new locations or replaced. Transient items, announcements of events, posters, and notices need suitable places for display in cases, holders, or similar units that permit posting within organized surroundings in order to discourage the ad hoc treatment that can decline into visual chaos.

Graphic design is a specialized design field that has its own aesthetic and vocabulary. The interior designer should be aware that the selection of lettering styles and typefaces and the layout of graphic elements call for expertise and skill. Many signage systems incorporate components of excellent graphic quality that foster signage programs requiring minimal design effort. A careful listing of every required sign within a project is a basic step in the selection of suitable products that will create an organized graphic program.

14.22 Signs and other graphic elements have a central role in many contract interiors. The drawing here illustrates the various kinds of signage that may be required to communicate essential information. **14.23** Graphics—typography and layout—for signs has

become a specialized phase of design detail called signage. This section of a New York subway station, the East Fifty-third Street concourse, was designed by Beyer Blinder Belle. The sign, produced by Whippany Park, is clear and decisive and provides a striking visual accent.

(Photograph: © 1985 Frederick Charles)
14.24 Graphic symbols that replace verbal messages with universally understandable visual images have been developed for many frequently used signs and labels. Illustrated here are several variations of symbols for rest rooms. Each

was developed for a specific organization; some were designed by the organization's design staff, while others were designed by outside consultants: (A) Dallas–Fort Worth, Henry Dreyfuss Associates; (B) Transport Canada, design staff of the Ministry of Air Transportation; (C)

A B C D E F

In business and institutional projects, the idea of an *identity program* may surface. This concept calls for a coordinated effort to relate all of the visible elements that an organization uses. A corporation may have a trademark or logotype, theme colors, and standardized ways of using typography in advertising, packaging, product identification, publications, letterheads, and other printed materials. Such firms as IBM, Olivetti, Knoll International, mtrak, and many airlines have developed highly successful identity programs that tie in with the interiors that serve these organizations. A strong identity program should be recognized and supported in interior design work. In projects where no such program exists, the designer may propose the establishment of such a coordinated graphic effort. In a restaurant, for example, a theme that gives the venture its character and style can be carried through signage, menus, ashtrays, matchbooks, and other materials that can be designed in relation to the forms and colors dominant in the interior itself.

Large-scale graphic elements that cover entire wall surfaces present an additional technique that can help to set character, guide circulation, and relieve monotony. Such decoration when introduced a few years ago came to be called *super graphics* and threatened to become something of a fad. But viewed as a tool of the designer, along with the use of accessories, artworks, and the more standard elements of functional interior design, such large-scale graphics are appropriate when they serve clearly defined purposes effectively and economically. When a project calls for extensive signage and other graphic elements, designers specializing in the field can be employed as consultants.

WAYFINDING

The complexity of many modern facilities (hospitals, airport terminals, office headquarters), can confuse visitors, particularly first-timers, delaying them in finding their ways to intended destinations. The term "wayfinding" has come into use to designate a specific effort to improve finding locations through design means. Most facilities are planned with basic functionality as a primary goal and means for wayfinding tend to be left to the last-minute introduction of signs, often a makeshift sort with limited effectiveness. Early concern for issues of wayfinding can focus on a number of approaches, as follows:

- *Planning* Basic layout, its logic and simplicity, can improve ease of wayfinding. A college campus may include many buildings, each with its classrooms, lecture halls, and offices. A major hospital can have many departments and special-purpose facilities. An airport terminal is a notorious scene of confusing patterns. Good planning can take account of the need for movement and circulation patterns that ease problems both for visitors and for regular users.
- *Colors and Graphics* Visible patterns in color bands in floor coverings, identification colors used in halls and lobbies to identify departments, or colored lines on floors in multi-story buildings can be helpful in wayfinding. Transport systems can make good use of colors to identify vehicles or stations otherwise easily confused. Graphics using lettering or symbols can also aid in reducing possible confusion.
- *Signage* Signs are the most obvious of wayfinding tools. Well-planned signage programs are consistent and orderly, and present needed information clearly and consistently. Since much sign information is subject to change over time, a good sign program provides for simple updating, while maintaining the overall signage program.
- *Numbering* Giving every space a number and assigning numbers in an orderly and logical way is a basic essential for easy wayfinding. Numbering provided in a form accessible to visually impaired persons (Braille number signs, for example) is a helpful step to users for whom signs and color-coding may have little effect.

Signage systems using good quality graphic design are available from a number of manufacturers who can also provide a consultation service. It is important to make sure that a chosen system will remain available for future years as sign systems may require revision and updating.

International Civil Aviation Organization, design staff; (D) German Airport Authority, M. Krampen and H. W. Kapitzki; (E) Port Authority of New York and New Jersey, design staff of the Aviation Department, Owen Scott, graphic designer; (F) Department of Transportation, American Institute of Graphic Arts, Cook and Shanoski Associates.

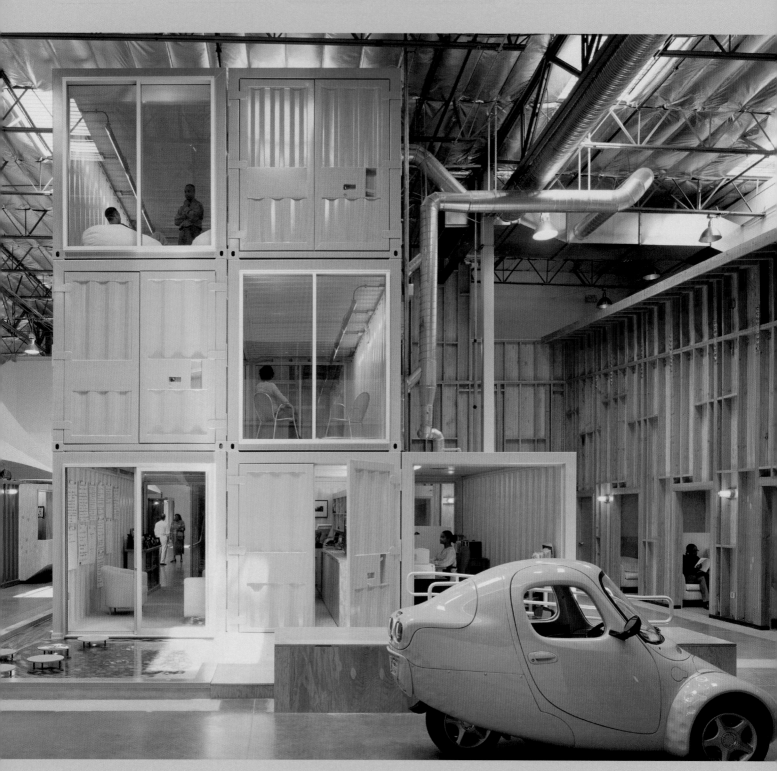

15.1 ↑

chapter fifteen. Mechanical Systems

Generally, the interior designer will not have to deal with excessively demanding technical issues in the course of most projects. Many residential and other smaller projects hardly make any technical demands at all. Larger and more complex projects may introduce issues of some importance. While the architect, engineer, and contractors will probably be responsible for resolving these, the interior designer should have a good general knowledge of technical fields, as an aid in talking with these and other professionals and consultants and as a basis for handling the impact these matters have on interiors.

The term *mechanical systems* describes aspects of building technology of major importance. These are the electrical, plumbing, and HVAC (heating, ventilation, and air-conditioning) systems. Other mechanical systems relating to acoustics, safety and security, and communications are also discussed here.

Typically, the interior designer faces such technical questions as, Can a new sink be provided here? Can this bathroom be relocated? Can a new bath be added here? Is the electrical service adequate for the new lighting and the appliances? Can the ducts be concealed? These questions may require consultation with specialized experts for firm answers, but a good sense of what such problems involve and of what questions to ask and of whom is an important part of the designer's special skills. The interior designer often acts as a liaison between the architect, mechanical engineer, or contractor and the client.

HVAC

Heating, ventilation, and air-conditioning are the mechanical systems that provide thermal comfort within buildings. The factors that influence bodily comfort are air temperature (the most obvious and easily measured element), humidity level, radiation to or from nearby surfaces, and the movement of air. In addition, good air quality is dependent on HVAC performance. Cleanliness of air and absence of objectionable odors, smoke, and fumes affect both comfort and health.

Human body temperature must be maintained within a narrow range to sustain normal functioning. When body heat is lost to cold surroundings, discomfort is felt in a way that everyone has experienced at one time or another (fig. 15.2). Replacing heat loss is a primary function of HVAC systems.

The four ways in which heat can be provided (fig. 15.3) are as follows:

- *Convection*. Warmed air conveys heat and warms whatever it touches—objects and human bodies alike. A thermometer measures air temperature and is the most familiar indicator of the thermal comfort level within a space.
- *Radiation*. Heat energy can be transmitted directly as a form of radiant energy. Heat from the Sun reaches Earth in this way. Even with a cold ambient air surround, the human body can be warmed by radiation—a familiar experience in bright

15.1 This huge warehouse in Los Angeles is home to the headquarters of a charity fundraising company, Pallotta TeamWorks. The architect Clive Wilkinson has created this unusual and informal work environment appropriate to the philosophy of a low-budget organization. Offices, some stand-alone, are spaced throughout the building, providing air-conditioned areas without the cost of air-conditioning the entire warehouse structure. (Courtesy Clive Wilkinson Architects)

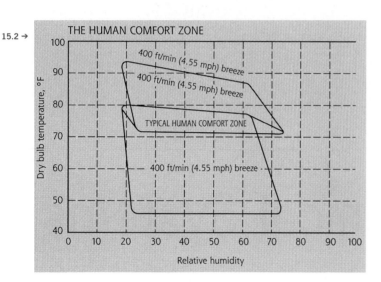

THE HUMAN COMFORT ZONE

400 ft/min (4.55 mph) breeze

400 ft/min (4.55 mph) breeze

TYPICAL HUMAN COMFORT ZONE

400 ft/min (4.55 mph) breeze

Dry bulb temperature, °F

Relative humidity

← 15.3

sun

radiation

evaporation

conduction

convection

sunlight on a cold day. Radiant heat can be supplied by many small, portable heaters and by systems of floor or panel heating that have little effect on air temperature but still maintain body comfort. A reverse effect occurs when cold surfaces cause body heat to radiate outward, as when a cold glass window surface creates sensations of chill even when air temperature is adequate.

- *Conduction.* When a cooler mass contacts one that is warmer, heat flows from the warmer to the cooler mass. Touching a cold surface chills the body part making contact. Bare feet on a cold floor, or hands resting on cold metal or stone surfaces, allow body heat to escape. Contact with a warm surface provides heat to the contacting body. A hot-water bottle or a warm bath provides heat by conduction.

- *Evaporation.* Heat transfer by evaporation is effective in removing excess heat rather than in supplying heat. Cooling results as moisture is evaporated from surfaces of the human body. Sweating is a natural means of dissipating heat through evaporation. The level of humidity in the air limits the degree of evaporation that can take place. The discomforts of a hot, humid day relate to the inability of humid air to allow enough evaporation to carry off excess body heat. Evaporative cooling is the basis for the refrigeration used to remove heat for summer air-conditioning.

Cooling is the direct opposite of heating, with the same methods of heat transfer operating in reverse. *Convection* provides cooler air to carry off excess heat. *Conduction* similarly carries off heat through contact with cooler surfaces. *Radiation* of body heat to cool surfaces is also a means of reducing excess levels of heat, while reduction of humidity favors *evaporative cooling.*

The HVAC systems in general use include a variety of systems that are considered separately in the following sections.

HEATING SYSTEMS

Heating systems are essential in all buildings in any but tropical climates. The interior designer is generally concerned only with the visible elements that deliver heat—radiators, convectors, registers, outlet grilles, and ducts or pipes. These must either be concealed or treated to minimize their effects on the interior design. The common heating systems are as follows:

Hot Water or Steam In hot-water or steam systems a boiler heats water that is circulated through pipes to the spaces to be heated. Hot-water heating may use a *one-pipe system*, in which water is fed to a single pipe that connects to each radiator or convector unit, a *two-pipe system*, in which separate pipes supply heated water and return the water to the boiler, or a *loop system*, in which the heated water flows through interconnected radiators in a continuous ring (fig. 15.4). One- and two-pipe systems permit individual control

15.2 The relationship between temperature, humidity, air movement, and radiation establishes a limited range of conditions under which human comfort is assured. **15.3** Heat and cold move from one medium to another in four ways, as this schematic drawing shows.

Conduction transfers heat and cold through direct contact with a physical object. Convection involves transfer through the atmosphere by means of air currents. Evaporation, a cooling process, occurs when moisture vaporizes. Radiation is heat transfer through space.

15.4 A forced hot-water (or *hydronic boiler*) system uses heated water circulating through pipes and convectors to deliver heat. **15.5** A warm-air system heats air in a furnace and circulates it through ducts with the aid of a blower. The ducts also return cooled air to the furnace.

15.6 Electric heating converts electric power into heat and then delivers it either through baseboard units that warm the air or by direct radiation from panels in ceilings or walls. Electric heat is clean at its use point and convenient but generally costly, depending on local electricity rates.

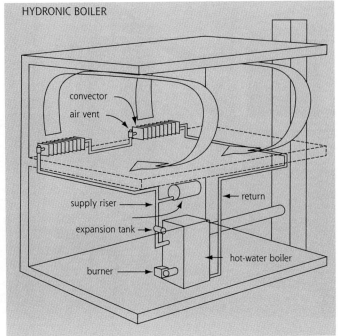

15.4 → HYDRONIC BOILER

convector
air vent
supply riser
expansion tank
burner
return
hot-water boiler

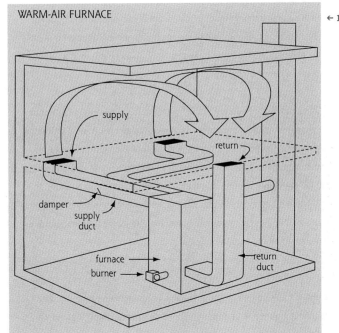

WARM-AIR FURNACE ← 15.5

supply
return
damper
supply duct
furnace
burner
return duct

of each radiator by valves. Air is heated as it passes over the radiators naturally or as it is blown over the radiator pipes by blowers in fan-coil units placed as needed. Steam heating is similar except that the boiler raises water temperature to a level that generates steam, which is piped to radiators. As the steam cools, it condenses into water and is returned to the boiler by gravity. Radiators or *convectors* (similar to radiators) are usually located under windows or in baseboards. The concern is to conceal them and the connecting pipes with covers of inoffensive appearance.

Warm (or "Hot") Air Warm-air systems require a furnace in which air is passed over a heating unit that warms the air to a temperature controlled by one or more thermostats. A fan blows the heated air through ducts to the spaces to be heated. In older hot-air systems, the heated air rose naturally, without a fan, and returned to the furnace as it cooled and dropped downward (fig. 15.5). Control of temperatures in various rooms was difficult with such gravity systems.

In modern systems, ducts are sized to deliver suitable quantities of heated air to outlet grilles or *registers* (openings to admit air) in floors, baseboards, or ceilings. Concealment of these outlets with covers of satisfactory appearance is a primary concern. Ducts serving the outlets must also be placed in concealed or unobjectionable locations. When air-conditioning is also provided, heated air and cooled air are usually circulated through the same duct and outlet systems. When a suspended ceiling is used, the space above the ceiling (called a *plenum*) may be used to distribute air to supply grilles to return air to the furnace by means of return grilles and ducts. Doors of individual rooms may incorporate vent grilles or be *undercut* (cut short of the floor by an inch or two) to permit air to move through corridors or open spaces to large return grilles, thus avoiding the need for a separate return grille and duct from each room.

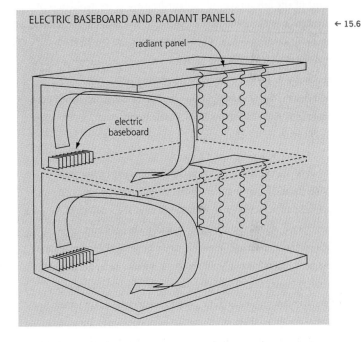

ELECTRIC BASEBOARD AND RADIANT PANELS ← 15.6

radiant panel
electric baseboard

Warm-air systems can provide controlled humidity along with heating and, since they share ductwork and outlets with air-conditioning, offer simplicity and certain economies as compared with totally separate heating and air-conditioning systems. The sound of air passing through supply grilles and, if it is close by, the sound of the circulating fan may create objectionable background noise, particularly if the fan operates intermittently. Recirculation of air can be a troublesome source of indoor air pollution if filtration and cleaning of returned air is inadequate. Fresh air drawn from outside should be added to recirculated air to improve air quality.

Ducts, grilles, and furnace can all be eliminated through the use of electric heat provided by baseboard or wall units in each heated space (fig. 15.6). Individual room thermostats provide

good local control. However, in most locations, the comparatively high cost of electrical energy makes electric heating costly; when air-conditioning is also required, a savings in ducts and outlets cannot be realized.

Radiant Heating Systems using radiant heat require pipes that carry heated water or electric heating wires embedded in floors, walls, or ceilings, resulting in few visible elements. However, they make more specific demands in terms of material choices. The heat-supply elements must be fixed in materials that conduct well (embedded in plaster or concrete; placed under stone, brick, or tile) and must not be blocked by elements that act as insulators, such as rugs.

Radiant heating is often used as the backup system for solar heating (another form of radiant heat). The same surfaces that conduct radiant heat can be used to absorb solar heat by day and radiate it back at night. Floors are particularly suited to working in this way since sunlight normally falls on them.

One of the advantages of radiant heating is its avoidance of unattractive pipes and radiators through the hidden, underfloor location of heating pipes. This can be a significant factor in favor of radiant heat for use in renovated older buildings if new floor slabs can be introduced to carry heat pipes (fig. 15.7). Wood or tile floors provide a finished surface that transmits the radiant heat successfully as long as soft floor coverings are kept to small rugs in limited areas.

Solar Heating Using heat from the sun requires some basic architectural involvement in terms of orientation, the size and placement of windows and overhangs, and the choices of interior materials for floors and, in some systems, for ceilings.

Passive solar heating does not use mechanical equipment. Sun heats enters through windows and heats interior surfaces, primarily floors (fig. 15.8). In some systems, special blinds reflect the heat up to ceilings, where heat-absorbing panels are placed. The heated surfaces radiate heat back into the space, keeping occupants comfortable, and store heat so that the surfaces continue to radiate at night and on dark days (fig. 15.9). A backup heating system, either radiant or conventional, is needed to provide additional heat when solar radiation is insufficient (in very cold weather or during protracted cloudy or stormy periods).

Active solar heating uses sun heat to heat air or water in collector elements. The heated air or water is then circulated by mechanical fans or pumps to deliver heat when and where it is needed. The circulating medium also heats a storage medium (a tank of liquid or, in some systems, a mass of stones), which radiates heat back into the system when solar output is insufficient. The same mechanical system that circulates the radiant heat is also used to distribute backup heat provided by a conventional fuel.

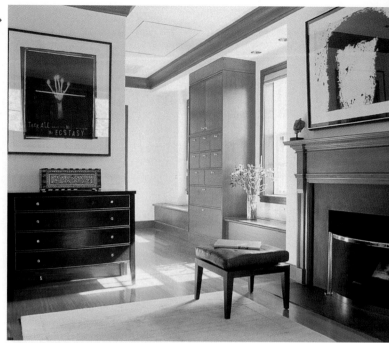

15.7 →

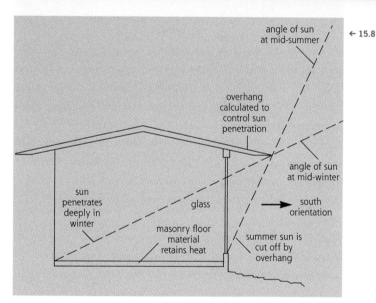

← 15.8

The fuel used for any of the nonsolar heat systems is usually chosen on an economic basis and has no significant influence on interior design considerations.

VENTILATION

Ventilation is essential to provide fresh air to replace air made stale by smoking, cooking, and the bodily functions (primarily breathing) of human occupants, as well as to remove pollen, dust, and odors. In the past, the opening of windows and, perhaps, doors and the air leaks of ordinary construction generally provided adequate ventilation of all but totally internal (windowless) spaces. Modern warm-air heating and air-conditioning systems can provide fresh air and filter recirculated air. With other systems, separate mechanical ventilation may be required. Windowless interior spaces always need some provision for ventilation. This is usually a legal requirement for interior bathrooms, but other spaces may need smoke vents or other such arrangements involving ducts and

← 15.9

15.7 Radiant heating as used here in a remodeled Boston town house is totally invisible—there are no radiators or base-board units required. The space illustrated is a dressing area. Manuel de Santaren was the interior designer, David Hacin the architect. (Photograph: Jeff McNamara, as seen in *Metropolitan Home*, Sept./Oct. 2000) **15.8** Passive solar heating requires large glass areas facing south and carefully planned overhanging shading. The shading must be placed to permit rays of the low winter sun to enter the space but to block rays from the higher summer sun. **15.9** Architect Marlys Hann installed large glass panels in the bathroom of her home in New York's Catskill Mountains to create a passive solar heat trap. The bathroom receives the sun's heat by day, retaining it in the tiled areas to reduce nighttime energy consumption. (Photograph: © Paul Warchol)

fans. Meeting and conference rooms and places where many people gather are especially in need of ventilation.

The interior designer must remember to address ventilation needs in the design. Inadequate ventilation is a source of problems that have come to be identified as sick-building syndrome.

Buildings, of course, cannot themselves be sick, but their occupants may suffer from problems that range from annoyance to actual illness as a result of poor interior air quality. Natural ventilation is not possible within buildings that are windowless or have sealed windows, now commonplace in order to conserve energy used for heating and air-conditioning. Recirculation of heated or cooled air tends to retain and concentrate interior air pollutants, which can be of chemical origin, such as volatile organic compounds (VOCs) from off-gassing of such materials as carpet or wall panels, or of external origin if fresh air drawn into the system is itself a carrier of pollutants, such as automobile exhaust gases or industrial pollutants. Biological contaminants can be molds, fungi, bacteria, or viruses. Filtration of recirculated air, adequate circulation of clean fresh air in combination with recirculated air, and maintenance of HVAC equipment to prevent buildup of contaminants are important in developing satisfactory interior air quality (fig. 15.10). However, with the growing emphasis on green design, the role of natural ventilation alone is once again assuming importance.

AIR-CONDITIONING

Cooled air has become a widely demanded comfort, particularly in areas where summer heat tends to be a problem. The term *air-conditioning* describes systems that provide cooling, controlled humidification (or dehumidification, as required), and air filtration and purification. The windowless or sealed window design of many modern buildings makes mechanical air-conditioning essential.

The cooling function of air-conditioning systems is provided by mechanical refrigeration, which removes heat from the conditioned spaces and discharges it to the outside in the form of warmed air or water. Water, chilled at a central unit, can be passed through pipes to units distributed through the served spaces where fans blow air over the cooled pipes to provide cooled air. Other systems circulate air over coils carrying cooled water or refrigerants at a central location and then distribute the cooled air through ducts to outlet grilles in the same way that warm air is distributed in cold weather. Dehumidification of the cooled air is an important aspect of establishing reasonable comfort levels,

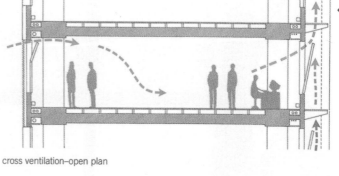

← 15.10

cross ventilation–open plan

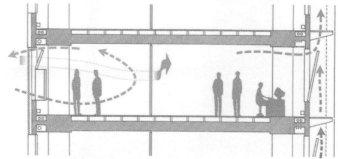

cross ventilation–partitioned office

← 15.11

since excess humidity is often associated with the excessive heat of summer climates.

Built-in systems, which normally provide central locations for machinery, require only that the designer place the outlet ducts in inconspicuous locations and consider how to handle the return of exhaust air to the system. As in warm-air heating systems, the built-in systems often call for doors with either vents or undercuts to permit air to pass along corridors toward return air grilles. Supply outlets can often be provided as part of ceiling light fix-

15.10 The diagram shows patterns of air circulation in an open-plan office (top) and in a partitioned office (bottom), planned for the extension to and renovation of GSW Headquarters, Berlin, Germany, by Sauerbruch Hutton Architects. The building's facade acts as a chimney, drawing warm air upward, which spurs entry of cooler air from the opposite side. Vents in office partitions permit airflow between offices. (Courtesy Sauerbruch Hutton Architects) **15.11** A ceiling provides acoustical absorption and houses architectural lighting and air-conditioning outlets, while the hollow space above conceals wiring, ductwork, piping, and other mechanical and structural elements. The suspended ceiling is designed to facilitate access. (Photograph courtesy USG Interiors, Inc.) **15.12** In this installation, HVAC delivery is related to individual office workstations, giving direct personal control to each worker. HVAC delivery is incorporated in a panel framework of the office system called Platform by its manufacturer, Inscape. (Photograph courtesy Inscape)

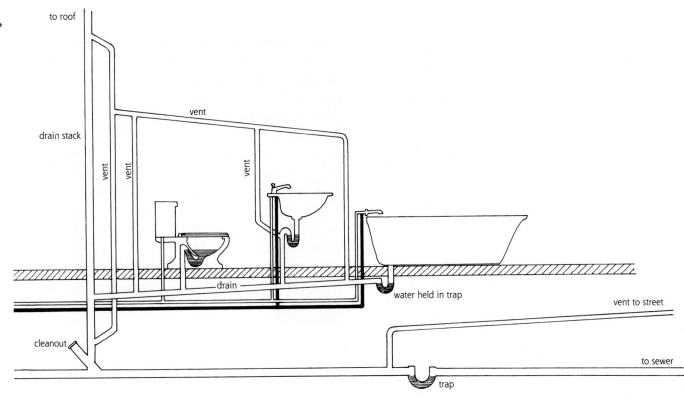

locations. *Risers*, the vertical lines of pipes running upward through a building from the basement, must be located (they are usually found adjacent to existing baths or kitchens) and then connected to the new pipes, which run horizontally to the new fixtures. The new pipes may be concealed by running them in walls, under floors, above ceilings, or in specially built enclosures. Since drainpipes pose more difficulties, they will most often determine when and where new *wet facilities* can be provided. Drains use not pressure but gravity to steer waste downward to the pipes leading to a sewer or other disposal arrangement. Therefore, drainpipes must always slope downhill. Drains from basins and sinks need only slope down at a gentle angle, but the large soil pipes serving toilets must slope sharply to discourage clogging. New facilities must be placed close enough to vertical existing drains to make the required down slope possible without damage to spaces below the intended location. The vertical drain that carries wastewater from sinks and washbasins is called a *waste stack* and is normally two or three inches in diameter. A drain carrying human wastes is a *soil stack* and must have an inside diameter of four inches, making it too large to fit within the thickness of a normal partition wall. It must run within a special vertical shaft called a *pipe chase* or through a partition of extra thickness.

Many people fail to realize that drains are also connected to upward stacks that must be carried up through the roof of a building. The stack is part of a safeguarding system that begins with a *trap* at each fixture. The trap holds water in such a way as to form a seal, preventing gases present in drainage pipes from entering living spaces and bringing objectionable odors. Beyond each trap, there must be a vent that prevents suction from

pulling water out of the trap and that carries gases up and out to the air at roof level. Just as drains angle downward to a vertical stack, vents must angle upward and connect to the same stack as it travels up to the roof. This means that every drain location must allow for the provision (and concealment) of these upward vents without disturbing the spaces *above* it. In a single-story building, it is usually practical to provide water and drainage in almost any location, but in a multistory building, the impact of plumbing changes on spaces above and below can be significant. In tall buildings, it may be out of the question to install pipes, drains, and vents in a new location because of the need to pass pipes through spaces occupied by other tenants or because it may be prohibitively expensive.

The interior designer may have to turn to an architect, engineer, or plumbing contractor to arrive at a firm conclusion about whether a certain plumbing change will be easy, possible but difficult (and therefore costly), or virtually impossible, but the designer will find it useful to be able to make a reliable preliminary judgment. In general, it is easiest to locate new fixtures adjacent to walls where pipes already exist, that is, next to existing fixtures; close to pipe chases; or, in large buildings of steel- or concrete-frame construction, close to *wet columns*, structural columns that have an added space for pipes. Piping locations are sometimes difficult to identify on site, but building plans show them clearly.

Fire-safety equipment calls for additional plumbing installations. Codes require that taller buildings (whose upper floors cannot be reached easily by fire-company equipment) have various systems to make water available wherever a fire might occur. A *standpipe system* uses a large main pipe that leads to hose cabinets

located on each floor, so that a hose can reach any point on that particular floor. The standpipe is filled with city water and may also be connected with a roof-level water tank. Another connection to the standpipe is located on the outside of the building, where firefighters can connect a hose to supply additional water under pressure from fire hydrants and a pumper fire engine.

Sprinkler systems, however, provide even more effective fire protection since they are fully automatic. Large main pipes are connected to smaller pipes that feed sprinkler heads located at or near ceiling level. In case of fire, heat causes a sprinkler head to release and spray water over the area it covers. Sprinkler systems in larger buildings also provide an outside connection (with two inlets and thus called a *siamese* connection) for fire-company pumpers in case the building water system is inadequate to control a larger fire. An outside (and usually also inside local) shutoff valve can be used to stop the flow of water after a fire has been extinguished. Sprinkler release causes a drop in water pressure in the system that sets off an alarm to a local fire company, facilitating prompt fire fighting and sprinkler shutoff, ideally before major water damage occurs. Sprinkler systems provide the best available fire protection for larger buildings. Modern sprinkler heads of reasonably neat and unobtrusive design are available. Placing the heads to satisfy code requirements (see pages 477–78) and coordinating their locations and piping with other equipment are part of the interior designer's task.

Plumbing systems are subject to strict legal regulation. Plans and diagrams must be filed for approval for any significant plumbing work, which must be carried out by licensed contractors and inspected and approved when completed. Such work can entail high costs, surprising to many clients who have never had extensive plumbing work done before. Finally, it should be mentioned that since, unfortunately, all plumbing is subject to the possibility of leaks, access for repairs must be provided. This can be done by building access panels or locating pipes in closets or other semihidden spaces. This possibility also calls for judgment to avoid locating pipes above places where a leak could cause unusually costly or troublesome damage. Plumbers and engineers may not think of such issues, but a designer should point them out to a client.

← 15.17

Table 30.
Noise Reduction Coefficients (NRCs)

MATERIAL	NRC[*]
Bare concrete floor	.05
Tile or linoleum on concrete	.05
Carpet (⅛″ pile)	.15
Carpet (¼″ pile)	.25
Carpet (⁷⁄₁₉″ pile)	.40
Plaster ceiling	.45
Metal pan acoustic ceiling	.60
Partition system surfaces	.55 –.80 (.60 typical)
Carpet over padding	up to .65
Acoustical ceiling systems	up to .90

[*]An NRC rating is a single number indicating the effectiveness of a material in absorbing sound. With a range from 1.00 to .00, an NRC of .99 indicates almost total absorption, .01 virtually none. The higher the NRC of a particular material, the more effectively it absorbs sound.

Acoustics

Acoustics can present several technical problems that have direct bearing on interior design. Major acoustical problems may call for the services of specialized consultants, but most can be dealt with by the designer simply through planning and material selection.

The common acoustical problems are of several types. They concern excessive noise levels; the transmission of noise from one space to another; guarding the privacy of individual spaces; main-

taining the intelligibility of speech in relation to background noise; providing suitable background noise in certain situations; and, in the case of auditoriums and larger meeting rooms, the qualities that give the characteristics described as good acoustics.

EXCESSIVE NOISE

Excessive noise can be disturbing in spaces where many people are present and involved in sound-producing activities. Offices, restaurants and cafeterias, and factory production spaces commonly present noise problems. The best way to limit general,

oping. Natural finishes on wood are less likely to show damage and are easier to repair (fig. 16.18). Paint finishes on wood are less durable than similar metal finishes, but repainting is comparatively easy. Plastic laminate is a durable alternative. Since neither material has an overall clear advantage, selection is primarily a matter of personal taste. A possible compromise is the use of metal cabinets with wood door and drawer fronts.

Counters The standard counter height of 36 inches will not serve all tasks and all users, but it is widely adopted as a compromise norm. When a kitchen is planned for a particular user, it may be appropriate to consider counters higher or lower than standard to suit that person. Wheelchair occupants need counters placed at 34-inch height or adjustable from 28 to 36 inches. Open space at least 30 inches wide is required under countertops for knee clearance.

Many surface materials are possible, each with various advantages and disadvantages. Favorite choices include plastic laminate, wood (butcher block), tile, granite, marble, stainless steel, and special synthetic composition materials (fig. 16.19).

Countertops present special problems at front and back edges, where a crevice that may be unsightly and hard to keep clean will occur if materials must be joined at these points. Front edges may be of laminate or may use a trim molding of plastic or metal. The best treatment results when the top material is thick enough to form its own edge (as with wood or granite) or when the material is rolled over to form an edge, as provided with some laminates and with metal. A similar problem occurs at the rear of counters, where it is usual to provide a *backsplash* of easily cleaned material 4 to 6 inches high. Here also a continuous material, rolled upward from the top, avoids a crevice (laminates are available with such integral backsplashes). When sinks or cooktops are recessed into counters and wherever counters meet other

elements—walls, appliances, or counters with different top materials—special attention is required to avoid cracks that are difficult to clean and maintain.

Floor Materials Linoleum, resilient tile, ceramic tile, quarry tile, and slate all lend themselves to the kitchen environment (fig. 16.20). Wood and carpet specially made for wet-location use may also be considered.

Hard-surface floor materials such as tile and slate, while easy to keep clean, can be noisy and may chip easily when objects are dropped. Some users may also find them tiring to stand on for extended periods of time. Although more resilient materials are quieter and may feel more pleasant to stand on, they do not wear as well and may prove difficult to keep clean. Color and pattern of floor material also have an impact on ease of maintenance. Plain colors, especially light tones, show every spill and foot mark and demand constant cleaning. Medium colors and small-scale textures or patterns conceal minor spotting but for that very reason do not express perfect cleanliness. The attractive gleam of glossy surfaces is harder to maintain than matte finishes, and many such surfaces create an actual slipping hazard. Floor tile with a dimpled surface has become a popular choice, even though soil tends to collect at the edges of the raised discs, presenting some difficulty in cleaning. Points where the flooring meets walls, cabinets, or appliance bases call for special attention to ensure a neat joint without a hard-to-clean crack; a cove baseboard treatment is ideal.

Wall Surfaces Paint, plastic sheet material, plastic laminate, and tile are popular choices for wall surfaces.

Ceiling Materials Sheetrock, plaster, and acoustical materials are possible choices for ceiling surfaces.

Miscellaneous Items Other details that call for consideration include lighting, ventilation, and a variety of accessories and gadgets. A central globe light, often provided for general illumination, tends to place the user in his or her own shadow and gives an overall effect of bleakness. The most effective lighting comes from strips concealed under wall cabinets or shelves. Downlights directed at counters also work well (fig. 16.21). A range hood, ideally outside-vented, is the best cure for kitchen smells and deposits of cooking fumes and grease and usually includes a downlight. A window fan or ceiling fan is an inferior alternative. Accessories, such as towel racks, pinup boards, clocks, spice racks, and many other popular gadgets, will become items of clutter if not planned for.

APPEARANCE

It is a curious fact that the appearance of residential kitchens is most often spoiled by efforts at beautification, usually realized

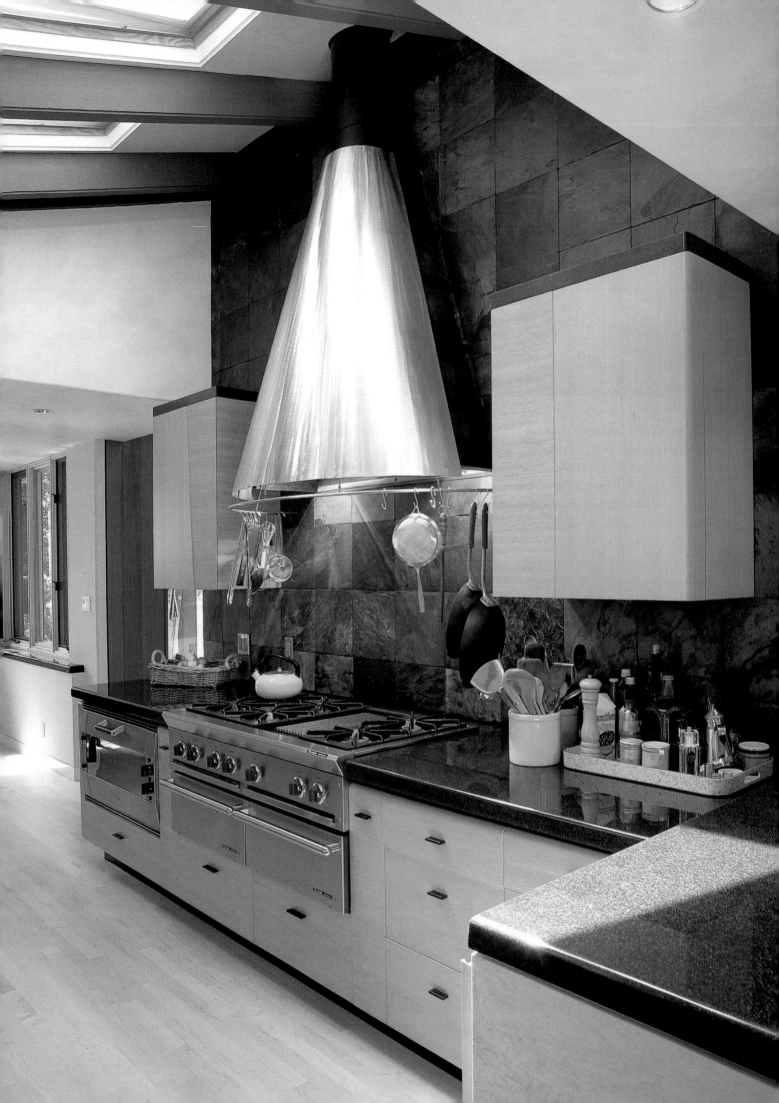

16.19 →

← 16.21

16.20 →

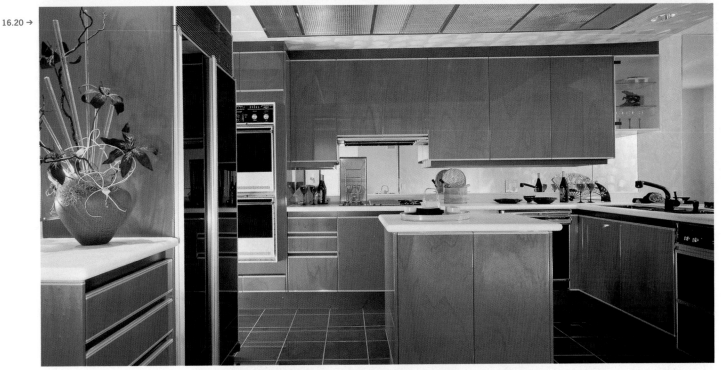

← 16.18 **16.18** A harmony of natural colors is established in this kitchen through the use of wood flooring and cabinets, granite for countertops, and brushed stainless steel for the oven front and the custom-designed range hood. Fu Tung Cheng was the architect for the house, located in Portola Valley, California. (Photograph: © Alan Weintraub, courtesy *Metropolitan Home*) **16.19** The kitchen in a

Knightsbridge, London, project of Eva Jiricna uses a stone (pietra laro) floor, plaster walls, and steel-fronted counters and equipment. A freestanding island unit is topped by a cooktop, a charcoal grill, and a small auxiliary sink. The vertical steel doors carry a linen-textured finish, while overhead cabinets use sandblasted glass fronts. Durocon, a scratch- and chemical-resistant plastic, is used for the

countertops and larger sinks. (Photograph: © Arcaid/Richard Bryant) **16.20** In a kitchen using the Red Aspen system, manufactured by Snaidero, the black of the floor tile and the refrigerator sets off the dominant red color scheme. (Photograph courtesy Regba Diran, Inc., New York) **16.21** This unusual kitchen is part of a house in Tokyo constructed entirely of prefabricated, industrially

produced elements. The long counter serves as both a work surface and a place for eating. Small wheeled units roll under the countertop to provide movable storage; the long suspended bar is used to hang lighting units that can be moved about as needed. The house was designed by architect Toyo Itoh. (Photograph: Gilles de Chabaneix)

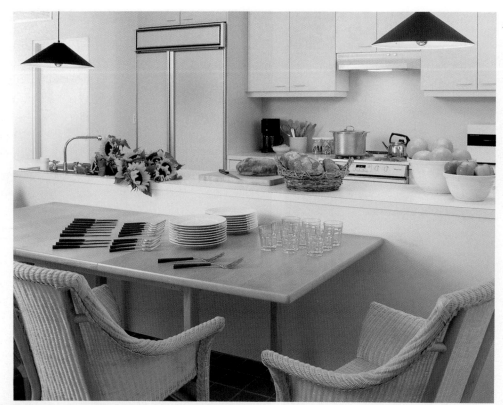

← 16.22

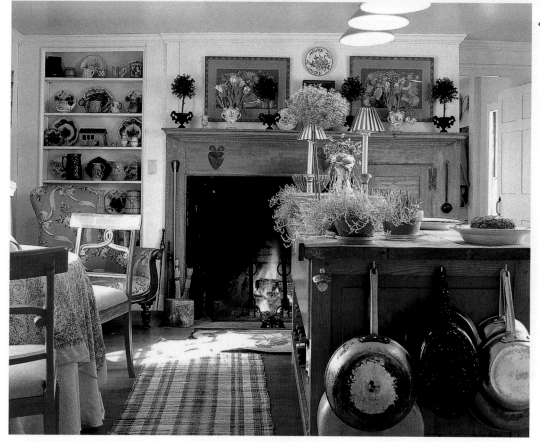

← 16.23

16.22 Restrained color and a simple design characterize the communal kitchen of Friends in Deed, a facility established in a loft space to serve terminally ill residents of the SoHo area of New York. Bob Patino was the designer. (Photograph: © Stephen Barker, courtesy *Metropolitan Home*) **16.23** In a traditional Litchfield, Connecticut, house, the kitchen combines the functions of food preparation, eating, and storage. A collection of majolica pottery displayed on open shelves acts as a decorative element. The house is owned by designer Bunny Williams. (Photograph: John Vaughan, courtesy Crown Publishers, Inc.)

in one or both of two ways: by importing an artificial charm, which may derive from inappropriate period decor and fussy elements such as patterned curtains, overdecorative tile, and other ornamental materials, or by using imitative materials. Modern cabinets faced in imitation—or even real—knotty pine or with French provincial details; linoleum that imitates Spanish tiles, flagstone, or brick; wallpapers that simulate Dutch (or any other) tiles—all these set a tone of falseness and visual clutter. Such elements are all too often featured in consumer publications that provide advice on kitchen design. A more practical and straightforward design will hold up better, both in use and in attractiveness, over a period of time (figs. 16.22, 16.23). This approach eliminates neither comfort nor, at best, genuine beauty.

Bathrooms

Like kitchens, bathrooms are usually given a minimum of space and designed according to formula, with a few "special features," such as a counter *lavatory* (washbasin), possibly added to soften the effect. While bath functions are less complex than those of kitchens, they deserve more attention than the formula layouts devote to them.

RESIDENTIAL

The modern bathroom has its origins in the Victorian introduction of modern plumbing (fig. 16.24). The toilet owes its alternative name of *water closet* to its frequent introduction, quite literally, into an existing closet. The bathroom most often began as an existing room, perhaps a small bedroom or storage room, and was converted by the installation of the three standard fixtures: toilet, washbasin, and bathtub.

Placing these fixtures together in one room has a certain logic since the privacy of all three functions is ensured with one closable door to the room. The disadvantage is that one user ties up the entire room as long as the door remains closed. Moreover, modern bathroom use often calls for, in addition to the basic three fixtures, a shower (or substitutes this for or combines it with the bathtub), twin washbasins, perhaps a bidet (common in parts of Europe but unusual elsewhere), provision for exercise, rest, or special bathing facilities (such as a sauna or Jacuzzi), and, occasionally, laundry facilities.

One bathroom can hardly accommodate all of these elements. Also, if there will be more than one user, two or more units have clear advantages. A number of possible combinations can be considered (fig. 16.25), including adding a *lavatory* or *powder room* (without tub or shower) accessible to guests as well as family; creating a *split bathroom*, for example, with toilet or toilet and washbasin in a unit separate from a bathing unit; and providing two or more complete bathrooms.

Whatever their layout, all bathroom spaces must connect to plumbing, most economically with pipes shared by another bath or kitchen, ideally back-to-back. The toilet requires a larger drainpipe called a *soil stack*, which can pass through only a thick partition wall or pipe chase space. Efficient plans usually line up all fixtures with pipes along one wall. Minimal dimensions are well-known standards, widely published. However, these make for rather cramped facilities; actual use patterns give a better guide to dimensions. Easy access for people with disabilities, particularly for wheelchair users, requires additional clearances, as well as consideration of fixture and cabinet heights and provision of grab rails in certain locations (see pages 224–28).

Toilets Toilets (*water closets* or *W.C.s* is the plumbing-trade designation) are made with either separate or integral tanks. In modern high-rise buildings, a *syphon-jet* flush does not require a tank. Bowls are now made in a variety of shapes, some more attractive than the traditional oval. Although seat and cover must be chosen to suit the bowl form, assorted colors and texture patterns are available. Reduced-flush toilets are available to conserve water, and many cities offer building owners incentives for using them. Toilets are now manufactured in versions that omit the usual tank in favor of a powered flush system permitting a compact, simple appearance.

Washbasins Washbasins (*lavatories*) vary from complete units with a pedestal base or with legs to bowls that can be wall-hung (figs. 16.26–16.30). It has become popular to set bowls into a countertop to provide generous surrounding space for soap dishes and other accessories. Mounting options are self-rimming, under the counter, and above the counter. Bowls are available in a range of sizes, shapes, and finishes. The surround can be of plastic laminate, marble, tile, or any other material that is reasonably water-resistant. Twin basins are a favorite luxury in a master bathroom.

Bathtubs Tubs are made in various shapes and sizes, and manufacturers have vied with one another to develop luxury units in unusual shapes. Some provide a rim wide enough to serve as a seat; others suggest opulence by approaching a small pool in size. Whirlpool Jacuzzis and hot tubs remain popular. Even the old-fashioned tub on legs continues to seem attractive and appropriate in certain settings. Many tubs provide their own exterior front or front and end surfaces, while others are designed to be recessed into a constructed surround or platform. Tubs sunken into the floor require clearance below or an elevated platform into which the tub can be recessed. If the bathroom is large, a central tub is an option (see figs. 16.31, 16.32). Materials include porcelain-enameled iron, a lighter enameled sheet steel, and some modern units in fiberglass plastic. As the population grows to taller average heights, tub lengths beyond the standard 60 inches deserve consideration.

All tubs call for safety precautions. Getting into and out of a tub with wet and slippery surfaces both inside and possibly outside can be hazardous, particularly for the elderly and those with disabilities (see page 226). Textured bottom surfaces and suitable handrails can reduce the danger of slipping. Bathtubs with a hinged side door are available, offering easy and safe access to elderly and disabled users.

Showers Commonly provided with tubs, showers can also be separate units. Standard shower stalls are available as complete units, or shower areas can be custom-built from appropriate materials that must, of course, be water-resistant. At floor level, a shower stall may use a manufactured bottom pan with coved edges and center drain, or a base can be custom-built with surfaces sloping to a drain. Shower enclosure is needed to confine spray and steam. A simple shower curtain on a rod works well but may not seem as luxurious as a sliding or swinging door. Glass enclosure, however attractive, is hazardous. In addition to spray, showers produce steam that condenses on surrounding surfaces, requiring special attention in material selection and detailing within the entire bathroom to minimize danger from excess moisture. Shower heads providing reduced water flow are available.

Bidets Sanitary fixtures long accepted in France and some other European countries, bidets are rarely used in America. The units are roughly similar in size and shape to a toilet.

All standard bathroom fixtures are available in various designs and in a range of colors, in addition to the ubiquitous white. All bathroom spaces require ventilation as well as heat. The former may be by means of either a window or skylight or a fan and duct, or by a combination of the two. Details of a bath include provision for soap, towels, toilet-paper dispensers, medicine cabinet, mirror, and suitable lighting. Materials need to be selected for water-resistance. Tile, slate, and marble are more durable than plaster, wood, and wallpaper, which, although commonly used, must be regularly renewed.

Bathrooms have a bad record as locations for accidents. The presence of slippery surfaces, water (particularly hot water), soap, electric outlets, and, often, glass-enclosure elements, alone or in combination, creates a variety of hazards, especially for children, the elderly, and people with disabilities. As mentioned above, glass shower enclosures should be avoided, mirrors placed with care to prevent accidental breakage, nonskid surfaces and grab rails provided, and electrical outlets using a ground-fault interrupter specified.

Space and budget permitting, bathrooms can become outstandingly attractive, with good daylight, night lighting, growing plants, space and equipment for rest and exercise, and handsome materials and colors. Small details such as faucets, soap dishes, and towel racks—even the towels themselves—can add to

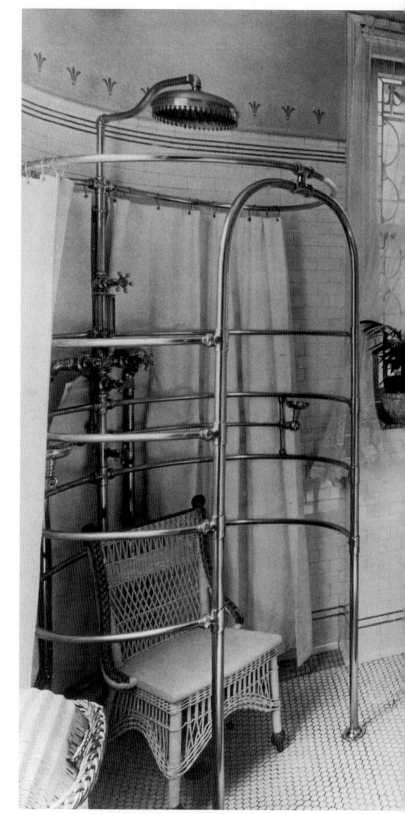

the design quality of a bathroom (see fig. 14.5). Storage space for towels, soap, and similar items can be provided within or adjacent to a bath (see fig. 16.28). Dressing and makeup facilities can be combined with or located adjacent to a bathroom (see fig. 16.38).

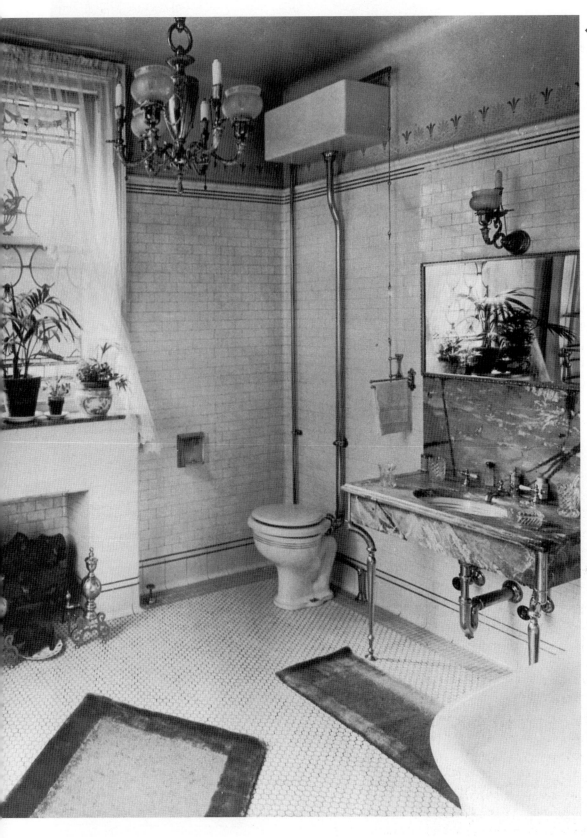

16.24 This luxurious, late-Victorian bathroom dates from the beginning of the twentieth century. Note the fireplace with stained-glass window above, the chandelier, and the marble washbasin counter and backsplash. The extraordinary arrangement at the left offers seated comfort while showering. Museum of the City of New York. Wurts Collection

BATHROOM PLANS

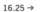

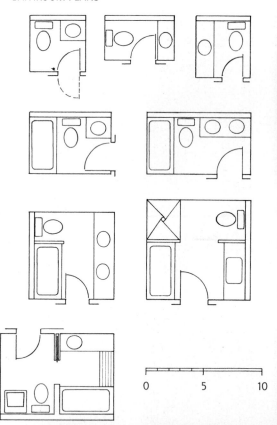

16.27 ↑

16.25 Here are layouts of typical bathrooms, ranging from the lavatory or powder room to complete baths, in minimal, simple, and split-bath arrangements. Pipes are hidden in the walls indicated with a double line. **16.26** Designed by Bernard Tschumi Architects

in 2004, this Beijing apartment features a lot of bamboo, including floors, ceilings, window coverings, furnishings, and (shown here) the bathroom. **16.27** A bathroom sink that stands above the marble counter has both functional and aesthetic merits: it is at a convenient

height for adult use, but its unusual placement also highlights its decorative quality. Eva Jiricna was the architect for the modern renovation of an 1820s vintage building in Knightsbridge, London. (Photograph: © Arcaid/Richard Bryant) **16.28** In a bathroom designed by Brian

Murphy for a Hollywood, California, house, sandblasted glass forms the side enclosures for the washbasin. The exposed pipes, which allow for easy cleaning are also decorative in effect. (Photograph: © Tim Street-Porter, courtesy *Elle Decor*) **16.29** An Eileen

← 16.29

16.31 ↓

16.30 ↑

16.32 ↑

Gray mirror is an elegant feature of an uncluttered bathroom designed by Andrée Putnam. Note the band of decorative tile and the glass-block wall of the shower alcove. (Photograph: © Grant Mudford, courtesy *House & Garden*) **16.30** The bathroom fixtures of Kohler Co., a global leader in bathroom design, combine cast iron with a thick layer of enamel that resists staining, scratching, and chipping, and rich colors and graceful lines. **16.31** This luxury bathroom in Santa Monica, California, was created by London-based designer Susan Minter as an "elegant calming room for private contemplation." It is also suited to simultaneous users, with twin sinks (wall-mounted to reduce clutter), central tub, and a shower (barely visible on the left, reflected in the mirror). Small square cabinets mounted on the mirror make cabinet vanities unnecessary. (Photograph: John Ellis) **16.32** The Consonance whirlpool by Kohler Co. has distinct bathing areas and separate controls for two individuals, combining form and function.

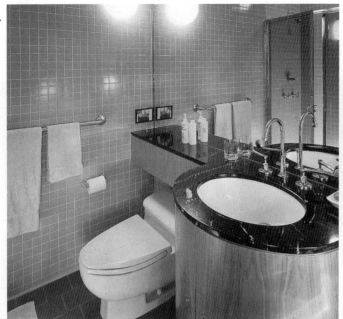

NONRESIDENTIAL

Bathrooms for hotels and motels, dormitories, hospitals, and the *executive washroom* now often provided in office facilities (fig. 16.33, 16.34) follow home practice, with appropriate modifications for the special needs of these situations. Bathrooms in hotels and motels are important expressions of the level of quality and luxury that a particular establishment offers. An elaborately luxurious bathroom can play a very substantial role in guests' satisfaction with the room or suite they are staying in.

Public toilets, or *rest rooms*, for offices, stores, restaurants, and other public situations demand more complex planning (figs. 16.35, 16.36). One basic planning issue concerns how the size of public rest rooms is to be determined. Ideally, the size and type of facilities provided should relate in some logical way to the number of people using a space. Although some rules have been suggested, this is not a simple problem. The area of a floor is not a reliable guide to the number of people who will use the space—that number may change over a period of time, as in offices or industrial structures where the number of workers may vary as tasks are changed. In many situations there is a problem of peak loading, as in theaters and auditoriums where intermissions lead to heavy use of facilities that may be almost unused at other times. In schools or college buildings, use may be maximal during periods between classes. In addition, it is difficult to predict the proportion of men and women who will be using public rest rooms. While it has been customary to allot similar floor areas to men's and women's rest rooms, this is quite illogical when the user population can be predicted to not be equally mixed. In addition, women's rest rooms require more space for a given user population to ensure an adequate number of stalls and to allow for the longer time women tend to take using the facilities.

In public rest rooms the basic fixtures of home bathrooms—toilets and washbasins—are augmented by provisions of urinals in men's rooms and by the need for stalls and screens for privacy. Rest-room stalls are standard manufactured products available in many colors and finishes, supported from walls and floors or wall-hung without floor support. The latter, particularly when used with other wall-hung fixtures, permit clear floors that are easily cleaned and maintained (fig. 16.37). Public rest rooms also require soap dispensers, towel holders, trash containers, and, in some locations, hot-air hand dryers and various vending machines. Details of faucets and other hardware need to be carefully considered for practicality and appearance. In many locations, including theaters, better restaurants, and corporate office buildings, spacious rest rooms of high aesthetic quality express organizational respect for the comfort of users.

Rest rooms accessible to a large general public may be designed to be more strictly utilitarian. Such facilities must also provide maximal protection against vandalism (the ever-present graffiti) and crime. The selection of materials that are resistant to damage and easily cleaned aids maintenance, while a thoughtful plan layout (one that avoids areas of isolation, for example) can discourage trouble. Guidelines for barrier-free access must also be adhered to (see pages 224–28).

16.33 Executive washrooms have become favorite status symbols in business office complexes. Handsome materials and details add to the sense of opulence in this example, designed by Gwathmey Siegel & Associates Architects, for the offices of FDM Productions, New York. (Photograph: O. Baitz, Inc., courtesy Gwathmey Siegel & Associates Architects) **16.34** The low profile of Toto's Neorest 600 toilet results from the elimination of the tank. The lid's pearly finish reflects ambient light, and it automatically opens or closes when an individual approaches or leaves. **16.35** At the Phoenix Level Restaurant of the Garden State Racetrack, Cherry Hill, New Jersey, a richly detailed public toilet displays strong colors and opulent materials, which transform a necessary utility into a dramatic space. Ewing, Cole, Cherry, Parsky was the designer. (Photograph: © 1985 Tom Crane) **16.36** The men's room of the Cut and Chase bar and restaurant, Newcastle upon Tyne, England, generates a sense of sanitation and a quality of futurism through use of blue tile, stainless-steel fixtures, glass, and mirror. The design is

16.36 ↑

by Paul Daly Design Studio. (Photograph: David Stewart, courtesy Paul Daly Design Studio) **16.37** A gleaming stainless-steel cone forms the support of the washbasin in a guest bath of the Paramount Hotel, New York. The sink is one of several unusual elements in

Philippe Starck's interior renovation of the Paramount. (Photograph: Tom Vack, courtesy Starck)

Storage

RESIDENTIAL

Closets make up the primary storage provision in modern residential practice, although shelving, cabinets, files, and even entire storerooms may also be called for. Intelligent design begins with a careful estimate of what is to be stored and a consideration of where suitable storage spaces should go. Commonly, a coat closet is needed near each primary entrance to a dwelling, a clothes closet for each bedroom (ideally double for double occupancy), and at least one linen closet to hold bedding, blankets, and bathroom linens. In addition, the great variety of things that modern families accumulate—sports gear, toys and games, photography equipment, records, tapes, CDs, luggage, and even such bulky items as bicycles, snow tires, and skis—demands general storage space.

Conventional closets must be large enough to provide hanging space for clothing and require full front access through sliding or accordion doors. Shelves, shoe racks, built-in drawer units, and other specialized provisions can make storage space more efficient and convenient. Such storage arrangements can be specially detailed and built or can be developed through the use of widely available ready-made systems of closet accessories. More extensive storage arrangements include the *walk-in closet*, actually a small room with hanging space and other storage fittings on both sides of an aisle, and the *dressing room*, in which closets and other storage spaces are combined with space and equipment for dressing, grooming, and makeup, including good mirrors and lighting (fig. 16.38). A dressing room is often used as a transitional element between bedroom and bath.

There are several ways to introduce extra storage space into a plan that lacks adequate closets:

- *A line of closets replacing a wall between two rooms*. The storage wall usually goes between two bedrooms and is divided so that each room gains half (or some other fraction) of the total. Each space loses only one-half the total closet depth while otherwise retaining its shape.
- *Storage furniture*. Storage pieces can be placed (or built-in) where needed (figs. 16.39–16.41). Wardrobes and armoires, widely used in Europe in place of built-in closets, are available as imports, often as elements of storage systems that also provide drawers, shelving, and special-purpose elements such as desks, bars, and TV/audio equipment arrangement.
- *Room divider and wall storage unit*. Other furniture approaches to adding storage are room dividers and wall storage units (see fig. 13.22). They are best suited to the storage of smaller objects, such as books, records, dishes, and glassware rather than clothing. A room divider is used, as the name implies, between two spaces—where there is a large opening, where an opening can be created by the removal of a wall, or where one large space can be divided to serve multiple functions. The most usual locations are between living and dining areas and between dining area and kitchen. Wall units stand against, and may be attached to, a blank wall. Both types of units are usually made up of modular elements, available in a range of sizes and with varied functions. This means that the complete unit can be custom-designed to fit particular needs, even though the elements are factory-made. Similar units can also be specially designed and custom-built, often at a lower cost than a similar installation of ready-made elements. Storage walls can often accommodate such items as sporting gear, hobby equipment, and so on (fig. 16.42).
- *Ingenious ways to use space*. Where space is limited, ingenious use of space can often provide extra storage. Drawers or rolling box units under beds are one example. Closets often contain waste space above the normal hat shelf that can be developed for dead storage of rarely used objects. Shelves or cabinets high up on walls, while inconvenient, can hold items needed only occasionally if a suitable stepladder or stool is accessible. Space above standard kitchen wall cabinets may be used in this way, thus avoiding the problem of dirt collecting on cabinet tops at the same time. In a garage, it is often possible to develop storage space at an upper level over the hood of a parked car or over the entire car with some arrangement for a rack or container that can be lowered and raised as needed.

NONRESIDENTIAL

Storage provisions for hotels, motels, and dormitories follow residential practice, although, obviously, it is impossible to design for unique, individual needs. Office storage in executive and managerial offices also follows similar patterns in providing closets and space for books and equipment. For general and open offices, hanging space is necessary for outdoor clothing and for smaller items, jackets, handbags, and personal possessions. Wardrobe units are often placed close to general work spaces, with a lockable drawer or locker compartment nearby. Larger coat rooms located near entrances pose security problems that have discouraged their use.

Offices present special problems in the storage of records, documents, computer-related materials, and supplies. File cabinets, the traditional basis of office storage, are produced in a great variety of sizes and types by a number of manufacturers. Most file systems also offer utility cabinets, wardrobes, and other storage units in modular sizes that make it possible to assemble neat banks of storage elements, which may also be used as space dividers (fig. 16.43). For file rooms and archives, systems with banks of files on roller tracks are available; the units are solidly packed with no aisle space except at a single location where the

16.38 Ward Bennett was the interior designer of this dressing room in a New York City apartment. Simple, elegant forms are accentuated by the Josef Hoffmann chair of Vienna Secessionist vintage. Note the stainless-steel washbasin with the hospital-type faucet controls. (Photograph: Jaime Ardiles-Arce)

16.39 →

← 16.40

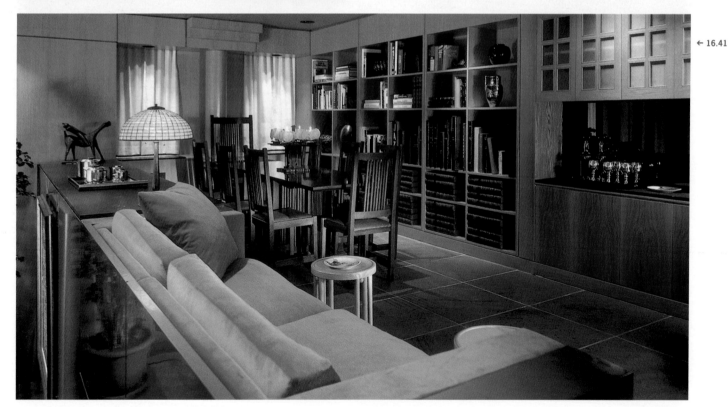

← 16.41

16.39 In a New York studio apartment, storage is ingeniously fitted into every possible space underneath and surrounding the access stair to a loft bed. Special drawers were designed to fit under the stair, where they accommodate objects of various sizes. Andrew M. Tuller of Tuller-McNealus Architects was the designer. (Photograph: Charles Maraia, courtesy *Metropolitan Home*) **16.40** Eileen Gray's ingenious storage cabinet with pivoted swinging bins in place of conventional drawers is here realized in lacquered wood and nickel-plated metal. (Photograph courtesy Ecart Internationa/Palluco) **16.41** The most traditional wall storage—bookcases—can be installed wall to wall, floor to ceiling, or both. Shown here is a New York City apartment designed by Gwathmey Siegel & Associates Architects. (Photograph: Norman McGrath, courtesy Gwathmey Siegel & Associates Architects)

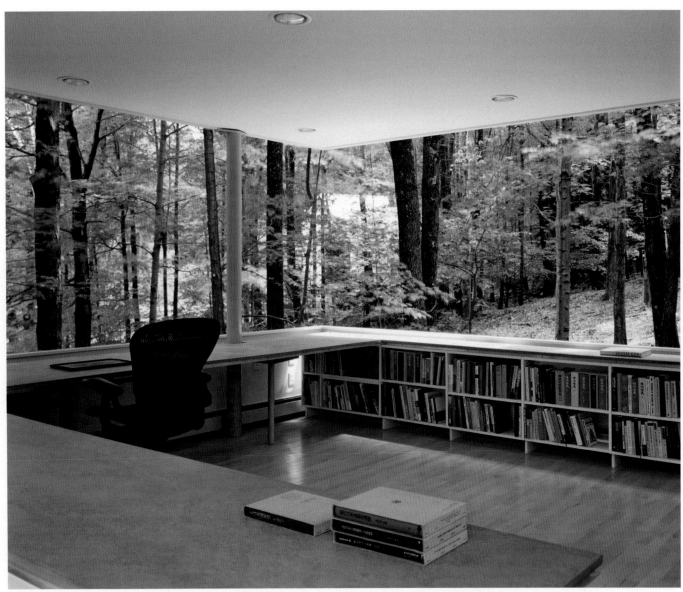

banks are rolled apart to permit access (fig. 16.44). When file cabinets are closely banked, the weight of the files can build up heavy floor loadings that may exceed the limits permissible for the structural system of the building. In new construction, engineers can provide extra support for dense file locations. In existing buildings, it is important to know what structural limitations may influence the placement of files.

Adequate provision of general storage—for supplies, equipment, and odds and ends such as sample products—is important if office spaces are to maintain a sense of neatness and order. Papers and objects that cannot be discarded but do not fit any available storage space contribute greatly to the chaos that all too often characterizes office interiors.

Other Special-Purpose Spaces

The interior designer occasionally encounters other special types of interior spaces. Some of these gain their special character from a particular kind of building or plan type, others from a special function. The following section presents a survey of such spaces.

LOFTS

A *loft* is simply an open space, usually unfinished in detail, intended for utilitarian uses such as manufacturing or storage. In larger cities, loft buildings provide space in multifloor configurations similar to the open areas typical of large office buildings. Artists in search of studio space were the first to recognize that,

16.42 Designed by Peter L. Gluck and Partners, the Scholar's Library in Olive Bridge, New York, is an independent building with a study area and storage space for 10,000 books on Japanese history. Continuous glass on all four sides transforms into an open area by sliding open the large glass panels. Nature is never far away.

16.43 →

16.43 Executive workstations at American Capital, Houston, in a semiopen plan are separated by large, custom-built wall units, some with central openings. The units, designed by ISD Incorporated, provide storage as well as defining individual offices. (Photograph: Charles McGrath, courtesy ISD Incorporated) **16.44** A mobile system of double-banked bookcases can greatly expand the storage capacity of a given lateral space. The front unit rolls in tracks to give access to the units behind. (Photograph courtesy Punt Mobles, S.L.) **16.45** The northern exposure—ideal for artists' studios because of the consistent light— and the pleasant view of a public park make this double-height loft space particularly attractive. It was designed by Bray-Schaible Design and Joseph Paul D'Urso to house the designers' New York studios. (Photograph: © 1979 Peter Aaron/Esto)

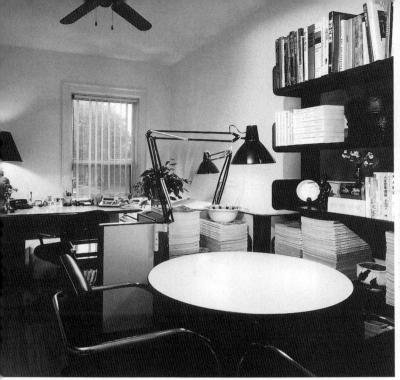

16.51 ↑

← 16.52

Table 34. Home Office Checklist

- Isolation from other household activities
- Adequate work surfaces
- Provision for computer equipment with monitor in proper viewing position, keyboard at correct height and angle (or adjustable), and space for mouse or input slate if needed
- Space for computer printer (and typewriter if required), copying machine, and scanner as required
- Suitable location for telephone(s), answering machine, fax machine, paper shredder, plus any other special equipment
- Good general lighting and suitable task lighting with avoidance of glare, veiling reflections, and reflections from monitor screen (for a thorough discussion of office lighting needs, see Chapter 11, "Lighting")
- Files as needed
- Storage for supplies, reference books, and magazines
- A carefully selected ergonomic office chair
- Provision for any special needs, such as display of objects, pictures, pinup tackboard or chalkboard, drafting table, computer plotter, flat storage (for drawings or layouts), TV or audio equipment, intercom, clock

A home office may be a single piece of furniture sharing space in a bedroom, library, living room, or kitchen. It may be a special built-in grouping in a study, an extra bedroom, or even a closet (figs. 16.49, 16.50). If extended use is anticipated, it may become a room not unlike a typical private office in a larger office grouping (figs. 16.51, 16.52).

There are many issues to be considered in planning a home office. (See Table 34, "Home Office Checklist," opposite.) Basic amenities, such as adequate space, suitable ventilation, heat, and air-conditioning, are, of course, as necessary as in any other room of a home.

MEDIA ROOMS

The media room is a new and developing functional room type based on the special conference rooms and meeting rooms utilized by many office facilities. It is really a small theater designed to provide a comfortable and convenient setting for viewing and listening to television, videotapes, DVDs, and projected film and slides (figs. 16.53, 16.54). A special space for these purposes is obviously a luxury only possible in a large house or apartment, although to someone who is professionally active in television, film, and related advertising fields, it may be a necessity.

Ideally, the media room is a specially dedicated space with arrangements for its own equipment, seating, and acoustics. If this is not possible, the required equipment may be built into or incorporated into the living room or entertaining space.

16.51 Work space, storage, and a tiny conference area are all accommodated in the small, spare home office of designer Ken Hsia's Toronto, Canada, apartment. Note the creative use of stacked magazines as room dividers. (Photograph: Fraser Day, courtesy Ken Hsia)

16.52 A somewhat formal and well-appointed home office in the Whalen town house, New York, is given some isolation from household activity by its position on a balcony level, viewed here from a terrace. Steven Harris Architects were the designers who converted an 1868 lumber warehouse into this family residence. (Photograph: Scott Frances)

16.53, 16.54 An elliptical conference room for the New York offices of Elektra Entertainment also serves as a media demonstration theater (fig. 16.54). (Photograph: © Peter Mauss/Esto) The table was custom-designed by the architects, Bausman-Gill Associates. As indicated on the axonometric drawing (fig. 16.53), the walls and panels of the room are movable. (Courtesy Bausman-Gill Associates, New York) **16.55** This conservatory porch doubles as an informal living area. The hydraulically operated windows can be retracted into the base-ment, thus opening the space to the out-doors. The West Porch of Westbury House, Old Westbury Gardens, Old Westbury, New York, is a modern renovation of the 1906 mansion. (Photograph: Richard Cheek) **16.56** A courtyard enclosed by glass on two sides and an outside wall on a third brings light and greenery into the Seth Stein Residence, Kensington, London, and yet retains privacy. The HVAC grilles at the base of the glass walls protect inside areas from heat and cold. The project was designed by Seth Stein Architects. (Photograph: © Arcaid/Richard Bryant)

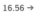

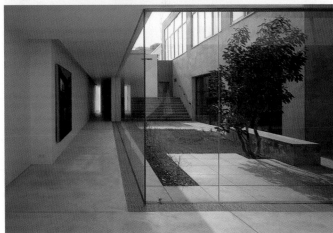

Specialized consultants can be very helpful with technical requirements. Besides making the space attractive, the interior designer must deal with positioning complex equipment so that it can be easily concealed, if desired, as well as used.

CONSERVATORIES

A special room or alcove for plants has been a desired feature of many residential spaces at least since the Victorian era (fig. 16.55). Big windows, preferably facing south, are the basic requirement for a conservatory. Shelves for plants and, for larger plants, a suitably water-resistant floor are needed. A conservatory that houses tropical plants must be isolated from other interior spaces and have its own separate controls to maintain the proper levels of heat and humidity. Glass partitions accomplish isolation without giving up visibility.

GREENHOUSES

A greenhouse is a special type of conservatory that has glass walls and roof to maximize the entrapment of solar energy for plant growth. Adaptations of the freestanding greenhouse used by professional nurseries, in forms that can be attached to a residence, have become popular. Adding a greenhouse to other living spaces by extending it into garden space or onto a deck or patio is a pleasant way to open up the interior to light while providing space for growing plants. In fact, many people add greenhouse space simply to gain living area with a particular feeling of brightness and openness.

In order to put in a greenhouse, sufficient south-facing space with unobstructed light must be available. Issues that must be considered are how to handle the connection between greenhouse and existing walls; the type of opening for access and closure; and the type of flooring, taking into account the damp conditions. A greenhouse addition works well as an extension of living, dining, or kitchen areas. The greenhouse used for serious plant cultivation, like the conservatory, needs isolation and separate atmospheric controls. At the other extreme, when no space is available for a larger, walk-in unit, tiny greenhouse units that fit into a window opening offer a limited greenhouse function.

COURTYARDS

A *court* is, in effect, an outdoor room, surrounded by adjoining enclosed spaces and differing from them only in being roofless. Courts have been a traditional element in home design in Mediterranean regions since ancient times. They continue to be

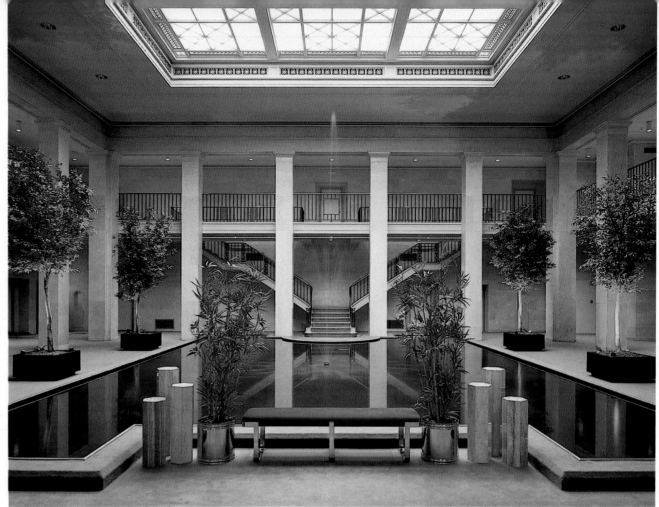

← 16.57

an attractive possibility in larger residential plans but may also be found in smaller, special purpose plans. A court is normally an element in a one- or possibly two-story building, but it is technically feasible at the top level of a taller building, too.

A court may have a primarily gardenlike character, or one closer to that of an interior room, or any possible mixture of these characteristics. Pools and fountains are favorite elements for inclusion in a courtyard. With the modern availability of glass or window walls, an open court can be seen and enjoyed even in the cold months in more northern climates (fig. 16.56). The materials and furniture used in a courtyard, like those for terraces, decks, and patios, must be selected for the special qualities that outdoor service demands. In addition, unless the courtyard is at ground level, the construction must ensure that there is no water leakage into spaces below. Some kind of lighting may be desired for nighttime use.

ATRIUMS

The word *atrium* is simply Latin for *courtyard*. It has recently come to refer to a large interior space roofed over with glass—an interior courtyard that is actually a special kind of interior room (fig. 16.57). The atrium has become a much-favored element in large new hotels and in some corporate office headquarters buildings. In a private house, an atrium plays almost the same role as the courtyard, with the difference that it is independent of the effects of weather and climate. Introducing an atrium into an older, conventional row house is one way to open up the interior into a more

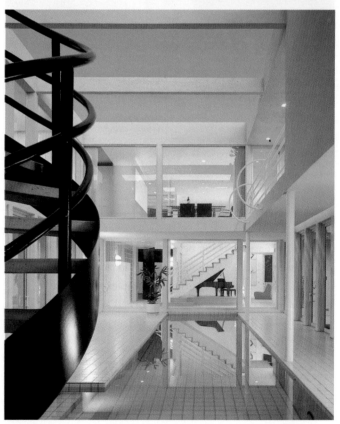

← 16.58

modern set of spatial relationships. Incidentally, it can also help to bring daylight into what might otherwise be dark interior spaces. An atrium is often used as an indoor garden or conservatory, where growing plants up to the size of small trees can thrive.

chapter seventeen. Public Interiors

Interior design work separates into two main fields, described as *residential* and *contract*. The first term is self-explanatory, but the second merits a closer look. It comes from a semiobsolete business practice in which nonresidential projects were often taken on under an inclusive contract to provide all the needed elements, similar to the kind of contract usually entered into for building construction. The term has come to refer to all interior design work that is not specifically related to private residential space—that is, the kinds of spaces that are discussed here as public interiors.

Residential design is characterized by relatively small-scale projects and a close working relationship with the client (in fact, the client may even be his or her own designer). The resulting space has been carefully tailored to the needs, desires, and tastes of the individuals who will be its occupants and users.

Nonresidential interior design tends to have a different character. Projects are generally larger, sometimes huge. More often than not, users are not the clients of the designer but some segment of a public that may include staff, workers, employees, executives, and professionals, plus, in many projects, outsiders from a general public of customers, visitors, travelers, guests, and casual passersby. Their relationship to the project may vary from quite close (occupants of a dormitory, patients in a hospital, or workers in an office) to very tenuous (customers in a shop, visitors to a museum or gallery, or passengers in a depot or terminal).

Public interiors are accessible to a large range of users and include highly visible, even spectacular spaces that attract inter-est and excitement. Professional interior design has, in recent years, come to focus on contract work, partly because it includes large and lucrative projects, partly because such projects almost always require the services of design professionals. A high proportion of residential spaces are still put together, for better or for worse, without help from any trained specialists. This used to be the case with public spaces as well. Some years ago, a typical office was simply furnished with whatever the office manager thought necessary to make work possible. A restaurant was often designed by the contractor who built the installation, while major public buildings (courthouses, churches, libraries, and museums) received furniture and lighting almost as incidental details.

Various factors have brought an increasing number of public spaces into the sphere of interior design. These include a new awareness of environmental influences on human behavior: the way in which an office interior influences work performance, for example, or the way in which the design of a restaurant fosters the satisfaction of the restaurant's customers. Design has come to be seen as an important factor in the commercial success of many enterprises. The good design of a store, bank, hotel, or office makes an impression on the people who visit the spaces, raising their confidence and encouraging a return visit. Bad design can have an opposite and highly negative impact.

Designers aim to make public spaces serve their purpose well, that is, to be comfortable and convenient for both the public and

17.1 Designed by Mario Botta and completed in 1995, the Museum of Modern Art in San Francisco hosts four exhibition floors plus this ground floor. A striking feature of the ground floor is the direct relationship established between the foyer area and the central "eye" that opens to the sky. This relationship permits visitors to find their way easily around the exhibition floors. Black granite is used throughout the building on the floors, which are complemented by white painted walls and wooden ceilings.

the staff. A second, equally important goal is to create pleasant, exciting, and memorable spaces. This may serve strictly commercial ends in bringing in (or bringing back) customers, or it may serve wider purposes in building morale and confidence in an institution, an organization, a town, or a nation.

In working on such projects, the interior designer is guided by the same concerns that govern residential projects: the functional issue of having a space work in a practical way; choosing materials and construction techniques to serve the practical requirements; and resolving the first two issues in a way that makes an aesthetic impact.

Contract design is often quite specialized. Some designers concentrate on certain fields, such as offices, hotels, restaurants, or hospitals. While specialization tends to build efficiency and skill in a particular field, it can also lead to repetitious formula design. A designer who tackles a new kind of project for the first time is more likely to come up with a fresh approach than a designer who works on an endless stream of similar projects. Still, many modern assignments have such specialized technical requirements that some specialization seems necessary. Hospitals and healthcare facilities, for example, demand technical expertise, but a specialized consultant or an association with a designer experienced in such a field can bring the necessary skills into a firm taking on such a project for the first time. The skills that lead to first-rate work in one kind of project are generally transferable to even highly specialized projects when all the necessary specialized knowledge is drawn into a design team.

The increasing variety of projects that come to the attention of interior designers has extended the range of practice in this field to make it a more varied and lively profession than it was only a few years ago. Such seemingly unlikely interiors as those of spacecraft, submarines, laboratories—even jails—are now appropriate areas for professional design concern. An extensive literature deals with the specialized problems of various interior types, including offices, hotels, restaurants, hospitals, museums, and retail stores. It is impossible to go into detail about every one of these fields here. Instead, this section offers a survey of typical projects in a wide range of types, with some brief comments about each area of practice.

Commercial Spaces

OFFICES

Modern business generally regards the drab and often depressing quality displayed by business offices in the early part of the twentieth century as unacceptable. It has been realized that appearance makes a difference. Visitors to an office form impressions and draw conclusions about the business's character and quality based on the design of the offices they see. In addition, the setting in which employees spend their regular working days heav-

ily influences their attitudes toward their employers and their consequent productivity.

The offices of major corporations and other big modern organizations (such as government agencies) have become large, even vast complexes, sometimes occupying many floors or entire buildings. Planning such office projects is a demanding and specialized activity, and office design and planning have become an important field of interior design practice. Decisions about the layout, the size of offices, and the provision for privacy through partitioning (figs. 17.2, 17.3) or (often in modern practice) without partitioning (fig. 17.4) must be balanced against the requirements of the work function, the projection of individual rank and status, and the overall style and objectives of the organization.

The many design firms that have chosen to specialize in office planning (often called *space planning*) have developed highly systematized ways of dealing with such projects. Over time, the typical single room with a door that served the solitary lawyer, manager, or executive grew in larger organizations to an unwieldy agglomeration of private spaces. Secretaries were often placed in an outer office, in effect guarding access to the private-office occupant. Stenographers, typists, bookkeepers, and clerks were all thrown into larger rooms (often called *bull pens*), entirely without privacy. A typical office plan of this sort placed managers and executives in private rooms along the outside walls, with assistants, secretaries, and other staff in central, usually windowless spaces. While many offices are still planned and built in this general way, modifications have come into use that make most modern offices both more attractive and more functionally effective.

About 1951, a concept often called *office landscape*, or *open planning*, emerged. Traditional walled private offices were abandoned, and all personnel—managers and staff alike—were placed in an open space with movable storage units or screen panels to provide limited privacy where necessary. The result was simplified communication among all workers, ease in making layout changes as work processes might require, and a reduced emphasis on hierarchical status.

It must be recognized that some office work calls for privacy, quiet, and freedom from interruption. The nearly universal acceptance of computers as vital to office work, requiring a small computer or computer terminal (CRT—cathode-ray tube—unit) at almost every workstation, has led to the development of furniture systems that provide screen panels, partition elements, and work and storage components that can create every sort of work space without resorting to fixed partition walls. Such systems (see pages 415–17) are now basic to most office planning. Techniques for developing layout for such systems through surveys of needs, matrix charts, and link and bubble diagrams have been discussed in Chapter 6, "Planning."

Office systems using panels to define workstations have led to

1. elevator lobby
2. reception
3. board room
4. conference
5. legal assistants
6. word processing
7. secretarial stations
8. lawyers
9. copy/printer/coffee

the wide acceptance of office plans based on a modular grid, with cubicles formed by panels that carry work surface and equipment. The resulting monotonous sea of cubicles in large offices has caused some reaction against this popular office plan. The individual cubicle tends to isolate each worker in a standardized (and some think dehumanizing) box, while the use of the panel partitions to carry power and communications cable makes changes in plan configuration costly and difficult.

The need for real flexibility in office layout, for easy communication and the development of team approaches to office work organization, has led to a movement away from cubicles and toward more freely shaped and organized office furniture systems. As a result, it is now possible to recognize several types of office interiors all of which remain in use, although they have developed in a historical sequence:

- *The traditional office plan*, with private offices for executives and managers and totally open *pool areas* (places with a ready supply of workers) for support staff (see figs. 17.2, 17.3).
- *The open or landscape office* in which private offices are eliminated and all workstations are composed of freestanding furniture with only limited use of movable privacy screens. This approach, new in the 1950s, developed toward the use of systems offering increased privacy without fixed partitions (fig. 17.5).
- *The modular office system*, developed by furniture manufacturers, using panels to create cubicles and carry wiring. This approach represents a compromise between open and partitioned offices and became dominant in the 1980s and 1990s (fig. 17.6).
- *The freestanding reconfigurable system* that offers greater flexibility in workstation form, more openness, and simplified wiring connection, usually by overhead distribution. This approach, a reaction against the rigidity of cubicle planning, developed in response to the fast-moving pace of the electronic and telecommunication industries. It is an approach gaining in popularity as the twenty-first century proceeds (see fig. 17.4).

Combinations of these approaches are commonplace. Conventional partitioned spaces may be provided for individuals who alone have need for total privacy, while one or another form of open plan is used for those whose work involves more group communication and team creativity or who do not spend a great deal of time in the home office but do have to make periodic visits, a concept called *hoteling* (fig. 17.7).

17.2, 17.3 Office workstations for support staff are arranged along a circulation route (fig. 17.3) in the law offices of Perkins Coie LLP, Seattle, Washington; lawyers occupy traditional enclosed offices along the perimeter. Beechwood grid screens give the support staff a partial sense of enclosure (fig. 17.2). Gensler and Associates Architects were responsible for the interior design. (Photograph: © Peter Aaron/Esto) **17.4** The offices of SEI Investments Corporate Headquarters, Oaks, Pennsylvania, are in a totally open, skylit area. Even top executives share the nonpartitioned space. All furniture and equipment is on rollers with overhead wiring feed. Staff members are encouraged to place workstations as desired. Circulation is along clear paths preserved at the exterior walls and down a central spine. Meyer, Scherer & Rockcastle Ltd. were the architects. (Photograph: Timothy Hursley)

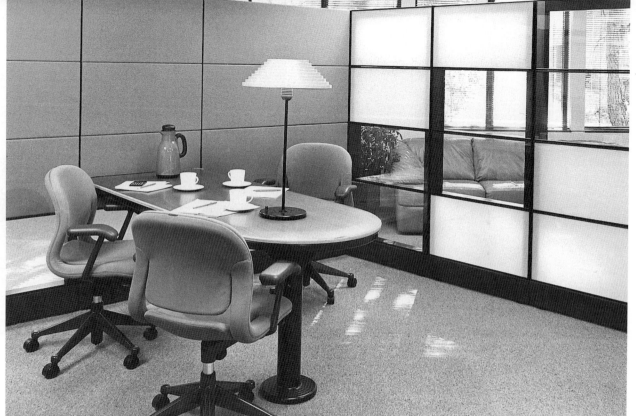

← 17.5

17.6 →

← 17.7

■ Reconfigured
interior architecture
■ Reconfigured
furniture

17.5 Privacy in open-plan offices can be achieved as needed by means of flexible office partition systems. The solid, opaque, and clear-glass panels of this partition are part of a system that includes furniture design by William Stumpf for Herman Miller. (Photograph: Peter Kiar, 1985, courtesy Herman Miller, Inc.) **17.6** Three successive configurations show how an office system can provide adjustment to changing work conditions. The system is called Pathways and is produced by the manufacturer Steelcase. (Courtesy Steelcase)

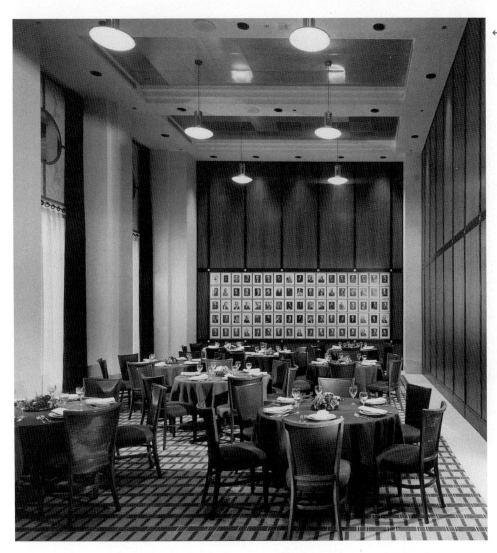

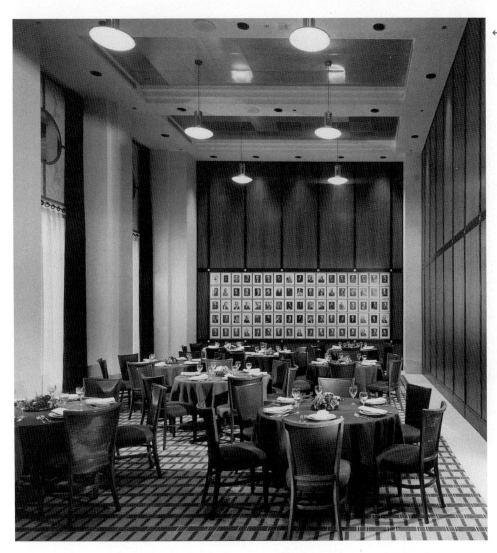← 17.8

In addition to the layout of actual workstations, office design includes such special-purpose spaces as conference, board, and meeting rooms, reception areas, dining facilities, lounges and rest areas, mail and shipping rooms, and file spaces (fig. 17.8).

The need to make any office comfortable and attractive to its workers as well as to visitors involves appropriate plan layout, suitable lighting, and sound choices of materials, finishes, and colors, so that the completed project expresses the nature of the user organization in a way that builds efficiency and staff loyalty. Dreariness and monotony are constant dangers in the offices of large corporations or any sizable organization in which hundreds of workers may feel lost in a vast hive. Efforts to break up expansive spaces into smaller units, to use spaces with more individual character (such as those in older existing buildings), and to encourage personal expression in the vicinity of the individual work space have produced many positive results.

Some offices are primary contact points with the public. This is true of ticket offices, the consumer service offices of insurance or loan companies, brokerage offices, and the public offices of different organizations where people come to apply for credit, make complaints, or confer about other matters. In all of these situations, the ambience of the office itself conveys a strong impression about the nature and quality of the organization (fig. 17.9).

The design of all offices includes the selection of suitable work equipment and seating. Modern office furniture and equipment are available in great variety and are, at best, of very high design quality. Computers and modern communications equipment have brought new efficiency to office work, creating what is often called the *electronic office*, but have created new problems as well. The need to maintain a fixed seating position can result in physical problems (muscular or back pains), while long

17.7 The term *hoteling* is used to describe office accommodation for workers (traveling sales personnel, for example) who are rarely in the office but use it like a hotel for brief visits to do paper and computer chores. Here, in the New York offices of Scient Corporation, a provider of Internet and technology consulting services, overhead wiring provides laptop computer connections for hoteling workers, while lockers and drawers on the back wall form short-term storage units for personal materials. The project was designed by architect William Green. (Photograph: Andrew Bordwin)

17.8 The Winston & Strawn President's Room, in the facilities of the Chicago Bar Association, is used for meetings, seminars, and dining. A wall of photographs of past presidents serves as a decorative focus in the double-height space, which has wall panels of teak and recessed ceiling panels of brushed steel. Greg Landahl of the Landahl Group was the interior designer; the building was designed by Tigerman McCurry Architects. (Photograph: Jon Miller/Hedrich-Blessing)

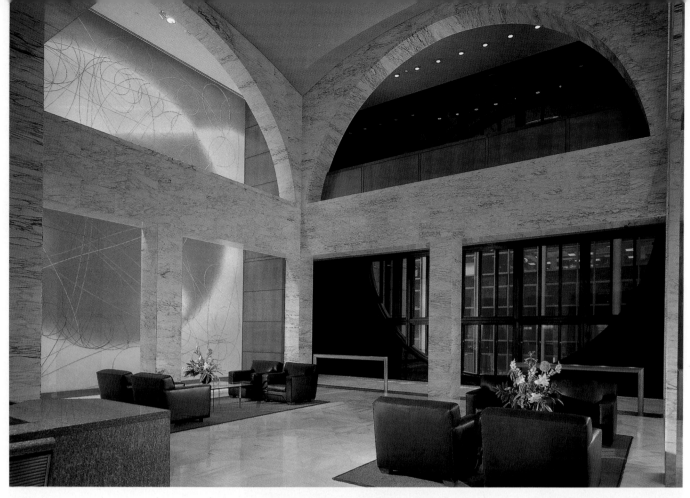

hours working with the computer terminal under unsatisfactory lighting can cause eye-strain. A work pace set by the electronic equipment rather than by the worker's own normal habits can generate nervous and emotional problems. Research has shown that these can be minimized with careful design. Spatial arrangement, color, lighting, and acoustics influence the ease and efficiency of work and establish an atmosphere that can reduce stress, make work easier and less tiring, and support morale. Means are now available to give the individual office worker personal control of furniture configuration (adjustable work surfaces and seating), lighting, air temperature and quality, acoustical conditions, and levels of visual privacy. Such recognition of the individual workers' varied needs along with selection of the most appropriate planning and system selection give to the office designer an opportunity (and an obligation) to achieve some of the best interior design work currently being produced.

BANKS

The tradition of formal, templelike architectural structures for bank facilities has been upset by the new competitive struggle among banks to attract depositors. The "friendly banking" movement has drawn banks toward the liveliness and attraction of a retail shop or display pavilion for their public spaces (fig. 17.10). This is no easy goal, considering that banks have no merchandise or products to display and that the growth of automation is gradually replacing human tellers and counter attendants with machines.

At its best, the interior design of today's banks ranges from a modern but still dignified formality to visually spectacular displays of light and color. Some of the most interesting of bank designs involve older bank buildings of fine design quality, even of landmark status. These have been modified internally to improve convenience and project a sense of contemporary vitality while still retaining and respecting the older setting with its architectural dignity (fig. 17.11).

In addition to the public banking room spaces, banks usually include semipublic spaces, such as a safe-deposit box area, and an office area with formal executive quarters and more utilitarian backstage work areas. All of these spaces can be examples of design excellence.

17.9 Simple furniture and brilliant colors (in wall frescoes by Dorothea Rockburne) seem appropriate in the monumental "sky lobby" of the Sony headquarters in New York (formerly the AT&T Headquarters). Philip Johnson and John Burgee were the architects of the building, and Gwathmey Siegel & Associates Architects designed the interior. (Photograph: © 1993 Durston Saylor)

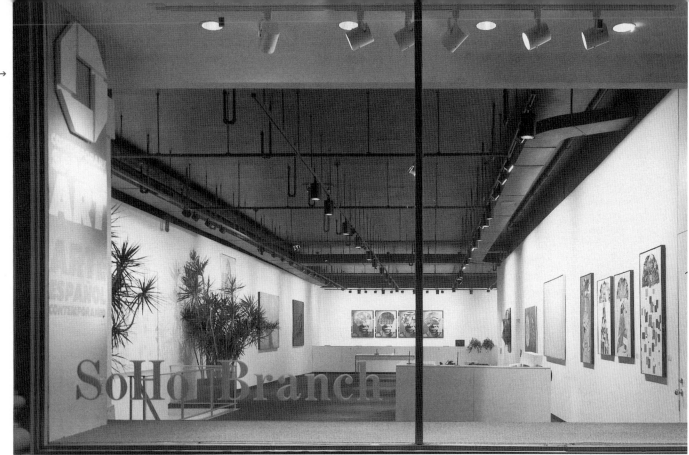

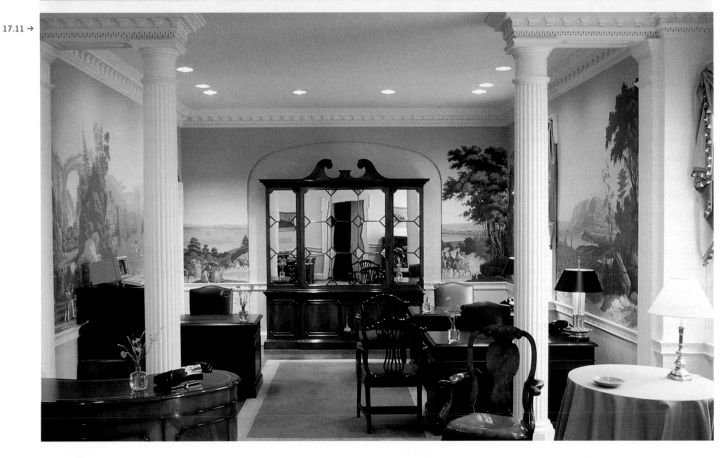

17.10 A neighborhood branch of the Chase Manhattan Bank in New York's SoHo district, a favorite location for artists' lofts and studios, features artwork in a gallery atmosphere in order to express a kindred orientation. Plants add another "friendly" touch. Skidmore, Owings & Merrill were the designers. (Photograph: © Wolfgang Hoyt/Esto)

17.11 Many bank facilities are designed to project a sense of dignified conservatism. This space, designed by John F. Saladino for the Chase Manhattan Bank of New York, is in a building constructed circa 1933 and was renovated in 1986. The atmosphere suggests a Georgian residence or club, while the modern electric lighting from recessed ceiling fixtures provides illumination for contemporary working conditions. (Photograph: © Langdon Clay)

The planning of a bank combines some of the elements of a retail shop with aspects of office design and yet other considerations unique to banking. The major space of a typical bank or bank branch is a public area where depositors may fill out forms at a counter, stand in line near the tellers' windows, and, with as little waiting as possible, conduct a transaction at the tellers' counter. This traditional pattern has been modified with the introduction of automated teller machines (ATMs) that can deal with the vast majority of banking transactions without human contact. At the same time, most banks offer a number of special services, such as loans, mortgages, and brokerage and insurance services, that require more complex customer contacts either at counters, in semiprivate or private offices, or in conference rooms.

The planning of a banking space must begin with estimates of the number and kinds of customer transactions that will take place. Brief use of an ATM calls for a treatment different from that required by personalized service (whether at a teller's window or in a more extended meeting with staff at a counter, desk, or table). Although the need for nonpublic areas in a bank has been greatly diminished by computerization, these spaces remain necessary and their requirements are frequently no different from those of other office spaces. The area directly behind the tellers' counters, however, demands particularly tight security, including internal control, as well as protection from the public.

Many banks offer a safe-deposit service requiring public access to the vault. Access to this area (often in a basement location) requires special security control, with booths for customer use adjacent to the vault within a secure area. In smaller banks the vault is also used by the bank itself, creating a complex problem of circulation for both staff and customers, who must retain separate but equally secure access. Banks also commonly offer drive-up window service, complicating planning with the further need to make both human tellers and ATMs available at an external driveway.

BROKERAGE OFFICES

Brokerage offices constitute another special office type that mixes public service with internal functional needs. The typical brokerage office has a public space (either at street level or on an upper floor) where customers can watch the board that displays transactions, consult literature, obtain services at a counter, and request conversation with an individual broker or customer representative. In a generally open area, brokers have workplaces that include a desk surface with an array of electronic screens and keyboards, along with a visitor's chair to accommodate a customer. Other areas not accessible to customers include managerial office spaces, private offices and conference rooms, and areas called trading rooms, unique to financial institutions, where by means of electronic devices brokers or traders buy and sell securities and

17.13 →

other financial instruments. Traders must have eye and voice contact with one another while using a variety of screens, telephones, and keyboard-communication devices (figs. 17.12, 17.13). Large trading rooms are spaces that call for highly specialized, technologically oriented design.

SHOPS

In the modern, aggressively commercial world, shopping is an important activity, and shops form the setting for a wide range of practical and emotional experiences. People expect to be lured, charmed, and entertained in the process of selecting and buying goods. The design of a shop should convey a variety of messages about style, quality, and attitudes toward its products and services at the same time that it provides a practical setting for the display, storage, and actual sale of goods. The shop designer is expected to grasp the special character of a particular store—sometimes even to help invent that character—and then project it visually in a concrete way that the customer and potential customer can feel, remember, and enjoy.

All of these features can be studied in some fine older shops in many of the world's great cities. The special qualities of these stores have been arrived at through tradition and the individual shopkeeper's sense of what appeals to a particular type of customer. Lacking a tradition, the shop designer must find ways to put across comparable impressions and to do it with the more impersonal realities of most modern merchandising.

The nature of the goods to be sold, their price level, and the style of marketing will all influence the design. A shop may be conservative or avant-garde, it may present a masculine or a femi-

nine aspect, or it may impart a sense of bargains waiting to be snatched up in a hurry or a feeling of leisurely and careful service. Small shops can convey a highly distinctive and personal feeling, while larger stores, such as major department stores, must provide varied settings for different departments and still suggest an overall character that can catch and hold customer loyalty. Along with all of this, display techniques, color, and lighting are deployed to make merchandise look its best and, for shops that sell apparel and related goods, to flatter the customer as well. Even fitting or dressing rooms call for consideration in this respect.

An organization devoted to the planning of retail shops and showrooms is the Institute of Store Planners (ISP). It includes members who are architects, planners, interior designers, lighting experts, specialists in CAD and IT, as well as professionals in store project management and construction. Some members are also involved with retail businesses, manufacturers and suppliers of components used in store and showroom interiors. The aim of the organization is to help all of those involved with store and showroom planning to produce projects of the highest possible quality.

In planning a retail shop (whether a small specialty shop, a section of a larger department store, or a large mass-marketing outlet) the designer will need to anticipate the customer's experience of the space, as well as the related roles of staff and management. A shopper will first encounter the space from outside. The storefront, open to the interior or composed of display windows, offers a preview of the shop's character. Big windows loaded with merchandise express the bargain outlet of mass marketing. Closed windows, each with a display planned like a stage set, characterize high-end specialty stores. Even the shopper who comes to a known store with a set purpose needs reassurance that the store is of the kind, in terms of pricing and quality, that is expected. A storefront can serve as a major advertising vehicle with signs, display, and lighting that lure the chance passerby and reinforce the intentions of the purposeful customer.

Once inside, the shopper's experience will be considerably more positive if needed information (where to go, what is available) is close at hand and if circulation paths are clear and obvious. The open displays of mass marketing invite the customer to inspect, compare, and make choices among goods on open shelves, in bins, or on racks. When merchandise for sale is more costly or specialized and the customer requires the help of salespeople, the character of the shop must establish the territory of movement open to the shopper, by means of counters or displays and other boundaries to indicate work spaces for staff. Retailers

17.12 In one example of the highly specialized office facility called a trading room, the floor is raised six inches to provide for communication cables, while duct work and sprinklers are left exposed overhead to accommodate the existing low ceiling height. The facility serves the American Stock Exchange in New York. Swanke Hayden Connell Architects were the designers, with Altan Gursel, design director of the American Stock Exchange. (Photograph: Robert Miller Photography) **17.13** In the main control room of the digital broadcasting facilities of Sirius Satellite Radio, New York, the controllers' desks and large monitor screens support the High Tech atmosphere. Large screens are useful in situations where many people need access to data, as in the war rooms of various organizations and in brokerage offices. Design was by HLW International LLP. (Photograph: Peter Paige, courtesy HLW International)

← 17.14

are constantly seeking to maximize the ways in which shoppers can find and select merchandise on their own.

Cashier and checkout locations need to be intelligently planned and clearly marked, as do areas of special services, such as packing and wrapping, placing special orders, and information booths. Certain kinds of retailing call for special elements that relate to the goods in question. A shoe store calls for chairs for customer fitting and appropriate mirrors. Clothing stores need fitting rooms and large, even triple, mirrors. Food shops are usually divided into open shelving or rack areas for general packaged products, refrigerated cases for perishables, and serviced areas where attendants behind counters cut meat or serve delicatessen items.

The spacing of components within a shop must relate to the pace of activity, the price and quality level of merchandise, and the type of customer desired. The clutter and bustle of a discount shop encourage quick buying decisions but discourage the questions, comparisons, and thoughtful choices associated with the selection of costly items in a luxury store. The purchase of fine jewelry and watches, an expensive rug, or a fine camera is aided when the set-

ting provides both space and time for careful selection (although such items may also be effectively sold, if offered at very low prices, within a bargain setting). In any setting, efficiency and orderly organization work to the advantage of both customer and management; chaotic layout will only irritate and frustrate.

Almost all retail outlets require backstage areas for stock, for lockers and rest rooms for staff, and, possibly, for offices (fig. 17.14), wrapping, and shipping and receiving areas. In addition to considering circulation patterns of customers, it is useful to consider the movement of goods through a shop. Where do goods arrive, where are they stored, how are they brought into display and customer contact, and how do they leave the shop? How is money handled and protected and what security provisions are required to minimize shoplifting, mischief, and shrinkage (pilferage by employees)? Along with these planning issues, the considerations of color and finishes, lighting, and graphic elements are all significant in showing merchandise to best advantage and making the customer's experience pleasant, possibly even exciting, to ensure return visits.

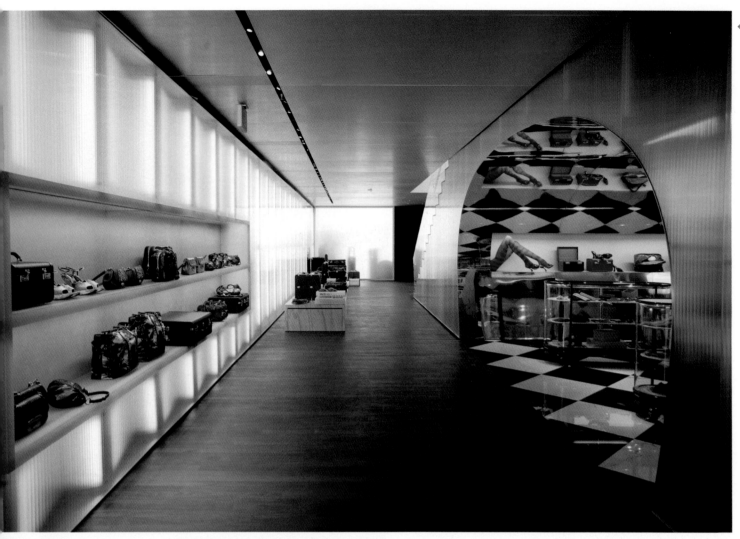

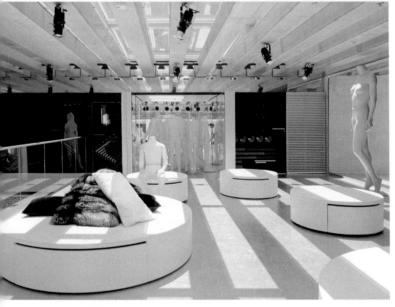

17.16 ↑

In recent years the act of shopping has developed into an act of recreation, a form of amusement as a way of spending time and being entertained. The design of shops has taken on the quality of theater, the shop itself as much a goal as the merchandise offered. (figs. 17.15, 17.16).

SHOPPING CENTERS

The shopping center, plaza, and mall are commercial centers that have rapidly become extremely popular public gathering places, bringing together retail shops, restaurants, cinemas, even hotels in one setting. At their best, they offer pleasant, even beautiful interior spaces that easily attract crowds, although many people come without intending to shop. This makes it highly advantageous for the individual shops within the shopping center or mall to develop designs that will offer special attractions in such a highly competitive environment.

17.14 The New York office for Ebel, a Swiss watchmaking firm, includes a double-height retail space designed by Andrée Putman, who also designed the custom furniture of oak ceruse. (Photograph: © Peter Mauss/Esto) **17.15, 17.16** Designed by OMA, Rem Koolhaas and Ole Scheeren, the Prada Epicenter store opened in Los Angeles in 2004. It consists of 14,750 square feet of retail space on three floors. Climatic separation is achieved through an environmentally responsive air-curtain system that profits from Los Angeles's pleasant weather. Roller tables form part of an airport-like display installation that draws reference to today's omnipresent security procedures. Plasma screens built into furniture or hanging between garments and merchandise are driven by daily news feeds and stock market data and connect the store to actual events in the world outside. A mixture of linguistic and visual representations creates multiple visions that oscillate between the outside world and personal desires. The resulting blend of 'truth' presents a cornucopia of today's virtual or mediated reality.

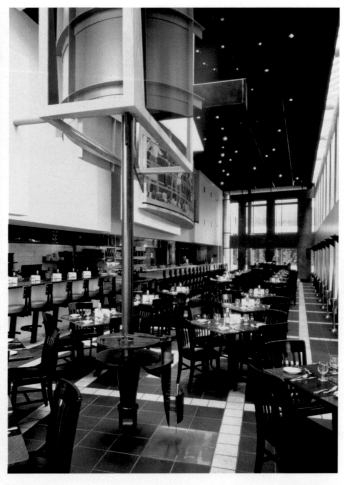

SHOWROOMS

The use of design as a tool for competitive selling has also become an important factor in the showrooms maintained by manufacturers of products and materials used by the design professions in their architectural and interior projects and in the showrooms serving the fashion trades. The showroom not only displays goods, it is also a source of design stimulation, an expression of company attitudes and philosophy, and almost a kind of theater for the projection of new ideas associated with products that often have a strongly fashion-related character. A well-designed showroom or display space may be as important to sales as the design of the actual products offered for sale (fig. 17.17).

Hospitality Spaces

RESTAURANTS

The aim of restaurant design is to create an atmosphere or ambience that supports the character of the food and service being offered and that makes the experience of dining memorable, encouraging the customer to return to and recommend the restaurant to others (figs. 17.18, 17.19). Restaurants vary from simple to elaborate, from frenzied to leisurely, from cheap to staggeringly expensive. All of these possibilities have their usefulness and their own particular clientele.

Although they may be clichés, certain familiar practices serve to make prospective patrons aware of the character of a restaurant and can help to satisfy their expectations. A fast-food shop should *look* fast, with bright lights and colors, slick surfaces, and an atmosphere of efficiency. A luxury restaurant calls for richer colors and materials, soft lighting, carpets, and a quiet atmosphere. The style of food served can also be expressed through choice of color, materials, and detail. One expects blue and yellow colors in a Swedish restaurant, red and white if the establishment is Danish. Seafood is associated with solid-oak tabletops and nautical accessories, while formal service and haute cuisine are better expressed in a setting of traditional elegance. It is all too easy to overdo restaurant theme expressiveness with decor so exotic as to approach absurdity.

17.17 The TOTO Neorest toilet design, Wellington, West Palm Beach, Florida, designed by the Pavlik Design Team, 2005. The design challenge for Pavlik was to create a showroom that established a strong brand identity and a luxurious environment that would reflect the quality of the product. The elegant design of the showroom is unique and minimalist, complementing the sleek, modern, and revolutionary design of the Neorest toilet.
17.18 Kate Mantilini restaurant by Morphosis (www.morphosis.net). The Kate Mantilini restaurant in Beverley Hills, California, was designed by the Los Angeles firm of Morphosis: a long, narrow space with windows on the right, a serving counter on the left, and tables arranged along an aisle close to the windows. Downlights in a random arrangement in the dark ceiling suggest a starry night sky.
17.19 In the spectacular, high-ceiling bar area of an elaborate—and expensive— New York restaurant called Palio, designed by Skidmore, Owings & Merrill, the large mural by Sandro Chia is the dominant design element. (Photograph: © 1986 Wolfgang Hoyt/Esto)

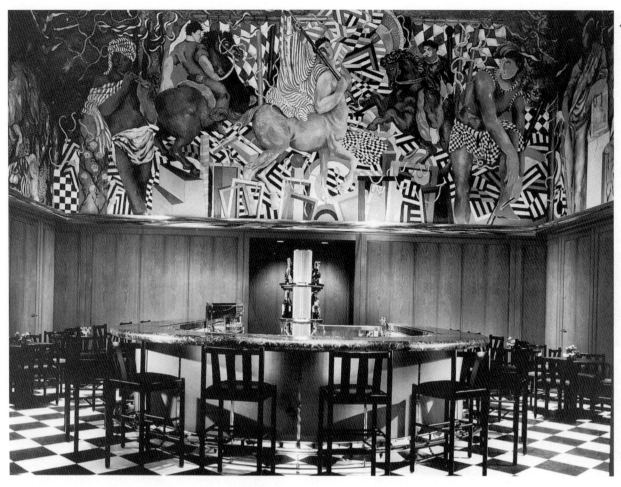

← 17.19

The involvement of the interior designer in restaurant projects is usually limited to the public spaces, which will include some or all of the following:

- Waiting area
- Checking area or hanging space for coats
- Bar (possibly combined with a cocktail lounge)
- Counter seating
- Serving counter (for cafeteria service only)
- Dining room with table seating, possibly with banquettes or booths
- Private dining room(s)
- Rest rooms
- Cashier's station

The kitchens and other service portions of a restaurant not visible to the public are usually not part of the interior designer's concern. An area comprising between 20 and 50 percent of the dining space is allocated to services; detailed planning of this part of the restaurant is often provided by the makers of kitchen equipment, working closely with the restaurant's management and chefs. The dining areas of hotels and motels are, of course, also restaurants. In larger hotels there are often several different dining areas, perhaps a coffee shop, a service restaurant and bar, and private dining and banquet facilities. Hotel kitchens and other services are usually grouped for efficiency, posing com-

plex problems in planning when there are multiple dining areas.

Design must reinforce the best aspects of a restaurant's qualities while promoting functional efficiency, ensuring the comfort and pleasure of the diner and serving the economic needs of the management to make the place a business success. Adam Tihany's design for Aureole Las Vegas at Mandalay Bay Resort and Casino, Las Vegas, is a model of success in achieving this goal. (See Case Study 10, "A Luxury Restaurant," pages 548–550.)

HOTELS, MOTELS, INNS

Hotels, motels, and inns range from the simplest of small guesthouses to vast complexes, complete resorts, or urban meeting places on a major scale (figs. 17.20–17.23). At a minimum, hotel guests seek comfort. They have come to expect entertainment as well—the active entertainment of sports facilities, casino, or nightclub or the more passive entertainment of using interesting or exciting public spaces and occupying guest rooms that are more than mere places to sleep. The *boutique hotel* has emerged as a special hotel type. The term refers to hotels that project a unique character and style—they are usually small and are defined by a design character far more personal, even sometimes quirky, in distinction to the large hotels and motels that are usually chain-owned and -operated. The boutique hotel offers the guest an escape from the sameness that characterizes hotels and motels that can be called *typical*. The ability to individualize guest rooms through special lighting and color control is a developing aspect of

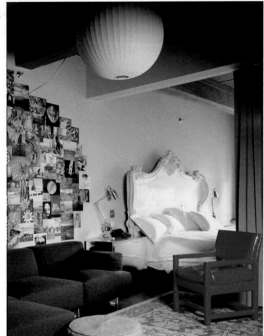

17.20 This example of a one-off guest room at Soho House in New York, designed by Studioilse in 2003, illustrates how different this designer hotel is from the major chain hotels. **17.21** A spa treatment room in the Vigilius Mountain Resort in Meran, Italy, 2003. Warm and neutral colors combine with the exterior view through the sliding doors to create an atmosphere of calm and relaxation. The horizontal wood louvers are adjustable to provide sun control. Matteo Thun was the architect. **17.22** At Prague in the Czech Republic, Eva Jiricna was the architect and interior designer for Hotel Josef. The reception area illustrated has a glass front on the street, a counter and bar on one side, and a descending spiral stair at its center. The front desk is at the rear.

17.23 →

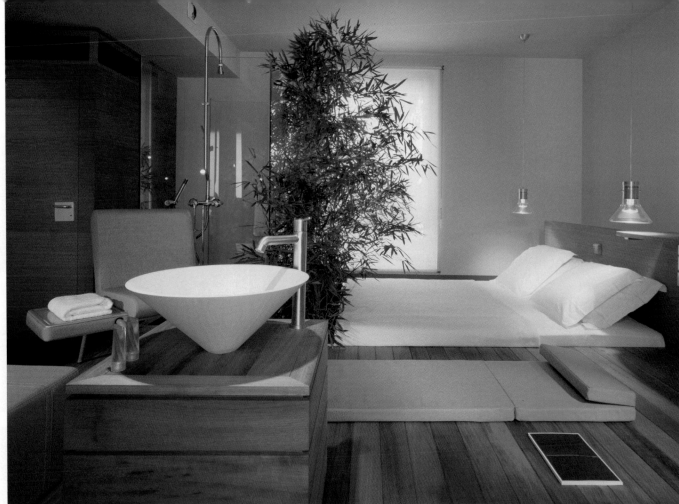

the newest boutique hotels (see fig. 10.46). Modern hotels and motels serve a variety of guests, ranging from the vacationer through the expense-account business traveler to celebrities who expect their lodging place to set off their personalities and styles.

Hotels at many resort locations have now developed into complete resorts or spas providing self-contained facilities for activities and recreation within themselves. In the design of such developments, the facilities go far beyond providing basic lodging. Design may expand in order to become a form of entertainment in itself. Geographical location, climate, and such features as beach or mountain landscape can affect and guide design development.

CLUBS, SPORT FACILITIES

Clubs combine, in various proportions, the qualities of meeting halls, restaurants, hotels, and residences. Their design needs to express the particular quality that has brought together a specific membership. The clubhouse is something of a secondary home at the same time that it serves the needs of such groups as golfers, businesspeople, gamblers, yacht owners, or whatever group has chosen to band together. The interiors of some older clubs are showcases of

fine traditional design that modern design cannot easily equal.

Gymnasiums, swimming pools, and other kinds of health and exercise facilities formerly were of a strictly functional character. Today, their design has more and more come to emphasize their value as places for recreation and social contact. The growth of these facilities, in connection with hotels, clubs, and institutions or independently, and the increasing importance of giving them a strong visual character have made them another field for interior design expression.

Institutional Spaces

To say that the design of a building is *institutional* is not normally a compliment. The word suggests dreary corridors and drab color schemes of green and brown. There is no reason, however, why institutional buildings should be any less attractive than other buildings; in fact, it is increasingly acknowledged that interior design of high quality can improve the function and morale of every institutional type.

17.23 An "Indoor terrace" guest room in the Hi Hotel in Nice, France. Green foliage screens the shower enclosure at the left. A saucer-shaped washbasin and its faucet (in the left foreground) act as a visual accessory. Frederic Ducic was the architect, Matali Crasset the interior designer.

ADMINISTRATIVE BUILDINGS

Courthouses, city halls, capitols of states, and legislative build-
ings of nations have usually been designed to include some mon-
umental and ceremonial spaces of strong architectural character.
Offices and public service spaces (information counters, cashiers'
windows, registries of public documents, and so on) in the same
buildings are often drab, inconvenient, and unattractive. In
recent years, public buildings of more modern design have
appeared, and many of these have more functional, comfortable,
and attractive interior spaces. In many older public buildings,
improvements have been made through superior interior renova-
tion. In some situations, a change in use has stimulated an inte-
rior renovation that greatly improves the building while
preserving the best aspects of its traditional character.

CORRECTIONAL FACILITIES

Even so unpromising a type as the modern jail, or correction
facility, can be shown to be more effective when its interiors
avoid depressing grimness. Interior design has met with consid-
erable resistance in many institutional areas. Government agen-
cies often feel that a demonstration of respect for economy
requires the most austere and unattractive treatments that can be
produced, while the design of prisons (figs. 17.24, 17.25) has
often followed the even more oppressive view that such places
should contribute to the suffering of occupants rather than to

17.26 ↑

17.24, 17.25 A jail cell may seem an unlikely professional design project, but the value of intelligent planning in such facilities is receiving increasing recognition. The cell (fig. 17.25) and the public seating area (fig. 17.24) were designed by architects Ehrenkrantz & Eckstut, in collaboration with Jacob/Wyper Architects (Philadelphia) for the Philadelphia Industrial Correctional Center. (Photographs: © 1986 Paul Warchol) **17.26** The Student Recreation Center at the University of Cincinnati includes, among its many functions, an aquatic center with a varsity pool that forms the foreground of this image. Morphosis/KZF were the architects.

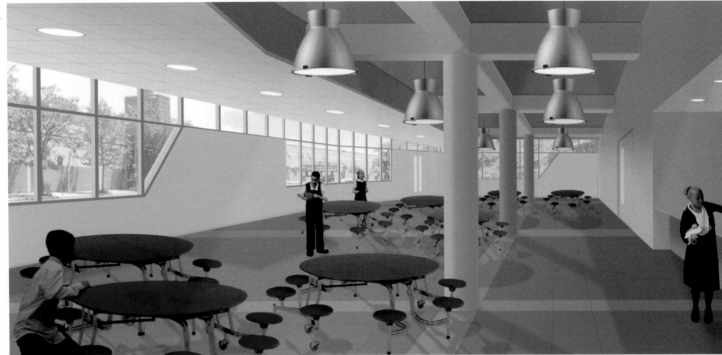

their rehabilitation. Modern research has demonstrated that superior design for such places can improve their effectiveness while making the life of staff and professionals easier, pleasanter, safer, and more productive.

EDUCATIONAL FACILITIES

The public school is, for most children, the first important experience of interior space outside their own homes. The modest one-room schoolhouse of the past has evolved into the larger multiroom school, complete with such special-purpose spaces as an auditorium, gymnasium, and cafeteria (figs 17.26, 17.27). Experiments with open classrooms have generated mixed response. The introduction of the desktop computer and, more recently, the laptop computer has suggested new responses. Design thinking can take account of such developments.

Public schools too often seem rather like jails, although the most modest thought and effort could easily make them pleasant, even stimulating places. Historically, college and university buildings have often included beautiful and inspiring spaces. The interior design of these buildings, which include dormitories, lounges, student centers, classrooms, lecture halls, dining halls, auditoriums (fig. 17.28), offices, and libraries, should satisfy the minimum requirements of making the spaces function well, with good lighting, seating, acoustics, and color. Provision for computer connections everywhere—in students' rooms, in classrooms,

17.28 ↑

libraries (fig. 17.29), and lecture halls—has become essential in modern educational institutions. Residential facilities and dormitories also invite design treatment that will support the morale of their occupants, make for comfort and convenience, and allow users a degree of personal expression by providing a suitable balance between preestablished or fixed design elements and design details that can be modified, changed, and adjusted. The quality of life in such places is strongly influenced by the design of both private spaces (such as bedrooms) and the shared spaces of living

17.27 A computer-generated image showing a cafeteria and recreation space in a Charter School in the Bronx, New York, as designed by Peter L. Gluck and Partners, Architects. (Courtesy Peter L. Gluck and Partners, Architects) **17.28** The steeply stepped seating of the 450-seat auditorium of the Getty Center, Los Angeles, California, assures excellent sight lines for all members of the audience. Richard Meier, architect. (Photograph: © Scott Frances/Esto)

or common rooms, dining halls, and circulation spaces. Together, all of these concerns can be developed to create memorable, exciting, and inspiring spaces.

HEALTHCARE FACILITIES

The field of healthcare includes a wide variety of facilities, ranging from the relatively simple doctor's or dentist's office to the quite complex modern general hospital. Offices for group medical practice, for specializations such as pediatrics, radiology, or dialysis, and for medical laboratories have emerged as separate units, some of which also appear as elements within the larger hospital. All healthcare facilities share a common problem in that they must serve a number of user groups whose requirements differ and may sometimes conflict. These groups include doctors, nursing and other support staff, patients and companions, visitors, maintenance personnel, and management and business staff.

Healthcare interior design has become a somewhat specialized field which is represented by the American Academy of Healthcare Interior Designers (AAHID), a professional organization that offers certification to its members who must offer evidence of experience in the field supported by reference letters and a portfolio of four to six projects representing the work of the applicant. Passage of the NCIDQ examination and a college-level degree in interior design must precede an examination offered by the AAHID.

The basic units of a medical office include a reception desk, waiting area, doctor's consulting room (office), examining or treatment rooms or both, business office with files, and additional service areas, notably bathrooms and suitable storage space.

The waiting rooms, office or consulting rooms, and treatment rooms of the professional offices of doctors (see fig. 9.57), dentists (fig. 17.30), and similar individual practitioners (whether in practice alone or as part of a group) can strongly influence the patient or client. An ugly, cramped, or depressing waiting room and office can add to a patient's anxiety. In the end, professional competence is more important than appearances, but an appropriate and attractive setting reinforces confidence in professional skills and improves the patient's experience.

In a hospital the basics found in a doctor's office are expanded and duplicated to serve such departments as admitting, emergency care, and outpatient treatment. Other components that support the major areas of patients' rooms and associated nursing services (figs. 17.31, 17.32) are grouped to relate to the various departments concerned with surgery, pediatrics, maternity, and general medical care. Depending on the type and size of a particular hospi-

← 17.29

17.30 ↓

tal, there may be various other departments, each with its special needs. An emergency room, intensive care, radiology, cardiology, neurology, opthalmology, and physical therapy are among the functions present in many larger hospitals. In addition, hospitals associated with medical schools and schools of nursing, so-called *teaching hospitals*, require facilities for their students, including lecture rooms and classrooms similar to those of other colleges and universities. Many hospital departments require special facilities, among them the delivery rooms and nurseries for maternity care, as well as the operating rooms, doctors' dressing and scrub rooms, and patient recovery rooms associated with surgery. Other hospital spaces include waiting rooms, laboratories (fig. 17.33), storage

17.29 The Irving S. Gilmore Music Library, Yale University, New Haven, Connecticut, is a vast space where structure and color combine to generate an inspiring ambience. Note the outlets for laptop computer and audio equipment connection at each carrel desk. The architects were Shepley Bulfinch Richardson and Abbott. (Photograph: © Peter Aaron/Esto) **17.30** A dental treatment center in Setagayu, a section of Tokyo, Japan, is of simple design and strong color. It is called Luminescence in reference to its program of teeth whitening. Design is by Studio 80/Shigeru Uchida, Tokyo. (Photograph: Toshi Asakawa)

17.31 →

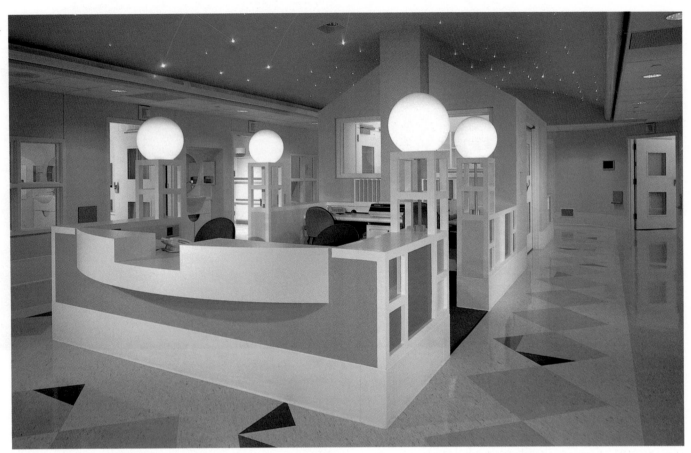

17.32 →

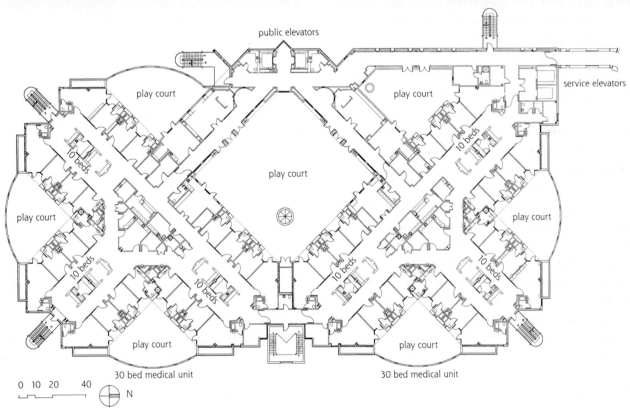

17.31, 17.32 Unlike the sterile and depressing atmosphere of so many hospital interiors, the Children's Hospital and Health Center, San Diego, California, offers a dynamic, cheerful ambience. As indicated in the plan (fig.17.32), 30-bed nursing units are subdivided into three "neighborhoods," each with ten "houses," or beds, and play courts. Each of the nurses' stations resembles a house, complete with peaked roof, chimney, and garden wall. Pastel colors are used throughout to distinguish individual rooms, and at night fiber-optic lighting in the ceilings creates sparkling constellations. The hospital was a project of NBBJ Architecture Design Planning, with David Noferi as design director. (Photograph and plan courtesy NBBJ Architecture Design Planning)

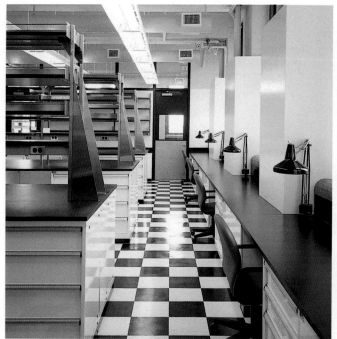

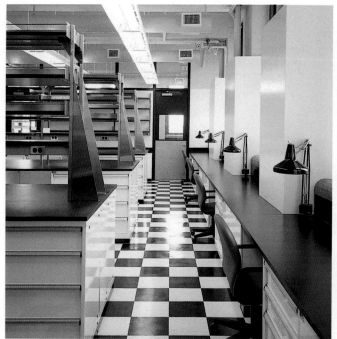 17.33 →

17.34 ↑

areas, and offices, as well as such ancillary services as food-preparation areas, dining rooms, and gift shops.

Many existing hospitals occupy facilities that are to some degree outmoded and in constant need of renovation, expansion, or replacement. Recent developments that have had an impact on healthcare facilities include the introduction of new technologies, some of which demand extensive facilities to accommodate large pieces of equipment, such as computerized axial tomography (CT) scanners and magnetic resonance imaging (MRI) machines. Modern medical practice has turned toward the reduction of long hospital stays, with an increased emphasis on outpatient care and greater reliance on home and nursing-home care. Many medical procedures, including minor surgery, medical tests, X ray, and CT and MRI examinations, do not require hospitalization and can be performed in specialized facilities apart from a hospital.

When working on healthcare projects, the designer must be aware that the client, usually a doctor, dentist, or hospital administrative personnel, represents just one set of requirements. However important these concerns may be, they frequently do not take into account the needs of the other people the facility is intended to serve, particularly patients, who often feel that their needs are treated as secondary to the requirements of technology and the professionals who deal with that technology. Designers have an opportunity to act as advocates for the patients' needs, as well as for the concerns of staff, visitors, and others who are users of healthcare facilities but who may lack input at the planning stage.

Two considerations call for special design attention. The first is the need during planning to minimize the conflicts that result from shared circulation and occupancy by too many activities. In the corridors and elevators of the typical hospital, doctors, nurses, visitors, staff, patients (ambulatory or on stretchers), and carts of food, as well as trash, are all jumbled together in confusion. Patients are continually moved to and from their rooms to various locations for tests and treatment. Crowding and the ensuing delays raise tension levels, which can interfere with treatment and convalescence.

The second consideration derives from an increasing realization (supported by research) that patients' recoveries are influenced by the quality of convenience and comfort a facility provides. Pleasant rooms decorated in suitable colors, outdoor views of pleasant surroundings, accommodation of visitors, and minimization of the annoyances generated by noise and disturbing activity are all desirable and all considerably affected by the design of the facility (see figs. 17.31, 17.32). A grim and depressing hospital filled with noise and conflict tends to influence the behavior of doctors, nurses, and staff and to increase the anxiety and stress felt by patients. A sense of calm and order, pleasant surroundings, and well-organized treatment are important aids to patients' well-being and recovery.

Economic competition among hospitals and other healthcare facilities has led to an increasing realization that improved visual design can be advantageous in making spaces attractive to patients and their guests in a way that avoids the depressive institutional

17.33 The black-and-white checked floor and yellow overhead ducts relieve the austerity of a laboratory at the Center for Molecular Recognition, College of Physicians and Surgeons, Columbia University, New York. Freeman & Pizer were the architects. (Photograph: © 1992 Michael Moran) **17.34** Warm colors and furniture suggesting residential use help to humanize this patient room in the Lauder Center for Maternity Care, Mt. Sinai Medical Center, New York. Guenther 5 Architects were the designers. (Photograph: Paul Warchol)

17.35 Designed by Guenther 5 Architects, the Patrick H. Dollard Discovery Health Center, located in upstate New York, reveals a quiet dignity to the interior. Long-life materials, geothermal design, and solar shading reflect an environmentally conscious design.

atmosphere of many older facilities. The experience of hospitality facilities has guided healthcare design toward pleasant spacial experience at arrival points, in patients' rooms, and wherever possible in treatment areas as well. Maternity (fig 17.34) and neonatal care areas need special attention to design that maximizes pleasant and favorable attitudes on the part of patients and visitors. The somewhat frightening appearance of some medical equipment (radiation, CT, and MRI units for example) can be made less distressing through planned space layouts and the use of color and improved lighting.

Hard and highly polished floor surfaces in hospitals, thought to promote sanitation, are found to be dangerous, and are now best replaced with smooth but non-reflective surfaces that minimize the danger of slipping. Uniformity among patients' rooms (avoiding mirror-image plans and other variations) tends to minimize mistakes while the location of nurses' stations for convenience and easy supervision of patients' rooms needs to be planned. Bathroom locations for easy access and with maximum safety arrangements benefit patients with disabilities.

A good plan for any healthcare facility (fig 17.35) is best generated by charting the experience of each typical user, whether patient, doctor, visitor, nurse, or other staff member. What are the sequential steps from arrival through treatment, work, or visit to departure, and how are these steps related to suitable spaces? Once this is determined, the spaces can then be assigned areas, arranged with appropriate adjacencies, and organized into plans. Tracing the movement of the different user groups on a diagrammatic plan is the primary tool for simplifying circulation patterns and minimizing conflicts.

CHILDCARE ACCOMMODATIONS

The need for childcare facilities outside the home has risen greatly in recent decades, propelled by the increase in two-career families and single-parent families. Day-care centers are now pro-

vided in many housing developments, in some business and industrial facilities, and in independent locations (see fig. 8.6). The typical day-care facility is similar to a kindergarten or nursery school except that it must provide for longer daytime stays and, in some establishments, for night care as well. A typical facility will include the following elements:

- *Entrance area.* Space for arriving children and parents and for taking off and putting on outer clothing, including some seating with benches and stools, and possibly some seating for waiting parents, is required. Compartmented hanging space for children's outer garments and one space (cubby) for each child's belongings should be provided.
- *Main play area.* Good lighting, pleasant color, adequate space (New York City code, for example, requires 30 square feet per child), and suitable play equipment are called for, including storage shelves and cabinets for blocks, toys, and other equipment. According to the ages of children to be accommodated, appropriate tables and chairs or stools of easily movable types are necessary. Wall surfaces should provide for the display of children's artwork and other visual materials. Movable cots for rest periods need suitable storage space, along with compartmented storage for sheets and blankets.
- *Kitchen or kitchenette.* Refrigerated storage, sink, and equipment for food preparation are necessities.
- *Children's bathroom.* A minimum of one toilet and one washbasin mounted at appropriate height for every fifteen children is required in New York City.
- *Separate adult bathroom.* For staff use.
- *Service facilities.* Space for janitor supplies, trash collection, and general storage should be provided.
- *Access to outdoor play space.*
- *Cribs.* For each child under one year of age, space for cribs and diaper-changing shelves are necessities.

Safety matters, such as protection from hazardous steps, sharp edges, and window and door openings, are essential. Codes require safe fire-exit provisions, usually two separate means of egress not counting fire escapes. Fire extinguishers, alarms, exit signs, and other safety devices are required by codes; sprinklers are necessary in childcare spaces located in nonfireproof structures. Normal provisions for HVAC to provide satisfactory air quality are, obviously, also required.

In selecting materials and colors, the designer should consider the need for a bright and cheerful atmosphere, as well as for easy cleaning and maintenance. The customary use of bright primary colors in spaces for young children is based on the finding that such colors are readily recognized and enjoyed by children. Some researchers now suggest that less aggressive color—pleasant but restrained—may be less distracting and may encourage the use of children's own work as a visual stimulus.

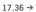

← 17.37

HOUSES OF WORSHIP

Religious buildings have a tradition of monumentality and pure architectural expression. In referring to the great cathedrals or other historic religious buildings, one can hardly speak of interior design independent of the basic structural form. Modern interior design ideas have come to play a part in the design of contemporary religious buildings in a variety of ways (fig. 17.36). The same thoughtful interior design that goes into other, secular spaces has greatly influenced the success of many new religious buildings. The renovation and restoration of older buildings often call for new thinking about color, lighting, and functional issues concerning both ritual and public accommodation.

Along with the actual sanctuary space, religious buildings often include related spaces for teaching, social functions, and similar secondary uses that present design problems closely related to those of similar secular building types. Interior design can have a significant and creative role in making houses of worship both serviceable and inspiring in visual character.

Cultural and Recreational Spaces

Such public and semipublic facilities as museums, galleries, libraries, theatres, auditoriums, and arenas often suffered in the past from an emphasis on monumentality at the expense of utility. Newer buildings invite creative solutions to providing gen-

uine service to the public, while the renovation of older buildings can often greatly improve both the function and attractiveness of their interior spaces.

MUSEUMS

In recent years, many museums have launched an aggressive effort to attract a large public to exhibitions planned and designed with a sense of showmanship comparable to that of the commercial world. Dramatic settings and use of color and lighting can convert a museum from a dusty warehouse of antiquities to a lively and exciting space in which educational values merge with entertainment (figs. 17.37, 17.38).

GALLERIES

Private galleries for the exhibition and sale of works of art and related objects are generally smaller in scale than museum spaces and do not attempt to serve as large an audience. They share the need to show off exhibited objects to best advantage through intelligent planning of space, color, and lighting.

LIBRARIES

Libraries may be public institutions varying from very small to large and complex (fig. 17.39); they may also be specialized parts of a larger project such as a school, an office, or an institution. All must provide book storage and protection (plus provision for modern book alternatives, such as microfilm materials and com-

17.36 Symmetry and a sense of ceremonial procession generate an atmosphere suitable to a space for religious observances. The nondenominational Marjorie Powell Allen Chapel on the grounds of Powell Gardens, about thirty miles from Kansas City, Missouri, was designed by E. Fay Jones + Maurice Jennings Architects. (Photograph: Laurie Lambrecht. Originally appeared in *House & Garden*) **17.37** At Tate Modern, London—Britain's new national museum of art, which displays a collection of international modern art from 1900 to the present—the task of remaking an old electric power station into a modern museum was undertaken by the Swiss architectural firm Herzog & de Meuron. The original turbine hall is now a 115-foot-high gallery that acts as a circulation space and also housed the giant Louise Bourgeois sculpture visible here in the distance, one of several the artist created especially for this space (see also fig. 3.18). (Photograph: © Arcaid/Richard Bryant)

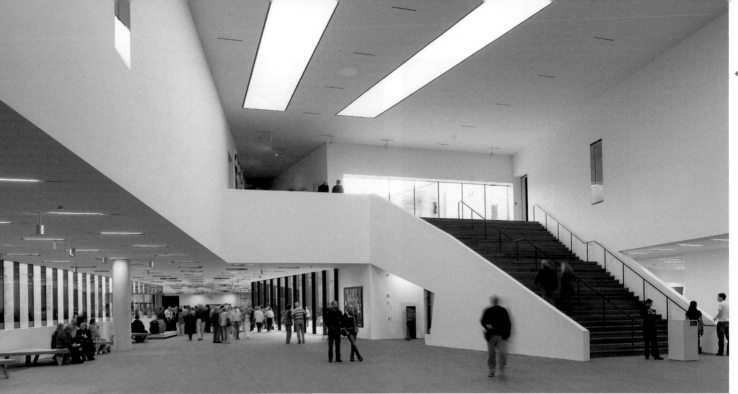

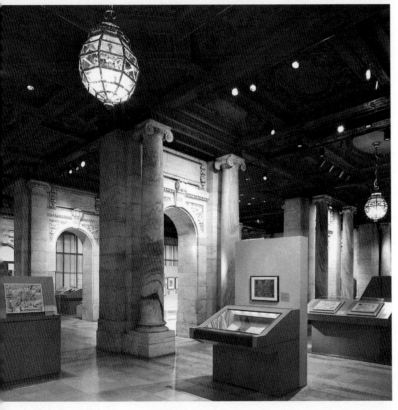

17.39 ↑

THEATERS, CONCERT HALLS, AUDITORIUMS, ARENAS

Auditorium spaces present special and interesting interior design problems. An audience numbering in the hundreds or even in the thousands must be seated in reasonable comfort within a space that provides good sightlines and satisfactory acoustical conditions for all. In addition, safety considerations impose very stringent demands, usually expressed in legal codes, on lengths of seating rows, aisle widths, arrangements of steps, and exit doors.

Along with the solution of these technical problems, the designer is expected to create a visual ambience appropriate to the events that will take place in the facility. The traditional opera house or theater is expected to present an atmosphere of festivity and opulence without overwhelming the performance that takes place within it. A more modern approach gives the hall a totally neutral and simple setting that focuses all attention on the performance event. Ancillary spaces, such as lobbies, lounges, bars, and cafés, present a wide range of related design problems. Specialized consultants have an important part in dealing with the problems of sightlines, acoustics, and lighting, as well as the complexities of backstage mechanics.

Large performance spaces, convention halls, and sports arenas tend to be more strictly functional in character, with the enclosure, seating, and performance space dominating interior design elements (fig. 17.40). In such projects, however, color, lighting, and the design of access spaces present interior design problems of considerable scope.

puter terminals) along with space for the users of the facility to read, study, and take notes. Specialized libraries (law, music, or for children, for example) modify library basics to suit a particular need.

17.38 The de Young Museum in San Francisco was redesigned by Herzog & de Meuron and Fong & Chan Architects in 2005. Founded in 1895, in 2005 it re-opened in a state-of-the-art new facility that integrates art, architecture and the natural landscape in one multi-faceted destination. **17.39** The New York Public Library, a famous work of 1911 by John Merven Carrère and Thomas Hastings, formerly draftsmen in the office of McKim, Mead and White, remains an outstanding example of classicism in the American architecture of its day. The area illustrated was restored and modernized by Davis Brody Bond. Now the D. Samuel and Jeane H. Gottesman Hall, it is a monumental circulation space also used to display exhibitions. The original wood ceiling was carved by Maurice Grieve. The arches and columns are of Cipollino marble, the walls of white Danby marble. The modern, unobtrusive track lighting is easily adapted to the changing exhibits. (Photograph: © 1985 Peter Aaron/Esto)

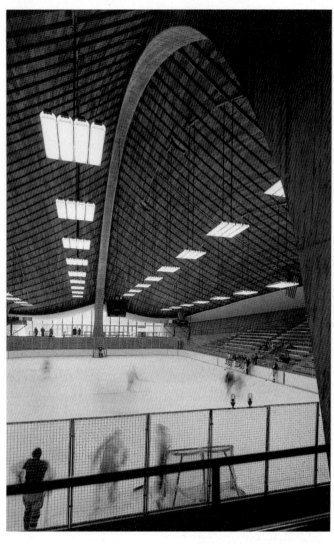

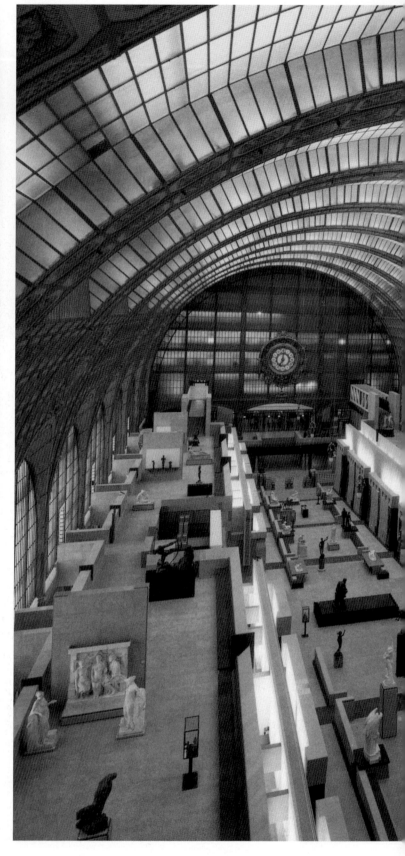

Other Spaces

EXHIBITION DESIGN

Exhibits ranging from small to vast are a ubiquitous part of the
modern commercial and institutional world. Shows of automo-
biles, boats, various kinds of manufactured goods, even military
hardware take place in exhibition halls built for the purpose.
These structures are simply empty shells that shelter the mater-
ial on display and the crowds of visitors that come to view it.
Exhibits range from a small booth setting in such a structure to
entire buildings with all their contents, as in the major exhibit
pavilions at a world's fair.

The exhibit designer is a highly specialized kind of interior
designer who must create settings that can be constructed
quickly, that will communicate effectively in a competitive and
sometimes confusing environment, and, often, that employ
standard and reusable elements. The temporary nature of
exhibits sometimes offers the designer an extraordinary freedom
to try out experimental and adventurous approaches that
might seem too risky for more lasting projects. Exhibit design
can be an experimental showcase for future-oriented design
directions, as it has proved to be in the past. The great world
fairs have always been design showcases.

TRANSPORTATION

Transport calls for two kinds of interior space: the interiors of sta-
tions, terminals, ticket offices, and other fixed-base locations that
serve transport; and the interiors of the transport vehicles them-
selves: buses, trains, airplanes, ships, and private automobiles.
Some of these, for example, cars and planes, may seem to fall

17.45 The plan of Aureole Las Vegas, Mandalay Bay Resort & Casino, shows the restaurant's two levels: the upper, or access, level (top) with bridge to the stair that surrounds the wine tower, and the lower level housing the main restaurant (bottom). The architects and interior designers were Adam D. Tihany International Ltd. (Photograph courtesy Adam D. Tihany International Ltd. Design Atelier) **17.46** This entry bridge leading to the glass-enclosed wine tower connects the casino to the restaurant. (Photograph: ©Mark Ballogg/Steinkamp-Ballogg) **17.47** A stair wrapping around the wine tower leads down to the bar on the main dining level. (Photograph: ©Mark Ballogg/Steinkamp Ballogg) **17.48** The main dining room is one of two eating areas. All decorative lighting and much of the furniture were custom-designed by Tihany. (Photograph: ©Mark Ballogg/Steinkamp-Ballogg) **17.49** A glass arch with waterfall spilling over glass sculpture by Luciano Vistosi of Murano, Italy, acts as a transition from the main dining room to the Swan Court, a private dining area. (Photograph: ©Mark Ballogg/Steinkamp Ballogg, Chicago) **17.50** The intimacy of the Swan Court contrasts with the openness of the main dining room. Glass doors lead to the outdoor terrace on the right. (Photograph: ©Mark Ballogg/Steinkamp-Ballogg)

17.48 ↓

17.47 →

← 17.49

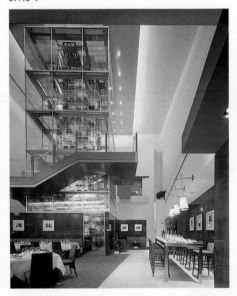

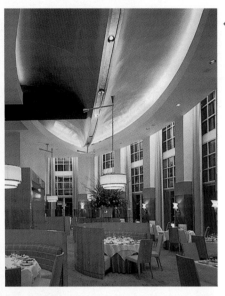

17.50 →

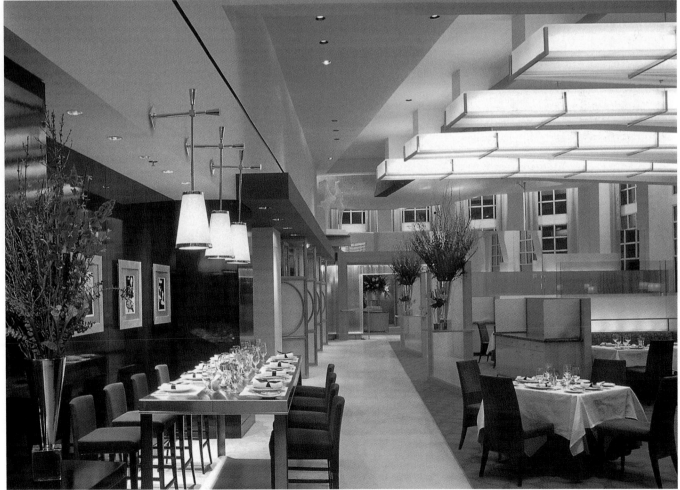

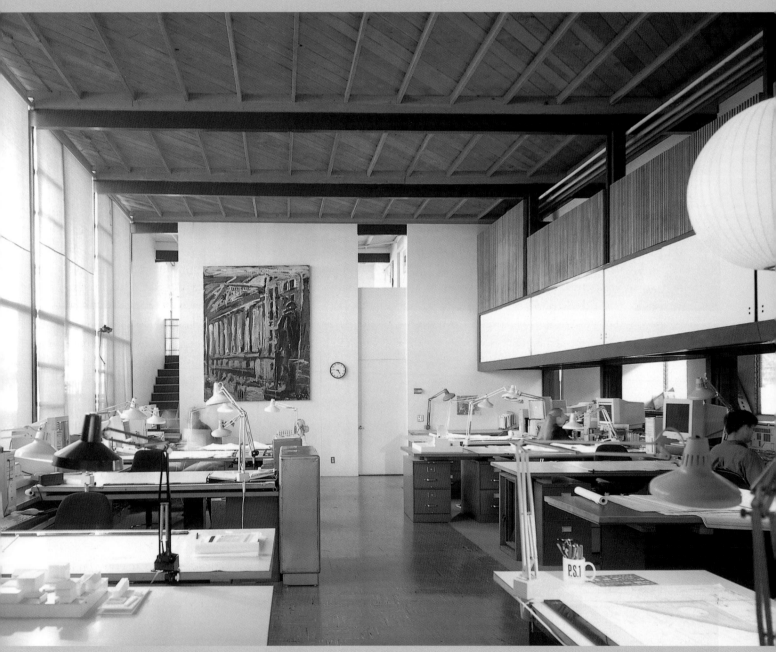

18.1 ↑

chapter eighteen. The Business of Interior Design

Employment of Interior Designers

Most designers acquire work experience after their school training by taking a job in the office of an established designer. Entrance-level positions (often called *junior*) are sometimes available while a student is still in school—during summers or on a part-time basis. Although working while in school may lead to a work overload, most students find it helpful to establish early contact with the professional world through some work experience. The junior designer is often given chore work, including gathering samples, mounting presentation items, and even filing, but he or she can also hope to be given creative work from time to time, such as designing and developing color schemes. Making construction drawings under supervision is an invaluable form of on-the-job training.

A large office presents opportunities to participate in a variety of bigger projects, whereas a small office is more likely to offer varied experience in seeing a particular project go through all of the steps from beginning to end. A junior designer who does good work can expect advancement to greater responsibility, leading to a major role in projects, possibly with the title of *associate*. Office jobs in design can be volatile due to the expansion and contraction that follow fluctuating workloads. Changing jobs for this reason does not reflect on a junior designer's abilities, and it is often wise to make a voluntary change when an ongoing job ceases to offer varied experience or advancement.

Work in a firm can develop into a satisfying long-term career position with major design responsibilities yet without the burdens of running a business. In larger design firms, projects are often beyond the capacities of any one staff member. Teams become essential, each team dealing with particular projects. Working as part of a team may seem to deprive a designer of some share of autonomy, but, in exchange, the stimulation of cooperative work with others offers its own rewards. Designers near the beginning of a career can find special benefits in team membership, where learning through cross-stimulation from one's peers can be valuable experience. A design team may include designers with special skills in such areas as planning, color, lighting, acoustics, or project management. Such experts may be part of a larger design organization or may be independent practitioners working one or another specialty. There is increasing willingness in design organizations to accept input from other fields, such as psychology or sociology. Experts in such fields can contribute to team effectiveness through membership on a continuing or temporary basis.

A role as *partner* in a firm can make it easier to get credit for work done and provides many of the advantages of individual practice. A number of designers grow into positions where they are in charge of an interior design department within a larger firm. Some architectural offices operate an interior design department or have established an affiliated interior design organization. Other possibilities include facilities-planning or space-planning

18.1 In the high-ceilinged, balconied design office of Fredrick Fisher & Partners Architects, Los Angeles, work tables are traditional drawing boards, but a computer monitor and keyboard are also present at each workstation. The painting on the end wall is by Roger Herman. (Photograph: Tim Street-Porter)

departments within large corporate organizations. Some hotel and restaurant chains have in-house design groups that supply interior design services to their facilities; organizations with large office facilities often maintain similar in-house services. Furniture manufacturers or dealers have occasionally established *planning units* that provide interior design services to customers. Although a designer is somewhat captive to the organization in such positions, he or she can nonetheless have the advantage of a secure job with a flow of interesting work. Some planning services have produced work of very fine quality, quite comparable with that of the best interior design firms. Interior designers sometimes develop a strong interest in a particular specialty, such as lighting or planning, and elect to become consultants working with a number of different design offices. A background in design on the part of a consultant tends to be helpful in making designer-consultant communication easy and effective.

Setting Up a Workplace

Most designers start out by working at home. While some modest work can be done in the corner of a living room or bedroom, active work will usually soon require a separate room. As a design practice grows, so will the need for an outer office with reception desk and waiting space, a place for meetings and conferences, and workplaces for assistants, drafting, models, sample storage, and filing. If there are to be partners or senior associates, each will probably require an office. Such a professional office commonly occupies rented space in an office building in a suitable location. Eventually a design firm may choose to build a building of its own that can be an effective demonstration of the quality of the firm's work. The need to expand and contract office facilities as the volume of work changes tends to make rental space the most practical choice for the majority of designers.

Whether it is the solitary beginner or the staff designer in a larger organization who needs a suitable place to work, setting up a workplace where drawings can be made, samples and catalogs stored, and work in progress kept together is a wise preparatory step to the design process (fig.18.1). The essential piece of furniture is a sturdy desk or table for drawing. A drafting table made for the purpose is ideal, but a separate drawing board placed on a table or desk also works well and has the advantage of being portable so that it can be put away or moved easily. A large board on the sawhorses used for carpentry is an inexpensive way to make a drafting table. Drawing-board or drafting tabletops must be large enough to accommodate the largest drawing to be made, preferably 30 by 50 inches, with 24 by 36 inches as a practical minimum.

A suitable chair or stool and good lighting are also needed. Windows give the best light, but a lamp will be needed for dark days and for evenings. The widely available adjustable Luxo lamp

is a great favorite. The best version has a large reflector and a long arm and takes a 75- or 100-watt lamp (bulb). A large board may call for two Luxos. There must also be a straightedge whose length matches the width of the board. A T square is traditionally used for the purpose. Parallel rules attached more or less permanently to the board also answer this need. They may seem easier to use since, unlike the T square, they have no head (the crosspiece of the T square) to be held in place while drawing. The yet more elaborate *drafting machine*, highly favored for engineering drafting, offers accuracy in drawing horizontal, vertical, and diagonal lines but is expensive and unnecessary for interior work. It will serve well if available.

The other necessary tools and equipment are all fairly simple and inexpensive to acquire. Several of these will probably be found at hand already:

- *Triangles.* Two are needed, one of 45 degrees and a second of 30–60 degrees, each of 8- or 10-inch size. A single adjustable triangle may be substituted.
- *Scale.* An architect's scale is needed. The triangular variety with various scales along its three edges is the usual choice.
- *Templates.* A circle-guide template is the most useful. A template with squares and hexagons in small sizes may be helpful, as will an ellipse guide with various ellipse shapes in a range of sizes. A furniture template with typical furniture units in plan at scale can be a convenience, as long as it does not tempt the user to avoid drawing furniture in more varied ways. Furniture manufacturers often give away templates for their own product lines.
- *Measuring tools.* A yardstick, a carpenter's folding foot rule, and a 6-foot tape are essential. A 100-foot tape may be wanted eventually.
- *Pencil sharpener.* A good crank-type is best, plus a small pocket-type for portability. An electric sharpener is also a common choice.
- *Eraser and shield.* Staedtler Mars 526 50 is the ideal plastic eraser. Bad erasers can damage or ruin a drawing and should be avoided. An eraser shield makes it easy to erase small details.
- *Miscellaneous items.* The drawing board should be covered with sturdy paper or illustration board. An accessory metal edge for the board's left side is helpful if a T square is used. A roll of drafting tape and a few thumbtacks and pushpins should be at hand. An adjustable curve or several *French curves* may be helpful, and a drafting compass may be needed occasionally. Drafting instrument sets in neat boxes, while attractive, will rarely be used and hardly justify their cost. Good scissors and a matte knife are vital.

Consumable materials can be acquired as needed. A basic stock for starting out would be the following:

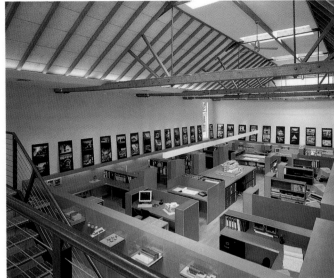

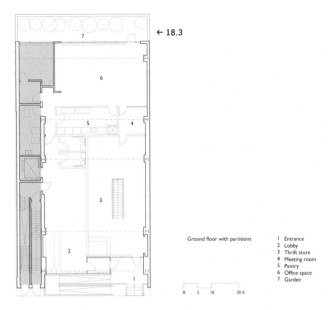

Ground floor with partitions

1 Entrance
2 Lobby
3 Thrift store
4 Meeting room
5 Pantry
6 Office space
7 Garden

0 5 10 20 ft

- *Paper*. Thin yellow (or canary) tracing paper is the norm for rough sketching. Tracing paper in rolls is most common. Twelve- or 18-inch rolls are convenient; stock plenty since it will be used in quantity. For more finished drawings, a good-quality white tracing paper in 36- or 42-inch rolls is standard. Avoid vellum papers. A pad of tracing paper and a white drawing pad may also be useful. Illustration board, in white on one side, gray on the other, is often used for presentation drawings and for color charts. Twenty by 30 inches is a convenient size.
- *Pencils*. Good-quality pencils are necessary. A few ordinary No. 2 pencils are useful, but drafting is usually done with special pencils that come in grades of hardness. Stock a few in grades H, F, HB, B, and 2B. Berol Turquoise is a good brand, with Derwent Cumberland Pencil Company's Rexel Cumberland a fine English alternative. Berol Draughting Pencil No. 314 is a favorite for sketching (not, in spite of its name, for drafting). A few colored pencils, or a set in a range of colors, can be useful; the Sanford brand Prismacolor is a good choice.
- *Pens*. Since ink drafting is rarely used for interior design work in the United States, special pens and the technical pen sets widely available are not needed. Felt-tip marker pens, however, are widely used. A few thin-line markers in black will be useful, and color markers are a favorite sketching medium. Staedtler Marsgraphic 3000 Duo series color markers have a convenient flexible foam point and a fine color range. A good fountain pen with nonclogging black ink is a good sketching medium, but a disposable felt-point pen can serve as well and is more convenient than keeping a fountain pen in working order.

- *Miscellaneous supplies*. Colored papers may come in handy. Color-Aid paper is a good brand; a book of samples is available and full sheets can be bought as needed. Transfer lettering in a few styles may be helpful in making neat titles. Duco cement is a good adhesive. Avoid rubber cement. A box of single-edge razor blades is often useful.

Normal office supplies will also be needed from time to time. Standard typing paper, lined yellow pads, index cards, file folders, labels, tape, and similar supplies will be used constantly. A computer with an up-to-date word-processing program is basic to a working setup. Papers, catalogs, and samples, which can expand to alarming proportions all too easily, call for filing space. Drawings can be rolled and stored in tubes until the quantity of work builds up and calls for a flat file made for the purpose—an expensive item. In another category, a camera, an exposure meter (built-in or separate), a tripod, and photo lights will be useful. Almost any kind of camera can serve, but the most versatile choice is a 35-millimeter single-lens reflex.

In most design firms (and even in individual practice) the computer has become accepted as a vital tool. A few design firms prefer to stick with traditional drawing techniques, using pencil and paper, T square and triangle, in the belief that direct contact between the designer's hand and the work produced is essential. The more widely accepted belief is that computer-aided design (CAD) offers such great possibilities as to make its acceptance essential. In many firms a computer can be found at each design workstation. In fact, it is not unusual to find a design firm where drafting tables have disappeared altogether, with the computer taking over all of the roles of the traditional designer's tools (figs. 18.2, 18.3).

18.2 The Culver City, California, atelier of Steven Ehrlich, Architects, was originally a dance hall but now houses workplaces for ten or more staff members. The studio was designed to showcase innovative use of materials and preferred design details, such as daylighting techniques, steel details, concrete finishes, window systems, and skylighting and shading mechanism. Note that computer monitors and keyboards are the equipment of each workplace rather than the traditional drawing board and T square. (Photograph: Marvin Rand, courtesy Steve Erhlich,

Architects) **18.3** The Family Health Service Center in New York was designed by Peter L. Gluck and Partners, Architects. This computer-drawn floor plan is typical of modern office practice.

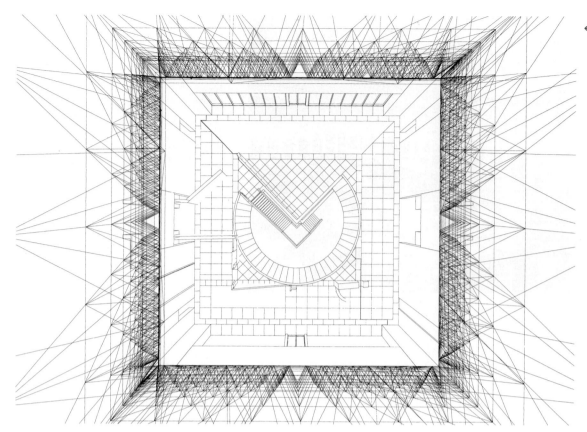

Interior Design Drawings

With a workplace set up and tools and materials assembled, it is possible to turn to the most specialized aspect of interior design work, the making of drawings.

Drawings fall into two major categories. *Design drawings* develop the conceptual approach and visual form of a space. *Construction drawings* are made for use in taking bids and directing and controlling the work of contractor and workers. Books and courses devoted to *drafting*, or (as it is often called in schools) *mechanical drawing*, are widely available. With a suitable book or two and the necessary tools at hand, it is possible to teach oneself to draw. However the skills are acquired, every interior designer will find some drawing ability helpful and useful. Design drawings and construction drawings, are discussed in greater detail below.

DESIGN DRAWINGS

In large measure the design process is, in fact, a matter of making drawings. Ideas, however valuable and exciting, only begin to relate to reality when they are made visible—to the designer and, at appropriate times, to others, including colleagues and possibly clients. An emerging design concept is first expressed visually in sketches. Concept sketches may be abstract or tiny, sometimes made in a notebook or on any available piece of paper. At the drawing board the usual medium is the inexpensive yellow tracing paper described above, used in quantity and perhaps discarded as sketches are developed. A soft pencil is the most-used tool because it produces a flowing line, a series of tones from pale gray to black, and is easily erased. A felt-tip marker is an alternative, to which color tones from colored pencils or markers can be added. For most projects sketching begins with plans, but elevations, sections, and perspectives can be useful as well. First sketches may not be to scale, but bringing concepts into scale form as soon as possible helps to discipline ideas and relate them to reality. The concept of drawing to scale is basic to all design communication. (For a complete discussion of drawing to scale, see page 147.)

Computer programs can readily take over many of the steps involved in preliminary design. The ease of making perspectives taken from various viewpoints and the possibilities for introducing color and trying out alternative color applications make CAD techniques particularly attractive in these phases of design work (figs. 18.4–18.10). The production of highly realistic perspectives having a precision that suggests photography makes such drawings ideal as means of visual communication between designer and client.

The drawings made to show a completed design to a client are normally called *presentation drawings* and are often grouped with material and finish samples, as well as photographs of proposed furniture and other purchased-item selections.

CONSTRUCTION DRAWINGS

Once a design has been set and approved, drawings must be made for use in obtaining estimates or bids and for the use of the contractors who will execute the work. These *working drawings* are a key part of the *contract documents* that define the work that a construction contract calls for. Working drawings differ from design drawings in that they show all necessary information about construction and materials in great detail. The skills involved in

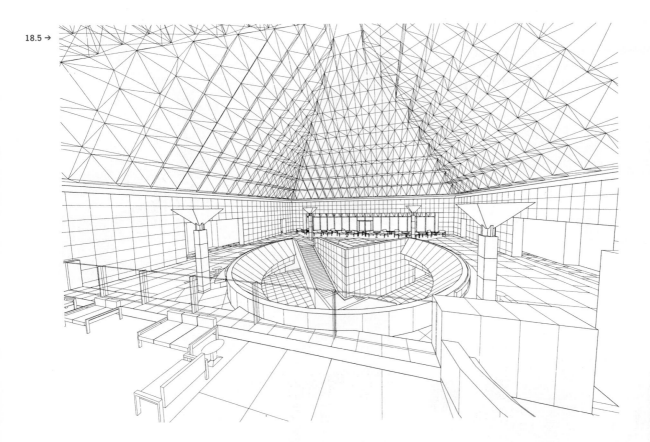

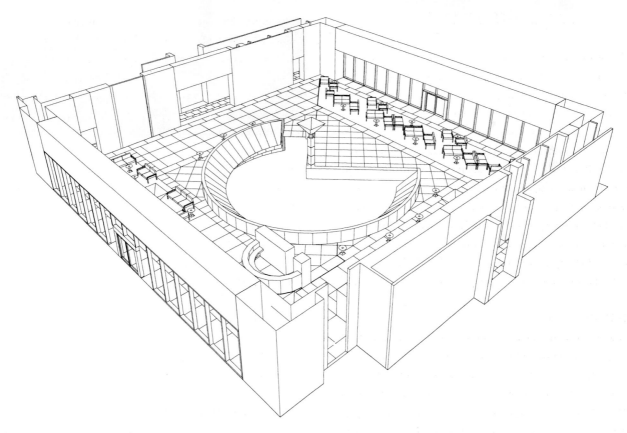

18.4–18.6 These three drawings were computer-generated. Once the basic data about an interior have been entered into the computer, any number of perspectives can be generated instantaneously, either on a screen or on paper, as required. In figure 18.4 a one-point perspective looks straight downward into a space—the floor plan of the atrium of one of the five buildings at the IBM Somers Complex, New York, designed by I. M. Pei & Partners. Figure 18.5 shows the plan at eye level. Figure 18.6 shows the atrium in axonometric projection. (Courtesy CAD/East, Inc.)

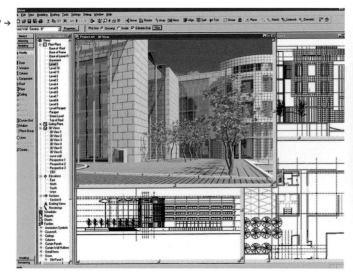

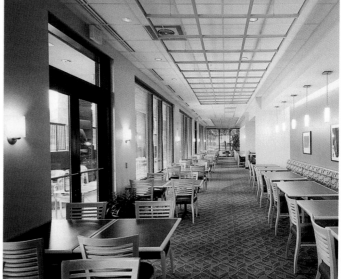

making working drawings are not limited to drafting; they must include full knowledge of the materials and techniques of construction. These skills are not easily taught either in school or in texts. They are usually learned in an office while working under the supervision of an experienced master—most often an old-timer who has been making such drawings for many years.

Every designer needs to learn to make working drawings, if only as a way of learning to *read*, that is, to understand, such drawings. A set of drawings for a major project can appear overwhelmingly complex, and an interior designer working on a space in an architect-designed building must understand the architectural drawings as a starting point for interior work. Construction drawings are organized in a set of several, even many, sheets. A typical set of drawings will include the following:

- *A cover sheet*. This identifies the project, gives a list of the sheets that make up the set, and carries general notes that apply to the project as a whole.
- *Floor plans*. For multifloor projects, several floors may appear on one sheet if there is space. Each floor may be on a sheet of its own or, for a very large project, may be shown broken up to fit on several sheets.
- *Elevations and sections*. These drawings show height relationships and other information not clear from plans.
- *Details and schedules*. These include drawings for windows, doors, and wall sections.
- *Furniture plan(s) and schedule*.
- *Finish plan and schedule*.
- *Reflected ceiling plant(s) and fixture schedule*.

18.7 Revit is a parametric 3-D building modeler similar to the "intelligent" modelers used by automotive manufacturers. The model "understands" the relationships between building components; for instance, a roof is automatically reshaped when the wall below it is moved. All two-dimensional drawings are different views of the same three-dimensional model, automatically guaranteeing internal consistency. Revit Technology Corporation is the producer. (Courtesy Revit Technologies) **18.8** This computer-generated color image shows a sectional perspective of a house as planned for a Minneapolis, Minnesota, site by architect Joel Sanders. The ease with which an interior space can be assembled in relation to ground level and such external elements as the parked car and the distant neighboring house with computer aid makes such images possible. (Computer image: Joel Sanders, architect) **18.9, 18.10** The computer-generated perspective image in figure 18.9 shows the interior of a cafeteria as planned for CAT Financial Services, Nashville, Tennessee. Notice the details of

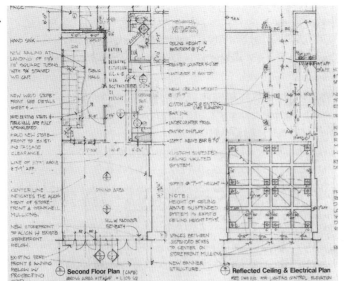

If the project requires it, additional sheets will show electrical, plumbing, and HVAC work. Although these sheets are usually prepared by a mechanical engineer, they must be checked and coordinated with the interior design drawings. Sheets prepared by a structural engineer showing basic constructional elements also appear in any complete set of architectural drawings for building construction.

Plan drawings are developed by making a base sheet that shows the basic layout of spaces. For each final plan drawing, a fresh piece of tracing paper or vellum is laid over the base sheet so that the basic plan can be traced to provide the general floor plan, reflected ceiling plan, and other special-purpose plans. To save tracing, prints of the base sheet can be made on tracing paper or vellum so that it is necessary to draw in only the information for each of the other plans not on the base sheet. The numerous symbols, figures, and words indicating materials, dimensions, door types, and the locations of details can make a basic floor plan look quite complex. Similarly, a reflected ceiling plan showing lighting, electrical layout, HVAC, and, possibly, ceiling systems, sprinklers, and related data can become extremely complicated (fig. 18.11). Schedules are the best way to convey information about door types, finishes, equipment, light fixtures, and, if furniture has been selected and ordered at the time the drawings are completed, furniture location. Details make use of elevations and sections, often at large scale to show construction.

Construction drawings are especially suited to the use of CAD techniques (see figs. 5.37, 11.55). The overlays, often called *layering*, that use the same base layout for successive special sheets (reflected ceiling plan, lighting plan, furniture layout, electrical

work, and so on) are readily produced with minimum effort through computer techniques. Repeated elements, such as window or door indications, or furniture units with groupings can be inserted into computer drawing with instantaneous ease. Areas of complex drawing can be enlarged for detail study and then reduced into their proper place.

The fact that CAD drawings held in computer memory can be easily transmitted electronically is an enormous convenience in communication with clients, other members of the design team, consultants, and contractors. Instead of the costly and time-consuming process of making prints of many large sheets and shipping such rolls of drawing to where they are needed, drawings can be transmitted instantly to any desired location, even to remote locations anywhere in the world.

Specifications

In addition to drawings, contract documents normally include written specifications that spell out information not readily conveyed in drawings, such as verbal descriptions of materials, methods of work, and standards that are to be met in the quality of both materials and workmanship. Specifications are particularly important when competitive bidding is to take place, so that all bidders will base their estimates on the same precise basis of quality. Standard specifications are available for many materials, products, and construction techniques. Such model specifications can be used when appropriate or modified to apply to a given project.

Models

Models are helpful devices in presenting design concepts. They convey a sense of reality, are readily understood by clients who may find drawings confusing, and generally have a certain toy-like charm that helps to make a proposal attractive to a client or sponsor. Many designers make their own models or have a staff member who is expert in this medium. There are also professional model builders who work from drawings and color and finish samples to build models with a high level of finish. Interior models are usually built without a ceiling or with a removable ceiling so that they can be viewed from above to give a bird's-eye view of a project. A scale of ¼″ = 1′0″ is suitable for

furniture, carpet pattern, and lighting. (Computer model: Derek Schmidt, courtesy Design Collective, Inc.) The completed cafeteria (fig. 18.10) is extremely similar to the computer image. Although some details have been changed, the overall effect is so accurate

as to make it easy to confuse the computer image with the photo. The design is by Design Collective, Inc., Nashville. (Photograph: Michael Houghton, StudiOhio, courtesy Design Collective, Inc.) **18.11** Shown here are typical construction drawings—a floor plan and a

reflected ceiling plan—for a small restaurant project. The restaurant, Cafe Word of Mouth, New York, was designed by Alfredo De Vido Associates. (Courtesy Alfredo De Vido Associates)

18.12 →

design so often makes use of repeated elements that are fairly well standardized (furniture, appliances, plumbing fixtures, doors, closets, and so on). When such data as catalog numbers, manufacturers' identifications, and prices are stored in computer memory, this information can be called up as needed instantaneously for incorporation into drawings, specifications, estimates, and purchase orders.

Information technology is increasingly proving helpful in running other aspects of a design business as well. The design-office tasks that computers can aid range from mundane business and clerical chores through drafting, specification writing, and perspective drawing, and assistance in the actual planning process, and then on through budgeting, purchasing, marketing, and project management. The more complex tasks demand large and powerful computer equipment, but the ever-expanding capacities of even the smaller machines, plus the ability of personal computer terminals to tap into larger networks over telephone wires, are making it possible to use highly sophisticated computer techniques with comparatively small and simple equipment.

What computers can do now for interior designers has meant change for the typical design office. (See "Computer Tasks," page 560.) Design offices are becoming less rooms filled with drafting tables and more rooms with groups of computer terminal workstations, with drafting tables serving as an adjunct for occasional use. Most designers with a heavy investment in their knowledge of conventional planning and drafting skills have quickly adapted to techniques that at first appeared unfamiliar and difficult.

Many routine computer skills tend to become the province of specialists who work from the verbal or sketched instructions of designers, much as draftspersons now translate the ideas of architects into finished construction drawings. The aspects of computer use that serve creative design are generally quite easy to learn and, once the learning begins, turn out to be a source of pleasure and satisfaction to those willing to take the step. Computers and their associated programs constantly become less abstruse and more accessible to the nonspecialized user. The tasks desired are selected from a menu of choices displayed on a screen in easily understandable form, and processes that are slow and demanding when done by hand become quite easy and almost amusing with the aid of a computer.

Design schools make current computer techniques available to students, offering them basic familiarization with CAD and computer applications to three-dimensional design. The computer field is subject to such rapid development and change that techniques learned in school are virtually certain to be obsolete by the

models of groups of rooms or of a whole floor. Models of a single room are often made at a scale of 1″ = 1′0″ to show detail (many materials, accessories, and even some furniture are available ready-made for architectural modeling and for the use of dollhouse hobbyists). Larger scale models also make it easier to view the interior at normal eye levels, either through openings or removable walls. Photographs of models can be very effective in conveying a sense of realism (figs. 18.12–18.14). Color slides of larger scale models, when projected, may be hardly distinguishable from actual interior views.

Although computer-generated images and the techniques of virtual reality may lessen the usefulness of models in some ways, the qualities of a *real* (not virtual) reality that are associated with models makes them of continuing usefulness. A model shares the reality of the proposed design in every way except size—it can be viewed from any angle and studied by different people at different times. Models continue to play a special role in convincing viewers of the merits of the design being presented.

Information Technology

The term *information technology* refers to the storing, recovering, and disseminating of recorded data by means of computer applications. Such computer-based techniques can be of great usefulness in the business of interior design. This is because interior

18.12 This preliminary model of an interior of the Guggenheim Museum, Bilbao, Spain, shows the complex computer-developed form of the building atrium. (See also figs. 4.84, 4.85, which show the completed building.) Although computer simulations are in wide use, models still provide a way to show interior space in three dimensions. Frank O. Gehry was the architect. (Photograph courtesy Frank O. Gehry, architect) **18.13, 18.14** Based on a design by Alfredo De Vido, these models show the forthcoming Berty House and a connected glass house in New York. The buildings will utilize solar principles with overhangs or shades to protect the glass from the hot summer sun, letting low winter sun penetrate. The glass house's masonry floor will be warmed by the sun's rays and re-radiate heat at nighttime. For cooling, windows will be equipped with sensors that ventilate the house automatically, without air conditioning.

18.13 →

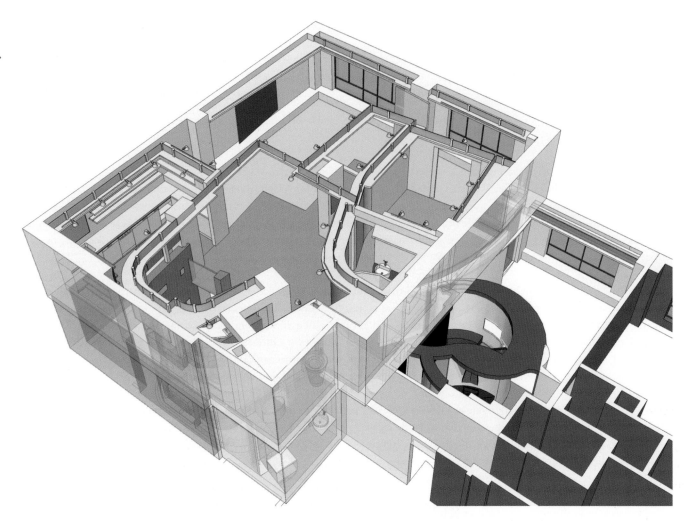

18.14 →

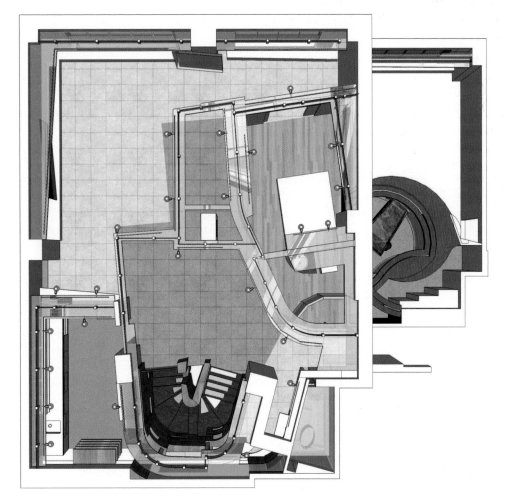

Computer Tasks

ADMINISTRATIVE WORK Computers can expedite bookeeping, payrolls, billings and purchase orders, tax returns and filing, and, through word-processing techniques, a considerable proportion of ordinary correspondence.

RESEARCH The Internet offers instant access to vast quantities of information, which makes it possible to call up almost any sort of data that may be pertinent to a particular design project. The information in manufacturers' catalogs and literature and the data in handbooks and journals, together with legal codes and restrictions, often otherwise diffcult to locate, use, and store, can be accessed with ease on the Internet or kept in compact memory and called up as needed. Central data banks can store vast amounts of such information and make it available to any subscribe over telephone lines. The centralized data will usually be updated constantly to prevent the unintentional use of outmoded information.

DRAFTING Placing and moving points and lines on the computer monitor builds up a constructed drawing similar to one done with pencil and instruments but accomplished with great rapidity and ease in making changes (see figs. 18.3–18.7). Standard elements, plans of architectural elements, furniture items, and fixtures can be drawn from computer memory, moved about, and fixed in place. Lettering and dimensioning can be added with the same ease. Once completed at the computer, the drawing can be printed out by a printer or actually drawn by pen by a plotter, entirely mechanically, with a high level of precision and at great speed. Changes can readily be introduced in the computer memory and new prints produced as needed.

PERSPECTIVE DRAWING Programs are available to generate perspectives from basic plan and elevation data. The position of station point and angle of view can be changed, with the resulting varied perspective views instantly available on the monitor. As with other types of drafting, prints can be produced. Images of objects (such as furniture items) can be held in computer memory, to be called up and inserted into a perspec-tive view, moved about, and shifted into the desired position. An interior thus developed in perspective can be redrawn as a plan or elevation and printed out in that form. Color tones can be added into such drawings for diagrammatic or realistic effect (see figs. 18.7, 18.9). Lighting can be inserted into a perspective and the visual effect of various positions and intensities of light sources studied in quite realistic images.

PLANNING Current programs are able to convert information about required areas and relationships into plan proposals. Although somewhat diagrammatic, these can form the basis for conventional planning. The ability of computers to hold and manipulate vast amounts of information makes these techniques particularly useful for very large and difficult projects, such as airport terminals, hospital complexes, and large corporate and government offices.

ESTIMATING With cost data in computer memory, it is possible to convert plan proposals into cost estimates almost effortlessly and instantaneously. As design progresses and various alternatives are considered, an ongoing estimated total, reflecting every new idea under consideration, can be constantly calculated.

SPECIFYING AND ORDERING Catalog data, numbers, and prices held in computer memory, much as in estimating, can be used to prepare specifications and orders for products and goods such as furniture, light fixtures, carpeting, and fabrics. Orders can then be transmitted electronically directly to suppliers. This kind of electronic data transfer, in wide use in such fields as banking and financial markets and in the stock and inventory control of retail chains and mail-order houses, is an application rapidly increasing in design practice (see fig. 18.16).

REPORTS AND PRESENTATIONS The computer can store scanned photos, drafted plans, and photos of models and completed projects for insertion into written reports or for conversion to Powerpoint slides to be used with a laptop and a digital projector in a formal presentation before colleagues or clients.

MARKETING AND PUBLICITY The computer can aid in gathering information about potential clients and projects and can forward to appropriate contacts information that has been directly requested. Through designer websites the computer can also provide information about completed work as well as copies of published articles and news items that enhance the recognition achieved by a designer or design firm (see figs. 18.17, 18.18).

COMMUNICATION Easy communication of both verbal and visual materials to client, other team members, other design firms (architect, engineer, consultant, for example), contractors, and sources of purchased elements (such as furniture, light fixtures, floor coverings, textiles) through electronic media can greatly simplify the conduct of a project.

18.15 →

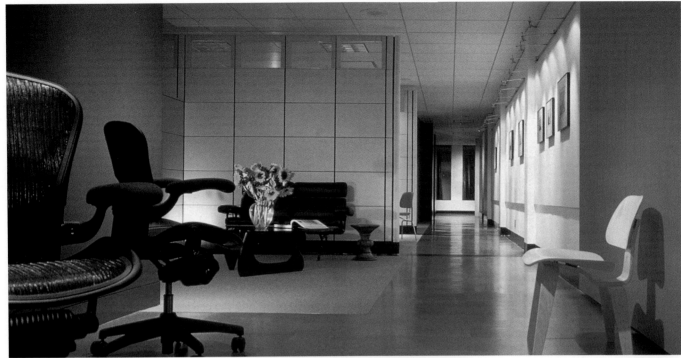

18.16 →

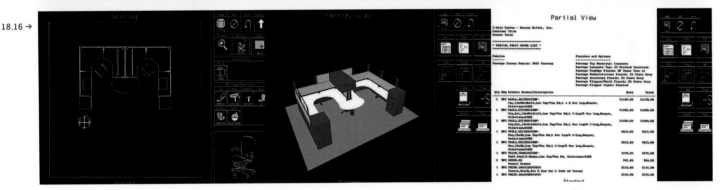

time the student graduates and is in office practice. Fortunately, learning current techniques takes only a few weeks of specialized study and practice at present, and equipment and programming has become ever more accessible and easy to use.

For the designer who is not a full-time professional directing or working for a design office—the individual consultant designer, or the nonprofessional who wants to deal only with smaller private projects—computer techniques may seem to have less significance since they are available at this level only through connection into centralized equipment provided by manufacturing firms or by independent services. The typical home computer, for example, is not capable of producing complex interior perspective drawings, but access over phone lines to more sophisticated equipment enables the individual designer working at home to produce sophisticated computer perspective drawing.

The showrooms of the larger manufacturers of interior-related products may offer computer services to customers, either directly or with the aid of specialists whom the showroom might have on staff (figs. 18.15, 18.16). When working with a client, the designer and salesperson will often find it helpful to sit at a computer terminal and make immediate visual comparisons between various possibilities, instantaneously calling up appearance data and relative costs.

Business Matters

While interior design is primarily a field for artistic creativity, every project involves some business matters. Large interior projects may demand substantial business management. Problems,

18.15 A showroom provides designers and their clients with a way of viewing furniture and systems while making purchasing decisions. Showrooms exist in many major cities. This example is the Herman Miller showroom in Seattle, Washington, designed by NBBJ, Seattle.

(Photograph: Paul Warchol, courtesy Herman Miller, Inc.) **18.16** Z-AXIS, a three-dimensional software program developed by Herman Miller, Inc., shows clients the office furniture they are ordering before it arrives, then prices it. Many larger manufacturers of interior-

related products offer similar services. (Photograph courtesy Herman Miller, Inc.)

misunderstandings, even lawsuits are far more likely to arise from business issues than from creative issues. Interior design benefits from employing sound practices applicable to all types of businesses. At the same time, it introduces several unique considerations. Of the issues discussed here, some will be important only for large and complex projects and larger design firms, some will apply to smaller projects and to individual designers, while a few are important even to the individual who is his or her own client for a do-it-yourself project.

BUDGETS

Any project that goes beyond shifting furniture already at hand will involve costs. Planning for those costs—estimating and controlling them—is a primary need for almost every interior project. Since costs vary from place to place and change rapidly with the passage of time, it is not practical to provide specific figures here. The general basis for budgeting is, however, easy to review.

Estimating Budgets A preliminary budget is usually calculated on the basis of the area, expressed in square feet, involved in a project. Once the extent of work to be done and the general level of quality desired are known, it is possible to arrive at an approximate cost for a project. The dollar cost per square foot may come from the designer's recent experience with similar projects; from costs for completed projects published in professional magazines; or from contractors or other professionals active in the field. Generating a cost range of low, average, and high figures can aid in setting the price goals for a project and in beginning to plan ways in which the project will be financed.

Clients often initiate a project with unrealistic ideas of prices and may need a period of adjustment to get accustomed to the realities of current costs, either by modifying the project concept or rethinking the way they will handle the financing. With an approved preliminary budget in mind, design can be undertaken with a clear idea of the work to be done and the range of materials and products to be selected. An economy budget restricts the design in terms of both work and selection; a luxury budget places few limitations on design.

As design decisions are made, a detailed budget can be developed on an item-by-item basis. Construction work can be estimated (possibly with the help of a contractor) on the basis of the square or linear footage of each item (ceiling, partitioning, plumbing, electrical work, and so on). Items to be purchased are selected and priced, with the cost multiplied by the number of units desired and added up to give a reasonably firm final total. A cushion, or contingency allowance, should be included to allow for unexpected on-site developments, price changes, and similar surprises, almost certain to be in the upward direction. A skeleton outline for a typical budget follows:

- Basic construction (contracts)
 Demolition
 General construction
 Electrical
 Plumbing
 HVAC
 Painting
- Decorative items (purchases)
 Floor covering (plus installation)
 Wall treatment (paper, vinyl, and so on)
 Furniture (plus cover fabrics and installation)
 Drapery (fabric plus makeup and installation)
 Lighting fixtures and lamps
 Accessories
 Art
- Fees
 Architectural and engineering
 Consultants
 Interior design
- Other
 Permits, insurance, and other items not included above
 Contingencies

Studying budgets for previous specific projects can be very useful. (See Table 35, "Sample Budget," at right.)

Estimates and Bids Following such budget estimating, actual prices are usually obtained from contractors. One general contractor or each trade separately can provide a figure based on time (the working time of employees on the job) and materials, plus allowances for profit and overhead, typically added as a percentage of time and materials. This is called a *firm estimate* if it is based on specific plans and specifications and put in writing. Similarly, suppliers of furniture and other purchased items will quote firm prices in writing.

In theory, the total of all such firm estimates will be the total cost of the project. In practice, this figure often turns out to be low, with time and material costs rising to well beyond estimated levels. To obtain tighter controls, estimates must be converted to firm prices, or *bids*. This involves asking for prices from several potential contracting firms (usually three), each of which is provided with identical plans and specifications. All the bidders, chosen on the basis of reputation and recommendations, must be acceptable, ensuring that the low bidder's price and quality of work will be satisfactory. Taking bids for very small projects is rarely practical; even larger projects are often contracted on the basis of a firm, or *guaranteed*, estimate rather than through bidding.

Once bids or firm estimates have been accepted, it might seem that the cost of construction work would be fixed. In practice, design changes—additional or altered items; new choices of

Table 35. Sample Budget*

ITEM	COST
GENERAL CONTRACT	
Demolition (remove existing closets)	$2,200
Repair walls and floor	1,355
Supply and install built-in bookshelves	1,320
Electrical: new outlets and wiring	1,240
Painting: walls and ceiling	2,180
Refinish floor	1,540
FURNITURE AND FURNISHINGS	
Sofa (existing, reupholstered)	1,380
3 lounge chairs	1,830
Dining table	1,410
4 dining chairs	2,020
Desk	1,610
Desk chair	890
Stereo/TV cabinet (custom-made)	1,450
Rug (existing, cleaned)	620
Blinds (2 windows)	600
LIGHTING	
Fixtures	1,232
3 lamps	930
SUBTOTAL	23,807
DESIGN FEES (ESTIMATED)	3,300
CONTINGENCIES	2,200
TOTAL	$29,307

* This sample budget is proposed for the renovation of a living room in an apartment in 2001. Since prices vary in different regions and are subject to change, the costs given here cannot be considered a reliable guide, but the items and proportionate costs will probably remain stable.

decoration fields are generally assigned a *list price*, which is subject to a large discount when purchased by trade or professional buyers, usually ranging from 25 to 50 percent, with 40 percent common. The availability of such discounts is significant in encouraging clients to turn to a professional design service rather than making direct purchases. Materials and objects available at retail are not subject to such discounts, a factor leading to the sharp separation between retail and "to the trade" suppliers. The same products are rarely offered in both markets.

Traditionally, interior decorators acted as specialized retailers, purchasing items at *trade*, or discount, prices and reselling them to their clients at marked-up prices. The difference between the purchase and selling prices provided the decorator's fee or profit. This way of working has been largely supplanted by the more professional practice of offering all trade or discount prices directly to the client and billing a designer fee clearly separated from the cost of products or construction services. The designer offers access to showrooms and trade sources, but the client, or end user, makes purchases, either directly from the manufacturer or through authorized dealers who provide installation and other services figured into a firm price.

Suppliers are generally prepared to sell directly to clients on the basis of purchase orders written or authorized by designers. It is important to clarify credit responsibility since suppliers are sometimes concerned about large orders when placed by designers or firms with limited financial responsibility. Payment in advance (with an order) by the client directly or through the designer's firm will usually allay any fears and make orders fully acceptable to trade sources.

Design Fees Designers' professional fees can be arrived at in several different ways. A percentage of the cost of work—usually in the range of 10 to 15 percent—has some traditional standing but is now generally regarded as illogical. Simply choosing the color of a carpet may lead to a large purchase and, therefore, a large fee, while demanding work over small details may entail no purchases, therefore generating no fees. There is also always the concern that a percentage fee may motivate the designer to urge more rather than less costly solutions to every problem.

For these reasons, a fee based on working time expended, or *hourly rate*, has become more widely accepted as most truly professional. Such charges combine the actual salary costs for each person involved in a project with overhead and profit margins. Charges are billed on the basis of time-sheet hours and agreed-upon standard rates. A billing rate of between two and a half and three times the actual salary cost is usual. The solitary designer must establish an hourly rate related to this basis. Expenses (travel, telephone, making prints, and so on) are billed in addition.

For the many clients who are unwilling to enter into open-ended fee arrangements, designers will calculate an *estimated fixed maximum* based on anticipated working time. Such estimates

materials or finishes; even major replanning—may be necessary for one or another reason, each change entailing a cost adjustment, usually in an upward direction. Once the job has been contracted for, the contractor is under no pressure to minimize the pricing of such *extras*. Making many changes in design after work is under way will almost certainly lead to cost overruns. While some changes will undoubtedly be necessary, minimizing them is an important factor in keeping project costs under control.

The purchase of such items as furniture, floor covering, fabrics, and lighting fixtures normally does not involve bidding since such items are unique. Those offered to the interior design and

often turn out to be the effective total fee, making them similar to fixed fees, an alternative basis for design service compensation in which an agreed-upon figure is established on the basis of the work involved. It is a good idea to bill design fees on a monthly basis, so that any dissatisfaction with performance or billings will surface before the sums in dispute become major.

MARKETING

Finding clients and assignments is now widely recognized as a necessary concern for any design service that intends to stay in business. The commercial term *marketing* is used as a euphemism for sales strategies that may be considered too commercial for a professional service. Time-honored marketing techniques include such public relations efforts as obtaining publication of completed projects in professional journals or magazines, with reprints available for mailing to prospective clients. A group of reprints together with some introductory text is often used to form a sales portfolio. Giving talks to interested groups and organizing conferences and seminars are other ways of gaining recognition for a particular design firm.

With the growth of technological sophistication, computers are used extensively in marketing efforts. Computer searches of databases that contain information on corporate and governmental project plans can help identify possible future clients and projects. Once prospect lists have been developed, e-mail provides a vehicle for delivering information to prospective clients, as does the maintenance of a website, where information and illustrations can be made available to an even wider audience of interested people and organizations (fig. 18.17).

When marketing efforts reach a certain level of success, a personal presentation or interview is usual. In addition to direct conversation, the most useful presentation tool is a visual display, traditionally a slide show of a firm's work, both completed and in progress. Slides have been the most convenient medium for displaying images until recently. However, the ability to scan professional photographs into digital storage in large quantity in computer memory and then to retrieve and organize desired images in custom-tailored sequences has made it possible to make presentations at the office of a prospective client with the aid of a laptop computer and a digital projector. Brochures using conventional print media are useful for mailing and as backup for presentations made in person (fig. 18.18).

A written proposal is the documentary tool that connects marketing efforts with the development of a contract and the start of a project. While the proposal is nominally a factual summary of

← 18.17

← 18.18

what is to be done and how it will be billed, it is also a marketing tool in that it presents a design firm's ideas to a prospective client in as complete and convincing form as possible. The client-to-be, having received several competing proposals, is strongly influenced by the appropriateness and quality of thinking that each proposal presents. Storing proposals in a database makes the preparation of a new proposal a simple matter of retrieving and revising an earlier document to suit the newest prospect.

18.17, 18.18 Marketing is an increasingly important aspect of running a design business. This page (fig. 18.17) from the practice module of the website developed by the New York architectural firm Davis Brody Bond (DBB) provides a brief description of the firm and a photograph of a recent project. To visit other parts of this module, the viewer clicks on a keyword at the left; a click on one of the keywords above takes the viewer to other modules. The three brochures shown in figure 18.18 were developed by DBB to foster familiarity with their work. Most larger design firms produce such materials. (Courtesy Davis Brody Bond)

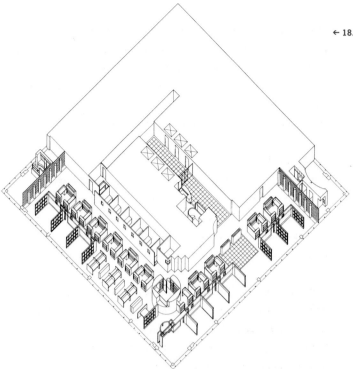

CONTRACTS

Two kinds of contracts are involved in interior design projects: between designer and client and between client and contractor or supplier. The latter is made for work or a product after a bid or purchase price proposal is accepted. The designer has a role in supervising such contracts to ensure that the terms are fair and carry no ambiguities that could later lead to disputes.

The contract between designer and client may take the form of a standardized agreement as developed by the various professional organizations or a simple letter of agreement in which the designer sets forth the terms on which work will be billed and the client makes an acceptance in writing. Strictly verbal agreements can be valid contracts, but since the terms are not recorded, they can readily become subject to dispute. Experience suggests that some agreement in writing is always best. For larger projects, a review of contractual documents by a lawyer familiar with the field is generally advisable.

It is important that the limits of the designer's responsibility be made clear to the client, since disputes often arise over such issues as perfection of work done or conformance to time schedules, which the designer cannot guarantee. Designers are also wise to carry insurance against being held liable for product failures or any risks that can possibly arise out of the complex events that a major design project can involve, from peeling wallpaper to major injury to a worker. The specifics of written designer-client agreements should establish the obligations that the designer assumes and the limits of these obligations.

If designers retain the services of consultants and other professionals, such as architects and engineers, and bill the consultants' fees to clients as expenses, they can become involved in any problems arising from such services. Therefore, while the designer will often aid the client in selecting consultants, financial arrangements are best made directly between client and consultant.

In general, the professional designer will find it best to limit all financial dealings with a client to direct professional fees while arranging for the client to pay for all purchases, professional fees, and any other costs directly, without going through the designer. This eliminates possible tax liabilities and many bookkeeping problems while reducing possibilities for financial disputes.

PROJECT MANAGEMENT

In addition to taking bids and awarding contracts, complete project management involves negotiating lease terms, scheduling, and expediting—that is, coordinating the work of different trades, scheduling the delivery and installation of purchased items, and reviewing and approving all bills and invoices as they are received. The aim is overall control of performance in terms of both time schedule and costs. For large projects, project management may be assigned to a special person or a firm with experience in this field. Employing sophisticated control systems such as Critical Path Method (CPM) or Project Evaluation and Review Technique (PERT), which make use of charts and, sometimes, computer techniques, can be helpful for complex projects (see pages 137–38). Interior designers and space planners may take on all or part of project management responsibilities in connection with smaller projects.

When space is to be leased in an office or loft building, project management most often begins with the negotiation of lease terms. Most such leases require the building owner to provide elements of interior finish (finished floors, ceiling, partitions, and lighting) to create usable space of a quality defined as *building standard*. Such standards normally allow for a minimal, utilitarian office installation, including a specified amount of partitioning, number of doors, and level of lighting. If the client accepts building-standard work, the designer usually has no role beyond making a plan layout and selecting paint colors. In practice, most offices are designed for a quality level far above this standard (fig. 18.19).

A negotiated lease defines the work to be done by the owner, with costs covered by the negotiated rent, and the items to be

18.19 An axonometric drawing illustrates an office design project. Building-standard interiors furnish a floor covering, utility-quality lighting, and a minimum linear footage of partition walls with doors. The glass-block walls, special partitions, and workstation units shown here raise the interior far above the building-standard level; the tenant must either pay for the enhancements or, if they are provided by the building owner, negotiate a higher rent than the base rent charged for building-standard space. This largely open office space was designed by Tod Williams for BEA, an investment banking firm in New York. (Courtesy Tod Williams and Billie Tsien Associates, Architects)

paid for by the tenant. Tenants unfamiliar with interior projects often accept highly disadvantageous terms, exposing themselves to unexpectedly large costs for work that could have been covered under terms of the lease. A document called a *work letter* defines exactly the details of the work to be provided under a lease. Drawings and specifications are often made part of the lease terms. Once a lease is signed, any additional work becomes an *extra*, which is billed on the basis of time and materials plus overhead and profit (a *cost-plus* basis). This poses another hazard for the unwary tenant, since the contractors are employed by the building owner and no restraints exist to keep the costs of extras down. As a result, such costs can easily mushroom, to disastrous effect on the project budget.

Good project management strives to minimize extras by establishing lease terms that define building-standard work as accurately as possible and by setting firm prices for all work beyond the standard covered in the lease. Changes in requirements that develop while a job is in progress and unforeseen conditions that surface after the lease is signed usually make some extras inevitable, but good planning keeps these situations to a minimum, thus avoiding cost overruns and many disputes as well.

Another major source of disputes is scheduling, an issue that involves move-in dates, when rent payments begin, and, if delays occur, the payment of double rents. When a project is in the planning stage, designers tend to be optimistic about rapid completion. Contractors anxious to be assigned work often give unrealistic completion dates. Whether acting as or working with project managers, designers have a responsibility to develop realistic schedules, leaving provision for the delays that always seem to occur, whether through late delivery of materials, the need to correct errors, changes made while work is in progress, or such unpredictable events as strikes, accidents, and storms.

Modern project management is greatly aided by computer techniques (including such methodologies as PERT and CPM) that can monitor project progress and keep track of time schedules and costs. A regularly produced printout of all aspects of a project's status made available at intervals, such as weekly, is an ideal means of keeping information visible to a design firm's business management and can be used to transmit reports to a client's management as well. It is well known that delays and changes initiated by a client are often the cause of trouble that can then be blamed on the designer. Regular documentation of all actions that affect schedule and budget help to keep clients aware of their responsibilities and add to the sense of responsible management on the part of the designer.

While small projects involve lesser sums of money and fewer complexities of scheduling, the same problems may arise. Careful and realistic project management is just as important to the residential client undertaking a minor renovation as it is to a large corporation engaged in a vast project. The reputation of a designer often rests as much upon efficient handling of time schedule and money matters as upon the aesthetic success of the completed project.

Human Problems

In addition to the many technical and practical problems already discussed, there is another group of problems rarely discussed in design schools. These are the problems created by people—by clients, by the designers themselves, and by the relationships between them—that arise in the course of a design project. Any design professional will admit, at least unofficially, that people problems are more common and more difficult than technical problems. Among themselves, designers often grumble, "Design would be easy if it weren't for clients." While the human problems of design work have no clear solutions, they are worth reviewing in order to avoid or minimize them.

Every client-designer relationship—except when the designer takes both roles—begins with two strangers who have different backgrounds, training, and objectives. The client wants a design problem dealt with quickly, economically, and, often, in accordance with some preconceived ideas. The designer wants a project that will be, above all, a credit aesthetically, a source of professional satisfaction, and, perhaps, a link to additional projects. No designer wants to lose money or have a disgruntled client to deal with, but many designers consider publication in a respected professional magazine a more significant measure of success than monetary profits or even client satisfaction.

For many clients, the design project is their first such experience; in fact, it may be their only one. Clients face difficult decisions, perhaps involving troubling compromises and large sums of money. At the same time, they harbor desires and expectations that are likely to be a mix of realism, hopes, ideas, dreams, and notions that may be anything from useful to absurd. Projects are usually more complex, slower, and more expensive than they expect. In the modern world, it seems to be an unfortunate reality that the quality of work constantly declines while costs and delays constantly increase. Clients' past experience of the lower prices and better-quality performance that were the norms of a few years ago tends to generate expectations that often cannot be justified under present conditions. Designers often find the temptation to tell the clients what they want to hear at the start of a project all too strong, inevitably resulting in disappointments and recriminations.

It cannot be denied that some clients and designers are difficult—demanding, unrealistic, quarrelsome, arbitrary, and inconsistent. Every experienced designer can tell stories of clients who change their minds endlessly, who have wildly unrealistic ideas about money, who blame every trouble on their designer, and who fly into unreasonable rages, often leading to

lawsuits. Stories of designers with comparable tendencies who make promises that cannot be kept, who overrun budgets by appreciable amounts, and who hide behind the screen of "artistic temperament" also have some unfortunate basis in fact. For a project to run smoothly, both client and designer must act reasonably, making an effort to understand the other's point of view, to cooperate together, and, above all, to be honest in terms of communication, expectations, and actual dealings of every sort.

First meetings between client-to-be and designer are very important. Issues of taste and aesthetic preferences can be explored by looking at published illustrations of completed projects by the designer and others in magazines and books and by making onsite visits to the designer's previous projects. If marked differences of opinion emerge in such sessions, they should be regarded as danger signals. At the same time, qualities of personality and compatibility can be assessed to see if designer and client can set up a cooperative relationship. For the designer, any hint that a prospective client is contentious, suspicious, devious, mean, or cranky suggests that it is best to leave the project to someone else. It is not easy to pass up an interesting assignment voluntarily, but the strain of following through on a project

under those circumstances promises to worsen rather than improve the relationship.

The term *client* implies an individual person, but many interior design clients are families, firms, organizations, or other groups of people. Dealing with groups multiplies the probabilities of human problems and calls for considerable tact. A business may be represented by an owner, by several partners, by one or more top executives, or by a committee representing various aspects of the client organization. These people are subject to change (through retirement, resignation, firing, illness, and death), and replacements may not be as sympathetic and cooperative as their predecessors. Committees and groups often have members with differing points of view or even direct conflicts. Steering a course between such members without succumbing to the politics involved can be very complex. The success of many well-known designers of large projects comes as much from their skill in this territory as from their design talent.

Residential clients present a less complex pattern but similar hazards. Many appear as couples who may approach a long-awaited new house or apartment with the expectation that both parties have totally matching desires, only to discover unexpected differences. Every designer with residential experience can tell stories of difficult and painful sessions, even quarrels and breakups, generated by planning a home. Early discovery of such possible frictions is another danger signal to be heeded. The designer's tact and skill may be stretched to the limit in dealing with such problems.

Given reasonable and cooperative people on both sides of a client-designer relationship, avoiding problems is largely a matter of exercising good professional skills with particular emphasis on all matters relating to time schedule and to budget. Not surprisingly, money is one of the most common causes of difficulties and disputes. Following good business procedures meticulously and making sure that the client understands them are probably the most important keys to satisfactory client relationships. Even when inevitable differences occur, good business practices will help to minimize the strains and avoid the unhappy problems of litigation. (See Table 36, "Do's and Don'ts of a Good Designer-Client Relationship," at left.)

Design Business Models

Design can be practiced by a single individual, but as work grows in scope and complexity, designers tend to form groups in which skills and responsibilities are shared. The size of such design groups can range from as few as two or three people to firms employing hundreds.

Interestingly, successful design firms have taken to operating satellite offices in different cities, as well as different countries, in order to grow their firm's business beyond the original starting

point. A large firm may have offices in five, six, or more loca-
tions, with each of those offices developing into a self-contained
unit fully equal to the original home office. This raises the ques-
tion of why each office does not become separate and indepen-
dent, with its own identity. The obvious answer is that the
reputation of the parent firm supports all of the firm's offices,
however remote, while clients are impressed by the implications
of excellence carried by both size and geographic distribution. It
is also typical that the various offices of a firm share in the firm's
design approach and philosophy. It is assumed that the quality of
work will be the same whichever office is selected to actually pro-
duce a particular project.

The internal structure of a large firm with several offices must
include the means of assuring that quality of work and approach
are consistent from one office to another. The leadership of the
firm, its founder or partners in charge, have an obligation to set
the style or character of the firm's work as produced at any one of
the remote offices. Senior design staff for remote offices is often
selected from those well established with experience in the home
office, and even more junior staff may begin with a period of
work at the home base. The ease with which visual material can
be communicated digitally through electronic media has made
communication between offices easy and rapid, so that even an
office on a remote continent can be in touch with a home base
despite differences in time zone.

Whether at a single location or with offices in several cities,
the business organization of a design firm is always of a particu-
lar type. The most common types of organization are sole propri-
etorship, partnership, and incorporation, which are discussed
below.

SOLE PROPRIETORSHIP

The individual designer usually starts out, and may continue
throughout a career, as a *sole proprietor* (fig. 18.20). The designer
simply owns his or her business and receives fees and pays bills
out of a personal bank account or, often, from a separate business
account maintained as an aid in keeping personal and business
funds identifiable as clear entities. Sole proprietorship has the
advantage of simplicity and directness; it requires no formal steps
to start up and may serve well for many design businesses. A sole
proprietor can, of course, hire employees and even build up a
large organization.

An owner can retire while retaining ownership of the ongoing
business. In practice, however, the continuation of a business usu-

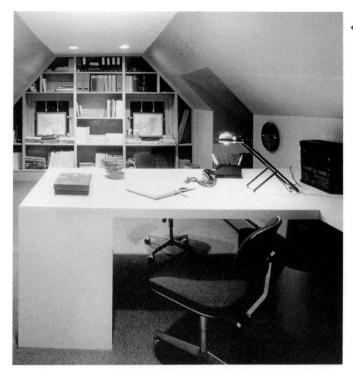

ally works out better through one of the other forms of owner-
ship. A sole proprietorship is, at least in the design fields, most
often difficult to sell if the owner wants to retire or give up the
business for any reason. Reputation and good will are usually so
firmly attached to the person of the owner as to leave the business
with little else of value beyond any outstanding contracts and
some furniture and equipment.

PARTNERSHIP

When a sole proprietor decides to share ownership with
another person (perhaps an employee, another designer, or a
business aide) or several people decide to establish a joint busi-
ness, a *partnership* is the obvious form of organization. Several
partners may bring various projects into a firm or may con-
tribute a variety of complementary skills. Few individuals
demonstrate equal abilities as designer, salesperson, office man-
ager, and financial manager, while partners often represent such
varied skills. A *silent partner* is someone who simply invests
money in a partnership for profit, taking no part in the opera-
tion of the firm. Since design businesses rarely need large
sums of money to start up, such investing partners are not
common in design firms.

Typically, each partner invests some funds or contributes
something else of value (such as a contract with a client) to
the setting up of a partnership. This establishes each partner's

18.20 This workplace answers all
the professional and business
requirements of a sole proprietor—
a designer who works alone. Antine
Polo designed his own office, in
Englewood, New Jersey. A laptop
computer can be used here or taken
along to wherever needed. (Photograph:
© Peter Paige)

share of ownership and forms the basis for the division of profits from the business. Partners may be equal, each with a half share, or may own different percentages of the business. The concept of junior and senior partnerships (with smaller and larger shares of ownership) is often used to give some share of ownership to employees who make a significant contribution to a firm. Partners normally take funds from the business through a *drawing account*, which provides regular payments similar to a salary for normal living expenses. At a longer interval, usually once a year, an accounting is made and any profits divided according to the terms of the partners' agreement. In small partnerships, the partners often adjust their rate of draw so as to take out profits on a continuing basis, leaving little to be divided annually.

Even when partnerships are started on a very informal basis, it is best to draw up a written agreement (with the help of a lawyer) that spells out the terms of the partnership in detail and covers such matters as the division of profits, the basis on which new partners may be taken in, and the terms for withdrawal of a partner or dissolution of the firm. In a *general partnership* each partner is fully liable for all of the debts of the partnership. It is also possible to limit the liabilities of individual partners by establishing a *limited liability partnership* (LLP) under state law.

In a regular partnership, each partner can be found personally liable for any debts of the partnership. The recent increase in liability suits brought against business of all kinds has made this a troublesome fact in partnership organizations. The terms of a limited liability partnership insulates partners from any liabilities incurred by other partners, giving the LLP organization some of the benefits of incorporation. Unlike a regular partnership, withdrawal, death or bankruptcy of one partner in a LLP does not require dissolution of the partnership.

Many design and architectural firms are partnerships, sometimes with the name of the founder (as in Robert A. M. Stern Architects) or with the names of all (or several senior) partners. A partner may retire while retaining an interest in the business or may sell an interest according to whatever terms may be agreed upon. Many partnerships have remained in business for many years, retaining the original name (for example, Skidmore, Owings & Merrill LLP) after new partners join the firm and the founders retire.

The advantages of partnerships result from the adaptability of this form to group efforts and the ease with which ownership interest can be offered to new partners, allowing a firm to carry on almost indefinitely, even long after its founders have withdrawn. A matching disadvantage arises from the need for partners to get along well and agree about business decisions. Small partnerships (two or three partners) are particularly subject to trouble when a major disagreement occurs among the partners, often leading to the breakup of the firm. Differences in interests and styles, often the basis for making a partnership work, also commonly lead to problems that develop with the passage of time.

INCORPORATION

The third important format for a design business is *incorporation*. It is possible for one person to form a corporation, but it is a more generally used format for a firm with several principals or large firms with many owners. A *corporation* is an organization recognized by law as having an identity apart from its owners. Owners hold stock that represents their individual shares of ownership in the corporation. Profits are distributed as dividends, paid out at regular intervals. Most large businesses are *public corporations* whose stock is held by many investors and traded in a public stock market. Small corporations are generally *closely held*, that is, the stock is sold only to a restricted group—the original incorporators perhaps, or employees of the firm, or certain investors who have provided financial backing.

A corporation is controlled by a board of directors elected by the stockholders. The board elects officers who are usually the corporation's top executives. In a small corporation, the officers, the board, the stockholders, and the managers are often all the same people, perhaps those who would have been the partners if that form of organization had been chosen. Compensation to managers (as to employees) is generally through a salary and, possibly, bonuses instead of dividends. A corporation can accumulate undistributed income in ways that may have tax advantages and can provide funds for expansion, ownership of assets (such as cars or a building), investment in new ventures, and retirement income for managers. The corporate form of structure also shields the private assets of stockholders against any liability suits that may be brought against the firm. The professional corporation (PC) is an alternative for an individual practitioner, but it can have only one stockholder so as to insulate the principal from personal liability in any legal action, although his or her business assets remain at risk.

Incorporation of small professional businesses has become increasingly popular in recent years because of the tax and other financial advantages that it can provide. It is important to consult legal and accounting advisers before deciding whether to incorporate a design business and to help in working out the details of incorporation. As in the case of partnerships, corporations can offer ownership shares to staff or to others and enable a business to continue beyond the involvement of any particular people. As prospective clients, big businesses and other large organizations are often reassured by this form of organization, which parallels their own organizational structures and avoids the more personal involvement of smaller firms. All of these factors tend to encourage the formation of design corporations.

Many designers are inclined to regard business matters as annoying and intrusive interruptions to creative work. They may therefore be tempted to deal with them grudgingly and carelessly. This attitude can lead to truly troublesome and intrusive problems on a major scale. Time and effort devoted to the relatively small demands of good business practices pay off, in the long run, by making projects go smoothly, by *freeing* time for creative work, and by helping to build a reputation for professional performance.

Appendixes

APPENDIX 1. Architectural Symbols

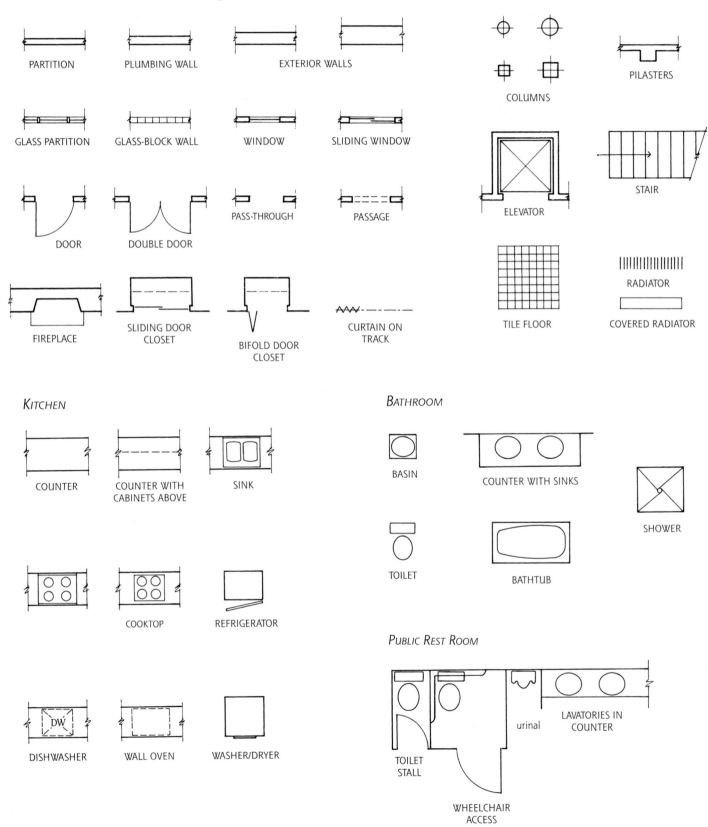

PARTITION

PLUMBING WALL

EXTERIOR WALLS

COLUMNS

PILASTERS

GLASS PARTITION

GLASS-BLOCK WALL

WINDOW

SLIDING WINDOW

DOOR

DOUBLE DOOR

PASS-THROUGH

PASSAGE

ELEVATOR

STAIR

FIREPLACE

SLIDING DOOR CLOSET

BIFOLD DOOR CLOSET

CURTAIN ON TRACK

TILE FLOOR

RADIATOR

COVERED RADIATOR

Kitchen

COUNTER

COUNTER WITH CABINETS ABOVE

SINK

COOKTOP

REFRIGERATOR

DW
DISHWASHER

WALL OVEN

WASHER/DRYER

Bathroom

BASIN

COUNTER WITH SINKS

SHOWER

TOILET

BATHTUB

Public Rest Room

urinal

LAVATORIES IN COUNTER

TOILET STALL

WHEELCHAIR ACCESS

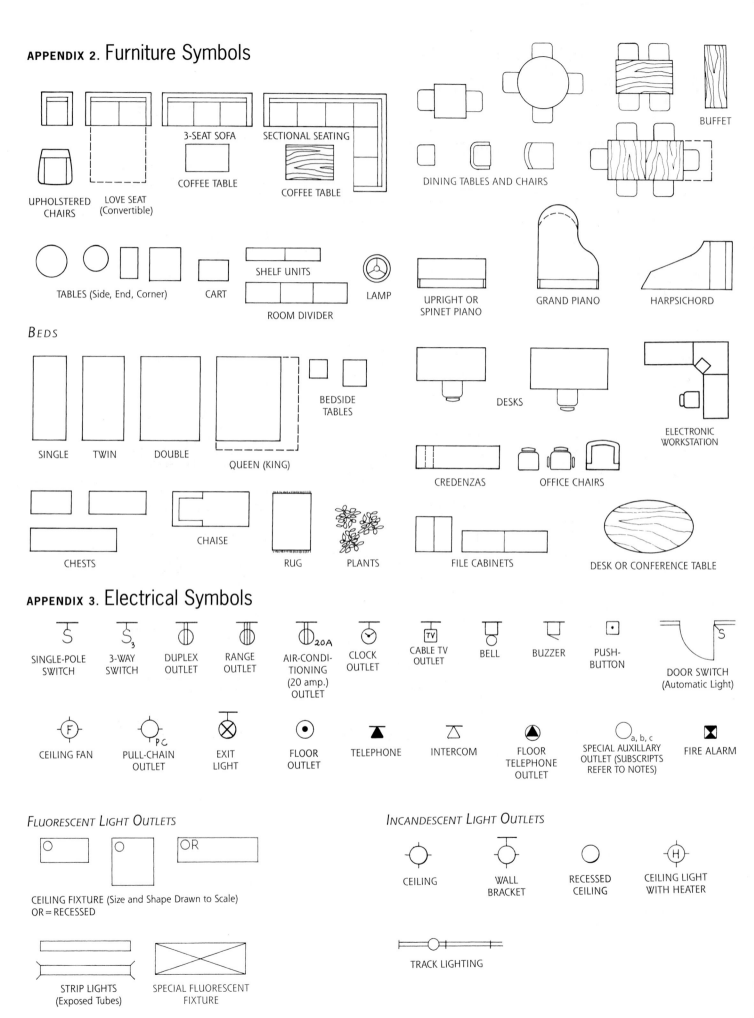

APPENDIX 2. Furniture Symbols

UPHOLSTERED CHAIRS

LOVE SEAT (Convertible)

3-SEAT SOFA

COFFEE TABLE

SECTIONAL SEATING

COFFEE TABLE

DINING TABLES AND CHAIRS

BUFFET

TABLES (Side, End, Corner)

CART

SHELF UNITS

ROOM DIVIDER

LAMP

UPRIGHT OR SPINET PIANO

GRAND PIANO

HARPSICHORD

BEDS

SINGLE

TWIN

DOUBLE

QUEEN (KING)

BEDSIDE TABLES

DESKS

ELECTRONIC WORKSTATION

CREDENZAS

OFFICE CHAIRS

CHESTS

CHAISE

RUG

PLANTS

FILE CABINETS

DESK OR CONFERENCE TABLE

APPENDIX 3. Electrical Symbols

SINGLE-POLE SWITCH

3-WAY SWITCH

DUPLEX OUTLET

RANGE OUTLET

AIR-CONDI-TIONING (20 amp.) OUTLET

CLOCK OUTLET

CABLE TV OUTLET

BELL

BUZZER

PUSH-BUTTON

DOOR SWITCH (Automatic Light)

CEILING FAN

PULL-CHAIN OUTLET

EXIT LIGHT

FLOOR OUTLET

TELEPHONE

INTERCOM

FLOOR TELEPHONE OUTLET

SPECIAL AUXILLARY OUTLET (SUBSCRIPTS REFER TO NOTES)

FIRE ALARM

FLUORESCENT LIGHT OUTLETS

CEILING FIXTURE (Size and Shape Drawn to Scale)
OR = RECESSED

STRIP LIGHTS (Exposed Tubes)

SPECIAL FLUORESCENT FIXTURE

INCANDESCENT LIGHT OUTLETS

CEILING

WALL BRACKET

RECESSED CEILING

CEILING LIGHT WITH HEATER

TRACK LIGHTING

APPENDIX 4. Material Indications in Section

Wood

ROUGH SOLID

FINISHED SOLID

PLYWOOD

PLYWOOD VENEER FACE

SOLID-CORE PANEL

PARTICLEBOARD-CORE PANEL

PLASTIC LAMINATE OR PLYWOOD

HARDBOARD

Masonry

STONE

TERRAZZO

SLATE/BLUESTONE/SOAPSTONE

BRICK

TERRA-COTTA OR CLAY TILE

PLASTER

GYPSUM BLOCK

GYPSUM WALL BOX

CONCRETE

CONCRETE BLOCK

CONCRETE BLOCK (ALTERNATE INDICATION)

Metal

STEEL

BRASS/BRONZE

ALUMINUM

SMALL-SCALE METAL

Other

GLASS

GLASS BLOCK

CARPET

INSULATION

RIGID INSULATION

ACOUSTIC TILE

TWO-WAY DRAPERY

VERTICAL BLINDS

APPENDIX 5.
Estimating Material Requirements

FABRIC Before ordering drapery or upholstery fabrics or carpet, it is best to obtain an estimate of the quantity required from the firm that will install the material. A *drapery workroom* and installation contractor will take measurements and calculate the required yardage when quoting a price for the installation. Furniture manufacturers note in their price lists the correct yardage needed for customer's own material (COM) cover fabrics for each individual product. The contractor who will install the carpet computes the yardage needed and takes responsibility for making a correct estimate.

Interior designers must often make preliminary estimates for budget purposes before precise figures can be obtained. The budget may have to include the cost of upholstery fabrics before final selections of furniture have been made; or the approximate carpet yardage may be a factor in selecting carpet—or in comparing it with another floor covering. A pocket calculator can help in making such budget estimates.

DRAPERY YARDAGE Drapery fabrics come in a number of widths, the most common being 36, 42, 45, 50, 52, 54, 56, and 118 inches. Since prices are quoted in linear (lengthwise) yards, it is necessary to determine, or at least assume, the width of the fabric to be used. Curtains are made up with *fullness*, that is, extra width to allow them to hang in folds; this means that the fabric must always be wider than the window or other space to be covered by the closed curtains. This fullness is expressed as a percentage; for example, 100 percent fullness means that the actual flat fabric will be twice the width it will cover when hung. Fullness usually ranges from 100 to 200 percent. Thin and sheer materials require more fullness; than heavier materials. Estimating will follow these steps:

1. Measure (on-site or from drawings) the width of the space the closed drapery will cover.
2. Multiply that width by the factor that gives the desired percentage of fullness: for example, by 2, or twice the width, for 100 percent fullness, and by 3 for 200 percent.
3. Divide the resulting total width by the width of the fabric to be used. This gives the number of widths, or panels, required.
4. Measure (on-site or from drawings) the total height of the drapery—from floor to ceiling, floor to *window head*, or sill to window head, according to the design planned. Add to this dimension an allowance for hems at the foot and head of each panel of made-up drapery. This will range from 6 to 16 inches, according to the details selected and the nature of the fabric. The result gives the total length, or height, of each panel *(width)* in inches.
5. Multiply this height dimension by the number of widths. Add a factor to allow for waste (usually 10 percent). Divide the total figure in inches by 36 to obtain yardage. If the pattern requires matching, allow an extra percentage factor for waste.

In addition to estimating the required fabric, the installation firm will quote a price for making up the curtains, including the cost of lining material, if any, and any decorative elements such as fringe, cords, and tassels. It will also price the hardware (track, traverse rods, and so on) and

any related elements, such as valances or lambrequins, plus the cost of labor for on-site installation. Having drapery made up and installed usually costs at least twice the cost of the fabric (of average price) alone.

UPHOLSTERY COVER FABRIC Makers of upholstered furniture usually make a wide variety of cover materials available with prices according to the cost of the material chosen. If a selection is made from that offering, the maker provides the material and includes it in the cost of the finished piece. In many cases, a designer or client may wish to select a material from another source. This is referred to as COM. A purchase order for the correct yardage must then be sent to the fabric house with instructions to deliver the material to the upholstery maker marked for the specific piece and order. The yardage can be estimated as described below, but a purchase order should show the yardage requested by the upholstery shop for the specific item being ordered.

Mistakes are easily made with COM orders, especially if many pieces covered in various materials are to be sent to one project. Errors are costly to correct and cause delays, so it is important to be extra careful to give correct and exact order instructions.

Even before making final furniture selections, it is possible to estimate the fabric yardage needed to cover a piece, given its general type and size, by looking in a manufacturer's catalog or price list. This will enable the designer to estimate cost before making final furniture selections. Typical requirements will be in the following ranges:

Small side chair (armless)1–2 yards
Small armchair (unupholstered arms)2–3½ yards
Executive office armchair................................4–5 yards
Fully upholstered chair...................................3–4 yards *
Fully upholstered two-seat sofa6–8 yards *
Fully upholstered three-seat sofa8–12 yards *
Ottoman...2–3 yards

* ADD 1½ YARDS FOR EACH FULLY UPHOLSTERED ARM.

Most upholstery fabrics are made in 52-inch widths. An allowance must be made for narrower widths. The matching of stripes or patterns calls for an extra allowance. Natural leather is priced in hides, not by the yard. The leather supplier can indicate the approximate yield in yards per hide, equivalent to yards of 36- or 52-inch-wide fabric, for any particular leather.

CARPET YARDAGE Carpet, priced by the square yard, used to be made in widths of 27 or 36 inches. Now it is usually manufactured in various *broadloom* widths, commonly 6, 9, 12, and 15 feet. Since many room dimensions do not easily accommodate broadloom widths, it may take some ingenuity to work out an economical way to lay out widths so as to minimize waste. The easiest way to estimate the yardage required is to make a tracing-paper overlay with lines spaced to indicate the bands of width and to move this about over the actual space plan to arrive at the best layout of widths and seams.

Once a rough layout is made, measure the length of each band in feet and add all the band lengths together. Multiply the total of the band lengths by the broadloom width in feet. Divide by 9 to convert the area in feet to yards. Add 5 to 10 percent for waste (the larger the area, the smaller the allowance) plus an allowance for matching if there is a pattern. Carpet squares or tile can be estimated simply by figuring the area to be covered and adding a small allowance for waste.

To the cost of the carpet alone, it is necessary to add

the cost of any underlay or other installation materials and the cost of installation, which will vary with the location and size of the project. When quoting price per yard, a carpet manufacturer can usually give a fairly accurate estimate of the total cost, including installation in a particular location.

WALLPAPER Wallpaper is priced in units called *single rolls*, although it is produced and distributed in larger (double or triple) rolls as well. Allowing for waste, one single roll will cover 30 square feet of surface, found by measuring the actual ceiling or wall area and subtracting the dimensions of any openings. Very large patterns may call for 10 to 20 percent extra waste allowance to match the pattern properly.

APPENDIX 6.
Metric Equivalents

LINEAR MEASURE
10 millimeters (mm) = 1 centimeter (cm)
10 centimeters = 1 decimeter (dm)
10 decimeters = 1 meter (m)
10 meters = 1 dekameter (dam)
10 dekameters = 1 hectometer (hm)
10 hectometers = 1 kilometer (km)

1 inch (in.) = 2.54 centimeters
1 foot (ft.) = 12 inches = 0.3048 meter
1 yard (yd.) = 3 feet = 0.9144 meter
1 rod = 5½ yards or 16½ feet = 5.029 meters
1 furlong = 660 feet = 40 rods = 201.17 meters
1 mile (statute) = 5,280 feet or 1,760 yards =
 1,609.3 meters
1 league (land) = 3 miles = 4.83 kilometers

SQUARE MEASURE
100 square millimeters = 1 square centimeter
 (sq cm or cm^2)
100 square centimeters = 1 square decimeter
 (sq dm or dm^2)
100 square decimeters = 1 square meter (sq m or m^2)
100 square meters = 1 square dekameter
 (sq dam or dam^2)
100 square dekameters = 1 square hectometer
 (sq hm or hm^2)
100 square hectometers = 1 square kilometer
 (sq km or km^2)

1 square inch = 6.452 square centimeters
1 square foot = 144 square inches =
 929 square centimeters
1 square yard = 9 square feet = 0.8361 square meter
1 square rod = 30¼ square yards = 25.29 square meters
1 acre = 43,560 square feet or 4,840 square yards =
 0.4047 hectare or 160 square rods
1 square mile = 640 acres = 259 hectares or
 2.59 square kilometers

CUBIC MEASURE
1,000 cubic millimeters = 1 cubic centimeter
 (cu cm or cm^3)
1,000 cubic centimeters = 1 cubic decimeter
 (cu dm or dm^3)
1,000 cubic decimeters = 1 cubic meter (cu m or m^3)

1 cubic inch = 16.387 cubic centimeters
1 cubic foot = 1,728 cubic inches = 0.0283 cubic meter
1 cubic yard = 27 cubic feet = 0.7646 cubic meter

FORMULAS FOR COMPUTING CONVERSIONS

When you know	You can find	By multiplying known amount by

LIQUID VOLUME

ounces	milliliters	30.00
pints	liters	0.47
quarts	liters	0.95
gallons	liters	3.80
milliliters	ounces	0.034
liters	pints	2.10
liters	quarts	1.06
liters	gallons	0.26

MASS

ounces	grams	28.00
pounds	kilograms	0.45
short tons	megagrams	0.90
grams	ounces	0.035
kilograms	pounds	2.20
megagrams	short tons	1.10

LENGTH

inches	millimeters	25.40
feet	centimeters	30.48
yards	meters	0.90
miles	kilometers	1.60
millimeters	inches	0.04
centimeters	inches	0.40
meters	yards	1.10
kilometers	miles	0.60

AREA

square inches	square centimeters	6.50
square feet	square meters	0.09
square yards	square meters	0.80
square miles	square kilometers	2.60
acres	square hectometers	80.40
square centimeters	square inches	0.16
square meters	square yards	1.20
square kilometers	square miles	0.40
square hectometers	acres	2.50

An example: When you know square yards, you can find the number of square meters by multiplying the number of square yards by .80 to convert to square meters:

10 square yards x .80 = 8 square meters

Another example: When you know linear yards, you can find the number of linear meters by multiplying the number of linear yards by .90 to convert to linear meters:

12 yards x .90 = 10.8 meters

APPENDIX 7.
Professional Organizations

Several organizations set standards for the profession by offering membership to individuals qualified in interior design and providing various services. The following organizations are national in scope:

AMERICAN SOCIETY OF INTERIOR DESIGNERS (ASID)
608 Massachusetts Avenue N.E.
Washington, DC 20002-6006
www.asid.org
Membership in this primary professional organization attests to the qualification of its members, who may use the initials ASID. It conducts programs, monitors legislation, and coordinates interior design concerns with those of related professions.

**ASSOCIATION OF REGISTERED
INTERIOR DESIGNERS OF ONTARIO (ARIDO)**
717 Church Street
Toronto, Ontario M4W 2MS Canada
www.arido.on.ca
Only membership in this self-regulatory professional organization entitles one to use the title "Interior Designer" in the province of Ontario.

**FOUNDATION FOR INTERIOR DESIGN EDUCATION
RESEARCH (FIDER)**
146 Monroe Center, N.W., Suite 1318
Grand Rapids, MI 49503-2822
www.fider.org
This organization focuses on design education and the accreditation of design schools and their programs.

INSTITUTE OF STORE PLANNERS (ISP)
25 North Broadway Tarrytown, NY 105910
www.ispo.org
An international organization of designers concerned with retail store planning and design.

INTERIOR DESIGN EDUCATORS COUNCIL (IDEC)
7150 Winter Drive, suite 300
Indianapolis, IN 46268
www.idec.org
An organization of interior design educators, practitioners, researchers, scholars, and administrators at institutions of higher education.

INTERIOR DESIGNERS OF CANADA (IDC)
717 Church Street
Toronto, Ontario
M4W 2M5 Canada
www.interiordesigncanada.org
The Canadian equivalent of ASID.

**INTERNATIONAL INTERIOR DESIGN ASSOCIATION
(IIDA)**
13-500 Merchandise Mart
Chicago, IL 60654-1104
www.iida.org
A professional networking and educational organization.

**NATIONAL COUNCIL FOR INTERIOR DESIGN
QUALIFICATIONS (NCIDQ)**
1200 Eighteenth Street, N.W., Suite 1001
Washington, DC 20036-2506
www.ncidq.org
The organization that administers and scores the interior design qualification examination.

The following organizations serve the professions most closely related to interior design:

AMERICAN INSTITUTE OF ARCHITECTS (AIA)
1735 New York Avenue, N.W.
Washington, DC 20006
www.aiaonline.com
The primary American architectural organization.

INDUSTRIAL DESIGNERS SOCIETY OF AMERICA (IDSA)
45195 Business Court, Suite 250
Pulles, VA 20166-6717
www.idsa.org
The professional organization of the American industrial design field.

**INTERNATIONAL FURNISHINGS AND DESIGN ASSOCIATION
(IFDA)**
191 Clarksville Road
Princeton Junction, NJ 08550
www.ifda.com
An all industry association whose members provide services and products to the design and furnishings industry.

**INTERNATIONAL FACILITY MANAGEMENT ASSOCIATION
(IFMA)**
1 East Greenway Plaza, Suite 1100
Houston, TX 77046-0194
www.ifma.org
An international professional organization dedicated to facility management.

NATIONAL KITCHEN AND BATH ASSOCIATION (NKBA)
687 Willow Grove Street
Hackettstown, NJ 07840
An international trade association dedicated to the kitchen and bath industry.

There are, in addition, state and local organizations concerned with various aspects of design, national organizations in other countries, and several international organizations that coordinate the activities of the national organizations.

Glossary

Words or terms in *italics* within the definitions are also defined in the glossary.

ABSORPTION Dissipation of sound-wave energy within a material. The absorption coefficient of a material indicates the percentage of sound energy that will be absorbed on contact.

AC (ALTERNATING CURRENT) The form in which electrical energy is commonly delivered to buildings.

ACCESS FLOOR/CEILING Systems of manufactured elements that provide accessible hollow spaces below floors or above ceilings, where any combination of wiring, piping, and *ducts* may be placed.

ACCESSIBLE ROUTE A path within a building that permits movement by disabled (including wheelchair-bound) persons.

ACCESSORIES Decorative and useful objects added to an interior to complete its design.

ACHROMATIC A term used to refer to light or objects reflecting light without chromatic color content; in practice, white, grays, and black.

ACOUSTIC SHADOW A location shielded from unwanted sound penetration by blocking objects.

ACRYLIC A transparent *thermoplastic,* usually made up into sheets, rods, or tubes. It can also be thermoformed into complex curved shapes, made translucent, or colored. Plexiglas and Lucite are trade names.

ACTIVE SOLAR *Solar heating* making use of mechanical systems such as pumped water or forced air circulation to transfer energy in order to provide environmental comfort.

ADA The abbreviation for the Americans with Disabilities Act of 1990, the legislation most significant in mandating *barrier-free* access.

ADAPTABILITY The suitability of interiors to the accommodation of occupants with disabilities.

ADAPTIVE REUSE The conversion of older buildings or spaces to serve current uses.

ADDITIVE COLOR In lighting, color mixing that involves the addition of colors. The mixing of dyes or pigments, on the other hand, *subtracts* color through absorption. The additive *primary* colors are red, green, and blue.

ADJACENCY The nearness of various elements to one another within an interior space. Adjacency studies develop criteria for planning based on the need for nearness between elements.

AESTHETIC RESPONSE Human reaction to the artistic qualities of a sensory experience.

AGGREGATE Small stones and sand added to *cement* and water to make *concrete.*

AMBIENT LIGHT Also called general lighting, this is the overall level of light in a space, which should be adequate for comfortable movement and for seeing people and objects.

ANALOGOUS COLORS Colors that are adjacent or close in their position in the *spectrum* or on the *color wheel.*

ANODIZING A process for treating aluminum to create a corrosion-resistant surface.

ANTHROPOMETRICS The study of the dimensions and articulation of the human body by means of systematic, statistical observation of large numbers of people.

ANTIQUE Old and with aesthetic or monetary value or both; also, made in the style of work of an earlier period.

ARCHITECTURAL ENGINEER A civil engineer who specializes in the structure of buildings.

ARCHITRAVE In the classical *orders* of architecture, the horizontal *molding* just above the capital of a column. Also, the molding around a doorway or other opening.

AREA DIAGRAM A chart in which spaces are shown as blocks whose size is determined by the area requirements for each space.

ART DECO A popular term for the stylistic development of the 1920s and 1930s that stemmed from Exposition Internationale des Arts Décoratifs et Industriels Modernes held in Paris in 1925. These included interiors, furniture, and other objects designed in a modern style that came to influence architecture as well. At the time, this style was called Moderne or, in English, Modernistic.

ART NOUVEAU A stylistic development of the late nineteenth century centered in Belgium and France. Abandoning all historical references, this genuinely modern style used instead elaborately curved decorative detail, generally based on natural forms.

ARTS AND CRAFTS MOVEMENT An aesthetic inspired by the desire to reform design by closing the gaps between fine arts, crafts, and design in architecture, interiors, and decorative objects. It developed in England in the latter half of the nineteenth century, with William Morris as its primary spokesman. Subsequent design directions have close ties to Arts and Crafts theory and attitudes.

ASBESTOS A mineral fiber with excellent insulating and fire-resistant properties. Loose asbestos fibers present serious health hazards, which have led to a marked decrease in the use of this material.

ASHLAR Building stone cut into square or rectangular blocks; masonry construction made up of such stone blocks.

ASYMMETRICAL BALANCE Equilibrium achieved through means other than *symmetry.*

ATRIUM In classical Roman architecture, the central courtyard of a house; by extension, any central courtyard or open space around which a house is built. In current usage, the term describes an interior space roofed over with glass, as in more recently built hotels, office buildings, or other large projects.

AUBUSSON A decorative scenic *tapestry* used for wall hangings or upholstery; also a *rug* woven with no *pile* to resemble Aubusson tapestry.

AWNING WINDOW A window with a sash that pivots at the top and swings outward.

AXMINSTER A traditional *carpet* construction using a jute back and wool *cut pile.* Made by a now-obsolete mechanical weaving process, these carpets display a wide variety of colors and patterns.

AXONOMETRIC A system of drawing projection in which a three-dimensional illusion is generated by lines representing horizontals drawn at a consistent angle (such as 30 or 45 degrees). *Isometric* drawing, in which all lines can be drawn at true scale dimensions, is a special case of axonometric drawing.

BACKSPLASH A raised barrier at the rear of a counter to prevent water over flow or spatter.

BALLAST In electrical parlance, a *transformer* or electrical device that converts the current in a circuit to that required by *fluorescent lamps.*

BALLOON-FRAME CONSTRUCTION A method employed primarily in building small houses of wood. Structural members are placed close together as framing; exterior sheathing and interior finishes create hollow spaces within walls and beneath floors, providing locations for pipes, wiring, and insulation. This simple, economical system was developed in mid-nineteenth-century America.

BALUSTER A vertical post or support for a railing, most often a stair rail.

BAMBOO A plant providing reed and wood materials, available in abundance.

BANDSAWING Woodworking techniques using a bandsaw machine that permits carving in free curves.

BANQUETTE A continuous, benchlike seat, usually upholstered.

BAROQUE The design of the latter part of the Renaissance, characterized by complex forms and elaborate decorative detail. Baroque design originated in Italy and was widely accepted in Germany, Austria, and related European regions, but less so in northern Europe. Most significant Baroque work dates from the seventeenth century.

BARRIER-FREE SPACE A space or *circulation* route that permits movement by disabled persons.

BASEBOARD A band of protective or decorative trim or *molding* along the bottom of a wall where it meets the floor.

BASKET WEAVE A textile weave of two strands over two that resembles the pattern of a woven basket.

BATIK Textile technique using resist dyeing to generate designs in varied colors.

BATTING Layers of cotton or wool used as lining for quilts and similar textiles.

BAUHAUS A German school of art and design that operated from 1919 to 1933. Under the direction of Walter Gropius, the school exerted a profound influence on the development and practice of *Modernism* in art, architecture, and design. The name of the school has come to describe work in the severe, functional, and often mechanistic style favored at the school.

BAY A vertical repeated unit of the exterior or interior structural system of a building marked not by walls but by windows, *orders, buttresses, vaults,* and so on.

BEAM A horizontal structural support element. The bending stresses generated in a beam include both tensile and compressive stresses.

BEARING WALL See *load-bearing wall.*

BEAUX ARTS A term referring to the École des Beaux-Arts (School of Fine Arts) in Paris and, by extension, the style of design based on an ornate form of classicism taught at that school.

BENDING STRESS Tension and compression generated by forces creating bending action.

BENTWOOD The product of a technique in which thin strips of solid wood are softened by steam and bent around molds. Furniture made by this method was developed in the latter half of the nineteenth century by Michael Thonet.

BIODEGRADABLE Material that degrades to original elemental matter over time.

BLOCK DIAGRAM A diagram showing areas as blocklike rectangles in scale size, often with relationships indicated by lines linking the blocks.

BLOCK PRINTING A technique of printing patterns or designs using a carved block to transfer dye or ink onto a paper or textile surface.

BONDING The arrangement of masonry elements in overlapping joints to increase strength and stability.

BOOK MATCHING The arrangement of strips of *veneer* to create mirror repetition of grain pattern.

BOUTIQUE HOTEL A small hotel designed with special emphasis on style and atmosphere.

BOX SPRING A bed spring of metal coil springs enclosed in a boxlike housing.

BREAKFRONT A chest-desk combination with the lower (or desk) portion projecting out beyond the upper (or chest) portion.

BRICK A small masonry unit formed of burned or baked clay.

BRIGHTNESS The intensity of light level produced by a light source or reflected back from a lighted surface. The *footlambert* (fL) is the unit of measurement for brightness.

BROADLOOM *Carpet* woven on a loom at least 54 inches wide so as to avoid the need to seam narrow strips and usually laid wall-to-wall.

BROCADE A richly figured jacquard-woven cloth using three-element weave to achieve a raised pattern.

BRUSHED FINISH A metal finish created by contact with a rotating wire brush.

BUBBLE DIAGRAM A drawing in which elements of an interior are drawn as soft, bubblelike shapes whose sizes are proportional to the various area requirements and whose placement is determined by *adjacency* requirements.

BUFFET A table or counter used for serving food.

BUILDING STANDARD The basic interior elements, such as partitions, floors, ceilings, doors, and light fixtures, provided without additional charge to tenants of large modern office buildings by the building owners.

BUNK BED A bed arrangement with two or more superimposed levels.

BURL A marked irregularity in a wood grain resulting from abnormal tree growth. Burled wood is most often used to make a *veneer* with striking color and pattern.

BUS BAR A heavy-duty electrical conductor distributing power to branch circuits.

BUSHHAMMER FINISH A textural finish of *concrete* surfaces created by parallel strokes of a powered hammerlike tool.

BUTCHER BLOCK Wood block made of parallel strips of wood joined to form a single surface; often used for countertops or tabletops.

BUTTRESS An element of masonry structure providing bracing or support.

C

CABRIOLE A furniture leg with a double, or S-shaped, curvature, often decoratively carved and ending in a more or less elaborate foot. The shape is used in many traditional furniture styles.

CAD The abbreviation for computer-aided design.

CALENDERING A process for finishing textiles or forming thin sheets, for example, of plastic, by passing the material between rollers under pressure.

CANDELA A unit of light intensity approximately equal to the more commonly used *footcandle* (fc), the level of light falling on a surface with an area of one square foot placed at a distance of one foot from a standard candle.

CANDLEPOWER A unit of light intensity equal to the output of a standard candle.

CANTILEVER A horizontal projecting beam or structure anchored at one end only.

CANVAS A closely woven cloth usually of cotton or linen.

CAPITAL The top element of a classical column.

CARPET Woven floor covering. Used both for *broadloom* (wall-to-wall) carpeting and for *rugs* of oriental origin.

CARREL A small semi-enclosed desk unit suitable for study in a library.

CASEMENT WINDOW A window hinged at the side and swinging open like a door, most often used in pairs.

CASHMERE A fine wool made from the undercoat of the Kashmir goat or a textile woven of such wool.

CASTER A small roller or wheel used on furniture legs to permit rolling.

CAST IRON Iron formed by pouring melted metal into a mold to generate a desired shape.

CATHEDRAL CEILING A misleading popular term for any very high and sloping ceiling.

CEMENT Powder of lime and other minerals burned in a kiln to make a material used in the preparation of mortar and *concrete*.

CEMENT (OR CONCRETE) BLOCK A masonry unit made from *cement* or *concrete* and used in building construction as an alternative to stone or brick.

CERTIFIED WOOD Wood identified as available from non-endangered sources.

CHAIR RAIL A molding, usually of wood, that runs along a wall at the height of chair backs, thus protecting the wall from being scraped or otherwise marred.

CHAISE LONGUE A reclining chair with a seating surface long enough to provide support for the sitter's legs. (Often corrupted to "chaise lounge.")

CHASE A vertical shaft that holds *ducts*, piping, or wiring.

CHESTERFIELD An overstuffed sofa with padded arms.

CHINOISERIE A style that uses decorative elements derived from Chinese traditional design, particularly popular in French and English eighteenth-century design.

CHINTZ A *plain weave* cotton textile with printed and (usually) glazed surface.

CHROMA A color's purity, or saturation, in the *Munsell* color system, it is measured by a range of numbers from 1 to 14. The highest numbers indicate maximum intensity, although different hues reach maximum chroma at different numbers.

CIRCULATION The movement patterns of a space's occupants. The study of circulation patterns is particularly important in planning complex interiors made up of many rooms, corridors, or other areas.

CLASSIC MODERN Modern design of the early Modern period (1920–40) or later design based on early Modern practice.

CLERESTORY An outside wall, pierced with windows, carried above an adjoining roof, as in the upper walls of the nave of a *Gothic* church; also, a wall with a window or band of windows placed high.

CLUSTER ARRANGEMENT A grouping of elements into a close configuration.

CLUSTER HOUSING Residential buildings arranged in close groupings.

COFFER Originally a chest or other box. By extension, coffers are the recesses that form three-dimensional decorative patterns in ceilings, vaults, or domes.

COLD-CATHODE LIGHT A light source that uses thin, luminous, gas-filled tubes similar to those of neon signs but that produces normal white light. The tubes are often custom-designed and permanently installed, usually in ceiling *coves*.

COLLECTIBLE An object (often furniture) having design characteristics that make it popular to collectors.

COLONIAL A term applied to early-American architecture, including a version of English *Georgian*. The same term is used, rather loosely, to describe more modern imitations of that design.

COLOR SOLID An arrangement of all possible colors according to the method of classification determined by a particular color system as shown in a diagram or three-dimensional model.

COLOR TEMPERATURE A single number expressed in kelvins (K) that indicates the relative warmth or coolness of lighting.

COLOR WHEEL A circular arrangement of *hues* in their spectrum, or rainbow, order of red, orange, yellow, green, blue, and violet. When colors are thus organized, each *secondary* color falls between the *primaries* that make it up, and all colors are directly opposite their *complementaries*.

COM The abbreviation for customer's own material.

COMPACT FLUORESCENT LAMP (CFL) A *fluorescent lamp* made in compact form so as to be interchangeable with an *incandescent* lamp.

COMPLEMENTARY COLORS Colors placed in opposite locations on a *color wheel*, such as red and green.

COMPOSITION Material made of several combined elements, useable for *treads*, flooring, countertops, and tabletops.

COMPRESSIVE LOAD Weight applied to a structural member causing a stress that tends to press fibers together.

CONCEPT A basic idea dominating the thinking on a particular topic or project.

CONCEPT SKETCH A sketch suggesting conceptual design without reference to dimensions or forms.

CONCRETE An artificial stone made from *cement*, sand, and *aggregate* mixed with water and poured into a form or mold.

CONCRETE BLOCK A masonry element made of concrete. See also *cement block*.

CONDUCTION The transfer of heat through contact between elements of different temperatures.

CONSTRAINT In design, any restriction that influences planning.

CONSTRUCTION Regarding a textile, the way in which fibers are made into a cloth.

CONSTRUCTION DRAWING A drawing made to aid in taking bids and for contractors or artisans to use in executing work; also called a *working drawing* or blueprint.

CONSTRUCTIVISM Three-dimensional (sculptural) artwork of abstract character using a combination of separate elements. Also, architectural design based on Constructivist concepts.

CONTEMPORARY DESIGN Current or recent design work. The term commonly describes work that neither refers to historical precedent nor displays the strong stylistic austerity and simplicity associated with *Modernism*. The term "transitional" is sometimes used, mistakenly, as a synonym for "contemporary" in a design context.

CONTINUOUS-SPECTRUM LIGHT Light that contains all of the energy wavelengths—colors—that make up white light. When viewed through a prism or spectroscope, such light reveals a continuous rainbow band of colors. Sources of continuous-spectrum light include the sun, candles, *incandescent* electric light, and oil lamps.

CONTRACT DESIGN All non*residential* interior design. Contract design includes the production and distribution of elements such as furniture, textiles, and light fixtures used primarily in larger commercial and institutional projects. These elements are purchased under contracts rather than through retail channels.

CONTRACT DOCUMENTS Drawn and written materials that provide information sufficient to form a basis for legally binding bidding and construction contracts.

CONVECTION The transfer of heat through the movement of heated air.

CONVECTOR A heat-supply device similar to a *radiator* but designed to maximize the effective flow of heated air by *convection*, that is, the circular motion of air at nonuniform temperatures.

CORDUROY A cotton or synthetic textile *pile* woven in ridges or *wales*.

CORNICE A horizontal band of projecting decorative *moldings* at the top of a wall or building. In the classical *orders* of architecture, the uppermost of the three bands that make up the *entablature*. Also, a projecting horizontal band placed above a window to conceal curtain rods.

COST-PLUS A system of charging for construction work in which the final charge represents the actual costs of materials and labor, plus an established percentage for overhead and profit.

COVE (1) A trough or other recess, often part of a ceiling design, occasionally built into a wall. The cove conceals an *indirect light* source (cove lighting), usually *fluorescent* or *cold-cathode*; (2) a concave molding, particularly one placed where the wall meets the ceiling or floor.

CPM (CRITICAL PATH METHOD) A system for charting a sequence of operations against a time base so as to show their interdependence.

CRADLE-TO-CRADLE Life cycle of material from its origin through production, use, and final disposal.

CREDENZA A horizontal chest or cabinet common in interiors of the Italian Renaissance. In modern usage, the term describes an office storage cabinet of dimensions similar to those of a desk, with doors and sometimes drawers.

CRI (COLOR RENDERING INDEX) A measure of the ability of light of a particular kind to permit accurate evaluation of the color of objects.

CROCKET A carved ornamental detail of bud or leaf shape.

CROCKING The transfer of color from one fabric to another through rubbing contact.

CROSS-BANDING In the construction of veneered *panels* for furniture, doors, paneling, and other interior elements of wood, the layer beneath the exposed, or face, *veneer*. The grain of the cross-banding runs at right angles to the grains of both the solid-wood core and the face veneer, preventing splits and warping.

CRT (CATHODE-RAY TUBE) The element providing the screen of a television set or computer monitor. A computer unit including a screen is often called a CRT unit.

CUBBY A small storage compartment usually provided for use by a child in school.

CUT PILE Fabric of *pile* weave with the surface cut flat as in the making of velvet.

D

DADO (1) The lower part of an interior wall treated with paneling or other special surface materials; (2) in classical architecture, the middle band of a pedestal.

DAMASK A jacquard-woven textile of cotton, linen or silk with elaborate floral or geometric patterns obtained using two-element weave. The pattern is distinguished from the ground by contrasting luster and is reversible.

DECIBEL (DB) A unit of sound intensity or loudness.

DECONSTRUCTION The taking apart of elements as a means of analysis.

DECONSTRUCTIVISM An approach to design in which elements are taken apart and reassembled in partially disconnected relationships.

DECORATOR A professional *interior designer* doing work chiefly concerned with selection of furniture, materials, colors, and finishes.

DEDICATED CIRCUIT An electrical supply circuit that serves only one device, such as a computer.

DESIGN DRAWING A drawing made to illustrate or aid in the development of design. Normally, design drawings emphasize visual concepts and do not include the dimensions and details needed for construction.

DE STIJL A movement (1917–29) in the development of *Modernism*. Centered in the Netherlands, it took its name from the magazine that was its primary organ. Gerrit Rietveld, Theo van Doesburg, and Piet Mondrian were the most active in defining this style.

DHURRIE A thick, simple, striped or patterned *rug* without *pile* made in India.

DIFFUSED LIGHT Light from other than point sources (such as reflective surfaces) and that is largely shadow-less. A device for t his purpose is known as a diffuser.

DIMMER A device for dimming light through electrical or electronic means.

DIP SWITCH A very small switch usually provided in a group of such switches to modify an electrical circuit.

DIRECTOR'S CHAIR A simple folding arm chair with back and seat usually of cotton *duck* similar to the type used by film directors on the set.

DISCONTINUOUS-SPECTRUM LIGHT Light in which only some wavelengths—colors—are present. Although such light appears to be white, a spectroscope shows bright lines of certain colors and blanks elsewhere along the spectrum. Gaseous-discharge lamps, such as *mercury* or *sodium* lights, produce discontinuous-spectrum light. *Fluorescent light* is a mixture of discontinuous- and continuous-spectrum light.

DISTRESSED FINISH A trade term for a finish of reproduction antique furniture that has been deliberately damaged to imitate wormholes and other signs of age.

DOME A circular *vault* derived from rotation of an arch; may be hemispherical, flattened (saucer dome), or elliptical in plan.

DORMER WINDOW A window made possible by a projection from a sloping roof.

DOUBLE GLAZING The insertion, in a window, door, or skylight, of two panes of glass with a dead-air space in between to provide insulation; the principle is that of the storm window.

DOUBLE-HUNG WINDOW A window sash made up of two separate panes that slide vertically.

DOUBLE-LOADED CORRIDOR A corridor giving access to rooms on both sides.

DOVETAIL JOINT An element of wood joinery, made up of two interlocking pieces. Dovetails may be hand cut, as in fine traditional cabinetry, or machine cut. A through, or slip, dovetail uses a lengthwise, wedge-shaped tab that slides into a matching groove.

DOWEL A round pin, usually of wood. A dowel (or dow-eled) joint uses one or more dowels fitted into bored holes to form a wood joint widely used in cabinetmaking.

DOWNLIGHT A can-shaped housing that directs light from an *incandescent lamp* downward for general lighting. Down-lights may be surface-mounted, recessed into a ceiling surface, or hung from a stem. *HID* versions are increas-ingly available for larger spaces.

DRAFTING The making of mechanically accurate draw-ings, by hand or computer (*CAD*) techniques.

DRAPERY Textiles made into curtains for window covering or other uses.

DROPPED CEILING A ceiling plane lower than its surround or a ceiling lowered in its entirety.

DRYWALL A technique in general use for building interior partitions. Large *panels* or sheets of *wallboard*, *gypsum* board, plasterboard, or *Sheetrock* are used in place of plaster to cover *studs* or other structural wall-support materials.

DUCK A broad term for a variety of *plain-weave* utility-quality cotton fabrics.

DUCT An air passage, usually made of sheet metal and usually rectangular, but sometimes round. In *HVAC* systems, ducts carry heated or cooled air to inlet grilles.

E

EBONIZING A wood finishing process using black dye or stain to resemble ebony.

ECLECTICISM Generally, the borrowing of ideas from many sources. In design, the term Eclecticism describes an architectural and interior design direction of about 1900 to 1940, which referred to historic precedents from the distant past, imitating them with considerable accuracy.

ECO-DESIGN Design with special attention to ecological or green issues.

EFFICIENCY UNIT A small one-room apartment; also, a small kitchenette.

EGG AND DART A decorative detail with alternating egg-shaped and dartlike elements used to ornament molding in classical architecture.

EGG CRATE In lighting, an arrangement of deflectors (baffles) in small squares to permit distribution of light while blocking direct vision of sources.

ELEVATION An *orthographic* drawing showing a front, side, or *oblique projected* view in true or consistently scaled dimensions.

EMBROIDERY Ornamental surface stitching on a textile.

EMPATHETIC SKETCHING Drawing in which sketches are developed on an intuitive basis.

EMPHASIS A design principle that through force or intensity of expression gives importance to one or more elements of design.

ENTABLATURE The part of a classical architectural *order* that extends horizontally above the columns. It is made up of three bands, from bottom to top: the *architrave*, the *frieze* (sometimes omitted), and the *cornice*.

ERGONOMICS The study of human body mechanics and sensory performance in relation to the designed environment, especially in work situations.

EXHIBITION DESIGN A branch of design specializing in displays and public showings.

EYEBALL An *incandescent* lighting fixture, usually recessed into a ceiling. The *lamp* is installed in a pivoting, spherical element that permits direct light to be focused as desired.

F

FACILITIES PLANNING A specialized interior design activity concerned with the planning of commercial and institutional projects.

FASTNESS The ability of dyed fabric to resist color fading.

FEDERAL An American decorative and furniture style associated with the *Greek Revival* movement in the first half of the nineteenth century.

FENG-SHUI A traditional, ancient Chinese philosophical approach to design using mystical concepts as guides or determinants to the choice of a building site and its configuration.

FIBER The fundamental material used to make yarn for use in weaving a textile.

FIBERGLASS A hybrid material that uses glass fibers to reinforce a polyester *thermosetting plastic*. In translucent form, fiberglass is often employed for skylights or roofs. Other applications are automobile bodies, small boat hulls, chair bodies, and other furniture parts.

FIBER OPTICS Fibers of glass or plastic capable of transmitting light; used in cables for telephone and data transmission and as a means to transmit light to locations remote from an illumination source.

FIELDSTONE Stone of irregular or rough shape.

FILLING The horizontal or *weft* strands of a woven cloth.

FILL LIGHT Background, *ambient*, or diffused light that reduces the contrast between dark areas or shadows and primary or *task light*.

FLAT FINISH A finish of *matte*, dull, or nonglossy character.

FLIGHT (OF STAIRS) A grouping of stairs serving one change of level.

FLITCH A set of sheets of *veneer* cut from one solid plank so as to generate the same or similar grain pattern in each sheet.

FLOATING CEILING A ceiling area not touching adjacent walls and without any visible support.

FLOCKING A velvetlike surface made by applying *fibers* to an adhesive backing, often creating a pattern in relief. Flocking is sometimes used in the manufacture of economy-grade carpeting.

FLOOR PLAN A plan drawing showing layout at floor level.

FLOWCHART A diagram showing sequence of operation according to time sequence.

FLUORESCENT LIGHT A combination light source that gives off light both from glowing gas inside a sealed *lamp* and from fluorescent phosphors that coat the inner surface of the lamp. The lamp is usually tubular, and, occasionally, circular, although fluorescent bulb shapes are also produced.

FOOTCANDLE (fc) A unit of light intensity. The illumination of a surface at a distance of one foot from a standard candle equals one footcandle.

FOOTLAMBERT (fL) A unit of measurement of light reflected from an illuminated surface.

FORMALDEHYDE A chemical used in production of some building materials. A potential carcinogen whose use is best avoided.

FOSSIL FUELS Fuels such as coal, oil, and gas, non-renewable and from finite sources.

FREESTANDING SYSTEM A desk or storage system or both with units not attached to walls or other supports.

FRENCH CURVE A *drafting* instrument in the form of a flat piece of material, often plastic, that combines a number of curves not based on parts of circles; also known as an irregular curve.

FRIEZE In the classical *orders* of architecture, the section, often decoratively sculpted, of the *entablature* between the *architrave* and the *cornice;* hence, any horizontal ornamental band such as that often placed at the top of a wall.

FULCRUM The center or pivot point of a balance system.

FULLNESS In drapery measurements, the percentage of excess width over the actual dimension of the opening being considered.

FULL-SPECTRUM LIGHT Light that contains the complete range of wavelengths present in daylight, including the invisible radiation at each end of the visible spectrum.

FUNCTION The purpose for which a design is developed.

FUNCTIONALISM A design philosophy basing design decisions on practical or utilitarian consideration. Also, Modernist design in which this concept is dominant.

FURNITURE LAYOUT A plan drawing showing furniture arrangement.

FURRED DOWN CEILING A lowered ceiling constructed below a higher ceiling.

FURRING The lining of a wall with wood, brick, or metal strips to support interior finish material, such as plaster or *wallboard*. The term also describes the strips of metal that support a furred or *furred down ceiling*.

FUTON A movable soft pad of the type used in Japan as a portable bed placed at floor level.

G

GABLE The triangular end wall of a structure with slanted roofs.

GANGING Placement of furniture units (usually chairs) in connected rows.

GARDEN CITY A planned community providing extensive open or garden space.

GATELEG TABLE A drop-leaf table in which a hinged leaf is supported by a leg unit that swings out in the manner of a gate.

GAUGE The thickness of metal sheet or wire as indicated by a number.

GEORGIAN The mid- to late-English Renaissance style developed approximately concurrently with the reigns of George I and George II and the first part of the reign of George III, from about 1714 to 1800. The term is also used for the parallel American design of the same period.

GINGHAM A medium or lightweight cotton or synthetic *plain-weave* cloth made from carded or combed dyed yarns in stripes, checks, plaids, and other simple patterns.

GIRDER A structural member, a large beam supporting other beams.

GLARE Excessively bright light reflecting from a surface in such a way as to obscure observation of detail.

GLAZING (1) The process or act of installing window glass; (2) the transparent material (glass) used for windows; (3) in fabric and wall finishes, surface treatment to create a glossy surface.

GLOSS The reflectivity of a smooth surface.

GOLDEN SECTION A proportional relationship expressed numerically as 1:.618 *or* 1.618:1—and used in various historic periods and by some modern designers as an aid to aesthetic excellence in design. The golden section is a proportion in which a straight line (or a plane figure such as a rectangle) is divided into two unequal parts so that the ratio of the whole to the larger part is the same as the ratio of the larger part to the smaller part, expressed as 1.618:1 = 1:.618 *or* 0.618:1 = 1:1.618.

GOODWILL In placing a value on a business, the amount estimated to represent the value of intangibles such as experience and reputation.

GOTHIC The architectural and decorative style of the latter half of the Middle Ages (about 1150–1500) in Europe. Its most striking characteristic is the pointed arch and *vault*, used in stone construction and, in similar forms, other design work.

GREEK REVIVAL An architectural and decorative style developed in imitation of ancient Greek design and paralleling the interior *Federal* style. It was popular in America, England, and Germany, and, to a lesser extent, other European countries from about 1800 to 1840.

GREEN DESIGN Design that takes ecological and sustainable concerns into account.

GREENGUARD Standards for materials and products with low chemical and particle emissions for use indoors.

GREIGE GOODS In the textile industry, fabrics that have not been dyed and finished.

GRILLE A grid of bars or slats.

GRILLEWORK An arrangement of grilles or bars in a grouping.

GROUND-FAULT INTERRUPTER A safety device for electrical circuits that shuts off power in case of a short circuit in order to prevent shocks. Its use is suggested where electrical outlets or devices are close to water or metal pipes, as in bathrooms or near pools.

GROUND PLAN A *plan* drawing showing elements of a building as arranged at ground level.

GROUT A *cement* mortar, or other material with similar properties, used to fill holes or as an adhesive for setting tiles.

GUIMPE A flat ornamental textile trim with wire or cord running through.

GYPSUM A mineral substance used to make plaster, block for building interior partitions, and gypsum board, a sheet wall-surface material also known as plasterboard, *wallboard,* or *Sheetrock* (a trademark name), used in *drywall* partition construction.

H

HALF-TIMBER CONSTRUCTION Large-scale timber framing with an infilling of *panels* of brick rubble and plaster, resulting in a characteristic exterior of exposed dark wood beams against a lighter material. This was the primary system of wood construction in northern Europe from the Middle Ages until well into the eighteenth century. The same structure, but with an exterior facing, was continued in the American colonies.

HALOGEN LIGHT See *tungsten-halogen light*.

HAND The textural feel of a fabric.

HARDBOARD A generic term for any of various types of fiberboard, made from pressed wood fibers and hardened in manufacture by heat and pressure. Masonite is the trade name for one kind of hardboard.

HARDWOOD The dense wood produced by deciduous trees, such as oak, birch, maple, and walnut.

HARVARD FRAME A metal bed frame used to support a *box spring* and *mattress*.

HIBACHI A small Japanese charcoal stove used for heat or for cooking or for both.

HIDE An animal skin; a unit in which leather is produced and sold, each hide being a complete skin of one animal.

HID LIGHT The abbreviation, in current use, for high-intensity discharge. HID *lamps* are a special type of *incandescent* lamps that employ *mercury, metal halide,* or high-pressure *sodium* in a sealed globe to produce a high level of output efficiently.

HIGHBOY A tall chest with many drawers.

HIGH-INTENSITY DISCHARGE LAMP See *HID light*.

HIGH KEY Color dominated by light, pastel, and pale tones.

HIGH TECH A design direction beginning in the early 1970s that incorporates elements from industrial, aerospace, and other advanced technologies, giving it a characteristically sleek and gleaming mechanistic look.

HOTELING In office design, the provision of work space for temporary use by employees who work outside the office and need only occasional in-house facilities.

HUE The distinctive characteristics of a color described by a basic color name and assigned a particular position in the spectrum. There are three *primary* hues (red, yellow, and

blue) and three *secondary* hues (violet, orange, and green).

HUMAN FACTORS The aspects of design that relate to human comfort and convenience.

HVAC The abbreviation in current use for heating, ventilating, and air-conditioning systems.

HYDRONIC BOILER A boiler that provides forced circulation of hot water as part of a heating system.

HYPOSTYLE (HALL) Space containing many columns supporting a roof structure above.

IDENTITY PROGRAM Design planning to coordinate graphic and other visual elements to represent the identity of a corporation or other organization.

INCANDESCENT LIGHT The most common light source, from a *lamp* that produces light by means of an electrically heated wire filament within a sealed globe.

INDIRECT LIGHTING Lighting directed against a reflecting surface, most often a ceiling. Such an arrangement generates diffuse, *ambient* lighting.

INLAY A decoration set into the surface of an object and finished flush. Inlays of variously colored wood *veneers* and, occasionally, other materials such as mother-of-pearl or metals are elements in many traditional furniture styles.

INSULATION Materials that block the transfer of energy from one material or space to another. The undesirable transfer of heat or sound is commonly limited by appropriate insulation.

INTELLIGENT BUILDING A building designed and constructed to incorporate facilities for telecommunication and data transmission as well as other advanced technological systems.

INTERIOR ARCHITECT A term used in Europe for an architect working only in interior design.

INTERIOR DESIGNER A designer working on interior planning and technical systems as well as on aesthetics of form and color.

INTERNATIONAL STYLE A direction of post–World War I architecture and related interior design characterized by large glass areas, flat roofs, rectilinear forms, an emphasis on functionalism, and an absence of ornament. It originated in 1920s Europe, was developed by the *Bauhaus* school, and became the dominant Modern style worldwide from about 1930 until recent years.

ISLAND UNIT A freestanding element, usually a kitchen counter grouping of appliances or other elements, surrounded by circulation space.

ISOMETRIC A special form of *axonometric* drawing in which an illusion of three-dimensionality is created by lines representing horizontals drawn at a 30-degree angle or at 30- to 60-degree angles. True scale dimensions can be measured on lines at the angled axes and on vertical lines.

JALOUSIE A window or door with an arrangement of overlapping, adjustable, horizontal slats, which controls ventilation, light, or both. Jalousie doors for interior use—such as closet doors—often have fixed slats.

JAMB A vertical element at the side of a door, window, or other opening.

JOINERY Assembly of wood elements as used in cabinetwork or paneling.

JOIST A horizontal structural member supporting a floor. Joists are, in effect, small, closely spaced beams.

JUGENDSTIL The German term for the style that is more generally referred to by the French term *Art Nouveau*.

KILIM A handwoven flat-weave (no *pile* or nap) reversible oriental *rug* or *carpet*.

KITCHENETTE A small, compact kitchen.

KLISMOS An ancient Greek form of chair with forward curving front legs and curved rear legs and back supports attached to a concave curved back.

KNIT A fabric construction in which yarn is interlaced by means of needles. Hand-knitting is a traditional craft technique, but knitting machines have been developed for the industrial production of knitted fabrics.

KNOCKDOWN (KD) Furniture or other objects designed to be made and shipped in separate parts for assembly at point of use.

LADDER-BACK CHAIR A chair with horizontal bars across the back resembling a ladder.

LAMBREQUIN A boxlike, usually fabric-covered trimming that holds and decorates drapery at the top or top and sides of a window or door. Also, a short decorative drapery along a shelf edge or window.

LAMINATE Any product of the process of *lamination*, but the term most often describes a plastic sheet made of layers of paper soaked with *melamine* resin. The result is a tough surface material used for table and countertops and other furniture that calls for resistance to wear and impact damage. Common trade names include Formica, Micarta, Colorcore, and Nevamar.

LAMINATION The process of adhering layers of thin material to make up a thicker sheet. *Plywood*, flat or molded, is made by lamination. Plastic *laminate* is widely used as a tabletop, countertop, and general furniture surface material.

LAMP In nontechnical usage, any portable lighting device, such as a floor or table lamp. In the lighting trades and professions, the term refers to the light source itself, the bulb or tube that converts electrical energy to light.

LANDMARK An important building or other feature forming an easily recognized element in a particular location, especially one that is officially designated and set aside for preservation.

LANDSCAPE ARCHITECTURE Design of gardens and other outdoor spaces as provided by a specially qualified profession.

LATE MODERN A term for recent work that continues the concepts of the Modern movement of the 1920s to 1950s but with more varied designs.

LATERAL FILE A file cabinet in which storage bins are arranged sidewise rather than in drawers.

LATH Thin strips of wood nailed to the *studs* of a wall to support a plaster or other surface. The term is now also used for metal mesh and perforated sheet serving the same purpose.

LAWSON A sofa with arms lower than the back.

LEATHERETTE A material with a textile base and a surface imitative of natural leather.

LED (LIGHT-EMITTING DIODE) An electronic (digital) device that converts electrical energy into light.

LEED (Leadership in Energy and Environmental Design) Rating system establishing standards for Green use and recycling.

LENO A textile weave of loose, open, gauzelike character formed by pairs of *warp* yarns that cross one another and thereby lock the filling yarn into position..

LICENSING The regulation of design practice through legislation requiring that work affecting safety, health, and well-being be done only by holders of a professional license.

LIFE-CYCLE COST Cost of material or product, including all costs from production through installation and use to final recycling or disposal.

LINTEL A short, horizontal member spanning an open space between columns or over a door, window, or other opening.

LOAD-BEARING WALL A wall that provides structural support for a floor or roof.

LOAD FACTOR (OCCUPANT) A figure establishing the number of occupants legally permitted in a space as a function of area and use.

LOFT An open interior space usually not divided into rooms, most often in a warehouse or business building.

LOFT BED A bed built as part of an elevated platform structure.

LOGGIA A covered area open to the out-of-doors on one or more sides.

LOVE SEAT A two-seat sofa.

LOW KEY Color using dark and saturated tones as dominant values.

LUMEN A unit of light flow generated by the light of one standard candle.

LUMINAIRE In the lighting trades or professions, a complete light fixture, including the *lamp* or lamps, power connections, and any enclosures, reflectors, lenses, baffles, or other elements.

LUMINOUS EFFICACY Lumens emitted by a light source divided by power input expressed in lumens per watt.

LUX A metric unit of light intensity equal to one lumen per square meter. One lux equals 10.76 *footcandles*.

MALIMO A composite fabric constructed by binding together many *weft* threads with a third yarn element, knitted into place.

MANTEL A horizontal shelf above a fireplace opening.

MAQUETTE An interior *plan* with related *elevations*—representing walls—placed around and adjacent to it; when the group is cut out and the elevations folded up, a boxlike model of the interior is formed.

MARQUETRY Inlaid decorative detail on furniture and flooring using variously colored woods or other materials.

MARQUISETTE A group of textiles in which pairs of *warp* threads cross between strands of *weft* to permit a loose open mesh without slipping.

MASS CONCRETE *Concrete* used without reinforcing.

MATCH LINE In printed fabric or paper, the line where repeated design-pattern elements meet.

MATELASSÉ A textile combining single and double cloths to produce a quilted appearance.

MATRIX CHART A chart in which the relationship between two lists of items is displayed in numerical or symbolic form.

MATTE Dull or flat; lacking in gloss.

MATTRESS A constructed pad to provide a soft surface on a bed.

MECHANICAL SYSTEMS Electrical, plumbing, heating, and air-conditioning systems taken together.

MELAMINE A highly resistant *thermosetting plastic* used to make *laminates* for tabletops or countertops or other furniture applications.

MEMO SQUARE A textile sample, usually a square yard, made available by fabric houses for designers' use in color planning.

MERCURY LIGHT A type of gaseous-discharge *lamp* that uses mercury gas in a sealed tube. It is highly efficient, but its *discontinuous-spectrum light* is an unpleasant bluish color unsuitable for all but utilitarian purposes such as highway lighting.

METAL-HALIDE LIGHT An economical *HID light* that provides high output.

METAMERISM The modification of perceived color caused by variation in the color of *ambient light*.

METOPE In ancient Greek architecture, the square *panel* that alternates with *triglyphs* in the frieze of a classical Doric *entablature*.

MEWS HOUSE A house located on a narrow alley or street; also, urban living quarters adapted from former stables.

MILLWORK Wood elements, such as doors, door and window frames, paneling, *baseboards*, and *moldings*, that are produced by a mill for on-site installation in an interior.

MITER A joint made by fitting together two pieces of material cut to meet at matching angles, usually 45 degrees, to form a corner, usually 90 degrees.

MOBILE A sculpture incorporating movable elements.

MODERNISM A general term for design styles developed in the twentieth century that make little or no reference to earlier historic periods, characterized instead by functional simplicity.

MODULAR FURNITURE Furniture made in geometric units that can be combined in organized geometric arrangements.

MODULE (1) A standardized unit of measurement used in planning and construction, such as 8-inch bricks or 2-by-4-inch studs, to facilitate convenient and economical usage; (2) one of a set of standardized units in an integrated system that allows numerous combinations, as in a furniture set (a modular couch or storage system).

MOLDED PLYWOOD *Plywood* that is shaped under pressure while the adhesive between its component layers is still malleable. Molded plywood is used in many modern furniture products.

MOLDING An architectural band that covers and trims a line where parts or materials join or that creates purely decorative linear patterns. Moldings are often of wood, sometimes of metal, plaster, or plastic.

MONK'S CLOTH A simple, coarse textile of *plain* or *basket weave*.

MONOCHROMATIC COLORS Colors of a single hue.

MORTAR A paste made from lime, *cement,* sand, and water for use in masonry and *brick* construction.

MORTISE AND TENON In woodworking, a joint in which a projecting element, the tenon, is fitted into a corresponding cavity, the mortise.

MOSAIC Very small stones or tiles arranged to create patterns or images.

MULLION A vertical member dividing *panels* or panes of a door or window.

MUNSELL COLOR SOLID In the Munsell color system, the mass that results when the steps of *value* are arranged in a vertical axis, the *hues* form a sphere in the horizontal planes around the axis, and the steps of *chroma,* or saturation, radiate from the axis (least saturated) to the circumference (most saturated).

MUNTIN A vertical member dividing *panels* or panes of a door or window.

MUSLIN A thin, soft *plain weave* cotton cloth often used as backing.

NEOCLASSIC A stylistic development based on a return to the principles of classic—ancient Greek and Roman—architecture and design. For example, Neoclassicism characterizes French design of the period following the French Revolution and extending into the nineteenth century, including the Directoire and Empire interior styles.

NEW TOWN A planned community built at a particular time.

NONENDANGERED Species of plants and animals available in ample supply and so not in danger of extinction.

NOSING The projecting front edge of the *tread* of a stair.

NRC (NOISE REDUCTION COEFFICIENT) A decimal number that indicates the ability of an interior surface material to absorb sound by giving the percentage of sound that will be absorbed. Hard materials have a low NRC, while materials with good sound-absorbent qualities have high NRC ratings, up to a maximum of about .90.

OBLIQUE Slanted or on a diagonal.

OBLIQUE PROJECTION A system of drawing projection in which one plane (usually a *plan* or an *elevation*) is drawn orthographically (perpendicular to the drawing surface) while receding lines are drawn at an angle (30, 45, or 60 degrees) to give a three-dimensional effect.

OFF-GASSING The giving off of fumes or gasses from materials and products used in interior spaces.

OILCLOTH A plain cotton fabric coated on one side with linseed oil and pigment mixture to produce a smooth surface of strong color.

OPAL GLASS White translucent glass.

OPAQUE Blocking passage of light; not transparent.

OPEN PLAN A layout with few or no walls or partitions. The term has become associated with a system of office planning that, instead of separate, enclosed offices, uses screens or other furniture elements to provide some degree of privacy within a single, open space.

ORDERS The classical systems of architectural detail and ornament based on columns supporting an *entablature*. Developed in ancient Greece and Rome, the most commonly found orders are Doric, Ionic, and Corinthian, named after their supposed places of origin.

ORGANZA A lightweight, sheer fabric in *plain weave* similar to organdy and made of fine filament yarns, such as silk, rayon, or nylon.

ORIENTATION The placement of a building, room, window, skylight, or other relevant element in relation to the points of the compass.

ORTHOGRAPHIC See *oblique projection*.

OSTWALD COLOR SOLID In the Ostwald color system, steps of *value* are arranged in a vertical axis; the steps of *chroma*, or saturation, radiate outward from the neutral center (least saturated) toward the *hues* (most saturated), which form the outer layer on a horizontal plane. Unlike in the *Munsell* system, steps of variation in chroma are equalized to form a smooth, double-conical solid.

PANEL A rectangular unit of material, usually framed by some sort of border. Wood paneling is a popular wall treatment. Rail-and-panel construction is a system of making doors or parts of furniture by setting thin wooden panels into a frame of *rails*.

PANEL-HUNG SYSTEM A system of office furniture in which work surfaces and storage elements are supported by hanging on movable panels.

PANIC BOLT A door latch operated by a horizontal bar to permit opening by means of hand or body pressure.

PARABOLIC ALUMINIZED REFLECTOR (PAR) LAMP An *incandescent lamp* of mushroom shape incorporating a reflector element.

PARQUET *Inlaid* woodwork made up of small blocks of hardwood arranged to form a geometric design or pattern, often in contrasting colors, primarily used in flooring.

PARTICLEBOARD A sheet material made up of wood chips, sawdust, or both, bonded with a resin adhesive. Painted or *veneered,* particleboard provides a finished surface equal to *plywood* or solid wood.

PASSIVE SOLAR Heating systems using *solar energy* and natural means of energy circulation to provide environmental comfort with little or no mechanical assistance.

PATENT LEATHER Leather with a hard, smooth, glossy surface.

PATINA A surface texture or coating acquired through age, or use or both, and sometimes artificially.

PEDIMENT A triangular *gable* over a door, window, or portico; also, the *molding* edging on a gable roof.

PERSPECTIVE The system of realistic pictorial drawing representing objects and spaces in relative distance or depth. Distant objects appear smaller than nearer objects, and horizontal lines move into the distance, converging toward vanishing points on the horizon.

PHOTO SENSOR An electronic device to convert light into an electrical signal in order to control the action of equipment in response to *ambient light*.

PILASTER A flattened form of column set against a wall surface.

PILE A cloth or *carpet* surface of raised yarns, looped or cut flush. *Velvet* and *terry* cloth are two pile fabrics.

PIPE CHASE A vertical shaft accommodating plumbing pipes.

PIRACY (IN DESIGN) Unauthorized imitation or duplication of another's design.

PLAIN WEAVE A simple weaving technique using basic over and under mesh of threads.

PLAN A depiction, drawn to scale, of a horizontal section of a building or other unit taken at or near ground or floor level. Such ground plans or floor plans are the most important drawings used in architectural and interior design. The term "planning" refers to the development of such plans and, by extension, any subsequent systematic design actions.

PLANNED DEVELOPMENT A real-estate subdivision or housing group built according to an overall plan.

PLANTER A container for growing ornamental plants.

PLASTERBOARD See *wallboard*.

PLATE GLASS A usually large glass sheet rolled to achieve optical clarity, usually for shop windows.

PLENUM A hollow space above a ceiling or below a floor, often used for return air circulation in an *HVAC* system or for placing architectural lighting fixtures.

PLUSH A textile with long *pile* less dense than *velvet*.

PLYWOOD A sheet material made by *laminating* layers of *veneer* (veneer plywood) with their grains running at right angles. Some types of plywood contain a solid-material core and are finished with a good veneer. The first is most commonly used for carpentry or, *molded,* for furniture; the second, for furniture.

POINTED ARCH AND VAULT A structural arch or vault of peaked form as used in Gothic architecture.

POINT-SOURCE LIGHT Lighting that comes from a concentrated source virtually identical to a point in space.

The sun, the flames of candles and oil lamps, and the filaments of *incandescent lamps* give point-source light, as distinguished from the diffuse light of cloudy skies, *fluorescent* tubes, and luminous or *indirectly lit* ceilings.

PORTICO A covered porch or veranda with columns supporting an overhead element.

POST-AND-BEAM CONSTRUCTION See *post-and-lintel construction.*

POST-AND-LINTEL CONSTRUCTION A system of construction in which upright members—posts—support horizontals—*lintels*—to form a structural frame or grid, usually in timber or stone masonry. When the material used is wood, the system is described as *post-and-beam construction.*

POST-MODERNISM A term coined to describe stylistic developments in architecture and design that diverge from the precepts of *Modernism.* Eccentric ornament, historicism as metaphor, and a certain whimsical quality are characteristic of this direction.

POWDER ROOM A small lavatory or bathroom.

POWER MANAGEMENT Use of rugs or carpeting to convey electrical power through woven-in wiring.

PRESENTATION DRAWING A drawing made for the purpose of showing design to clients or public.

PRIMARY COLOR One of a group of colors from which all other colors may be generated, but which itself cannot be made by mixing. The *subtractive* (pigment or dye) primaries are red, yellow, and blue; the *additive* (colored light) primaries are red, green, and blue.

PROBLEM STATEMENT A written listing of requirements for a particular design project.

PRODUCTION FURNITURE Furniture produced in quantity, usually for retail sale.

PROGRAM An initial, verbal statement of objectives and requirements for a design project.

PROGRAMMING The process of organizing project requirements into a formal list or *program.*

PROJECT BRIEF See *problem statement.*

PROXEMICS The systematic study of the psychological impact of space and interpersonal physical distances.

PROXIMITY The relative nearness of elements in a planned space.

PROXIMITY SWITCH An electrical switch turning a circuit on or off in response to the close presence of a human user.

PUNCH LIST A list of items requiring correction or other action.

Q

QUARTERED Wood from a log that has first been cut into lengthwise quarters in order to maximize the yield of boards at or close to a radial position in the log.

QUARTER MATCHING An arrangement of *veneers* in four similar sections around a central point.

QUATERNARY In a *color wheel,* a color step between each *tertiary* and the adjacent *primary* or *secondary* hue as part of a twenty-four *hue* wheel.

QUILTING A process for the material produced by the process of stitching through two or more layers of fabric with a filling layer between, producing a material that is tufted or patterned; used often for blankets and bedcovers, often of colorful design.

QUOIN A large stone at the corner of a building that provides visual emphasis.

R

RABBET A cut or groove in the edge of a material, usually wood, that fits a corresponding cut in another piece so as to form a joint.

RACEWAY A horizontal channel that carries electric and telephone wiring.

RADIANT HEAT A system in which surfaces are heated by water passed through warming coils or by electric heat elements. Unlike *convection,* which circulates heat throughout a space, this system radiates heat directly into a space. Radiant heating is often used in combination with *solar heating.*

RADIATION The transfer of energy (heat or light) by direct electromagnetic wave action.

RADIATOR A heating device made up of a coil, pipes, or a hollow metal unit through which hot water or steam is passed, transferring (radiating) heat into the surrounding air and space. The term is somewhat misleading, since the common radiator distributes heat more by *convection* than by *radiation.*

RAFTER A horizontal or sloping structural member supporting a roof.

RAG RUG A *rug* made from discarded textiles in strips woven together.

RAIL A horizontal element such as a stair rail or a wooden frame member combined with *panels* in *rail-and-panel construction.*

RAIL-AND-PANEL CONSTRUCTION An assembly of wood elements with straight, narrow *rails* holding thinner flat *panels.*

RANGE A kitchen cooking stove.

RECTILINEAR A pattern formed by straight lines in right-angle relationships.

RECUTTING A process for making *veneer* by slicing through laminated strips of wood.

RECYCLABILITY Suitability of material or product for recycling.

RECYCLING Processing of material or product to produce material suitable to reuse.

REFLECTANCE The proportion of incident light reflected from an illuminated surface, expressed as a percentage.

REFLECTED CEILING PLAN A *plan* matching the related *floor plan* but showing location of ceiling elements, such as lighting fixtures and *HVAC* grilles or diffusers, as well as patterns of material, such as acoustical panels or tiles.

REFRACTION The bending of light as it passes from one medium to another of different density.

REGISTRATION The regulation of design practice through legislation requiring that practitioners meet certain standards of competence to obtain a registration certificate.

REINFORCED CONCRETE A hybrid structural material combining *concrete,* which resists compressive stresses, with embedded steel rods and mesh, which resist tensile stresses.

RENEWABLE ENERGY Energy from sources not subject to depletion, such as solar, hydroelectric, and wind energy.

REPEAT In printed textiles or paper, a small design used repeatedly; also, the distance in inches of one repetition.

RESIDENTIAL DESIGN The design of houses and other residential projects and their interiors as distinguished from *contract design,* which addresses commercial and institutional spaces.

RESIST PRINTING The printing of wax onto a textile that is then dyed. When the wax is washed out, the printed pattern remains in dye color.

RESTORATION The reconstruction of an older room, building, or neighborhood to re-create its original state.

RETURN AIR Air that returns to air-conditioning equipment after circulating through a space. Grilles, for example, permit air to return to *ducts,* a *plenum,* or through corridors.

REVEAL A groove or recess between adjacent elements.

REVERBERATION Successive reflections of sound (echoes) that cause a gradual decrease in intensity after production of the sound has stopped. Reverberation time is the time required for a sound to die away to inaudibility.

RISER (1) In stair construction, the vertical element of a step; (2) in plumbing or wiring, a vertical stretch of equipment, usually serving the upper floors of a building.

ROCOCO The stylistic developments in eighteenth-century French and, to a lesser extent, German and Austrian interior design, and decorative detail typical of the latter part of the French Baroque. Rococo, although characterized by very elaborate surface decoration, retains relatively simple basic forms.

ROMANESQUE The architectural style of the Early Middle Ages in Europe (c. 900–1200), featuring solid masonry walls, rounded arches, and masonry vaults. Despite its name, it is not a Roman style but is so called because of its prominent use of semicircular—or Roman—arches. Romanesque design reflects Byzantine and Islamic, as well as imperial Roman and other sources. In England, such design is commonly designated Norman.

RONDEL A round element of surface decoration often containing a sculptural element.

ROOM DIVIDER A furniture unit that separates spaces as an alternative to a wall.

ROW HOUSE A house built as one of a number in a connected row.

RUBBLE Broken stone or other irregular material.

RUG A movable woven floor covering. An oriental rug is also often called a *carpet.*

RUN (OF STAIRS) A short group of steps without intermediate landing; the horizontal dimensional length of such a group.

RUSTICATION Stonework treated with projecting stones and recessed joints to form a strong surface pattern.

S

SADDLE A slightly raised element at the bottom of a doorway or other opening; also called a threshold.

SAILCLOTH A heavy canvas textile woven in a one-to-two relation of *warp* to *weft* threads, producing a sturdy cotton fabric suitable for making sails.

SAMPLE BOARD A display on a mounting board of materials and colors planned for use in an interior space.

SATEEN A cotton textile of *satin weave,* with lustrous surface, plain, dyed, or printed.

SATIN FINISH Surface finish of metal or other material having texture that limits degree of gloss or reflectivity.

SATIN WEAVE A textile construction with from four to seven warp threads on the surface, producing a fabric with a characteristic smooth surface.

SATURATION See *chroma.*

SCALE (1) A measuring rule, such as an architect's scale, graduated in units applicable to scale drawing; (2) the system of representing objects or spaces in a compact drawing by reducing them by a certain proportion (e.g., ¼" = 1'0"); and (3) the concept that all objects and elements of a design should convey proper and true size relationships.

SCALE PLAN A floor *plan* accurately drawn to a particular scale.

SCONCE A wall-mounted lighting fixture, which generally directs light upward.

SCREEN PRINTING A method of printing a color design on paper or textiles with the use of stencils to control placement of ink or dye color.

SCREEN WALL A wall separating spaces without enclosure.

SECESSION (OR VIENNA SECESSION) A design movement in Austria at the end of the nineteenth century, parallel with *Art Nouveau*.

SECONDARY COLOR A color that results from mixing two *primaries*. The *subtractive* secondaries are orange, green, and violet.

SECTION A drawing showing hidden constructional elements by illustrating an imaginary plane cut through the structure shown.

SHADE A darkened form of a color *hue* produced by the addition of black or gray.

SHED In weaving, the opening of the *warp* in a loom to permit the passing of *weft* threads.

SHEETROCK See *wallboard*.

SHOJI A sliding screen, usually of wood or paper, used in traditional Japanese interiors.

SICK-BUILDING SYNDROME Problems of environmental quality within a building resulting from poor air quality, *off-gassing* from materials, and similar factors causing health problems among occupants.

SIGHT LINES In auditorium planning, lines of direction from an audience member's eye to the stage, screen, or other focus of interest.

SILL (1) In construction, a horizontal structural member; (2) the horizontal shelflike surface below a window, door, or other opening.

SIMULTANEOUS CONTRAST An effect of contrast between two colors that when placed adjacent appear to change in *hue* as a result of their relationship.

SINGLE-LOADED CORRIDOR A corridor giving access to rooms on one side only.

SKYLIGHT A window or other opening in a roof to admit daylight.

SLIP MATCHING An arrangement of *veneer* strips side by side with grain in shifted position.

SOCLE A base, pedestal, or plinth at the bottom of a surface or column.

SODIUM LIGHT A gaseous-discharge light source that uses sodium gas in a sealed tube. Sodium light has a *discontinuous spectrum*, giving it a strong orange tone that makes it unpleasant for general use. Because of its high efficiency, however, it is sometimes used for street and highway lighting.

SOFFIT A lowered portion of a ceiling, or, generally, the underside of a structural element.

SOFT FLOOR COVERING A *carpet* or *rug*.

SOFTWOOD Wood from conifers, such as pine, spruce, fir, and redwood.

SOIL STACK A vertical plumbing pipe that carries sewage downward and provides venting above.

SOLAR HEATING Heating using sunlight as a source of energy.

SPACE PLANNING A specialized aspect of interior design concerned with the layout of rooms or other spaces in plan. It is a function specific to large corporate and institutional offices that fill whole floors.

SPECTRUM The band of colors, ordered from longest wavelength (red) to shortest (violet), visible when light passes through a prism, as in a spectroscope. Daylight and other white, *continuous-spectrum* light produce a complete rainbow spectrum.

SPLIT-COMPLEMENTARY A color relationship in which a *hue* on one side of the *color wheel* is opposite to two colors closely placed on the opposite side of the wheel.

STACK In plumbing, a vertical waste pipe that extends downward to a sewer connection and upward to the open air to permit the venting of gases.

STACKING PLAN A chart or diagram showing the assignment of various functional units to the floors of a multifloor project.

STAINED-GLASS WINDOW A window formed from colored glass in small pieces joined with metal strips.

STC (SOUND TRANSMISSION CLASS) A number rating that indicates the effectiveness of a material or structure in preventing sound transmission. Low STC values (15–20) denote a poor sound barrier, higher values (40–60), a superior ability to block sound transmission.

STILE A vertical member in a door or window, usually combined with *rails* and *panels* in *rail-and-panel construction*.

STIPPO An Italian Renaissance cabinet.

STORAGE WALL A furniture unit providing storage space while also acting as a wall or partition.

STRAPWORK Carved or plaster decorative detail suggesting bands cut from leather.

STRETCHER A horizontal brace, or crosspiece, such as the member set between two legs of a chair or table.

STUDIO APARTMENT A one-room apartment, usually with kitchenette and bath.

STUDS Vertical frame elements in the construction of walls and partitions. Wood studs are usually 2-by-4-inch members placed 16 inches apart. In modern practice, metal studs are also used.

STYLOBATE The base, usually three steps, on which a colonnade rests.

SUBTRACTIVE COLOR The colors of pigments and dyes absorb—that is, subtract—some of the light that strikes them, reflecting the color that results from this subtraction. Mixing pigments to produce *tints* and *shades* is a subtractive process.

SUPINE WORKSTATION A unit for office work in which the user is placed in a reclining position.

SUSTAINABLE DESIGN Design taking account of ecological issues, such as avoidance of materials from endangered species and consumption of nonrenewable resources. Also known as *green design*.

SYMMETRY The placement of identical elements in matching positions on either side of one or more axes.

SYSTEMS FURNITURE Furniture that is designed to combine with other elements. Furniture systems are most often developed in terms of storage walls and office *workstations* that may double as partitioning.

TAFFETA A group of *plain-weave* silk or synthetic fiber cloths with a smooth, crisp finish.

TAMBOUR A furniture front or top made with strips of wood adhered to a fabric backing that allows it to roll in curves. A tambour door slides in a track or groove, often into a hidden trough, to open.

TAPESTRY A heavy, woven textile used for wall hangings, often with handwoven pictorial design.

TASK-AMBIENT LIGHTING A lighting system using strong illumination at location of visual tasks combined with more subdued general lighting.

TASK LIGHT Light necessary for specific kinds of work, or tasks, and installed close to a work surface so as to illuminate the area with minimal spill and thus with maximum energy efficiency.

TATAMI Straw mats of standardized dimension used as a floor covering in traditional Japanese houses.

TEMPLATE A guide used in drafting to trace given outlines. The templates most common in the design trade are cut-out plastic sheets with drafting forms such as circles, ellipses, or furniture shapes in scale.

TENSILE STRENGTH The strength of a structural member as it resists forces that pull and stretch.

TERRAZZO A flooring material using small chips of marble embedded in *cement* and given a polished surface.

TERRY (CLOTH) A textile with loop *pile* often used for toweling.

TERTIARY In a *color wheel*, a step between a *primary* and an adjacent *secondary* resulting in a twelve-hue color wheel.

TETRAD COLOR A color scheme using four hues equally spaced on a color wheel.

THERMOPLASTIC Any plastic material that softens with the application of heat and hardens on cooling. *Acrylics*, vinyls, and polyethylene are thermoplastics.

THERMOSETTING PLASTIC A soft plastic that permanently sets, that is, hardens, with the application of heat. Phenolics, *melamines*, and polyesters are thermosetting plastics.

TINT A form of a color made lighter by mixture with white or light gray.

TITLE LEGISLATION A form of legal registration or licensing that restricts the use of a professional title but permits practice without restriction.

TOILE A *plain-weave* or *twill*-weave fabric, most often of linen.

TONGUE AND GROOVE A joining technique used with wood and other materials in which a projecting lip, or tongue, is slipped into a corresponding channel, or groove. In wood boarding, the line of the joint is often emphasized with a cut *molding* to give a pattern or parallel lines.

TORCHÈRE A freestanding lighting unit directing lighting upward.

TRABEATED CONSTRUCTION A structural system using upright elements (posts) to support horizontal elements (beams or *lintels*).

TRACK LIGHTING A system of lighting in which a continuous fixed band, or track, supplies current and supports movable fixtures.

TRANSFORMER An electrical device that converts an electrical current to a lower voltage, in the case of such elements as doorbells or intercom units, and to a higher voltage for *fluorescent* and *HID* lighting units.

TRANSLUCENCY The quality of a material that permits passage of light but blocks vision.

TRANSPARENCY The quality of a material that permits the passage of light and vision.

TRAP In plumbing, a curved section of pipe that connects a fixture to a drain. The trap permanently holds water, thus forming a seal that prevents sewer gases from escaping back into a bathroom.

TRAVERTINE A soft limestone marble characterized by small voids, which may be filled with plaster or mortar.

TREAD The horizontal step surface of a stair.

TRIAD COLOR A color scheme using three hues equally spaced on a color wheel.

TRI-COLOR LAMP A lamp capable of emitting light of each of three colors.

TRIGLYPH A panel carved in three vertical strips used in alternation with the *metopes* that ornament the frieze of a Greek Doric *entablature*.

TROMPE L'OEIL Painting on a flat surface that gives an illusion of three-dimensional reality.

TRUNDLE BED A low bed with casters that can be rolled under another bed to save space.

TRUSS A structural framework made up of triangles that span wide spaces, supporting a floor or roof. Trusses may be of wood, steel, or a combination of these.

TUNGSTEN-HALOGEN LIGHT An *incandescent* light source that uses *metal halides* in compact, highly efficient *HID* bulbs, tubes, or reflectors. Because they generate a great deal of heat, halogen *lamps* require specially designed fixtures.

TURNERY The technique of producing parts made circular by rotational cutting on a lathe.

TURNING A round element, usually of wood, produced on a lathe.

TUXEDO (SOFA) A sofa with arms the same height as the back.

TWILL A textile weave in which *weft* strands pass over one or more and under one or more *warp* strands in a shifting sequence to produce a seeming diagonal pattern.

UNDERCUT A clearance at floor level that is larger than normal, created by shortening a door to permit air in an *HVAC* system to return along corridors.

UNIVERSAL DESIGN The design of objects, interiors, and buildings to permit convenient and safe use by all users, regardless of body size, age, or physical disabilities.

UPLIGHT Light directed upward toward ceilings or the upper sections of walls. The term is also used to describe floor lamps, or torchères, that cast all light upward.

VALANCE A short drapery concealing the tops of curtains. The term also describes any trim, of drapery or other material, hanging from an edge.

VALUE The lightness or darkness of a color in relation to a scale of grays ranging from black to white. Light values are *tints*, dark values, *shades*.

VAULT An arched roof or ceiling masonry construction. A barrel vault derives from the horizontal extension of an arch, a groin vault from the intersection of two arches.

VDT (VIDEO DISPLAY TERMINAL) The keyboard and *CRT* screen unit used to control a computer.

VEILING REFLECTION Glare produced by the reflection of a light source off a glossy surface.

VELOUR A *cut-pile* fabric usually of cotton and similar to *velvet* but made from coarser yarn.

VELVET A *cut-pile* fabric of silk, rayon, or wool having a short, dense pile.

VELVETEEN A fabric of cotton in *plain* or *twill weave* with a short *pile* in imitation of *velvet*.

VENEER Wood (or other material) cut in very thin sheets for use as a surface material (face veneer), usually of fine quality, or as a component layer of *plywood*.

VENT An air inlet. In plumbing, a vent connects to a drainpipe just beyond each *trap*, to prevent suction from removing water from the trap and to provide an outlet for gases into the open air.

VERNACULAR DESIGN Design developed traditionally without professional participation.

VIRTUAL REALITY The simulation of a real space through the use of computer-generated imagery.

VOC The abbreviation for volatile organic compound.

VOLITILE ORGANIC COMPOUND (VOC) Indoor air pollutants in forms of vapor or gasses that offer undesirable air quality.

VOLUTE A spiral decorative form used as the major element in the *capital* of a column in the Ionic *order* of architecture.

WAINSCOT A surface treatment of the lower part of an interior wall.

WALE In woven fabrics, a raised ridge or ribbonlike band on the surface, and characteristic of *corduroy*.

WALLBOARD A thin, manufactured sheet material used in the construction of interior walls and ceilings. The term is often used interchangeably with plasterboard or Sheetrock (a trade name).

WALL-WASHER A ceiling-mounted, adjustable lighting fixture that directs light sideways toward an adjacent wall, which is thus washed with more or less uniform light.

WARP Lengthwise strands of thread forming one of the two elements of woven fabric.

WASTE STACK See *soil stack*.

WEFT A crosswise strand of thread or other yarn crossing the *warp* threads at right angles to produce a woven fabric.

WELT A thin tube or cord of fabric used as a decorative trim and reinforcement along the edge of a cushion or other upholstery element.

WERKSTÄTTE Design- and craft-oriented studios and workshops active in Vienna in the late nineteenth and early twentieth centuries.

WET COLUMN A structural column housed together with space for plumbing pipes.

WET FACILITIES Spaces where running water is provided, such as bathrooms and kitchens.

WILTON CARPET A *carpet* woven with loops and having a *velvet cut pile*.

WINDER A step with a triangular tread as required in curved or spiral stairs.

WINDOW GLASS Glass made in small panes of adequate *transparency* for use in windows.

WINDOW HEAD The top of a window opening.

WORKING DRAWING A drawing from a set of *construction drawings* that is used as a basis for construction contracts and to direct actual construction work.

WORKSTATION Any of several systems of office furniture and equipment, often incorporating screens or other partitions to provide some degree of enclosure and privacy.

WORSTED A compact yarn made from long wool fibers; also, a fabric woven from worsted yarn.

WROUGHT IRON Iron made ductile in order for it to be bent into various curving shapes.

Bibliography

General

Abercrombie, Stanley. *Architecture As Art*. New York: Harper & Row, 1985.
———. *A Philosophy of Interior Design*. New York: Harper & Row, 1990.
Abercrombie, Stanley, and Sherill Whiton. *Interior Design and Decoration*, 5th ed. New York: Prentice-Hall, 2001.
Allen, Phyllis Sloan, Miriam F. Stimpson, and Lynn M. Jones. *Beginnings of Interior Environments*. 8th ed. Upper Saddle River, N.J.: Prentice-Hall, 2000.
Baldwin, Benjamin, *An Autobiography in Design*. New York: W. W. Norton, 1995.
Ballast, David Kent, *Interior Design Reference Manual*, 3rd ed. New York: Professional Publications, 2006.
Bayley, Stephen, ed. *Conran Directory of Design*. New York: Random House, Villard Books, 1985.
Brown, Erica. *Sixty Years of Interior Design*. New York: Viking Press, 1982.
Ching, Francis. *Interior Design Illustrated*. New York: Van Nostrand Reinhold, 1987.
Conran, Terence. *New House Book*. New York: Random House, Villard Books, 1985.
Diamonstein, Barbaralee. *Interior Design*. New York: Rizzoli International, 1982.
Dreyfuss, Henry. *Designing for People*. New York: Simon & Schuster, 1955.
Friedmann, Arnold, John F. Pile, and Forrest Wilson. *Interior Design: An Introduction to Architectural Interiors*. 3d ed. New York: Elsevier, 1982.
Garner, Philippe. *Contemporary Decorative Arts*. New York: Facts on File, 1980.
Kilmer, Rosemary, and W. Otie Kilmer. *Designing Interiors*. Fort Worth, Tex.: Harcourt Brace Jovanovich College Publishers, 1992.
Kurtich, John, and Garret Eakin. *Interior Architecture*. New York: Van Nostrand Reinhold, 1993.
Linley, David. *Design and Detail in the House*. New York: Harry N. Abrams, 2000.
Mumford, Lewis. *Technics and Civilization*. New York: Harcourt, Brace and Co., 1943.
Nielson, Karla J., and David A. Taylor. *Interiors: An Introduction*. 2d ed. New York: McGraw-Hill, 2002.
Nissen, LuAnn, Ray Faulkner, and Sarah Faulkner. *Inside Today's Home*. 6th ed. Fort Worth, Tex.: Harcourt Brace College Publishers, 1994.
Ozenfant, Amédée. *Foundations of Modern Art*. Translated by John Rodker. Reprint, New York: Dover Publications, 1952.
Rasmussen, Steen Eiler. *Experiencing Architecture*. Translated by E. Wendt. Cambridge, Mass.: MIT Press, 1962.
Riewoldt, Otto. *Intelligent Spaces: Architecture for the Information Age*. London: Laurence King, 1997.
Riley, Terence. *The Un-Private House*. New York: MOMA / Harry N. Abrams, 1999.
Shaw, Ros Byam. *Naturally Modern*. New York: Harry N. Abrams, Inc., 2000.
Sparke, Penny. *An Introduction to Design and Culture in the Twentieth Century*. New York: Harper & Row, 1986.
Steele, James. *Architecture Today*. New York: Phaidon Press, 1997.
Tate, Allen, and C. Ray Smith. *Interior Design in the 20th Century*. New York: Harper & Row, 1986.
Venturi, Robert. *Complexity and Contradiction in Architecture*. New York: Museum of Modern Art, 1966.
Wheatman, John. *Meditations on Design*. Berkeley, Calif.: Conari Press, 2000.
Whiton, Sherrill, and Stanley Abercrombie. *Interior Design and Decoration*. 5th ed. Upper Saddle River, N.J.: Prentice-Hall, 2002.

Introduction

ASID Professional Practice Manual. Edited by Jo Ann Asher Thompson. New York: Whitney Library of Design, 1992.
Interior Design Educators Council. *Interior Design As a Profession*. Richmond, Va.: IDEC, 1983.
National Council for Interior Design Qualification. *NCIDQ Examination Guide*. Washington, D.C.: National Council for Interior Design Qualification, 2000.

Design Quality

Deasy, C. M., and Laswell Thomas. *Designing Places for People*. New York: Whitney Library of Design, 1985.
Kaufmann, Edgar, Jr. *What Is Modern Design?* New York: Museum of Modern Art, Simon & Schuster, 1950.
———. *Introduction to Modern Design: What Is Modern Design & What Is Modern Interior Design*. Salem, N.H.: Ayer Company Pubs., 1953. Reprint, New York: Museum of Modern Art Publication in Reprint Series, 1970.
Kepes, Gyorgy, ed. *The Man-Made Object*. New York: George Braziller, 1966.
Lynes, Russell. *The Tastemakers*. New York: Harper & Bros., 1954. Reprint, New York: Dover, 1980.
Museum of Modern Art. *Machine Art*. New York: Museum of Modern Art, 1934. Reprint, New York: Arno, 1969.
Papanek, Victor. *Design for Human Scale*. New York: Van Nostrand Reinhold, 1983.
———. *Design for the Real World*. New York: Pantheon Books, 1971.
Pile, John F. *Design: Purpose, Form, and Meaning*. Amherst: University of Massachusetts Press, 1979. New York: W. W. Norton, 1982.
Read, Herbert. *Art and Industry*. London: Faber & Faber, 1934.

Design Basics

Arnheim, Rudolph. *Art and Visual Perception*. Berkeley: University of California Press, 1960.
De Sausmarez, Maurice. *Basic Design: The Dynamics of Visual Form*. New York: Van Nostrand Reinhold, 1983.
Doczi, György. *The Power of Limits*. Boulder, Colo.: Shambhala, 1981.
Huntley, H. E. *The Divine Proportion*. New York: Dover Publications, 1970.
Itten, Johannes. *Design and Form*. New York: Van Nostrand Reinhold, 1964.
Kepes, Gyorgy. *Language of Vision*. Chicago: Paul Theobold, 1944.
Lauer, David, and Stephen Pentak. *Design Basics*. 5th ed. Fort Worth, Tex.: Harcourt College Publishing, 1999.

Design History

GENERAL

Adelmann, Jan Ernst. *Vienna Moderne, 1898–1918*. New York/Houston: Cooper-Hewitt Museum/Sarah Campbell Blaffer Gallery, 1978.
Ball, Victoria Kloss. *Architecture and Interior Design: Europe and America from the Colonial Era to Today*. 2 vols. New York: John Wiley & Sons, 1980.
———. *The Art of Interior Design*. 2d ed. New York: John Wiley & Sons, 1982.
Banham, Reyner. *Theory and Design in the First Machine Age*. New York: Praeger, 1960.
Blakemore, Robbie G. *History of Interior Design and Furniture: Ancient Egypt to 19th-Century Europe*. 2 vols. New York: Van Nostrand Reinhold, 2d ed, 2006.
Clark, Robert Judson. *Design in America: The Cranbrook Vision: 1925–1950*. New York: Harry N. Abrams, 1983.
Copplestone, Trewin, ed. *World Architecture*. London: Hamlyn, 1963.
Drexler, Arthur, ed. *The Architecture of the École des Beaux-Arts*. New York: Museum of Modern Art, 1977.
Eidelberg, Martin, ed. *Design 1935–1965: What Modern Was*. New York: Harry N. Abrams, 1991.
Ferebee, Ann. *A History of Design from the Victorian Era to the Present*. New York: Van Nostrand Reinhold, 1970.
Fitch, James Marston. *American Building*. 2d ed., rev. and enl. Boston: Houghton Mifflin, 1966.
Fletcher, Sir Banister. *A History of Architecture on the Comparative Method*. 19th ed. Edited by John Musgrove. London: Butterworth, 1987.
Gere, Charlotte. *Nineteenth-Century Decoration: The Art of the Interior*. New York: Harry N. Abrams, 1989.
Giedion, Sigfried. *Space, Time and Architecture*. Cambridge, Mass.: Harvard University Press, 1941.
Gura, Judith, *Abrams Guide to Period Styles for Interiors*. New York: Harry N. Abrams, 2005.
Heyer, Paul. *American Architecture*. New York: Van Nostrand Reinhold, 1993.
Hiesinger, Kathryn B., and George H. Marens, eds. *Design Since 1945*. Philadelphia: Philadelphia Museum of Art, 1983.
Hine, Thomas. *Populuxe*. New York: Alfred A. Knopf, 1986.
Kouwenhoven, John A. *Made in America: The Arts in Modern American Civilization*. Rev. ed. Garden City, N.Y.: Doubleday, 1962.
Lucie-Smith, Edward. *A History of Industrial Design*. New York: Van Nostrand Reinhold, 1983.
Massie, Anne. *Interior Design of the Twentieth Century*. New York: Thames & Hudson, 1990.
McCorquodale, Charles. *A History of Interior Decoration*. New York: Vendome Press, 1983.
McFadden, David. *Scandinavian Modern Design*. New York: Harry N. Abrams, 1982.

Pevsner, Nikolaus. *High Victorian Design*. London: Architectural Press, 1951.

———. *Outline of European Architecture*. New York: Penguin Books, 1943.

———. *Pioneers of Modern Design from William Morris to Walter Gropius*. 2d ed. New York: Museum of Modern Art, 1949. Rev. ed. Harmondsworth, Eng.: Penguin Books, 1960.

———. *The Sources of Modern Architecture Design*. New York: Praeger, 1968.

Phillips, Lisa, ed. *High Styles: Twentieth-Century American Design*. New York: Whitney Museum of American Art and Summit Books, 1985.

Pile, John F. *Dictionary of 20th-Century Design, 2d ed.* New York: Facts on File, 1990.

———. *A History of Interior Design*. New York: John Wiley & Sons, 2005.

Praz, Mario. *An Illustrated History of Furnishing*. New York: George Braziller, 1964.

Schaefer, Herwin. *Nineteenth Century Modern*. New York: Praeger, 1970.

Schönberger, Angela, ed. *Raymond Loewy: Pioneer of American Industrial Design*. Munich: Prestel, 1990.

Smith, C. Ray. *A History of Interior Design in 20th-Century America*. New York: Harper & Row, 1987.

Thornton, Peter. *The Italian Renaissance Interior: 1400–1600*. New York: Harry N. Abrams, 1991.

Trachtenberg, Marvin, and Isabelle Hyman. *Architecture from Prehistory to Post-Modernism*. New York: Harry N. Abrams, 1986.

Varnedoe, Kirk. *Vienna 1900: Art, Architecture and Design*. New York: Museum of Modern Art, 1986.

Wiffen, Marcus, and Frederick Koerper. *American Architecture, 1607–1976*. 2 vols. Cambridge, Mass.: MIT Press, 1981.

ART DECO

Bush, Donald J. *The Streamlined Decade*. New York: George Braziller, 1975.

Sembach, Klaus-Jürgen. *Style 1930*. New York: Universe Books, 1971.

ART NOUVEAU

Amaya, Mario. *Art Nouveau*. New York: Dutton, 1960.

Brunhammer, Yvonne, et al. *Art Nouveau Belgium/France*. Houston: Institute for the Arts, Rice University, 1976.

Greenhalgh, Paul, ed. *Art Nouveau, 1890–1914*. New York: Harry N. Abrams, 2000.

Rheims, Maurice. *The Flowering of Art Nouveau*. New York: Harry N. Abrams, 1966.

Selz, Peter, and Mildred Constantine, eds. *Art Nouveau*. New York: Museum of Modern Art, 1960.

ARTS AND CRAFTS MOVEMENT

Cathers, David M. *Furniture of the American Arts and Crafts Movement*. New York: New American Library, 1981.

Volpe, Tod M., and Beth Cathers. *Treasures of the American Arts and Crafts Movement 1890–1920*. New York: Harry N. Abrams, 1988.

BAUHAUS

Naylor, Gillian. *The Bauhaus*. New York: Dutton, 1968.

———. *The Bauhaus Reassessed*. New York: E. P. Dutton, 1985.

Whitford, Frank. *Bauhaus*. New York: Oxford University Press, 1984.

Wingler, Hans. *The Bauhaus*. Cambridge, Mass.: MIT Press, 1969.

MARCEL BREUER

Gatje, Robert F. *Marcel Breuer: A Memoir*. New York: Monacelli, 2000.

Hyman, Isabelle. *Marcel Breuer, Architect: The Career and the Buildings*. New York: Harry N. Abrams, 2001.

Wilk, Christopher. *Marcel Breuer: Furniture and Interiors*. New York: Museum of Modern Art, 1981.

DE STIJL

Baljeu, Joost. *Theo Van Doesburg*. New York: Macmillan, 1974.

Jaffé, Hans L. C. *De Stijl, 1917–1931*. New York: Harry N. Abrams, 1967.

Overy, Paul. *De Stijl*. New York: Dutton, 1968.

CHARLES AND RAY EAMES

Demetrios, Eames. *An Eames Primer*. New York: Universe Publishing, 2002.

Drexler, Arthur. *Charles Eames: Furniture from the Design Collection*. New York: Museum of Modern Art, 1973.

Library of Congress and Virva Design Museum, *The Work of Charles and Ray Eames*. New York: Harry N. Abrams, 1997.

Neuhart, John, Marilyn Neuhart, and Ray Eames. *Eames Design: The Work of the Office of Charles and Ray Eames*. New York: Harry N. Abrams, 1989.

EILEEN GRAY

Adam, Peter. *Eileen Gray: Architect/Designer*. Rev. ed. New York: Harry N. Abrams, 2000.

WALTER GROPIUS

Fitch, James Marston. *Walter Gropius*. New York: George Braziller, 1960.

Giedion, Sigfried. *Walter Gropius*. New York: Reinhold, 1954.

HECTOR GUIMARD

Graham, F. Lanier. *Hector Guimard*. New York: Museum of Modern Art, 1970.

Rheims, Ferré. *Hector Guimard*. New York: Harry N. Abrams, 1988.

HIGH TECH

Kron, Joan, and Suzanne Slesin. *High Tech*. New York: Clarkson N. Potter, 1978.

JOSEF HOFFMANN

Sekler, Eduard F. *Josef Hoffmann: The Architectural Work*. Princeton, N.J.: Princeton University Press, 1985.

LE CORBUSIER (CHARLES-ÉDOUARD JEANNERET)

Besset, Maurice. *Who Was Le Corbusier?* Translated by Robin Kemball. Cleveland, Ohio: World Publishing Co., 1968.

Blake, Peter. *Le Corbusier*. Baltimore: Penguin Books, 1964.

Le Corbusier. *1929 Sitzmöbel*. Zürich: Galerie Heidi Weber, 1959.

———. *Towards a New Architecture*. Translated by Frederick Etchells. London: The Architectural Press, 1927. Reprint, New York: Praeger, 1970.

LOUIS I. KAHN

Brownlee, David B., and David G. De Long. *Louis I. Kahn: In the Realm of Architecture*. New York: Rizzoli, 1991.

Rykwert, Joseph. *Louis Kahn*. New York: Harry N. Abrams, 2001.

ADOLF LOOS

Rukschio, Burkhardt, and Roland Schachel. *Adolf Loos*. Salzburg and Vienna: Residenz Verlag, 1982.

CHARLES RENNIE MACKINTOSH

Barnes, H. Jefferson. *Some Examples of Furniture by Charles Rennie Mackintosh in the Glasgow School of Art Collection*. Glasgow: Glasgow School of Art, 1969.

Kaplan, Wendy, ed. *Charles Rennie Mackintosh*. New York: Abbeville Press, 1996.

Howorth, Thomas. *Charles Rennie Mackintosh and the Modern Movement*. New York: Wittenborn, 1953.

MEMPHIS

Horn, Richard. *Memphis*. Philadelphia: Running Press, 1985.

Radice, Barbara. *Memphis*. New York: Rizzoli International, 1984.

LUDWIG MIES VAN DER ROHE

Blaser, Werner. *Mies van der Rohe—Furniture and Interiors*. London: Academy Editions, 1982.

Glaeser, Ludwig. *Ludwig Mies van der Rohe: Furniture and Furniture Drawings*. New York: Museum of Modern Art, 1977.

Lambert, Phyllis, et al. *Mies in America*. New York: Harry N. Abrams, 2001.

Riley, Terence, and Barry Bergdoll. *Mies van der Rohe in Berlin*. New York: Harry N. Abrams, 2001.

Tegethoff, Wolf. *Mies van der Rohe: The Villas and Country Houses*. New York: Museum of Modern Art, 1985.

WILLIAM MORRIS

Clark, Fiona. *William Morris: Wallpapers and Chintzes*. New York: St. Martin's Press, 1973.

Day, Lewis F. *Decorative Art of William Morris and His Work*. London: H. Virtue and Co., 1899.

Morris, William. *Selected Writings and Designs*. Edited by Asa Briggs. Baltimore: Penguin Books, 1962.

Parry, Linda. *William Morris Textiles*. New York: Viking Press, 1983.

Wilhide, Elizabeth. *William Morris: Decor and Design*. New York: Harry N. Abrams, 1991.

MODERNISM, POST-MODERNISM, AND DECONSTRUCTIVISM

Cohen, Jean-Louis, et al. *Frank O. Gehry: The Art of Architecture*. New York: Harry N. Abrams, 2001.

Johnson, Philip, and Mark Wigley. *Deconstructivist Architecture*. New York: Museum of Modern Art, 1988.

Klotz, Heinrich. *Postmodern Visions*. New York: Abbeville Press, 1985.

Piano, Renzo. *Renzo Piano and Building Workshop: Buildings and Projects, 1971–1989*. New York: Rizzoli International, 1989.

Sudjic, Devon. *The Architecture of Richard Rogers*. New York: Harry N. Abrams, 1994.

Tasma-Anargyros, Sophie. *Andrée Putman*. 2d ed. Woodstock, N.Y.: Overlook Press, 1997.

Wiseman, Carter. *I. M. Pei. A Profile in American Architecture*. Rev. ed. New York: Harry N. Abrams, 2001.

SHAKER DESIGN

Andrews, Edward Deming. *Religion in Wood: A Book of Shaker Furniture*. 2d ed. New Haven, Conn.: Yale University Press, 1939.

Rieman, Timothy, and Jean M. Burks. *The Complete Book of Shaker Furniture*. New York: Harry N. Abrams, 1993.

THONET

Wilk, Christopher. *Thonet: 150 Years of Furniture.* Woodbury, N.Y.: Barron's, 1980.

LOUIS COMFORT TIFFANY

Couldrey, Vivienne. *The Art of Louis Comfort Tiffany.* Secaucus, N.J.: Wellfleet Press, 1989.

Duncan, Alastair, et al. *Masterworks of Louis Comfort Tiffany.* New York: Harry N. Abrams, 1989.

HENRI VAN DE VELDE

Osthaus, Karl Ernst. *Van de Velde.* Hagen: Folkwang-Verlag, 1920.

FRANK LLOYD WRIGHT

Gill, Brendan. *Many Masks: A Life of Frank Lloyd Wright.* New York: G. P. Putnam, 1987. .

Hitchcock, Henry-Russell. *In the Nature of Materials.* New York: Duell, Sloan and Pearce, 1942.

Wright, Frank Lloyd. *An Autobiography.* New York: Green and Co., 1932.

The Design Process

American Institute of Architects. *Architectural Graphic Standards.* 10th ed. Edited by Charles G. Ramsey and Harold R. Sleeper. New York: John Wiley & Sons, 2000.

Miller, Sam F. *Design Process: A Primer for Architectural and Interior Designers.* New York: John Wiley & Sons, 1995.

Shoshkes, Ellen. *The Design Process.* New York: Whitney Library of Design, 1989.

Planning

Cherry, Edith. *Programming for Design: From Theory to Practice.* New York: John Wiley & Sons, 1998.

DeChiara, Joseph, Julius Panero, and Martin Zelnik. *Time-Saver Standards for Interior Design and Space Planning.* New York: McGraw-Hill, 1991.

Duerk, Donna P. *Architectural Programming: Information Management for Designers.* New York: Van Nostrand Reinhold, 1993.

Karlen, Mark. *Space Planning Basics.* New York: John Wiley & Sons, 1997.

Pena, William. *Problem Seeking: An Architectural Programming Primer.* 3d ed. Washington, D.C.: AIA Press, 1987.

Human Factors and Social Responsibility

AIA and U.S. Environmental Protection Agency. *Environmental Resource Guide.* CD-ROM. New York: John Wiley & Sons, 1999.

Bell, Paul A., et al. *Environmental Psychology.* 5th ed. Fort Worth, Tex.: Harcourt Brace College, 2000.

Bennett, Corwin. *Spaces for People.* Englewood Cliffs, N.J.: Prentice-Hall, 1977.

Daniels, Klaus, *Technology of Ecological Building.* Basel: Birkhauer Verlag, 1997.

Diffrient, Niels, et al. *Humanscale One–Two–Three.* Cambridge, Mass.: MIT Press, 1974.

———. *Humanscale Four–Five–Six.* Cambridge, Mass.: MIT Press, 1981.

Gutman, Robert, ed. *People and Buildings.* New York: Basic Books, 1971.

Hall, Edward T. *The Hidden Dimension.* New York: Doubleday, 1997.

———. *The Silent Language.* Garden City, N.Y.: Doubleday, 1959.

Harrigan, J. E. *Human Factors Research: Methods and Applications for Architects and Interior Designers.* New York: Elsevier Dutton, 1987.

Kim, Leclair, and David Rousseau, *Environmental Design: A Sourcebook of Environmentally Aware Material Choices.* Vancouver BC: Hartley and Marus, 1992.

Landis, Scott, and Edward O. Wilson (eds.) *Conservation by Design.* Providence, R.I.: Rhode Island School of Design, 1993.

Lang, Jon, et al. *Designing for Human Behavior.* New York: McGraw-Hill, 1974.

Lee, Terence. *Psychology and the Environment.* London: Methuen, 1976.

Leibrock, Cynthia. *Beautiful Barrier Free.* New York: Van Nostrand Reinhold, 1993.

Liebrock, Cynthia, and Jamer Terry. *Beautiful Universal Design: A Visual Guide.* 2d ed. New York: John Wiley & Sons, 1999.

MacKenzie, Dorothy. *Green Design: Design for the Environment.* 2d ed. London: Laurence King, 1997.

Newman, Oscar. *Creating Defensible Space.* Upland, PA: Diane Publishing Co., 1997.

Panero, Julius, and Martin Zelnick. *Human Dimensions and Interior Space.* New York: Whitney Library of Design, 1979.

Perin, Constance. *With Man in Mind.* Cambridge, Mass.: MIT Press, 1970.

Schmitz-Guenther, Thomas, Loren Abraham, and Thomas Fisher, eds. *Living Spaces: Ecological Building and Design.* New York: Könemann, 1999.

Sommer, Robert. *Design Awareness.* San Francisco: Rinehart Press, 1972.

———. *Personal Space.* Englewood Cliffs, N.J.: Prentice-Hall, 1969.

———. *Social Design.* Englewood Cliffs, N.J.: Prentice-Hall, 1983.

———. *Tight Spaces.* Englewood Cliffs, N.J.: Prentice-Hall, 1974.

Steele, James, *Sustainable Architecture: Principles, Paradigms, and Case Studies.* New York: McGraw-Hill, 1997.

Sykes, Jane. *Designing Against Vandalism.* New York: Van Nostrand Reinhold, 1980.

U.S. Department of the Interior, National Park Service, *Guiding Principles of Sustainable Design.* Denver, Colorado: 1993.

Weaver, Martin E. *Conserving Buildings.* Rev. ed. New York: John Wiley & Sons, 1997.

Weeks, Kay D., and Anne E. Grimmer. *The Secretary of the Interior's Standards for the Treatment of Historic Properties: with Guidelines for Preserving, Rehabilitating, Restoring, and Reconstructing Historic Buildings.* Washington, D.C.: U.S. Department of the Interior, National Park Service, Cultural Resource Stewardship and Partnerships, Heritage Preservation Services, 1995.

Wilkoff, William L, and Laura W. Abed. *Practicing Universal Design: An Interpretation of the ADA.* New York: John Wiley & Sons, 1993.

Interior Design for Special Needs

Architectural and Transportation Barriers Compliance Board. *Americans with Disabilities Act: Accessibility Guidelines for Buildings and Facilities (ADAAG)/ Architectural and Transportation Barriers Compliance Board.* Washington, D.C.: U.S. Access Board, 1998.

Goldsmith, Selwyn. *Designing for the Disabled: The New Paradigm.* Woburn, Mass.: Butterworth-Heinemann, 1997.

Harkness, S., and J. Groom. *Building Without Barriers for the Disabled.* New York: Whitney Library of Design, 1976.

International Code Council. *Specifications for Making Buildings and Facilities Accessible to and Usable by Physically Handicapped People.* Falls Church, Va.: International Code Council, 1998. (ANSI/ICC A117.1)

Kearney, Deborah. *The New ADA: Compliance and Costs.* Kingston, Mass.: R. S. Means, 1993.

Lebovich, William L. *Design for Dignity: Studies in Accessibility.* New York: John Wiley & Sons, 1993.

Leibrock, Cynthia. *Beautiful Barrier Free: A Visual Guide to Accessibility.* New York: Van Nostrand Reinhold, 1992.

Lifchez, Raymond, and Barbara Winslow. *Design for Independent Living: The Environment and Physically Disabled People.* Berkeley: University of California Press, 1979.

Raschko, Bettyann. *Housing Interiors for the Disabled and Elderly.* New York: Van Nostrand Reinhold, 1991.

Materials and Their Uses

Ballast, David Kent. *Interior Construction and Detailing for Designers and Architects.* Belmont, Calif.: Professional Publications Incorporated. 1998.

Beylerian, George M., and Andrew Dent, *Material ConneXion.* Hoboken, NJ: John Wiley & Sons, 2005.

Clifton-Mogg, Caroline. *Curtains: A Design Source Book.* New York: Stewart, Tabori & Chang, 1998.

DeMoubray, Amicia, and David Black. *Carpets for the Home.* New York: Rizzoli International, 2000.

Eiland, Emmet. *Oriental Rugs Today: A Guide to the Best in New Carpets from the East.* Berkeley, Calif: Berkeley Hills Books, 1999.

Eiland, Murray L. *Oriental Rugs: A New Comprehensive Guide.* Boston: Bulfinch Press, 1981.

Eiland, Murray L., and Murray Eiland III. *Oriental Carpets: A Complete Guide,* Vol. 1. Boston: Little Brown & Company, 1998.

Hornbostel, Caleb. *Construction Materials: Types, Uses, and Applications.* 2d ed. New York: John Wiley & Sons, 1992.

Hull, William R. *Contract Interior Finishes: A Handbook of Materials, Products and Applications.* New York: Watson-Guptill, 1993.

Katz, Sylvia. *Plastics.* New York: Harry N. Abrams, 1984.

Manzinai, Ezio. *The Material of Invention.* Cambridge, Mass.: MIT Press, 1989.

Radford, Penny. *Designer's Guide to Surfaces and Finishes.* New York: Watson-Guptill, 1984.

Riggs, J. Rosemary. *Materials and Components of Interior Design.* 5th ed. Upper Saddle River, N.J.: Prentice-Hall, 1999.

Rupp, William, and Arnold Friedmann. *Construction Materials for Interior Design.* New York: Whitney Library of Design, 1989.

Smith, R. C. *Materials of Construction.* 4th ed. New York: McGraw-Hill, 1987.

Wilhide, Elizabeth. *Floors: A Design Source Book.* New York: Stewart, Tabori & Chang, 1998.

Color

Albers, Josef. *Interaction of Color.* New Haven, Conn.: Yale University Press, 1971.

Birren, Faber. *Color and Human Response.* New York: Van Nostrand Reinhold, 1984.

Evans, Ralph M. *An Introduction to Color.* New York: John Wiley & Sons, 1959.

Fehrman, Kenneth, and Cherie Fehrman. *Color: The Secret Influence.* Upper Saddle River, N.J.: Prentice-Hall, 2000.

Gage, John. *Color and Meaning.* Berkeley: University of California Press, 1999.

Itten, Johannes. *The Art of Color.* New York: Van Nostrand Reinhold, 1961.

Mahnke, Frank H., and Rudolf H. Mahnke. *Color, Environment, and Human Response: An Interdisciplinary Understanding of Color and Its Use as a Beneficial Element in the Design of the Architectural Environment.* New York: John Wiley & Sons, 1997.

Mahnke, Rudolf H., with Frank H. Mahnke. *Color and Light in Man-Made Environments.* New York: John Wiley & Sons, 1997.

Miller, Judith. *Color: Period and Regional Style from Around the World.* New York: Clarkson N. Potter, 2000.

Miller, Mary. *Color for Interior Architecture.* New York: John Wiley & Sons, 1997.

Munsell, A. H. *A Color Notation.* Baltimore: Munsell Color Company, 1981.

Munsell Color Company. *Munsell Book of Color.* Baltimore: Munsell Color Company, 1929.

Pile, John F. *Color in Interior Design.* New York: McGraw-Hill, 1997.

Lighting

Brandi, Ulrike, and Christoph Geissmar-Brandi. *Lightbook: The Practice of Lighting Design.* Basel: Birkhäuser Verlag, distributed by Princeton Architectural Press, New York, 2002.

Burton, Jack L. *Fundamentals of Interior Lighting,* Vol. 1. Upper Saddle River, N.J.: Prentice-Hall, 1999.

Couton, J. R., and A. M. Marsden. *Lamps and Lighting.* 4th ed. New York: John Wiley & Sons, 1997.

Egan, M. David. *Architectural Lighting.* 2d rev. ed. New York: McGraw-Hill, 1999.

Gordon, Gary, and James L. Nuckolls. *Interior Lighting for Designers.* 3d ed. New York: John Wiley & Sons, 1995.

Gruzowski, Mary. *Daylighting for Sustainable Design.* New York: McGraw-Hill, 2000.

Johnson, Glen. *The Art of Illumination: Residential Lighting Design.* McGraw-Hill, 1999.

Kay, Gersil N. *Fiber Optics in Architectural Lighting: Systems, Design, and Applications.* New York: McGraw-Hill, 1999.

Ott, John. *The Effects of Natural and Artificial Light on Man and Other Living Things.* New York: Pocket Books, 1976.

Phillips, Derek. *Lighting Historic Buildings.* New York: McGraw-Hill, 1997.

Rea, Mark, ed. *IESNA Lighting Handbook: Reference and Application.* 9th ed. New York: Illuminating Engineering Society of North America, 1999.

Rooney, William F. *Practical Guide to Home Lighting.* New York: Van Nostrand Reinhold, 1980.

Sorcar, Pratulla C. *Architectural Lighting for Commercial Interiors.* New York: John Wiley & Sons, 1987.

Steffy, Gary. *Architectural Lighting Design.* New York: John Wiley & Sons, 1997.

_____. *Lighting the Electronic Office.* New York: John Wiley & Sons, 1997.

Steffy, Gary, and Gary Woodall. *Time-Saver Standards for Architectural Lighting.* New York: McGraw-Hill, 2000.

Wilhide, Elizabeth. *Lighting: A Design Source Book.* New York: Stewart, Tabori & Chang, 1998.

Textiles

Albers, Anni. *On Weaving.* Middletown, Conn.: Wesleyan University Press, 1965.

Collier, Billie J., and Phyllis G. Tortora. *Understanding Textiles,* 6th ed. Upper Saddle River, N.J.: Prentice-Hall, 2001.

Hardingham, Martin. *The Fabric Catalog.* New York: Simon & Schuster, Pocket Books, 1978.

Harris, Jennifer, ed. *Textiles, 5,000 Years: An International History and Illustrated Survey.* New York: Harry N. Abrams, 1993.

Jackman, Diane, and Mary Dixon. *The Guide to Textiles for Interior Designers,* 2d ed. Winnipeg, Can.: Peguis Publishers, 1986.

Kadolph, Sara J., and Anna L. Langford. *Textiles.* 8th ed. Upper Saddle River, N.J.: Prentice-Hall, 1998.

Larsen, Jack Lenor. *A Weaver's Memoir.* New York: Harry N. Abrams, 1998.

Larsen, Jack Lenor, and Jeanne Weeks. *Fabrics for Interiors.* New York: Van Nostrand Reinhold, 1975.

Meller, Susan, and Joost Eltters. *Textile Designs: Two Hundred Years of European and American Patterns for Printed Fabrics Organized by Motif, Style, Color, Layout, and Period.* New York: Harry N. Abrams, 1991.

Neilson, Karla J. *Understanding Fabrics: A Definitive Guidebook to Fabrics for Interior Design and Decoration.* North Palm Beach, Fla.: L. C. Clark, 1997.

Thorpe, Azalea Stuart, and Jack Lenor Larsen. *Elements of Weaving.* New York: Doubleday, 1967.

Yeager, Jan, and Laura K. Teter-Justice. *Textiles for Residential and Commercial Interiors.* 2d ed. New York: Fairchild Publications, 2000.

Furniture

Boger, Louise Ada. *Furniture, Past and Present.* Garden City, N.Y.: Doubleday, 1966.

———. *The Complete Guide to Furniture Styles.* New York: Charles Scribner's Sons, 1969.

Boyce, Charles. *Dictionary of Furniture.* New York: Roundtable Press, 1985.

Bradford, Peter, and Barbara Prete, eds. *Chair.* New York: Peter Bradford & Thos. Y. Crowell, 1978.

Butler, Joseph T. *Field Guide to American Antique Furniture.* New York: Holt, 1986, 1995 (paper).

Chippendale, Thomas. *The Gentleman & Cabinet-Maker's Director.* Reprint, New York: Dover Publications, 1966.

Crochet, Treena, and David Vleck. *Designer's Guide to Furniture Styles.* Upper Saddle River, N.J.: Prentice-Hall, 1999.

Edwards, Clive. *Encyclopedia of Furniture Materials, Trades and Techniques.* Aldershot, Hants, England, and Brookfield, Vt.: Ashgate, 2001.

Emery, Marc. *Furniture by Architects.* New York: Harry N. Abrams, 1983.

Gandy, Charles D., and Susan Zimermann-Stidham, *Contemporary Classics: Furniture of the Masters.* New York: Whitney Library of Design, 1989.

Garner, Philippe. *Twentieth-Century Furniture.* New York: Van Nostrand Reinhold, 1980.

Hanks, David A. *Innovative Furniture in America from 1800 to the Present.* New York: Horizon Press, 1981.

Hepplewhite, George. *The Cabinet-Maker and Upholsterer's Guide.* Reprint, New York: Dover Publications, 1969.

Kaufmann, Edgar, Jr. *Prize Designs for Modern Furniture.* New York: Museum of Modern Art, 1950.

Landis, Scott, and Edward O. Wilson (eds.) *Conservation by Design.* Providence, R.I.: Rhode Island School of Design, 1993.

Larrabee, Eric, and Massimo Vignelli. *Knoll Design.* New York: Harry N. Abrams, 1981.

Lucie-Smith, Edward. *Furniture: A Concise History.* London: Thames & Hudson, 1985.

Mang, Karl. *History of Modern Furniture.* New York: Harry N. Abrams, 1979.

Noyes, Eliot F. *Organic Design in Home Furnishings.* New York: Museum of Modern Art, 1941. Reprint. New York: Arno Press, 1969.

Ostergard, Derek E., ed. *Bentwood and Metal Furniture 1850–1946.*, New York: American Federation of the Arts, 1987.

Page, Marian. *Furniture Designed by Architects.* New York: Whitney Library of Design, 1980.

Pile, John F. *Furniture: Modern and Postmodern.* New York: John Wiley & Sons, 1990.

Russell, Frank, Philippe Garner, and John Read. *A Century of Chair Design.* New York: Rizzoli International, 1980.

Sheraton, Thomas. *The Cabinet-Maker and Upholsterer's Drawing Book.* Reprint, New York: Dover Publications, 1972.

Walker Art Center. *Nelson, Eames, Girard, Propst: The Design Process at Herman Miller.* Minneapolis: Walker Art Center, *Design Quarterly* (no. 98/99), 1975.

Wanscher, Ole. *The Art of Furniture.* New York: Reinhold Publishing Corp., 1967.

Accessories, Art, Signage

Furuta, Tok. *Interior Landscaping.* Reston, Va.: Reston Pub. Co., 1983.

Gaines, Richard L. *Interior Plantscaping.* New York: Architectural Record Books, 1977.

McLendon, Charles, and Mick Blackstone. *Signage.* New York: McGraw-Hill, 1982.

Mechanical Systems

American Society of Heating, Refrigeration and Air-conditioning Engineers. *ASHRAE Handbook of Fundamentals.* New York: ASHRAE, 1997.

Ching, Frances, and Cassandra Adams. *Building Construction Illustrated.* 3d ed. New York: John Wiley & Sons, 2000.

Cowan, James. *Architectural Acoustics.* New York: McGraw-Hill, 1999.

Flynn, John E., Gary R. Steffy, and Arthur W. Segil. *Architectural Interior Systems.* 2d ed. New York: John Wiley & Sons, 1988.

Harmon, Sharon Koomen and Katherine E. Kennon. *The Codes Guidebook for Interiors*. 2d ed. New York: John Wiley & Sons, 2001.

Stein, Benjamin, and John Reynolds. *Mechanical and Electrical Equipment for Building*. 9th ed. New York: John Wiley & Sons, 2000.

Wilkes, Joseph A., and Robert Packard, eds. *Encyclopedia of Architecture: Design, Engineering and Construction*. 5 vols. New York: John Wiley & Sons, 1988–90.

Special-Purpose Spaces

Brett, James. *The Kitchen: 100 Solutions to Design Problems*. New York: Whitney Library of Design, 1977.

Cerver, Francisco Ascencio. *Lofts: Living and Working Spaces*. New York: Watson-Guptill Publications, 1999.

Conran, Terence. *The Bed and Bath Book*. New York: Crown, 1978.

————. *The Kitchen Book*. New York: Crown, 1977.

Kira, Alexander. *The Bathroom*. 2d ed. New York: Viking Press, 1976.

Kramer, Jack. *Garden Rooms and Greenhouses*. New York: Harper & Row, 1972.

Lee, Vinny. *Kitchens: A Design Source Book*. New York: Stewart, Tabori & Chang, 1998.

Paul, Donna. *The Home Office Book*. New York: Artisan (Workman Publishing Company), 1996.

Slesin, Suzanne, et al. *The International Book of Lofts*. New York: Clarkson N. Potter, 1986.

Tresidder, Jane, and Stafford Cliff. *Living Under Glass*. New York: Clarkson N. Potter, 1986.

Wise, Herbert. *Kitchen Detail*. New York: Quick Fox, 1980.

Public Interiors

Brandt, Peter B. *Office Design*. New York: Watson Guptill, 1992.

Chueca, Pilar, *Office and Corporate Interiors*. Barcelona: Carlos Brato I Comerma, 2005.

Din, Rashied. *New Retail*. London: Conran Octopus, 2000.

Harris, David A. A., William E. Fitch, and Byron Fingen. *Planning and Designing the Office Environment*. 2d ed. New York: John Wiley & Sons, 1990.

Israel, Lawrence J. *Store Planning/Design: History, Theory, Process*. New York: John Wiley & Sons, 1994.

Klein, Judy Graf. *The Office Book*. New York: Facts on File, 1982.

Mack, Lorrie. *Calm Working Spaces*. New York: Harper-Collins, 2000.

Myerson, Jeremy. *New Public Architecture*. London: Laurence King, 1996.

Pile, John F. *Open Office Planning*. New York: Whitney Library of Design, 1978.

Piotrowski, Christine, and Elizabeth Rogers. *Designing Commercial Interiors*. New York: John Wiley & Sons, 1998.

Rutes, Walter A., and Richard H. Penner. *Hotel Planning and Design*. New York: Whitney Library of Design, 1985.

The Business of Interior Design

Cook, Tony. *The ABC's of Architectural and Interior Design Drafting Using AutoCAD*. Upper Saddle River, N.J.: Prentice-Hall, 2000.

Ching, Francis D. K. *Architectural Graphics*. 3d ed. New York: John Wiley & Sons, 1996.

————. *Design Drawing*. New York: John Wiley & Sons, 1997.

Demkin, Joseph, ed. *Handbook of Professional Practice*. 13th ed. Washington, D.C.: AIA Press, 2002.

Diekman, Norman, and John F. Pile. *Drawing Interior Architecture*. New York: Whitney Library of Design, 1983.

————. *Sketching Interior Architecture*. New York: Whitney Library of Design, 1985.

Franklin, James R. *Architect's Professional Practice Handbook*. New York: McGraw-Hill, 2000.

Guthrie, Pat. *Interior Designer's Portable Handbook*. New York: McGraw-Hill, 1999.

Harmon, Sharon Koomen, and Katherine E. Kennon. *The Codes Guidebook for Interiors*. 2d ed. New York: John Wiley & Sons, 2001.

Haviland, David, ed. *Handbook of Professional Practice*. 12th ed. 4 vols. New York: AIA Press, 1994.

Jefferis, Alan, and David A. Madse. *Architectural and Drafting Design*. 4th ed. Albany: Thomson Learning, 2001.

Kirkpatrick, Beverly L., and James M. Kirkpatrick. *AutoCAD for Interior Design and Space Planning*. 3d ed. Upper Saddle River, N.J.: Prentice-Hall, 1999.

Knackstedt, Mary V., and Laura J. Haney. *The Interior Design Business Handbook*. 3d ed. New York: John Wiley & Sons, 2002.

Knoenig, Peter. *Design Graphics: Drawing Techniques for Design Professionals*. Upper Saddle River, N.J.: Prentice-Hall, 2000.

Knoll, W. *Architectural Models: Guide to Construction Techniques*. 2d ed. New York: McGraw-Hill, 1997.

Kurrent, Frederick, ed. *Scale Models: Houses for the 20th Century*. Princeton, N.J.: Princeton Architectural Press, 2000.

Mitton, Maureen. *Interior Design Visual Presentation: A Guide to Graphics, Models, and Presentation Techniques*. New York: John Wiley & Sons, 1999.

Montague, John. *Basic Perspective Drawing: A Visual Approach*. 3d ed. New York: John Wiley & Sons, 1998.

Morgan, Jim. *Management for the Small Design Firm: Handling Your Practice, Personnel, Finances, and Projects*. New York: Watson-Guptill, 1997.

Murphy, Dennis Grant. *The Business Management of Interior Design*. North Hollywood, Calif.: Stratford House Publishing Co., 1988.

Omura, George. *Mastering AutoCAD 2000*. Alameda, Calif.: Sybex, 1999.

Pile, John F. *Perspective for Interior Designers*. New York: Whitney Library of Design, 1985.

Piotrowski, Christine M. *Professional Practice for Interior Designers*. 3d ed. New York: John Wiley & Sons, 2001.

Ratensky, Alexander. *Drawing and Modelmaking*. New York: Whitney Library of Design, 1983.

Reznikoff, S. C. *Interior Graphic and Design Standards*. New York: Whitney Library of Design, 1986.

————. *Specifications for Commercial Interiors*. New York: Whitney Library of Design, 1989.

Sampson, Carol A. *Estimating for Interior Designers: Techniques for Estimating Materials, Costs and Time*. 2d ed. New York: Watson-Guptill, 2001.

Siegel, Harry, and Alan M Siegel. *A Guide to Business Principles and Practices for Interior Designers*. Rev. ed. New York: Watson-Guptill, 1982.

Staebler, Wendy W. *Architectural Detailing in Contract Interiors*. New York: Whitney Library of Design, 1988.

Steele, James, *Architecture and Computers*. New York: Watson-Guptill Publications, 2002.

Stitt, Fred A. *Uniform Drawing Format Manual*. New York: McGraw-Hill, 1999.

Wakita, Osamu A., and Richard M. Linde. *Professional Handbook of Architectural Working Drawings*. 2d ed. New York: John Wiley & Sons, 1987.

————. *The Professional Practice of Architectural Detailing*. New York: John Wiley & Sons, 1999.

Wallach, Paul I., and Donald E. Hepler. *Reading Construction Drawings*. 2d ed. New York: McGraw-Hill, 1990.

Wright, Lawrence. *Perspective on Perspective*. London: Routledge and Kegan Paul, 1983.

Wu, Kingsley. *Modeling and Visualizing Interiors: AutoCAD Release 13 and 13c4*. Upper Saddle River, N.J.: Prentice-Hall, 1998.

Yee, Rendow. *Architectural Drawing: A Visual Compendium of Types and Materials*. New York: John Wiley & Sons, 1997.

Periodicals

Abitare (Milan)
American Craft (New York)
Architectural Digest
Architectural Record (New York)
Domus (Milan)
Interior Design (New York)
Interiors (New York)
Restaurant and Hotel Design (New York)

Websites

Introduction

www.homeportfolio.com A one-stop remodeling site where consumers and homeowners can find referrals and profiles of interior designers.

www.improvenet.com A gallery for both homeowners and professionals for browsing styles and ideas; includes estimators and calculators to figure materials and budget, and an extensive database of products and professionals.

www.nascla.com For checking out contractors' credentials, with links to the licensing boards of almost every state so you can investigate the performance of a contractor.

Human Factors and Social Responsibility

eetd.lbl.gov Home of Lawrence Berkeley National Laboratories Environmental Energy Technologies Division, with information on air quality, energy analysis, indoor environment, building technology, and advanced technologies.

www.buildinggreen.com Home page for the on-line version of *Environmental Building News*, with current information on green building priorities and materials.

www.certifiedwood.org Home for the Certified Forest Products Council, offering database searches about certified forests and suppliers.

www.fscus.org Home for the Forest Stewardship Council, a nonprofit organization supporting environmentally appropriate, societally beneficial, and economically viable management of the world's forests, with current news, standards, and policies.

www.greenseal.org Home of Green Seal, a nonprofit organization promoting the manufacture and sale of environmentally friendly products. Includes standards for products and an index of approved goods.

www.nrdc.org Home for the latest information from the Natural Resources Defense Council on clean air and energy, clean water, toxic chemicals and health, cities and green legislation, and environmental legislation.

www.ran.org Home for the nonprofit Rainforest Action Network, with fact sheets on the rainforest and information on such topics as alternatives to old-growth wood.

www.usgbc.org Home for U.S. Green Building Council, a coalition of business, industry, government and academic leaders promoting green building policies, programs, technologies, standards, and design practices. Includes information on emerging trends, policies, and products and on the LEED™ Rating System for rating the environmental performance of new and existing commercial, institutional, and high-rise residential buildings.

Design for Special Needs

www.access-board.gov A governmental site for information on ADA accessibility guidelines and standards, and best practices related to accessible design.

www.adaptenv.org Home for Adaptive Environments Center, addressing issues that confront people with disabilities and the elderly by promoting accessibility and universal design. Includes basic information, articles, and images on universal design.

www.universaldesign.com On-line version of *Universal Design Newsletter*, including images of universal design excellence plus links to other universal design websites.

www.designlinc.com A website dedicated to providing design resource information for products and services available to the physically handicapped and their caregivers. Includes links to government resources and regulations for accessible design.

Materials and Their Uses

www.ansi.org Home of American National Standards Institute. Supplies the latest information on national and international standards-related activities

www.astm.org Home of American Society for Testing and Materials, with its proficiency test programs for various materials.

www.csinet.org Home of Construction Specifications Institute, representing architects, specifiers, engineers, owners, facility managers, contract administrators, and suppliers, Site of on-line *Construction Specifier* magazine and the National CAD Standard, which offers efficiency in the design and construction process documentation.

www.dhi.org Home of Door and Hardware Institute, a professional organization serving as a resource for education and information on doors, hardware, security, and specialty products.

www.greenguard.org Home of Greenguard Environmental Institute, a nonprofit organization that oversees the Greenguard certification program. GEI's mission is to improve public health and quality of life by improving indoor air.

www.hpva.com Home of Hardwood Plywood & Veneer Association, a professional organization providing industry statistics and news about new developments and technology affecting the industry.

www.nofma.org Home of National Oak Flooring Manufacturers Association, with information on estimating, installing, finishing, and caring for hardwood floors and answers to frequently asked questions.

www.pbmdf.com Home of *The World of Engineered Wood*, on-line newsletter of the Composite Panel Association and Composite Wood Council, with technical information, industry standards for engineered wood, and links to related industry associations, directory sites, building-code organizations, and more.

www.tileusa.com Home of Tile Council of America, a trade association of U.S.-based manufacturers and installers of tile, with a mechanism for answering questions about tile and help in solving technical problems.

Color

www.hermanmiller.com Home site for a leading non-residential furniture manufacturer that includes a research feature that leads to research papers on colorimetry, the science of the measurement and analysis of color, as it relates to commercial interiors.

www.interiordec.about.com/od/color. Facts about choosing and using color, including trends and tips on coordinating a color scheme. Compiled from a variety of commercial sources.

Lighting

eetd.lbl.gov Home of Lawrence Berkeley National Laboratories Environmental Energy Technologies Division, with a link to their Home Energy Saver website for solid information on lighting and lighting controls.

www.americanlightingassoc.com Home of American Lighting Association, a trade group providing consumer resources for general lighting and for lighting kitchens, bathrooms, and landscapes. The site also lists consultants and showrooms.

www.gelighting.com Home of General Electric, with information on all aspects of lighting related to home and business, including the quality of lighting and the Color Reading Index (CRI). Take an interactive tour of a virtual house and visit the Lighting Solution Center and the Lighting Institute.

www.iesna.org Home of the Illuminating Engineering Society of North America, with examples of lighting design.

www.lightingresource.com An on-line lighting resource with product profiles by advertisers, photometric data, and other related information.

www.lrc.rep.com Home of Rensselaer Polytechnic Institute's Lighting Research Center, the largest university-based lighting research and education organization, providing independent, objective information about energy- efficient quality lighting technologies, including surveys, consumer information, commercial and residential lighting news, and tutorials.

www.lsc.rpi.edu/programs/NLPIP Home of National Lighting Product Information Program, an on-line store and an objective source of manufacturers' specific performance information and evaluation of lighting products.

Textiles

www.carpet-rug.com Home for Carpet and Rug Institute, a trade association representing manufacturers and suppliers of residential and commercial carpets, rugs, and flooring, with useful information on selecting, care and cleaning, installation, indoor air quality, and technical matters, and the Green Label testing program.

www.ansi.org Home for American National Standards Institute, an accreditation organization, with information on the institute's latest national and international standards-related activities.

www.astm.org Home of American Society for Testing and Materials, with its proficiency test program for textiles.

www.atmi.org Home for American Textiles Manufacturers Institute, with a textile-buyer's guide to fabrics, home furniture, yarn, thread, and specialty finishes.

www.textileweb.com Home for National Association of Floor Covering Distributors, with information on standards and links to government and standards-related sites.

www.nfpa.org Home for National Fire Protection Association, with information on its building code and news related to it.

Furniture

www.dwr.com Home for Design Within Reach, offering high-end reproductions of classic modern designs.

Accessories, Art, Signage

www.artfact.com Source for art and antiques by category, including price.

www.novica.com Source for handcrafted works or art and home decoration, including paintings, ceramics, and sculptures.

Mechanical Systems

www.b4ubuild.com Information about building codes and standards, with links to code books, national and international councils, officials, building-permit departments, model energy codes, and residential construction guidelines.

www.bcap-energy.org Home of the Building Codes Assistance Project, the purpose of which is to accelerate the implementation of energy codes.

www.jccsafe.org BOCA International Code Council provides all types of building codes—southern building codes, international fire codes, international residential codes. Their site includes proposed code changes.

www.ce.net Home of the Consumer Electronics Association (CEA), a source of information about the consumer electronics industry.

www.cedia.org Home of the Custom Electronic Design & Installation Association, a trade group of companies specializing in planning and installing electronic systems for the home, typically media rooms or multiroom entertainment. Includes links and searchable directories.

www.electronichouse.com Home of EH Publishing's *Electronic House Online*, a consumer magazine focusing on integrated home electronics and connectivity.

www.icbo.org Home of ICBO Code Central, put up by the International Conference of Building Code Officials, developer and publisher of the International Building Code, Uniform Building Code, and fire, mechanical, plumbing, zoning and related codes for construction. Includes an on-line version of *Building Standards* magazine.

www.siaonline.org Home of Security Industry Association (SIA), a full-service clearinghouse and trade association representing manufacturers of security products and services, with information on security industry standards and new products.

Special-Purpose Spaces

www.faucet.com Best of the on-line kitchen and bath fixtures showrooms.

www.hermanmiller.com Home site for a leading nonresidential furniture manufacturer that includes a research feature that leads to research papers on space planning and other issues related to commercial interiors.

The Business of Interior Design

www.architecturalrecord.com Website for the *Architectural Record* Digital Architect feature, with articles ranging from technology tools for drawing to marketing and many other aspects of a design business.

Illustration Credits

Chapter One

Fig. 1.1 © Jeff Goldberg/Esto. All rights reserved; fig. 1.13 Photo: Michael Weber; fig. 1.15 Rendering by AMD; fig. 1.16 H3 Hardy Collaboration Architecture.

Chapter Two

Fig. 2.4 © Paul Warchol Photography, Inc.; fig. 2.5 © Peter Cook/VIEW; figs. 2.7, 2.9 National Museum of Natural History, Washington, D.C.

Chapter Three

Fig. 3.2 Feliciano, courtesy *House & Garden*. Copyright © 1984 by The Condé Nast Publications, Inc.; fig. 3.4 © Dennis Gilbert/VIEW; fig. fig. 3.13 Photo: Alberto Ferrero; fig. 3.14 © Scott Frances/Esto; fig. 3.15 From David Linley's *Design & Detail in the Home*. Photography by Jan Baldwin; fig. 3.24 Based on illustration in Le Corbusier, *Towards a New Architecture* (1932); fig. 3.39 © Paul Warchol Photography, Inc.; fig. 3.40 Antoine Bootz, courtesy *Metropolitan Home*. Reprinted with permission from *Metropolitan Home Magazine* © 1990. Hachette Filipacchi USA Inc.

Chapter Four

Fig. 4.1 Photo: Alfredo Dagliorti/© The Art Archive/Corbis; fig. 4.4 Model of Garden and Portico of a House. Wood, painted. From Tomb of Meket-Re. The Metropolitan Museum of Art, New York, Museum Excavation, 1919–20; Rogers Fund, supplemented by contribution of Edward S. Harkness. (20.3.13); fig. 4.7 From *Priene* by T. Wiegand and H. Schrader (1904); figs. 4.9, 4.21 From Palladio, *The Four Books of Architecture* (NY: Dover, 1965); fig. 4.18 Chair. Carved decoration. Oak. H. 68½, W. 28¼, D. 17¾". The Metropolitan Museum of Art, New York, Gift of J. Pierpont Morgan, 1916. (16.32.18) © 2002 The Metropolitan Museum of Art, New York; fig. 4.19 From *Letarouilly on Renaissance Rome* by John Barrington Bailey; fig. 4.27 Room from the Hôtel de Varengeville, Paris. Commissioned c. 1735 by the Duchess of Villars. Oak, painted white and gilded. Designer: Nicolas Pineau, 1684–1754. L. 40' 6½", W. 23' 2½", H. 18' 3¾". The Metropolitan Museum of Art, New York, acquired with funds given by Mr. and Mrs. Charles Wrightsman, 1963. (63.228.1) Photo © 2002 The Metropolitan Museum of Art, New York; fig. 4.28 Courtesy Bernard & S. Dean Levy, Inc., NY; fig. 4.38 © Wayne Andrews/Esto. All rights reserved; fig. 4.39 Percier and Fontaine. Vue due la Tribune et d'une partie de la Salle de Maréchaux, au Palais des Tuileries. From *Recueil de Décorations Intérieurs, Engraving*. The Metropolitan Musem of Art, New York, Harris Brisbane Dick Fund, 1928. (28.40.1[P1.49]); fig. 4.40 Hope, Thomas. *Household Furniture and Interior Decorations* (1807). The Metropolitan Museum of Art, New York, Harris Brisbane Dick Fund, 1930. (30.48.1); fig. 4.44 © John Pile; fig. 4.62 Wright, Frank Lloyd, office armchair. 1904–06. Painted steel, oak seat, 37½ x 24¹¹⁄₁₆ x 21⅛" (95.2 x 62.7 x 53.6 cm); seat height: 19" (48.2 cm). The Musem of Modern Art, New York. Gift of Edgar Kaufman, Jr. Photograph © 2002 The Museum of Modern Art, New York; fig. 4.63 © The Solomon R. Guggenheim Foundation, NY; fig. 4.65 Brandt, Marianne. Teapot. 1924. Nickel silver and ebony, height 7 x width 9" (height 17.8 x width 22.8 cm). Manufacturer: Bauhaus Metal Workshops, Weimar, Germany. The Museum of Modern Art, New York. Photo © 2002 The Museum of Modern Art, New York; fig. 4.67 Mies van der Rohe, Ludwig. German Pavilion. Barcelona, Spain. 1928–1929. Photograph courtesy the Mies van der Rohe Archive, The Museum of Modern Art, New York; fig. 4.69 Le Corbusier (Charles-Édouard Jeanneret), with Pierre Jeanneret. Villa Savoye. Model. 1929–31. Wood, aluminum and plastic, 25½ x 22½ x 11⅛" (64.8 x 57.2 x 28.2 cm). The Museum of Modern Art, New York. Exhibition Fund. Photograph © 2001 The Museum of Modern Art, New York; figs. 4.75, 4.80, 4.81 © Ezra Stoller/Esto. All rights reserved; figs. 4.85, 4.84 © Jeff Goldberg/Esto. All rights reserved; figs. 4.87, 4.88 © Peter Mauss/Esto. All rights reserved; fig. 4.90 Freer Gallery of Art, Smithsonian Institution, Washington, D.C.: Gift of Charles Lang Freer, F1904.61; fig. 4.92 Chair. Wood. Chinese. IVIII, c.1700. The Metropolitan Museum of Art, New York, Seymour Fund, 1967. (67.58); fig. 4.100 © Roger Wood/Corbis; fig. 4.101 Garden Rug. Wool, cotton. Persian. 18th c. The Metropolitan Museum of Art, New York, The James F. Ballard Collection, Gift of James F. Ballard, 1922. (22.100.128)

Chapter Five

Fig. 5.12 © Rpbw, Renzo Piano Building Workshop; fig. 5.13 Photo: Michel Denancé/© Rpbw, Renzo Piano Building Workshop; fig. 5.15 Courtesy Richard Meier & Partners Architects LLP/dbox; fig. 5.16 Olson Sundberg Kundig Allen Architects; fig. 5.25 Kirshenbaum Bond & Partners West; fig. 5.28 © Marcus Buck; fig. 5.29 © COOP HIMMELBLAU; fig. 5.30 Venturi, Scott Brown and Associates, Inc.; fig. 5.31 Venturi, Scott Brown and Associates, Inc.; fig. 5.32 Photo: Matt Wargo.

Chapter Six

Fig. 6.29 From *Japanese Style* by Suzanne Slesin, Stafford Cliff, Daniel Rozensztroch, and Gilles de Chabaneix. Copyright © 1987 by Suzanne Slesin, Stafford Cliff, Daniel Rozensztroch, and Gilles de Chabaneix. Reprinted by permission from Crown Publishers, Inc. All rights reserved.

Chapter Seven

Figs. 7.18, 7.20 © Jeff Goldberg/Esto. All rights reserved.

Chapter Eight

Fig. 8.11 © Wolfgang Hoyt/Esto. All rights reserved; fig. 8.13, From *Interior Design Reference Manual* by David K. Ballast with permission from the publisher, Professional Publications, Inc., copyright 1992.

Chapter Nine

Fig. 9.6 From *Interior Graphic and Design Standards* by S. C. Reznikoff. Copyright © 1986 by S. C. Reznikoff. Published by Whitney Library of Design, an imprint of Watson-Guptill Publications, New York; fig. 9.7 Photo: © Mark Darley/Esto. All rights reserved; figs. 9.8A, B, 9.10B–D Copyright © Farrell Design Associates; adapted from *Construction Materials for Interior Design* by William Rupp and Arnold Friedmann. Reproduced by permission of Watson-Guptill Publications. Illustrations copyright © by Philip Farrell; figs. 9.12, 9.14 Adapted from *The Visual Handbook of Building and Remodeling* by Charles G. Wing. © 1990 Charles Wing; figs. 9.13, 9.15 © Farrell Design Associates; adapted from *Construction Materials for Interior Design* by William Rupp and Arnold Friedmann; fig. 9.19 © Scott Frances/Esto. All rights reserved; figs. 9.54, 9.55, 9.56 From *Interior Graphic and Design Standards* by S. C. Reznikoff. Copyright © 1986 by S. C. Reznikoff. Published by Whitney Library of Design, an imprint of Watson-Guptill Publications, New York.

Chapter Ten

Fig. 10.1 Photo: Jean-Michel Landecy; fig. 10.5 Photo: Michael Weber; fig. 10.9 Martin-Senour Paints. From *Theory and Use of Color* by Luigina De Grandis, copyright © 1984 Arnoldo Mondadori Editoria SpA, Milan.fig. 10.16 From *Theory and Use of Color* by Luigina De Grandis, copyright © 1984 Arnoldo Mondadori Editors SpA, Milan; fig. 10.26 From *Theory and Practice of Color* by Frans Gerretsen. Uitgenerij Cantecleer BV, The Netherlands. Courtesy Uitgeverij Cantecleer BV, The Netherlands; figs. 10.27, 10.28 Reproduced with permission of the NCS-Scandinavian Color Institute, Stockholm; fig. 10.45 © Peter Aaron/Esto. All rights reserved.

Chapter Eleven

Fig. 11.4 From *Theory and Use of Color* by Luigina De Grandis, copyright © 1984 Arnoldo Mondadori Editors SpA, Milan; fig. 11.5 © Peter Mauss/Esto; fig. 11.6 © Gerald Zugmann; figs. 11.13, 11.41 © Peter Aaron/Esto. All rights reserved; fig. 11.45 Courtesy Flos.

Chapter Twelve

Fig. 12.1 Courtesy Pollack; fig. 12.15 © 1985 Michael Skott. From *Mary Emmerling's American Country West*, copyright © 1985 by Mary Ellisor Emmerling. Used by permission of Clarkson N. Potter, Inc.

Chapter Thirteen

Fig. 13.6 Rietveld, Garrit. "Red and Blue" Chair. (c. 1918) Wood, painted, height 34⅛"; width 26"; depth 26½" (86.5 x 66 x 83.8 cm); seat height: 13" (33 cm). The Museum

of Modern Art, New York. Gift of Philip Johnson. Photograph © 2002 The Museum of Modern Art, New York; fig. 13.7 J. M. Hasbrouck, Windsor armchair, 1752–87, 36 ¼ x 22 ¼ x 22 ¼". Gift of Emily Crane Chadbourne, 1952.943. Photo © The Art Institute of Chicago. All rights reserved; figs. 13.22, 13.23 © Ezra Stoller/Esto. All rights reserved; fig. 13.30 Courtesy Haworth; fig. 13.39 Gebrüder Thonet, company design, Rocking Chair. c. 1860. Beechwood, cane, height 37 ⅝", width, 22 ¾", depth, 42 ½" (95.6 x 57.8 x 107.9 cm). Manufacturer: Gebrüder Thonet, Vienna, Austria. The Museum of Modern Art, New York. Photograph © 2002 The Museum of Modern Art, New York; fig. 13.52 Belter, John Henry, attributed to. Tete-à-tete. Rosewood, ash, pine, walnut. H. 44 ½, W. 52, D. 43". (113.0 x 132.1 x 109.2 cm) The Metropolitan Museum of Art, New York, Gift of Mrs. Charles Reginald Leonard, in memory of Edgar Welch Leonard, Robert Jarvis Leonard, and Charles Reginald Leonard, 1957. (57.130.7); fig. 13.53 Easy Chair. Caleb Gardner. Walnut, maple. 46 ⅜ x 32 ⅜ x 25 ⅞". (117.8 x 82.2 x 65.7 cm.) View: front. The Metropolitan Museum of Art, New York, Gift of Mrs. J. Insley Blair, 1950. (50.228.3); fig. 13.62 Rocking Chair, Alta Loma, California, 1975. Sam Maloof (born 1916). Walnut. 45 x 27 ¾ x 46". (114.3 x 70.5 x 116.8 cm). Purchased through funds from the National Endowment for the Arts and the Gillette Corporation. Courtesy, Museum of Fine Arts, Boston. Reproduced with permission. © 2000 Museum of Fine Arts, Boston; fig. 13.63 From *Freestyle* by Tim Street-Porter, published by Stewart, Tabori & Chang.

Chapter Fourteen

Fig. 14.11 Lizzie Himmel, courtesy *House Beautiful*. Reprinted by permission from *House Beautiful*, copyright © August 1986. The Hearst Corporation. All rights reserved; fig. 14.17 Copyright © 1985 by Catherine Sabino and Angelo Tondini. Used by permission of Clarkson N. Potter, Inc.; fig. 14.22 From *Interior Graphic and Design Standards* by S.C. Reznikoff. Copyright © 1986 by S.C. Reznikoff. Published by Whitney Library of Design, an imprint of Watson-Guptill Publications, New York.

Chapter Fifteen

Fig. 15.1 Photo: Benny Chan; figs. 15.2, 15.4, 15.5, 15.6 Adapted from *The Visual Handbook of Building and Remodeling* by Charles G. Wing. © 1990 Charles Wing.

Chapter Sixteen

Fig. 16.1 © Paul Warchol Photography, Inc.; fig. 16.9 From David Linley's *Design & Detail in the Home*. Photography by Jan Baldwin; fig. 16.11 Courtesy Poggenpohl; fig. 16.13 Courtesy AGA; fig. 16.17 Photo: Diane Padys. From *Creative Kitchens*, copyright © 1984 by Knapp Communications Corp., courtesy *Home Magazine*; fig. 16.21 from *Japanese Style* by Suzanne Slesin, Stafford Cliff, Daniel Rozensztroch, and Gilles de Chabaneix. Copyright © 1987 by Suzanne

Slesin, Stafford Cliff, Daniel Rozensztroch, and Gilles de Chabaneix. Reprinted by permission from Crown Publishers, Inc.; fig. 16.25 From *Kitchens* by Chris Casson Madden. Copyright © 1993 by Interior Visions, Inc. Reprinted by permission of Crown Publishers, Inc.; fig. 16.26 Bernard Tschumi Architects; fig. 16.30 Courtesy Kohler; fig. 16.32 Courtesy Kohler; fig. 16.34 Courtesy TOTO USA; fig. 16.39 Charles Maraia, courtesy *Metropolitan Home*. Reprinted with permission from *Metropolitan Home Magazine* © 1991. Hachette Filipacci USA Inc.; fig. 16.42 © Paul Warchol Photography, Inc.; fig. 16.45 © Peter Aaron/Esto. All rights reserved; fig. 16.54 © Peter Mauss/Esto. All rights reserved; fig. 16.59 From *Mary Emmerling's American Country West*, copyright © 1985 by Mary Ellisor Emmerling. Used by permission of Clarkson N. Potter, Inc.

Chapter Seventeen

Fig. 17.1 Photo: Pino Musi; fig. 17.14 © Peter Mauss/Esto. All rights reserved; fig. 17.15 © floto + warner; fig. 17.16 Photo: Phil Meech; figs. 17.2, 17.29, 17.39 © Peter Aaron/Esto. All rights reserved; figs. 17.10, 17.19 ©Wolfgang Hoyt/Esto. All rights reserved; fig. 17.21 Photo: Augustin Ochsenreiter; fig. 17.22 Photo: Martyn Thompson; fig. 17.23 Photo: Jean-Michel Landecy; fig. 17.26 © Roland Halbe; fig. 17.28 Photo: © Scott Frances/Esto. All rights reserved; fig. 17.38 © Duccio Malagamba; fig. 17.40 © Ezra Stoller/Esto. All rights reserved; fig. 17.44 © Christian Richters.

Index